Yale Publications in the History of Art, 25
Vincent Scully, Editor

The Ancient View of Greek Art:

Criticism, History, and Terminology

J. J. Pollitt

New Haven and London, Yale University Press, 1974

Designed by John O. C. McCrillis
and set in Baskerville type.
Printed in the United States of America by
The Murray Printing Co., Forge Village, Massachusetts.

Published in Great Britain, Europe, and Africa by
Yale University Press, Ltd., London.
Distributed in Latin America by Kaiman & Polon,
Inc., New York City; in Australasia and Southeast
Asia by John Wiley & Sons Australasia Pty. Ltd.,
Sydney; in India by UBS Publishers' Distributors Pvt.,
Ltd., Delhi; in Japan by John Weatherhill, Inc., Tokyo.

In Memoriam
Otto J. Brendel

In Memoriam
Otto J. Brendel

Contents

Acknowledgments

The possibility that considerable light might be shed on the art criticism of the ancient Greeks by a close analysis of their critical terminology was first strongly impressed on me by a lecture given by Otto Brendel in 1960. My inclination to pursue the interest which this lecture aroused was generously encouraged by Professor Brendel and eventually resulted in a doctoral dissertation, "The Critical Terminology of the Visual Arts in Ancient Greece" (Columbia University, 1963), under his direction. In the intervening years I have altered, revised, and extended many of the ideas in that dissertation, and occasionally dropped some; but the insights which I owe to Otto Brendel, particularly his insight into the great importance of what will here be called "professional criticism," remain intact. This book is respectfully dedicated to him.

The nature of the subject of this study has often led me out of the history of art, where I would claim to have my academic "home," into related fields such as philosophy, literary criticism, and linguistics, where my lack of expertise may leave some readers unsatisfied. I would only plead that this topic needed doing, and to have shied away from it in order to escape criticism would have involved an academic cowardice which is probably worse than academic recklessness. Many colleagues have helped me to avoid errors I might otherwise have made. I am particularly grateful to Evelyn B. Harrison, Charles A. Kahn, and Emily Vermeule for their advice, criticism, and encouragement. The late Rudolf Wittkower, the late Moses Hadas, and Albert Hofstadter also gave me valuable suggestions, as has my colleague E. D. Francis. I would also like to express my gratitude for the highly sensible and productive editorial advice of Robin Bledsoe, Judith Yogman, and Edward Tripp of Yale University Press.

Postscript:

Otto Brendel died suddenly while this book was in the page proof stage. His broad, humane outlook on the history of art in general, and his profound insight into the nature of ancient art in particular, were an inspiration to his many students over the years. He always made us feel that both art and scholarship about art were deeply serious pursuits and that we should try to ask important questions about them.

Abbreviations

The abbreviations for periodicals and series used here are those recommended in the *American Journal of Archaeology* 74 (1970): 3–8. Abbreviations for Classical authors and their works, with the exception of those of Lucian, are taken from the *Oxford Classical Dictionary*, 2d ed. (Oxford, 1970). Abbreviations for the works of Lucian are those given in *LSJ*[9] (see below). The following abbreviations are also employed:

Brunn, *GGK*[2]	Brunn, Heinrich. *Geschichte der griechischen Künstler*. 2d ed. Stuttgart, 1889.
Diels, *Fragmente*[7]	Diels, Hermann, and Krantz, Walther. *Fragmente der Vorsokratiker*. 7th ed. Leipzig, 1949–54.
Ferri, *NC*	Ferri, Silvio. "Nuovi contributi esegetici al 'canone' della scultura greca." *Rivista del Reale Istituto d'Archeologia e Storia dell'Arte* 7 (1940): 117–52.
Ferri, *Vitruvio*	Ferri, Silvio. *Vitruvio, Architettura dai Libri I-VII*. Rome, 1960.
Jahn, *UKP*	Jahn, Otto. "Über die Kunsturtheile bei Plinius." *Berichte der königlichen sächsischen Gesellschaft der Wissenschaften, Phil.-Hist. Classe* 2 (1850): 104–42.
Loewy, *IgB*	Loewy, Emanuel. *Inschriften griechischer Bildhauer*. Leipzig, 1885.
LSJ[9]	Liddell, H. G.; Scott, Robert; and Jones, Henry Stuart. *A Greek-English Lexicon*. 9th ed. Oxford, 1940.
Overbeck, *Schriftquellen*	Overbeck, Johannes A. *Die antiken Schriftquellen zur Geschichte der bildenden Künste bei den Griechen*. Leipzig, 1868.
Richter, *SSG*[4]	Richter, Gisela M. A. *The Sculpture and*

Sculptors of the Greeks. 4th ed. New Haven, 1970.

Robert, *Arch. März.* Robert, Carl. *Archäologische Märchen aus alter und neuer Zeit*. Philologische Untersuchungen, zehntes Heft. Berlin, 1886.

Schlikker, *HV* Schlikker, F. W. *Hellenistische Vorstellungen von der Schönheit des Bauwerks nach Vitruv*. Berlin, 1940.

Schweitzer, *Xenokrates* Schweitzer, Bernhard. "Xenokrates von Athen." *Schriften der Königsberger Gelehrten Gesellschaft, Geistwissenschaftliche Klasse* 9 (1932): 1–52.

Sellers, *EPC* Sellers, Eugénie. *The Elder Pliny's Chapters on the History of Art*. Translated by K. Jex-Blake. London, 1896; reissued Chicago, 1966.

Von Arnim, *SVF* Von Arnim, H. F. A. *Stoicorum Veterum Fragmenta*. Leipzig, 1903.

The Ancient View of Greek Art

Prologue

This book attempts to answer a straightforward question: What did the ancient Greeks think about their own art? But while the question may be simple, the evidence upon which one must draw in order to provide an answer for it is often very complicated. We know that Greeks with a wide variety of backgrounds and interests—artists, philosophers, rhetoricians, historians, guidebook writers, for example—wrote about art in antiquity, but the works of very few of them have survived. Most of the extant evidence for the Greek view of Greek art occurs in the works of authors who, while discussing some other subject, make passing references to art for the purpose of analogy or illustration. The modern student who wishes to form a coherent picture of the development of Greek art criticism is therefore faced with the problem of assembling, organizing, and trying to make sense out of a mass of fragmentary information.

The point of departure selected in this study is the critical terminology of the Greeks, the terms they used to describe and evaluate sculpture, painting, and architecture. Critical terms represent ideas—values, preoccupations, even fixations—which survived over generations, and their use over generations provides us with a slim but continuous thread in Greek art criticism. By studying when different terms originated, who used them, how, and for how long, a coherent view of art criticism in ancient Greece begins to emerge.

For our purposes a *term* may best be defined as a word or phrase characteristic of a particular discipline and having a precise and limited meaning agreed upon and understood by those participating in or familiar with that discipline. The rigidity of the meaning of a particular term will, of course, vary with the degree of cohesiveness in the group which uses it. When a term like *symmetria* is used by a late antique rhetorician, one should probably not expect it to have the rigorous precision of meaning that it conveyed to a sculptor of the fifth century B.C. In general, it may be expected that the technical value of a particular term—that is, the value which is dependent upon the special knowledge and training of a particular group—will diminish as the size of the group using the term increases.

It is my intention to state the conclusions of this inquiry in as ob-

1

jective a manner as possible. No one who writes about art can completely suppress his own principles and predilections, and most authors who write about Greek art today make no attempt to do so. Each of us has a tendency to assume that we see ancient art very much as the ancients saw it. Yet we differ greatly among ourselves, and depending on our disposition to charity, we are apt to ascribe the divergent opinions of others to "a difference of viewpoint," "an error in judgment," or simply "blindness." One viewer may see a Greek *kouros* as a vibrant image of primeval animal vigor; another may see it as a careful exercise in anatomical observation; still another, as a tentative, ineffective solution to the challenge of carving a stone block.[1] Each view may be a partially accurate reflection of the intentions and preoccupations of the artist who made the *kouros*, but each cannot be exclusively correct. In this study it is my intention not so much to express personal opinions as to assess evidence. The critical terms of ancient Greek art criticism might be described as semantic crystals solidified out of the molten material of Greek aesthetic experience. Each term introduces us to standards and interests that can be objectively demonstrated to some extent. A number of the terms I shall discuss reveal, I must confess, principles of art criticism that to me seem trivial and at times even absurd, but I have tried to avoid letting these feelings inhibit my presentation of such principles. We can best reconstruct the nature of ancient art criticism by letting the sources speak for themselves. We need not always admire the result.

While it is my professed intention to see ancient art as the ancients saw it, I do not insist that this is the only, or even the most valid way to see it. It is a commonplace of art history that a great work of art achieves an independent existence which partially transcends the time and circumstances of its creation. Each age discovers something in the work of art that it finds particularly moving and significant. What they discover may never have occurred to or been felt by the artist who made it, but our own aesthetic experience is no less valid simply because it does not duplicate the experience of an earlier generation. A modern American may admire the Charioteer of Delphi without knowing or caring what it meant to the Greeks. It may be that we now admire works (such as the *kouroi*) which were considered hardly worthy of regard throughout most of antiquity. On the other hand, it is equally true that knowing something about how the ancient Greeks judged

their own art can, without stifling or enslaving our independent powers of criticism and appreciation, give us a useful perspective in making our evaluation of it. Therein, I would hope, lies the value of a study like the present one.[2]

We are all influenced, consciously or unconsciously, by two major critical attitudes toward Greek art that have been current since the Renaissance—*idealism* and *naturalism*. The basic idea behind idealism in the criticism of Greek art is that the images created by the Greeks mark a state of formal and moral perfection which, being perfect, cannot be improved upon and hence can only be emulated. Adherents of idealism hold that all the elements of physical beauty, balance of proportion, and spiritual nobility that one sees intermittently in day-to-day life come into single focus in a Greek statue. In the fifteenth and sixteenth centuries emulation of the Classical ideal was frequently more intellectual and emotional than practical. Vasari, like virtually all his contemporaries, was an admirer of ancient art and yet felt no hesitation about declaring that Michelangelo and Raphael not only rivaled the ancients but clearly surpassed them.[3] In the seventeenth and eighteenth centuries, however, the Classical ideal came to be treated with less aplomb. Under the growing influence of Platonism and Neoplatonism[4] the "idea" behind the "ideal" was reacquiring its ancient immutability. Theoreticians of art, such as Giovanni Paolo Lomazzo, Federigo Zuccaro, and Giovanni Pietro Bellori, helped to promote the growth of *academic classicism*, a long-lived subdivision of Renaissance idealism. The basis of classicism is the feeling that a single standard of perfection in all the arts has been achieved in the past and should be preserved by later generations. The artist's goal is to analyze, understand, and imitate that standard of perfection. Usually it is said to have a kind of intellectual existence, like a Platonic "idea," which can be expressed in a practical way by certain proportions, shapes, and colors. One of the most important and characteristic documents in the classicistic tradition is the chapter called "The Idea of the Painter, the Sculptor and the Architect chosen from the higher natural beauties of nature" from Bellori's *Lives of Modern Painters, Sculptors and Architects* published in 1672. This work had considerable influence on the thinking of the Royal Academy of Painting and Sculpture in France (founded in 1648) which, although later undergoing changes in name and organization, remained a citadel of classi-

3

cism up to the nineteenth, if not the twentieth, century and was in many ways prototypical for other academies.[5] Bellori's attitude toward ancient Greek art is exemplified by the following passage:

> Nature always means to produce excellence in its workings; nevertheless forms are altered through the inequality of matter, and human beauty is particularly muddled, as we see from the countless deformities and disproportions that are in all of us.
>
> For this reason the noble painters and sculptors imitate the first creator and also form in their minds an example of superior beauty and, reflecting on it, improve upon nature until it is without fault of color and line.
>
> This *Idea*, or, we might say, goddess of painting and sculpture, after opening the sacred curtains of the exalted genius of men like Daedalus and Apelles, unveils herself to us, and descends upon marbles and canvases.[6]

The two artists named, Daedalus and Apelles, were to the classicist archetypal names signifying Greek sculpture and painting. When one thought of the ideal, one immediately thought of Greek art. Bellori's faith in the perfection of ancient art is expressed with even greater fervor when he turns to architecture.

> But in respect to the decoration and ornaments of the orders, he [the architect] may be certain to find the *Idea* established and based on the examples of the ancients, who as a result of long study established this art; the Greeks gave it its scope and best proportions, which are confirmed by the most learned centuries and by the consensus of a succession of learned men, and which became the laws of an admirable *Idea* and a final beauty. This beauty, being one only in each species, cannot be altered without being destroyed. Hence those who with novelty transform it, regrettably deform it; for ugliness stands close to beauty, as the vices touch the virtues. Such an evil we observe unfortunately at the fall of the Roman Empire, with which all the good arts decayed, and architecture more than any other; the barbarous builders disdained the models and the *Ideas* of the Greeks and Romans and the most beautiful monuments of antiquity, and for many centuries frantically erected so many and such various fantastic phantasies of orders that they rendered it monstrous with the ugliest disorder.[7]

Naturalism, the second major critical concept which has been attached to Greek art since the Renaissance, is, oddly enough, the antithesis of idealism. The idea that the great achievement of Greek

art was to represent nature as it really is (or at least to simulate our optical experience of it), rather than to represent it by schematic formulas, is probably a direct outgrowth of the rise of scientific archaeology in the last one hundred years.

The classicists of the seventeenth and eighteenth centuries had very little factual knowledge about Greek art. Scarcely anyone could distinguish a Greek original from a Roman copy, and a large portion of the Greek art then known was, in fact, in the form of Roman copies. Greece itself had been under Turkish domination for several centuries and was visited relatively seldom by western Europeans.

Toward the middle of the eighteenth century these conditions began to change. Stuart and Revett's extensive trip through Greece in 1751–54 resulted in the publication of several magnificent volumes of engravings of the antiquities of Athens and finally introduced Europe to original Greek works of the Classical period. The first remotely scientific excavation of Classical sites began to be carried out at Pompeii (1748) and Herculaneum (1738). In the wake of new information such as this came Johann Joachim Winckelmann's *Geschichte der Kunst des Altertums*, published in 1764, the first work that sought to find a sequential development in Greek art from tentative beginnings to developed masterpieces. His attempts to collect accurate technical information about ancient art and to arrange the extant monuments in some kind of historical sequence set a pattern for scholars, particularly in Germany, in the nineteenth century. The establishment of an independent constitutional monarchy in Greece after the revolution of 1821 made access to the monuments of Greece itself increasingly easy, and the Winckelmann tradition was carried on with increasing precision by the researches of scholars like Karl Otfried Müller (1797–1840), Heinrich Brunn (1822–94), and Adolph Furtwängler (1853–1907). These and other scholars working in Greece brought to light types of monuments and styles of Greek art—what we now call "Archaic" art, for example—which were virtually unknown before the nineteenth century (and hardly appreciated until the twentieth).

The great task of Classical archaeologists working in the first half of the twentieth century was to establish a firm chronology for the growing catalog of ancient Greek monuments—particularly statues and vases. The formation of a chronology naturally demands some criterion by which one can judge whether a particular work is later or earlier

5

than another, and the criterion most often adopted in our time has been naturalistic representation; the extension of naturalism from a purely technical standard of chronology to a standard of qualitative criticism has followed almost without question. There is no doubt in anyone's mind that, on a superficial level at least, a Greek statue of the fifth century B.C. looks more "real" than one of the sixth century. In fact a statue of ca. 525 B.C. looks more real than one of ca. 560 B.C. Scholars who have given years of careful attention to the development of early Greek art can point to developments in the rendering of the eyes, the hair, the stomach muscles, and so on and point out in just what way each stage is an "improvement" over the previous one. This apparent progression toward naturalism has been felt by some to be not only a *fact* of Greek art but also its *aim*.

Both idealism and naturalism probably have some validity as bases for judging Greek art. Both concepts, as the critical terminology of the Greeks themselves will indicate, were in existence in antiquity. But the critical terminology also indicates that other principles of criticism existed along with them and seem, at certain times, to have exceeded them in importance. It is my hope that one of the fruits of the present study will be to shed light on the questions of when, where, and by whom the various viewpoints about Greek art and its purpose were propounded. Having done that, we can not only begin to construct a history of Greek art criticism, but we will also be able to weigh for ourselves the relative importance of each idea in antiquity.

The text of this study attempts to reconstruct, insofar as is possible, the nature, history, and sources of the criticism of Greek art in antiquity. Following the text is an extensive glossary that collects, translates, and interprets passages from the writings of ancient Greek and Latin authors that contain terms of Greek art criticism. (The reason for including Latin authors and terms in a study of Greek art is explained in chapter 6.) The interpretive narrative of the text is based on the individual detailed studies that make up the glossary, and I am aware that to some readers this order may appear to have put the cart before the horse. I would like to think, however, that the results of this study may be of interest to art historians and others who are not specialists in the Classical languages and who may feel neither equipped nor inclined to study all aspects of the glossary. The general conclusions of the text can, in any case, always be tested by reference to the glossary.

As further recognition of the fact that my general conclusions may be of interest to readers who are not specialists in Greek art or Classical literature, this study is being produced in an abridged as well as a complete edition. The introductory text is the same in both editions, but their glossaries differ. In the glossary of the unabridged edition all the terms which I have studied are presented in alphabetical order. The glossary of the abridged edition contains a selection of some of the most significant of these terms grouped under headings that suggest the category or aspect of Greek art criticism upon which the terms shed the most light. Although the glossary of the unabridged edition does not contain all the evidence on which the conclusions of the text are based, it does provide an adequate illustration of the method followed in reaching these conclusions.

The chronological range of the ideas about Greek art that are treated here extends from the eighth century B.C., if that be the correct date of the Homeric epics, to around the fourth century after Christ, if that be the correct date for Callistratus. In a few cases, however, I have gone beyond the latter boundary in order to draw upon Byzantine writers and works, such as Eustathius and the Suidas lexicon, which often contain information about the meaning of ancient Greek terms. Most of the ideas, theories, and judgments with which I shall be dealing, however, belong to the Classical and Hellenistic periods, that is, to the period from the fifth to the first century B.C. The reason for this emphasis is partly that most of our extant evidence deals with the art of this time and partly that it seems to have been the most fertile period in antiquity for critical thought about the visual arts.

Part I Art Criticism in Antiquity

Our knowledge of ancient art criticism is limited, and to an extent shaped, by the literary sources in which a trace of such criticism happens to be preserved. With the exception of the *De Architectura* by the Roman architect Vitruvius (late first century B.C.), there is no extant ancient treatise that deals directly and exclusively with art. This is even true of the elder Pliny's extensive passages on art in books 33–36 of the *Natural History*, where the primary topics are the metals and minerals from which statues, paintings, buildings, gems, tableware, and so on were made. The study of Greek art criticism is further complicated by the fact that many of our extant sources involve Latin translations of critical concepts originally formulated in Greek, and it is often necessary to translate the Latin back into Greek in order to understand more precisely the original thought.

The ancient authors who wrote about art and artists may be broadly classified into four groups. For the moment I will simply summarize what these groups were; their place in the history of art criticism will be more fully discussed in subsequent chapters. The most extensive and hence the best known of these might be called the *compilers of tradition*. The writers of this group are best exemplified by Pliny (ca. A.D. 23–79), whose chapters on art in the *Natural History* present a complex and often undiscriminating assemblage of technical judgments, anecdotes, and biographical facts about art and artists. Compilations of this sort can be traced at least as far back as Duris of Samos (ca. 340–260 B.C.), whom Pliny cites as one of his sources. Another important and quite different author in the compilers of tradition category is the antiquarian and traveler Pausanias (fl. third quarter of the second century A.D.), whose *Description of Greece* provides a sober and objective account of many of the great monuments of Greek art that had survived into the time of the Roman Empire. The types of art criticism found in the writings of the compilers are as disparate as the sources they drew upon. Our discussion of Pliny's sources (chap. 6) will illustrate this point. Frequently their writings contain no critical intent at all. Pausanias, for example, was sufficiently well acquainted

9

with Greek sculpture as to be able to distinguish regional schools at sight,[1] yet he almost never expressed personal preferences or values beyond pointing out that a certain work was "worth seeing."

A second group of writers on art in antiquity might be called the *literary analogists*. In this category belong the rhetoricians and poets who used the visual arts as a source for stylistic analogy with literature and who sometimes used works of art as subjects for literary exercises. Among the most obvious examples of the latter use are the many short, epigrammatic poems on statues and paintings in the *Greek Anthology* and the rhetorical descriptions of works of art by Greek writers during the time of the Roman Empire, notably Lucian, the Philostrati, and Callistratus.[2] The use of art and artists as a source of stylistic analogy with rhetoric is best exemplified by the short histories of art given by Quintilian and Cicero (see chap. 7) and by the writings of Dionysius of Halicarnassus. All of these writers may have used a comparative canon of artists and orators formulated in the second century B.C. (On the importance of rhetoricians in the development of Greek art criticism see chap. 3.)

A third important group of writers on ancient art includes Plato, Aristotle, and the other Greek philosophers who evaluated art on the basis of its influence on human morality and spiritual awareness. These writers might be called the *moral aestheticians*. Art criticism of this sort seems to have been first used extensively by Plato (and Socrates?), and his condemnation of painting in the tenth book of the *Republic* remains the best-known example of it. Nevertheless, it was not until the late Hellenistic period that the ideas of the moral aestheticians came to dominate Greek art criticism (see chap. 2).

The last important group of ancient writers on art criticism comprised the artists themselves, who might be called the *professional critics*. Although the number of architects, sculptors, and painters who wrote on art in antiquity was surprisingly large, only the relatively late and eclectic work of Vitruvius has survived to give an indication of what this tradition was like. Writings on architecture began at least as early as the mid-sixth century B.C. with the treatises by the architects Theodorus and Rhoecus on the Heraeum at Samos and by Chersiphron and Metagenes on the temple of Artemis at Ephesus.[3] Technical manuals on sculpture began at least as early as the second half of the fifth century B.C. with Polyclitus's famous *Canon*, and there is some

evidence suggesting that earlier treatises on the subject existed. In the indexes and text to book 35 of the *Natural History* Pliny refers to several fourth-century painters—Euphranor, Apelles, Parrhasius, Melanthius, Asclepiodorus—who wrote about their art.[4] The substance of all these treatises can be reconstructed to some extent from the brief quotations from and references to them that occur in other works, especially those of the compilers, and literary analogists. What evidence is available suggests that the writings of the ancient Greek artists were primarily concerned with formal problems in art and the technical procedures by which these problems were met and solved. They therefore concentrated on such demonstrable qualities as proportion and color and seem to have had only a secondary interest, or no interest at all, in the moral questions injected into art criticism by the philosophers.

THE TRADITIONAL CATEGORIES OF CRITICISM

In analyzing and classifying the terminology used by the Greeks in the criticism of the visual arts, it becomes apparent that many terms are interrelated and can be assigned to particular traditions of criticism. By a *tradition* I mean a body of thought that is historically identifiable in that it exists in a definable period of time and involves known historical figures who shared certain basic principles. By combining all these separate traditions into a single developmental picture, we can, within the limits of the available evidence, arrive at a history of Greek art criticism.

There seem to have been four basic traditions of art criticism in the ancient Greek world, each tradition showing considerable variety within itself. One was a professional artists' tradition, concerned primarily with analyzing and assessing the significance of the objectively demonstrable properties of form and design; a second tradition, found in both Classical and Hellenistic philosophy, concentrated on the moral and epistemological value of artistic experience, both of the artist and his public; a third tradition was essentially an offshoot of literary criticism and was concerned mostly with the question of style; and a fourth tradition, which we might call "popular criticism," dwelt on the marvelous and magical qualities of art.[5] These four traditions of criticism can be correlated to some degree with the four types of writers who wrote on art in antiquity. The first three of them may be said to have become articulate at different dates and can therefore be

arranged in a very general historical sequence. Professional criticism makes its appearance as early as the sixth century B.C. and continues until the late fourth or early third century B.C. Criticism of the visual arts in Greek philosophy makes its appearance in any significant degree in the second half of the fifth century B.C. and continues into late antiquity. Literary and rhetorical criticism using analogies to the visual arts belongs essentially to the Hellenistic period, although the roots of some of its ideas can be traced back to the fourth century B.C. Popular criticism may be viewed as a kind of undercurrent running beneath the other traditions.

While it would not be prudent to assert dogmatically that these four traditions encompass all the expressed ways of looking at art in ancient Greece, I suspect that they in fact do.[6]

1 Professional Criticism

EARLY TRACES

The surprisingly large number of Greek artists who wrote treatises about their art seem to have been the creators of the first major tradition of ancient art criticism. In his preface to the seventh book of the *De Architectura* (sections 11–17) Vitruvius provides an extensive list of treatises written by practicing architects, almost all of them Greeks, from the sixth century B.C. through the Hellenistic period. The earliest of these were written by Chersiphron and Metagenes on the temple of Artemis at Ephesus and by Theodorus and Rhoecus on the temple of Hera at Samos (both ca. 570–560 B.C.). What little is preserved about the content of these writings suggests that they dealt primarily with problems of engineering, such as preparing the foundations of a temple and transporting building materials to the site.[1] They may also have treated questions of form and proportion, since later architectural treatises, like those of Philo of Eleusis (second half of the fourth century B.C.) and Hermogenes (second half of the second century B.C.), were concerned almost exclusively with such problems.[2]

It is not known whether there were treatises on sculpture and painting in existence as early as the sixth century B.C., but the possibility that there were workshop manuals of some sort in circulation must be

considered. One of the early writers on architecture, Theodorus of Samos, was also a sculptor and a painter. There was a tradition, preserved by Diodorus (1.98.5–9), that Theodorus and his brother (or, according to other sources, his father) Telecles spent some time among the Egyptians and learned a canon of sculptural proportions from them.

> Among the old sculptors who are particularly mentioned as having spent time among them [the Egyptians] are Theodorus and Telecles, the sons of Rhoecus, who made the statue of Pythian Apollo for the Samians. Of this image it is related that half of it was made by Telecles in Samos, while the other half was finished at Ephesus by his brother Theodorus, and that when the parts were fitted together with one another, they corresponded so well that they appeared to have been made by one person. This type of workmanship is not practiced at all among the Greeks, but among the Egyptians it is especially common. For among them the *symmetria* of statues is not calculated according to the appearances which are presented to the eyes [κατὰ τὴν ὅρασιν φαντασίας],[3] as they are among the Greeks; but rather, when they have laid out the stones and, after dividing them up, begin to work on them, at this point they select a module from the smallest parts that can be applied to the largest. Then dividing up the layout of the body into twenty-one parts, plus an additional one-quarter, they produce all the proportions of the living figure. Therefore, when the artists agree with one another about the size of a statue, they part from one another, and execute [independently] the sections of the work for which the size has been agreed upon with such precision that their particular way of working is a cause for astonishment. The statue in Samos, in accordance with the technique of the Egyptians, is divided into two parts by a line which runs from the top of the head, through the middle of the figure to the groin, thus dividing the figure into two equal parts. They say that this statue is, for the most part, quite like those of the Egyptians because it has the hands suspended at its sides, and the legs parted as if in walking.

While we need not treat every last detail of this tradition as historical fact, there is probably a kernel of truth in it. When the Greeks first learned the technique of carving large-scale stone statues in the mid-seventh century B.C., they clearly made use of Egyptian workshop traditions. A general similarity in the schematic compositions of early Greek *kouroi* and Egyptian standing male statues is obvious, and a

13

number of similarities in specific details can also be pointed out.[4] Once the Greeks adopted Egyptian formulas, they began, slowly, to vary and augment them, thereby producing new formulas of proportions which they found more harmonious, expressive, and perhaps also more in conformity with natural appearances. Diodorus's passage suggests that Theodorus was an early experimenter in proportion; and one wonders if, since he is known to have written about architecture, he might not also have written a treatise which made public the results of his experiments in sculpture. He was one of the very few sculptors of the Archaic period whose fame survived in the succeeding periods. Possibly there was a written tradition which helped to perpetuate his memory.

PROFESSIONAL CRITICISM OF GREEK SCULPTURE

Polyclitus's Canon and the Idea of Symmetria

The first datable professional treatise on sculpture was the *Canon* of Polyclitus, probably written during the third quarter of the fifth century B.C. The *Canon* was the most renowned ancient treatise on art, and enough information is preserved about it in extant ancient texts to enable us to form some conception of its content.

If one assumes that there were practical workshop manuals in the Archaic period which tabulated the proportions and procedures by which a *kouros*, for example, was to be designed, Polyclitus's *Canon* might be viewed as a descendant of these manuals, augmented, however, by a greater knowledge of mathematics and geometry and also by a new philosophical purpose. This picture of the *Canon* is suggested by a passage in the writings of the physician Galen (second century A.D.). In commenting upon the opinion of the Stoic philosopher Chrysippus that health in the body was the result of the harmony of all its constituent elements, Galen adds the following interesting sidelight:

τὸ δὲ κάλλος οὐκ ἐν τῇ τῶν στοιχείων ἀλλ' ἐν τῇ τῶν μορίων συμμετρίᾳ συνίστασθαι νομίζει, δακτύλου πρὸς δάκτυλον δηλόνοτι, καὶ συμπάντων αὐτῶν πρός τε μετακάρπιον καὶ καρπόν, καὶ τούτων πρὸς πῆχυν καὶ πήχεως πρὸς βραχίονα, καὶ πάντων πρὸς πάντα, καθάπερ ἐν τῷ Πολυκλείτου Κανόνι γέγραπται. πάσας γὰρ ἐκδιδάξας ἡμᾶς ἐν ἐκείνῳ τῷ συγγράμματι τὰς συμμετρίας τοῦ σώματος, ὁ Πολύκλειτος ἔργῳ τὸν λόγον ἐβεβαίωσε, δημιουργήσας ἀνδριάντα κατὰ τὰ τοῦ λόγου προστάγμα-

14

τα, καὶ καλέσας δὴ καὶ αὐτὸν τὸν ἀνδριάντα, καθάπερ καὶ τὸ σύγγραμμα, κάνονα.

Beauty, he feels, resides not in the commensurability of the constituents (i.e. of the body), but in the commensurability of parts, such as the finger to the finger, and of all the fingers to the metacarpus and the wrist (carpus), and of these to the forearm, and of the forearm to the arm, in fact of everything to everything, as it is written in the *Canon* of Polyclitus. For having taught us in that treatise all the *symmetriae* of the body, Polyclitus supported his treatise with a work, having made a statue of a man according to the tenets of his treatise, and having called the statue itself, like the treatise, the *Canon*.[5]

It is clear that Polyclitus's *Canon* actually described in great detail, like a workshop manual, a set of proportions to be used by sculptors in constructing their figures. The aim of the *Canon*, however, was not simply to explain a statue but also to achieve *to kallos*, "the beautiful," in it; and the secret of achieving *to kallos* lay in the mastery of *symmetria*, the perfect "commensurability" of all the parts of the statue to one another and to the whole. This aim also seems to be expressed in one of the two fragments which purport to be direct quotations from Polyclitus: τὸ γὰρ εὖ παρὰ μικρὸν διὰ πολλῶν ἀριθμῶν γίγνεσθαι, "perfection [or the excellent] arises *para mikron* through many numbers."[6] The *Canon*, clearly, in addition to being a workshop guide, was also a treatise on the way in which mathematically expressible proportions produced perfect form.[7]

The *symmetria* concept is an aspect of one of the most deeply rooted and abiding features of ancient Greek thought, both artistic and philosophical.[8] The urge to discover or construct an order behind the flux of experience in the world is as inherent in the Greek mind as is, for example, the urge for identification with an incorporeal, transcendental existence in Hindu thought. Order is inconceivable without a conception of its essential characteristic—measure, which involves both definition (marking the boundaries of things) and analysis of the interrelationships of discrete forms. At the dawn of Hellenic (as opposed to "Helladic") art the urge for a clear definition of individual parts and a measured relationship of part to part in a decorative scheme appear in a simple form in protogeometric pottery and in increasingly complex forms in geometric art. In the earliest phase of Greek science

15

and philosophy, in Ionia, the overriding quest seems to have been to discover, or create, a cosmology in which the nature, relationship, and form of all phenomena were explicable. Whether all things were viewed as variations of a single substance (Thales, Anaximenes) or as the result of an unending but predictable tension of opposites (Heraclitus), the aim of the inquiry was in all cases to discern *kosmos* within *chaos*.

Even when later Greek philosophy turns away from cosmology and physics to a greater interest in ethics and epistemology, the feeling that measure must be an essential element in perceptible phenomena, even when these are abstractions, remains strong. The classic analysis of the moral connotations of measure occurs in the *Philebus* of Plato. In pursuing the question of what is "the good" for man, Plato insists that the determination of the good necessitates setting a limit (*peras*) on an infinitely variable mixture of phenomena. His discussion proceeds within the Pythagorean framework that the formative principles of the universe were the "unlimited," *to apeiron* (i.e. the infinite variability between smallness and greatness, hot and cold, and so on) and "limit," *to peperasmenon*, such as the unit, the odd, and the even.[9] A third class of phenomena involves a mixture of the two, that is, the setting of a precise limit on the infinitely variable opposites, thereby making them, in Plato's words, "commensurable, harmonious, and instilling number into them" (συμμετρία δὲ καὶ σύμφωνα ἐνθεῖσα ἀριθμόν; cf. *Philebus* 25D–E). Finally, those causal factors which bring about a precise mixture from the unlimited and limit (*Philebus* 23D) are identified as a fourth class of phenomena. In the light of these classifications it is determined that the good consists of a mixture of thought and (properly defined) pleasure, and that for this mixture to be a real compound and not a chaotic jumble, the causal factors measure (*metron*) and proportion (*symmetria*) must be present (*Philebus* 64D–E). At the end of the dialogue Plato proceeds to construct a hierarchy of possessions (*ktēmata*) that are essential to man's experience of the good. First in this list comes measure, followed by *symmetria* (*Philebus* 66A–B).[10] In the *Politicus* (283E–284B), moreover, Plato expresses the view that measure has an absolute existence and is not simply a relative comparison of pairs of opposites (e.g. the great and the small, the hot and the cold). If the latter were true, the arts, he maintains, would be destroyed:

Well then, will we not destroy the arts themselves and all their prod-

ucts with this doctrine?. . . For all these are in some degree concerned about excess and deficiency with regard to the mean (*to metrion*), treating it not as if it were nonexistent but as a real difficulty to be faced in the process of practical undertakings, and by preserving measure (*to metron*) in this way, they produce works that are good and beautiful. [*Politicus* 284A-B]

As this passage suggests, measure and beauty were essentially indistinguishable to Plato. In the *Philebus*, after explaining how his conception of good must partake of the nature of beauty (τοῦ καλοῦ φύσις) because both beauty and good are characterized by measure, he states his view explicitly: μετριότης γὰρ καὶ συμμετρία κάλλος δήπου καὶ ἀρετὴ πανταχοῦ ξυμβαίνεί γίγνεσθαι ("Measure and commensurability, as it turns out, are everywhere identifiable with beauty and excellence"; *Philebus* 64E).

While the *symmetria* concept that was the basis of the *Canon* of Polyclitus was thus an aspect of a deep-seated habit of Greek thought, it seems likely that its specific application to sculpture was suggested by and related to the doctrines of proportion, harmony, and cosmology that Aristotle and the later doxographers ascribe to Pythagoras and his followers.[11] According to Aristotle (*Metaphysics* 985b23–986b8), the Pythagoreans held that numbers (*arithmoi*) were the first principles of all things, the basic constituents (*stoicheia*) of the universe. Numbers formed the basis not only of sensible physical bodies (*Metaphysics* 1090a20) but also of abstractions such as justice (*Metaphysics* 985b30).

The origin of this idea, according to Aristotle, was the discovery, perhaps made by Pythagoras himself, that "the qualities of numbers exist in a musical scale (*harmonia*), in the heaven, and in many other things" (*Metaphysics* 1090a23). Perhaps by measuring the lengths of the intervals needed to produce harmonic correspondences on the taut string of a lyre—lengths that were expressible in numbers by the first four integers (2:1, 3:2, 4:3, and so on)—it occurred to Pythagoras that all discrete phenomena resulted from the imposition of numerically expressible proportions on an infinite continuum. If the sounds of an octave could be reduced to a series of consonant proportions, so also could the stars and planets and creatures on earth. The entire universe was thus seen as a harmony of consonant numbers (*Metaphysics* 986a5).

The conception of sensible bodies as being made up of "numbers" seems to have stemmed from the fact that the Pythagoreans did not

17

draw a strict distinction between mathematical units and geometric units (*Metaphysics* 1080b16). Perhaps as a result of presenting numerical concepts in diagrams consisting of points, they seem to have accepted the idea that units had a spatial existence and that each object "consisted of a definite number of unit-point-atoms."[12] This association of numbers with things seems to have become increasingly elaborate as time went on. The first four integers were associated with basic elements of geometry—1 with the point, 2 with the line, 3 with the plane, and 4 with the solid.[13] Eurytus, a fourth-century B.C. Pythagorean and a disciple of Philolaus, is said to have given characteristic numbers to such things as men and horses and to have demonstrated his conclusions by making diagrams of these things with pebbles. The number of pebbles required for the diagram constituted the "number" of man, and so on (Aristotle *Metaphysics* 1092b8).[14]

The explanation for this peculiar identification of numerical units with spatial phenomena has perhaps both an intellectual and a religious aspect: Intellectual, in that, as Raven has contended, early Greek philosophers probably did not really conceive of "abstractions" as we do. Whatever existed, existed, for them, in space.[15] Religious, in that the contemplation of harmony appears to have been, to at least some Pythagoreans, a means of purifying the soul, thereby allowing the philosopher to escape from the cyclical transmigration of souls and to attain some higher state of being.[16] To those who held this view it was desirable that the Pythagorean philosopher, who lived on earth as a witness rather than a participant,[17] be able to discern the divine pattern of numbers not only in "pure" mathematics but also in visible things. Symbolizing this fusion of mathematics and geometry as well as science and religious cosmogony was the conception of the "sacred" *tetractys*, or decad, a composition of ten points made up of a point representing 1 and of lines of points representing 2, 3, and 4: ∴∴. . From the four integers came not only the basic harmonies of the musical scale, which were also found in the heavens, but also the geometric components of visible objects (point, line, plane, solid). The *tetractys* thus symbolized the orderly genesis and divine pattern of the universe.

It is not unreasonable to conclude, in the light of the passages already discussed, that Polyclitus was influenced by, and perhaps contributed to, the Pythagorean doctrine of number and *symmetria*. J. E. Raven has

pointed out in a valuable article that the two passages which best describe the nature of Polyclitus's *Canon*—namely, the passage from Galen quoted earlier and the long description in Vitruvius, 3.1.1–5— both betray traces of Pythagorean influence.[18] In the Galen passage the idea that beauty arises from the *symmetria* of the parts of the body is discussed, as we have noted, in association with the concept that health arises from *symmetria* between the constituent elements of the body (hot, cold, wet, dry). The latter theory seems to have been developed by the physician Alcmaeon of Croton who was active in the early part of the fifth century and had close connections with the Pythagoreans.[19] The Vitruvian passage occurs in a discussion of the planning of temples. Vitruvius points out that a well-planned temple must have both a fixed module of measurement and also a system of *symmetria* which is modeled on that of the human body. He then describes the ideal proportions of the human body in detail and notes that "by making use of these the ancient painters and renowned sculptors won great and unbounded praise" (3.1.2). Finally, after explaining how these proportions are to be applied to temples, Vitruvius adds:

> Nec minus mensurarum rationes, quae in omnibus operibus videntur necessariae esse, ex corporis membris collegerunt, uti digitum, palmum, pedem, cubitum, et eas distribuerunt in perfectum numerum, quem Graeci "teleon" dicunt. Perfectum autem antiqui instituerunt numerum qui decem dicitur.

> Furthermore they [presumably the ancient Greek sculptors, painters, and architects] collected their theoretical conceptions of measurements, which are seen to be necessary in all works, from the parts of the human body, such as the finger, the palm, the foot, and the cubit, and they arranged them in a perfect number, which the Greeks call *teleon*. For the ancients determined that there is a perfect number, which is identified as ten. [3.1.5]

The last sentence in this passage is clearly a reference to the Pythagorean decad.

Was there perhaps a Pythagorean source, used by Galen and Vitruvius, in which the *Canon* of Polyclitus was summarized and brought into connection with other Pythagorean doctrines; and if so, what was the date of this source? Raven offers some interesting speculations on these questions. He notes that Philolaus is said to have believed health

19

to be the result of harmony among the constituents of the human body, which was only a variant of the concept that Galen discusses in the passage where he also describes the *Canon* of Polyclitus.[20] He also points out that a fragment of Speusippus preserved in the *Theologumena Arithmeticae* (ed. De Falco 82.10) includes the doctrine of equating numbers with geometric forms within a general discussion of the perfect nature of the decad, and that this passage is said to be dependent on Pythagorean sources, particularly Philolaus. Raven even notes a similarity in language between Vitruvius's passage and a fragment associated with Philolaus.[21] While the evidence is very sketchy, it is just possible that Philolaus, either as a result of direct contact with Polyclitus,[22] or by reading the *Canon*, or both, was the author of a treatise that incorporated the principles of the *Canon* into the broader scheme of Pythagorean doctrine. Furthermore, Eurytus was possibly under the influence of Philolaus when he created his famous pebble drawings. These, Raven has suggested, may have been intended not only to provide an essential number for man, and so on, but also to illustrate basic proportions, including the proportions of the human body. Eurytus used different colored pebbles in his diagrams, and it is possible that these colors were used to distinguish different parts of the body.

The association of Polyclitus and the Pythagoreans probably involved, as already suggested, a mutual exchange of ideas. It was perhaps from Pythagorean thought that Polyclitus derived the notion that *symmetria* in sculpture had a philosophical as well as a practical significance. This is suggested by the passages which indicate that the purpose of *symmetria* was to achieve τὸ εὖ (possibly a Pythagorean term; see note 6) or τὸ κάλλος— "the good" or "the perfect" or "the beautiful." Perhaps, like a Pythagorean philosopher, he may have even felt that the contemplation of harmony in the human body produced some spiritual benefit. And the Pythagoreans probably found in the *Canon* of Polyclitus a marvelously documented illustration of the general principle of harmony in which they had long believed.

Whether Polyclitus was the first artist to see a possible relationship between the traditional, practical *symmetria* of sculptors and the Pythagorean theories of harmony is not certain. We must take note, in this connection, of an equally tantalizing and even more obscure figure, the sculptor Pythagoras. In a passage in Diogenes Laertius (8.46),

20

the source of which is unknown but could be the sculptor–art historian, Xenocrates (see chap. 6), we learn that it was this Pythagoras who "seems to have been the first to have aimed at *rhythmos* and *symmetria*" (πρῶτον δοκοῦντα ῥυθμοῦ καὶ συμμετρίας ἐστοχάσθαι). Were it not for the fact that there are statue bases inscribed with the signature of Pythagoras and the fact that some specific works by him are described by Pliny and Pausanias, one might be inclined to feel that the sculptor was a fictional creation patterned on the career of Pythagoras the philosopher. It does not seem wildly speculative to suggest that the sculptor Pythagoras was also, philosophically speaking, a Pythagorean. He was born in the same place as the philosopher (Samos), bore the same name as the philosopher, and, again like the philosopher, he appears to have migrated at an early age to southern Italy.[23] Possibly the sculptor's parents were followers of the philosopher, perhaps even members of his family or at least of his brotherhood, and named their child after the philosopher in a spirit of reverence.[24] That the first sculptor whom we hear of as cultivating *symmetria* and *rhythmos* should seem to have such close connections with Pythagorean philosophy is probably more than a simple coincidence.

Although Polyclitus is the only sculptor whom we know for a fact to have written a *Canon*, it is not improbable that other sculptors did so too. Artists from the Renaissance to our own time have generally been eager to be accepted as intellectuals, men of culture, and not simply as workmen. The same was certainly true of Vitruvius and probably also of Classical Greek sculptors and painters.[25] One obvious way to win acceptance as an intellectual would have been to write a treatise that emphasized theory and demonstrated a breadth of learning. A treatise on *symmetria* would have done both.

Considering what Diogenes Laertius tells us about Pythagoras of Rhegion and what we learn about other sculptors from the Xenocratic tradition in Pliny, it is clear that the period during which *symmetria* was most intensely cultivated in Greek sculpture was what we now call the "Classical period" (ca. 480–320 B.C). During this time one gets the impression that prominent sculptors may have competed with one another in developing increasingly subtle systems of *symmetria*. Pliny's statement that Myron was *numerosior in arte quam Polyclitus et in symmetria diligentior* (*NH* 34.58), for example, may indicate that Myron's system was more complex but also less refined than that of Polyclitus.[26]

21

At the very least, the passage indicates that the divergent systems of the two sculptors invited comparison. One also gets the impression that each generation of sculptors felt driven to make improvements or at least variations upon the systems of earlier generations. We are told, for example, that Lysippus, who cultivated *symmetria* with great diligence, concentrated his energy on creating new systems of proportion and design which were at variance with those of earlier sculptors and were felt to be improvements on them (Pliny *NH* 34.65).

Lysippus appears to have been the last sculptor to place great emphasis on the development of *symmetria*, and it was probably this emphasis that prompted Xenocrates, a sculptor trained in Lysippus's own school, to make *symmetria* one of the basic critical standards of his history of art (see chap. 6). In doing so Xenocrates not only summed up a whole tradition but also guaranteed the perpetuation of the idea in ancient art criticism.

The Critical Terminology of Greek Sculptors

What follows is a reconstruction of the terminology and standards used by Greek sculptors to evaluate their own work, based on the analyses of individual terms. My suggestions are at times speculative, and the reader may wish to test them in the light of the evidence given in the glossary.

The Greeks felt that art at all times involved *technē*, a combination of knowledge and orderly procedure organized for the purpose of producing a specific result. The Archaic Greek sculptors, for example, like the Egyptian sculptors whose *technē* the Greeks became acquainted with in the seventh century B.C., obviously formulated procedures for chiseling stone in such a way as to produce a form that had certain prescribed dimensions.[27] Greek sculptors of the fifth and fourth centuries B.C., however, differed from the artists of both earlier and later epochs in that they were concerned with developing and disseminating theoretical explanations of their *technē*.[28] The earliest written examples of these theoretical elaborations on *technē* probably appeared, as we have previously suggested, in the Early Classical period, and it must have been in these treatises that the first systematic terminology of Greek art criticism began to take shape. The aesthetic goal and standards of these writings seem to have been based on the Pythagorean concept that formal perfection is to be found in a harmony

22

of numbers expressible in proportions, and their critical terminology was hence concerned with the properties of form—especially *symmetria* (commensurability of parts) and *rhythmos* (shape, composition). When the sum total of all the measurements (*metra*) and shapes (*rhythmoi*) of a work are arranged with mathematical precision (*akribeia*) so as to form the spatial equivalents of "perfect numbers" (*teleia*), the work as a whole becomes an expression of "truth" (*alētheia*), that is, a conceptual reality in which sense experience is controlled by intellectual principles. Different artists undoubtedly suggested different "patterns" (*paradeigmata*) of *symmetria* and *ryhthmos* which they felt improved upon those of their predecessors. Striking differences in the systems of proportion and composition employed by Polyclitus and Lysippus, as already noted, are emphasized by Pliny[29] and have been analyzed in still greater detail by modern scholars.[30]

By the fourth century certain extensions seem to have been made in this basic terminology. *Rhythmos* came to refer to the individual shapes within a composite form, as well as to the composition as a whole; and a new term, *eurhythmia,* came to be used to describe the qualitative effect of *rhythmoi* in general (see glossary). *Akribeia,* which had been used to refer to precision in the application of theories of proportion and composition to actual works of art, probably also came to refer to precision in the treatment of all the small details of a work, including such naturalistic features as the rendering of hair, veins, and so on.[31]

PROFESSIONAL TREATISES ON PAINTING

Although the earliest known theoretical treatise on painting, the study of perspective (*skēnographia*) by Agatharchus, probably dated from around the middle of the fifth century B.C., the most important era of professional criticism in painting seems to have been the fourth century, when many painters are known to have written about their art.[32] Some of their treatises dealt with problems of form that had also occupied the sculptors. Euphranor, for example, is said by Pliny to have written *volumina* on *symmetria* . . . (*NH* 35.129), and Apelles apparently discussed both proportion (*NH* 35.80: *mensuris*; 35.107: *symmetria*) and the disposition of figures (*NH* 35.80: *dispositione* = διάθεσις?).

The type of professional criticism that was most characteristic of

painting, however, dealt with problems of shading, color, and draftsmanship. After the introduction of shading (*skiagraphia*) into Greek painting by Apollodorus (later fifth century B.C.), many painters sought to make improvements and refinements in the system; and a variety of dependent terms—*tonos*; *harmogē*; *splendor* = Greek *augē*; *asperitas* = Greek *trachytes*—were created to express these refinements.[33] The substance of the professional treatises on color (such as Euphranor's *De Coloribus*; see Pliny *NH* 35.129) is less clear than that of those on shading. Lucian mentions the *krasis* ("blending" or "juxtaposition") of colors (*Zeuxis* 3; χρωμάτων . . . κρᾶσιν) as one of the basic elements of professional criticism. The use of different genres of color (*floridus-*ἀνθηρός and *austerus-*αὐστηρός, and perhaps also *durus-*σκληρός) probably also served as criteria of criticism (see these terms in the glossary). Our knowledge of the critical discussion of draftsmanship among the painters is even more obscure. Except for one unusual tradition in which Pliny (citing Xenocrates and Antigonus as his sources) and Quintilian praise the *subtilitas* (λεπτότης) of Parrhasius's drawing, the question of the criticism of draftsmanship is not dealt with in our sources.[34] The fact that the sculptor Xenocrates is directly referred to as a source for the tradition, however, suggests that it was originally part of professional criticism.[35]

OTHER TERMS RELATED TO PROFESSIONAL CRITICISM

Most of the terminology of professional criticism seems to have been transmitted to our Roman sources, and hence to posterity, through the histories of Xenocrates and Antigonus (see chap. 6). Whether these writers, who were themselves professional artists, were personally responsible for the creation of particular critical terms is difficult to say. *Gracilis* (*NH* 34.65) and *exilis* (*NH* 35.128), for example, words used by Pliny to describe physical proportions of the human figure, may reflect terms which Xenocrates developed (perhaps ἰσχνός and λεπτός) to facilitate his comparisons of the different painters and sculptors. It is also possible that Pliny's judgment on the "characters," ἤθη, and "emotions," πάθη, in the painting of Aristides (*NH* 35.98) may have first been made either by Xenocrates or Antigonus. In general, the examination of *ēthos* and *pathos* was a concern of literary criticism, and, if these terms played any role in professional criticism, it must have been at a rather late stage.

MEANING IN PROFESSIONAL CRITICISM

Almost all the terms of professional criticism dealt with objective problems of form and design. How a Greek sculptor would have explained the "meaning" or "content" of his works (if indeed he ever would have bothered to do so) is not easy to say. *Meaning* is ultimately an indefinable word, since it itself is the foundation on which all definition rests. But as a working definition it might be described as an assessment of experience, aesthetic and otherwise. If we follow Erwin Panofsky's division of this assessment into "primary," "conventional," and "intrinsic" meaning,[36] it would seem that the professional critics in ancient Greece were interested mainly in the first and the last of these.

To the extent that their art was representational, the Greek sculptors and painters were concerned with the problem of how pure forms—masses, lines, and colors—could be put together in order to convey most simply and most clearly the desired natural form—a man, a horse, and so on. The search for essential configurations to express these primary meanings, similar in principle to the Pythagorean pebble diagrams, would seem to have been one of the major concerns of the canon tradition.

Conventional meaning, that is, subject matter (Zeus and Athena, the Trojan War, the athlete Astylos), was restricted in Greek art by the seemingly willing acceptance of traditional conventions. With the apparent exception of a few painters like Pauson or Theon,[37] novelty of subject matter is never cited among the factors that made certain artists worthy of remembrance. The repetition of certain set themes and subjects (the battle of the gods and giants, satyrs and maenads dancing, athletes, deities with specific attributes) through the course of centuries was an accepted practice in Greek art, and no one seems to have felt that it was thereby lacking in "originality." The energy of Greek artists went not so much into innovation in subject matter as into perfecting the representation of established subjects.

But it was above all the *intrinsic meaning* of their works which, judging by Galen's description of the *Canon*, Greek artists like Polyclitus recognized and sought to explain. In seeking out the intrinsic meaning of a work of art, as Panofsky has put it, "we deal with the work of art as a symptom of something else which expresses itself in a countless variety of other symptoms, and we interpret its compositional and

25

iconographical features as more particularized evidence of this some-
thing else."[38] It is a characteristic of Greek thought—artistic, cosmo-
logical, and political—to view the specific in the light of the generic,
to see an individual thing as a representative of a type. Pre-Socratic
philosophy, as has already been noted, was characterized by the quest
for a basic substance, be it a material (water, fire, etc.) or an ontological
conception (tension, being, number) which would explain the nature
of particular phenomena. Likewise, to Plato, particular phenomena
had existence insofar as they participated in the unchanging transcen-
dental "ideas" that constituted ultimate reality. Thucydides saw the
actions and attitudes of the participants in the Peloponnesian War as
specific examples of the general and constant characteristics of human
behavior. To Thucydides and the Sophists who influenced him "human
nature" itself was a constant that made it possible to predict how,
under given conditions, an individual or group of individuals would
act. His history of the Peloponnesian War was thus by his own admission
"a possession for all time," a work that revealed general, permanent
truths in the light of specific events.[39] The preoccupation of the
Classical Greek artists with *symmetria* and other properties of form must
be viewed as a manifestation of this same intellectual tradition. In
mathematical and geometrical correspondences there could be found
an invariable conceptual reality underlying the structure of all physical
objects. Beauty, *to kallos* or *to eu*, was perhaps understood as a quality
of those objects in which this conceptual reality was most apparent.

The meaning of a work of visual art can no more be transcribed into
words than can the meaning of a piece of music. Form and meaning
are interdependent, not detachable. It is obviously impossible to
detach the meaning associated with a sculptural form and recast it
with precisely the same effect in the form of words. But in order not
to beg the question, we might suggest that the assessment of experience
that constitutes the intrinsic meaning of Classical Greek art as seen
through the eyes of the professional critics was a sense of exhilaration,
finality, and completeness stemming from the realization that there
is a unity behind all apparent diversity.

THE DECLINE OF PROFESSIONAL CRITICISM

In *NH* 34.50–52, Pliny presents a chronological list of sculptors

which runs from Phidias in the 83d Olympiad (448–445 B.C.) to the successors of Praxiteles and Lysippus in the 121st Olympiad (295–292 B.C.). He concludes this list with a remarkable statement that has puzzled modern critics and provoked considerable speculation: *cessavit deinde ars ac rursus Olympiade CLVI revixit* ("*Ars* thereupon ceased, and it revived again in the 156th Olympiad [156–153 B.C.]"). The passage certainly does not mean that art as a whole came to an end during the time between these two dates, since Pliny himself mentions works such as the Attalid victory monuments at Pergamon (*NH* 34.84), which were produced during this period. The key to the meaning of the passage must lie in the word *ars*, which is in all likelihood a translation of the Greek *technē* (see chap. 2) or a similar term which encompassed the intellectual principles upon which practical artistic procedure was based (e.g. *symmetria, rhythmos*). This value for the word *ars* is also suggested by other passages in Pliny. For example, he says that Polyclitus's *Canon* provided other artists with a kind of rule from which they could draw the bases of their own practice (*liniamenta artis ex eo petentes veluti a lege quondam*) and that Polyclitus was thus the first to put *ars* itself in a work of art (*artem ipsam fecisse artis opere iudicatur*; *NH* 34.55). Similarly his contention that Myron was *numerosior in arte* (ῥυθμικώτερος ἐν τέχνῃ) than Polyclitus can probably be understood as an expression of a difference in the theoretical principles followed by each artist (see glossary under *rhythmos*). Pliny's remark about the "cessation of art," then, probably refers to the fact that the theoretical principles of professional criticism died out in the early third century B.C. It probably also suggests that written theoretical treatises, like those of Polyclitus or Euphranor on *symmetria*, were no longer produced. Hellenistic artists seem on the whole to have been more concerned with innovations in subject matter and personal expression than with theories of proportion. Even the great artists of the late fourth century who, according to the Xenocratic history, had mastered and perfected all the categories of professional criticism (i.e. Lysippus and Apelles) seem to have been veering away from the formal problems of *technē* toward a new subjectivism. The revival of art of which Pliny speaks perhaps refers to the renewed interest in the standards of the Classical period, which are revealed in the classicistic sculpture of the late Hellenistic period. Perhaps sculptors like Damophon of Messene, Pasiteles, and the sculptors in the neo-Attic tradition began to study

27

the writings of the artists of the Classical period and to reapply their principles.[40]

SUBJECTIVISM IN THE FOURTH CENTURY B.C.

In the fourth century B.C. there are traces of a new trend toward subjectivity both in professional art criticism and in aesthetic theory in general. This new subjectivity is reflected in an increased interest in the question of how the formal elements of a work of art—proportion, composition, and so on—affected the viewer and what his reaction was to them. The established criteria of professional criticism such as *symmetria* and *rhythmos* were not abandoned,[41] but whereas the artists of the fifth century were perhaps most concerned with perfecting these formal elements, the artists of the fourth century were concerned with calculating what their effect might be. They took an interest not only in what was real and measurable but also in what was apparent or felt.

One distinct manifestation of this new spirit is an interest in the nature and value of optical illusion. In an interesting passage in the *Sophist* (235E–236C), which will be discussed more thoroughly in chapter 2, Plato notes that it was very common in his time for painters and sculptors who were producing large works to alter what would be the normal proportions of their figures in order to compensate for the distortion produced by viewing these works at a steep angle. The artists who produced such works are subjected to Plato's disapproval because they employed, in his words, "not the real proportions" (οὐ τὰς οὔσας συμμετρίας), but "those which only seem to be beautiful" (τὰς δοξούσας εἶναι καλάς). Leaving aside for the moment the question of what this passage tells us about Plato and treating it as a piece of historical evidence, we learn from it that it was common practice among fourth-century painters and sculptors to make intentional deviations from what must have been their "normal" canon of *symmetria* in order to produce a certain optical effect. The same practice seems to be referred to by Diodorus Siculus (first century B.C.) in a passage in which he compares the Egyptian method of designing sculpture (which, as we have seen, was studied by Theodorus and Rhoecus) with Greek practice as he knew it:

> For among them [the Egyptians] the *symmetria* of statues is not judged from the appearance which it presents to the eye [literally "the faculty of sight"], as it is among the Greeks.

παρ' ἐκείνοις γὰρ οὐκ ἀπὸ τῆς κατὰ τὴν ὅρασιν φαντασίας τὴν συμμετρίαν τῶν ἀγαλμάτων κρίνεσθαι, καθάπερ παρὰ τοῖς ῞Ελλησιν. [Diodorus 1. 98.7]

Evaluation of the optical effect produced by the composition and proportions of a work of art is closely bound up with the term *eurhythmia*, which appears first to become important in the fourth century B.C. This word basically means "the quality of being well shaped" and represents a subjective elaboration upon *rhythmos*, the basic term used by the artists of the Classical period to refer to design.[42] The artists of the fourth century seem to have recognized that *eurhythmia* could be produced by both real proportions and apparent proportions and that an artist could choose one or the other depending upon the effect that he sought to make.

It was probably a distinction of this sort which lay behind the well-known remark attributed to Lysippus by Pliny (*NH* 34.65) to the effect that other sculptors depicted men "as they were," while he represented them "as they appeared" or "were seen" (*ab illis factos quales essent homines, a se quales viderentur esse*). In taking account of appearances, Lysippus clearly did not abandon *symmetria* in favor of some kind of "photographic" naturalism,[43] since we are told by Pliny that, on the contrary, he cultivated *symmetria* with great care (*diligentissime custodiit*). What Lysippus seems to have done was to develop a system of *symmetria* which was based not, like that of Polyclitus, on reality (ἀλήθεια, with all that the word implies; see glossary) but on appearance (ὄψις, φαντασία). That such a distinction existed in antiquity is evidenced by a fragment attached to the treatise on optics by Damianus, a late antique writer who drew upon Hellenistic sources.[44] The goal of the architect, "Damianus" says, is to make his work *eurhythmos*, and in order to produce this appearance he is obliged to make compensations for optical distortion, aiming at *eurhythmia* and equality (ἰσότητος) not in reality (κατ' ἀλήθειαν) but in appearance (πρὸς ὄψιν). The implication is that there is a real, measurable, *eurhythmia* and a *eurhythmia* that one sees or feels, and that an artist could strive for one or the other.

A second distinct aspect of the growing subjectivism of the fourth century is seen in a concern for those characteristics of an artist's work that could not be measured or defined but had to be understood through a kind of personal intuition. The most revealing illustration

29

of this concern is the claim of the great painter Apelles that whatever technical virtues his colleagues and competitors may have had, they could not match his own *charis*, "charm" or "grace" (Pliny *NH* 35.79, a passage apparently derived from the writings of Apelles himself). This *charis*, as far as we know, did not signify any particular feature of color, or draftsmanship, or measurement. It was a subjectively understood grace that pervaded all aspects of a painting. One could not learn it by the study of theory; it was rather, like knowing when "to take one's hand away" from a picture (in which Apelles also took pride; *NH* 35.80), a matter of intuition.

Still another new development of the fourth century seems to have been the desire to incorporate the representation of character (*ēthos*) and (*pathos*) into art criticism.[45] Emotions are, obviously, not subject to precise definition and measurement, and the depiction or understanding of them is hence an essentially subjective matter. In the *Memorabilia* 3.10.1 ff, Xenophon describes a supposed conversation between Socrates and the painter Parrhasius, in which Parrhasius holds rather conservative views about the representation of emotion in art, and Socrates expresses the "new thinking" of the fourth century. Socrates and Parrhasius agree that the function of painting is to create a "likeness of visible things" (εἰκασία τῶν ὁρωμένων) by a process of imitation. Socrates then asks if it is possible for an artist to imitate the character of the soul (ἀπομιμεῖσθε τῆς ψυχῆς ἦθος), and Parrhasius replies that it is not possible because the soul has neither *symmetria*, nor color, nor any of the characteristics of a visible thing (the usual criteria of professional criticism). Socrates points out, however, that the soul can at least be indicated "through the face and through the positions (σχήματα) of men both standing and moving"; Parrhasius agrees. In a second conversation, this time between Socrates and the sculptor Cliton, Xenophon (*Memorabilia* 3.10.6 ff.) makes the same point. Socrates poses a rhetorical question to which an affirmative reply is expected: "Does it not provide a certain delight to the beholders when the emotions (πάθη) of bodies in action are imitated?" When Cliton agrees, Socrates adds, "It follows, then, that the sculptor must represent the activities of the soul." While one may doubt whether these conversations ever actually took place, they clearly indicate a current

in the art criticism of the time and can be viewed as theoretical coun-
terparts of developments that can be detected in extant fourth-century
sculpture.[46]

The representation of emotion and character may have become
particularly important in the criticism of Greek painting in the fourth
century. The Theban painter Aristides the Younger (a contemporary
of Apelles, hence to be dated around the time of Alexander the Great)
is said by Pliny to have been the first to paint the *ēthē* and *perturbationes*
(*pathē*) of men (*NH* 35.98). The meaning of the passage is possibly that
Aristides was the first to codify methods for representing particular
types of *ēthos* and *pathos*, thereby giving them a kind of formal status
in art criticism. Aristotle's well-known comments on *ēthos* in the work
of several Greek painters could conceivably have been influenced by
such a development.[47]

2 Art Criticism in Greek Philosophy

To the Greek philosophers of the fifth and fourth centuries B.C., the
technical aspects of art, which so preoccupied professionals, were of
minor concern. The focus of Greek philosophy during this period was
turning increasingly toward questions of ethics and of social and
political theory. The arts tended to be viewed as significant and worthy
of evaluation to the extent that they played a role in Greek society,
particularly in its educational institutions.

While there was never any unity of doctrine about the nature of the
visual arts in Classical Greek philosophy, two ideas, propounded in
particular by Plato and Aristotle and supported by their prestige,
came to dominate the philosophers' approach to art criticism. The
first was that these arts achieved their ends through *mimēsis*, the im-
itation of the phenomena, physical and mental, of the sensible world.
The second was that a man's character, the way he thought and the
way he behaved, could be affected by exposure to the arts; and hence,
particularly in the case of the young, society should harness and control
the arts as an educational force.

CONCEPTIONS OF ART, THE ARTS, AND IMITATION

Technē

It has frequently been pointed out that the ancient Greeks did not have a word for what we now call "art" and therefore presumably did not have the conception that the word *art* expresses.[1] Our distinction between art or fine art (e.g. poetry, music, painting) on the one hand and craft (e.g. shoemaking, carpentry,) on the other did not exist in antiquity. Both were expressed by the Greek word *technē*, which might be translated as "organized knowledge and procedure applied for the purpose of producing a specific preconceived result," or simply "rational production." The end product of *technē* could be physical objects (e.g. sculpture, painting), an active performance (e.g. singing, dancing), or a certain condition in men (e.g. a state of health achieved through the practice of medicine) or in animals (e.g. horse training).

It must be admitted that it is not easy to give a precise definition of what we mean today by art, but one can at least point to several important ways in which our attitude may be said to differ from that of the Greeks. We tend to feel that art, unlike craft, is essentially non-utilitarian. A work of art is appreciated for what it is, not for any practical function it might perform. It is true that a building, or even statue, may serve a practical function, but its artistic quality is seen to exist above and beyond its practical function. The artistic quality of a work of art, be it a poem, a musical composition, a statue, a building, or even an artistically made shoe, is found in the meaningful and in some way satisfying experience that is communicated to the beholder through form (words, musical sound, visual forms). An artist is one who creates or reproduces (as in the case of a performing musician) forms by which meaningful experience is communicated. Art is thus, for us, more a matter of experience—emotional, intuitional, intellectual—than action. We do of course recognize that an artist "does" something and has a "technique" (a good, simple translation of *technē*), but we tend to see even this artistic activity as an end in itself, a type of experience, rather than simply a practical means. However trite terms like *creativity* and *inspiration* may have become in our post-Romantic tradition, we still respect the idea behind them and like to

think that an artist paints a picture not to win a prize or to make money but for its own sake.

The Greeks were by no means unaware that there was an element of inspiration in the artistic process. The idea, in fact, appears at the very beginning of Greek literature in the appeals of Homer and Hesiod to the Muses.[2] But to the Classical Greek philosophers inspiration was neither essential to the nature of the arts nor relevant to the question of judging their functions and products. Plato, for example, who was perhaps more keenly aware of the role of inspiration in the arts than any other Classical author, looked on it as a kind of madness that confounded rational thought.[3]

In its earliest recorded uses, in Homer and Hesiod, *technē* seems to mean "cunning of hand" or "skill."[4] It seems at times even to have implied a kind of trickiness.[5] The concept of *technē* as "specific craft," in which a definite orderly procedure is used to produce a specific, preconceived result, seems to have originated somewhere around the middle of the fifth century B.C., perhaps under the influence of sophistic thought. The great Sophists, such as Protagoras, Gorgias, and Prodicus of Ceos, were in many ways the first professors. They earned their livelihood by organizing and purveying knowledge of various subjects to students who were willing to pay for their instruction. In view of their far-reaching involvement in the practical affairs of Greek society, it is not surprising that the interests of the Sophists were anthropocentric and tended to veer away from the preoccupation with natural science and cosmology that had characterized Greek philosophy in the sixth century. One result of this anthropocentric attitude was a tendency to feel that the final standard by which the nature of existence was to be judged was human perception. Moreover, whatever the basis of knowledge was, and some, like Gorgias, seem to have doubted that man could ever know, its value was to be judged by its utility in human life. Thus man, in Protagoras's catch phrase, which became the theme of sophism, was the "measure of all things," and his culture became the most compelling subject of study.

Human culture, seen in historical perspective, was viewed as a product of all man's various *technai*. This attitude gave rise to an anthropological view of society, in which the old Hesiodic view that the world as the Greeks knew it was a degenerate survival of a purer and better age was replaced by an evolutionary concept in which man

was seen as having progressed from brute savagery to civilization by the development of increasingly complex *technai* and the application of them to his environment. An evolution of this sort is sketched in a long speech put in the mouth of Protagoras by Plato (*Protagoras* 322 A–C) and also appears in a poetic form in the *Prometheus Bound* (476–506) of Aeschylus and in the first stasimon of the *Antigone* (lines 332 ff.) of Sophocles. (The appearance of the theory in drama around the middle of the fifth century indicates that it had attained a popularity that went beyond the confines of the sophistic "classroom.")

Protagoras maintained that the highest need of man in a civilized society was political *aretē*, the "excellence" that results from knowing how to live in a city and to conduct its affairs with justice and moderation (Plato *Protagoras* 323A ff.). This excellence was held to be the product of *technē*, just like any other achievement of civilization, and being like other *technai*, it could be systematized, taught, and passed on from generation to generation by competent instructors. The Sophists claimed to be just such instructors. Protagoras (or at least the Protagoras who is presented to us by Plato) saw his ultimate subject as "political *technē*," ἡ πολιτικὴ τέχνη (*Protagoras* 319A), the art of living in and managing a *polis*. All men, he insisted, had some degree of aptitude for this *technē*, but it nonetheless had to be acquired from a competent teacher (*Protagoras* 323C). Since the students who came to the Sophists, or to whom the Sophists came, were usually members of the aristocratic class who were in search of instruction that would help them to attain positions of power and influence in their respective cities, the influence of sophistic thought was widespread in the Classical Greek world.

Sophistic thought on the subject of *technē* influenced subsequent Greek thought in two important ways. First, it expanded the *technē* concept to include not only practical crafts but also the less concrete intellectual and emotional activities by which a man practiced "virtue" or "excellence" in his society. If a quality as inconcrete as moderation, for example, was the product of *technē* in much the same way that a shoe or a table was, then quite obviously poems or musical compositions or paintings were also. The Sophists may have been primarily responsible for the lack of a distinction between art and craft in Greek thought.

Second, sophistic thought encouraged a scientific description and analysis of the components of different *technai*. The prototype for such

analyses was perhaps the sophistic analysis of the *technē* of rhetoric. Control of the power of persuasion that was inherent in speech was an essential step in the mastery of political *technē*. To teach rhetoric and to learn it one had to understand what its components were and how they were to be used. Prose manuals dealing with rhetorical technique were not uncommon by Plato's time, as his discussion of them in the *Phaedrus* (266D) indicates; the earliest such works seem to have been written around the middle of the fifth century B.C. in the Greek cities in Sicily, whence came, among others, the Sophist Gorgias who was the most influential rhetorician of the century. While technical manuals on other specific arts existed even earlier (e.g. the manual on architecture by Theodorus and Rhoecus or the treatise on music by Lasus of Hermione),[6] the fifth-century manuals on rhetoric seem to have popularized the genre and to have influenced a variety of technical works (Polyclitus's *Canon* and Hippodamus's[7] treatise on city planning being perhaps among them) culminating in the research treatises of Aristotle and his followers, who in turn may have influenced Xenocrates the art historian.

Socrates, judging by his frequent use (according to Plato) of the arts of shoemaking, horse training, and so on as analogies for philosophical problems, appears to have been strongly influenced by the Sophists' expanded concept of *technē*; and so, clearly, was Plato. The sketch of a simple society presented in the *Republic* (369B ff.) prior to the delineation of an ideal society is reminiscent of the sophistic "anthropology," and his association of the simplest crafts with the literary and visual arts in a single category of productive art (see especially *Republic* 373 A–B) follows the model established by the Sophists. In other ways, it hardly need be said, Plato's deep differences with the Sophists—his rejection of their idea that moral virtue was a teachable commodity that varied from society to society and his disapproval of persuasive rhetoric —run throughout the dialogues and set him apart.

The *technē* idea receives its final and definitive analysis in the hands of Aristotle, who maintains the, by his time, traditional view that art includes all productive activities, but who ascribes a new and more profound significance both to the nature of its methods and to its role in human thought.

Aristotle's most basic statement of what art is occurs in the *Physics*, where he describes it as a purposive process that produces a final form

35

out of preexisting matter (194b24 ff.). A man builds a house by following an orderly series of steps that are aimed at creating a specific product in the same way that nature follows an orderly process when it produces the leaves of a plant. Art thus "imitates nature" (in the sense that its processes are analogous to nature's), but it can also be said to complete nature (199a8 ff.) in that it brings about forms that are inherent in nature's materials but which nature itself does not produce. The artist differs from nature in that the materials he uses are not inherent in himself, and his products differ from nature's in that their form is not natural to their material (i.e. nature uses wood to make a tree; an artist can use it to make a ship, a statue, etc.).

All arts followed this process according to Aristotle, and he seems not to have drawn any more of a distinction between "fine art" and "craft" than Plato did. He did recognize that the imitative arts (*Poetics* 1451a30) formed a special class because they used a certain type of raw material —human character, emotion, and behavior. But the imitative arts otherwise followed a procedure similar to that of all other arts, that is, they superimposed their own structural laws on their particular raw material in order to create a product that was peculiar to them. A dramatic poet may imitate an action that is "natural" to an actor, but, as Randall has put it, "the artist must convey, not its natural appropriateness and rightness, but rather a 'necessity or probability' inherent in the materials of his art" (e.g. plot, character, diction).[8]

The "natural interpretation" of art, that art imitates and completes the processes and possibilities of nature, was complemented by what might be called a "psychological interpretation," in which Aristotle identified art as one of the characteristic virtues of the human *psychē*, that part of man which perceives and thinks (*Eth. Nic.* 6.4.1 ff.). As such it was one of the instruments or skills by which man discovered truth and realized his own particular good. Aristotle maintained that the good of a thing resides in its characteristic function (*Eth. Nic.* 1097 b26). Man's characteristic function he saw as the active exercise of the *psychē* in accordance with *logos*, the "rational principle" (*Eth. Nic.* 1098a7). The characteristic function of the rational part of the *psychē* was the attainment of truth (*Eth. Nic.* 1139a12–13). Any function could be considered well performed when performed in accordance with its characteristic virtues, *aretai* (*Eth. Nic.* 1098a16–17). The "virtues" of the function of the rational part of the *psychē* (i.e.

36

attainment of truth) were found to be fivefold: *technē, epistemē* (scientific knowledge), *phronēsis* (practical wisdom), *sophia* (theoretical wisdom), and *nous* (intelligence) (*Eth. Nic.* 1139b16–17). *Technē* could be defined as the "trained ability (*hexis*) of making something under the guidance of rational thought," μετὰ λόγου ποιητικὴ ἕξις (*Eth. Nic.* 1140a9–10).

Although his association of art with the intellectual excellence of the soul and his view of the artist as one who can complete the processes of nature might seem in theory to ascribe a new and more exalted role to artists (i.e. that of human "creators" who by a special wisdom imitate the processes first established by the divine creator of nature), Aristotle himself gives no sign of having drawn such a conclusion. When it came to assessing the practical role of the visual arts (e.g. painting) in Greek society, his outlook was perhaps more tolerant but not fundamentally different from that of Plato.

Mimēsis

A second term of fundamental importance in understanding the analyses of art in Greek philosophy is *mimēsis*, usually translated as "imitation." Because of Plato's controversial and disturbing use of the term in connection with poetry, its history and significance have been widely discussed and debated (see note 23). The use of *mimēsis* in connection with the visual arts might not at first seem as vexatious as its application to poetry (since it is easier to see how sculpture and painting, for example, might be said to "imitate" nature). Yet it is clear that *mimēsis*, even when applied to the visual arts, usually implied something beyond the simple process of copying a natural model. An understanding of the full range of the term's connotations is essential for comprehending not only Plato's view of art but the role assigned to art in all Classical philosophy.

The pre-Platonic usages of *mimēsis* and its cognates, the verb *mimeisthai* and the nouns *mimos* and *mimēma*, have been admirably collected and analyzed by G. F. Else,[9] who identifies three shades of meaning for this word group prior to 450 B.C. The most common meaning and the one that appears to reflect the basic idea behind the μιμ- root is "miming" or "impersonation," which Else defines as "direct representation of the looks, actions, and/or utterances of animals or men through speech, song, and/or dancing."[10] In the Homeric *Hymn to Delian Apollo* (lines 162–63), perhaps dating from the seventh century

B.C., the poet praises the chorus of Delian maidens who "know how to mime the voices of all men" with such effectiveness that "each man would say that he himself was singing." The Delian maidens could apparently mimic the different accents of visitors to the sanctuary of Apollo. The same sense applies later to Aeschylus *Choephoroi* 564, where Orestes and Pylades agree to "mimic the tongue (dialect) of the Phocians." Else finds a second possible meaning for *mimeisthai* in Theognis 370, where the poet's claim that "no one of the unwise is able to imitate me" implies "imitation of the actions of one person by another, in a general sense, without actual miming." The date and even the authenticity of the passage have been questioned, however. A third meaning, applying to *mimēma* only, is "replication: an image or effigy of a person or thing in material form," and occurs in two fragments of Aeschylus—one referring to a frock that is a "copy" of a Libyrnian cloak; the other to a painting or painted image that resembled a "likeness done by Daedalus."[11]

Possibly all these meanings were suggestive of the *mimos*, the "mime," the short, popular dramatic performances, often scurrilous in nature, which were developed particularly in Sicily. The term *mimos* itself, however, is rarely used by Attic and Ionic writers, perhaps because, as Else suggests, it had a foreign and vulgar connotation.[12]

The earliest appearance of the word *mimēsis* would seem to be in Herodotus 3.37, where Cambyses is said to have made fun of an image of Hephaestus, which, Herodotus explains, was a *mimēsis* of a pygmy. The meaning in this case is clearly similar to that of *mimēma* earlier.

Later in the fifth century there is a trend away from the first of the meanings identified by Else (i.e. the mimicry characteristic of the actual "mime") toward the second, more general meaning of "doing as somebody else does," that is, following his example without actual physical mimicry. Examples occur in Aristophanes, Euripides, Herodotus, Thucydides, and Democritus. As typical examples we might cite Euripides *Helen* 940, where Helen counsels Theonoë to "imitate the ways" (μιμοῦ τρόπους) of her righteous father; or Thucydides 2.37.1, where Pericles boasts that the Athenians are a model for others rather than "imitators" (μιμούμενοι) of them.[13]

Plato carried on the tendency to assign an abstract sense to *mimēsis* and in doing so greatly expanded its range of meaning. By creating a category of "mimetic arts," to which poetry as well as the visual arts

were assigned, he raised the term to a new level of philosophical importance, and by using the *mimēsis* concept as the basis for his rejection of most poetry from the ideal state envisaged in the *Republic,* made it a controversial concept, at least for subsequent generations. Since his treatment of *mimēsis* is so intimately bound up with his theories on morality and education, I will reserve a detailed treatment of them until the next section. For the moment we are concerned only with delineating the range of meanings that Plato and others applied to the term. Plato recognized two varieties of *mimēsis* within the realm of *technē.* Although he never states the distinction in so many words, we might call these two varieties "literal imitation" and "imitation by psychological association." In the former the artist actually produces a reproduction of concrete features in a prototype, as when an actor impersonates a woman or a warrior, or when a painter depicts a man, tree, or animal. In the latter the formal components of an art, such as musical rhythm, are used to imitate states of mind—courage, indolence, and so on—which exist in the "real" world but are not so much copied as re-created by art. The two types of imitation are, of course, not mutually exclusive. A drama both literally depicts people and events and also, by the choice of words and rhythm, projects an emotional tone. Each type of *mimēsis* might further be subdivided into a *productive* and a *receptive* variety, the former referring to the artist who formulates the imitation, the latter to the listener or beholder who participates in it.

Mimēsis in Aristotle, like *technē* with which it is closely bound up, has both a practical and a cosmological significance. On the practical level he accepted the Platonic conceptions both of a literal imitation and of imitation by psychological association. The conceptions are most fully developed in the *Poetics,* where the first definitive statement made about dramatic poetry and music is that they are *mimēseis* (1447a16), which have species differing in three ways—by the generic means which they employ, by the objects they imitate, and by the manner they employ (within the generic means) in achieving this imitation. Those arts that employ sound, for example (poetry, prose, music), can be divided according to whether the generic means they employ is words, rhythm, or melodic pattern (ἁρμονία), used either singly or in combination (*Poetics* 1.2–6). Again, they can be divided according to whether the subjects they represent are noble or base, comic or serious, and so on (*Poetics* 2.1–7). Finally, within each generic means—words, for example

39

—they can be divided according to the manner they employ, for example, straight narrative, dramatic impersonation, or a combination of the two (*Poetics* 3.1–3).

This division could undoubtedly apply to any category of art; and, in fact, Aristotle seems to have the analogy of the visual arts in the back of his mind in this first section of the *Poetics*. He notes that just as those whose art involves sound use words, rhythm, and melodic pattern, so those who make images use color and forms in producing their many imitations, χρώμασι καὶ σχήμασι πολλὰ μιμοῦνταί τινες ἀπεικάζοντες (1447a18–19). And when he explains how the objects imitated can differ, he presents the well-known analogy to three painters—Polygnotus who depicted men as better than they are, Pauson as worse, and Dionysius as they actually were (1448a5–6).[14] Later, in discussing two of the most essential of the elements through which the tragic genre of poetry achieves its effects, plot and character, he again resorts to analogies with painting. A tragedy with plot is more satisfying to the mind than one without it, just as a simple black-and-white sketch is more satisfying than a series of beautiful colors applied to a surface at random (1450b1–3); and tragedy can emphasize the representation of character, as do the paintings of Polygnotus, or it can ignore it, as do the paintings of Zeuxis (1450a25–28).

To Aristotle, then, the literary and musical arts by declaration, and the visual arts by implication, literally imitate things, as when drama imitates events and people, and paintings and statues represent people and things; and they also imitate states of mind by use of their formal components. The latter type of imitation, by psychological association, is most obvious in music, especially, to use Aristotle's own examples, in harp playing or flute playing (1447a24), which use rhythm but do not represent specific narrative actions or, obviously, physical objects. But it is also present in visual arts such as painting, as Aristotle makes clear when he notes that we can find pleasure (a state of mind), through color or some other cause, even in a painting of a repulsive subject (1448b17–19). Both types of imitation, he states, are instinctive in men (1448b20).

Aristotle also entertains a cosmological view of *mimēsis*, in which the term actually serves as a definition of the way in which *technē* duplicates the teleological processes of nature. This type of *mimēsis* might be called "imitation by process." The view is summed up as

succinctly as possible in the following section of the *Physics*:

> If a house were one of the things produced by nature, it would be the same as it is now when produced by art. And if natural phenomena were produced not only by nature but also by art, they would in this case come into being through art in the same way as they do in nature. One step in their development exists for the sake of the next one. In short, art either completes the processes which nature is unable to work out fully, or it imitates them. [*Physics* 199a15–19]

This concept of *mimēsis*, is, as I stated earlier, a purely philosophical one, and Aristotle does not apply it to the practical problem of art criticism, that is, making value judgments about the arts.

THE EFFECT OF ART ON HUMAN CHARACTER

Plato

Plato's hostility to the arts in general, and to the visual arts in particular, is well known. Without going into all the aspects of the vast and vexing problem of why Plato felt as he did, it will be relevant to our subject to summarize (1) what the basis of his condemnation of sculpture and painting was, (2) what positive factors, if any, he saw in these arts, and (3) to what extent he may have influenced or been influenced by the art of his time.

To answer the first of these questions we must examine two sections of the *Republic*, one in the third book (mainly 392D ff.) and the other in the tenth (597A ff.), where the basic subject under discussion is the value of poetry in the education of the guardians of the ideal state. It is within the scope of this subject that Plato's interpretation of *mimēsis*, which we have already described briefly, is developed. The discussion begins with the observation that if manliness and a philosophical disposition are going to be instilled into the potential guardians from childhood, the poetry to which they are to be exposed must be controlled so that only good and noble images of the gods and of human life are impressed on their minds (*Republic* 377A ff.). Poets such as Homer and Hesiod, who often depict the gods in crude, comic, or scurrilous ways, should therefore be censored, although certain parts of their works that are conducive to such virtues as self-control may be retained (389E).

41

Turning to the representation of human life, Plato begins by drawing a distinction between poetry that proceeds "by simple narrative" (ἀπλῇ διηγήσει) and that which achieves its effect "by imitation" (διὰ μιμήσεως), for example, drama or the speeches in epics, in which dramatic impersonation of characters is involved (392D). The latter involves "literal imitation" of the sort employed by the mimist-actor, in which the gestures, thoughts, and emotions of a literary character are acted out. (Its equivalent in the visual arts would be simple "representation" in sculpture or painting of a certain subject—a man, tree, etc.) Dramatic poetry represents all types of character—good, bad, strong, weak—and the actor or reciter of such poetry is expected to throw himself into the part and identify with the character represented, just as the poet presumably did when he created the role. This is potentially dangerous, since "imitations, if continued from youth onward, become established in one's moral habits and nature and are revealed in one's body, voice, and thought," αἱ μιμήσεις, ἐὰν ἐκ νέων πόρρω διατελέσωσιν εἰς ἔθη τε καὶ φύσιν καθίστανται καὶ κατὰ σῶμα καὶ φωνὰς καὶ κατὰ τὴν διάνοιαν (Republic 395D). Imitation of bad character, in other words, can produce bad character; Plato is interested here in the receptive aspect of literal mimēsis.

The discusssion then turns to music, specifically music that accompanies poetic recitation, where we are introduced to what I have called "mimēsis by psychological association." Music is imitative, even without imitating birds or other natural sounds (which would be literal imitation), because its component elements, modes, and rhythms, can be used to suggest states of mind—softness, indolence, bravery, and so on (398B–399E).[15] Music, then, should be censored like poetry, and so, in fact, should all the arts, even architecture and furniture making (where literal imitation could scarcely apply), for these, like music, use rhythms and orderliness to produce good or bad effects on the character. "For disorder and lack of pattern and unfittingness are the kin of evil speech and evil character, but their opposites, on the contrary, are kin and imitations of moderation and noble character," καὶ ἡ μὲν ἀσχημοσύνη καὶ ἀρρυθμία καὶ ἀναρμοστία κακολογίας καὶ κακοηθείας ἀδελφά, τὰ δ'ἐναντία τοῦ ἐναντίου, σώφρονός τε καὶ ἀγαθοῦ ἤθους, ἀδελφά τε καὶ μιμήματα (Republic 401A). At the end of this section Plato is not so much interested in banishing all artists as in seeking out those who are able "to pursue the nature of the beautiful and the orderly,"

ἰχνεύειν τὴν τοῦ καλοῦ τε καὶ εὐσχήμονος φύσιν (401C), so that the youth may be assured a psychologically salubrious atmosphere.

When he returns to this subject in the tenth book of the *Republic*, after fully working out the theory of forms and its ramifications in the intervening sections, Plato again examines the question of the role of the imitative arts in education and subjects it to a second and considerably more severe critical appraisal, an appraisal that disturbingly jars with modern thought on this subject. The basic idea that has been developed in the intervening sections is that the aim of the philosopher, in fact the presumptive aim of all human effort, is to obtain direct knowledge of the "forms" or "ideas" (*eidē*) that constitute an immutable substratum of being. The objects of the sensible universe and the images of them that we create or perceive are illusory, mutable distortions of the real "forms" and belong to the realm of "opinion" (*doxa*), "faith" (*pistis*), and "supposition" (*eikasia*). The purpose of education should be to help men overcome the deceptive function of the senses and attain an undistorted knowledge of reality. Anything that inclines the mind to immerse itself uncritically in the changing forms of the sensible world stands in the way of this aim. Artists, lacking this insight into the true nature of things, can produce only imitations of things in the world of "opinion," a world which is itself already one stage removed from reality. Hence even the good imitative artists, who in the third book had tentatively been given a place in the ideal society, are rejected. Poets and painters, for example, are spurned because they can only produce, like mirrors, "appearances but not the true reality of things," φαινόμενα οὐ μέντοι ὄντα γέ που τῇ ἀληθείᾳ (596E). The painter gives us only a *phantasma* (598B), which is farther removed from reality than the thing he paints. In the case of a simple object, such as a couch, the "form" (εἶδος) is created by God (597B); a single particular couch is made by a carpenter and at least bears some resemblance to the "real" thing, τι τοιοῦτον οἶον τὸ ὄν (597A), but a painting of a couch is simply an imitation of an imitation. The painter, having no real knowledge of the objects that he reproduces, bases his judgment of them only on "colors and shapes" (601A) and thus imitates, not even the actual couch of the carpenter, but only one particular appearance of it. Plato sums up his view almost with ferocity: "Mimetic art, then, is an inferior thing, cohabiting with an inferior and engendering inferior offspring" (603B).

43

It has frequently been suggested that Plato's hostility to poetry in particular was provoked by the oracular role that many people in his own time ascribed to the early Greek poets. The Greeks had neither a revealed religion nor a scriptural tradition; nor did they have a single, consistent social ideology. The function that scriptures have performed in later European society was in Greece given to the ancient poets, particularly Homer and Hesiod. In the fifth century a fundamentalist tradition arose around these poets in which they came to be looked upon as a source of information about "all the arts, all human affairs relating to virtue and evil, and all things divine" (*Republic* 598D–E). This approach was no doubt promoted by professional Sophists, like the commentator on Homer satirized by Plato in the *Ion*, whose livelihood depended on having a key to all knowledge. It was also probably fostered by the fact that much of a Greek youth's education consisted of memorization and recitation of the poets, a process that encouraged the formation of a proverb-quoting type of mentality rather than a rational, deliberative one.[16] There can scarcely be any doubt that Plato did object to this development in the use of poetry and that the severity of his attitude was accentuated by it, but it is probably naïve to say that if Plato understood poetry as we do, he would undoubtedly have admired it as we do, and to conclude therefore that the modern reader should magnanimously forgive or comfortably ignore everything Plato says about poets in the *Republic*.

Conditions in Plato's own time have also been cited to explain and mitigate his unsympathetic and in some ways obtuse view of painting.[17] It has been suggested that the vehemence of his feelings about painting in particular was prompted by the development during his lifetime of the technique known as *skiagraphia*, literally "shadow painting," in which a subtle blending of light and dark tones, the process we now usually call chiaroscuro, was employed to create an increasingly accurate reproduction of the degree of light and shade present in our ordinary perception of objects in space. In Plato's youth the first steps in this development had been taken by the Athenian painter Apollodorus who became known as the *skiagraphos* and his style, *skiagraphia*.[18] Plato on a number of occasions singles out *skiagraphia* for special scorn, perhaps most bitingly in *Republic* 602C-D, where *skiagraphia* is said to take advantage of "a weakness in our nature, being not much different from sorcery and sleight-of-hand tricks" (ᾧ δὴ ἡμῶν τῷ παθήματι τῆς

φύσεως ἡ σκιαγραφία ἐπιθεμένη γοητείας οὐδὲν ἀπολείπει, καὶ ἡ θαυματοποιία).

Yet while Plato was no doubt particularly annoyed by the developments in painting in his own time, it is certainly wrong to suggest that these developments alone accounted for his hostility toward the visual arts. In the *Politicus*, a later dialogue in which the virulent tone of the *Republic* is absent, he expresses the opinion that the whole class of arts which produces imitations (μιμήματα) for our pleasure, is essentially a trivial "plaything," παίγνιον (288C).

The truth of the matter seems to be that Plato's stern evaluation of the arts, consistent throughout his mature life, was epistemological.[19] As a man he was clearly neither a philistine nor an iconoclast;[20] in fact, as we have noted earlier, he was keenly aware of the inspirational aspect of artistic creation and perception. What were probably his personal, nonepistemological feelings about art were best summed up toward the end of his life in the *Laws* 667B ff., where he suggests what the criteria should be by which lawgivers are to judge which types of art, particularly music, should be admitted in a well-organized society. The first standard should be *orthotēs*, "correctness" (in the mimetic arts, fidelity to the thing copied); the second should be *ōpheleia*, "usefulness"; and only last comes *charis*, the "charm" or immediate pleasure that art affords. Plato was clearly not insensitive to this element in the arts, and in making *charis* a criterion of artistic judgment, he may have been making what Schuhl has called a belated "légère concession faite, avec une courtesie dédaigneuse, à ses adversaires."[21] But whatever the attractions the arts might hold, Plato as a philosopher aimed at (what were to him at least) more sublime goals. And in the pursuit of these ends the arts were an epistemological and educational nuisance.

Nevertheless, because Plato's austere, even puritanical view of literature and the visual arts is so disappointing to modern scholars schooled in the tradition that the arts are among the higher pursuits of civilized man, attempts have frequently been made to discover a more positive, sympathetic outlook couched in a number of scattered passages throughout the dialogues. And it is undoubtedly possible to find occasional passages that reflect plato's private aesthetic predilections. His philosophical view of measure and *symmetria* and their relationship to beauty have already been discussed. A less formal aspect of the same attitude can be found in his approval of an orderly and appropriate

placement of parts, analogous to the arrangement of the parts of the human body, in an artistic composition, be it a discourse (*Phaedrus* 264C) or a painted statue (*Republic* 420C–D). He also expresses a fondness for pure (that is, unmixed) colors (*Philebus* 51D) and praises the beauty of geometrical forms (*Philebus* 51C; *Timaeus*, 53E–54A).[22] On one occasion he even praises a specific, historical artistic tradition, that of Egypt (*Laws* 656D–E). The Egyptians, he felt, by the use of a few "beautiful forms" (καλὰ σχήματα) had created an art that had undergone no change for "ten thousand years." It was above all this lack of change that pleased Plato.

These passages undeniably tell us something about Plato's "taste," but would we be justified in systematizing them into a positive Platonic theory of art and aesthetics, a theory of what might be called "good *mimēsis?*"[23] The answer is probably no, but the passages on which such a construction might be based are of interest both in themselves and for the influence they may have had on later Greek thought. In addition to the potentially receptive attitude toward the visual arts implied in the third book of the *Republic* (401A), there are two passages of particular importance that might be taken to imply that Plato recognized a type of *mimēsis* in which the artist imitated not simply appearances but the "forms" themselves; the *mimēma* so produced would be based on real knowledge rather than on opinion and would be, unlike the painting of the couch in the tenth book of the *Republic*, just one stage removed from reality.

One of these passages occurs in the *Sophist* and has already been referred to briefly. In it Plato compares a sophist to a painter, in the sense that both are capable of making imitations that deceive children (234B–235A), and proceeds to define further what the sophist is by the process of division into alternatives within the sphere of mimetic art, κατὰ μέρη τῆς μιμετικῆς (235C). Image-making art, εἰδωποιική, the term Plato uses for the arts of both the painter and the sophist, is thus divided into two branches—*eikastikē*, the production of images that are other than but like what they imitate (235D), and *phantastikē*, the production of images that appear to be like what they imitate but are in reality quite unlike it (236B–C). As an illustration Plato cites the techniques employed in making colossal statues and paintings. He notes that artists often intentionally alter the real proportions, ἀληθινὴ συμμετρία (235E), by shortening the legs and lengthening the torsos

46

of their figures in order to compensate for the distortions caused by the low vantage point from which they are seen. Such statues and paintings are examples of *phantastikē*; they deceive our senses into believing that they have the real proportions, τὰς οὔσας συμμετρίας, of beautiful forms, but in fact the beauty of their proportions is only an appearance, τὰς δοξούσας [συμμετρίας] εἶναι καλάς (236A). On the other hand, a statue that exemplifies *eikastikē* is one that reproduces the real proportions of the model, τὰς τοῦ παραδείγματος συμμετρίας (235D). Plato is more interested in delineating than evaluating in this passage, but, within the limits of the given alternatives, it is clear that he favored *eikastikē* over *phantastikē*. Such a preference is not only in keeping with the epistemological system outlined in the *Republic* but is supported by the fact that the sophist is contemptuously assigned to the realm of *phantastikē* (*Sophist* 268C–D).

The second passage that might possibly have some bearing on a Platonic concept of good *mimēsis* occurs in the *Timaeus* 28A–B:

> But if the maker of any object, gazing at that which is always the same, making use of a model of that sort, finishes to perfection its form and quality, that which results must be of necessity wholly beautiful; but if he gazes at what has a relative existence, using a created model, it will not be beautiful.

> ὅτου μὲν οὖν ἂν ὁ δημιουργὸς πρὸς τὸ κατὰ ταὐτὰ ἔχον βλέπων ἀεί, τοιούτῳ τινὶ προσχρώμενος παραδείγματι, τὴν ἰδέαν καὶ δύναμιν αὐτοῦ ἀπεργάζηται, καλὸν ἐξ ἀνάγκης οὕτως ἀποτελεῖσθαι πᾶν. οὗ δ'ἂν εἰς τὸ γεγονός, γεννητῷ παραδείγματι προσχρώμενος οὐ καλόν.

This passage suggests the possibility that if the artist,[24] like great philosophers or statesmen, could apprehend that which is real and permanent behind the changing appearances of sense experience, the object he created would be truly beautiful, καλόν, an analog of a divine model like Plato's ideal state.[25] If one combines the *eikastikē* idea of the *Sophist*—that there is a form of *mimēsis* which accurately imitates a thing as it is—and assumes that this thing is the "divine paradigm" of the *Timaeus*, the result is a kind of spiritual *mimēsis* in which the artist becomes a visionary and his work an emanation of the forms themselves.[26]

The real question is not whether one *could* extract such an idea from

the Platonic dialogues (since in the Hellenistic period some people in fact did), but whether one *should*. It is reasonable to assume that if Plato had felt strongly that there was a spiritual *mimēsis*, he would have discussed the subject explicitly. Moreover, there are passages in the later dialogues which seem to indicate that he preserved the opinions expressed in the *Republic* without any fundamental change. In the *Sophist* itself, for example, the processes of division that had resulted in the distinction between *eikastikē* and *phantastikē* within the general category of "image making" is continued in section 265 ff., where a new division is drawn between the acquisitive arts and the productive arts. The productive arts are then subdivided into a divine branch (things made by God or nature) and a human branch (man-made things). Each of these categories can be subdivided into the production of real things and of images, and this as before is divided into true and fantastic image making. The conception of the role of painting within this system of division does not appear to differ from the conception expressed in the tenth book of the *Republic*: "Shall we not say that we make an actual house with the art of building, and with the art of painting that we make another house, which is a kind of man-made dream (ὄναρ ἀνθρώπινον) for people who are wide awake?" (*Sophist* 266C).

Whether Plato's thought had any influence on the art of his time is doubtful. It would be difficult to discern any trace of it in extant Greek sculpture. The Roman copies and putative originals that are associated with Praxiteles, for example, suggest that he, the most influential Athenian sculptor of the fourth century, would hardly have sympathized with Plato's austere disapproval of the world of the senses. Possibly in Greek painting of the late fifth and of the fourth century B.C., completely lost except for a very limited echo in vase painting, there was some sympathy for Platonic ideas, although in view of Plato's persistent criticism of the painter's worth, this would be ironic. It has been suggested that the Sicyonian school, founded by the painter Pamphilus early in the fourth century and emphasizing *arithmetica et geometria* in the training of a painter (Pliny *NH* 35.76), might have been influenced by Plato.[27] (As we have seen, however, an interest in order and measure had existed among Greek artists long before the time of Plato.) In view of Plato's often expressed dislike of *skiagraphia*, one might also wonder whether Parrhasius's championing of draftsmanship and

48

linear precision over shading did not reflect a conservative tradition of criticism which was, if not directly influenced by, at least receptive to some aspects of Platonic thought.[28] But such ideas are obviously pure speculation.

Aristotle

Aristotle's analysis of what *technē* consisted of made him more sympathetic than Plato, at least in a theoretical way, to the "imitative" arts. His view that the rational process by which men produced works of art mirrored the processes of "nature" itself led him away from the Platonic conception of a painting as something "twice removed" from reality toward the view that a painting was a product resulting from the application of specific, orderly actions to a specific material with a specific end in view.

On the question of the role of art in a well-ordered society, however, Aristotle's view is not unlike Plato's. Since the arts played an important role in the education of the young, they should, he felt, be subjected to censorship to insure that their moral effect would always be beneficial. In discussing the educational value of music in the final book of the *Politics* (8.4.3 ff.), Aristotle maintains that music is something more than simply a form of amusement, since the moods it creates have a strong effect on the listener and the performer and help to shape their characters. The sort of music encouraged by the rulers of a city should therefore be carefully considered. The visual arts too have their moral effect, although in their case the effect is somewhat less intense because they deal not in "likenesses" (ὁμοιώματα), as does music, but in "signs" (σημεία) of character conveyed through the colors and forms used to represent the human figure. The young, therefore, should be allowed to look at the works of Polygnotus, who represented men as being better than they are, but not at the works of Pauson, who painted them as worse (*Politics* 1340a33 ff.).[29]

Aristotle's insistence on judging works of art by their contribution to moral education was, of course, not the result of a mindless puritanism any more than was Plato's and it must be understood, like his concept of *technē*, in the light of his broader ethical philosophy as presented especially in the first book of *Nicomachean Ethics*. Every action, to Aristotle, aims at some good, and the highest good at which human activity aims is "well being" or "happiness" (εὐδαιμονία), which was

49

traditionally defined (a definition acceptable to Aristotle) as "doing or living well" (τὸ εὖ ζῆν καὶ τὸ εὖ πράττειν, *Eth. Nic.* 1095a19-20). As we have already seen, Aristotle believed that the good in anything resides in that thing's proper function. The good of carpenters or shoemakers, for example, qua carpenters or shoemakers, is always judged in terms of their particular functions. The particular function that characterizes man is rational thought (λόγος) and the capacity to act under its influence, in other words an "activity of the soul under the guidance of rational principle," ψυχῆς ἐνέργια κατὰ λόγον (*Eth. Nic.* 1098a7–8).

A particular function is further judged to be well performed when it is performed in accordance with the *arētē*, "excellence" or "virtue," that is appropriate to it, κατὰ τὴν οἰκείαν ἀρετήν (*Eth. Nic.* 1098a16). The "virtues" that characterize man are of two types, intellectual and ethical (*Eth. Nic.* 1103a6–8). The intellectual virtues, such things as speculative and practical wisdom, *technē*, and the like, form the basis of ethical virtues, such as temperance and generosity, which are in fact really "trained habits," *hexeis*, acquired in this case by repeated efforts at making a proper forechoice (προαίρεσις) of the "mean" in any given situation (*Eth. Nic.* 1106b36 ff.). It is this concept of *hexis*, a habit that is the product of prolonged conditioning, that determines Aristotle's moralistic evaluation of the arts. In the conditioning process that leads to the establishment of a moral *hexis*, it is important that the environment, of which the arts are a prominent part, present nothing that would interfere with the formation of that *hexis* or create a "wrong" one.

A Counter Tradition: Gorgias

There are a few fragmentary texts suggesting that the renowned Sophist and orator Gorgias of Leontini[30] formulated a doctrine about the role of art and the nature of perception in art that was directly and perhaps deliberately opposed to that of Socrates and Plato. As summed up in the *Republic* (605 ff.), Plato's reason for banishing mimetic poets, especially tragic poets, from his ideal society was that they created "phantoms far removed from reality" (εἴδωλα . . . τοῦ δὲ ἀληθοῦς πόρρω πάνυ ἀφεστῶτα), which were pleasing to the lower, uncomprehending part of the soul and strengthened this lower part at the expense of the rational part. In short, the poets deceived men and became sources of ignorance and mental instability. Gorgias, by

contrast, praised the power of deception, *apatē*, which the mimetic arts possessed, and apparently suggested that a kind of wisdom could be derived from it. He is quoted by Plutarch, in a discussion of the means by which tragedy affects its viewers, as having said, "He who practices deception is more just than he who does not, and he who has yielded ιο deception is wiser than he who has not (ὁ τ'ἀπατήσας δικαιότερος τοῦ μὴ ἀπατήσαντος καὶ ὁ ἀπατηθεὶς σοφώτερος τοῦ μὴ ἀπατηθέντος).[31] It is not known from what work of Gorgias the quotation comes, nor is it even completely certain that it referred to one of the arts. But that Gorgias did encourage yielding to deception in the arts is made clear in his *Encomium of Helen*,[32] a lighthearted rhetorical exercise in which he offers a reasoned argument explaining why Helen should not be blamed for having run off with Paris. He maintains that it is natural for people to be affected by persuasive speech, which has the power to assuage pain, arouse pity, and so on (secs. 8, 9). Poetry, especially, is a kind of sorcery (γοητεία, the same word used by Plato in connection with painting), which strongly affects the soul and can sometimes lead to "deceptions" in one's opinions, δόξης ἀπατήματα (sec. 10). Painting and sculpture have the same effect. They create "images," εἰκόνες (sec. 17), which can be sources of both fear and delight. "Now in the case of painters, when they render to perfection a single form and composition out of many colors and forms, they delight the vision. And likewise the creation of statues and the working of images furnishes a divine sweetness to the eyes" (sec. 18). Helen yielded to the beauty of Paris, just as men normally yield to these beautiful images. There is a kind of divine power, θεία δύναμις (sec. 19), in such persuasion, and to yield to it may sometimes result in misfortune but should never be a cause for blame.

The philosophical basis for Gorgias's viewpoint, if we are to assume that he really had one, is perhaps to be found in his epistemological work *On Non-Existence or on Nature*, which is summarized by Sextus Empiricus. This work appears to have defended the subjective outlook of the Sophists on questions of existence and knowledge by using the Eleatic arguments in defense of being to prove that (1) nothing exists (i.e. no unchanging reality); (2) even if anything existed, man could not comprehend it; and (3) even if he could comprehend it, he could not communicate it to others.[33] While one may wonder how seriously Gorgias intended all this to be taken, there can be no doubt that he

genuinely disputed the "idealistic" view of knowledge and all that it implied for the arts. If there was no true reality beyond human sense perception, and if sense-perceived things, as such, were not communicable to others (speech and "things" being independent), there was no reason to criticize arts that dealt with illusion and deception. The contemporary painters who were experimenting with *skiagraphia* and perspective, and the sculptors who were experimenting with optical *symmetria*, if they cared about the opinions of philosophers at all, must have found Gorgias's views sympathetic.[34]

LATE HELLENISTIC IDEALISM

In the second century B.C., with the original creative forces that had shaped Classical Greece on the wane, a spirit of nostalgia for the past splendors of Greek civilization and an urge to idealize and glorify its achievements became increasingly common among Hellenistic intellectuals. One of the ideas that took shape as part of this retrospective movement in later Greek thought was the view that the great artists of the Classical period had been inspired seers, visionaries of a sort, who had been able to grasp the nature of divinity and convey it to their fellow men through the medium of the visual arts. In ancient art criticism this attitude is particularly apparent in the art histories of Quintilian and Cicero, where it is applied to the history of sculpture in particular (see chap. 7).

The key illustration used in presenting this classicistic inspiration theory is the role that Phidias was thought to have played in the development of Greek sculpture. It was felt that Phidias, above all other Greek artists, carried art beyond the simple representation of external nature and used it, especially in his Zeus at Olympia, to convey spiritual intangibles. In doing so he became a religious teacher and affected the course of Greek religion.[35] Perhaps the most vivid description of Phidias's achievement occurs in the *Life of Apollonius of Tyana* 6.19 by Flavius Philostratus (late second–early third centuries A.D.). The wandering sage Apollonius, in a conversation with an Egyptian wise man named Thespesion, criticizes the theriomorphic images of the Egyptian gods as undignified. Thespesion counters by suggesting that the anthropomorphic images of the Greek gods are equally earthbound, and the following conversation ensues:

"Well, did artists like Phidias and Praxiteles," he [Thespesion] said, "after going up to heaven and making copies of the forms of the gods, then represent them by their art, or was there something else which stood in attendance upon them in making their sculpture?" "There was something else," he [Apollonius] said, "a thing full of wisdom." "What is that?" he asked. "Certainly you would not say that it was anything other than imitation (*mimēsis*)?" "Imagination (*phantasia*)," Apollonius answered, "wrought these, an artificer much wiser than imitation. For imitation will represent that which can be seen with the eyes, but imagination will represent that which cannot."[36]

The contrast of *phantasia*, for which we have used the customary translation "imagination," but which might be even better translated as "intuitive insight" (since the word implies not simply fabricating something in the mind but actually "seeing" something that is not perceptible to the senses), with *mimēsis* emphasizes the radical departure that this theory makes from Classical Greek thought. *Mimēsis* is clearly used here to sum up the Classical philosophers' view of *technē*, in which all artists are craftsmen and the visual arts are crafts that copy external nature.

Where and how the "*phantasia* theory," as I shall henceforth call this Hellenistic doctrine of artistic inspiration, arose is a complex question. One can point to elements in it that are Platonic, Aristotelian, and Stoic. We have already seen how there is latent in Plato's treatment of art and imitation a conception of good *mimēsis*, whereby an artist might imitate not external nature but rather the "ideas" of which external nature itself is a copy. Plato himself, we have suggested, would probably have denied that this was actually possible, but it is not difficult to see how in a later age, increasingly inclined to mysticism and reverence for the past, the idea might have come to be applied to the great artists of the Classical era.

In Aristotle too we find lines of thought that could be used to formulate a new appreciation of the subjective, perceptive role of the artist in creating a work of art. His careful analysis of *phantasia* as an image-making faculty of the soul, derived from sense perception but not directly dependent on it (*De An.* 428A ff.), while obviously quite different from the later concept of *phantasia* as inspiration, can at least be said to have fostered an interest in the psychological processes and

53

implications of imagination. And it has been suggested[37] that his concept of a "form in the soul," εἶδος ἐν τῇ ψυχῇ (*Metaphysics* 1032bl and 23), from which the artist-craftsman proceeds, on the basis of his personal perception, to produce the object or condition that is the goal of his art, may have resulted in a deeper interest in the way an individual artist perceives his subject.

The Stoic Zeno carried the significance of *phantasia* beyond Aristotle's conception of it as simply the image-making element in the soul by recognizing one form of it, called *katalēptikē phantasia*, as essential to true understanding.[38] The existence of universals (e.g. Platonic "forms") was denied in Stoicism, and knowledge was therefore thought to be derived from sense perception of particulars. All particulars were material, and perception consisted of impressions or representations, φαντασίαι, of external particulars. In order to establish a criterion for truth and to avoid the skeptical relativism (which this type of epistemology naturally suggests) of earlier thinkers like Gorgias and the contemporary skeptics, Zeno and his followers recognized a *katalēptikē phantasia*, sometimes translated as "comprehensive representation," an impression that came from a real source, accurately reproduced that source, and could not have come from anything else. This impression was "true"; it demanded assent and could not be destroyed by discursive reasoning. Cicero seems to imply that Zeno ascribed this knowledge to the Stoic wise man and held that it was beyond the capability of the ordinary man.[39]

The jump from the irrevocable, true *phantasia* of the Stoic sage to the inspired, revelationlike *phantasia* of a revered artist is not a great one, and one would expect it to be made by a thinker, or school of thinkers, who were attempting to harmonize Stoic psychology with Platonic idealism. We might also expect him or them to have a classicistic outlook, that is, to appreciate and take pride in the achievements of Greek culture during the Classical period. All these conditions are fulfilled by the later development of Stoicism usually referred to as the Middle Stoa,[40] and it is tempting to speculate that the two outstanding figures of this school, Panaetius of Rhodes (ca. 185–109 B.C.) and Posidonius of Apamea (ca. 135–50 B.C.) had something to do with the invention of the *phantasia* theory. If we were to choose between them, Posidonius would seem the more likely of the two for a number of reasons. He had an enormously wide range of interests (Strabo 16.753 refers to him as πολυμαθέστατος), which must have encom-

passed the arts, and he was a prolific writer on the nature of religion and the gods.[41] There is evidence that he may have written a commentary on Plato's *Timaeus*, in which, as we have seen, the latent doctrine of a good *mimēsis* is particularly apparent and he was one of the teachers of Cicero,[42] the earliest of the authors in whose writings the *phantasia* theory is actually preserved.

The frequency with which the details, or at least the spirit, of the *phantasia* theory appears in writers who are primarily rhetoricians (Cicero, Quintilian, Seneca the Elder, Dio Chrysostum, Philostratus) suggests that there may have existed from the beginning some fundamental connection between it and rhetorical, or at least literary, criticism. It is therefore worth noting that Posidonius also wrote a treatise *On Style* ($\pi\epsilon\rho\grave{\iota}$ $\lambda\acute{\epsilon}\xi\epsilon\omega\varsigma$).[43] It was conceivably in this work that a picture of the development of Greek sculpture, with its culmination in the art of Phidias (perhaps originally formulated in one of Posidonius's religious writings), was first applied as an analogy to the development of rhetorical criticism. More will be said of this in the next chapter.

PLOTINUS

The thought of Plotinus stands, in many ways, at the end of ancient art criticism, for in it we have a final statement of some of the (by his time) venerable ideas of Classical and Hellenistic aesthetics, and also some of the first hints of a more mystical, anti-Classical view of artistic experience which was to characterize the Middle Ages. The *Enneads* of Plotinus seem to be based on notes for lectures which he gave in Rome for a group of pupils and friends between A.D. 245 and 270. After his death these notes were collected by his pupil Porphyry and arranged in six books, each consisting of nine essays (hence the title of the work as a whole). That such an artificially arranged collection should contain some inconsistencies is not surprising.

Plotinus was concerned first and foremost with working out the implications of statements in the Platonic dialogues about the nature of being and knowledge. Insofar as he was interested in knowledge, he was interested in perception; his examination of perception led him to the question of beauty; and within the scope of his discussion of beauty, he shows an occasional interest in the value of the visual arts. But being of tertiary or quarternary importance to him, what he had

55

to say about the arts probably often varied according to the exigencies of the reasoning he happened to be applying to "higher" topics. In any case one can detect at least three attitudes toward art in the *Enneads*—one purely Platonic, one an extension of the *phantasia* theory, and a third incipiently medieval.

The Platonic attitude is exemplified in the anecdote told by Porphyry that Plotinus refused to allow a painter or sculptor to make his portrait because his body was already a burdensome image imposed upon him by nature and a portrait would simply be an "image of an image."[44] This view of a portrait is, quite obviously, reminiscent of the couch "twice removed from reality" in the tenth book of the *Republic*. A more general statement of the principle behind it is expressed in the *Enneads* (4.3.10): "Art is posterior to nature and imitates it by making representations ($\mu\iota\mu\dot{\eta}\mu\alpha\tau\alpha$) which are indistinct and weak, playthings of a sort and not worth very much, even though it makes use of many mechanical devices in the production of images."[45]

When Plotinus approaches the problem of art in a more formal manner, however, especially in his treatise on beauty in *Enneads* 5.8.1 ff., he diverges from the Platonic tradition and ascribes a more exalted role to both art and artists. He implies that the beauty in a work of art has its roots in a higher spiritual form, an $\varepsilon\tilde{\iota}\delta o\varsigma$, within the divine mind ($\nu o\tilde{\upsilon}\varsigma$). The beauty of a stone statue does not reside in the stone, for if it did, an unworked stone would be equally beautiful. The beauty must therefore reside in the mind of the artist prior to his making of the statue; and the artist possesses this beauty not by the use of hands, eyes, and so on, but because he participates in his art. The beauty must therefore reside in the art, which contains the essential beauty of the objects that specific arts "make," an intelligible beauty derived from the idea or *logos* of those objects.[46] The artist, because his mind is a spark of the divine mind, can inwardly perceive the beauty of the divine form and produce a reflection of that beauty in gross matter—the actual statue that he shapes from unformed matter. The work of art can therefore directly convey a spiritual essence:

> [A critic of the arts] should realize that they [the arts] do not simply imitate the visible world, but that they refer back to the sources of emanation [*logoi*][47] from which nature is derived. Then he should also know that they do many things themselves. For since they possess beauty, they add to a particular thing whatever it may lack. When

> Phidias made the Zeus [at Olympia], he did not use any model that
> could be perceived by the senses, but rather he formed a conception of
> what Zeus would be like if he chose to reveal himself to our eyes.
> [*Enneads* 5. 8.1]

Although Plotinus always emphasized that this essence is by necessity
weakened and distorted because it is subject to the dispersive influence
of matter (the part of nature furthest removed from the primal "one"
in Plotinian cosmology), he was clearly willing to diverge from Plato
and admit that by embodying a spiritual essence, even if it be in a
diluted form, the work of art ceased to be an "imitation of an imitation,"
and had a value that was independent of any exterior model.

Insofar as it ascribes great importance to the artist's inner, intuitive
perception of spiritual exemplars, this system, is a logical continuation
of the *phantasia* theory of the late Hellenistic period. The idea that
Phidias made his famous Zeus not by imitating a model in nature but
by apprehending the "form of Zeus in his mind" was, as we have seen,
the "signature" of the *phantasia* theory and was already venerable by
the time of Plotinus (it first appears in extant literature in Cicero's
Orator 9).

Yet while Plotinus gave token recognition to the content of the late
Hellenistic theory, his attitude toward it and his use of it differed con-
siderably from that of other writers. To Cicero and Quintilian or Dio
Chrysostom, for example, the achievements of Phidias and other great
artists were significant because they made spiritual qualities vivid in
the world of men. To them the real value of a work of art was its
ethical and religious function in this world. Plotinus's focus of interest,
on the other hand, was essentially transcendental. The beauty of a
work of art was really "derivative and minor" (ἀπ' ἐκείνης ἔλαττον
ἐκείνου),[48] and once the more complete beauty had been glimpsed,
human art was of no significance at all.

From the fourth century B.C. onward, as we have seen, there was a
trend in the criticism of the visual arts away from objective analysis
toward subjectivism. Interest in art began to focus on the artist's
personal perceptions and the connoisseur's understanding of these
perceptions. Concentration on the subject matter, the "content" of a
work of art, began to supersede the analysis of form.[49] Plotinus, it may
be said, carried this critical subjectivism to a point where most of the
terminology of previous Greek art criticism became unworkable. He

even rejected the venerable Classical concept that beauty was to be found in the harmony of parts (*symmetria*), holding that it was possible to perceive beauty in things which had no parts—gold, for instance, or lightning (*Enneads* 1.6.1 ff.); in doing so he introduced what I have called an "incipiently medieval" aesthetic attitude into ancient art criticism, an attitude in which feeling totally eclipses critical analysis of form.[50] Perception of beauty, he noted, was often a direct, unanalyzed experience. Beauty was that which the soul recognized, desired, and wished to become united with. This object of longing was ultimately the One, the godhead from which all beings and objects have come and to which they struggle to return. Immediate beauty in the sensible world was only of value to the extent that it pointed the way to transcendental experience. But to engage in formal analysis of the proportions and colors of specific statues and paintings, to write histories of technical innovations in art, or to classify the personal styles of different artists was simply to add complexity to what was already inessential. To Plotinus, what was "real" in art was beyond the range of criticism; and art criticism, as earlier generations in the ancient world had known it, has no place in the *Enneads*.

3 Rhetorical and Literary Criticism

Because of its importance in public life and hence in education, rhetoric was the most closely analyzed and evaluated of all the arts of antiquity. Technical manuals delineating its aims and methods had already appeared in the fifth century B.C., and they continued to be written well into the time of the Roman Empire. The first such manuals seem to have been written by a Sicilian orator named Corax and by his pupil Tisias.[1] Their concern appears to have been to explain the methods of argumentation by which the persuasive rhetoric used in the law courts achieved its end.

Gorgias, also a Sicilian and pupil of Tisias, carried on their tradition and also applied his skill to developing *epideictic* rhetoric. He was particularly sensitive to the role that stylistic devices—choice of words, rhythm, and balance of phrases—played in the success of persuasive

rhetoric and was hence one of the first Greek rhetoricians to subject "style" to an intensive analysis. It is not completely certain whether Gorgias actually wrote a treatise on rhetoric,[2] or whether his ideas about stylistic devices were simply passed on to later writers by his pupils; but, in any case, it is easy enough, by reading the remains of his own speeches and the analysis of his approach in the *Gorgias* of Plato, to form some idea of how he used antithesis, alliteration, and so on for persuasive effects. Gorgias's thoughts and practice were apparently systematized and carried further by his pupil Polus.[3]

It is this Sicilian tradition in the criticism and analysis of rhetoric that Plato so frequently criticized, in the *Gorgias* and elsewhere, for its tendency to place greater value on successful persuasion than on the search for absolute truths; it was perhaps as a reaction to Plato's picture of the rhetoric of his time as amoral, meretricious, and opportunistic that the Athenian orator Isocrates (436–338 B.C.) was moved to defend rhetoric as a kind of practical philosophy and vehicle for cultural training in his *On the Antidosis* (written 355–353 B.C.).

Both the Sicilian view of rhetoric as the art of persuasion and the Isocratean conception of it as a humanistic discipline are brilliantly combined and recast in clear systematic form in the *Rhetoric* of Aristotle, where the Classical tradition in the analysis and practice of rhetoric received its definitive analysis.[4] Aristotle defines rhetoric as the "faculty of discerning the possible means of persuasion with regard to any subject" (*Rhetoric* 1.2.1). His emphasis is more on the categories and methods of rhetoric than on its benefits as a vocation. After an introduction in which he defends the usefulness of rhetoric in society, he proceeds to analyze the types of oratory and the methods of argumentation that they use (book 1); he discusses the ways in which an orator makes his impress on and the types of subjects he deals with (book 2) and then turns to an analysis of verbal style, λέξις, and the proper arrangement of the parts of a speech, τάξις (book 3). The third book is of great importance for later literary criticism, and also, it would appear, for the criticism of the visual arts. It established a prototype and set a standard for a long tradition of treatises on the nature of literary and rhetorical style, which includes Dionysius of Halicarnassus, Demetrius, Hermogenes, and Longinus as well as, by adoption, Cicero and Quintilian, and many lost or fragmentary authors.

Aristotle's section on verbal style is of particular importance because

it is not only analytical but prescriptive. It makes suggestions as to what a good style *should* consist of and, in doing so, proposes what the "essential excellences," *aretai*, of a good style are. Aristotle identified two basic excellences—clarity (σαφές) and appropriateness (πρέπον). His pupil and successor as head of the Peripatetic school, Theophrastus, in a treatise *On Style*, περὶ λέξεως, expanded the list of excellences to four—clarity, appropriateness, purity of language, and ornament, (for details see glossary of unabridged edition, under ἀρετή). The Peripatetic concept of an essential excellence or "virtue" of style (ἀρετὴ τῆς λέξεως; *virtus dicendi* in Latin) had a far-reaching influence. It not only became a point of departure for the great majority of later writers on rhetorical style, but it also provided a standard by which individual orators could be classified and judged. Different men could be admired and compared on the basis of the particular virtue or virtues that their styles seemed to embody.

In the Hellenistic period, when political conditions tended to make the role of forensic oratory less important, rhetoric became increasingly what Atkins has called a "scholastic" discipline, which played an important role in the educational process by which Greek culture was preserved and spread.[5] This role, combined with the tendency of the age to idealize the past and to place emphasis on the personal feelings and tastes of the individual, seems to have prompted some Hellenistic scholars to compile lists of earlier poets, orators and historians whose styles could serve as exemplars to be emulated by the students of later generations.[6] Each exemplar seems to have been chosen, at least in the case of rhetoricians, because his work embodied a particular *aretē* of style. The Peripatetic concept of a stylistic *aretē* thus fostered an acute awareness of personal style as well as style in general.

By the second century B.C. canons of exemplary rhetoricians seem to have been formulated, either at Alexandria or Pergamon or both; and in the first century B.C., or perhaps earlier, a specific canon of ten exemplary rhetoricians was in existence.[7] It would appear that at some point during this period someone hit upon the idea of comparing specific orators with specific sculptors and painters thereby creating a comparative canon that included a description of the *aretai* of different artists. The art histories of Quintilian and Cicero (see chap. 7) occur in just such a context. Both use the history of the visual arts in Greece as an analogy for the development of rhetorical style. Quintilian's

history of painting, in particular, dwells on the *virtutes* of each artist. Dionysius of Halicarnassus and Demetrius also use analogies of this sort in essays on rhetoric.[8]

At what point and by what means the idea of including a comparison with sculptors and painters in a canon of orators arose is a complex question. This is partly due to the lack of consistency in our sources. The Greek writers compare Greek sculptors and painters to Greek rhetoricians. Cicero and Quintilian, however, compare the same Greek sculptors and painters only to Roman orators. Thus, what our sources have in common is not a series of specific comparisons between orators and artists but only the idea of making such comparisons. Even Cicero and Quintilian differ markedly from one another in their comparison of painting and rhetoric, and they also differ slightly in their analyses of sculpture (see chap. 7). It is thus clearly impossible to maintain that all the rhetorical writers in question drew the details of their comparisons with the visual arts directly from a common source. On the other hand, it is not altogether impossible that the idea of making such comparisons was first suggested by a single writer. All of our rhetorical sources, both Greek and Roman, have at least one common thought running through them—that the art of Phidias represents the supreme achievement of Greek sculpture and that the most perfect rhetoric of the past should be compared to Phidias in its grandeur and perfection.[9]

This view of Phidias was also (see chap. 2) held by the creators of the *phantasia* theory and it is therefore not unreasonable to conclude that the writer who first began to compare orators and sculptors was aware of the details of the *phantasia* theory. One is again drawn to the attractive literary specter of Posidonius. Besides being one of the earliest writers whom we may plausibly associate with the *phantasia* theory, he was, as we have noted, interested in rhetoric, and he was one of Cicero's teachers. We might speculate that Posidonius either invented or inherited from Panaetius a theory of the history of sculpture in which that art was thought to have advanced from a simple stage in which its products were the result of imitation (executed with varying degrees of competence) to a stage of perfection, represented by the works of Phidias and probably Alcamenes, in which the artist's *phantasia* enabled him to conceive and give form to the grandeur of the gods. The theory may have originally been invented as a way of justifying the value that

the late Hellenistic period set upon Classical Greek art, but Posidonius would easily have seen wider applications for it. In his writings on rhetoric he might have pointed out how the achievement of supreme mastery in rhetoric paralleled the same achievement in sculpture. A great orator was required to have a vision of grandeur equal to that of Phidias;[10] and the history of rhetoric, like the history of sculpture, was seen as a transition from simplicity to perfection and grandeur.

Later Greek writers such as Dionysius and Demetrius might have derived their comparisons of orators and artists directly from a Posidonian treatise on rhetoric, while Cicero, Posidonius's outstanding Roman pupil, perhaps proceeded to adapt the substance of his teacher's theories to Roman rhetoric. His rendition of the (hypothetically Posidonian) comparison of orators and sculptors in *Brutus* 70, is probably a very abbreviated version of the original.

Quintilian may have either borrowed the idea of comparing artists and orators from Cicero or he may have consulted the Greek source directly. His history of sculpture, as we have said, is basically similar to Cicero's (although more detailed), but his history of painting is far more complex and seems not to be dependent on Cicero nor perhaps even on a single Greek source. His attribution of the mastery of shading to Zeuxis and subtle draftsmanship to Parrhasius are judgments that appear to go back to Xenocrates. On the other hand, the *diversae virtutes* that he ascribes to Protogenes, Pamphilus, Melanthius, Antiphilus, Theon, Apelles, and Euphranor are clearly viewed, after the manner of rhetorical criticism, as stylistic *aretai*. One can only guess at the source from which he derived his information on the latter group of painters, if there was a single source. It may have been Pasiteles (see chap. 6); it may have been one of the less well-known Hellenistic rhetoricians such as Apollodorus of Pergamon (ca. 104–22 B.C.); or it may even have been Antigonus of Carystus.

Carl Robert suggested that both Cicero's and Quintilian's histories of art were dependent on three Pergamene canons that listed ten outstanding orators, ten sculptors, and ten painters.[11] These canons, he suggested, originated between the time of Panaetius and Apollodorus and were primarily dependent on Antigonus of Carystus (see chap. 6), who had worked as a sculptor in Pergamon, for their critical judgments about sculptors and painters. Knowing what we do about the background of the *phantasia* theory and its application to the history

of sculpture, it is impossible to maintain with Carl Robert that all of Cicero's and Quintilian's material on the history of art was derived from such Pergamene canons. We may, however, salvage at least a portion of his theory by ascribing most of Quintilian's history of painting either directly to Antigonus or indirectly to a later rhetorician, like Apollodorus or Theodorus of Gadara (first century B.C.), who might have incorporated Antigonus's material into a rhetorician's canon.[12] Quintilian's history of painting would thus be the result of a blending of professional criticism as it was organized by the early Hellenistic art historians with later Hellenistic rhetorical criticism.[13] The idea of combining these two traditions may have been Quintilian's own.

4 Popular Criticism

Up to this point in our examination of the traditions of art criticism in antiquity we have been examining ideas of specialists—practicing artists and art historians—or intellectuals—the philosophers and rhetoricians who to a great extent constituted the intelligentsia of the ancient world. Beneath the often lofty and frequently technical expressions of these writers, there ran a current of criticism that we may identify as characteristic of the nonspecialist or average man and will simply term *popular criticism*. Its standards are not radically different from the popular criticism of our own time and usually turn up in the works of those writers who can be classified as compilers of tradition. (see chap. 1).

While we should not expect popular criticism in antiquity to be expressed in coherent, doctrinal theories any more than it is today, we can perhaps isolate three virtues that it often looked for in gauging the value of a work of art: (1) realism, (2) miraculous qualities, and (3) costliness.

Realism is simply a popular, unintellectual version of the *mimēsis* idea in Classical philosophy. Its standard of judgment is the feeling that the best works of art are those which simulate the external world with such uncanny exactitude that the boundary between art and life breaks down. The most successful artists were those whose "hands

wrought works of art which were completely alive," χεῖρες ζωτικὰ διόλου κατεσκεύαζον τὰ τεχνήματα (Callistratus 8.1). One of the most innocent and typical illustrations of this attitude is the story told by Pliny of the painting contest between Zeuxis and Parrhasius (*NH* 35.65). Zeuxis painted a picture, apparently as part of a stage setting, of a bunch of grapes which was so realistic that birds flew up and began to peck at it. Parrhasius then secretly painted a curtain over these grapes. Zeuxis later returned and asked that the curtain be pulled aside so that his picture could be displayed. When he discovered that the curtain was painted and not real, he acknowledged defeat.[1]

Admiration of miraculous qualities in works of art is often simply an extension of the realism concept into the realm of magic. Works of art not only seem real, they become real. There was a tradition, preserved by several authors,[2] for example, that the statues by the primeval sculptor Daedalus could see and walk. Webster has pointed out that the Greek word *kolossos* originally meant a statue which was thought of as a magical substitute for a human being, and also that the custom of putting identifying inscriptions on statues and paintings in the first person ("I am Cyllenian Hermes"; "Mantiklos dedicated me," etc.), particularly common in the Archaic period, suggests a magical "life" within the work of art.[3]

The miraculous nature of works of art could be appreciated in other ways as well: in technical ingenuity, for example, as in the case of a statue by Lysippus which could be moved by the touch of a hand but not dislodged by a raging storm (Pliny *NH* 34.40); or in wondrous associations, as in the case of the statue of Demosthenes, which preserved the probity of the man it represented by protecting for years a sum of money that a desperate soldier had placed in its hands.[4]

Admiration of a work of art for the costliness of the materials used in it or for the high price it might bring in a certain art market is a criterion that needs no explanation beyond the simple statement of it. This aspect of popular criticism is found in certain uses of the terms πολυτέλεια and *dignus*.

Judgments on technical questions of form and composition are almost entirely lacking in popular criticism. Only the term *schēma*, which is used by Pausanias and others to refer to the "form," "shape," or "bearing" of a statue may be said to represent a popular, or at least

informal, recognition of form in art. In professional criticism there were more specific terms—*rhythmos* and *diathesis*—to deal with the question of form and composition.

It has long been recognized that most of the popular criticism in Pliny occurs in biographical anecdotes and picturesque tales, which Pliny derived in all likelihood from Duris of Samos (ca. 340–260 B.C.)[5] August Kalkmann has suggested that Duris's book *On Painting* (περὶ ζωγραφίας) was intended as a criticism of and rebuttal to Xenocrates' scientific, systematic, and largely impersonal approach to the history of art.[6] Duris seems to have emphasized two themes in particular: first, a great artist was not one who was skilled in the traditional, formal techniques of art but rather one who could imitate nature most precisely; and, second, an element of chance or luck, τύχη, existed in the creation of most great works of art. Both of these themes are characteristic of popular criticism. A typical example of the emphasis on the role of chance in art is Pliny's story, in all likelihood derived from Duris, about Protogenes' struggle to paint successfully the foam on a horse's mouth. In desperation and anger Protogenes finally dashed a sponge against his painting, and this action produced the effect he previously had been unable to achieve even with great labor. In this case, Pliny tells us, "fortune" put "nature itself" into the painting (*fecitque in pictura fortuna naturam*; *NH* 35.103).

The most interesting of Pliny's actual references to Duris occurs in *NH* 34.61, where Duris is said to be the source for the tradition that Lysippus had no teacher but decided to enter upon a career as a sculptor after hearing a remark made by the painter Eupompus. When asked which of his predecessors he took as a model, Eupompus is reputed to have pointed to a crowd of people and said that one ought to imitate nature itself, not another artist (*naturam ipsam imitandam esse, non artificem*). Schweitzer has suggested that this passage may reflect a profound change in the attitude of the ancient world toward artists and artistic production, a change away from the view that the artist was simply a craftsman who learned his trade from other craftsmen toward the view that the artist must be understood as an independent creator with a deep understanding of nature.[7] Whatever Eupompus meant by his remark,[8] I doubt that any such far-reaching significance was attached to it by Duris. In its emphasis on the

unusual and its appreciation of imitative realism, the passage is a perfect expression of popular criticism.

5 Roman Variants

In this chapter I wish to discuss a few instances in which the blending of Greek and Roman critical thought about the arts is so complete that neither can be said to be dominant or dependent. On an intellectual plane, Rome of the first centuries B.C. and A.D. is an extension of late Hellenistic culture. The critical terminology of the Roman authors who wrote about the arts during this period—mainly Pliny, Vitruvius, Cicero, and Quintilian—includes many Greek words and even more Latin translations of Greek words. The thought of these writers cannot, any more than their language, be described as purely Greek or purely Roman. It is a fusion of both, and any history of Greek art criticism must of necessity have a "Greco-Roman" chapter.

VITRUVIUS

Vitruvius, whose *De Architectura*, written early in the reign of Augustus, is the sole preserved ancient treatise devoted exclusively to one of the visual arts, was deeply influenced by earlier Greek writers, but the nature and extent of this influence is complex and difficult to define. Vitruvius's treatise really functions on two levels. On one level it is a purely practical and purely Roman builder's manual giving helpful advice on where to get good building materials, how to mix good stucco, how to build a solid block-and-tackle apparatus, and so on. On another level, however, it attempts to demonstrate that architecture is an intellectual, humane discipline.

Vitruvius seems to have embraced the idea, perhaps first proposed by Varro (see chap. 6), that architecture, along with astronomy, rhetoric, and so on, was one of the "liberal arts." An educated man should be expected to have some knowledge of the theoretical principles (*ratiocinatio*) on which the liberal arts were based; the practical details (*opus*) of each art were to be mastered only by those who practiced it as a profession.[1] The *De Architectura* clearly undertakes to present both the

66

opus and the *ratiocinatio* of architecture. It is in connection with the second of these that Vitruvius draws upon Greek sources, Greek terminology, and Greek ways of thinking; and it is on this level in particular that the *De Architectura* stands at the end of a long line of theoretical treatises on architecture, written by architects, stretching back to the sixth century B.C.[2]

This dependence on Greek sources is obvious to anyone who reads the major theoretical sections of Vitruvius's treatise, the introduction to the fundamental principles of architecture (1.2.1–9) or his discussion of proportions (book 3), where he seems to show a particular indebtedness to the Hellenistic architects of Ionia, like Hermogenes, who were his not too distant predecessors. It also seems likely that these Greek sources either propounded critical theories of their own or at least drew upon well-known aesthetic standards of their own time. Some scholars have therefore tried to discover a single, coherent aesthetic system in the *De Architectura* which Vitruvius could be said to have adopted in toto from an earlier Greek source. Carl Watzinger identified a Stoic system, derived from Posidonius, as the underlying basis of Vitruvius's "aesthetic."[3] Pietro Tomei, on the other hand, felt that this underlying basis was a Peripatetic tradition developed by the Hellenistic poet and critic Neoptolemus of Parium (third century B.C.) and used later by Cicero (*De Oratore*) and Horace (*Ars Poetica*) as well as Vitruvius.[4] F. W. Schlikker hypothesized that Vitruvius's *"Schönheitslehre"* was derived from the writings of an architect of the early first century B.C., perhaps Hermodorus of Salamis.[5] This very diversity of modern opinion is an indication of how difficult it is to put a label on Vitruvius.

I myself doubt that Vitruvius's "principles" of architecture are derived from any single Greek source. I am even inclined to doubt that there is any particular systematic coherence in the principles presented in 1.2.1–9. His distinction between *taxis* and *symmetria*, for example, is hazy and redundant; so is his definition of *eurhythmia*, the relationship of which to *symmetria* becomes clear only later (see 6.2.5). One is almost inclined to suspect that Vitruvius is more interested in impressing his reader with the fact that the architect is a learned man who uses a learned (and therefore largely Greek) vocabulary than he is in probing the depths of architectural aesthetics. In any case, he does seem to have juxtaposed ideas and terms from different sources

without always clarifying the exact relationship between them. His aim, by his own admission, was not so much to perpetuate old systems as to create a new one of his own by synthesis.

> I certainly do not present this work, O Caesar, after having altered the titles of other men's books and inserting my own name, nor is it my intention to win approbation for myself by being vituperative about any other man's work. On the contrary, I express infinite gratitude to all authors, because, by bringing together outstanding examples of the skills of talented men, they have provided (each author applying himself to his own particular subject) abundant sources from which we, like men who draw water from fountains and use it for their own purposes, are able to formulate a treatise which is at once more fluent and better documented than it would otherwise be. It is by putting our trust in such authorities that we venture to produce a new set of principles (*institutiones*). [Vitruvius 7.praef.10]

Even the theoretical part of the new synthesis that Vitruvius offers, moreover, is not based purely on Greek ideas. The principle of *auctoritas*, for example, which he often looks for in evaluating architecture, is a Roman idea for which there is no real Greek equivalent. Like Cicero in his writings on rhetoric or Alberti in his *De Re Aedificatoria*, Vitruvius followed his own taste and preoccupations in selecting appealing ideas from a reservoir of earlier thought.

THE DECOR THEORY

While the *De Architectura* as a whole is an independent, eclectic creation, Vitruvius does share with a number of other writers, both Greek and Roman, the use of one particular, if rather broad, theory of art criticism which we might call the *decor* theory or, more formally, the "rational theory of appropriateness." We have previously seen that *to prepon*, "appropriateness," of which *decor* is the Latin translation, was praised by Aristotle as one of the essential virtues of rhetorical style and that Theophrastus perpetuated this idea in his treatise *On Style*. At some point during the Hellenistic period, probably late in the period when interassociation between the criticism of rhetoric and criticism in the other arts was especially prevalent, the *prepon-decor* idea seems to have been formulated as a general concept that could be applied both to literary criticism and to the visual arts.[6]

The basic principle of the *decor* theory is the unexceptionable idea that the form of a work of art should be appropriate to its meaning. When the general principle was applied to specific arts, however, it sometimes assumed surprisingly and, to many modern readers, unswervingly pedantic forms. As applied to architecture by Vitruvius, *decor* is the principle by which one judges whether the form of a building is appropriate to its function and location and whether the details of the building are appropriate to its total form (Vitruvius 1.2.5–7). Thus the architectural order of a temple should be appropriate to the deity worshipped in it: hypaethral temples should be dedicated to celestial gods like Jupiter, Caelus, the Sun, and the Moon; the Doric order, being the most austere, is appropriate to martial deities like Minerva, Mars, and Hercules; the softer Corinthian order was appropriate to flowery deities like Venus, Flora, and the Nymphs; the Ionic order, representing a middle stage between the austerity of Doric and the softness of Corinthian, was appropriate to deities with a mixed nature like Juno, Diana, and Bacchus. Moreover, the details of one order cannot be mixed with those of another without "giving offense." Similarly, in the location of buildings one must follow such obvious principles as choosing salubrious sites for temples to deities like Aesculapius and Salus; and in assigning the location of particular rooms within a house or villa one should follow such principles as providing an eastern exposure for bedrooms and libraries, a northern exposure for picture galleries (since these require a steadier light), and so on. Houses and villas as a whole should also be appropriate to the social status of their occupants (6.5.1–3). And, finally, *decor* also had to be considered in the complex problem of applying predetermined modules of measurement to the particular style of a building (e.g. Doric, Ionic).[7]

An offshoot or corollary of the decor theory is the idea that forms in art should have a rational relationship to their prototypes in nature. In a set of superimposed columns in a basilica, for example, the columns of the upper row should be smaller than those of the lower row because tree trunks, the natural prototypes of columns, diminish as they grow higher (5.1.3). The best-known application of this concept is Vitruvius's denunciation (7.5.1 ff.) of the imaginative, fantastic style of wall painting that was developing in his own time (presumably the third style of Romano-Campanian wall painting). The common decorative

69

motifs of this style—reeds serving as columns, candelabra supporting small shrines, statues growing out of stalks—"do not exist," in Vitruvius's words, "nor can they ever exist, nor have they ever existed." And he adds: "Minds obscured by weak powers of criticism are not able to make a valid judgment, with authority and with a rational understanding of what is proper (*cum auctoritate et ratione decoris*), about what can exist" (7.5.4).

While the only full statement of the *decor* theory as applied to the visual arts occurs in Vitruvius, it is possible to detect traces of it in other writers. Strabo, for example, writing around the time of Augustus, criticizes Phidias's almost universally admired statue of Zeus at Olympia because, had the statue been able to stand up, it would have gone right through the roof of the temple (Strabo 8.353–54). Writing in probably the early third century A.D. Dio Cassius relates that the cult images designed by the emperor Hadrian for his temple of Venus and Rome were criticized by his architect Apollodorus for the same reason (Dio Cassius 69.4.1–5).[8] The idea that the scale of a cult image should be adjusted in a naturalistic way to the scale of the temple in which it was placed betrays the same somewhat obstinate rationalism that characterizes Vitruvius's diatribe on painting.

THE MUSEOGRAPHIC THEORY

In book 34, sections 6–17, of the *Natural History*, Pliny sketches a theory about the evolution of the art of bronze working, apparently not dependent on his "Xenocratic" history (see chap. 6), in which Greek and Roman thought are again difficult to disentangle. The substance of the theory seems to be that bronze working, as it developed, came to be used for making utilitarian objects such as vessels and furniture, but eventually it came to be employed for images of gods, men, and animals. These representational statues may have been classified according to the degree of realism (*successus*) or technical daring (*audacia*) that they exhibited.[9] The components of this theory were first recognized by Friedrich Münzer and have been elaborated upon by Bernhard Schweitzer, who ascribes the theory to a Roman source.[10] It was perhaps developed in order to provide a system of classification for the enormous quantity of Greek bronzes—statues, vessels, furniture, and so on—which poured into Rome as the spoils of war during the third to first centuries B.C.[11] (hence I have chosen to

call it the "museographic theory"). If the theory was, in fact, created for this purpose, one might be tempted to conclude that it was purely Roman in character. Yet insofar as it seems to trace a development of bronze working from relatively humble begninings to a higher stage in which the representation of the gods became the triumphant achievement, it seems to be modeled, however remotely, on the *phantasia* theory.

Part II Art History in Antiquity

6 The Elder Pliny and His Sources

The writing of critical histories of art seems to have begun among the Greeks in the Hellenistic period.[1] Extant sources preserve at least two separate traditions—one (to be discussed in this chapter), apparently originating early in the Hellenistic period, preserved in books 34–36 of Pliny's *Natural History*; the other (to be treated in chapter 7), originating later, in Quintilian's *Institutio Oratoria* 12.10.3–9 and Cicero's *Brutus* 70.

Pliny fortunately took the time to prepare a bibliographical index for each of the books of the *Natural History*, and we are indebted to his indexes to books 33–36 for much of what we know about the development of art history and art criticism in Greece prior to the first century A.D. Pliny's work is, by his own admission, an encyclopedia dealing with diverse aspects of the natural world and representing the results of his perusal of two thousand separate volumes by over one hundred authors (authors, he adds, seldom referred to by others owing to the obscure nature of their subjects) (*NH* praef. 17). The value of the information (often demonstrably erroneous, occasionally absurd) contained in the *Natural History* depends on the source from which it is derived, and hence much of Plinian scholarship in modern times has devoted itself to disentangling and reconstructing the content of these sources.[2]

In the indexes to books 34–36 we meet the names of many Latin and Greek authors, a few well-known but most rather obscure, who supplied Pliny with information about the arts. A characteristic excerpt of particular interest is the following from book 34, the book which deals, among other things, with sculpture in metal:

> Externis: Democrito, Metrodoros Scepsio, Menaechmo qui de toreutice scripsit, Xenocrate qui item, Antigono qui item, Duride qui item, Heliodoro qui de Atheniensium anathematis scripsit, Pasitele qui de mirabilibus operibus scripsit.

> Foreign authors [from whom information has been derived]: De-

mocritus; Metrodorus of Scepsis; Menaechmus, who wrote on *to-reutikē* [the working of sculpture in metal]; Xenocrates, who wrote of the same subject; Antigonus, who wrote on the same subject; Duris, who wrote on the same subject; Heliodorus, who wrote on the votive offerings of the Athenians; Pasiteles, who wrote on marvelous works.

These are the authors who seem to have provided Pliny with the bulk of his information about sculpture. It is noteworthy that all the writers mentioned are Greeks. At some point either Pliny himself or an earlier Latin writer has translated these sources, including presumably much of their critical terminology, into Latin. It is for this reason, quite obviously, that Latin words form a major part of the present study. By analyzing those Latin terms that appear to represent translations from the Greek and by retranslating them back into Greek, we can reconstruct the critical terminology of the lost Greek writers to whom Pliny, and probably also Quintilian and Cicero, were indebted for much of their information.

Since the nineteenth century it has been felt that of the authors mentioned in the passage quoted above the most influential was Xenocrates,[3] who, like several others mentioned in the list, wrote a treatise on *toreutikē*.[4] Xenocrates was also a practicing sculptor. He is mentioned by Pliny twice in the text of the *Natural History*, where we are told that he was a disciple of the sculptor Tisicrates or, according to others, Euthycrates; that he surpassed both of them in the number of his statues, and that he wrote volumes about his art (*NH* 34.83). It is known that Euthycrates was the son of the great Sicyonian sculptor Lysippus and that Tisicrates was a pupil of Euthycrates (*NH* 34.66–67); so regardless of which of these artists was Xenocrates' teacher, it is clear that he was closely associated with the Sicyonian school of sculpture,[5] of which Lysippus was the guiding spirit. Pliny also cites Xenocrates, along with Antigonus, as the source for the observation that the painter Parrhasius was a master draftsman, and adds that Xenocrates and Antigonus wrote *volumina* about painting (*NH* 35.68).

Because of his strong connection with the Sicyonian school, Xenocrates has long been identified as the source of a particular theory of art history found in Pliny which betrays a distinct Sicyonian bias. This theory envisions a gradual evolution of Greek sculpture and painting toward a stage of perfection which was finally achieved in the late fourth century by the foremost sculptor and the foremost painter—Lysippus

and Apelles—of the Sicyonian school. In the course of the development of each art from a stage of "rude antiquity" (*rudis antiquitas*; *NH* 34.58), specific inventions and improvements, each a milestone in the road toward perfection, were ascribed to specific artists. In Pliny's text the innovator's achievements are often introduced with a phrase like *hic primus* ("this man was the first to . . .") and sometimes compared to those of a predecessor by a *quam* clause. In the case of the history of sculpture presented in book 34.54–65, the art is said to have been "opened up" by Phidias (*primusque artem toreuticen aperuisse*) and to have been "refined" by Polyclitus (*toreuticen sic erudisse, ut Phidias aperuisse*). Myron is then said to have used a greater variety of compositions and to have been more diligent in *symmetria* than Polyclitus (*numerosior in arte quam Polyclitus et in symmetria diligentior*).[6] Next Pythagoras is said to have surpassed Myron (*vicit eum*) by being the first to render effectively certain details, such as the sinews, veins, and hair (*hic primus nervos et venas expressit capillumque diligentius*). Finally Lysippus is said to have made many contributions to the art (*statuariae arti plurimum traditur contulisse*), both in proportion and in the rendering of details, which improved on the achievements of all his predecessors.

It might be noted parenthetically that the chronology of the sculptors in Xenocrates' system, assuming that Pliny preserves it correctly, is not in complete accord with that usually accepted by modern archaeologists. Myron, Phidias, and Polyclitus were contemporaries, but Myron seems, judging by the *Discobolus* (ca. 460 B.C.), to have begun his career earlier. Pythagoras, who comes fourth in the Xenocratic system, seems to have been the earliest of all.[7]

It may be that Xenocrates was mainly concerned with a theoretical progression of achievements, perhaps based upon personal observations of different statues, and did not worry about chronological details. It may also be that Pliny or an intermediate source has removed Pythagoras from his proper place in the progression. (The achievements in rendering naturalistic details that are ascribed to Pythagoras parallel in some ways those ascribed to Polygnotus in painting; he may therefore have originally occupied an early place in the progression similar to Polygnotus's in the progression of painters.)

The evolutionary sequence for the development of painting given in book 35 of the *Natural History* is different in detail but similar in principle to the picture of the development of sculpture. In the primitive stage

of painting Eumarus of Athens was the first to distinguish between men and women in painting (presumably, although it is not so stated, by painting the women's skin white and the men's a brownish red, a common convention in ancient art). Cimon of Cleonae then invented *katagrapha*, "three-quarter images,"[8] or, in modern terminology, the technique of foreshortening (*NH* 35.56). Polygnotus of Thasus carried the art a step further by making improvements in the rendering of naturalistic details (e.g. representing transparent drapery) and by introducing variety in facial expression.[9] Apollodorus next began the mature era of painting by developing the technique of shading, (*hic primus species exprimere*) (*NH* 35.60), or what the Greeks called *skiagraphia*. Apollodorus's improvements in the rendering of light and shade were then further refined by Zeuxis, who is said to have "passed through the gates" opened by his predecessor.[10] In the next stage Parrhasius, somewhat like Myron in sculpture, introduced *symmetria* into painting (*primus symmetrian picturae dedit*), improved upon the rendering of specific details, and emphasized clarity of draftsmanship in his work (*NH* 35.67). This last achievement, Pliny tells us, was highly praised by Xenocrates and Antigonus, who not only stated their opinion but "proclaimed it boldly" (*NH* 35.68). Following Parrhasius, Euphranor is said to have "made *symmetria* his own" (*usurpasse symmetrian*) and to have taken new steps in the rendering of facial expression (*NH* 35.128). Finally Apelles made many new inventions, *inventa eius et ceteris profuere in arte* (*NH* 35.97), and brought all the achievements of his predecessors together, *picturae plura solus quam ceteri omnes contulit* (*NH* 35.79).

It is clear that Xenocrates' critical history was concerned primarily with formal artistic problems—above all, problems of proportion and composition—and only secondarily, it would appear, with problems of naturalistic representation. The question of the moral value of art, which so preoccupied the philosophers of the fourth and third centuries B.C., seems, on the basis of the evidence available to us, to have been altogether ignored. As a practicing sculptor, Xenocrates must have been familiar with and influenced by the standards of art criticism employed by professional sculptors and painters, both in his own day and in the recorded past. He probably had access to technical treatises, like the *Canon* of Polyclitus, in which the standards of professional criticism were discussed in theoretical and practical terms, and em-

ployed the terminology of these treatises in his history. The presumed use of such material gives special significance to Xenocrates' work: his terminology helps us to understand the intentions, interests, and standards of the Greek artists of the Classical period.

Of the other writers mentioned in Pliny's index as writing about *toreutikē*—Antigonus, Menaechmus, and Duris—Antigonus seems to have been closest in spirit to Xenocrates. His name is coupled with that of Xenocrates as the source for Pliny's statements about the mastery of contour lines in the work of the painter Parrhasius (*NH* 35.68). Elsewhere Pliny mentions him as one of the sculptors who worked on the monuments that the Attalid kings of Pergamon erected after their victories over the Gauls and adds that *volumina condidit de sua arte* (*NH* 34.84). Antigonus is thus to be dated in the late third and early second centuries B.C. and appears to be identical with Antigonus of Carystus, a writer, known from other sources, who dabbled in biography, philosophy, and epigraphy as well as the visual arts.[11] It has been suggested that Antigonus may have produced an expanded version of Xenocrates' work, to which he added biographical details and granted recognition to important non-Sicyonian contemporaries of Lysippus—Praxiteles, for example—whom Xenocrates had ignored.[12]

Of Menaechmus, another sculptor who is listed as having written on *toreutikē* and who, as Pliny later tells us, *scripsit de sua arte* (*NH* 34.80), nothing can be said with certainty. If he is identical with the Menaechmus mentioned by Pausanias (7.18.8) as one of the sculptors of an image of Artemis Laphria at Calydon (later transferred to Patras by Augustus), he would be the earliest known writer on sculpture.[13]

The treatise on *toreutikē* by Duris was probably rather different in character from those of the writers discussed so far, all of whom were professional artists. Duris of Samos (ca. 340–260 B.C.) had a varied career, which found him at one time as tyrant of Samos, at another as an Olympic victor in boxing, and at still another as a pupil of Theophrastus. In addition to his treatise on *toreutikē* and a treatise *On painting* (Diogenes Laertius 1.1.39), his writings included literary criticism, essays, and historical chronicles. His historical works appear to have been strongly biographical in character and to have been known for their sensational or implausible anecdotes.[14] The same qualities may have characterized his writings on art. Duris seems a likely source

for many of the popular biographical anecdotes in Pliny—those, for example, about the painting contests between Zeuxis and Parrhasius (*NH* 35.65–66) and between Apelles and Protogenes (*NH* 35.81–83)—in which there is a strong emphasis on the miraculous and in which the underlying aesthetic principle is that the proper function of art is to imitate nature as accurately as possible. Both of these factors play an important role in the popular criticism of antiquity (see chap. 4).

Pasiteles, another of the authors cited by Pliny in his bibliography, wrote a work the subject of which is described not as *de toreutice* but as *de mirabilibus operibus* (*NH* 34, index) or *quinque volumina . . . nobilium operum in toto orbe*. Pasiteles' dates are reasonably well fixed by Pliny; we are told that he lived "around the time of Pompey the Great," that is 108–48 B.C. (*NH* 33.156) and that he was a south Italian Greek who received Roman citizenship, presumably when the Greek towns in south Italy were enfranchised after the Social Wars (89–88 B.C.; see *NH* 36.39). He appears to have been well known both as a sculptor who was equally proficient in metal, ivory, and stone and as an engraver (*caelator*).[15]

In addition to the literary evidence, we can draw certain conclusions about Pasiteles from ancient art. Although no works by the master himself have been positively identified, works by members of his school are known. A statue of a youth signed by "Stephanus the pupil of Pasiteles" is preserved in the Villa Albani, and another group, apparently representing Orestes and Electra and signed by "Menelaus the pupil of Stephanus," is in the Terme Museum in Rome.[16] Both of these works may be described as classicistic or neoclassic, in that they bypass the stylistic mannerisms of Hellenistic sculpture and echo those of Classical Greek sculpture.[17]

Judging by his date, by the fact that he worked in Rome, and by the style of his pupils' works, we are surely justified in associating Pasiteles with the neo-Attic movement of the late second and first centuries B.C. By this time most of the vital movements in Hellenistic sculpture had run their course, and Greek sculptors were beginning to find a new market for their services in the growing circle of Roman connoisseurs and collectors whose taste ran strongly to the Classical style. Not only were new works, like the Stephanus youth, made in the Classical style, but exact copies of famous Greek originals—those copies that dominate so many modern museums—began to be made. Pasiteles may even have

played an important role in the development of the copying industry. Pliny quotes Varro as saying that Pasiteles never made anything without "molding" it beforehand, *nihil umquam fecit ante quam finxit* (*NH* 35.156). The usual interpretation of this passage is that Pasiteles made clay models before he began casting bronze or carving stone. Richter has suggested, however, that *finxit* may actually refer to the making of plaster molds from an original statue in order to produce a copy.[18]

Pasiteles, then, wrote his *quinque volumina* in an age of retrospective nostalgia which idealized and sought to recover the spirit of Classical Greek art. One would expect the tone of such a work to differ strikingly from that of the rational, analytical treatise of Xenocrates. The title of Pasiteles' work—"Renowned (*nobiles*) Works" or "Marvelous (*mirabiles*) works"—suggests that like the rhetoricians of later antiquity, he may have offered personal "appreciations" of particular famous statues. It is impossible to say with certainty whether his works included historical and technical information. It is equally difficult to say just where and how Pasiteles influenced Pliny (who seems to imply that most of his information on Pasiteles was transmitted to him via Varro; see *NH* 36.39–40). In view of his apparent connection with the rise of neo-Attic sculpture in the late Hellenistic period, one is tempted to associate him with the classicistic theory of the history of sculpture preserved by Cicero and Quintilian (see chap. 7), but even this association is hypothetical.

Still another Greek writer who conceivably contributed information of an art historical nature to Pliny is Democritus, who is mentioned in the indexes to both book 34 and book 35. The reference is presumably to the atomist philosopher Democritus of Abdera (ca. 460–370 B.C.). Pliny does not specify what works of Democritus he used, nor does he refer to him as a source for any particular statements about art. It is known, however, that Democritus wrote a treatise *On Painting* (Diogenes Laertius 9.48), and some modern scholars have suggested that he may have theorized about the place of the arts in cultural evolution.[19] His influence on Pliny (and, for that matter, on Xenocrates and Pliny's other sources) must remain a subject for speculation.

The roles of three other writers mentioned at various points in Pliny's indexes—Heliodorus, who wrote *On the Votive Offerings of the Athenians*; Metrodorus, who wrote *On Architecture*; and Juba—are equally open to question. Nothing is known about Metrodorus beyond the mere fact

of his existence.[20] Heliodorus seems to have lived in the mid-second century B.C., and it is known that at least a portion of his work dealt with the monuments of the Athenian acropolis.[21] Juba is undoubtedly King Juba II of Mauretania (fl. late first century B.C.), a highly cultured ruler who was known as an art collector and as a prolific author (in Greek) whose works dealt with grammar, history, art, and archaeology.[22] A treatise by him on painting and painters is mentioned by Harpocration and Photius; but Pliny, oddly enough, does not cite him in the index to his book on painting.[23]

In rounding out this picture of Pliny's Greek sources we should note that in the index to book 35 of the *Natural History*, he claims to have made direct use of the writings of five professional painters—Apelles, Melanthius, Asclepiodorus, Euphranor, and Parrhasius. While the writings of these artists were probably not historical in character, they were, in themselves, subjects for history. Their content, where it is ascertainable, seems to suggest still another link between Pliny and the professional critics of the Classical period (see chap. 1).

In addition to Pliny's Greek sources, one Latin writer appears to have influenced his formulation of the history of Greek art. This was the scholarly antiquarian Marcus Terentius Varro (116–27 B.C.), the author of over fifty-five treatises covering vitually every area of knowledge in the ancient world. Pliny mentions him in his text more frequently than any other source.[24] It is uncertain which of Varro's many works provided Pliny with information on sculpture and painting, since Pliny does not refer to any specific treatise, and among the preserved titles of Varro's works, there is none that can be said obviously to have dealt with these subjects. Perhaps the best solution to this problem is Kalkmann's suggestion that Varro appended sketches of the history of sculpture and painting to a work known as the *disciplinarum libri novem*, an examination of nine "liberal arts."[25] The last of the arts examined in this treatise was architecture, and since there is evidence that Varro appended subtopics like optics and metrics to his discussions of the basic liberal arts, it may be that sculpture and painting were appended to the chapter on architecture. This hypothesis is supported by the contention of Vitruvius, who knew Varro's work (7.praef.14) and also emphasized architecture's importance as a liberal art, that a good architect should have at least theoretical

knowledge of all the decorative arts that served architecture (1.1.12–15).

Vitruvius also emphasized that one who was not a specialist in sculpture, painting, and related arts could only be expected to have knowledge of their theory or principles (*ratiocinatio*), not the details of their practice (*opus*).[26] The same distinction between theory and practical details was probably also found in Varro's treatment of the liberal arts. In tracing the development of the arts from Classical Greece to Rome, he perhaps began by paraphrasing the critical theories found in Greek treatises like those of Xenocrates and Antigonus and added material on Roman art to them. In summing up Varro's achievement I can only repeat what I have said elsewhere:[27] It was probably through the mediation of Varro that Pliny preserved as much as he did of Greek art criticism, and it was probably also from Varro that he learned to write about art in other than an anecdotal manner. If there is any validity in the view that Varro both preserved the Hellenistic art histories and served as an exemplar to the Romans of how to write about architecture, sculpture, and painting in a serious and systematic manner, he must be recognized as the most important Roman writer on art.

7 Quintilian and Cicero

The history of Greek art preserved by Quintilian and the fragment of the same history preserved by Cicero differ strikingly from that of Pliny. Quintilian presents his histories of painting and sculpture as part of a discussion about what type of style an orator should adopt (*Inst.* 12.10.1 ff.). He points out that the works of different orators differ not only in species—as statue differs from statue—but also in genus—as Greek art differs from Etruscan art. He then notes that many orators have their respective followers and admirers and that there is no unanimity of opinion about what constitutes a good style. Different artists are famed for particular points of excellence (*diversae virtutes*). The same is true of painters and sculptors. In painting, for example, early artists like Polygnotus and Aglaophon are admired by (in Quintilian's opinion, pretentious) connoisseurs for their simplicity.

Later Zeuxis and Parrhasius contributed to the progress of painting and were admired for certain particularly praiseworthy qualities— Zeuxis for his mastery of light and shade and Parrhasius for his fine draftsmanship. From the time of Philip down to Alexander (i.e. the fourth century B.C.) there was an even greater divergence of styles and achievements. Protogenes won fame for his meticulousness (*cura*), Pamphilus and Melanthius for intellectual contributions to the art (*ratio*), Antiphilus for ease of execution (*facilitas*), Theon for imaginative inventions (*phantasia*), and Apelles for natural talent and charm (*ingenium* and *gratia*). Euphranor, being both a sculptor and a painter, was admired for his versatility.

There is no direct evidence for the source of this picture of the development of painting. Insofar as it praises Zeuxis and Parrhasius for specific technical achievements—innovations in shading and draftsmanship—it bears some resemblance to the system of Xenocrates and may be in part derived from him (directly or indirectly). The other parts of the history, however, would seem to find their best analogy in the criticism of rhetoric. Hellenistic writers on rhetoric were particularly interested in the distinctive points of excellence (*virtutes* in Latin, *aretai* in Greek) which made the styles of different artists worthy of note. The possible line of descent of Quintilian's history of Greek painting from earlier studies of rhetorical style has already been examined in chapter 3.

Quintilian's history of sculpture resembles his history of painting in that it points out the particular excellence ascribed to various artists, but differs from it in that a cycle of evolution is seen to underlie the development of sculpture. In its early phases, sculpture is seen to evolve from a state of "hardness" to "softness": the works of Callon and Hegesias are "rather hard" (*duriora*) and resemble Etruscan statues in style; the works of Calamis are "less rigid" (*minus rigida*), and those of Myron are still "softer" (*molliora*). After this early phase a conceptual and technical high point is reached in the art of Polyclitus and Phidias. Polyclitus was famed for his great "precision" and for the "appropriateness" of his figures (*diligentia ac decor*) and also for having perfected the representation of the human figure. He lacked, however, that breadth of vision which made it possible to represent the gods successfully. This achievement was reserved for Alcamenes and, most important of all, for Phidias, whose great images of Athena in Athens and Zeus at

Olympia "added something to traditional religion" because the majesty of their conception was equal to the godhead itself (*adeo maiestas operis deum aequavit*). After Phidias the development of sculpture was marked by a decline in which grandeur of conception was replaced by realism. Lysippus and Praxiteles were admired for their accurate representations of nature (*veritas*), but Demetrius was censured for being "fonder of similitude than beauty" (*similitudinis quam pulchritudinis amantior*).

Cicero's discussion of sculpture[1] in *Brutus* 70 is a casual, offhand display of learning intended to illustrate the point that all arts take time to mature and reach perfection but that even in the immature phases of an art, there are always qualities one can admire. In sculpture, he notes, the early statues of Canachus were "harder" than they should have been if they were to imitate nature successfully; those of Calamis were "softer"; and those of Myron were "close enough to nature" (*satis ad veritatem adducta*) so that one would not hesitate to call them "beautiful" (*pulchra*). Polyclitus then created works that were "more beautiful" and, in fact, "quite perfect" (*plane perfecta*). Cicero's narrative breaks off at this point without mentioning Phidias, who, judging by the similarity of Cicero's history to Quintilian's, might be expected to occur next in the list. He makes up for this deficiency in *Orator* 9, where he refers to the Athena and the Zeus of Phidias as the most perfect statues in their genre, notes that it is impossible to conceive of statues more beautiful, and praises the great spiritual intuition of Phidias.

There can be little doubt that Cicero and Quintilian derived their histories of sculpture from a common source. Quintilian is the later of the two but preserves the system in a more complete form and cannot therefore be dependent on Cicero. Unlike "Xenocrates," who pointed to the art of Lysippus in the later fourth century B.C. as the culminating point in the development of sculpture, the source of the Quintilianic-Ciceronian system saw this culmination in the art of Phidias during the second half of the fifth century B.C. The supreme achievement of Phidias, moreover, lay not in the mastery of formal problems but in his ability to perceive and give form to the ineffable majesty of the gods. He was held to have been gifted with a kind of spiritual intuition,[2] and the images he created under the influence of this intuition were apparently understood as revelations of the divine nature.[3] This view of the development of Greek sculpture, and of Phidias's role in it, is

83

characteristic of what I have called the *phantasia* theory in Greek art criticism (see chap. 2, p. 53). It is probable that Cicero and Quintilian derived some or all of their information from that theory (see chap. 3, p. 61).

Epilogue

While it may seem reckless to attempt to sum up the development of art criticism in ancient Greece when so much is conjectural, I do think that our sources permit us to identify at least one trend that may be said to characterize the development in its entirety. This would be the gradual shift from objectivity toward subjectivity in the rendering of critical judgments; from the preoccupation of the professional artist with form and the means of controlling form toward the connoisseur's preoccupation with his reactions to art and the philosopher's interest in evaluating its extrinsic meaning; from an interest in perfecting a product, of "putting together" a work of art in the most effective manner, toward an interest in the personality and the state of mind of the man who produced it.

At the beginning of this development stands what I have called professional criticism; toward its end comes the *phantasia* theory. By the late Hellenistic period, the statues and paintings that the artists of the Classical period had labored with such diligence to perfect came to be accepted as established *exemplares* or *paradeigmata*, which were emulatable but not surpassable. The critics of the time were concerned not with how technical improvements in art might be made but with what the cultural and philosophical value of earlier artistic achievements was. At this point "aesthetics" in the academic sense became divorced once and for all from the problems of professional technique and replaced professional interests as the leading force in the criticism of the visual arts.

The early and middle Hellenistic periods appear to have formed an era of transition, in which the substance of professional criticism was made public in historical form by artist-critics Xenocrates and Antigonus and then absorbed by the critics of rhetoric, who used the data on individual artists as comparative material in their analyses of the styles and personal qualities of famous rhetoricians. Their "canonization," literally and metaphorically, of famous artists must in turn have served as raw material for the formulators of the *phantasia* theory.

What we have called popular criticism probably ran as an inconspicuous current parallel to all of these developments, and in the time of Callistratus, when the impetus that had prompted more ambitious traditions of criticism was spent, this type of criticism was all that remained.

85

Notes

1 As a sample of these opinions, in the order stated, see Ernst Buschor, *Frühgriech-ische Jünglinge* (Munich, 1950), pp. 5 ff.; G. M. A. Richter, *Kouroi*, 2d ed. (London, 1960), pp. 3 ff.; and Rhys Carpenter, *Greek Sculpture* (Chicago, 1960), esp. pp. 47–48.

2 In this respect, I think I should emphasize, my intention is not to contradict or rival modern analyses of the aesthetics of ancient art—e.g. Robert Scranton's *Aesthetic Aspects of Ancient Art* (Chicago, 1964) or Rhys Carpenter's *The Esthetic Basis of Greek Art,* rev. ed. (Bloomington, Ind., 1959)—but to provide an ancient perspective for them. Nor am I attempting to supplant philosophical studies, such as Julius Walter's *Die Geschichte der Ästhetik im Altertum* (Leipzig, 1893), which attempt to fit the ancient literary material into the formal academic categories of contemporary aesthetics.

3 Giorgio Vasari, *Lives of the Most Eminent Painters, Sculptors and Architects,* trans. G. du C. de Vere (London, 1912), 4: 79–85 (reproduced in E. G. Holt, ed., *A Documentary History of Art* [Garden City, N.Y., 1958], 2: 25–31); 9: 44. There are many examples of the respectful but highly independent attitudes of the Renaissance toward the ancients. Alberti, for example, often expresses admira-tion for Vitruvius but admits that he is at times incomprehensible. See *De Re Aedificatoria* 6.1; also Sir Anthony Blunt, *Artistic Theory in Italy 1450–1600* (Oxford, 1940; paperback reprint, 1962), p. 13. The most outspoken expression of the independent aspect of the Renaissance view occurs in a letter from Aretino to Michelangelo dated 1537: "Wherefore, when we gaze on you, we no longer regret that we may not meet with Phidias, Apelles, or Vitruvius, whose spirits were but the shadow of your spirit. But I consider it fortunate for Parrhasius and the other ancient painters that Time has not consented to let their manner be seen today: for this reason, we, giving credit to their praise as proclaimed by the documents, must suspend granting you that palm which, if they came to the tribunal of our eyes, they should have to give to you, calling you unique sculptor, unique painter, and unique architect." See Robert Klein and Henri Zerner, *Italian Art 1500–1600: Sources and Documents in the History of Art Series* (Englewood Cliffs, N.J., 1966), p. 57.

4 Cf. Blunt, *Artistic Theory in Italy,* pp. 20–22, 142–43 and passim; N. A. Robb, *Neoplatonism of the Italian Renaissance* (London, 1935), esp. pp. 212–38; Erwin Panofsky, "Idea," *Ein Beitrag zur Begriffgeschichte der älteren Kunsttheorie,* Studien der Bibliothek Warburg, no. 5 (Leipzig/Berlin, 1924), esp. pp. 57–63.

5 See Nikolaus Pevsner, *Academies of Art, Past and Present* (Cambridge, 1940), pp. 84–109.

6 Trans. Kenneth Donahue, in Holt, *A Documentary History of Art,* 2:95.

7 Ibid., p. 105

INTRODUCTION TO PART I

1 See Pausanias 1.42.5, 10.17.12, 5.25.13.

2 The Greek word *ekphrasis* is often used by modern critics as the general term for the practice of describing works of art as a literary exercise. It has been demonstrated by Eva C. Harlan, *The Description of Paintings as a Literary Device and Its Application in Achilles Tatius* (Ph.D. diss., Columbia University, 1965), that the exercise which the ancient rhetoricians referred to as *ekphrasis* commonly referred to a description of a historical event and, later, to a description of a secluded place. It apparently was not applied to literary descriptions of works of art until the later third century A.D.

Lucian's approximate dates are ca. A.D. 120–200. Flavius Philostratus, the author of the *Life of Apollonius of Tyana* was a contemporary of Septimius Severus. "Philostratus the Elder" or "the Lemnian" was apparently the son-in-law of Flavius. "Philostratus the Younger" was a grandson of the Elder Philostratus and was active about A.D. 300. Nothing is known about the life or background of Callistratus. It has been conjectured on the basis of his style that he may be as late as the fourth century A.D.; see the edition of Karl Schenkl and Aemilius Reisch (Leipzig, 1902), pp. xxii–xxiii.

3 See Vitruvius 7.praef.12; also 3.2.7 and 10.2.11–12; Pliny *NH* 36.90 and 95–97.

4 See Pliny's index to book 35 of the *Natural History*. The evidence for artists' writings in antiquity is collected in H. L. Urlichs, *Über Griechische Kunstschriftsteller* (Würzburg, 1887).

5 I consider these traditions separate in that their basic emphases are clearly different, but obviously their separateness should not be exaggerated by rigid, dogmatic boundaries. Polyclitus's interest in proportion clearly had a philosophical as well as a practical aspect, and Plato occasionally shows an interest in the professional problems of the artist. But in their general attitudes toward art, the two were undeniably poles apart.

6 T. B. L. Webster in an important and useful article, "Greek Theories of Art and Literature Down to 400 B.C.," *CQ* 33 (1939): 166–79, identifies seven ways of looking at art among the Greeks, four based on the words for "statue," plus three others: (1) the *eikon* or "likeness" view, i.e. art imitates nature; (2) the *xoanon* or "carved object" view, i.e. art as "craft"; (3) the *agalma* or "object of joy" approach or what Webster calls the "hedonistic" view; (4) the *kolossos* or "magical substitute" view, i.e. the idea that works of art are magically alive; (5) the artist as educator; (6) the "monument" idea, in which a portrait is thought to confer immortality on its subject; and (7) the artist as inspired by a divine source. I would prefer to call these seven ideas "ways of looking at art" rather than "theories" (Webster uses both phrases), since theory implies a coherent formulation of thought that is not apparent in all cases. I also suspect that ways 4 and 6 should be amalgamated, since they are both expressions of the basic idea that a work of art can have a magical life of its own. These ways of looking at art do not really constitute "traditions" in the sense that I have defined them here, but all of them do appear at different times within the definable critical traditions.

CHAPTER 1. PROFESSIONAL CRITICISM

1　See Pliny *NH* 36.90 and 95–97; Vitruvius 10.2.11–12.
2　Translations of some of the relevant passages may be found in my *The Art of Greece: 1400–31* B.C. (Englewood Cliffs, N.J., 1965), pp. 185–88, 211–13. See also Schlikker, *HV*, pp. 6–33, for an assessment of the writers on architecture who were Vitruvius's principal sources.
3　I believe that in this passage Diodorus is speaking of the Greek sculpture of the late fourth century B.C. and of the Hellenistic period. He may be drawing upon Xenocrates. The technique he ascribes to Greek sculptors involves the "optical" *symmetria* and *eurhythmia* which were especially studied by Lysippus and his pupils; see entries for these terms in the glossary. This interpretation of the passage is also maintained by Brunilde S. Ridgway, "Greek Kouroi and Egyptian Methods," *AJA* 70 (1966): 68–70. Her article was prompted by questions raised by Rudolf Anthes, "Affinity and Difference between Egyptian and Greek Sculpture and Thought in the Seventh and Sixth Centuries B.C.," *Proceedings of the American Philosophical Society* 107, no. 1 (1963): 60–81, who takes Diodorus's passage to refer to Archaic practice.
4　Frederick Grace, "Observations on Seventh-Century Sculpture," *AJA* 46 (1942): 341–59; Kim Levin, "The Male Figure in Egyptian and Greek Sculpture of the Seventh and Sixth Centuries B.C.," *AJA* 68 (1964): pp. 13–28. The relationship of the proportional system of early *kouroi* to contemporary Egyptian *Canons* is explored by E. Iversen, "The Egyptian Origin of the Archaic Greek Canon," *Mitt Kairo* 15 (1957): 134–47. Iversen's article proves beyond any reasonable doubt that canons did exist in Archaic Greece and suggests that the Greek canons were more flexible than their Egyptian prototypes. Iversen attributes this flexibility to the Greek desire to adhere as closely as possible to natural appearance, but it might equally well be attributable to the inherent experimental attitude with which the Greeks approached proportional systems.
5　See Diels, *Fragmente*[7], 40A3 (Galen *De Placitis Hippocratis et Platonis*, ed. Müller, 5:425). Included under the same heading is Galen *De Temperamentis* 1.9, where it is implied that all Polyclitus's proportions were directed toward capturing "the mean" (τὸ μέσον) in whatever form was represented. This mean was perhaps an ideal balance which formed one aspect of the εὖ which Polyclitus seems to have seen as the end product of his efforts.
6　The phrase is quoted (apparently) by Philo Mechanicus *Syntaxis* 4.1.49, 20 (ed. Schöne [Berlin, 1893]). See also Diels, *Fragmente* [7], 40B2. The use of τὸ εὖ as a substantive is not common, but Aristotle's use of it in *Metaphysics* 1092b26 ff. suggests that it may have had Pythagorean connections. He uses it in the course of his general critique of the Pythagorean concept that numbers are the primary constituents of the cosmos and implies that the Pythagoreans used τὸ εὖ to express the ethical or spiritual good which was derived from the contemplation of numerical proportion.

　　The phrase also occurs in Plato *Timaeus* 68E to express "the Good" that is fashioned by the cosmic Demiurge in all "generated" phenomena. Even here

there may be some Pythagorean background to the phrase, since the first stages by which the Demiurge generates a *kosmos* involves his use of the "fairest" geometrical forms by which determinate forms are imposed upon matter (*Timaeus* 53C–56A). But the background of the cosmology of the Timaeus is so complex that it is best not to insist on this point.

The meaning of the phrase παρὰ μικρόν has been widely discussed. Philo's interpretation seems to be that it means "from a minute calculation," in other words, that a very slight difference in measurement determines whether a work will be a success or a failure. This is the general sense accepted by Diels, *Fragmente* [7], 40B2 ("wobei Kleinstes den Ausschlag gibt"). Another interpretation is that the phrase means "except for a little" or "almost" (see *LSJ* [9], 3:5c, s.v. μικρός), implying that after all the accurate proportions are calculated, there is still something else that must be added—alterations prompted by the artist's intuition—before the work achieves τὸ εὖ. For this view see Carpenter, *The Esthetic Basis of Greek Art*, p.124; D. Schulz, "Zum Kanon Polyklets," *Hermes* 83 (1955): 200–20, esp. 215. Henry Stuart Jones, *Ancient Writers on Greek Sculpture* (London and New York, 1895; reprint Chicago, 1966), p. 129, took it to mean "from a small unit," i.e. from a module. Still another meaning might be "gradually," or "with each little step" (using the meanings for παρὰ in *LSJ*[9], 1:9–10; see also 3:5c, s.v. μικρός). This last interpretation appeals to me, but this is a question on which one can hardly be dogmatic. Such a meaning would really only be an extension of Philo's understanding of the phrase; it would imply that τὸ εὖ emerges from a *series* of minute, precise measurements. Kranz's alternative translation to that of Diels, "in kleinsten Schritten," seems to point in this direction. F. Hiller, "Zum Kanon Polyklets," *Marburger Winckelmann-Program* (1965), pp. 1–15, does not offer a translation but prefers to adhere as closely as possible to Philo's interpretation (see ibid., p. 13n8).

7 For the ancient literary references to the *Canon*, selections from modern criticism, extant works attributed to Polyclitus, and a critical bibliography, see Paolo Arias, *Policleto* (Milan, 1964). On the evidence for the nature of the *Canon* based on literary evidence see in particular Silvio Ferri, "Nuovi contributi esegetici al 'Canone' della scultura greca," *RivIstArch* 7 (1940): 117–52; Schulz, "Zum Kanon Polyklets" (who adds Plutarch *De Aud.* 13 (Moralia 45C-D) to the literary testimonia relating to the *Canon*); and Hiller, "Zum Kanon Polyklets." On the *Canon* tradition in general and a discussion of Polyclitus in that context see H. Oppel, "Kanon: Zur Bedeutungs-geschichte des Wortes und seinen lateinischen Entsprechungen," *Philologus*, suppl. 30, no. 4 (1937): 1–108, esp. 13–17.

Modern attempts to reconstruct the *Canon* by measuring extant copies of Polyclitan statues are always highly conjectural because there is no way of determining, except through personal intuition, the points from which Polyclitus took his measurements. An interesting, but, it seems to me, fundamentally subjective attempt to extract the *Canon* from a combination of the New York and Athens copies of the Diadoumenos is D. E. Gordon, and F. Cunningham, "Polykleitos' Diadoumenos—Measurement and Animation," *The Art Quarterly*

25 (1962): 128–42. Arias's bibliography may be supplemented by that of Schlikker, *HV*, p. 55.

8 For a general survey of the importance of proportion, especially the proportions of the human body, in ancient art and in later European art see the second chapter of Erwin Panofsky, *Meaning in the Visual Arts* (New York, 1955).

9 See G. S. Kirk and J. E. Raven, *The Pre-Socratic Philosophers* (Cambridge, 1962), pp. 240–48.

10 These are followed by wisdom (νοῦς), right knowledge (δόξαι ορθαί) in the arts and sciences, and by "pure" pleasures (i.e. pleasures not involving a contrasting pain).

11 The only facts about Pythagoras that are based on contemporary, or nearly contemporary, references are the statement that his father's name was Mnesarchus (Heraclitus 129) and that he believed in the transmigration of souls (implied by. Xenophanes, frag. 7). His date can with reasonable certainty be fixed in the late sixth century B.C. Aristotle usually ascribes Pythagorean doctrine to "the Pythagoreans" or to "the Italians" (i.e. the members of the school). See Kirk and Raven, *The Pre-Socratic Philosophers*, pp. 217–19. Apparently Pythagoras wrote nothing himself, and Pythagorean doctrine as a whole was not committed to writing until the time of Philolaus (late fifth century B.C.). This does not mean, of course, that Pythagorean thought would have been totally unfamiliar to those outside the confines of Croton prior to the time of Philolaus (as Heraclitus, Xenophanes, and Herodotus [4.95] attest).

12 Kirk and Raven, *The Pre-Socratic Philosophers*, p. 249.

13 See especially Speusippus as quoted in the *Theologumena Arithmeticae*, ed. De Falco, pp. 82–84 (Diels, *Fragmente*[7], 44A13), and Sextus Empiricus *Math.* 10. 281. For a collection of the relevant passages with commentary, see Kirk and Raven, *The Pre-Socratic Philosophers*, pp. 253–57.

14 The process is also described by Alexander of Aphrodisias in his commentary on the *Metaphysics* (827.9); he says that the pebbles were placed on a "shadow drawing" (*skiagraphia*). This term (see glossary) could mean either a simple outline or possibly a drawing in which "shading" was employed to suggest mass. In that case the diagram might have been understood as a three-dimensional one; Kirk and Raven, *The Pre-Socratic Philosophers*, pp. 313–17.

15 Kirk and Raven, *The Pre-Socratic Philosophers*, pp. 248–49.

16 While few are likely to doubt that the Pythagorean interest in harmony had a religious background, the exact relationship between Pythagorean "scientific" thought and religious thought must of necessity be a tenuous hypothesis based on passages that range widely in quality and date. See ibid., pp. 222–28 and especially Raven's reconstruction, p. 228.

17 See Diogenes Laertius 8.8.

18 J. E. Raven, "Polyclitus and Pythagoreanism," *CQ* 45 (1951): 147–52.

19 On Alcmaeon see Kirk and Raven, *The Pre-Socratic Philosophers*, pp. 232–35. His term for the balance of elements in the body was apparently *isonomia* (Aetius 5.30.1) rather than *symmetria* (used by Galen), but the idea was the same.

20 The source is Meno *Iatrica* (late fourth, early third centuries B.C.) quoted in the

papyrus known as the *Anonymous Londinensis* 18.8.31.

21 Raven, *CQ* 45 (1951): 151. The fragment (frag. 11, from Stobaeus *Ecl.* 1.1.3) appears, unfortunately, to be a post-Aristotelian forgery but may well reflect the ideas of Philolaus.

22 Philolaus seems to have been born around the middle of the fifth century B.C. (Diogenes Laertius 9.38, 41, on the authority of Apollodorus). Polyclitus seems to have been active in the 420s and perhaps as late as 405 B.C. See Richter, *SSG⁴*, p. 189; Arias, *Policleto*, pp. 9–13.

23 This conclusion would rest on the hypothesis that there was only one Early Classical sculptor named Pythagoras. Both Pliny *NH* 34.59–60 and Diogenes Laertius 8.47 speak of two sculptors, Pythagoras of Rhegion and Pythagoras of Samos. Pliny records a tradition that the two sculptors were almost indistinguishable in their features (*facie quoque indiscreta similis fuisse traditur*), and that a certain Sostratus was a pupil of the Rhegian and a nephew of the Samian. Since at least as early as L. Urlichs's *Chrestomathia Pliniana* (Berlin, 1857), pp. 320, 321, most modern scholars (e.g. the standard handbooks of Richter and Lippold) have taken Pythagoras of Rhegion and Pythagoras of Samos to be one and the same. Herodotus 6.22–23, records how a large contingent of Samians migrated in 494 B.C. from their homeland to Italy, besieged and settled in Zankle-Messena, and thus became subjects of Anaxilas of Rhegion. If a sculptor named Pythagoras was part of this migration, it is easy to see how he might have come to be known as both a Samian and a Rhegian. Centuries later Pliny and Diogenes Laertius would have assumed that there were two different sculptors named Pythagoras and have been puzzled by their astonishing similarity.

 In addition to the statements of Pliny and Diogenes, the existence of a Pythagoras of Samos is attested by a signature on a base found at Olympia for the statue of a runner, Euthymus of Locri Epizephyrii (see Loewy, *Igb*, no. 23; Wilhelm Dittenberger and Karl Purgold, *Die Inschriften von Olympia* [Berlin, 1893], no 124). This statue of Euthymus is mentioned by Pausanias, who assigns it to "Pythagoras" without giving an ethnic (6.6.6). Pausanias never mentions a Samian Pythagoras. He refers on four occasions to Pythagoras of Rhegion (4.4.3; 6.6.1; 6.13.7; 6.18.1) and on two other occasions uses the name without an ethnic (6.7.10 and 6.13.1); the latter, however, is a reference to the runner Astylus, whose statue is ascribed by Pliny *NH* 34.5.59, to Pythagoras of Rhegion. The fact that Pausanias seems to recognize only one sculptor, a Rhegian, has been taken by many as further evidence that the Samian of the Euthymus base and the Rhegian are the same. One could add to this that Euthymus, a western Greek, might have been more apt to have had his statue made by a western Greek sculptor than by a Samian.

 Recently, however, Andreas Rumpf has suggested that the "one-Pythagoras hypothesis" is doubtful (*RE*, under "Pythagoras," nos. 14, 15 [1963]) and reaffirms the ancient idea of two separate sculptors. He disputes the value of the Herodotus passage by pointing out that Pythagoras of Rhegion is said by Pausanias 6.4.3–4 to have made a statue of Leontiscus "of Messina on the strait," thus indicating that Zankle-Messina and Rhegion were two different places to

Pausanias and that when he called someone "a Rhegian," he actually meant that that person was from Rhegion itself. (One could argue in reply to this that Anaxilas might well have summoned a gifted artist like Pythagoras to his court, and Pythagoras unlike most of the other Samians, would actually have become a Rhegian.)

One cannot but admire Rumpf for taking a new, critical look at a hypothesis which, in the course of a century, has almost come to be regarded as fact; and yet the "one-Pythagoras hypothesis" still seems an attractive one to me. It is natural to wonder, as Urlichs did, whether Pythagoras might not, at the beginning of his career before he and his Samian kinsmen completely identified themselves with the west, have chosen to sign himself "the Samian," and later, when he decided that Italy was to be his permanent home, switched over to "the Rhegian." The difficulty with this idea is that the inscription on the Euthymus base at Olympia mentions all three of Euthymus's victories (484, 476, and 472 B.C.), which means that *after* 472, some twenty years after his hypothetical arrival in Italy, Pythagoras was still calling himself a Samian. This subject may already seem overburdened with hypotheses, and I half heartedly apologize for offering another. But could it be that there were political conditions in the late 470s which would have made a patron from Locri Epizephyrii look unfavorably on a sculptor from Rhegion? Anaxilas had threatened Locri in 477–476 B.C. (Pindar *Pyth.* 2.18 and scholia on *Pyth.* 1.99), and after his death in 476 Rhegion was ruled by the usurping regent Micythus, who suffered a disastrous defeat at the hands of the Messapian Iapygians (Herodotus 7.170; Diodorus 11.48). Perhaps Pythagoras, in order not to lose a commission, chose to present himself to Euthymus as a Samian.

24 Charles Seltman, "The Problem of the First Italiate Coins," *Numismatic Chronicle* (1949): pp. 5–9 and 19–21, goes so far as to suggest that Pythagoras the sculptor was actually the grandson of the philosopher. He also suggests that τορευτική was the hereditary family profession and that the philosopher was skilled in the art. G. Vallet, *Rhégion et Zancle* (Paris, 1958), pp. 238–39, contests Seltman's view.

25 On Vitruvius see chapter 5. The painter Pamphilus, a member of the Sicyonian school in the early fourth century B.C., was, according to Pliny *NH* 35.76, *primus in pictura omnibus litteris eruditus, praecipue arithmetica et geometria, sine quibus negebat artem perfici posse* and helped to win a place for painting in the general educational curriculum in Greece. On developments along the same line in the Renaissance see Blunt, *Artistic Theory in Italy*, pp. 48–57 and passim.

26 See glossary under *diligens*.

27 Dimensions probably based on the *embatēr*, "module." See Schlikker, *HV*, pp. 34–60.

28 It is possible that the Greek sculptors had another term for "theory" in general which was distinct from *technē* (which denotes the totality of the various steps involved in the practical procedure of making something; see chap. 2). This distinction would be analogous to the distinction drawn by Varro and Vitruvius between *ratiocinatio*, the theoretical principles on which an art rests, and *opus*,

the practical knowledge with which those who actually practice an art have to be familiar.

Some scholars have felt that the Greek term *sophia*, denoting the intellectual and inspirational aspects of artistic activity, should be contrasted to *technē* in this way. Bernhard Schweitzer analyzed early uses of *sophia* in connection with the arts in Greek literature and suggested that *sophia* did indeed have this meaning but that it was ascribable only to poets, practitioners of the visual arts being always too closely associated with "handwerkliche Tradition." See "Der bildende Künstler und der Begriff des Künstlerischen in der Antike, "*Neue Heidelberger Jahrbücher* 2 (1925): 66. The major literary reference in question is Solon 1.49–52 (Diehl) where the craftsman is taught by Athena and Hephaestus to earn his living by making objects (ἔργα) with his hands, but the poet is taught by the Muses and hence ἱμερτῆς σοφίης μέτρον ἐπιστάμενος, "knowing in the measure of the lovely *sophia*." T. B. L. Webster disagrees with Schweitzer that the early use of *sophia* refers only to the poet's art: "The archaic artist like the archaic poet called his art *sophia* (wisdom), and claimed to have been taught by the Muses"; see *Greek Art and Literature 530–400* B.C. (Oxford, 1939), p. vi, and also *CQ* 33 (1939): 171. In support of this contention he cites epigrams from Archaic inscriptions: the first on a fragment of a vase, early-mid sixth century from the Athenian Acropolis, the second a statue base from Delos of a work by Mikkides and/or Archermos of Chios, in both of which the artists claimed to have executed their work with *sophia* (in the plural): σοφίαισιν and σοφίεισιν respectively. See Johannes Geffcken, *Griechische Epigramme* (Heidelberg, 1916), nos. 2 and 29. (The reading of the statue base is difficult and controversial; add to Geffcken's bibliography, the new edition of the inscription in Marcadé, *Receuil*, 2: 21.) Geffcken adds to these references: Anacreon 109 (Bergk), on a robe made by two women who were equally competent in the art of weaving (ξυνὴ δ'ἀμφοτέρων σοφίη). Webster's line of thought is followed, at least for the fifth century, by O. J. Brendel, who would use *sophia* to translate certain uses of the Latin *ars* by Pliny; see "Prolegomena to a Book on Roman Art," *MAAR* 21 (1953): 54.

It seems to me that there is no passage associated with the Archaic period in which *sophia* cannot simply be translated as "skill" which is its earliest recorded meaning (*Iliad* 15.412). In the fifth century and afterward the situation is less clear. Both Schweitzer and Webster take note of Pindar, *Ol.* 7.53, where after relating how Athena had taught the Rhodians to make ἔργα which seemed almost alive, Pindar adds: δαέντι δὲ καὶ σοφία μείζων ἄδολος τελέθει, the point of which is that an artist who really knows what he is doing does not find works of art mysterious. *Sophia* could still be translated as "skill," but its connotation is becoming more intellectual than manual. This trend culminates in Aristotle (*Eth. Nic.* 6.7), where *sophia* is defined as "theoretical wisdom," involving a combination of intelligence (νοῦς) and scientific knowledge, ἐπιστήμη (*Eth. Nic.* 1141a19). The discussion of the meaning of the term in ethics is prefaced by a reference to its meaning in the arts: τὴν δὲ σοφίαν ἔν τε ταῖς τέχναις τοῖς ἀκριβεστάτοις τὰς τέχνας ἀποδίδομεν οἷον Φειδίαν λιθουργὸν σοφὸν

καὶ Πολύκλειτον ἀνδριαντοποιόν, ἐνταῦθα μὲν οὖν οὐθὲν ἄλλο σημαίνοντες τὴν σοφίαν ἢ ὅτι ἀρετὴ τέχνης ἐστίν(1141a9–13). The principal difference between σοφία in the arts and in ethics is that in the arts it is confined to one department of knowledge (κατά μέρος), whereas in ethics it is general (σόφους . . . ὅλως). Σοφία could be used in this passage simply in the old sense of "skill," and the passage could mean that "skill in the arts we attribute to those who are most thorough [or "precise"] in respect to the arts, such as Phidias the maker of stone statuary and Polyclitus the maker of bronze statuary, meaning by sophia in this case nothing other than that it is excellence of art." In the Metaphysics 981a26–982a3, however, Aristotle makes it quite clear that the σοφία of an artist is based on theoretical knowledge of first principles and causes; and this explains why, among other things, an artist is "wiser" than a man with simple empirical knowledge (ὁ δὲ τεχνίτης [σοφώτερος] τῶν ἐμπείρων), the architect "wiser" than an ordinary workman (χειροτέχνου δὲ ἀριχτέκτων), and theoretial knowledge generally "wiser" than practical knowledge (αἱ δὲ θεωρετικαὶ τῶν ποιητικῶν μᾶλλον). See Metaphysics 981b30–34. It is therefore possible that the σοφία ascribed to Phidias and Polyclitus in the Eth. Nic. implies theoretical knowledge as well as practical skill. I also believe that the words ἀκριβεστάτοις and ἀρετή in that passage may suggest a connection with artistic theory; i.e. ἀκρίβεια perhaps suggests "precision" in the application of theoretical knowledge, and ἀρετή may refer to the "essential excellence" or "essence" of the art, that is, its theory. For further comment on these questions see the commentaries under ἀκρίβεια and diligens in the glossary, and under ἀρετή in the glossary of the unabridged edition.

In spite of the implications of these Aristotelian passages, however, I do not think that the use of sophia as a general term for "theory" or "doctrine" in the Classical period is proved. The one passage known to me where sophia does quite certainly imply something of this sort is in the Eikones of the Elder Philostratus 1.1.3, where he speaks of a friend, Aristodemus of Caria, who painted "according to the sophia of Eumelus" (ἔγραφε δὲ κατὰ τὴν Εὐμήλου σοφίαν). W. Tatarkiewicz ("Classification of Arts in Antiquity," Journal of the History of Ideas 24 [1963]: 231–40), however, feels that the Philostratean concept of sophia points not to the theories of individual artists but to the first unified conception of the "fine arts" (as opposed to the practical crafts) in antiquity.

It is worth noting here that it was the rhetoricians who led the way in writing technical treatises in the Classical period (see chap. 2) and that these treatises were customarily referred to as technai. "Die Bedeutungsgeschichte von τέχνη als bildender Kunst," as Schweitzer has said, "enthält die Geschichte der Kunstanschauung" ("Mimesis und Phantasia," Philologus 89 [1934]: 295). Technē probably implied both theory and practice to a Classical sculptor.

29 Pliny NH 34.65. Pliny's judgment seems to go back to the system of Xenocrates; see chap. 6.

30 See glossary of unabridged edition under τετράγωνος.

31 I allow for the possibility that akribeia had always been used in this sense. See glossary under ἀκρίβεια.

32 Agatharhcus's book is mentioned by Vitruvius 7.praef.11 (see glossary under σκηνογραφία). Among the painters who wrote on their art, Parrhasius, Euphranor, Asclepiodorus, Melanthius, and Apelles are mentioned by Pliny; Protogenes and Pamphilus are mentioned in the Suidas lexicon.

33 Apollodorus, Zeuxis, and Nicias seem to be the painters who made special developments in σκιαγραφία (see glossary). It is not known whether any of them actually wrote on the subject. According to Pliny, however, Apollodorus was at least known to have written epigrams (NH 35.62; the source here is probably Duris of Samos).

34 Pliny NH 35.68; Quintilian 12.10.5. See glossary under *lineamenta* and glossary of unabridged edition under *subtilitas* and λεπτότης.

35 It is at least worth considering that Parrhasius himself, since he is mentioned as an author in Pliny's indexes, may have written a defense of his own style. Possibly he defended his own linear style against the prevailing taste for σκιαγραφία, which was championed by his contemporary Zeuxis. Plato (see chap. 2) may have been the champion of Parrhasius's cause.

36 Panofsky, *Meaning in the Visual Arts*, pp. 28 ff.

37 On Pauson see Lucian *Dem.Enc.* 24; on Theon see Aelian *VH* 2.44; Quintilian, *Inst.* 12.10.6. Another painting that was famed for the novelty of its sudject matter was the Centaur Family of Zeuxis (see glossary under ἀκρίβεια, passage 18), but note also Zeuxis's supposed indignation when people admired the picture for its novelty and not for its technical excellence. These passages may be found in my *The Art of Greece 1400–1431 B.C.*, pp. 110–11 and 220n2.

38 Panofsky, *Meaning in the Visual Arts*, p. 31.

39 On the intellectual background of Thucydides see especially John Finley, *Thucydides* (Cambridge, Mass., 1942; reprint Ann Arbor, Mich., 1963), chap. 2.

40 As suggested by Brendel, *MAAR* 21 (1953): 54, A.W. Lawrence, "*Cessavit ars*: Turning Points in Hellenistic Sculpture," *Mélanges d'archéologie et d'histoire offerts à Charles Picard* (Paris, 1949), 2: 581–85, agrees. In his opinion *ars* in Pliny refers specifically to the High Classical style in Greek art and its neo-Attic imitation. Pliny's statement, Lawrence suggests, is derived directly from the writings of Pasiteles. By the classicistic standards of Pasiteles, according to Lawrence, middle Hellenistic art, such as that of the Pergamene school, could not be considered true *ars*. Margarete Bieber, "Pliny and Graeco-Roman Art," *Hommages à Joseph Bidez et à Franz Cumont*, Collection Latomus, no. 2 (Brussels, 1949), pp. 39–42, connects the "revival of art" with the classicistic style of sculpture exemplified by Damophon of Messene around the middle of the second century B.C.

41 Here I differ with Schlikker, *HV*, pp. 34–84, who presents a valuable survey of the relevant texts.

42 For a detailed treatment of these terms see glossary.

43 Notwithstanding the remark of Duris, preserved by Pliny *NH* 34.61, that Lysippus had no teacher and took nature as his model. On the significance of this passage, see chap. 4.

A number of distinguished scholars in the nineteenth century chose to translate

viderentur in *NH* 34.65 by the Greek ἔοικεν ("as they ought to be"); see Karl Ottfried Müller, *Kleine Schriften* (Breslau, 1847), 2:331; also Reinhard Kekulé, "Über einen angeblichen Aussprach des Lysipp," *JdI* 8 (1893): 31–51; and Brunn, *GGK²*, 1:264. Those scholars interpreted the passage to mean that Lysippus was striving for an "ideal" beauty which surpassed the literal imitations of nature produced by his predecessors. Brunn recognized that Lysippus may well have studied the optical effect of his statues but felt that his goal was "die Kunst sich über die Wirklichkeit zu erheben und eine jenseit der Natur liegende Schönheit zu erreichen." It is more likely, however, that Lysippus's aim was just the opposite of this; that is, while not abandoning *symmetria*, he may have been striving to make his statues more naturalistic by simulating actual optical experience rather than relying exclusively on theoretical systems of measurement and proportion.

44 I will henceforth cite the author of this interesting passage as "Damianus," always using quotation marks. For the text see the edition of R. Schöne, *Damianos Schrift über Optik mit Auszügen auf Geminos* (Berlin, 1897), app., p. 28. The fragment in question was attached to the manuscripts of Damianus in the sixteenth century. It is sometimes attributed to Heron of Alexandria, whose date is uncertain but is probably late Hellenistic (see the edition of Hultsch [Berlin, 1864]); and sometimes to Geminus, whose date is also uncertain but seems to have been a contemporary of Posidonius (hence ca. 70 B.C.). On these attributions I can add nothing to the clear summary given by P. M. Schuhl, *Platon et l'art de son temps* (Paris, 1933), pp. 74–77.

It is not inconceivable that the passage actually does belong to Damianus, who is dated by Hultsch (*RE*, under "Damianos") to around the fourth century A.D. Since the possible dates of the passage can thus range over a period of four hundred years, I have placed it last in the lists of texts presented in the glossary; see σκηνογραφία, passage 12.

45 The representation of character and emotion was, of course, not new to Greek art. Pausanias's description of Polygnotus's famous paintings in the Lesche of the Cnidians at Delphi supports Aristotle's contention that "character study" played an important role in the art of Polygnotus (see glossary, under ἦθος καὶ πάθος). But there is no evidence that Polygnotus ever made any theoretical pronouncements about *ethos* in art, thereby bringing the term into professional criticism. His portrayal of "character" was probably the intuitive, spontaneous expression of his reactions to the conventional meaning (i.e. the narrative subjects) of his paintings.

46 E.g. the heads from the pedimental sculptures of the temple of Athena Alea at Tegea, dating from around 360–340 B.C., presumably reflecting the style of Scopas (Richter, *SSG⁴*, figs. 737–40) and the head identified as Priam from the pediment of the temple of Ascelpius at Epidaurus, dating from around 390–380 B.C. (J. F. Crome, *Die Skulpturen des Asklepiostempels von Epidauros* [Berlin, 1951], pl. 41).

47 On the Aristotelian passages and their significance see chap. 2 and the glossary under ἦθος καὶ πάθος.

CHAPTER 2. ART CRITICISM IN GREEK PHILOSOPHY

1 See Werner Jaeger, *Paideia* (New York, 1944) 2: 129–30; R. G. Collingwood, *The Principles of Art* (Oxford, 1938), pp. 5–7, where a brief history of the Latin *ars*, the normal translation of *technē*, is given; Tatarkiewicz, *Journal of the History of Ideas* 24 (1963): 231–40.

2 On this subject in general see Webster, *CQ* 73 (1939): 173–75 (see chap. 1, note 6). We do not have much evidence as to the Greek artists' views on inspiration, but it is reasonable to assume that they were even more conscious of it than the philosophers. As an example one might cite Apelles' avowed trust in his own intuition (see chap. 1, under "Subjectivism in the Fourth Century B.C."). Perhaps Strabo's story (8.354) that Phidias's Olympian Zeus was inspired by some descriptive lines in the *Iliad* (1.527–30) is another example. Phidias is said to have acknowledged the inspiration in response to a question posed by his brother, the painter Panaenus.

3 See especially *Apology* 22C, where poets are said to "do what they do, not by wisdom but by a certain natural gift and because they are inspired" (οὐ σοφίᾳ ποιοῖεν ἃ ποιοῖεν ἀλλὰ φύσει τινὶ καὶ ἐνθουσιάζοντες); also *Phaedrus* 245A ff.; and *Ion* 533D ff. This aspect of Plato's thought about the arts is emphasized (perhaps overemphasized) by W. J. Verdenius, *Mimesis* (Leiden, 1949).

4 For example: *Iliad* 3.61, where a shipwright is said to work a ship's timber "with skill" (τέχνη); *Odyssey* 6.234, where the reference is to a worker of precious metal whom Hephaestus and Athena have taught "every sort of skill" (τέχνην παντοίην).

5 For example: *Odyssey* 4.455, where the reference is to the "magical cunning" by which Proteus turned himself into various shapes; and 529, where the reference is to the deceitful treachery (δολίη τέχνη) of Aegisthus. The same phrase occurs in Hesiod *Theogony* 160, for the plot of Gaia against Ouranos.

6 Probably born in 548 B.C. He is said (Suidas, under "Lasus") to have written the first treatise on music.

7 See Aristotle *Politics* 2.5.1–2.

8 J. H. Randall, *Aristotle* (New York, 1960; paperback, 1962), p. 276. In assessing Aristotle's view of art in general I favor an approach like Randall's over the ambitious but probably unjustified attempt of S. H. Butcher to interpret Aristotle's "mimetic arts" as "fine arts" which were distinctly different in nature and value from the merely "useful" arts (see *Aristotle's Theory of Poetry and Fine Art*, 4th ed. [London, 1907; reprint, New York, 1951], pp. 113–62). From various remarks in the *Poetics* (e.g. 1451b8: poetry deals with the universal, τὰ καθόλου, while history deals with particulars; and 1461b9-14: the arts should strive to represent, τὸ βέλτιον, even when what is represented does not really exist), Butcher constructs a general theory that the goal of one who practices a "fine art" is to produce "not a copy of reality, but a βέλτιον, or higher reality" (p. 152). A fine art, unlike a useful art, he continues, sets practical needs aside and, by the use of image alone, avoids the flaws and failures of nature and gives "the ideal . . . concrete shape" (p. 158). A useful art,

on the other hand, "uses nature's own machinery . . . to affect the real world, to modify the actual." One can object to Butcher's view on many grounds. Aristotle clearly did prefer to see a certain moral elevation in the imitative arts, but if he insisted that this quality was essential to fine art, how, for example, would he have classed the art of Pauson, who painted men as worse than they are (*Poetics* 1448a6)? Did painting in Pauson's hands cease to be a fine art? Certainly it could not then be said to revert to the category of a useful art. And if a lack of practicality was an index of fine art, how would one classify an art like vase making when practiced for amusement rather than for need? Also, can it really be said that the mimetic arts do not "modify the actual" in the same way that a useful art does? As a potter modifies clay and gives it a form that is not found naturally, so a sculptor modifies stone, and a playwright modifies human behavior into forms that do not exist without the agency of art. In each case the raw material is actual, and the arts shape it according to their proper goals. In the mimetic arts the final forms, it is true, are images as well as objects, and this fact distinguishes them as a particular group; but Aristotle nowhere indicates that he thought of their modus operandi as different from that of other arts.

Like the notion of a good *mimesis* in Plato's thought, the conception of fine art in Aristotle's thought is probably an example of a modern critic's finding what he would like to find in ancient thought rather than what is really there. If he had felt that there was a special group of fine arts, it seems likely that Aristotle would have said so in a straightforward manner.

9 G. F. Else, "Imitation in the Fifth century," *CP* 53 (1958): 73–90, which is in part a critical review of Hermann Koller, *Die Mimesis in der Antike* (Berne, 1954).

10 Else, *CP* 53 (1958): 78.

11 For the first: August Nauck, *Tragicorum Graecorum Fragmenta* (Leipzig, 1899; photomechanical reprint, Hildesheim, 1964), no. 364 (from an uncertain play). The second, from the *Theoroi* (*Isthmiastai*), see *Oxyrhynchus Papyri* vol. 18, no. 2162 (line 7). The text with commentary by Hugh Lloyd-Jones may be found in vol. 2 of the Loeb edition of Aeschylus, p. 550; also H. J. Mette, *Supplementum Aeschyleum* (Berlin, 1939), no. 190.

12 Else, *CP* 53 (1958): 76. The occurrences of the word that can be associated with the fifth century are (1) in a fragment of the *Edonoi* of Aeschylus (Nauck, *TGF*, frag. 57, line 9, from Strabo 470F), where the reference is apparently to "bull-roarers" serving as "mimes" of the bellowing of real bulls; (2) in Euripides (?) *Rhesus* 256, referring to Dolon, dressed in a wolf skin, performing a kind of "mime" of a four-footed animal; and (relating to the fifth century) (3) Aristotle *Poetics* 1447b10, a reference to the mimes of Sophron and Xenarchus.

13 For the collected passages see Else, *CP* 53 (1958): 79–83. In all these passages, it might be noted, the idea of literally "imitating" someone's action rather than the more abstract idea of following his example impresses itself on the reader. In Aristophanes, especially, the sense of "miming" is very pronounced. E. A. Havelock, *Preface to Plato* (Oxford, 1963), pp. 57–59, objects to Else's use of the

phrase "ethical imitation" for the second (general) meaning of the *mimesis* words because, he feels, this sets up an abstract, Platonic separation between the imitation and the person or thing imitated that is not present in the pre-Platonic passages. It is perhaps impossible to draw a firm boundary between literal and abstract meanings for *mimesis*. Human perception does not operate on the basis of scholarly definitions. A late-fifth-century Greek watching a play of Euripides might well have attached both senses to the word.

14 If we were to apply Aristotle's three-part division to the visual arts in detail, the discussions would run as follows: (1) difference by generic means, as sculpture using bronze or stone in three dimensions differs from painting using colors on a flat plane; (2) difference by the type of representation, as Polygnotus differs from Pauson; and (3) difference by manner within the means, as when a certain subject is represented in relief sculpture or in freestanding sculpture.

15 It is suggested by Koller, *Die Mimesis in der Antike*, that the idea of bringing together what I have called literal *mimesis* and *mimesis* by psychological association was derived by Plato from the fifth-century Athenian musician Damon, who is mentioned in this passage. Else, *CP* 53 (1958): 85–86, admits the possibility that Damon influenced Plato, but doubts that Damon himself was concerned with *mimesis*.

16 The last point is urged especially by Havelock, *Preface to Plato*, who maintains that full literacy was not widespread in Classical Greece, that the standard learning process was therefore still essentially one of oral repetition and memorization, and that this discouraged the thought processes necessary for dialectic.

On the fundamentalist use of the early poets in the Classical period see Plato *Ion* 531C ff.: *Republic* 598D ff.; Xenophon *Symposium* 4.6. For a general discussion, Jaeger, *Paideia*, 1:296, 2:360.

17 On this question, and in general on the relationship between Plato and the art of the late fifth and fourth centuries B.C., see R. G. Steven, "Plato and the Art of His Time," *CQ* 27 (1933): 149–55; Schuhl, *Platon et l'art de son temps*; Bernhard Schweitzer, *Platon und die Bildende Kunst der Griechen* (Tübingen, 1953).

18 See especially Pliny *NH* 35.60; Overbeck, *Schriftquellen*, 1641–46; and the glossary under σκιαγραφία and *species*, where the relevant passages are collected and discussed. The painting of Plato's day also undoubtedly included σκηνογραφία, painting with the illusion of perspective, which would have been equally galling to him.

19 For a detailed analysis of Plato's theory of the levels of cognition and the place of art within it, see H. J. Paton, "Plato's Theory of εἰκασία," *Proceedings of the Aristotelian Society* 22 (1922): 67–104, esp. 93–103.

20 If the thirteenth Platonic epistle is genuine, one might in fact be justified in believing that Plato was a connoisseur of sculpture. In this letter "Plato" speaks with satisfaction of a statue of Apollo by Leochares that he had purchased for Dionysius II (*Epistle* 13.361A). His sense of connoisseurship is also evident in other passages, for example, *Ion* 532E ff.

21 Schuhl, *Platon et l'art de son temps*, p. 45.

22 In *Philebus* 51C he emphasizes that the beauty of geometrical forms is to him

quite different from the beauty of "living things and paintings" (ζωγραφήματα) that most people admire.

23 It must be admitted that nowhere in the Platonic dialogues is there an explicit treatment of this subject as such. The view that Plato recognized a form of *mimesis* that imitated the "forms" and was hence only one stage removed from reality is defended by J. Tate, "Imitation in Plato's *Republic*," *CQ* 22 (1928): 16–23; and idem, "Plato and Imitation," *CQ* 26 (1932): 161–69, where the relevant passages are assembled. Among the scholars who have accepted this approach see especially R. O. Lodge, *Plato's Theory of Art* (London, 1953); Verdenius, *Mimesis*. For further bibliography and a concise review of this question see Havelock, *Preface to Plato*, pp. 33–35n37. It should be noted that most writers on this subject are very much concerned with redeeming Plato's view of poetry and, with the exception of T. B. L. Webster, have only an incidental interest in his view of the visual arts.

24 It should be noted that δημιουργός refers here not to the cosmic "demiurge" of the world but simply to the maker of any object.

25 In the *Republic* 500E it is maintained that the state would never be successful unless its designers were philosophers who, in the manner of painters, made use of a "divine paradigm" (οἱ τῷ θείῳ παραδείγματι χρώμενοι ζωγράφοι). The reference to painting in this passage is, of course, purely metaphorical.

26 One might also draw upon *Phaedrus* 249–51A, where the doctrine that pure beauty is recollected by the soul upon seeing beautiful things in this world is presented, although the arts are not dealt with in this passage.

27 Steven, *Plato and the Art of His Time*, p. 154.

28 On Parrhasius's skill in draftsmanship see Pliny *NH* 35.67–68. The choice of Parrhasius as the interlocutor of Socrates in Xenophon's *Memorabilia* might be taken to suggest that Parrhasius had some remote association with Socratic ideas on art which Plato developed in his own way. See glossary under *lineamenta*.

29 In this assessment of Aristotle's criticism of the visual arts I have omitted the theory of Butcher, *Aristotle's Theory of Poetry and Fine Art*, p. 198 (see note 8), that, in Aristotle's view, "the end of fine art is to give pleasure" because, as far as I know, there is no passage in which Aristotle uses the capacity to give pleasure as a criterion for judging the visual arts. He clearly did recognize that some arts were directed "toward pleasure," πρὸς ἡδονήν, and others "toward necessity," πρὸς τἀναγκαῖα (*Metaphysics* 981b21). With regard to the visual arts (and possibly all the mimetic arts), he identified the source of this pleasure in the recognition that the imitation and the object imitated were like one another (*Rhetoric* 1371b6–10, *Poetics* 1448b10–19). In theory, it is possible that Aristotle might have considered the painting of, say, Polygnotus superior to that of Pauson because Polygnotus's imitations were more accurate and hence more pleasurable, but no judgment of this nature is preserved, and it is unlikely that one ever existed.

30 According to Philostratus *VS* 19.6, Gorgias lived to be 108. The existing evidence suggests 483–375 B.C. as his dates (see especially Diels, *Fragmente*[7], 82A6,7). He

was thus an active contemporary of both Socrates and Plato.

31 Diels, *Fragmente*[7], 82B23 (Plutarch *De glor. Ath.* 348c). On the background of Gorgias's theory of *apatē* see Schuhl, *Platon et l'art de son temps*, app. 4, "Gorgias et l'esthetique de l'illusion," pp. 78–81; Thomas Rosenmeyer, "Gorgias, Aeschylus, and *Apate*," *AJP* 76 (1955): 225–60, esp. 231–32.

32 Text in Diels, *Fragmente*[7], 82B11.

33 Sextus Empiricus *Math.* 7.65 ff.; Diels, *Fragmente*[7], 82B1–5. Rosenmeyer, *AJP* 76 (1955): 225–60, feels that Gorgias's conception of *apatē* applies principally to the third of these tenets, i.e. that nothing can be communicated: "Gorgias chose a negative term to stress his discovery of the autonomy of speech. *Apatē* signals the supersession of the world of the *logos* in place of the epic world of things" (p. 232).

34 Schuhl, *Platon et l'art de son temps*, p. 32, suggests that one of the general terms around which the "Gorgian" view of the arts centered was *psychagogia*, which one might translate in this context as a "swaying" or "transport of the soul." Plato uses it in the *Phaedrus* (261A, 271C) to describe the function of persuasive rhetoric. Aristotle uses the adjectival and verb forms of the word to describe the effects produced in a tragedy by staging, costume, etc. (*Poetics* 1450b17) and for the emotional effects of the elements of the tragedy itself, such as "reversal" and recognition scenes (*Poetics* 1450a32). Apollodotus (or Apollodorus) of Cyzicus, a follower of Democritus, is said by Clement of Alexandria to have proposed *psychagogia* as the end of ethical behavior (Diels, *Fragmente*[7], 68b4.74.1; Clement *Stromateis* 2.130). There is no direct evidence associating this term with the visual arts, but one might suspect that an artist like Praxiteles, who in all probability had little interest in the moral philosophy and epistemology of the Academy, would have felt that it adequately expressed the aim of his work.

35 See especially Quintilian *Inst.* 12.10.9 (see chap. 7), and Cicero *Orat.* 9; also Dio Chrysostom *Orationes* 12.50–52, where the spiritual effects of the Zeus are described. The idea appears even in Plotinus *Enneads* 5.8.1, Plotinus's only direct reference to an ancient artist. See also Seneca *Rhetor. Controv.* 10.34.

On the profound change from the view of the artist as a simple craftsman to the view of the artist as a creator and seer see Schweitzer, *Neue Heidelberger Jahrbücher* 2 (1925): 28–132, esp. 102 ff., and also the works of Schweitzer and Birmelin listed in the succeeding notes.

Schweitzer is undoubtedly right in insisting that the role of inspiration in the visual arts should be studied separately from its role in poetry. The ancient world was much more reluctant to ascribe inspiration to men who worked with their hands than it was to poets. The stigma of being βάναυσος clung to sculptors and painters throughout antiquity; witness the revealing passages in Plutarch *Pericles* 2 and Lucian *Somnium* 6–9. See also Schweitzer's article in *Philologus* 89 (1934): 286–300.

36 The text of this passage and an examination of other passages that use the same terminology are examined in the commentary on φαντασία in the glossary. A similar contrast, pitting the value of the Classical standard of *symmetria* against *phantasia* occurs in the *Eikones* of the Younger Philostratus (proem. 5). On the

background of the artistic theory and criticism contained in the *Life of Apollonius* see Ella Birmelin, "Die Kunsttheoretischen Gedanken in Philostrats Apollonios," *Philologus* 88 (1933): 149–80, 392–414.

37 Birmelin, *Philologus* 88 (1933): 171–72. Her ideas are given a sound critical evaluation and amplification by Schweitzer, *Philologus* 89 (1934): 296. His objections to Birmelin's use of passages in the *Poetics* that deal exclusively with poetry to construct an aesthetic theory for the visual arts seem valid to me.

38 Von Arnim, *SVF*, 1: 56–68.

39 Ibid., p. 66 (Cicero *Academica* 2.144–45).

40 This connection has been particularly emphasized by Schweitzer, *Neue Heidelberger Jahrbücher* 2 (1925): 28–132, esp. p. 107; also *Xenokrates von Athen*, app. 2, "Eine klassizistische Kunstgeschichtliche Theorie des späten Hellenismus."

41 On Posidonius in general: Karl Reinhardt, *Poseidonios* (Munich, 1921), and idem, the article under "Poseidonios" in *RE* (1953); L. Edelstein, "The Philosophical System of Poseidonius," *AJP* 57 (1936): 286–325. On Panaetius: Modestus Van Straaten, *Panétius* (Amsterdam, 1946), fragments and commentary. Among the works ascribed to Posidonius are: *On the Gods* (περὶ θεῶν); *On Divination* (περὶ μαντικῆς); *On Destiny* (περὶ εἱμαρμένης), see Diogenes Laertius 7.138–39, 149; *On Heroes and Demigods* (περὶ ἡρώων καὶ δαιμόνων), Macrobius, *Saturnalia* 1.23.7.

In one fragment of the writings of Posidonius a new appreciation of the role that art could play in conveying an idea of the godhead to men seems detectable: ἔσχον δὲ ἔννοιαν τούτου (i.e. θεοῦ) πρῶτον μὲν ἀπὸ τοῦ κάλλους τῶν ἐμφαινομένων προσλαμβάνοντες οὐδὲν γὰρ τῶν καλῶν εἰκῇ καὶ ὡς ἔτυχε γίνεται ἀλλὰ μετά τινος τέχνης δημιουργούσης. καλὸς δὲ ὁ κόσμος (Von Arnim, *SVF*, 2: 1009). Man forms his idea of God, Posidonius says, first from beauty, especially the beauty of outward things. But nothing that is beautiful is brought forth without the application of some art. This is true for the whole cosmos as well as for human life.

Although the evidence would seem to point more to Posidonius than Panaetius as the framer of the *phantasia* theory, Panaetius's thought nevertheless may have played an important role in it. His concept of πρέπον (= Latin *decor*) in particular seems to have been at the heart of the theory.

42 As a teacher of Cicero, see Cicero, *Nat.D.* 1.3.6; *Fin.* 1.2.6; Plutarch *Cicero* 4. The evidence for a commentary on Plato's *Timaeus* is Sextus Empiricus *Math.* 7.93 (adv. *Dogmaticos* A. 93): φησὶν ὁ Ποσειδώνιος τὸν Πλάτωνος Τίμαιον ἐξηγούμενος. Posidonius thus obviously commented on the *Timaeus*, but some have doubted that he actually wrote a separate commentary on it; on this question see Reinhardt in *RE*, under "Poseidonios" (1953). Birmelin, *Philologus* 88 (1933): 406–14, and Schweitzer, *Philologus* 89 (1934): 287, also entertain the possibility that the Platonic side of the *phantasia* theory ("the ἰδέα-*Lehre*" which they detect in Cicero *Orat.* 9) might have been worked out by Antiochus of Ascalon (ca. 130–68 B.C.), the founder of the "Fifth Academy," who was also one of the teachers of Cicero. Cicero, it is to be noted, does not actually use the term *phantasia* in *Orat.* 9.

43 Diogenes Laertius 7.60. Diogenes emphasizes Posidonius's contention that poetry

should imitate the divine. Quintilian *Inst.* 3.6.37 also seems to be drawing on this treatise.

44 Porphyry *Life of Plotinus* 1. Translations of this and other passages relating to Plotinus's view of the arts are collected in my volume, *The Art of Rome c. 753 B.C.–337 A.D.*, Sources and Documents (Englewood Cliffs, N.J., 1966), pp. 215–19.

45 Eugénie de Keyser, *La signification de l'art dans les Ennéades de Plotin* (Louvain, 1955), pp. 33–34, suggests that the deprecatory tone taken toward art in this passage is to be ascribed to rhetorical exaggeration. Plotinus is comparing the varieties of human creation to the greatness of the creation of the universal demiurge.

46 *Enneads* 5.8.1: εἰ δ' ἡ τέχνη ὅ ἐστι καὶ ἔχει τοιοῦτον ποιεῖ —καλὸν δὲ ποιεῖ κατὰ λόγον οὗ ποιεῖ—μειζόνως καὶ ἀληθεστέρως καλή ἐστι τὸ κάλλος ἔχουσα τὸ τέχνης, μεῖζον μέντοι καὶ κάλλιον ἢ ὅσον ἐστὶν τῷ ἔξω.

47 A *logos* in Plotinus's system is a force projected from a higher plane of existence, which shapes a reflection of itself on a lower plane. Thus the cosmic mind is a *logos* of the absolute oneness, and the universal soul is a *logos* of the cosmic mind. The *logoi* referred to are presumably the (Platonic) forms or ideas—that is, the transcendent archetypes for the objects of the sensible world.

48 *Enneads* 5.8.1.

49 This does not mean, of course, that content was either lacking in the art of the Classical period or unappreciated by the critics of that period (see chap. 1). And it is also true that formal analyses usually played some role in later criticism, especially in that of the "literary analogists" of the Hellenistic period.

50 We may trace a trend in the same direction in the proem to the *Eikones* of the younger Philostratus, probably a slightly younger contemporary of Plotinus (see especially proem. 5). On the aesthetics of Plotinus and their relationship to the visual arts see André Grabar, "Plotin et les origines de l'esthétique médiéval," *Cahiers Archeologiques* 1 (1945): 15–34; de Keyser, *La signification de l'art dans les Ennéades*, pp. 29–52; Fiametta Vanni Bourbon di Petrella, *Il Problema dell' Arte e della Bellezza in Plotino* (Florence, 1956), pp. 106–21.

CHAPTER 3. RHETORICAL AND LITERARY CRITICISM

1 See Aristotle *Rhetoric* 1402a17; Cicero *Brutus* 46.

2 Diels, *Fragmente*[7], ascribes three fragments to a τέχνη (82B12–14). Mario Untersteiner, *Sofisti, Testimonianze e Frammenti* (Florence, 1961), 2:12–14, prints the same fragments as Diels. Diodorus 12.53.2, says that Gorgias "was the inventor of rhetorical *technai*" (τέχνας ῥητορικὰς πρῶτος ἐξεῦρε); and Diogenes Laertius 8.58, on the authority of Satyrus, says that he was "a man who was preeminent in the art of rhetoric and who bequeathed a *technē* to posterity" (ἄνδρα ὑπερέχοντα ἐν ῥητορικῆι καὶ τέχνην ἀπολελοιπότα). It seems likely to me that τέχνη is to be taken in the latter passage as the title of a treatise. J. W. H. Atkins, writing in *Literary Criticism in Antiquity* (Cambridge, 1934; reprint, Gloucester, Mass., 1961), 1:20, seems to doubt the existence of such a treatise, and in his entry on Gorgias in the first edition of the *Oxford Classical Dictionary* he

flatly denies it.

3 See Suidas, under "Polus."

4 The *Rhetoric* was, in fact, only one of several treatises on the subject by Aristotle, among which was a work called the συναγωγὴ τεχνῶν, which provided a history of rhetorical theory up to his own time. For the fragments of the latter work see Valentin Rose, *Aristotelis qui ferebantur librorum fragmenta* (1886; reprint, Stuttgart, 1967), 23: frags. 136–41.

5 Atkins, *Literary Criticism in Antiquity*, 1: 8–9, 166–67.

6 See J. E. Sandys, *A History of Classical Scholarship* (Cambridge, 1903), pp. 129–30.

7 The earliest preserved record of the "Canon of Ten Orators" is the treatise περὶ τοῦ χαρακτῆρος τῶν δέκα ῥητόρων by the Sicilian rhetorician Caecilius of Calacte, who was active during the reign of Augustus. The remains of this work are edited in the edition of Ernst Ofenloch (Leipzig, 1907), pp. 89–129. The ten "canonical" orators were: Antiphon, Andocides, Lysias, Isocrates, Isaeus, Aeschines, Lycurgus, Demosthenes, Hyperides, and Dinarchus. This canon, as well as the canons of poets and historians, is preserved in two medieval manuscripts, one from Mount Athos, the other in the Bodleian (see Sandys, *A History of Classical Scholarship*, p. 130).

The existence of an Alexandrian canon of poets in the second century B.C. is inferred from Quintilian 10.1.54, where it is pointed out that Apollonius of Rhodes was excluded from the "role drawn up by scholars" (*ordinem a grammaticis datum*) because Aristophanes of Byzantium (ca. 257–180 B.C.) and Aristarchus of Samothrace (ca. 217–143 B.C.), both scholars in the Alexandrian library, did not include contemporary poets in their list. It would not be unreasonable to assume that Aristophanes and Aristarchus also drew up a canon of rhetoricians. Others, however, trace the canon of rhetoricians to Pergamon in the second century B.C.: principally, J. Brzoska, *De Canone decem Oratorum Atticorum* (Breslau, 1883); and, following him, Carl Robert in *Arch. März.* Still others assume that the canon of ten specific authors mentioned above was the invention of Caecilius (e.g. Wilhelm von Christ, Otto Stählin, and Wilhelm Schmid, *Geschichte der Griechischen Litteratur* [Munich, 1920], 2.1.28–29.

The Quintilian passage does seem to indicate that canons existed in the second century B.C. It is not unlikely that there were several in existence, and it may have taken some time for the canons to become canonized.

8 See Dionysius *Isoc.* 3; *Dem.* 50; *Thuc.* 4; *De Dinarcho*, 7; *De Isaeo*, 4; Demetrius *Eloc.* 14. For a summary reference to these sources See Pollitt, *The Art of Greece*, pp. 223–24.

9 In addition to the authors already cited in connection with the *phantasia* theory (see chap. 2, n. 35) add Demetrius *Eloc.* 14; Dionysius *Isoc.* 3.

10 Cicero *Orat.* 9 is the most forceful statement of this idea.

11 Robert, *Arch. März.*, pp. 53 and 73. He follows the ideas of Brzoska, *De Canone decem Oratorum Atticorum.*

12 According to Quintilian 2.15.21 Theodorus held that rhetoric was a τέχνη; to Apollodorus it was an ἐπιστήμη (see Brzoska, in *RE*, under "Apollodorus," no. 64); this perhaps suggests that Theodorus would have been more interested

in the visual arts.

13 Robert proposed that Quintilian's history of painting is exclusively modeled on the canon of ten orators. In fact, Quintilian names eleven painters, but Robert suggests that Polygnotus, who seems somewhat out of place in a sequence that otherwise began with Zeuxis and ended, chronologically speaking, with Apelles, has been added to the canon by Quintilian. See Robert, *Arch. Märch.*, p. 71.

CHAPTER 4. POPULAR CRITICISM

1 The role of imitative realism as a criterion of popular criticism is represented by certain uses of the terms ἀλήθεια, *veritas, similitudo,* and *successus.*

2 Diodorus 4.76.1 ff.; Plato *Meno* 97; Callistratus 8.1; Euripides *Hecuba* 838. See Overbeck, *Schriftquellen,* 119–42.

3 Webster, *Greek Art and Literature,* pp. 176–77.

4 Plutarch *Demosthenes* 31.

5 August Kalkmann, *Die Quellen der Kunstgeschichte des Plinius* (Berlin, 1898), pp. 144–71; H. L. Urlichs, *Griechische Kunstschriftsteller,* pp. 21 ff.; Friedrich Münzer, "Zur Kunstgeschichte des Plinius," *Hermes* 30 (1895): 531 ff.; Sellers, *EPC,* pp. xlvi-lxvii.

6 Kalkmann, *Quellen des Plinius,* p. 244; see chap. 6.

7 Schweitzer, *Philologus* 89 (1934): 290–91.

8 This tradition about Lysippus may have some connection with his apparent interest in the viewer's optical experience of the traditional, formal aspects of sculptural design, such as *symmetria* and *rhythmos.* See the earlier discussion of this topic in chapter 1, esp. note 43.

Eupompus and Lysippus might also have been referring to their break with an earlier teacher-pupil tradition of professional criticism and with the theories and standards that were part of that tradition.

But one may well doubt that Duris and Pliny were aware even of these implications in the remark of Eupompus.

CHAPTER 5. ROMAN VARIANTS

1 Vitruvius 1.1.15.

2 Vitruvius gives a catalog of his sources in 7.praef.12 and 14.

3 Carl Watzinger, "Vitruvstudien," *RhM* 44 (1909): 203–23. Watzinger's interesting article is discussed in detail in the glossary of the unabridged edition in connection with the terms *decor* and *diathesis.*

4 Pietro Tomei, "Appunti sull'Estetica di Vitruvio," *Bollettino del Reale Istituto di Archeologia e Storia dell'Arte* 10 (1943): 57–73.

5 Schlikker, *HV*, pp. 29–33.

6 Tomei suggests that it was Neoptolemus of Parium who formulated the πρέπον-*decor* idea in such a way that it became appealing to Cicero, Horace, and Vitruvius.

7 See glossary of unabridged edition, under *decor.*

8 Note that both Strabo and Dio write in Greek, but mainly for a Roman audience and, in the case of the latter, on a Roman subject. We are again dealing neither

with purely Greek nor with purely Roman thought, but with a thorough blending of the two.

9 I base this possibility, not recognized by Münzer or Schweitzer, on *NH* 34.38. See glossary of the unabridged edition, under *successus* and *audacia*.

10 Münzer, *Hermes* 30 (1895): 499–502; Schweitzer, *Xenokrates*, pp. 41–46. There is no evidence as to who the inventor of the theory was. It might have been Varro or even Pliny himself.

11 For a collection of passages illustrating this development see my *The Art of Rome*, pp. 37–48 and 63–74.

Chapter 6. The Elder Pliny and His Sources

1 Unless the lost writings on art by Democritus were historical in nature.

2 The more notable studies are: Jahn, *UKP*; Adolph Furtwängler, "Plinius und seine Quellen über die bildenden Künste," *Jahrbücher für Klassische Philologie, Supplementband* 9 (1877), reprinted in *Kleine Schriften von Adolf Furtwängler*, ed. Johannes Sieveking and Ludwig Curtius (Munich, 1913) 2: 1–71. Robert, *Arch. Märch.*; Urlichs, *Greichische Kunstschriftsteller*; Münzer, *Hermes* 30 (1895); Kalkmann, *Quellen des Plinius*. Still the best presentation of this material in English is Sellers's introduction to *EPC*. Schweitzer's *Xenokrates*, pp. 1–52, is a basic work not only for the nature of Pliny's sources but for Greek art criticism as a whole. A valuable recent edition of Pliny is that of Silvio Ferri, *Plinio Il Vecchio* (Rome, 1946).

3 See the sources in the previous note. Also Lionello Venturi, *History of Art Criticism* (1936; reprint, New York, 1964), pp. 37–45. Venturi ascribes more of Pliny's material to Xenocrates than I am inclined to.

4 The meaning of τορευτική in Pliny has been debated. It is connected with τόρος (a "borer"), τορός ("piercing"), τείρω ("rub," "bore"), τορεύω ("bore through," "beat") and clearly refers to the art of working the surface of a material with a drill, punch, or hammer, i.e. "chasing." The Latin equivalent of τορευτική is *caelatura*.

Pliny says that the art of τορευτική was first "opened up" (*aperuisse*) by Phidias (*NH* 34.54) and was refined (*erudisse*) by Polyclitus (*NH* 34.55). This has suggested to many scholars that τορευτική in Pliny meant sculpture in general. Jex-Blake, Sellers, Kalkmann, Furtwängler (for bibliography see note 2) were among those who held this opinion. G. M. A. Richter and M. J. Milne, however, have argued from literary evidence that τορευτική in Pliny does not refer to sculpture but rather to the working of small objects—bowls, plates, statuettes, sword hilts—in gold, silver, ivory, and other precious materials. See G. M. A. Richter, *AJA* 45 (1941): 375–83, in connection with a silver phiale in the Metropolitan Museum of Art in New York; and M. J. Milne, "The Use of τορεύω and Related Words," *AJA* 45 (1941): 390–98. Others have held that τορευτική refers to bronze sculpture only (Schweitzer, *Xenokrates*, p. 48) or to chasing as a part of sculpture (Alan Wace, *Approach to Greek Sculpture* [Cambridge, 1935], pp. 7–8).

Although Richter and Milne are correct in saying that *statuaria* and *toreutice*

are not synonyms in Pliny, I believe that they have overstated their case when they suggest that *toreutice* in Pliny refers only to chryselephantine statuary or to the working of small objets d'art. In his analysis of the work of Polyclitus, Pliny mentions several bronze works—the Doryphorus, the Diadoumenus, etc.—but fails to mention his one known chryselephantine statue (the Hera in the Argive Heraeum, see Pausanias 2.17.4). If one assumes that *toreutice* does not refer to bronze sculpture at all, then one must assume that Pliny's phrase *toreuticen sic erudisse, ut Phidias aperuisse* appears in the text completely out of context and has no relationship to any work that Pliny has mentioned in the same paragraph. It seems more reasonable to assume that τορευτική was a particular part of *statuaria* (ἀνδριαντοποιία)—that part which was executed during the assemblage of the pieces of a bronze statue and the chasing of fine details on the surface of these parts. The technique employed in this stage of working bronze sculpture was the same as that employed in chryselephantine sculpture and in the work of smaller objets d'art such as bowls, swords, gems, and so on. On the history of τορευτική in Greek art see chapter 1 of Charles Seltman's *Approach to Greek Art* (London and New York, 1948).

5 The signature of a sculptor Xenocrates the son of Ergophilus has been found on three bases apparently dating from the early third century B.C.—two from Oropus, one from Elateia—and on one of these the sculptor refers to himself as an Athenian. See Loewy, *IgB* 135a,b,c (*IgB* 135a,b = *IG*, VII, 336, 332 from Oropus). If this sculptor is the same as the Xenocrates who was Pliny's source, we are then confronted with an Athenian who was a prominent member of, and spokesman for, the school of Sicyon. This need not be considered remarkable. Apelles, the great painter of the Sicyonian school, was from Cos. At the time of this writing, these inscriptions have not yet appeared in Jean Marcadé's *Receuil des signatures de sculpteurs grecs* (Paris, 1953–).

6 The precise meaning of these terms and phrases are dealt with in chapter 1 and in the glossary under *numerosus*, ῥυθμός, *diligens*, and ἀκρίβεια.

7 The dates given by Pliny in his chronological table (*NH* 34. 49–52) are: Phidias in the 83d Olympiad (448–445 B.C.); Polyclitus, Myron, and Pythagoras in the 90th Olympiad (420–417 B.C.); and Lysippus in the 113th Olympiad (327–324 B.C.). Excepting that of Pythagoras, these dates are within the limits of toleration permitted by the monumental and literary evidence. The pertinent general evidence may be found in the convenient modern handbooks by Richter (*SSG*[4]), Picard, and Lippold. For some more recent evidence, see Erik Sjöquist, *Lysippus: Lectures in Memory of Louise Taft Semple* (Cincinnati, 1966); Alfred Mallwitz and Wolfgang Schiering, *Die Werkstatt des Pheidias in Olympia*, ed. E. Kunze (Olympische Forschungen, vol. 5 [Berlin, 1964], pp. 272–77).

The hypothesis that there was only one Early Classical sculptor named Pythagoras, not two (Pythagoras the Rhegian and Pythagoras the Samian being identical), raises many complex questions and has already been examined in chapter 1, note 23.

The date to be assigned to Pythagoras (or to the two sculptors of that name, since there is no chronological distinction between them) is derived from the

Olympiads in which the different athletes of whom he (they) made statues were victorious. The earliest date possible is 488 B.C., the time of the first victory of the runner Astylus of Croton (see Pausanias 6.13.1; Pliny *NH* 34.59). The latest date would be 448 to 436 B.C. (the latter being the *very* latest), when Cratisthenes of Cyrene was victorious with a four-horse chariot (Pausanias 6.18.1). These dates are deduced from the fact that the list of Olympic victors in one of the Oxyrhynchus Papyri supplies other names for the preceding and following years. See B. P. Grenfell and A. S. Hunt, *Oxyrhynchus Papyri*, II (London, 1899), CCXXII, pp. 85–95; also Carl Robert, "Olympische Sieger," *Hermes* 35 (1900): 141–95, esp. 164 ff. Other secure dates exist for: the boxer Euthymus, who was victorious in 484, 476, and 472 (Pausanias 6.6.4; the last two also listed on the papyrus), Mnaseas of Cyrene in the armed footrace (Pausanias 6.13.7 and the papyrus) in 456 B.C., and Leontiscus of Messina in wrestling in 456 and 452 (Pausanias 6.4.3–4 and the papyrus). The statues of the runner Dromeus of Stymphalus (Pausanias 6.7.10) and Protolaus of Mantineia, who won in the boys' boxing matches (Pausanias 6.6.1), must have been very early or very late works, since no suitable place for them can be found in the Olympic lists in the 470s through the 450s.

While the earliest of these dates are to some extent problematical, there can be little doubt that Pythagoras's main period of activity fell between ca. 485 and 445 B.C. Unless one wishes to conjure up the wraith of still another Pythagoras, the best thing to do with Pliny's date of 420 B.C. for Pythagoras (*NH* 34.50) is simply to ignore it. This is by no means the only questionable point in Pliny's chronology. He places Critius, Nesiotes, and Alcamenes in the 83d Olympiad (448 B.C.) and Scopas in the 90th (420 B.C.).

A general summary of the material available for dating Pythagoras's votive statues of athletes may be found in Henri Lechat, *Pythagoras de Rhégion* (Lyon and Paris, 1905), pp. 9–19.

8 Pliny defines κατάγραφα as *obliquae imagines* (35.56). He does not give a date for Cimon, but an epigram of Simonides (*Anth. Pal.* 9.758) refers to a painter named Cimon as a co-worker with another painter named Dionysius. The latter is probably Dionysius of Colophon, who appears to have been a contemporary of Polygnotus (Aelian *VH* 4.3; Aristotle *Poetics* 1448a5). This evidence may imply that Cimon's career partly overlapped with that of Polygnotus. His *floruit* should perhaps be put in the first decade of the fifth century. See Brunn, *GGK²*, 2: 7–8. The achievement that Pliny attributes to Cimon is undoubtedly reflected in the experimentation with foreshortened figures in early Attic red-figure vase painting. See G. M. A. Richter, *Attic Red-figure Vases*, 2d ed. (New Haven, 1958), pp. 38–46.

9 . . . *Polygnotus Thasius, qui primus mulieres tralucida veste pinxit, capita earum mitris versicoloribus operuit plurimumque picturae primus contulit, siquidem instituit os adaperire, dentes ostendere, voltum ab antiquo rigore variare* (*NH* 35.58).

10 Note that the same metaphor is used in connection with Phidias, who, like Apollodorus, "opened up" an art, which was then refined by his successor.

11 On Antigonus see Ulrich von Wilamowitz-Moellendorff, "Antigonos von Karystos," *Philologische Untersuchungen*, no. 4 (Berlin, 1881).

12 For a convenient summary of the important points about Antigonus see pp. xxxvi-xlv of Sellers's introduction to *EPC*. At least one passage, Pliny *NH* 35.98, on the painter Aristides—*primus animum pinxit et sensus hominis expressit, quae vocant Graeci ἦθη*—is presented in the Xenocratic formula but does not seem to reflect Xenocrates' own criticism. This passage should perhaps be attributed directly to Antigonus. See commentaries in glossary under *animum et sensus pingere* and ἦθος καὶ πάθος.

13 Pausanias notes that Menaechmus and his colleague Soidas were active not much later than Canachus and Callon, who are datable to the late Archaic period.

14 The sources are collected in Felix Jacoby, *FGrHist* (Berlin, 1926), 2A.76. On the character of Duris's writings about art see Kalkmann, *Quellen des Plinius*, pp. 144 ff.; Sellers, *EPC*, pp. xlvi-lxvii. Duris's veracity is challenged by Plutarch *Pericles* 28.3 (Δοῦρις μὲν οὖν οὐδ'. . . . εἰωθὼς κρατεῖν τὴν διήγησιν ἐπὶ τῆς ἀληθείας).

15 He made an ivory image of Jupiter for Metellus's temple in the Campus Martius (probably the temple of Jupiter *Stator* within the *Porticus Metelli*) and was once nearly attacked by a panther while making engravings of caged African animals in the dockyards (*NH* 36.39). He also made a silver plate illustrating the story of the birth of the actor Roscius (Cicero, *Div.* 1.36.76). On Pasiteles and his school in general, see Maurizio Borda, *La Scuola di Pasiteles* (Bari, 1953).

16 On the Stephanus youth see *Br Br*, pl. 301; Richter, *SSG*⁴, fig. 851. The figure may represent Orestes. Another copy of it, associated with a figure of a young girl (Electra?), is in Naples; and still another, associated with another youth (Pylades?), is in the Louvre. See Margarete Bieber, *The Sculpture of the Hellenistic Age*, 2d ed. (New York, 1961), figs. 784–86. On the group by Menelaus see Richter, *SSG*⁴, fig. 775; Bieber, *The Sculpture of the Hellenistic Age*, figs. 787–88.

17 The Stephanus youth, in the opinion of Richter, is "derived from a work of the early classical epoch of the second quarter of the fifth century B.C."; see *SSG*⁴, p. 140. All the works in question appear to be free renderings of Classical prototypes rather than copies in the strict sense.

18 G. M. A. Richter, *Ancient Italy* (Ann Arbor, Mich., 1955), pp. 112–16.

19 Karl Reinhardt, "Hekataios von Abdera und Demokrit," *Hermes* 47 (1912): 492–513, has suggested that the theory of cultural evolution found in the fifth book of the *De Rerum Natura* of Lucretius and also implicit in the history of Egypt given in book 1 of Diodorus Siculus are derived from the Μικρὸς Διάκοσμος of Democritus. Schweitzer has expanded on Reinhardt's idea by suggesting that Democritus was the first writer to theorize about the place of art in cultural evolution, and that the conception of Daedalus as the first great artist in the Greek world stemmed from Democritus's writings on art. The importance of Daedalus in Diodorus 1.97 ff. (τὸν τε ῥυθμὸν τῶν ἀρχαίων κατ' Αἴγυπτον ἀνδριάντων τὸν αὐτὸν εἶναι τοῖς ὑπὸ Δαιδάλου κατασκευασθεῖσι παρὰ τοῖς ῞Ελλησι) is probably a result, according to Schweitzer, of the inclusion of Democritus's cultural theory in the Αἰγυπτιακά of Hecataeus of Abdera, one of Diodorus's sources; see Diodorus 1.47. (The connection of Hecataeus with Democritus had already been suggested by Reinhardt.) See Schweitzer, *Xenokrates*, p. 26. The ideas are attractive but admittedly purely hypothetical.

Reinhardt's theory has been subjected to a critical evaluation by Walter Spoerri, *Späthellenistische Berichte über Welt, Kultur, und Götter* (Basel, 1959), pp. 132–63, especially pp. 162–63. Spoerri sees Diodorus's book as a general assemblage of diverse theories current in his own time and doubts that it stands in a direct line of descent from Democritus. Thomas Cole, *Democritus and the Sources of Greek Anthropology*, A.P.A. Philological Monographs, no. 25 (1967), reaffirms Diodorus's dependence on Democritus but sees the "Entstehungsgeschichte" as far more complex than Reinhardt had supposed.

20 Heliodorus is mentioned in the indexes to books 33–35; Metrodorus, in the index to book 35; and Juba, in the indexes to books 33 and 36. The Metrodorus who wrote on architecture seems to be distinct from Metrodorus of Scepsis (late second/early first century B.C.), whom Pliny refers to in the index to book 34 simply as "Metrodoro Scepsio."

21 See Athenaeus 45C, 229E, 406C.

22 Jacoby, *FGrHist* 3A (1940), pp. 127–55.

23 Harpocration, under "Parrhasius" and "Polygnotos"; Photios *Bibliotheca* 103a.

24 See, for example, *NH* 33.155 (on Mentor); 34.56 (on Polyclitus); 35.154 (on the temple of Ceres in Rome); 35.155 (on Possis and Arcesilaus); 35.156–57 (on Pasiteles); 36.17 (on the Nemesis of Agoracritus); 36.41 (on statues in Rome); 37.11 (on gems). Varro's name also appears in each of the indexes for books 33–36.

25 See Kalkmann, *Quellen des Plinius*, pp. 86–89. The liberal arts examined were apparently grammar, dialectic, rhetoric, geometry, arithmetic, astronomy, music, medicine, and architecture.

26 Vitruvius 1.1.15.

27 See the introduction to my *The Art of Rome*, p. xx; an assessment of Pliny's other Roman sources is also given in this introduction.

CHAPTER 7. QUINTILIAN AND CICERO

1 I omit any historical analysis of what Cicero says about painting in this chapter because his remarks are so brief, offhand, and jumbled that it would be unwise to base any serious conclusions on them. Cicero refers to an early phase of painting in which Zeuxis, Polygnotus, and Timanthes restricted themselves to the use of only four colors but were renowned for their fine draftsmanship; this was followed by a second stage in which Aetion, Nicomachus, Protogenes, and Apelles brought the art to a stage of perfection. Pliny, however, tells us that the four-color painters were Apelles, Aetion, Melanthius, and Nicomachus and states specifically what the four colors were and what they were made from (*NH* 35.50). Pliny's statement seems more authoritative. All the painters whom he mentions belong to the fourth century B.C. and hence to a very sophisticated stage of Greek painting. Since the original of the Alexander mosaic in Naples—generally assumed to be a painting by a master of the late fourth century—seems to have been a highly sophisticated four-color painting, there is also archaeological evidence in support of Pliny. Cicero's assumption that four-color painting was a primitive limitation of early Greek painting seems to be erroneous, as is his

uncritical lumping together of Polygnotus (second quarter of the fifth century), Zeuxis (late fifth–early fourth centuries), and Timanthes (early fourth century) as "early" painters. I have the impression that Cicero's remarks about the four-color painters are about as precise as that of a modern speaker might be if, as a reaction to abstract art, he were to say, "Give me the old-time representational painters like Giotto, Michelangelo, Leonardo, and Rembrandt." In other words, Cicero gropes for a few famous names to illustrate a point and is not really giving much attention to the dates and relationship of the artists he names.

As a basic reference to the Alexander mosaic see Bernhard Andreae, *Das Alexandermosaik* (Bremen, 1959); for a color illustration: Amadeo Maiuri, *Roman Painting* (Geneva, 1953), p. 69.

Vincent J. Bruno, *Form and Color in Greek Painting* (Ph. D. diss., Columbia University, 1969, available on microfilm), chaps. 2–4, has recently proposed that the four-color theory is connected with a doctrine of primary colors developed by Democritus and Empedocles, that it did probably exist in the Early Classical period, and that Cicero's ascription of it to Polygnotus is accurate. He suggests that all painters from Polygnotus to Apelles were "four-color painters." This interpretation seems to me to negate the basic point of Cicero's remarks—that there was an immature and a developed stage in painting just as in rhetoric. Bruno's technical analysis of what four-color painting may have involved (in particular, his suggestion that Pliny's black *atramentum* may have been a dark blue used both as a toning and coloring agent) is, however, of great value.

2 The concept of spiritual intuition—*phantasia*—has already been discussed in chap. 2 See also under *phantasia* in the glossary. In *Orat.* 9, Cicero says of Phidias: *Nec vero ille artifex cum faceret Iovis formam aut Minervae, contemplabatur aliquem e quo similitudinem duceret, sed ipsius in mente insidebat species pulchritudinis eximia quaedam, quam intuens in eaque defixus ad illius similitudinem artem et manum dirigebat.* See also glossary under *pulchritudo.*

3 As is implied not only by Quintilian's statement that the Zeus and Athena *adiecisse aliquid etiam receptae religioni videtur; adeo maiestas operis deum aequavit* (*Inst.* 12.10.9) but also by Dio Chrysostom's Twelfth or "Olympian" oration, where the Zeus is said to have had the power to bring peace to a troubled soul (Dio Chrysostom 12.50–52).

111

Glossary

In this glossary the principal terms of Greek art criticism and the Latin terms that were used, at least at times, to translate the Greek terminology are examined. Under each term the relevant ancient testimonia are listed in chronological order. Authors who were virtually contemporary are listed in alphabetical order.

The English translation appended to each ancient passage is intended to be of help to the nonclassicist and also, when necessary, to provide an explanatory context for the passage under consideration. The translations are not intended as definitive statements of my opinion about the meaning of the term in question. In some passages there may be several possible shades of meaning, and the correct one is not always obvious. These shades of meaning, as well as other problems, are examined in the commentaries that follow each series of testimonia. It will be seen that I have seldom resisted the temptation to speculate about the terms, but I have also tried to do justice to other interpretations than my own and to make sure that the raw materials—that is the texts—are presented with sufficient objectivity so that each reader may draw his own conclusions. Some passages may contain more than one important term and are therefore repeated under different headings. In most cases the text and the English translation are given only once, and cross references are provided elsewhere; but in a few cases I have repeated small phrases of text in order to give the reader a quick reminder of the passage which is under discussion.

Most of the terms listed are "critical" in the strict sense, that is, they signify or are related to standards on the basis of which value judgments were made about art. A few, however, like παράδειγμα, are not strictly critical but are so closely bound up with conceptions of how works of art are produced and perceived (analogous to τέχνη and μίμησις examined in the text

113

[chap.2]) that they seemed to me to deserve a place in a work on criticism. One term, τύπος, lacks, in my opinion, even this tangential relationship to criticism, but since many modern writers have assumed that this relationship exists, I have included a summary catalog of the passages in which the word is used and an assessment of the different proposals as to its meaning.

If my decision to list the terms of this glossary in alphabetical order seems unimaginative, I would plead that it is the most efficient in view of the disparate and often inconsistent nature of the testimonia. An attempt, for example, to assemble all the terms that deal with color in painting under a single heading would be defeated by the fact that a number of important terms belonging to this category, for example, ἁρμογή and *austerus*, are also used, with rather different meanings, in connection with sculpture. The reader who, in spite of the inevitable duplication and overlapping, would prefer to examine the glossary along categorical lines, might, however, find the following divisions to be of some help.

A. The Nature and Methods of Artistic Representation
 1. General: ἀλήθεια (*veritas*), ὁμοιότης, παράδειγμα, τύπος, φαντασία, *exemplum, similitudo, species, successus*
 2. Painting: σκιαγραφία, σκηνογραφία, *compendiaria, lumen et umbra, species, splendor*

B. The Nature of the Artist
 1. His perception and attitude: ἀρετή, φαντασία, χάρις, *docilis, ingenium*
 2. Individual styles: ἀρετή, χάρις, *concinnus, cothurnus, cura, durus, elegantia, gratia, gravitas, iucundus, severus, sollers* (see also C.5)
 3. His technique and skill: εὐστοχία, τόλμα, *audacia, cura, diligens, facilitas, ingenium, labor, ostentatio, sollers*
 4. His reputation: ἔνδοξος, *auctoritas, dignitas, docilis, gloria, ingenium, nobilis*

C. The Nature of the Work of Art
 1. Properties of form and composition: ἀκρίβεια, ἁρμογή, ἁρμονία, διάθεσις, εὐρυθμία, λεπτός, πρέπον, ῥυθμός, συμμετρία, σχῆμα, τέλειος τετράγωνος-*quadratus, concinnus, constantia, decor, diligens, dispositio, exilis, forma, gracilis, grandis, numerus, perfectus, siccus*
 2. Finish and detail: ἀκρίβεια, εὐστοχία, τέλειος, *absolutus, consummatus, cura, diligens, labor, numerus, perfectus, subtilitas*
 3. Color and draftsmanship: ἀνθηρός, ἁρμογή, ῥῶπος, τόνος, *austerus, claritas, durus, floridus, iucundus, lineamenta, severus, simplex*
 4. Subject matter: αὐθάδεια, ἦθος καὶ πάθος, ῥῶπος, σκληρός, *animum et sensus pingere, cothurnus.*
 5. General qualities of style: τὸ ἀξιωματικόν, ἀρχαῖος, εὐσταλής, εὐσχημ-

114

οσύνη, κάλλος, λεπτός, μεγαλοπρεπής, μέγεθος, πολυτέλεια, πρέπον, σεμνός, σκλμρός, auctoritas, austerus, constantia, cothurnus, decor, durus, elegantia, emendatus, firmitas, gratia, gravitas, iucundus, magnificus, maiestas, liquidus, mollis, pondus, pulcher, rigor, severus, subtilitas, venustas, vetustas

6. Value and reputation of works of art (general): θαυμαστός, πολυτέλεια, claritas, dignus, firmitas, gloria, mirabilis, nobilis

In the commentaries that follow the testimonia I have sometimes ascribed ideas and terms to "Xenocrates, the Xenocratic tradition," and "the *phantasia* theory." The theories about the development of ancient art to which these phrases refer have been described in chapters 2 and 6. That these theories existed in antiquity is beyond doubt, since they survive in extant texts. On the other hand, the proposals I have made about their date, the personalities connected with them, and the milieu of their formulation are obviously hypothetical. If I have sometimes said simply "Xenocrates" rather than "the author of the evolutionary theory of the development of painting and sculpture as preserved by Pliny," it has been principally in the interest of verbal economy. Except in cases where Pliny directly cites Xenocrates as his source or where the text makes it clear that I am dealing with a hypothesis, I have normally put "Xenocrates" in quotation marks in order to emphasize that, however reasonable it may be, the association of his name with the evolutionary theory is only a matter of conjecture. Similarly, for those who may be skeptical about its connection with the Middle Stoa, "*phantasia* theory" may be taken simply as a conventional label.

The apparatus criticus for the Greek and Latin passages in the glossary is confined to variant readings of the critical term under discussion and/or to other variants which seriously affect the meaning of a passage. The apparatus has been adapted from the following editions:

Aristotle. *Poetics*. Edited by Johannes Vahlen. Leipzig, 1885.
_____. *Poetics*. Edited by D. W. Lucas. Oxford, 1968.
Athenaeus. Edited by Georg Kaibel. Leipzig, 1887–1905.
Callistratus. Edited by Karl Schenkl and Emil Reisch. Leipzig, 1902.
_____. Edited by Arthur Fairbanks. London and New York, 1933.
Cicero. *Inv. Rhet.* Edited by Eduard Stroebel. Leipzig, 1915.
_____. *Orator*. Edited by P. Reis. Leipzig. 1932.
Dio Chrysostom. Edited by Guy de Budé. Leipzig, 1919.
_____. Edited by J. W. Cahoon. London and New York, 1932.
Diodorus Siculus. Edited by Friedrich Vogel and C. T. Fischer. Leipzig, 1888–1906.
Heliodorus. Edited by R. M. Rattenbury and T. W. Lumb. Paris, 1938.
Lucian. *Zeuxis*. Edited by K. Killburn. London and Cambridge, Mass.,

1959.

Plato. *Sophist*. Edited by John Burnet. Oxford, 1900.

Pliny. *NH*. Edited by K. F. T. Mayhoff. Leipzig, 1897; reissued Stuttgart, 1967.

Thucydides. Edited by Henry Stuart Jones and J. E. Powell. Oxford, 1942.

Vitruvius. Edited by Valentin Rose. Leipzig, 1898.

_____. Edited by Friedrich Krohn. Leipzig, 1912.

_____. Edited by Frank Granger. London and New York, 1931.

_____. Edited by Silvio Ferri. Rome, 1960.

ἀκρίβεια (akribeia)

1. Aristotle *Eth. Nic.* 1141a9.

> τὴν δὲ σοφίαν ἔν τε ταῖς τέχναις τοῖς ἀκριβεστάτοις τὰς τέχνας ἀποδ-
> ίδομεν, οἷον Φειδίαν λιθουργὸν σοφὸν καὶ Πολύκλειτον ἀνδριαντοποιόν,
> ἐνταῦθα μὲν οὖν οὐδὲν ἄλλο σημαίνοντες τὴν σοφίαν ἢ ὅτι ἀρετὴ τέχνης
> ἐστίν.

We apply the word *sophia* in the arts to those men who are most precise
[or "most skilled"] in respect to the arts, like Phidias the stonecarver
and Polyclitus the maker of statues, meaning by *sophia*, in this instance,
nothing other than excellence in art.

2. Aristotle *Rh.* 1414a7.

> Ἡ μὲν οὖν δημηγορικὴ λέξις καὶ παντελῶς ἔοικε τῇ σκιαγραφίᾳ. ὅσῳ
> γὰρ ἂν πλείων ᾖ ὁ ὄχλος, πορρωτέρω ἡ θέα, διὸ τὰ ἀκριβῆ περίεργα καὶ
> χείρω φαίνεται ἐν ἀμφότεροις.

The deliberative style [of rhetoric] is exactly like a sketch employing
shading; for the greater the crowd, the farther away the view; conse-
quently, as a result of both conditions, precise details appear to be
beside the point and even a disadvantage.

3. Dionysius of Halicarnassus *Ant. Rom.* 16.3.6. See ῥῶπος, ῥωπογραφιά,
passage 3.

4. Dionysius of Halicarnassus *Comp.· Verb.* 25 (ed. Roberts, p. 266). See
εὐστοχία, passage 1.

5. Demetrius *Eloc.* 14. See ἀρχαῖος, passage 4.

6. Dio Chrysostom *Or.* 12.44.

> λέγω δὲ γραφέων τε καὶ ἀνδριαντοποιῶν καὶ λιθοξόων καὶ παντὸς
> ἁπλῶς τοῦ καταξιώσαντος αὑτὸν ἀποφῆναι μιμητὴν διὰ τέχνης τῆς
> δαιμονίας φύσεως, εἴτε σκιαγραφίᾳ μάλα ἀσθενεῖ καὶ ἀπατηλῇ, πρὸς
> ὄψιν, εἴτε* χρωμάτων μίξει καὶ γραμμῆς ὅρῳ σχεδὸν τὸ ἀκριβέστατον
> περιλαμβάνουσης...

*εἴτε add. Capps.

[Among those who have fostered human conceptions of the divine are
those who practice the visual arts,] I mean the painters and statue

117

makers and carvers of stone and, in short, anyone who has felt himself worthy of appearing as an imitator of the divine nature through art, either through shading, which is weak and deceptive to the vision, or through the mixing of colors and the application of a distinct outline which approaches being the most precise [of all].

7. Dio Chrysostom *Or.* 12.56.

καὶ ὅσα μὲν λιθοξόων ἔργα ἢ γραφέων ἀρχαιότερα τῆς ἐμῆς τέχνης σύμφωνα ἦσαν, πλὴν ὅσον κατὰ τὴν ἀκρίβειαν τῆς ποιήσεως, ἐῶ λέγειν.

And all the works of sculptors or painters which were earlier than my [Phidias's] own art but in harmony with it except in regard to precision of workmanship, these I forgo mentioning.

8. Plutarch *Pericles* 13.2.

ἡ γὰρ ἐν τῷ ποιεῖν εὐχέρεια καὶ ταχύτης οὐκ ἐντίθησι βάρος ἔργῳ μόνιμον, οὐδὲ κάλλους ἀκρίβειαν.

[Zeuxis's comment on the painting of Agatharchus:] For facility of hand and quickness in an artist's work do not endow it with profound permanence nor with perfection of beauty.

9. Galen *De Temperamentis* 1.9.

καὶ πού τις ἀνδριὰς ἐπαινεῖται, Πολυκλείτου κανὼν ὀνομαζόμενος, ἐκ τοῦ πάντων τῶν μορίων ἀκριβῆ τὴν πρὸς ἄλληλα συμμετρίαν ἔχειν ὀνόματος τοιούτου τυχών.

[In creating beautiful works, all artists search for a measured mean between extremes,] and in this regard, I believe, a certain statue is also praised, the one by Polyclitus named the *Canon*, which happened to get such a name from the fact that it has an exact commensurability of all the parts to one another.

10. (Pseudo-) Lucian *Am.* 14.

τῶν δὲ τοῖς ἰσχίοις ἐνεσφραγισμένων ἐξ ἑκατέρων τύπων, οὐκ ἂν εἴποι τις ὡς ἡδὺς ὁ γέλως. μηροῦ τε καὶ κνήμης ἐπ᾽ εὐθὺ τεταμένης ἄχρι ποδὸς ἠκριβωμένοι ῥυθμοί.

[An Athenian expatiates on the charms of Praxiteles' Aphrodite of Cnidus:] How neatly wrought are the shapes of the thigh and the ankle as they extend downward to the foot!

11. Lucian *D. Mort.* 24.1.

Μαυσ.: Τὸ δὲ μέγιστον ὅτι ἐν ῾Αλικαρνασσῷ μνῆμα παμμέγεθες ἔχω ἐπικείμενον, ἡλίκον οὐκ ἄλλος νεκρός, ἀλλ᾽ οὐδὲ οὕτως ἐς κάλλος ἐξεσκημένον, ἵππων καὶ ἀνδρῶν ἐς τὸ ἀκριβέστατον εἰκασμένων λίθου τοῦ καλλίστου, οἷον οὐδὲ νέων εὕροι τις ἂν ῥᾳδίως.

Mausolus: Most important of all [I am proud] because I have a huge tomb resting over me; no other deceased person has one comparable to it in size, nor one which is so beautifully decked out, decorated as it is with representations of horses and men, executed with the utmost exactitude in extremely beautiful stone; one would not easily find even a temple to compare with it.

12. Lucian *J. Tr.* 11.

Κολοσσ.: καὶ πρόσεστιν ἡ τέχνη, καὶ τῆς ἐργασίας τὸ ἀκριβὲς ἐν μεγέθει τοσούτῳ.

Colossus of Rhodes: There is art [in me] and precision of workmanship, even with my great size.

13. Lucian *Phal.* 1.11.

οὗτος... κατασκευάσας τὸν βοῦν ἧκέ μοι κομίζων κάλλιστον ἰδεῖν καὶ πρὸς τὸ ἀκριβέστατον τὸν εἰκασμένον.

This man [Perilaus] . . . wrought a statue of a bull and came bearing it to me, a statue which was exceedingly beautiful to look upon and a likeness of the greatest exactitude.

14. Lucian *Pr. Im.* 11. See ἀλήθεια-veritas, passage 5.

15. Lucian *Pro Merc. Cond.* 42.

ἡδέως μὲν οὖν ᾽Απελλοῦ τινος ἢ Παρρασίου ἢ ᾽Αετίωνος ἢ καὶ Εὐφράνορος ἂν ἐδεήθην ἐπὶ τὴν γραφήν. ἐπεὶ δὲ ἄπορον νῦν εὑρεῖν τινα οὕτως γενναῖον καὶ ἀκριβῆ τὴν τέχνην, φίλην ὡς οἷόν τέ σοι ἐπιδείξω τὴν εἰκόνα.

I would gladly have retained some Apelles or Parrhasius or Aëtion or Euphranor for the painting [an imaginary picture illustrating what a salaried post in an aristocratic house is like], but since it is now impossible to find anyone so noble and exact in his art as they, I will describe the picture to you as far as possible in simple prose.

119

ἀκρίβεια (akribeia)

16. Lucian *Rh. Pr.* 9. See σκληρός, passage 1.

17. Lucian *Salt.* 75.

τὸ δὲ σῶμα κατὰ τὸν Πολυκλείτου κανόνα ἤδη ἐπιδείξειν μοι δοκῶ. μήτε γὰρ ὑψηλὸς ἄγαν ἔστω καὶ πέρα τοῦ μετρίου ἐπιμήκης, μήτε ταπεινὸς καὶ ναννώδης τὴν φύσιν, ἀλλ' ἔμμετρος ἀκριβῶς.

And now I think I should demonstrate how his [the ideal dancer's] body is in accord with the *Canon* of Polyclitus. Let it be neither too tall nor lanky beyond proper measure; nor should it be short and stunted in its nature, but just precisely measured.

18. Lucian *Zeux.* 3–7.

a. Sec. 3.

. . . καί τι ἀλλόκοτον ἂν καὶ ξένον ἐπινοήσας, ἐπ'ἐκείνῳ τὴν ἀκρίβεια τῆς τέχνης ἐπεδείκνυτο.

[On the Centaur Family of Zeuxis:] . . . and whatever he conceived of that was unusual or strange, he demonstrated the precision of his art by representing it.

b. Sec. 5.

οἷον τὸ ἀποτεῖναι τὰς γραμμὰς ἐς τὸ εὐθύτατον καὶ τῶν χρωμάτων ἀκριβῆ τὴν κρᾶσιν.

[Technical achievements in painting] such as great exactitude in lines and the precise mixing of colors.

c. Sec. 7.

ὡς ἐν παρέργῳ τίθεσθαι τὴν ἀκρίβειαν τῶν πραγμάτων. . . . τῶν δὲ αὖ φώτων* εἰ καλῶς ἔχει καὶ κατὰ τὴν τέχνην, οὐ πολὺν ποιοῦνται λόγον, ἀλλὰ παρευδοκιμεῖ τὴν ἀκρίβειαν τῶν ἔργων ἡ τῆς ὑποθέσεως καινοτομία

*τῶν δ'ἐφ' ὅτῳ N.

[Zeuxis saw that his novel subject matter distracted people and] that the precision of the details was treated as something secondary. [He thus withdrew the work from public scrutiny, complaining that, as far as his rendering·of the effects of light was concerned, the spectators] did not seem to think it of much importance whether it was well done and done with art or not; rather, the new-fangled nature of the subject was valued above the precision of the artistic achievements.

19. Pausanias 3. 18.10. For reference: idiomatic use of ἐπ᾿ ἀκριβές.

20. Pausanias 4.31.6.

. . . ἄγαλμα Μητρὸς θεῶν, λίθου Παρίου, Δαμοφῶντος δὲ ἔργον, ὃς καὶ τὸν Δία ἐν Ὀλυμπίᾳ, διεστηκότος ἤδη τοῦ ἐλέφαντος, συνήρμοσεν ἐς τὸ ἀκριβέστατον.

. . . an image of the Mother of the Gods in Parian marble [at Messene], the work of Damophon, who also made new joins with the utmost precision in the Zeus at Olympia after its ivory had split.

21. Pausanias 10.38.6.

ἐδήλωσα δὲ ἐν τοῖς προτέροις τοῦ λόγου, Σαμίους Ῥοῖκον Φιλαίου καὶ Θεώδωρον Τηλεκλέους εἶναι τοὺς εὑρόντας χαλκὸν ἐς τὸ ἀκριβέστατον τῆξαι. καὶ ἐχώνευσαν οὗτοι πρῶτοι.

I have shown in the earlier part of my narrative that the Samians Rhoecus, the son of Philaeus, and Theodorus, the son of Telecles, were the discoverers of the technique of smelting bronze with the utmost precision. And these artists were also the first to cast bronze.

22. Aelian VH 4.3.

Πολύγνωτος ὁ Θάσιος καὶ Διονύσιος ὁ Κολοφώνιος γραφέε ἤστην. Καὶ ὁ μὲν Πολύγνωτος ἔγραφε τὰ μεγάλα, καὶ ἐν τοῖς τελείοις εἰργάζετο τὰ ἄθλα. τὰ τοῦ Διονυσίου, πλὴν τοῦ μεγέθους, τὴν τοῦ Πολυγλώτου τέχνην ἐμιμεῖτο εἰς τὴν ἀκρίβειαν, πάθος καὶ ἦθος καὶ σχημάτων χρῆσιν, ἱματίων λεπτότητας, καὶ τὰ λοιπά.

Polygnotus the Thasian and Dionysius of Colophon were both painters. Polygnotus painted large scenes [subjects?] and executed his works with perfect details [?]. The works of Dionysius, except in the case of size, imitate the art of Polygnotus in its precision, expression of emotion and character, use of patterns of composition, the lightness of the drapery, and the like.

23. Themistius Orationes 34.11.40 (Overbeck, Schriftquellen, 1052).

οὐδὲ γὰρ ἄλλης τέχνης οὐδεμιᾶς τὸ πλῆθος τῶν ἔργων ἐπιζητοῦμεν, ἀλλὰ τὸ κάλλος καὶ τὴν ἀκρίβειαν. καὶ τὸν Φειδίαν τεθαύμακα ἐπὶ τῷ Διὶ τῷ Πισαίῳ, καὶ τὸν Πολύγνωτον ἐπὶ τῇ Λέσχῃ καὶ τὸν Μύρωνα ἐφ᾿ ἑνὶ βοιδίῳ.

ἀκρίβεια (akribeia)

> Nor in any other art do we pay attention to the number of works but rather to the beauty and precision [of individual works]. And thus I have marveled at Phidias for his Zeus at Pisa and at Polygnotus for his [paintings in the] clubhouse [of the Cnidians at Delphi] and at Myron for his heifer.

24. *Suidas*, s.v. Ἀγαλματοποιοί.

> ... οὗτοι ἀκριβεῖς. Λύσιππος, Πολύκλειτος, Φειδίας.

Image makers . . . the following were exacting artists: Lysippus, Polyclitus, Phidias.

Commentary

The term ἀκρίβεια (adjective ἀκριβής) is apparently connected with ἀκίς, "a pointed object," and ἄκρον, "peak" or "point." Ἀκρίβεια first appears in extant Greek literature in the second half of the fifth century and has the general meaning of "precision," "detail," "exactitude." Thucydides, in explaining the problem of recording speeches made during the Peloponnesian War, observes: χαλεπὸν τὴν ἀκρίβειαν αὐτὴν τῶν λεχθέντων διαμνημονεῦσαι... (1.22). Ἀκρίβεια is perhaps best translated here as "exact form." In the same paragraph he also states that it was his policy, in studying the events of the war, to investigate each event ὅσον δυνατὸν ἀκριβείᾳ, "with the greatest possible throughness." In the *Clouds* of Aristophanes, Strepsiades bewails his inability to learn the λόγων ἀκριβῶν σκινδαλάμους, "the hairsplitting quibbles of precise discourses." In the fourth century ἀκρίβεια was generally used to refer to the "fine points"[1] or "punctiliousness"[2] in anything.

As the size of the catalog of passages listed here shows, ἀκρίβεια was one of the most widely used terms in Greek art criticism. The Latin translation of the term appears to have been *diligentia* (see *diligens*), and in evaluating the significance of the critical principle represented by ἀκρίβεια and ἀκριβής, the passages in which *diligentia* and *diligens* are used are of considerable importance.[3]

When applied to the arts ἀκρίβεια and ἀκριβής have several subtle shades of meaning and association, but the basis of all of these variations is always

1. Aristotle *Pol.* 1331a2, concerning the development of seige machinery.
2. Plato *Laws* 844B, concerning the preservation of water.
3. The translation of ἀκρίβεια by *diligens* was suggested by Robert, *Arch. März.*, p. 32, and is adopted by Schweitzer and others.

122

the fundamental idea of "precision" or "exactitude." The different uses of the term can be broken down into a number of basic categories:

A. *Applied to artists* (passages 1, 15, 24). The significance of Aristotle's observation in passage 1 is discussed in connection with τέχνη. Here ἀκριβεστάτοις would seem to imply a high degree of control over the theoretical bases of sculpture and over the techniques involved in applying them in practice. As used by Lucian (passage 15) and in the very late reference from the *Suidas* lexicon (passage 24) the term is used so loosely that it might almost be translated simply as "good" or "capable."

B. *"Exactitude" in general* (passages 4, 7, 23). Perhaps all of these passages imply in particular "attention to minute detail," which is clearly the case with Dionysius's use of the term in passage 4.

C. *Applied to painting* (passages 2, 3, 6, 8, 18, 22). In painting ἀκρίβεια was recognized most distinctly in draftsmanship, that is, the drawing of lines (passage 3), and in the preparation and application of colors (passage 18b). Its association with precision in drawing lines seems particularly strong, since in two of our passages (2 and 6) work which was ἀκριβής was contrasted with σκιαγραφία (q. v), that is, painting in which variations of light and shade were apparently of more importance than outline. In a somewhat similar manner, Zeuxis's ἀκρίβεια is contrasted with the signs of haste (perhaps "sketchiness") which Agatharchus's work is said to have shown. In this case, however, ἀκρίβεια must imply "care" and "diligence" more than linear exactitude, since Zeuxis was famed for his use of light and shade, and his work was contrasted by Xenocrates and Antigonus with the linear style of Parrhasius (see σκιαγραφία and *lineamenta*).

D. *Applied to sculpture in general* (passages 5, 10, 11, 12, 16). The emphasis, as in group B, seems to be on precision in the rendering of individual details in a work of art. In passage 16, it is worth noting, there is again an emphasis on precision of line.

E. *Applied to technical procedure in sculpture* (passages 9, 17, 20, 21). Passages 9 and 17 refer to the application of the system of proportions described in the *Canon* of Polyclitus. Passage 21, in which Theodorus's and Rhoecus's invention of the art of smelting bronze is mentioned, may also refer to a theory, or set of principles and their application, rather than simply to manual precision in a general way. The latter is clearly what is referred to in passage 20.

F. *Exactitude of a likeness* (passages 11, 13).

G. *Miscellaneous* (passages 14, 19). Passage 14 refers to thoroughness in an examination of statues. In passage 19 ἐπ'ἀκριβὲς is an idiomatic phrase meaning "in detail." Neither passage has a critical value.

ἀκρίβεια (akribeia)

The crucial question about ἀκρίβεια, it seems to me, is whether or not it formed part of the terminology of what I have called "professional criticism." I believe that it did for the following reasons:

1. A number of the uses of *diligens*, which almost certainly was the Latin translation of ἀκριβής, clearly belong to the Xenocratic tradition in Pliny, in which professional criticism was summed up (see *diligens*). I would note in particular *NH* 34.58, in which Myron is said to have been *in symmetria diligentior* than Polyclitus; and *NH* 35.137 in which the painter Nicophanes is said to have been pleasing for his *diligentia quam intellegant soli artifices*. If this *diligentia* was something which only artists could appreciate, it must have been something more than hard work or detail because at least some nonartists obviously could appreciate these. The word must refer to special types of knowledge and technique that only artists could be expected to know, the σοφία ἐν ταῖς τέχναις, which, as Aristotle says in passage 1, made an artist ἀκριβέστατος.

2. Ἀκριβής is used, as we have noted, in connection with the συμμετρία described in the *Canon* of Polyclitus, one of the most important documents of professional criticism. Note also that Quintilian *Inst.* 12.10.7, praises Polyclitus for his *diligentia* (= ἀκρίβεια).

3. The frequent use of the term in connection with linear precision in painting suggests that the term played a role in the shading versus draftsmanship controversy discussed by Xenocrates and Antigonus (Pliny *NH* 35. 67–68).

4. Ἀκρίβεια occurs twice in passages which seem to list criteria of professional criticism (passages 18b, 18c, and 22). Passage 18b, that is, Lucian *Zeux.* 5, is of particular importance (for full text see ἁρμονία, passage 1). In this passage Lucian provides a list of the technical aspects of painting —for example, proportion, perspective, draftsmanship, precision in the mixing (or juxtaposition?) of colors,[4] and shading—which are not apparent to amateurs (ἰδιώταις) but about which it is the job of painters' apprentices to know. He acknowledges, in other words, that these criteria belong to professional criticism. One wonders if Lucian's unusual awareness of these criteria might not be a survival of his own brief encounter with a career in the visual arts.[5]

Putting all the evidence together, it seems likely that ἀκρίβεια was a term in professional criticism used primarily to assess the degree of precision with which an artist had translated theory into practice (or in Vitruvian

4. It should be noted that Lucian applies ἀκριβής to the mixing of colors but does not apply it to shading. There is no contradiction, therefore, between this passage and those which apply ἀκρίβεια to draftsmanship as opposed to shading.

5. See *Somn.* 1–4, where he describes his brief apprenticeship in a sculptor's workshop.

terminology *ratiocinatio* into *opus*; see chap. 5).[6] The term was perhaps also used to evaluate exactitude in the rendering of small details.

'Ακρίβεια is used as early as the fourth century B.C. to denote precision in rhetoric and is frequently used as a criterion of stylistic comparison between rhetoric and the visual arts (on the background of such comparisons see chap. 3); for example, in passage 2 Aristotle compares the lack of ἀκρίβεια in the deliberative style in rhetoric to σκιαγραφία; in passage 4 Dionysius compares refinement of the details of a speech to the sculptor's and painter's ἀκρίβεια in the rendering of veins and other such μικρολογία (compare Pliny on Pythagoras, *NH* 34.59, *Hic primus nervos et venas expressit . . .*); in passage 5 Demetrius compares rhetoric of the fourth century B.C. and later to the art of Phidias for its τι καὶ μεγαλεῖον καὶ ἀκριβὲς ἅμα; and finally, in passage 23 the fourth-century A.D. orator Themistius speaks of the κάλλος and ἀκρίβεια, which can be found in all the arts but which is particularly represented by Phidias, Polygnotus, and Myron in the visual arts (compare the κάλλους ἀκρίβεια referred to by Plutarch in passage 8). The term ἀκρίβεια alone, however, did not play an important role in any system of rhetorical criticism,[7] and for that reason it is at least worth considering the possibility that the word originated as a critical principle among the sculptors and painters of the Classical period and was borrowed by critics of rhetoric in the Hellenistic period in order to facilitate drawing comparisons between the visual arts and rhetoric (for an analogous borrowing see *floridus*).

ἀλήθεια-veritas (*alētheia-veritas*)

1. Plato *Soph.* 235E ff.

> Ξε: Οὔκουν ὅσοι γε τῶν μεγάλων πού τι πλάττουσιν ἔργων ἢ γράφουσιν.
> εἰ γὰρ ἀποδιδοῖεν τὴν τῶν καλῶν' ἀληθινὴν συμμετρίαν, οἶσθε

6. Schlikker, *HV*, p. 62n.101, in summing up his own view on ἀκρίβεια, as well as those of Schweitzer (*Xenokrates*, p. 12) and H.K. Süsserott (*Griechische Plastik des 4 Jahrhunderts* [Frankfurt am Main, 1938], p. 18) says: "Der Begriff ist ursprünglich handwerkliche Genauigkeit der Arbeit, die meist klassischen Künstlern, noch Lysipp in besonderem Masse, zugeschrieben wird. Bei Platon heisst der Begriff Teilhabe an mathematischen Gesetzen, bei Aristoteles Übereinstimmung mit einer ideellen Vorschrift." I would agree that "handwerkliche Genauigkeit" is a good general translation of ἀκρίβεια, but it does not seem to do justice to the term in all its usages. In particular, if Polyclitus's *Canon* involved ἀκρίβεια, as it seems to have, Schlikker's insistence on "handwerkliche Genauigkeit" without "Teilhabe an mathematischen Gesetzen" is incorrect.

7. See J. C. Ernesti, *Lexicon Technologiae Graecorum Rhetoricae* (Leipzig, 1795; reprinted Hildesheim, 1962), s.v. ἀκρίβεια, ἀκριβεῖς, ἀκριβολογία.

σμικρότερα μὲν τοῦ δέοντος τὰ ἄνω, μείζω δὲ τὰ κάτω φαίνοιτ' ἄν διὰ τὸ τὰ μὲν πόρρωθεν, τὰ δ' ἐγγῦθεν ὑφ'ἡμῶν ὁρᾶσθαι.

Θεαι: Πάνυ μὲν οὖν.

Ξε: Ἆρ οὖν οὐ χαίρειν τὸ ἀληθὲς ἐάσαντες οἱ δημιουργοὶ νῦν οὐ τὰς οὔσας συμμετρίας, ἀλλὰ τὰς δοξούσας εἶναι καλὰς τοῖς εἰδώλοις ἐναπεργάζονται;

Stranger: Those who model or paint certain large works of art do not [attempt to reproduce the thing which they imitate just as it is]. For if they rendered the actual commensurability of beautiful forms, you would think that the upper parts were smaller than what was necessary, and the parts below would seem larger, because the former would be seen by us as far off, but the latter would be seen close up.

Theaetetus: That is certainly correct.

Stranger: So artists simply cease to concern themselves about what is real, and they now render in their images not real commensurate proportions but only those which give the appearance of being beautiful.

2. Aristotle *Pol.* 1281b10.

ἀλλὰ τούτῳ διαφέρουσιν οἱ σπουδαῖοι τῶν ἀνδρῶν ἑκάστου τῶν πολλῶν ὥσπερ καὶ τῶν μὴ καλῶν τοὺς καλούς φασι καὶ τὰ γεγραμμένα διὰ τέχνης τῶν ἀληθινῶν, τῷ συνῆχθαι τὰ διεσπαρμένα χωρὶς εἰς ἕν, ἐπεὶ κεχωρισμένων γε κάλλιον ἔχειν τοῦ γεγραμμένου τουδὶ μὲν τὸν ὀφθαλμὸν ἑτέρου δέ τινος ἕτερον μόριον.

But the difference which makes good men superior to any of the common run of men, as handsome men, so they say, to those who are not handsome, and things represented in the graphic arts to actual things, consists in this—namely, that details which are disparate are brought together in one place, since, if taken separately, the eye of an actual person is more beautiful than one which is painted, and another feature of a particular person is more beautiful than that of some other person.

3. Polybius 30.10.6.

διότι μεγάλην ἔχων προσδοκίαν τῆς 'Ολυμπίας, μείζω τῆς προσδοκίας εὑρηκὼς εἴη τὴν ἀλήθειαν.

[Lucius Aemilius, when he saw Phidias's Zeus at Olympia, was over-

whelmed, and praised Phidias as the only sculptor who had been able to represent Homer's Zeus.] For that reason, though he had come to Olympia with great expectation, he had found the reality even greater than the expectation.

4. Plutarch *De glor. Ath.* 2 (*Mor.* 346F).

ἀλλ'οὐκ ἂν οἶμαι τὴν ζωγράφου κρίσιν προθείητε πρὸς τὸν στρατηγόν, οὐδ'ἀνάσχοισθε τῶν προτιμώντων τὸν πίνακα τοῦ τροπαίου καὶ τὸ μίμημα τῆς ἀληθείας.

[Comment on Euphranor's picture of the battle of Mantineia:] But I do not think that you would prefer the judgment of the painter to that of the general, nor would you be content with those who prefer the picture of the trophy and the imitation of the real thing.

5. Lucian *Pr. Im.* 11.

"'Ακούω" ἔφη, "πολλῶν λεγόντων—εἰ δὲ ἀληθές, ὑμεῖς οἱ ἄνδρες ἴστε —μηδ' 'Ολυμπίασιν ἐξεῖναι τοῖς νικῶσι μείζους τῶν σωμάτων ἀνεστάναι τοὺς ἀνδριάντας, ἀλλ'ἐπιμελεῖσθαι τοὺς 'Ελλανοδίκας, ὅπως μηδὲ εἰς ὑπερβάληται τὴν ἀλήθειαν, καὶ τὴν ἐξέτασιν τῶν ἀνδριάντων ἀκριβεστέραν γίγνεσθαι τῆς τῶν ἀθλητῶν ἐγκρίσεως."

"I hear many people say," she said, "whether it is true or not you men know, that it is not permitted for victors in the Olympic games to set up statues which are greater in scale than their own bodies, but that the Hellanodicae oversee the matter so that none exceeds the true scale and that the inspection of the statues is more exacting than the examination of the athletes."

6. Maximus of Tyre *Diss.* 26.5. See ἀρετή, passage 4.

7. Aelian *VH* 2.3.

'Αλέξανδρος θεασάμενος τὴν ἐν 'Εφέσῳ εἰκόνα ἑαυτοῦ τὴν ὑπὸ 'Απελλοῦ γραφεῖσαν οὐκ ἐπῄνεσε κατὰ τὴν ἀξίαν τοῦ γράμματος. εἰσαχθέντος δὲ τοῦ ἵππου καὶ χρεμετίσαντος πρὸς τὸν ἵππον τὸν ἐν τῇ εἰκόνι, ὡς πρὸς ἀληθινὸν καὶ ἐκεῖνον, "ὦ βασιλεῖ," εἶπεν ὁ 'Απελλῆς, "ἀλλ'ὅ γε ἵππος ἔοικέ σου γραφικώτερος εἶναι κατὰ πολύ."

Alexander, when he saw the portrait of himself by Apelles in Ephesus, did not praise it for the quality of its draftsmanship. Thereupon a horse was brought in, and when it neighed at the horse in the picture, as if

that horse were also a real one, Apelles said, "O King, this horse seems far more sensitive to painting than you."

8. The Elder Philostratus Εἰκόνες 1. proem. 1.

Ὅστις μὴ ἀσπάζεται τὴν ζωγραφίαν ἀδικεῖ τὴν ἀλήθειαν.

Whoever does not revere painting does an injustice to true reality.

9. Callistratus *Descriptiones* 11. 1.

καὶ γὰρ ἁπαλὸς ἦν,* μαχομένην τῇ ἁπαλότητι τὴν οὐσίαν ἔχων καὶ πρὸς τὸ ὑγρὸν ἤγετο ἐστερημένος ὑγρότητος, καὶ ὅλως ἐξέβαινε τῆς αὐτοῦ φύσεως ὁ χαλκὸς τοὺς ὅρους, εἰς τὸν ἀληθῆ τύπον μεθιστάμενος,

*ἦν μὴ mss.; ἦν μαχομένην Olearius; μηχανωμένην A.

For it [a bronze statue of a youth] was tender even though possessed of a nature which is at war with tenderness, and it was inclined to a pliant softness even though [bronze is] deprived of softness, and so the bronze went completely beyond the boundaries of its nature, transferring itself to the nature of the real prototype.

10. "Damianus" *Optica* (ed. Schöne, pp. 28 ff.). See σκηνογραφία, passage 12.

11. Cicero *Brut.* 70.

Quis enim eorum qui haec minora animadvertunt non intellegit Canachi signa rigidiora esse quam ut imitentur veritatem?

For who of those who give their attention to these lesser arts does not understand that the statues of Canachus are more rigid than they should be in order to imitate reality?

12. Cicero *Brut.* 70.

Nondum Myronis satis ad veritatem adducta, iam tamen quae non dubites pulchra dicere.

Even the statues of Myron have not yet been brought satisfactorily to the stage of naturalistic representation, although you would not at that stage hesitate to call them beautiful.

13. Cicero *Div.* 1.13.23.

Quidquam potest casu esse factum quod omnes habet in se numeros

veritatis? . . . aspersa temere pigmenta in tabula oris lineamenta effingere possunt; num etiam Veneris Coae pulchritudinem effingi posse aspersione fortuita putas?

Is it possible that anything can be made by chance which contains within itself all the *numeros* of truth? . . . Can colors scattered around at random represent the lines of the face? Surely you don't think that the beauty of the Venus of Cos could have been produced by random scattering?

14. Cicero *Inv. Rhet.* 2.1.2–3.

"Praebete igitur mihi, quaeso," inquit, "ex istis virginibus formosissimas dum pingo id quod pollicitus sum vobis, ut mutum in simulacrum ex animali exemplo veritas transferatur."

[Zeuxis prepares to paint his Helen at Croton:] "Therefore turn over to me, I beseech you," he said, "the most beautiful of these virgins while I paint the picture I have promised you, so that reality may be transferred from the living example to the mute image."

15. Vitruvius 4.2.6. See *perfectus, perfectio*, passage 11.

16. Vitruvius 7.5.4 ff.

[Vitruvius's remarks on new trends in the mural painting of his day and the story of the stage setting painted by Apaturius of Alabanda:]

a. Sec. 4.

Neque enim picturae probari debent, quae non sunt similes veritati, nec, si factae sunt elegantes ab arte, ideo de his statim debet 'recte' iudicari, nisi argumentationes certas rationes habuerint sine offensionibus explicatas.

For pictures should not be given approbation which are not similar to reality, even if they are produced with elegant finish through art; nor ought one for that reason [i.e. their elegance] to consider them correct, unless their subjects have firm rational bases which are clearly set forth without offensive errors.

b. Sec. 6.

Si ergo, quae non possunt in veritate rationem habere facti, in picturis probaverimus, accedimus et nos his civitatibus, quae propter haec vitia insipientes sunt iudicatae.

129

If therefore we give approval in pictures to things which cannot have a rational, factual basis in reality, we shall also add ourselves to those cities which are judged to be foolish for these very faults.

c. Sec. 7.

Itaque Apaturius contra respondere non est ausus, sed sustulit scaenam et ad rationem veritatis commutatam postea correctam adprobavit. . . . Sed quare vincat veritatem ratio falsa, non erit alienum exponere.

And so Apaturius did not dare to speak up in his own defense; rather he removed the stage setting, and, after changing it so as to have a rational basis in reality, he gave satisfaction with a correct version. . . . But why a false theory of representation wins out over the representation of reality, it will not be irrelevant for our purposes to explain.

17. Petronius *Satyricon* 83.

nam et Zeuxidos manus vidi, nondum vetustatis iniuria victas et Protogenis rudimenta cum ipsius naturae veritate certantia non sine quodam horrore tractavi.

For I saw the work of the hand of Zeuxis, not yet conquered by the ravages of age and I beheld, not without a certain awe, the preliminary sketches of Protogenes vying with the reality of nature itself.

18. Pliny *NH* 34.38. See *similitudo,* passage 5.

19. Pliny *NH* 34.58.

Primus hic multiplicasse veritatem videtur, numerosior in arte quam Polyclitus, et in symmetria diligentior.

[Since the complex terminology of this passage requires word by word analysis before it can be properly understood, I omit a general translation, which would only be misleading.]

20. Pliny *NH* 35.65.

. . . Parrhasius. descendisse hic in certamen cum Zeuxide traditur et, cum ille detulisset uvas pictas tanto successu, ut in scaenam aves advolarent, ipse detulisse linteum pictum ita veritate repraesentata, ut Zeuxis alitum iudicio tumens, flagitaret tandem remoto linteo ostendi picturam . . .

. . . Parrhasius. There is a tradition that he entered into a contest with

Zeuxis, and, when the latter depicted some grapes with such success that birds flew up to the painted stage setting, the former depicted a curtain with such realism that Zeuxis, swelling with pride at the verdict of the birds, eventually demanded that the curtain be removed and the picture [of the grapes] exhibited . . .

21. Pliny *NH* 35.103.

Displicebat autem ars ipsa: nec minui poterat et videbatur nimia ac longius a veritate discedere, spumaque pingi, non ex ore nasci. anxio animi cruciatu, cum in pictura verum esse, non verisimile vellet, absterserat saepius mutaveratque penicillum. . . .

But the art itself displeased him [Protogenes]: it was not simply that it could not be made less obvious but rather that it was decidedly too prominent and departed rather far from reality, for the foam appeared to be painted, not to originate naturally from the horse's mouth. Tortured by an anxious mind because he wanted reality itself in the painting and not simply a likeness of reality, he had erased his work quite often and changed brushes . . .

22. Quintilian *Inst.* 12.10.8.

Nam ut humanae formae decorem addiderit supra verum, . . .

See *decor*, passage 5.

23. Quintilian *Inst.* 12.10.9.

Ad veritatem Lysippum ac Praxitelen accessisse optime adfirmant. Nam Demetrius tanquam nimius in ea reprehenditur et fuit similitudinis quam pulchritudinis amantior.

In naturalistic representation critics agree that Lysippus and Praxiteles were supreme. Demetrius, however, is reproved for being too extreme in this respect, for he was more fond of similitude than beauty.

Commentary

As the foregoing catalog shows, ἀλήθεια and its Latin translation *veritas* appear frequently in ancient literature in connection with the visual arts. Their standard lexical meaning, "truth," while no doubt accurate in general, is a word with so many implications and connotations that it gives us very little help in understanding the passages in question. A cursory observation of these passages will show that "truth" does not mean the same thing in

each instance and that we must ask, "What kind of truth?" before we can really appreciate what these passages mean.[8]

In connection with the visual arts, one can identify at least four semantic values of the terms ἀλήθεια and *veritas*, varying from what appears to be a precise technical usage in professional criticism to a variety of informal uses in popular criticism.

A. On the broadest level, we find ἀλήθεια meaning "real experience" as opposed to "anticipation" or "imagined experience." In passage 3, for example, Polybius tells us that Aemilius Paulus's προσδοκία ("anticipation") of the experience of first seeing Phidias's statue of Zeus at Olympia was exceeded by the ἀλήθεια, the actual seeing of it. This meaning of ἀλήθεια has no direct connection with art criticism (it could be used to characterize any experience) and is only incidentally related to the arts at all.

B. Turning to the passages that are more specifically related to the visual arts, we may identify a group in which ἀλήθεια refers to the "real thing," an external physical reality, as opposed and contrasted to the representation of it. In passage 2, Aristotle distinguishes ἀληθινά, "real things," from representations of them, γεγραμμένα διὰ τέχνης. The same semantic value can also be found in the use of *veritas*. In passage 21, for example, Protogenes' representation of the foam on a horse's mouth is said to depart "too much from reality" (*longius a veritate*), "reality" once again meaning the real thing as opposed to the representation of it, and in passage 16a *similes veritati* gives us the Latin version of μιμήματα τῆς ἀληθείας—*veritati* meaning the real thing and *similes* the imitation of it. Plutarch's comparison of a picture of a trophy, which is called a μίμημα τῆς ἀληθείας, to the real thing in passage 4 implies that the representation is inferior to the real thing in the same way that the judgment of an artist, in military matters, is inferior to that of a general. In passage 5 we are told that the judges at the Olympic games inspected votive statues to make sure that they did not "exceed the truth," that is, that they were not bigger than the actual person whom they represented. The same distinction between the work of art and the real thing holds in passage 9, where Callistratus distinguishes the bronze of a statue from the ἀληθὴς τύπος, the actual human flesh which the bronze represents. In passage 7 Aelian relates how Alexander's horse neighed at a picture of a horse painted by Apelles, thus behaving ὡς πρὸς ἀληθινὸν, "as toward the real thing."

C. The passages discussed above are related to but distinct from another

8. In Greek literature as a whole the basic semantic division in the use of ἀλήθεια is between its early use, especially in Homer, to mean "truth as opposed to a lie" and a later sense, appearing first in the fifth century, referring to "reality" as opposed to "appearance." E.g. *Il.* 24.407, ἀληθείην κατάλεξον; *Od.* 11. 507; Plato *Rep.* 598*B*, φαντάσματος ἢ ἀληθείας.

group in which *veritas* implies not the real as opposed to the representation but rather the "visible reality accurately represented" as opposed to "inaccurate representation" or the representation of imaginary subjects (which have no "real" existence). In this group the emphasis is not so much on the distinction between the real world and imitations of it as it is on the similarities between them. This meaning appears to be applied in both popular criticism and in the systematic, classicistic tradition represented by Cicero and Quintilian. On the level of popular criticism we may point to passages 14 and 20 as examples of *veritas* in this sense. In passage 20 Parrhasius is said by Pliny to have painted a curtain with such truth that Zeuxis thought the curtain was real and asked to have it removed. I doubt that there is any philosophical or technical content implied in *veritas* here; it simply means in a general sense "truth to life." The phrase *ratio veritatis* in Vitruvius's criticism of the decorative wall painting[9] of his day in passages 15, 16b, and 16c probably also belong to this category. *Veritas* implies in these passages that the subject of a painting should be based on what one sees and knows rather than what one imagines. Columns, as everyone knows, stand on floors, and, if, as in the scene painting by Apaturius, they are shown rising above a rooftop with their bases out of sight, they lack *veritas* (7.5.6).

In passages 11, 12, 22, and 23, which describe the first stage of what we have called the phantasia theory (see chap. 2), that is the stage prior to Polyclitus and Phidias, in which sculptors struggled to make their works softer and more natural looking, *veritas* also seems to imply an "accurate representation of visible things."

D. In still another group of passages ἀλήθεια and *veritas* seem to imply reality or truth as confirmed by measurement. This differs from the passages in the preceding group in that the latter seem to accept the idea that reality is that which one sees with the physical eyes, whereas the former seem to distrust even the senses and recognize as real only that which can be confirmed by the mind. In passage 1, which is also referred to in chapter 2, Plato describes how the sculptors of his day made adjustments in the proportions of colossal statues in order to counteract the optical distortion which the viewer would experience by seeing these statues from a low vantage point. Such statues when seen from below would appear to be "larger below" ($\mu\varepsilon\acute{\iota}\zeta\omega$ δὲ τὰ κάτω) and "lacking above" (δέοντος τὰ ἄνω); in other words the hips, legs, feet, and so on, being nearer the viewer, would appear disproportionately

9. Represented in Pompeian wall painting by the late second and early third styles, probably at the point of transition between the two styles ca. 20 B.C. Most of the details mentioned by Vitruvius are characteristic of the third style—stalks and reeds serving as columns, etc.— but the spatial illusionism objected to in the theater scenery of Apaturius of Alabanda is more commonly associated with the second style.

large in comparison with the upper torso. Disproportionately large or small in comparison to what? Plato's answer is τῶν καλῶν ἀληθινή συμμετρία, "the real *symmetria* of beautiful forms" which the artists of his day "put out of mind" (χαίρειν τὸ ἀληθὲς ἐάσαντες). What Plato means by "truth" and "true symmetry" is that which can be verified by actual measurement, is free from optical distortion, and hence is κατὰ τὰς τοῦ παραδείγματος[1] συμμετρίας τις ἐν μήκει καὶ πλάτει καὶ βάθει, "in accordance with the *symmetria* of the model in height and width and depth." In other words reality is not so much what the eye sees as what the mind knows.

In passage 10, "Damianus" describes a process whereby architects made alterations in the forms (ῥυθμούς) in their buildings which served to correct optical distortion (τῆς ὄψεως ἀπάτας ἀλεξήματα). These corrections were the result of aiming at proportion and gracefulness of shape (ἰσότητος ἢ εὐρυθμίας), which were calculated not according to the truth (κατ' ἀλήθειαν) but "by eye" (πρὸς ὄψιν, πρὸς φαντασίαν). 'Αλήθεια here, as in Plato, refers to shapes and proportions in the dimensions of a form which can be confirmed by measurement. A form in which these actual measurements were altered to compensate for optical illusion was a deviation from this "reality" or "truth."

The Latin *veritas,* in a number of passages, may also express the sense of "true form" or the "true nature of things" as confirmed by measurement. Passage 21, in which Pliny relates that Protogenes wanted his painting to have *verum* rather than simply to be *verisimile,* is somewhat vague, but, in Pliny's source the intent was probably to distinguish ἀλήθεια, "measureable truth," from "apparent similarity."[2] In passage 14 the *veritas* which Zeuxis transferred from the living models to his paintings could also have been a "measured form," although it is more likely that *veritas* is used here in the simple sense of "visible reality" (category C).

Veritas as used by Cicero and Pliny in passages 13 and 19 also signifies truth or reality as confirmed by measurement. The language of Pliny's passage: *primus hic multiplicasse veritatem . . .* represents a complex extension in Latin of the terminology of earlier Greek professional criticism as organized by "Xenocrates." I am inclined to think that Cicero's phrase *numeros veritatis* in passage 13 may have the same background. Since both passages are discussed in detail under *numerus* and ῥυθμός, I will give only a summary of their significance here. In both passages the connection between the terms *numerus* and *veritas* is of particular importance. The Greek equivalent of *numerus,* as Cicero himself indicates elsewhere, is ῥυθμός, a word which, in the criticism of the visual arts, implies a form and apparently also the number or

1. On this passage see παράδειγμα.
2. See ὁμοιότης, *similitudo,* and φαντασία.

numbers which correspond either to that form as a whole or to smaller geometric shapes within it. A ῥυθμός-numerus was therefore a form or shape with measurable proportions. The total of these forms in a painting or a statue made up its ἀλήθεια, its true nature, confirmable by measurement. This is perhaps what Cicero means by the numeros veritatis of Apelles' Venus of Cos. And the original meaning of the observation, preserved in the Xenocratic tradition in Pliny, that Myron "multiplied the truth," may be that Myron added to the number of measured shapes (ῥυθμοί) which were involved in the final "true" form of his statues. Hence he could reasonably be called numerosior in arte (ῥυθμικώτερος).

It should perhaps be pointed out that this interpretation of Pliny's multiplicasse veritatem is not the one usually accepted by modern writers. The phrase has most commonly been taken to mean that Myron made certain improvements in naturalistic representation. Perhaps a typical translation is the one offered by G. M. A. Richter: "He is thought to have been the first to extend lifelike representation (veritatem) in art."[3] Brunn, Jahn, Klein, and other scholars in the nineteenth century also took veritatem in the sense of "lifelike representation" or "fidelity to nature" and coupled it with numerosior which, they felt, indicated that Myron was able to apply his skill at naturalistic representation to a greater variety of subjects.[4] To these scholars, "reality" or veritas had endless variety, and hence, in order to represent it truly, Myron had to "multiply" his subjects. Carl Robert, who was the first to recognize that numerus translated the Greek ῥυθμός, felt that multiplicasse veritatem meant "Mannigfaltigkeit der Motive."[5] This translation marked a significant change, in that numerosior and veritas were thought of as referring to the actual forms of Myron's work rather than simply to the variety of subjects which the artist represented. Veritatem was still thought of, however, as referring to a prototype in nature which the work of art "imitates"; that is, in representing a greater variety of subjects, Myron explored more of the poses which the human body can assume in reality.

The interpretation of veritatem in Pliny's passage on Myron as "imitative fidelity to nature" has also been proposed in a more complex form, by Silvio Ferri. At the end of his article on the meaning of τετράγωνος-quadratus(q.v.)in the Canon of Polyclitus, Ferri introduces two "corollaries" which are intended to clarify certain apparent contradictions between Pliny on the one

3. Richter, SSG⁴, p. 164.

4. Brunn, GGK², 1:107–08; Jahn, UKP, p. 130; Wilhelm Klein, Geschichte der Griechischen Kunst (Leipzig, 1904–07), p. 160.

5. Robert, Arch. Märch., p. 29. He translates numerosior by εὐρυθμώτερος (p. 34), not seeing any distinction between ῥυθμός and εὐρυθμία. For a complete discussion of the meaning of these terms, see ῥυθμός and εὐρυθμία.

hand and Cicero and Quintilian on the other.[6] The first of these contradictions, Ferri feels, is between Pliny's statement that Lysippus rendered men *quales viderentur,* while Lysippus's predecessors rendered men *quales essent* (*NH* 34.65). Ferri assumed that *quales essent* referred to statues which were careful imitations of *veritas* (in the sense of "real things, nature"); he interprets *quales viderentur,* on the other hand, as referring to statuary which is designed on the basis of appearance rather than on nature itself. In Quintilian *Inst.* 12.10.9 (passage 23), however, it is said that Lysippus and Praxiteles *ad veritatem . . . optime accessisse.* To Ferri, Quintilian's statement contradicts Pliny's, for in Pliny it is Lysippus's predecessors whose works are characterized by *veritas,* while in Quintilian Lysippus's own works exhibit the greatest *veritas.* The contradiction can be solved, Ferri proposes, by interpreting the two passages in the light of the theory of the three levels of μίμησις presented by Aristotle in the *Poetics* 1460b8–11. Aristotle says that artists imitate things (1) οἷα ἦν ἢ ἔστιν, "as they were or are"; (2) οἷά φασιν καὶ δοκεῖ, "as they are said to be or seem"; and (3) οἷα εἶναι δεῖ, "as they ought to be." Interpreting Pliny and Quintilian in this light it might be said that Lysippus's predecessors reached only level 1, imitation of things as they were; but Lysippus himself reached level 2, that is, imitation of things as they seem; and it is this level of μίμησις which Quintilian speaks of in connection with Lysippus. Both levels, in Ferri's opinion, were types of *veritas;* level 1 involved simple imitation of things as they are, while 2 involved an illusionistic representation of reality in which one searches for ἀλεξήματα to counteract optical illusion (see σκιαγραφία).

While admitting its ingenuity, I am disinclined to accept Ferri's explanation of these passages for three reasons: (a) In Pliny's passage on Myron (*multiplicasse veritatem*) the meaning of *veritas* differs from its meaning in Quintilian; in Pliny the term refers to the true nature of a thing as confirmed by measurement, while in Quintilian it refers to "fidelity to nature"; hence there is no contradiction between the two terms. (b) *Veritas* is not actually used in *NH* 34.65 and, as far as I can see, has no connection with it. (c) Even if there were a contradiction between Quintilian and Pliny, it could be explained on the basis of the different sources they use.

The second contradiction that Ferri recognizes is between Pliny's statement that Myron *multiplicasse veritatem videtur* (passage 18) and Cicero's judgment that Myron's statues were *nondum . . . satis ad veritatem adducta.* Ferri resolves this contradiction by proposing that in the Cicero passage *veritas* simply means accurate representation, while in Pliny the term refers to the composition of a statue in which the separate parts of the body were

6. Ferri, *NC,* pp. 136–39, 143–45.

arranged in a circular pattern. He arrives at the latter conclusion by assuming that *multiplicasse* equaled the Greek πολλαπλασιάζειν and that this verb in turn conveys the same idea as στρέφω, συστροφή, and συνεστραμμένον in rhetoric. The last of these terms is used by Demetrius (*Eloc.* 20) to describe a style of rhetoric in which the sentences had an εἶδος which was συνεστραμμένον and κυκλικόν. In the same way, Ferri suggests, the separate parts of the Discobolus of Myron were thought of as being rhythmically[7] composed in a circular pattern; these separate parts were called ἀληθινά, *veritates* in Latin; and the circular arrangement between them was conveyed by *multiplicasse*. He hypothesizes the existence of phrases like πολλὰ πλέκειν τὴν ἀλήθειαν and πολυπλόκως συστρέφειν τὴν ἀλήθειαν in Pliny's sources.

Once again Ferri's work is exemplary in its sensitivity to the frequently technical nature of Pliny's language, to the importance of Pliny's Greek sources, and to the common ground which the critical terminology of the visual arts seems to have shared with other disciplines. His suggestion that πολλαπλασιάζειν might be the Greek prototype of *multiplicasse* and that Pliny's use of this verb may have a close parallel with the critical terminology of rhetoric are of considerable value. I find it more difficult, however, to accept his interpretation of *veritas* in Cicero's and Pliny's evaluations of Myron. There is nothing in the literary sources, as far as I can see, to support the very close relationship which he hypothesizes for πολλαπλασιάζειν and συστρέφω; and Pliny's language certainly gives no other hint of a circular εἶδος in the sculpture of Myron which is proposed on the basis of the relationship between these two verbs. The simplest explanation of the apparent contradiction between Pliny and Cicero is, once again, that the word *veritas* is used in two different senses.

Finally, passage 8 in our catalog is difficult to classify. When Philostratus says that one who dishonors painting dishonors τὴν ἀλήθειαν, it is difficult to say whether he is referring to "truth" in some philosophical sense, as Schweitzer seems to feel,[8] or whether he simply means "visible reality." The latter is suggested by the fact that in the same paragraph he classifies painting as a form of μίμησις which is "most akin to nature." On the other hand, when he praises poets and painters for their contribution to man's knowledge of the looks and works of great heroes and adds that for "one who wishes to theorize" painting might be said to have been invented by the gods, his attitude seems to be more in the tradition of the *phantasia* theory.

7. He uses *ritmicamente* here in the modern sense; ibid., p. 144.
8. Bernhard Schweitzer, "Mimesis und Phantasia," Philologus 89 (1934): 292.

ἀνθηρός (anthēros)

To sum up: When used in connection with the arts ἀλήθεια and *veritas* have four meanings:

A. The "real experience" of seeing a work of art, as opposed to the imaginary experience of what it might be like.
B. "Reality" as contrasted with imitation.
C. "Accurate representation of the natural (i.e. optical) appearance of a thing."
D. "Reality" or the "real nature" of a thing, as it is expressible through mathematics and knowable by measurement. This is in essence the Pythagorean concept of reality and is probably the sense attached to the term in professional criticism. We may assume the Greek artists knew that actual measurements taken with calipers were always subject to minute inaccuracies and were therefore not as "true" as purely mathematical expressions of formal relationships (e.g. canons of proportion) in art. Ἀλήθεια in professional criticism was probably primarily a theoretical criterion of excellence, of which individual works of art were external expressions. This concept of truth or reality might be likened to that of the reality of an atom as conceived in modern physics. The atom cannot be seen, but it is considered real by virtue of the fact that its properties can be expressed and demonstrated mathematically.

ἀνθηρός (anthēros)

1. Dionysius of Halicarnassus, *Ant. Rom.* 6.3.6. See ῥῶπος, ῥωπογραφία, passage 3.

2. Dionysius of Halicarnassus *Comp.* 23 (ed. Roberts, p. 234).

 ἔοικέ [i.e. ἡ δὲ γλαφυρὰ καὶ ἀνθηρὰ σύνθεσις] τε κατὰ τοῦτο τὸ μέρος εὐητρίοις ὕφεσιν ἢ γραφαῖς συνεφθαρμένα τὰ φωτεινὰ τοῖς σκιεροῖς ἐχούσαις.

 In this respect it [the smooth or florid style of composition] resembles finely woven fabrics, or paintings in which the light parts fuse almost imperceptibly with the shadows.

3. Plutarch *De Pyth. or.* 2 (*Mor.* 395B).

 ἐθαύμαζε δὲ τοῦ χαλκοῦ τὸ ἀνθηρὸν ὡς οὐ πίνῳ προσεοικὸς οὐδ᾽ ἰῷ, βαφῇ δὲ κυάνου στίλβοντος.

 He [a learned visitor to the sanctuary at Delphi] marveled at the

138

brightness of the bronze [statues] because it resembled neither patina nor rust, as it shone with the color of dark blue dye.

4. Callistratus 3.4.

πλόκαμοι δὲ αὐτοῦ τὴν κεφαλὴν ἐσκίαζον ἀνθηροὶ καὶ ἔνουλοι νεοτήσιον ὑπολάμποντες ἄνθος

[On a statue of Eros:] His bright locks shaded his head, curls which shone with the bloom of youth.

5. Callistratus 6.1.

... τὴν δὲ χρόαν εἶχεν ἀνθηρὰν τῇ λαμπηδόνι τοῦ σώματος τὰ ἄνθη δηλῶν.

. . . he [the Kairos of Lysippus] had a blooming complexion which set off by its luster the finest features of the body.

Commentary

For the role of ἀνθηρός as a critical term in painting and its connection with the ἀνθηρός χαρακτήρ of Hellenistic rhetoric, see *floridus* and *austerus*.

In connection with sculpture ἀνθηρός apparently played no significant role. Its use by Plutarch and Callistratus in passages 3 and 4 cannot be considered part of a system of formal critical terminology. Callistratus's reference to the ἀνθηρὰν of the "skin" of Lysippus's Kairos provides an example of the use of the word in a poetic sense, that is, the "bloom" of the skin.[9] Plutarch uses the term in a more concrete way to indicate the dark blue hue of the bronze surface of a statue at Delphi. In short, when used with reference to sculpture, ἀνθηρός refers to certain properties, physical or metaphorical, of the surface of work. It differs fundamentally from its use in connection with painting in that it does not describe a style.

ἀξιωματικός, τὸ ἀξιωματικόν (axiōmatikos, to axiōmatikon)

1. Dionysius of Halicarnassus *Isoc.* 3.

δοκεῖ δέ μοι μὴ ἀπὸ σκοποῦ τις ἂν εἰκάσαι τὴν μὲν Ἰσοκράτους ῥητορικὴν τῇ Πολυκλείτου τε καὶ Φειδίου τέχνῃ κατὰ τὸ σεμνὸν καὶ μεγαλότεχνον καὶ ἀξιωματικόν.

9. See Euripides *Cyc.* 541.

ἀξιωματικός, τὸ ἀξιωματικόν (axiōmatikos, to axiōmatikon)

It seems to me that one would not be far wrong if one were to liken the rhetoric of Isocrates to the art of Polyclitus and Phidias because of their holiness, dignity, and grandeur.

Commentary

This passage is principally of interest because of the possibility that Dionysius's term τὸ ἀξιωματικόν is the prototype for the term *auctoritas* in Quintilian's observation that Polyclitus *non explevisse deorum auctoritatem videtur* (see *auctoritas*). If it was, τὸ ἀξιωματικόν may have been an important term in the classicistic tradition of Greek art criticism, which is exemplified by the *phantasia* theory and by references to art and artists in Hellenistic and Roman writers on rhetoric (see chaps. 2 and 3).

The meaning of τὸ ἀξιωματικόν (from ἄξιος "worthy"), "dignity, quality worthy of honor," is straightforward. Its use in connection with style appears exclusively in works on rhetoric. Dionysius of Halicarnassus uses it in *De Demosthene* 18 to describe a quality in the speech of Isocrates, and in *De Compositione Verborum* 13 he speaks of ῥυθμὸς ἀξιωματικός as one of the necessary qualities of beautiful speech. Likewise the rhetorician Hermogenes (second century A.D.) uses ἀξιωματικῶς λέγειν (περὶ ἰδεῶν 2.6).

While there seems clearly to be some connection between Dionysius's statement about the ἀξιωματικόν of Polyclitus and Phidias and Quintilian's attribution of *auctoritas* to Phidias, it does not necessarily follow that Quintilian was borrowing directly from Dionysius or some other Greek rhetorician. Dionysius's comparison of Isocrates with Phidias and Polyclitus on the basis of ἀξιωματικός and other qualities may be connected with a canon tradition in the criticism of Greek rhetoric (see chap. 3), while Quintilian's remark about *auctoritas* is connected with a specific systematic approach to criticism, the *phantasia* theory.

Not all scholars, it might be noted, have been unanimous in accepting Bernhard Schweitzer's equation of *auctoritas* with ἀξιωματικόν.[1] Ferri,[2] following the lead of André Jolles,[3] has maintained that the proper translation of *auctoritas* in *Inst.* 12. 10. 7 should be αὔξησις, "increase," a term which is related to *auctoritas* etymologically. He feels (see *auctoritas*) that the *auctoritas deorum* which Quintilian recognized in the works of Phidias refers not to any quality of loftiness or grandeur, not to the particular ἀρετή of the gods, but simply to the size of the works of Phidias. Polyclitus's

1. See commentary under *auctoritas*.
2. Ferri, *NC*, p. 142.
3. André Jolles, *Vitruvs Aesthetik* (Freiburg Br., 1906), p. 31.

representations of the gods were inferior to Phidias's in the eyes of ancient critics, Ferri would maintain, because they were lifesize, whereas the gods themselves must be overlifesize.[4] It is hard to believe that either Quintilian or any other ancient critic was so naïve that he looked upon Phidias's Zeus or Athena as the greatest works of Greek sculpture simply because they were the biggest.[5] Cicero's praise of Phidias in the *Orator* 9 (see *pulchritudo*), as well as Quintilian's statement that the Zeus at Olympia "added something to traditional religion," make it amply clear that what the late Hellenistic and Roman critics valued in the art of Phidias was not simply the size of his statues but the spiritual qualities these statues were thought to reveal.

ἁπλότης, ἁπλοῦς (haplotēs, haplous)

1. Dionysius of Halicarnassus *De Isaeo* 4.

εἰσὶ δὴ τίνες ἀρχαῖαι γραφαί, χρώμασι μὲν εἰργασμέναι ἁπλῶς καὶ οὐδεμίαν ἐν τοῖς μίγμασιν ἔχουσαι ποικιλίαν, ἀκριβεῖς δὲ ἐν ταῖς γραμμαῖς καὶ πολὺ τὸ χάριεν ἐν ταύταις ἔχουσαι. . . τούτων μὲν δὴ ταῖς ἀρχαιοτέροις ἔοικεν ὁ Λυσίας κατὰ τὴν ἁπλότητα καὶ τὴν χάριν.

Suppose there were some ancient paintings, executed with simple colors and having no variegation whatsoever in the mixing of colors, but precise in their lines and having much in them which was charming. . . . Lysias would be like these older paintings because of his simplicity and charm.

2. Dio Chrysostom *Or.* 12.77.

προσομοιοῖ δὲ τὸν Κτήσιον καὶ τὸν Ἐπικάρπιον ἥ τε ἁπλότης καὶ μεγαλοφροσύνη δηλουμένη διὰ τῆς μορφῆς.

[On the attributes of Zeus which were apparent in Phidias's statue at Olympia:] The simplicity and magnanimity apparent in the figure represent the Spirit of Wealth and the Spirit of Fruitfulness.

4. See also Ferri, *Vitruvio*, p. 58, where he has modified his views to the extent that he admits several equivalents for the Latin *auctoritas*. In connection with the *auctoritas deorum* of Quintilian, however, he adheres to his previous opinion, that is, *auctoritas*=αὔξησις.

5. The ancient critics must have been aware that overlifesize statues had existed in Greek art long before Phidias, e.g. a number of the early *kouroi*. See G. M. A. Richter, *Kouroi*, 2d ed. (New York, 1960), figs. 33–35 and 84–86.

ἁπλότης, ἁπλοῦς (haplotēs, haplous)

3. Pausanias 5.17.1.

. . . ἔργα δέ ἐστιν ἁπλᾶ.

[In the temple of Hera at Olympia there was a seated image of Hera, and another of Zeus, bearded and helmeted, standing beside her.] . . . these were simple [uncomplicated? primitive?] works.

4. Quintilian *Inst.* 12.10.3.

. . . Polygnotus atque Aglaophon, quorum simplex color tam sui studiosos adhuc habet, ut illa prope rudia ac velut futurae mox artis primordia maximis, qui post eos exstiterunt, auctoribus praeferant, pro prio quodam intelligendi, ut mea opinio est, ambitu.

[The first painters whose work was of interest for something more than the simple fact of its antiquity were] Polygnotus and Aglaophon, whose simple color still has admirers who are so zealous that they prefer works which are almost primitive and rather like the foundations of an art which was to develop in the future, to the works of the greatest artists who came later, their private motive being, in my opinion, a desire to make a display of connoisseurship.

Commentary

The use of the term ἁπλοῦς[6] (Latin *simplex*) in connection with colors in painting appears to be derived from a critical tradition which in its origin is separate from that of the other color terms—*floridus, austerus, durus*. While the latter appear to have been part of the vocabulary of fourth-century Greek painters and to have been adopted as critical terms by Hellenistic rhetoricians, ἁπλότης as a critical term may be derived from a Platonic tradition in art criticism. Plato's praise of pure—that is, unmixed—colors (*Phlb.* 51 ff.) as being closer to "truth" (a whiteness which is totally free from mixture with another color is most truly white) is discussed in chapter 2.[7] Plato's view was completely at odds with the prevailing taste of his time, for the most progressive and famous painters of his time were undoubtedly those who employed the technique of σκιαγραφία, the essence of which was found in the blending of light and dark shades of color. Plato, as we have said, had no sympathy with such painting (see σκιαγραφία).

6. Ἁπλοῦς and *simplex* seem to be formal cognates derived from the same Indo-European prototype. The basic meaning seems to be something like "having only one fold" or "one part," hence "uncomplicated, simple." See Hjalmar Frisk, *Griechisches Etymologisches Wörterbuch* (Heidelberg, 1960–72), s.v. ἁπλόος.

7. *Phlb.* 53A: ἀληθέστατον. . . τῶν λευκῶν.

ἁπλότης, ἁπλοῦς (haplotēs, haplous)

While Plato's view probably had little effect on the art of his time, it may have taken on new importance during the late Hellenistic period and during the Roman Empire, when a taste for neoclassical and archaistic styles in the visual arts and in literature became from time to time widespread. In passage 1 Dionysius of Halicarnassus speaks favorably of ἀρχαῖαι γραφαί, which used simple colors (i.e. colors that had no variety produced by mixture), but whose draftsmanship had great precision. Quintilian specifies Polygnotus and Aglaophon as artists whose *simplex color* had, in his (Quintilian's) time, zealous adherents (passage 4). The fact that Quintilian accuses these adherents of "making a display of connoisseurship" (*intellegandi. . .ambitu*) suggests that the value of pre-Apollodoran painting was a matter of controversy in the first century A.D. Quintilian seems to imply that the new appreciation of such painting in his own time was a kind of fad.

"Simple color" undoubtedly referred to pure color unmodulated by shading or any kind of mixture. This is evident not only from the passage in the *Philebus* mentioned previously but also from the pseudo-Aristotelian περὶ χρωμάτων (791a), where the ἁπλᾶ τῶν χρωμάτων are defined as those which are not the result of any mixture. Whether the colors used by Polygnotus and Aglaophon were completely unmodulated by shading, or whether they simply appeared so when compared to later work is impossible to determine.

One thing which does seem certain however is that *simplex color* does not refer to four-color painting. I have expressed elsewhere my misgivings about the accuracy of Cicero's contention that the four-color painters were Polygnotus, Zeuxis, and Timanthes.[8] It may be that four-color painting was the outcome not of a primitive stage in Greek painting but rather of a sophisticated theory of painting developed in the fourth century B.C. In any case four-color painting was not confined exclusively to early painters of the time of Polygnotus, whose works with their *simplex color* were considered *artis primordia* by Quintilian.

The uses of ἁπλότης in connection with sculpture (passages 2 and 3) do not seem to be connected with any systematic tradition of criticism. It is interesting to note, however, that, as was the case with color in painting, the idea of simplicity seems to be particularly associated with Archaic and Early Classical Greek art. To the modern eye these two styles are quite different in their effects. Archaic art often has an ornamental complexity which contrasts with the stolid simplicity of the "severe style." Perhaps it was the austerity and relative lack of χάρις (q.v.) of these two styles when compared to the styles which followed that united them in the ancient mind. In general, it does seem that "simple" also implies "early" in ancient art criticism.

8. See chapter 7, note 1.

ἀρετή (aretē)

1. Aristotle *Eth. Nic.* 1141a9. See ἀκρίβεια, passage 1.

2. Dionysius of Halicarnassus *Thuc.* 4.

> οὐδὲ γὰρ τὰς Ἀπελλοῦ καὶ Ζεύξιδος καὶ Πρωτογένους καὶ τῶν ἄλλων γραφέων τῶν διωνομασμένων τέχνας οἱ μὴ τὰς αὐτὰς ἔχοντες ἐκείνοις ἀρετὰς κρίνειν κεκώλυνται, οὐδὲ τὰ Φειδίου καὶ Πολυκλείτου καὶ Μύρωνος ἔργα οἱ μὴ τηλικοῦτος δημιουργοί.

[The fact that one lacks the ability of Thucydides does not disqualify one from making a critical evaluation of him.] Nor in the case of Apelles, Zeuxis, Protogenes, and the other painters are those who lack the same virtues as these artists hindered from passing judgment on them, nor do craftsmen who are not of the same stature refrain from evaluating the works of Phidias, Polyclitus, and Myron.

3. Plutarch *De Alex. fort.* 2.2 (*Mor.* 335B).

> μόνος γὰρ οὗτος, ὡς ἔοικε, κατέμηνε τῷ χαλκῷ τὸ ἦθος αὐτοῦ καὶ ξυνέφερε τῇ μορφῇ τὴν ἀρετήν. οἱ δ᾽ ἄλλοι τὴν ἀποστροφὴν τοῦ τραχήλου καὶ τῶν ὀμμάτων τὴν διάχυσιν καὶ ὑγρότητα μιμεῖσθαι θέλοντες οὐ διεφύλαττον αὐτοῦ τὸ ἀρρενωπὸν καὶ λεοντῶδες.

Only he [Lysippus], it appears, captured his [Alexander's] character in bronze and gave a suitable form to his essential nature. For others, wishing to reproduce the turning of his neck and the melting look and the brightness of his eyes, did not capture the manly and leonine side of his nature.

4. Maximus of Tyre *Diss.* 26.5 (ed. Hobein).

> ἡ Ὁμήρου ποίησις τοιάδε τις ἐστίν, οἷον εἰ καὶ ζωγράφον ἐννοήσαις φιλόσοφον, Πολύγνωτον ἢ Ζεῦξιν, μὴ γράφοντα εἰκῆ. καὶ γὰρ τούτων ἔσται τὸ χρῆμα διπλοῦν, τὸ μὲν ἐκ τῆς τέχνης, τὸ δὲ ἐκ τῆς ἀρετῆς, κατὰ μὲν τὴν τέχνην τὰ σχήματα καὶ τὰ σώματα εἰς ὁμοιότητα τοῦ ἀληθοῦς διασώζοντι. κατὰ δὲ τὴν ἀρετὴν εἰς μίμησιν τοῦ κάλλους τὴν εὐσχημοσύνην τῶν γραμμάτων διατιθέντι.

The poetry of Homer is rather like the work of a painter, say Polygnotus or Zeuxis, if you were to consider that painter a philosopher, a painter who does not just paint at random. For of such men the aim of their efforts will have two aspects: one aspect derived from art, the other from

[an awareness of] virtue; for he draws upon art in capturing the similarity of postures and bodies to real appearance, while he draws upon virtue in arranging lines into just the right form so as to produce an imitation of beauty.

Commentary

'Ἀρετή was not a frequent term in the criticism of the visual arts in Greece; and, when it did begin to play a role in such criticism, it already had a long history in Greek poetry and philosophy. The general lexical values of ἀρετή in English, "virtue" or "excellence," are hardly specific enough to render accurately all the uses of the word. In order to understand the precise significance of ἀρετή in the passages cited, we are obliged to form our judgment on the combined bases of the context of the passage in question and of what we know about the history of the word.

In Homer ἀρετή has the basic meaning of "excellence" or "capability," as in the *Iliad* 20. 411, where Polydorus, the swift-footed son of Priam, makes a show of his ποδῶν ἀρετή. More often in Homer, however, the term is used to refer to a quality of character, especially the particular excellence of a warrior, and is perhaps best translated as "valor." So in the *Iliad* 13.275 ff., Idomeneus tells Meriones that he is aware of the latter's ἀρετή because he has seen him stand firm in an ambush ἔνθα μάλιστ' ἀρετὴ διαείδεται ἀνδρῶν ("where the *aretē* of men is best discerned").[9] In the *Odyssey* the meaning of ἀρετή is extended to cover all good qualities of ability and character, as when Penelope refers to her husband as being παντοίῃς ἀρετῇσι κεκασμένον ἐν Δαναοῖσιν (*Od.* 4.725).

Thus already in Homer ἀρετή can be considered to have two distinct but obviously related shades of meaning: first, "excellence in the functioning of a particular thing"; and second, the excellence of certain traits of character. The latter shade of meaning develops in the fourth century into the concept of "moral virtue,"[1] that is, excellence in the practice of ethical behavior.

Both Plato and Aristotle indicate that their use of ἀρετή in this sense of "virtue" is really a convenient abbreviation for ἀνθρωπίνη ἀρετή (Aristotle *Eth. Nic.* 1.13.5; περὶ ἀρετῆς δὲ ἐπισκεπτέον ἀνθρωπίνης δῆλον ὅτι. . .; Plato *Rep.* 335C: 'Ἀλλ' ἡ δικαιοσύνη οὐκ ἀνθρωπεία ἀρετή) and that there

9. See also *Il.* 20.242; 11.90.

1. E.g. Plato *Rep.* 500D; *Laws* 968A. Aristotle's view of ἀρετή has already been discussed in chapters 2 and 3. His view of moral virtue is most clearly set forth in *Eth. Nic.* 2.5 ff. Moral virtues are defined as trained habits (ἕξεις) which enable a man to choose the mean between excess and deficiency in ethical behavior; see especially *Eth. Nic.* 1106b36 ff. The idea of "excellence in function" is, obviously, inherent in Aristotle's use of ἀρετή, even when the general translation of the word as "moral virtue" is employed.

145

were other types of ἀρετή not connected with man or with moral behavior. In the *Republic* 335B, C, for example, Socrates is made to point out, in refuting the validity of "doing harm" as an ethical principle, that the harm done to horses, dogs, and men, must be gauged according to the particular ἀρετή of each.

In the last-mentioned passage ἀρετή is used to convey not only the traditional idea of "excellence" but also the "essential nature" of the thing referred to. This value of the word is especially emphasized by Aristotle in the *Metaphysics* 1021b20, where he defines perfection as existing in a thing or person ὅταν κατὰ τὸ εἶδος τῆς οἰκείας ἀρετῆς μηδὲν ἐλλείπῃ μόριον τοῦ κατὰ φύσιν μεγέθους, "when according to the form of its characteristic excellence [or perhaps simply 'particular character'] it lacks nothing of its natural magnitude."

With this much background in mind, let us attempt to settle on the particular meaning of ἀρετή in the passages we have cited in connection with the visual arts. Beginning with passage 1, from the *Nicomachean Ethics,* we are confronted with the problem of establishing the exact meaning of οὐδὲν ἄλλο σημαίνοντες τήν σοφίαν ἤ ὅτι ἀρετὴ τέχνης ἐστιν, "meaning with regard to *sophia* nothing other than that it is (the) *arete* of (an) art." A variety of wordings are possible in the translation, but there can be no doubt that σοφία and ἀρετὴ τέχνης are being equated and that σοφία refers to some type of knowledge rather than to a particular character or activity. "Virtue" certainly is an unsatisfactory translation of ἀρετή. Even "excellence" is somewhat deceptive, since this term suggests a type of πράξις or performance, whereas what Aristotle is really referring to in Phidias and Polyclitus is their combination of scientific knowledge (ἐπιστήμη) and understanding or intelligence (νοῦς)—for so he defines σοφία in the passage immediately following the one in question (1141a19). As I understand this passage, Aristotle does not say that the σοφία of Phidias and Polyclitus is different in kind from the σοφία he defines, but he does imply that it is of an inferior order to that of the philosophical wise man because it is κατὰ μέρος ("partial, confined to one area of knowledge") and not ὅλως ("general"). Since ἀρετή appears to be synonymous with σοφία in this passage, it is probably best understood as a reference to the "knowledge which gives rise to excellence in art." If this is the correct interpretation, the sort of knowledge Aristotle is thinking of is most likely the principles and techniques which we have associated with professional criticism.[2]

Turning to the other passages illustrating the use of ἀρετή in connection with the visual arts, we will find once again that the term can only be under-

2. On this question, see chap, 1, n. 28.

stood properly when one takes account of the context in which it appears and the historical tradition to which the writer who uses it belongs. By drawing an analogy to the criticism of painting and sculpture in passage 2, Dionysius of Halicarnassus defends the right of the critic to evaluate great writers whose talent was clearly superior to the critic's own talent. In these arts, he maintains, those who did not have the same ἀρετάς as the artists (as few people could) did not feel hindered from rendering critical judgment (κρίνειν) on the works of these artists. This passage occurs in a work dealing with literature and rhetoric, and the meaning of ἀρετή here must be explained in the light of a specific usage of the term which developed in the rhetorical writings of the late fourth century b.c.[3]

Hellenistic rhetoricians recognized a number of essential or particular excellences in speech (λέξις), narration (διήγησις), and other branches of rhetoric. These ἀρεταί formed the foundation of the categories of criticism by which the critics of the late Hellenistic and Roman periods Dionysius and Quintilian, for example, judged the rhetorical literature of the past. The origin of this use of ἀρετή to denote a particular and essential element in literary style can be traced to Aristotle's *Rhetoric* 1404b1, where he speaks of the λέξεως ἀρετή as being σαφῆ. It is generally recognized, however, that the writer who first established a system of stylistic "excellences" for a good rhetorical style was Theophrastus, Aristotle's pupil and successor, whose four ἀρεταὶ λέξεως appear, with variations and partial omissions, in almost all later writers on rhetoric. Theophrastus's four ἀρεταί were Ἑλληνισμός ("purity of language"), σαφές ("clarity"), πρέπον ("appropriateness"), and κατασκευή ("ornament").[4] The Theophrastan concept of studying and criticizing the different parts of literary technique on the basis of their ἀρεταί was adopted by the Stoics, who apparently added one new ἀρετή—συντομία, "conciseness"—to the catalog.[5]

3. For the historical development of ἀρετή in rhetoric and the relevant sources see Johannes Stroux, *De Theophrasti Virtutibus Dicendi* (Leipzig, 1912).

4. See Cicero *Orat.*79 ff.: *Sermo purus erit et Latinus, dilucide planeque dicetur, quid deceat, circumspicietur; unum aberit, quod quartum numerat Theophrastus in orationis laudibus: ornatum illud, suave et affluens.* This is the most conclusive of the scattered sources which attribute these ἀρεταί to Theophrastus. The normal Latin translation of ἀρετή, as will be shown, was *virtus.* It has been plausibly suggested by W. Rhys Roberts in his introduction to the Loeb edition of Demetrius's *De Elocutione* that Cicero uses *laudibus* here to avoid confusion with the ethical connotation of *virtus.*

5. See Diog. Laert. 6:59, Ἀρεταὶ δὲ λόγου εἰσὶ πέντε. In the scattered references to Theophrastus's περὶ λέξεως we do not have a direct quotation of his use of ἀρετὴ τῆς λέξεως. But the fact that Aristotle originated the use of the term in a stylistic sense, plus its frequent use by Dionysius who acknowledges use of Theophrastus's work (*Comp.* 16), and the passage from Diogenes cited above make it almost certain that ἀρετή was Theophrastus's term for

147

ἀρετή (aretē)

As noted in chapter 3, these stylistic ἀρεταί came to be used in the course of the Hellenistic period as the basis for critical histories of rhetoric. The identification of particular excellences in the work of particular rhetoricians not only seems to have led in time to the development of a "Canon of Ten Orators" used by Caecilius Calactinus and other authors, but also produced works like the περὶ τῶν ἀρχαίων ῥητόρων of Dionysius of Halicarnassus, in which the stated purpose was to determine τί παρ'ἑκάστου (i.e. each of the orators analyzed) δεῖ λαμβάνειν ἢ φυλάττεσθαι (praef. 4).

As pointed out in chapter 3, at some point in the late Hellenistic period someone appears to have conceived the idea of compiling a comparative canon of rhetoricians and artists which compared their various ἀρεταί. Thus a critical approach originally developed for rhetoric came to be applied to the visual arts and fostered a keener awareness of the individual styles of different artists.

In passage 3, Plutarch's reference to Lysippos's portraits of Alexander, we find ἀρετή used in a way which is analogous to that in Hellenistic rhetoric—its ethical connotations are attenuated, and the real value of the word is something like "essence" or "essential characteristic." Only Lysippos, Plutarch says, could express Alexander's character (ἦθος) and give form to his ἀρετή. That ἀρετή does not simply mean "ethical virtue" or even "excellence" in the ordinary sense is made clear by the succeeding sentence in which Plutarch explains that the fault of other sculptors was that they concentrated on Alexander's surface characteristics—the turn of his neck, his liquid gaze—and thereby failed to preserve what was the real essence of his appearance—his ἀρρενωπόν, ("virile look") and his λεοντῶδες ("leonine quality").

We turn finally to passage 4, form the *Dissertationes* of Maximus of Tyre, a passage the importance of which was first recognized by Bernhard Schweitzer.[6] The passage may be summarized as follows: the poetry of Homer is comparable to the painting that a painter—such as Polygnotus or Zeuxis—would produce if he became a philosopher. This painter's method of creation would be twofold. First, through art (τέχνη) he would organize shapes and forms into a likeness of the "truth,"[7] and second, through ἀρετή, he would establish the "appropriate form" (εὐσχημοσύνη) of the painted figures to form an imitation of "the beautiful."

Schweitzer (*Xenokrates*, pp. 36 ff.) uses this passage to add another dimension to the φαντασία theory beyond what we have described in the text. He

what the Romans called *virtus dicendi*. The fragments of Theophrastus's treatise on style are edited by August Mayer, *Theophrasti περὶ λέξεως Libri Fragmenta* (Leipzig, 1910).

6. Schweitzer, *Xenokrates*, p. 40.

7. See ἀλήθεια-*veritas*.

feels that along with the development from naturalistic representation to spiritual expression, the formulators of this theory also recognized a progression in the levels of being—animal, human, and divine—whose essences were successfully captured in art. Myron, one of whose most famous works represented a heifer, mastered the ἀρετή of animals; Polyclitus captured the essence of the human form by giving it *decor*; and Phidias managed to express the ἀρετή of the gods. This progression is not directly stated by either Cicero or Quintilian, and I am inclined to suspend judgment on it. But Schweitzer is certainly correct in his assertion that Maximus's observations are related to the *phantasia* theory. Ἀρετή, in fact, seems to function as a synonym for φαντασία in this passage. As Schweitzer puts it, "Mit ἀρετή kann hier nicht etwa die Vorzüglichkeit des Künstlers gemeint sein—das ergäbe keinen reinen Gegensatz zu τέχνη in dem sie einbegriffen ist—sondern nur die des (idealen) Gegenstandes." Ἀρετή is here not the artist's own ethical virtue but his intuitive understanding of the characteristic excellence or essence of his subject.

The language into which the passage is set seems vaguely Platonic; ἀρετή is used in the sense of ἐπιστήμη, and μίμησις τοῦ κάλλους refers to the imitation of a Platonic ἰδέα.[8] This interpretation of the passage is supported by its context. Maximus is discussing the two levels of meaning on which Homer could be read—first, the obvious level of the story and its characters and, second, the level on which Homer's characters were to be interpreted as essential types—εἰκόνες παθῶν or νεότητος, for example. The first level would be that of τέχνη, the second that of ἀρετή.[9]

In this analysis of our passages in which ἀρετή occurs in connection with the visual arts we have discovered four distinct shades of meaning which are variations upon the basic sense of essential excellence. In at least two of the passages (2 and 4) and possibly three (passage 1) the variation in meaning seems to be dependent upon the particular tradition of criticism with which the passage happens to be associated. This fact emphasizes how important an appreciation of the varieties of ancient art criticism is for understanding individual passages. A particular critical term may have a widespread application not only in different areas of the visual arts but, as Ferri has pointed out,[1] even in completely separate disciplines—for

8. Note that in Hellenistic rhetoric the terms ἀρετή and ἰδέα were sometimes synonymous. See Mayer, *Theophrasti περὶ λέξεως Libri Fragmenta*, pp. 15 ff. and 17n1.

9. It is worth noting that elsewhere Maximus uses ἀρετή in the ordinary sense of "moral virtue." His *Dissertation* 27, for example, is entitled εἰ τέχνη ἡ ἀρετή, "Whether Virtue Is an Art." Here ἀρετή and τέχνη are compared rather than contrasted.

1. Silvio Ferri, "Tendenza unitaria delle arti nella Grecia antica," *Atti. R. Accademia di Palermo*, ser. 4, no. 2 (1942), 531–60.

ἁρμογή (harmogē)

example music or rhetoric; and yet the precise meaning of the term may vary considerably in these different contexts.

ἁρμογή (harmogē)

1. Pliny *NH* 35.29.

 Quod inter haec et umbras esset, appellarunt tonon, commissuras vero colorum et transitus harmogen.

 See *lumen et umbra*, passage 2.

2. Lucian *Im.* 6.

 ἔτι καὶ στόματος ἁρμογὴν ὁ αὐτὸς καὶ τὸν αὐχένα, παρὰ τῆς Ἀμαζόνος λαβών [παρέξει].

 And he [Phidias] will also furnish the merging of the mouth [with the face], and the neck, taking them from his Amazon.

 For context see εὐρυθμία, passage 8.

3. Lucian *Zeux.* 6.

 καὶ ἡ μῖξις δὲ καὶ ἡ ἁρμογὴ τῶν σωμάτων, καθ' ὃ συνάπτεται καὶ συνδεῖται τῷ γυναικείῳ τὸ ἱππικόν,. . .

 [On Zeuxis's picture of a family of centaurs:] The mixing and the transition of the bodies, whereby the horse part is fitted with and bound to the female part [is gradual and without harsh transitions.]

Commentary

In *harmoge*, the Latin transliteration of ἁρμογή (from ἁρμόζω, "fit, join"; hence "a joining, a fitting together"),[2] Pliny seems to have preserved for us one of the technical terms of Greek painting. The relationship between *lumen* and *splendor* on the one hand and *umbra* on the other was called τόνος, while the *commissuras* ("juxtaposition") and *transitus* ("transition from one color to another") was called ἁρμογή.

In passages 2 and 3 however, ἁρμογή lacks the precise technical significance which it has in Pliny's passage on painting. Lucian refers simply to the

2. The word is also used to mean the working union of different parts of a government (Polybius 6.18.1); in medicine it refers to the joining of bones (Galen [ed. Kühn] 19.460); in architecture to the jointing of masonry (Josephus *AJ* 13.11.3).

150

harmonious way in which the mouth of Phidias's Amazon was joined to the rest of the face (passage 2) and to the joining of the equine and human portions of a female centaur (passage 3).

'Ἁρμογή was also a term of literary criticism, referring to composition. Dionysius of Halicarnassus uses it to refer to the joining of clauses, words, and letters (*Comp.* 8, 22, 23). In painting, however, the term is part of a complex technical vocabulary and is too precise in its meaning to be simply a borrowing from literary criticism. Like τόνος and *splendor* (αὐγή), ἁρμογή was probably part of the terminology used by the Greek painters themselves and was probably transmitted to Pliny through professional treatises, such as Euphranor's *De Coloribus*. In Lucian, on the other hand, it is not improbable that ἁρμογή represents a term of literary criticism casually adapted to the needs to the writer's informal criticism of the fine arts.

ἁρμονία (*harmonia*)

1. Lucian *Zeux.* 5.

Τὰ μὲν οὖν ἄλλα τῆς γραφῆς, ἐφ' ὅσα τοῖς ἰδιώταις ἡμῖν οὐ πάντη ἐμφανῆ ὄντα τὴν ὅλην ὅμως ἔχει δύναμιν τῆς τέχνης, οἷον τὸ ἀποτεῖναι τὰς γραμμὰς ἐς τὸ εὐθύτατον καὶ τῶν χρωμάτων ἀκριβῆ τὴν κρᾶσιν καὶ εὔκαιρον τὴν ἐπιβολὴν ποιήσασθαι καὶ σκιάσαι ἐς δέον καὶ τοῦ μεγέθους τὸν λόγον καὶ τὴν τῶν μερῶν πρὸς τὸ ὅλον ἰσότητα καὶ ἁρμονίαν γραφέων παῖδες ἐπαινούντων, οἷς ἔργον εἰδέναι τὰ τοιαῦτα.

As for the other aspects of painting which are never completely apparent to amateurs like us but nevertheless contain the whole power of art—such as drawing lines with the most exact straightness, a precise mixture of colors and appropriateness in the application of them, shading according to need, the theory of magnitude [i.e. perspective], and proportion and harmony of parts to the whole—let the apprentices of painters praise them, for it is their job to know about such things.

2. Pausanias 8.41.8.

ναῶν δὲ ὅσοι Πελοποννησίοις εἰσί, μετά γε τὸν ἐν Τεγέᾳ προτιμῷτο οὗτος ἂν τοῦ λίθου τε ἐς κάλλος καὶ τῆς ἁρμονίας ἕνεκα.

[On the temple of Apollo at Bassae:] Of all the temples in the Peloponnesus, this one might be reckoned second only to that in Tegea for the beauty of its stone and its harmony.

151

ἁρμονία (harmonia)

3. Elder Philostratus Εἰκόνες 1.16.2.

κάθηται δὲ ἐφ'ἁρμονίᾳ τῆς βοὸς καὶ τοὺς Ἔρωτας ξυνεργοὺς ποιεῖται
τοῦ μηχανήματος, ὡς Ἀφροδίτης τι αὐτῷ ἐπιδεῖν.

He [Daedalus] is placed in front of the framework of the bull and is
depicted with Cupids as his assistants in the work on the device, so that
there should be something of Aphrodite connected with it.

Commentary

In spite of the close connections between the rise of professional art
criticism in fifth-century Greece and Pythagorean theories of proportion and
numerical harmony, the term ἁρμονία, which seems to have been a crucial
word in the Pythagorean vocabulary,[3] apparently played only a very small
role in the criticism of the visual arts.

The most literal meaning of ἁρμονία is "a fitting together" (from ἁρμόζω,
"fit"). It is so used by Homer to refer to the joining together of the planks
and bolts of ships (*Od.* 5.248 and 361). Later writers also use the word in
the sense of "a fitting together of physical parts," applying it to a variety
of disciplines such as anatomy[4] and building.[5] The use of ἁρμονία in
passage 3, from the *Imagines* of the Elder Philostratus, is clearly related to
these literal, concrete meanings. The ἁρμονία τῆς βοός referred to must
indicate a frame made of beams and joints upon which Daedalus was con-
structing the legendary bull. The passage thus really has no importance in
art criticism.

The extension of the meaning of ἁρμονία from a literal "fitting together"
of physical parts to the value of "harmony" in the sense that we use the word
today—an aesthetically or spiritually pleasing concord of diverse elements—
appears to have first arisen among musicians. Possibly the fact that the strings
of a lyre had to be "fitted together" properly before tonal concord could be
achieved led to the identification of tonal concord with ἁρμονία. In the earliest
usages of the term with reference to music, the idea of the actual stringing
of the lyre is clearly preserved. See Heraclitus, frag. 51 (Diels) ἁρμονία
τόξου καὶ λύρας (Plato *Symp.* 187A).

By the time of Aristotle ἁρμονία had already been adapted to the terminol-
ogy of rhetoric under the heading of λέξις, "style," and Aristotle's use of
the term (with reference to voice control and tone) clearly shows its musical

3. See Aristotle's use of the word in connection with Pythagorean thought: *Met.* 986a3 ff.
4. Hippocrates, κατ' ἰητρεῖον, 25; τὰ δὲ καὶ τῶν διστασίων τῶν κατὰ τὰς ἁρμονίας ἐν
τοῖσι κατὰ τὴν κεφάλην ὀστέων, i.e. the "joining" of bones.
5. Diodorus Siculus 2.8.2, referring to the fitting of blocks into a wall.

origin: τρία ("qualities of the voice") γὰρ ἐστὶ περὶ ὧν σκοποῦσιν. ταῦτα δ'ἐστὶ μέγεθος ἁρμονία ῥυθμός.[6] At a slightly earlier date Plato used ἁρμονία to refer to a fitting arrangement of words adaptable to music: ἁρμονίαν λόγων λαβόντας ὀρθῶς ὑμνῆσαι θεῶν τε καὶ ἀνδρῶν εὐδαιμόνων βίον ἀληθῆ (Tht. 175E).

By the end of the Hellenistic period, when the terminology of rhetoric (as well as many other disciplines) had been codified and standardized, we find ἁρμονία established as a standard term for composition of words with special regard for the concord between them. Dionysius of Halicarnassus uses ἁρμονία as a synonym for σύνθεσις ("composition"). Hence, in the περὶ συνθέσεως ὀνομάτων (De compositione Verborum) the different styles of composition are referred to as ἁρμονίαι: τῆς μὲν οὖν αὐστηρᾶς ἁρμονίας (sec. 22 beginning) or ἡ δὲ τρίτη καὶ μέση τῶν εἰρημένων δυεῖν ἁρμονιῶν, ἣν εὔκρατον καλῶ (sec. 24 beginning).

It is probably in this rhetorical sense that Lucian uses ἁρμονία in the passage from his Zeuxis cited passage 1. The whole passage is interesting as a rhetorician's confession of his own inadequacy to deal competently with the technical criteria which the painters themselves used to judge their own works. Lucian singles out precision of line, blending of colors, application of colors, control of shading, perspective,[7] and τὴν τῶν μερῶν πρὸς τὸ ὅλον ἰσότητα καὶ ἁρμονίαν, "the equation and harmony of parts to the whole," as characteristic technical criteria. The last phrase seems to be a rhetorician's way of expressing what a painter would express by συμμετρία; it is, in fact, a definition of συμμετρία. Since ἁρμονία is used as part of this definition, it would seem that the word itself did not have any independent status as a critical term in the visual arts.

Passage 2 raises one minor but interesting problem with regard to the meaning of ἁρμονία. As already pointed out, the term was used in a very literal way to refer to the jointing or fitting together of blocks in a stone building. Is it in this sense that Pausanias uses the term when he praises the ἁρμονία of the temple of Apollo at Bassae, or is he using the term in a more metaphorical way to express the overall effect of the proportions, decoration, setting, and so on of the temple? Since Pausanias does elsewhere use the term to mean a literal "jointing" or "fitting" (e.g. 8.8.8, where in discussing fortification walls, he notes that blocks can be dislodged ἐκ τῶν ἁρμονιῶν, i.e. "from their fittings;" also 9.33.7), one could take this as the meaning of the term

6. Rh. 3.1.4 (1403b31). 'Ρυθμός is used, in this case, in the sense of rhythmic "time." See ῥυθμός.

7. The likely meaning of τοῦ μεγέθους τὸν λόγον.

in connection with the Bassae temple.[8] My own feeling, however, is that Pausanias is, in this instance, implying something subtler than literal "jointing." The intent of the passage in question, unlike the others in which ἁρμονία is used, is clearly critical. He might, of course, simply be thinking in terms of good and bad jointing (although if the Bassae temple was covered with marble stucco, the jointing would have been, I assume, difficult to see). Pausanias was on the whole rather literal minded; but whether he was so literal minded that he could retain a mental image of the jointing of all the temples in the Peloponnesus and rank these images on a scale of relative excellence, is another question.

Silvio Ferri[9] has suggested that ἁρμονία and σύνθεσις were the terms which Pliny renders by *constantia* in *NH* 34.66, where it is said of Euthycrates that he *constantiam potius imitatus patris quam elegantiam austero maluit genere quam iucundo placere*. For discussion of this suggestion see *constantia*.

ἀρχαῖος (archaios)

1. Lindos Temple Chronicle 99 B.C., lines 88–90. See C.S. Blinkenberg, *Lindos, Inscriptions* (Berlin and Copenhagen, 1941), sec. 2, vol. 1, p. 167.

> . . . πίνακα [παναρχ]αικόν ἐν ᾧ ἦν ἐζωγραφημένος Φύλαρχος καὶ δρόμεις ἐννῆ πάντες ἀρχαικῶς ἔχοντες τοῖς σχήμασι. . .

> . . . an extremely ancient painted panel on which are depicted a Phylarch and nine runners, all represented in old-fashioned-looking formats. . .

2. Diodorus Siculus 5.55.2.

> ἀγάλματά τε θεῶν πρῶτοι κατασκευάσαι λέγονται, καί τινα τῶν ἀρχαίων ἀφιδρυμάτων ἀπ' ἐκείνων ἐπωνομάσθαι.

> They [the Telchines] are said to have been the first to make images of

8. For example, William B. Dinsmoor, *The Architecture of Ancient Greece* (London and New York, 1950), p. 155, seems to be leaning in this direction when he speaks of the "harmonious jointing" of the temple which attracted the attention of Pausanias; and Helmut Berve and Gottfried Gruben, *Greek Temples, Theaters, and Shrines* (New York), render ἁρμονία by "precision of jointing." On the other hand, W. H. S. Jones in the Loeb edition of Pausanias translates it by "symmetry," and Sir James Frazer in his translation uses "symmetry of proportions."

9. Ferri, *NC*, p. 139 (corollary 2).

the gods, and certain ancient images are said to derive their name from them.

3. Dionysius of Halicarnassus *De Isaeo* 4. See ἁπλότης, passage 1.

4. Demetrius *Eloc.* 14.

διὸ καὶ περιεξεσμένον ἔχει τι ἡ ἑρμηνεία ἡ πρὶν καὶ εὐσταλές, ὥσπερ καὶ τὰ ἀρχαῖα ἀγάλματα, ὧν τέχνη ἐδόκει ἡ συστολὴ καὶ ἰσχνότης, ἡ δὲ τῶν μετὰ ταῦτα ἑρμηνεία τοῖς Φειδίου ἔργοις ἤδη ἔοικεν, ἔχουσά τι καὶ μεγαλεῖον καὶ ἀκριβὲς ἅμα.

Thus the older style [the style of Gorgias, Isocrates, and Alcidamas] has a certain polish and orderliness, rather like ancient statues, of which the technique seemed to be characterized by compactness and spareness, while the style which was current later on is like the works of Phidias, in that it already seems to have a certain grandeur and precision.

5. Dio Chrysostom *Or.* 37.11.

ἵνα δὲ καὶ τῆς ἀρχαίας τέχνης ᾖ τῆς Δαιδαλείου. . . .

Well, suppose that the statue [a statue of the speaker, probably not Dio, set up in Corinth] were an example of the ancient workmanship of Daedalus [so that it could move freely].

6. Pausanias 3.22.4.

. . .ἐπεὶ Μάγνησί γε, οἳ τὰ πρὸς Βορρᾶν νέμονται τοῦ Σιπύλου, τούτοις ἐπὶ Κοδδίνου πέτρᾳ μητρός ἐστι θεῶν ἀρχαιότατον ἁπάντων ἄγαλμα.

[The inhabitants of Acriae in Laconia claim that their sanctuary of the Mother of the Gods is the oldest in the Peloponnesus,] although the Magnesians, those who dwell on the northern slope of Mount Sipylus, have on the rock called Coddinus the most ancient image of all of the Mother of the Gods.

7. Pausanias 8.40.1.

Φιγαλεῦσι δὲ ἀνδριάς ἐστιν ἐπὶ τῆς ἀγορᾶς Ἀρραχίωνος τοῦ παγκρατιαστοῦ, τά τε ἄλλα ἀρχαῖος καὶ οὐχ ἥκιστα ἐπὶ τῷ σχήματι.

At Phigalia there is a statue in the agora of the pankratiast Arrhachion,

155

ἀρχαῖος (archaios)

which is old-fashioned looking in a number of ways, not the least of which is its composition.

8. Pausanias 10.38.7.

τοῦτο οὖν τὸ ἄγαλμα τῆς ἐν τῇ ᾽Αμφίσσῃ ᾽Αθηνᾶς καὶ ἰδεῖν ἐστιν ἀρχαιότερον καὶ ἀργότερον τὴν τέχνην.

This particular image [of Night, by Rhoecus, in the temple of Artemis at Ephesus] is certainly more ancient looking and cruder in workmanship than the Athena in Amphissa.

See also Pausanias 1.27.1, 1.24.3, 7.5.5.

9. Philostratus *VA* 4.28.

. . . τὸ δὲ ἔργον τῶν δακτύλων καὶ τὸ μήπω διεστὼς τῇ ἀρχαίᾳ ἀγαλματοποιίᾳ προσκείσθω.

[Apollonius interprets an archaic statue of Milon of Croton at Olympia] . . . as to the way the fingers are represented, the fact that there is no space between should be ascribed to an old-fashioned style of image making.

Commentary

By the first century B.C. the use of the term ἀρχαῖος in connection with the visual arts appears to have had specific chronological and stylistic connotations, which also apply to *vetus* and *vetustas*, the Latin counterparts of ἀρχαῖος and ἀρχαιότης.

First, we shall discuss the chronological connotations. The rhetorician Demetrius apparently classifies all pre-Phidian statues as ἀρχαῖα ἀγάλματα (passage 4); Quintilian (*Inst.* 12. 10.3) implies that the only interest a pre-Polygnotan painting could have was the quality of *vetustas*. Dio Chrysostom (passage 5) associates ἀρχαῖα τέχνη with the art of Daedalus. Pausanias, as far as we can tell, uses ἀρχαῖος to refer to works of what we now call the Archaic period.[1] Diodorus Siculus appears to refer, in passage 2, to the oldest statues then known in Rhodes. Taken together, these authors seem to indicate that ἀρχαῖος could be used to describe works of art dating from anywhere between the remote, legendary past and the Early Classical period.

1. Sir James Frazer, *Pausanias' Description of Greece* (London, 1898), vol. 4 in commenting on Pausanias 8.40.1 (passage 7), claims to have seen a damaged Archaic statue in a village near Phigalia, which he identified with the Arrhachion described by Pausanias.

The works of the Early Classical period itself, according to Quintilian's and Cicero's presentation of the history of art, were transitional, retaining some of the Archaic *rigor* but gradually approaching the *pulchritudo* that characterized the art of Phidias. In general, then, we may say that later Greek writers use ἀρχαῖος in a manner that is very close to the use of *Archaic* by twentieth-century art historians, that is, to characterize works of art produced before about 480 B.C.

Like our word *Archaic*, ἀρχαῖος connoted not only the date of a work of art but also its style; hence Pausanias had no trouble in recognizing that the Arrhachion was ἀρχαῖος καὶ οὐκ ἥκιστα ἐπὶ τῷ σχήματι (passage 7), and the writers of the Lindos Chronicle (passage 1) could recognize figures (in a painting) that πάντες ἀρχαικῶς ἔχοντες τοῖς σχήμασι. Their ability to formulate these judgments need not surprise us, especially when we remember that Greek artists after the Archaic period always had a clear idea of what the Archaic style was. To cite just a few examples, Alcamenes recalled it in his Hermes Propylaeus;[2] the sculptors of the frieze of the temple of Apollo at Bassae recalled it in their representation of an ancient cult image,[3] and the sculptors of the Hellenistic period produced archaistic reliefs to cater to the retrospective taste of their time.[4]

Finally there is the question of what value ancient writers on the history of art attached to the ἀρχαῖος or ἀρχαϊκὸς σχῆμα. Pausanias accepts its existence as an artistic fact and expresses no personal opinion as to its merits or faults, although in passage 8 he admits that its appearance was perhaps "rough," or "unrefined" (ἀργότερον). Demetrius commends its "compactness" and "spareness" but clearly prefers the art of Phidias and his successors (passage 4). Dionysius of Halicarnassus admires the simplicity, charm, and precision of ἀρχαῖαι γραφαί (passage 3), and his admiration probably reflects to some extent the taste of his time (see ἁπλότης), but there is no indication that he in general preferred "Archaic painting" to later, more complicated styles.

The ambivalence suggested here is amplified by the Roman writers. Quintilian, presumably deriving his material from earlier writers on rhetoric but using an evolutionary approach to art which probably goes back to Xenocrates, says that no work before Polygnotus is interesting for anything but its age and that even the works of Polygnotus are "almost primitive" (*prope rudia*). The earliest sculptors whom he mentions, Callon and Hegesias, are *Tuscanicis proxima*, "close in style to Tuscanic works," that is, like Archaic Etruscan art.[5]

2. Richter, *SSG*⁴, p. 182 fig. 673.

3. Hedwig Kenner, *Der Fries des Tempels von Bassae—Phigalia* (Vienna, 1946), pl. 5.

4. Werner Fuchs, *Die Vorbilder der neuattischen Reliefs* (Berlin, 1959), pp. 44–59.

5. *Tuscanicus* is used here as it is used by Vitruvius 4.6.6, not to mean Etruscan (which

αὐθάδεια (*authadeia*)

To Quintilian's evolutionary outlook, which saw little merit in Archaic art, we may contrast Pliny's admiration for architectural sculptures dating from around the time of the Etruscan sculptor Vulca (ca. 490 B.C.): ". . . *mira caelatura et arte suique firmitate, sanctiora auro, certe innocentiora*" (see *firmitas*, passage 2). Presumably this remark is indicative of Pliny's personal taste, since most of his sources, as noted in chapter 6, seem to have reserved their praise for the art of later eras.[6] The difference in outlook between Pliny and Quintilian suggests once again a parallel between ancient and modern views of what characterizes Archaic art. In our own time, as in the first century A.D., there have been critics who revered Archaic art for its purity and innocence and those who looked upon it as an essentially primitive precursor to greater, later developments.[7]

αὐθάδεια (*authadeia*)

1. Diogenes Laertius 4.18.

> καὶ ὅλως ἦν τοιοῦτος οἷόν φησι Μελάνθιος ὁ ζωγράφος ἐν τοῖς περὶ ζωγραφικῆς, φησὶ γὰρ δεῖν αὐθάδειάν τινα καὶ σκληρότητα τοῖς ἔργοις ἐπιτρέχειν, ὁμοίως δὲ κἂν τοῖς ἤθεσιν

> And he [Polemon] was just such a man as Melanthius describes in his treastise on painting, for he says that one should strive to put a certain willfulness and hardness into one's works, just like that which exists in the characters.

Commentary

This passage appears to be one of the rare examples of a direct quotation

would be *Tuscus*) but Etruscanlike, having a style which in Italy was perhaps most commonly exemplified by Etruscan art.

6. It is possible that Pliny's remark reflects the emperor Vespasian's desire to revive respect for ancient Italic traditions as an antidote to the decadent philhellenism of Nero. But archaism was a part of the taste of his time, and he may simply be expressing a feeling which came to many educated men in the late Hellenistic and early Roman periods.

Another indication of an appreciation of the virtues of Archaic art is suggested by the use of the word πίνος in the criticism of rhetoric. One literal meaning of the word is the patina on an aging bronze statue, as in Plutarch *De Pyth. or.* 395b: . . . ἐθαύμαζε δὲ τοῦ χαλκοῦ τὸ ἀνθηρὸν ὡς οὐ πίνῳ προσεοικὸς οὐδ' ἰῷ. In rhetoric the term suggested a style which had an "Archaic flavor"; e.g. Dionysius of Halicarnassus *Pomp.* 2: ὅ τε πίνος ὁ τῆς ἀρχαιότητος ἠρέμα αὐτῇ καὶ λεληθότως ἐπιτρέχει; also *Dem.* 38; *Comp.* 9, 13, 22.

7. Ernst Buschor, *Frühgriechische Jünglinge* (Munich, 1950), p. 1; Rhys Carpenter, *Greek Sculpture* (Chicago, 1960), pp. 47 and 57.

from an ancient treatise on painting;[8] it also provides the only recorded example of the use of αὐθάδεια in connection with the visual arts. This term is included in the glossary, not because it is of great importance in the terminology of Greek art criticism as a whole, but because it documents the personal opinion of a prominent fourth-century painter, whose views were undoubtedly symptomatic of the taste of his age.

The word αὐθάδεια, "stubbornness, willfulness," is frequently used to describe a type of character; it is, in fact, a subclassification of ἦθος (q.v.). Aeschylus uses "αὐθαδίαν" in *Prometheus Bound* 79 to describe the nature of the personification of κράτος, "Power"; Aristotle classifies it in the *Eudemian Ethics* 1221a8 as a mean between ἀρέσκεια and σεμνότης; and Theophrastus exemplifies it in his *Characters* 15.[9]

It seems probable that Melanthius also used αὐθάδεια to describe a quality of human character rather than a formal quality of style or technique. A convincing explanation of our passage along these lines was offered by H. L. Urlichs,[1] who held that Melanthius's comment referred specifically to portraiture rather than to painting in general. The αὐθάδεια τινα καὶ σκληρότητα which the painter felt should appear in works of art were those which were τοῖς ἤθεσιν, "in the character," in other words in the personality and hence in the appearance of the subjects whose portraits were painted. Such an interpretation is consistent with the context in which the passage appears: Diogenes Laertius uses Melanthius's comment to illustrate what kind of man (ἦν τοιοῦτος) Polemon (head of the Academy, 314–276 B.C) was.

διάθεσις (diathesis)

1. Polybius 12.28.Al. See σκηνογραφία, passage 2.

2. Diodorus Siculus 4.76.2.

βλέπειν τε γὰρ αὐτὰ καὶ περιπατεῖν καὶ καθόλου τηρεῖν τὴν τοῦ ὅλου σώματος διάθεσιν, ὥστε δοκεῖν εἶναι τὸ κατασκευασθὲν ἔμψυχον ζῷον.

For these [the statues of Daedalus] could see and could walk and completely preserved the entire disposition of the body, so that what was actually a construction of art seemed in fact to be a living being.

8. See also Pliny *NH* 35.80, which may be a direct quotation from Apelles' writings.
9. Here to be interpreted as "surliness" more than "stubbornness."
1. H. L. Urlichs, *Über Griechische Kunstschriftsteller* (Würzburg, 1887), pp. 19–20.

διάθεσις (*diathesis*)

3. Vitruvius 1.2.1–2.

Architectura autem constat ex ordinatione, quae graece taxis dicitur, et ex dispositione, hanc autem Graeci diathesin vocitant. . . . Dispositio autem est rerum apta conlocatio elegansque conpositionibus effectus operis cum qualitate. Species dispositionis, quae graece dicuntur ideae, sunt hae, ichnographia, orthographia, scaenographia.

Architecture consists of Order [*Ordinatio*], which in Greek is called *taxis*, and of Arrangement [*Dispositio*], which the Greeks call *diathesis*. . . . Arrangement involves a suitable grouping of parts in respect to one another and also an elegant execution in composition which depends upon subjective evaluation [rather than measurement]. The subcategories of Arrangement, which in Greek are called *ideai* are ground plan, elevation, and perspective.

4. Plutarch *Arat*. 32.3.

τὸ δὲ ἔργον ἐν τοῖς μεγίστοις διεβοήθη, καὶ Τιμάνθης ὁ ζωγράφος ἐποίησεν ἐμφαντικῶς τῇ διαθέσει τὴν μάχην ἔχουσαν.

This deed [Aratus's rescue of Pellene from the Aetolians] was praised as one of his greatest, and the painter Timanthes did a picture which, through its disposition of details, shows the battle very vividly.

5. Plutarch *De def. or*. 47 (*Mor*. 436B).

ἄνευ δὲ φαρμάκων συντριβέντων καὶ συμφθαρέντων ἀλλήλοις, οὐδὲν ἦν οἷόν τε τοιαύτην διάθεσιν λαβεῖν καὶ ὄψιν.

[Works of art are the products of reason and art working upon raw material. This is the case, for example, with Polygnotus's Sack of Troy at Delphi.] For without pigments being ground together and blending with one another so as to lose their identity, it would not have been possible to achieve [or grasp?] such a composition and such a sight.

6. Plutarch *Dem*. 22.2.

ἔτυχε τοῖς Ῥοδίοις ὁ Καύνιος Πρωτογένης γράφων τὴν περὶ τὸν Ἰάλυσον διάθεσιν,. . .

It happened that the painter Protogenes of Caunus was working on a representation of the story of Ialysus for the Rhodians [when Demetrius attacked the city].

7. Plutarch *Pericles* 13.5.

Τὸ δ' Ὠδεῖον, τῇ μὲν ἐντὸς διαθέσει πολύεδρον καὶ πολύστυλον, τῇ δ'ἐρέφει περικλινὲς καὶ κάταντες ἐκ μιᾶς κορυφῆς πεποιημένον, . . .

The Odeum, in its interior arrangement, had many seats and columns, and, as for its roof, it was made so that it sloped and descended from a single peak, [a form which was said to be an imitation of the tent of the Persian king].

8. Maximus of Tyre *Diss.* 26.5. See ἀρετή, passage 4.

9. Pausanias 5.20.2.

. . . ὄπισθε δὲ ἡ διάθεσίς ἐστιν ἡ τοῦ ἀγῶνος.

. . . and on the back [of a gold table by Colotes at Olympia] the scene represented is the agonistic festival.

10. Athenaeus 196F.

. . . τινὲς μὲν εἰκόνας ἔχουσαι τῶν βασιλέων ἐνυφασμένας, αἱ δὲ μυθικὰς διαθέσεις.

. . . [decorating the piers of the festival tent of Ptolemy II there were, among other things, soldiers' cloaks,] some having portraits of kings woven into them, others mythological scenes.

11. Athenaeus 204F–206B.

a. 204F.

. . . ἡ δὲ διάθεσις τοῦ μὲν καταγείου περιστύλῳ παραπλήσιος·

. . . the arrangement of the one [one of the outer promenades on the river boat of Ptolemy IV] below the deck was like a peristyle.

b. 205A.

τοῦτο δὲ διελθοῦσιν ὡσανεὶ προσκήνιον ἐπεποίητο τῇ διαθέσει κατάστεγον ὄν.*

*κατάστεγον ὄν. K; κατάστεγον. νωι A.

Passing through this [a doorway in the entrance vestibule of the ship] a kind of proscenium, which was roofed over in its design, was constructed to confront one.

διάθεσις (diathesis)

c. 205E.

στέγη δὲ τῆς τοῦ θεοῦ διαθέσεως οἰκεία, and elsewhere.

[The ship contained a chamber dedicated to Dionysus.] The ceiling was appropriate to the nature [or disposition] of the god.

12. Athenaeus 210B.

καὶ Πολέμων ὁ περιηγητὴς εἶπεν ἐν τρίτῳ τῶν πρὸς 'Αδαῖον καὶ 'Αντίγονον, ἐξηγούμενος διάθεσιν ἐν Φλιοῦντι κατὰ τὴν πολεμάρχειον στοὰν γεγραμμένην ὑπὸ Σίλλακος τοῦ 'Ρηγίνου,. . .

Likewise Polemon the traveler in the third book of his *Epistles to Adaeus and Antigonus,* in describing the subject matter [or disposition of details?] of a painting in the Polemarcheum in Phlius painted by Sillax of Rhegium, says . . . [that a bronze vessel-stand with a cup upon it was depicted in it.]

See also Athenaeus 201F: . . . διάθεσεις πολλαί . . . ("many items" or "many subjects" in the procession of Ptolemy II).

13. Porphyry *Abst.* 4.3. See ῥῶπος, passage 4.

Commentary

Aristotle, in the *Metaphysics* 1022b1, defines διάθεσις as follows:

Διάθεσις λέγεται τοῦ ἔχοντος μέρη τάξις ἢ κατὰ τόπον ἢ κατὰ δύναμιν ἢ κατ' εἶδος. θέσιν γὰρ δεῖ τινὰ εἶναι, ὥσπερ καὶ τοὔνομα δηλοῖ ἡ διάθεσις

Diathesis is the arrangement of that which has parts, either in space or in power or in form. It must be a kind of positioning, as the word *diathesis* implies.

Aristotle's definition of διάθεσις on the basis of its component parts (διά +τίθημι = "place throughout") clearly gives us the basic sense of the word; and yet, upon a review of the passages in which διάθεσις appears in connection with the visual arts, we find that this basic sense of "disposition" or "arrangement" is not actually the most common meaning of the term.

In several of the passages quoted here the term seems to mean "subject matter" or "content." In passage 6, for instance, Plutarch's phrase περὶ τὸν 'Ιαλυσὸν διάθεσιν is best translated "the story about Ialysus." In passage 12 Polemon explains the διάθεσις of a painting by Sillax of Rhegium which was on the wall of the Polemarcheum in Phlius by saying that it was "a bronze vessel-stand and upon it a cup" while the idea of composition or "arrange-

162

ment" is no doubt latent in Polemon's explanation, the most colloquial translation of διάθεσις would seem to be "subject" or "scene." When Pausanias says in passage 9 that on the back of a gold table by Colotes at Olympia "the διάθεσις is of the *agon*," the term is perhaps best translated as "scene," implying perhaps both its form and its subject matter. Athenaeus, in passage 10, describing tapestries hung in the festival tent of Ptolemy II, says that some had portraits of kings woven into them, while others had μυθικάς διαθέσεις. Again it seems most reasonable to translate the phrase as mythical "subjects" or perhaps "scenes." I have also used "subjects" to translate Polybius's use of διάθεσις in passage 1, although here "compositions" or even "structures" are possible.

The meaning of διάθεσις in passage 4 is less certain. The phrase Τιμάνθης ὁ ζωγράφος ἐποίησεν ἐμφαντικῶς τῇ διαθέσει τὴν μάχην ἔχουσαν has been variously translated. Bernadotte Perrin, the translator of the Loeb edition of Plutarch's *Life of Aratus*, rendered it by "Timanthes the painter made a picture of the battle in which its composition vividly portrayed the event." Such a translation, although fluent in English, is really a paraphrase of the Greek wording. F.W. Schlikker takes διάθεσις in the sense of "Entwurf, Auffassung" and apparently would translate it: "Timanthes made a painting of the battle which was vivid in its conception."[2] It is also possible, however, that the sentence simply means, "Timanthes made a vivid painting having the battle as its subject."[3] In my own translation I have chosen to adhere to the basic meaning "disposition of details." Passage 5 is also ambiguous. Plutarch probably refers to "composition" or "arrangement," but he could also mean "subject" or "scene."

Besides the sense of "subject matter," our catalog shows other peculiar shades of meaning for διάθεσις. In passage 11c Athenaeus, in speaking of a ceiling over a sanctuary in the great ship of Ptolemy IV, says that the ceiling was "appropriate to the διάθεσις of the god." The simplest translation of διάθεσις here would be "nature" or "character." Perhaps, in order to preserve a suggestion of the root idea of "disposition," one could also translate it as the "makeup" of the god. Porphyry's use of διάθεσις in passage 13 to mean "salability" seems to derive from a strange twist in the semantic develop-

2. Schlikker, *HV*, p. 78n18. He omits the final ἔχουσαν in quoting the passage. It is not clear to me whether by "Entwurf, Auffassung" he means the actual composition of the painting or, in a more abstract way, its conception.

3. One early editor, Madvig, proposed that γραφήν should be added to the text after ζωγράφος. This reading would account for the difficult final participle ἔχουσαν, which otherwise must be taken as a useless modifier of μάχην. If γραφήν is either added to or understood in the text, the translation of τῇ διαθέσει τὴν μάχην ἔχουσαν as "having the battle for its subject" or "in its subject matter" is perhaps possible.

ment of διά and τίθημι: in putting something into order, one is in a sense disposing of it (compare Latin *dispositio*); that which can be disposed of is salable, hence "salability" could be called διάθεσις (see *LSJ*⁹, 1:4).

In all of the passages discussed here it is not difficult to see how the original sense of "arrangement" or "disposition" was extended to mean "subject" or "nature" or "costume," for all these meanings express the result of an arrangement or disposition of parts. A relief of the Olympic games or a painting of a battle, for example, undoubtedly necessitated the placement of many figures. These figures, when taken together, formed not only the composition of the painting but also its content—both expressed by διάθεσις. In the same manner the nature of a god might be thought of as the result of an arrangement of diverse elements.[4]

Our catalog also indicates, however, that these various meanings of διάθεσις cannot be assigned to any particular period of time or any particular author. Plutarch and Athenaeus, for example, both of whom used the word in the sense of "subject," also use it in the more literal sense of "arrangement." In passage 11a Athenaeus describes the διάθεσις of a lower deck in the ship of Ptolemy IV as being "like a peristyle" and in 11b he describes another room in the ship as being "a kind of proscenium" in composition. In passage 7 Plutarch describes the inner διάθεσις of the Odeum of Pericles by saying that it had many seats, many columns, and so on. It is clear that in all these passages διάθεσις means "arrangement" or "composition." This basic meaning is also illustrated by passage 2, where Diodorus refers to the "composition" of the body in the statues of Daedalus, and passage 8, where Maximus of Tyre uses a participial form of διατίθημι to refer to the "arrangement" of drawn figures.

With this background we turn to what are really the two most important passages relating to διάθεσις in the visual arts, passage 3, which is Vitruvius's discussion of διάθεσις-*dispositio* as a basic component in architecture, and *NH* 35.80, in which Pliny quotes Apelles as saying that he (Apelles) was inferior in *dispositione* to the painter Melanthius (for text see *dispositio*, passage 4).

In order to make an intelligible translation of Vitruvius's definition of διάθεσις-*dispositio* as a *rerum apta conlocatio elegansque conpositionibus effectus operis cum qualitate,* the meanings of two problematical terms, *effectus* and *qualitas* have to be determined; and beyond that, certain liberties have to be taken with the Latin grammar. *Effectus* can mean either "effect" or "execution." In two common English translations of the work we find that the former sense

4. In the case of διάθεσις meaning "nature," it is interesting to note that the English word "disposition," derived from the Latin translation of διάθεσις, is also used to mean both "arrangement" and "temperament," or "nature"—e.g. a "quarrelsome disposition."

is adopted. Frank Granger in the Loeb edition of Vitruvius translates the whole definition by: "arrangement, however, is the fit assemblage of details, and, arising from this assemblage, the elegant effect of the work and its dimensions, along with a certain quality or character";[5] M. H. Morgan renders it by "arrangement includes the putting of things in their proper places and the elegance of effect which is due to adjustments appropriate to the character of the work."[6] Silvio Ferri, on the other hand, takes *effectus* in the sense of "execution" and translates the definition as follows: "La 'dispositio' è l'adatta messa in opera delle cose, e l'elegante esecuzione dell' edificio nelle varie composizioni, dal punto di vista della qualità."[7]

A decision as to which of these meanings is correct probably depends upon how one interprets the phrase *cum qualitate*. The significance of this phrase was put into what is probably its proper perspective in an extremely valuable article by Carl Watzinger written in 1909.[8] Watzinger observed that just as there is a basic division in Vitruvius's thinking between the *opus* and the *ratiocinatio* in the activity of an architect (see chap. 5), that is, between practical activity and theory, so too, in criticism and analysis of a work of architecture there is a basic distinction between understanding what a building consists of and what its effect is. These two poles of evaluation could be summed up by the dual Greek standards ποσότης-ποιότης, of which the Latin equivalents are *quantitas-qualitas*.

Watzinger proposed that the six elements of architecture which Vitruvius describes in 1.2.1–9—namely, τάξις (*ordinatio*), διάθεσις (*dispositio*), εὐρυθμία, συμμετρία, decor (probably the Greek πρέπον), and οἰκονομία (*distributio*)—actually constituted three separate critical principles, each consisting of pairs of terms constructed on the ποσότης-ποιότης antithesis. These pairs were:

τάξις-συμμετρία
διάθεσις-εὐρυθμία
οἰκονομία-πρέπον (decor)

Within each of these pairs one term referred to the artist's activity or task and the other to the effect which was produced by the successful completion of this task. Thus, in the first pair τάξις (*ordinatio*), which, Vitruvius says, *conponitur ex quantitate quae graece posotes dicitur*, referred to the artist's adjustment of the measurements and proportions in his work, while συμμετρία, the

5. Loeb Classical Library edition of Vitruvius (London; Cambridge, Mass., 1931), p. 25.
6. M. H. Morgan, *Vitruvius, the Ten Books on Architecture* (Cambridge, Mass., 1914; reissued New York, 1960), p. 13.
7. Ferri, *Vitruvio,* p. 53.
8. Carl Watzinger, "Vitruvstudien," *RhM* 64 (1909): 202–03.

165

counterpart of ordinatio-τάξις, referred to the result within the work of art produced by these adjustments. A similar relationship existed between διάθεσις-dispositio and εὐρυθμία. In Watzinger's opinion the pair τάξις and συμμετρία referred only to the measurements of the individual members of a work and their commensurability with other members, while διάθεσις + εὐρυθμία referred to placement of all these elements together and the resultant effect—in short, to architectural composition. The final pair οἰκονομία and decor (πρέπον) referred to the creation of a form appropriate to its meaning. The system to which these groups of terms belonged was felt by Watzinger to be of Stoic origin and was thought to have been first developed by Posidonius, perhaps for use in literary and rhetorical criticism.[9] I have suggested in chapter 5 that it is unlikely that Vitruvius derived his critical terminology from any single source,[1] and our commentaries on some of the other terms used by Vitruvius will, I think, bear this out; but the fundamental value of Watzinger's observations is not lessened by these reservations.

If we return to Vitruvius's definition of διάθεσις-dispositio and remember that διάθεσις seems to be a matter of ποσότης rather than ποιότης (or, in a parallel phraseology suggested by Watzinger, an ἔργον rather than a τέλος [see n. 9]), we should perhaps take effectus as a reference to the architect's actual work, hence "elegant execution" as suggested by Ferri, and take the phrase cum qualitate to refer to the particular qualitas, that is, eurhythmia, which must accompany διάθεσις.[2]

In spite of the complicated associations which διάθεσις has taken on in Vitruvius's system, it is clear that the word basically referred to composition —to the placement of individual parts within a whole—in the critical tradition from which Vitruvius drew. Since passage 3 is the only example, among the passages which we have thus far discussed, of διάθεσις used as a technical term in a branch of professional criticism, it has an important bearing on our interpretation of Pliny NH 35.80, which also seems clearly to stem from

9. Watzinger, RhM 64(1909):207 and 221–23. He notes that the relationship between each term in the Vitruvian pairs might be alternatively described as that between the ἔργον and τέλος of an art. This distinction, in a Latin version, is recognized by Cicero Inv. Rhet, 1.5.6 when he speaks of the officium and finis of the rhetorician. The same type of division is expressed in an even more general way by Vitruvius when he speaks of "that which signifies" (significat) and "that which is signified" (significatur) in architecture (1.1.3). This latter pairing has a close parallel in rhetoric in the division between vox or verba and res (that which does the signifying and that which is signified), which is attributed by Quintilian, Inst 3.6.37, to Posidonius.

1. Ferri, Vitruvio, p. 51 (bottom), agrees.

2. Watzinger, p. 12, suggested that the Greek source from which Vitruvius derived the second half of his definition probably read: ἡ ἐκ τῶν συνθέσεων εὐπρεπὴς τοῦ ἔργου ἐξεργασία μετὰ ποιότητος. Vitruvius may have struggled with such language (assuming that it is reasonably close to the original), and one may wonder to what extent he really understood it or cared to understand it.

the tradition of professional criticism. Apelles is quoted in this passage as saying that he was inferior in *dispositione* to Melanthius. We may reasonably assume, using Vitruvius's equation of *dispositio* and διάθεσις as evidence, that Apelles referred in the original Greek to διάθεσις and that he was using a technical term for some aspect of composition which formed part of the critical vocabulary of Greek painters in the fourth century B.C. (It is, of course, possible that he was referring to "subject matter," which, as we have seen, was a common meaning of διάθεσις when used in connection with painting; but the fact that the passage is derived from professional criticism would seem to favor interpreting it in the sense of "composition.")[3] Our understanding of the exact meaning of the term, however, is complicated by the fact that Apelles, in the same passage, reportedly acknowledged his inferiority to Ascelpiodorus in *mensuris* (τοῖς μέτροις?), which Pliny defines as *quanto quid a quoque distare debet*, "how much one thing should be distant from another." It is clear from this that *mensuris* also referred to an aspect of composition. In view of the fact that διάθεσις can refer to the disposition of separate elements within a total form (e.g. passages 3 and 7), it may be that the term refers to "grouping" in painting—that is, how the figures within the painting are placed in relationship to one another. This would be more a question of pattern than measurement. *Mensuris* in Apelles remark would then refer to the actual distances between the figures and groups of figures. It may also possibly have referred to the apparent "distance" between the figures in a painting in terms of perspective. In any case it may be that *dispositione* and *mensuris* in Pliny's version of Apelles' remark are related in the same way as διάθεσις and τάξις in Vitruvius.

ἔνδοξος (endoxos)

1. Strabo 14.2.19.

ἐν δὲ τῷ προαστείῳ τὸ Ἀσκληπιεῖον ἐστι, σφόδρα ἔνδοξον.

In the outskirts [of the city of Cos] is the Asklepieion, a place of great renown.

3. Schlikker, *HV*, p. 78n18, appears to imply that the διάθεσις in which Apelles yielded to Asclepiodorus meant "creative conception" or "imaginative disposition." There are parallels in literary criticism for such a meaning, for example Polybius 34.4, where διάθεσις is included with ἱστορία and μῦθος as one of the component parts of "poetic license." The aim of ἱστορία is to record the truth; the end of μῦθος is to provide pleasure; and the end of διάθεσις is to make an effect (ἐνάργειαν), as in battle scenes. This interpretation is possible, but I still feel that the Vitruvian meaning, "disposition of parts," will best fit the use of διάθεσις in

ἔνδοξος (endoxos)

2. Dio Chrysostom 12.25.

. . . παγκάλων καὶ σφόδρα ἐνδόξων θεαμάτων . . .

[A description of the votive offerings visible at Olympia:] . . . extremely beautiful and sights of the utmost renown . . .

3. Athenaeus 48B.

ἤκμασε δ'ἡ τῶν ποικίλων ὑφή, μάλιστα ἐντέχνων περὶ αὐτὰ γενομένων Ἀκεσᾶ καὶ Ἑλικῶνος τῶν Κυπρίων. ὑφάνται δ' ἦσαν ἔνδοξοι.

The art of weaving elaborate fabrics reached its peak at the time when the Cypriotes Akesas and Helikon were the outstanding practitioners of this art. They were renowned weavers.

4. Athenaeus 782B.

ἔνδοξοι δὲ τορευταὶ Ἀθηνοκλῆς, Κράτης, Στρατόνικος, Μυρμηκίδης ὁ Μιλήσιος, . . .

The famous engravers were Athenocles, Crates, Statonicus, Myrmecides the Milesian . . .

5. Suidas, s.v. Πάμφιλος.

Πάμφιλος. Ἀμφιπολίτης ἢ Σικυώνιος ἢ Νικοπολίτης φιλόσοφος, ὁ ἐπικληθεὶς Φιλοπράγματος. εἰκόνας κατὰ στοιχεῖον. τέχνην γραμματικήν. περὶ γραφικῆς καὶ ζωγράφων ἐνδόξων.

Pamphilos. A citizen of Amphipolis or Sicyon or Nicopolis; a philosopher who was called the *Philopragmatos*. Author of *Eikones* in alphabetical order; the *Technique of Grammar; On Painting and Famous Painters* . . .

6. Scholiast on Demosthenes *De Falsa Legat.* 237 (Overbeck, *Schriftquellen*, 1958).

. . . ὁ Φιλοχάρης ζωγράφος ἦν κατὰ Ζεῦξιν ἢ Ἀπελλῆν γε ἢ Εὐφράνορα ἢ τινα τῶν ἐνδοξοτάτων . . .

. . . Philochares was a painter like [or "contemporary with"?] Zeuxis or Apelles or Euphranor or any of the most renowned [artists].

the writings of Apelles. Apelles' treatise must have been closer in spirit to Vitruvius's architectural theory than to literary criticism.

Commentary

Otto Jahn, writing in 1850,[4] was the first to suggest ἔνδοξος as the Greek equivalent for *nobilis* in the title of the treatise on art by Pasiteles recorded in Pliny *NH* 36.40: *volumina scripsit nobilium operum in toto orbe.* The problem of the title of Pasiteles' work is discussed in the commentaries on *nobilis* and *mirabilis.* The passages cited above, showing the use of ἔνδοξος in connection with the visual arts, do not add any new information in regard to this problem. They do serve to confirm Jahn's notion, however, that ἔνδοξος is probably the Greek equivalent of *nobilis.* Like *nobilis* ἔνδοξος basically signified "known" or "renowned," but it could perhaps also, at times, connote a nature which was "noble" either by virtue of high birth or fineness of character. The latter might be its meaning in Plato *Sophist* 223B, where the Sophists are accused of engaging in a hunt after νέων πλουσίων καὶ ἐνδόξων "rich and noble youths" (although "prominent" or "notable" would do equally well).

In the passages cited here ἔνδοξος should in all cases probably be translated as "renowned" or "well known." Like *nobilis* it could refer either to things (passages 1 and 2) or people (remaining passages).

There are indications in these passages that οἱ ἔνδοξοι may have been the phrase that later writers conventionally employed to refer to the outstanding figures in any particular art. Thus Athenaeus speaks of ἔνδοξοι τορευταί (passage 4), and the *Suidas* lexicon and the scholiast on Demosthenes speak of ζωγράφων ἐνδόξων or ἐνδοξοτάτων (passages 5 and 6). If a similar conventional phrase was applied to works of art as well as artists—say ἔνδοξα ἔργα (compare Dio Chrysostom's ἐνδόξων θεαμάτων in passage 2)—it would serve as an exact prototype of *nobilia opera* in Latin.

See also *nobilis* and *mirabilia.*

εὐρυθμία (eurhythmia)

1. Xenophon *Mem.* 3.10.10–12.

> [*Socrates*:] ἀτάρ, ἔφη, λέξον μοι, ὦ Πιστία, διὰ τι οὔτ' ἰσχυροτέρους οὔτε πολυτελεστέρους τῶν ἄλλων ποιῶν τοὺς θώρακας πλείονος πωλεῖς;
>
> [*Pistias*:] Ὅτι, ἔφη, ὦ Σώκρατες, εὐρυθμοτέρους ποιῶ.
>
> [*Soc.*:] τὸν δὲ ῥυθμόν, ἔφη, πότερα μέτρῳ ἢ σταθμῷ ἀποδεικνύων πλείονος τιμᾷ; οὐ γὰρ δὴ ἴσους γε πάντας οὐδὲ ὁμοίους οἶμαί σε ποιεῖν, εἰ γε ἁρμοττόντας ποιεῖς.
>
> [*Pist.*:] Ἀλλὰ νὴ Δί', ἔφη, ποιῶ. οὐδὲν γὰρ ὄφελός ἐστι θώρακος ἄνευ τούτου.

4. Jahn, *UKP*, p. 124.

[Soc.:] Οὐκοῦν, ἔφη, σώματά γε ἀνθρώπων τὰ μὲν εὔρυθμά ἐστι, τὰ δὲ ἄρρυθμα;

[Pist.:] Πάνυ μὲν οὖν, ἔφη.

[Soc.:] Πῶς οὖν, ἔφη, τῷ ἀρρύθμῳ σώματι ἁρμόττοντα τὸν θώρακα εὔρυθμον ποιεῖς;

[Pist.:] Ὥσπερ καὶ ἁρμόττοντα, ἔφη, ὁ ἁρμόττων γάρ ἐστιν εὔρυθμος.

[Soc.:] Δοκεῖς μοι, ἔφη ὁ Σωκράτης, τὸ εὔρυθμον οὐ καθ᾽ ἑαυτὸ λέγειν, ἀλλὰ πρὸς τὸν χρώμενον

[Part of Socrates' conversation with the armorer Pistias, whose work Socrates has admired:]

Socrates: . . . But tell me, Pistias, why do you sell your breastplates for a higher price, although they are no stronger nor any more costly to produce than those of other manufacturers?

Pistias: Because, Socrates, those which I make are better fitting [or "better shaped"].

Soc.: And how do you make this shape known when you ask a higher price, is it by measurement or weight? For I doubt very much that you make them all of the same specifications, if you make them to fit properly.

Pist.: By Zeus, of course I make them to fit properly. For without that a breastplate is of no value.

Soc.: Well then, are not the bodies of some men well shaped, and of other ill shaped?

Pist.: Yes indeed.

Soc.: How then do you make a well-shaped breastplate to fit an ill-shaped body?

Pist.: I make it to fit; that which fits is well shaped.

Soc.: It seems to me then, that you do not speak of [a breastplate's being] well shaped in an absolute sense, but only in regard to its function.

2. Philo Mechanicus *Syntaxis* 4.4 (ed. Schöne).

διὰ [τὸ] τῆς πείρας οὖν προστιθέντες τοῖς ὄγκοις καὶ ἀφαιροῦντες καὶ μύουρα ποιοῦντες καὶ παντὶ τρόπῳ πειράζοντες κατέστησαν ὁμόλογα τῇ ὁράσει καὶ εὔρυθμα φαινόμενα.

[The eye sometimes deceives and makes parts of buildings appear different from what they really are.] Therefore by a process of trial and error, adding to masses and again subtracting from them, and establishing tapers and trying out every possible means, architectural forms are

produced which are suited to the vision and have the appearance of being well shaped.

3. Strabo 14.1.40.

'Εν δὲ τῇ νῦν πόλει, τὸ τῆς Λευκοφρυήνης ἱερόν ἐστιν 'Αρτέμιδος, ὃ τῷ μεγέθει τοῦ ναοῦ καὶ τῷ πλήθει τῶν ἀναθημάτων λείπεται τοῦ ἐν 'Εφέσῳ, τῇ δ'εὐρυθμίᾳ καὶ τῇ τέχνῃ τῇ περὶ τὴν κατασκευὴν τοῦ σηκοῦ πολὺ διαφέρει.

Now within the city [Magnesia on the Maeander] is the sanctuary of Artemis Leucophryene, which, insofar as the size of the temple and the number of votives is concerned, falls short of the one in Ephesus; but, in its well-designed appearance and in the artistry visible in the fitting out of its sacred enclosure, is much superior.

4. Vitruvius 1.2.3.

Eurhythmia est venusta species commodusque in compositionibus membrorum aspectus. Haec efficitur cum membra operis convenientia sunt altitudinis ad latitudinem, latitudinis ad longitudinem, et ad summam omnia respondent suae symmetria.

Eurhythmia is a beautiful appearance and a fitting aspect of the parts in compositions. This is achieved when the parts of a work have a height suitable to their width, a width suitable to their length; in short, when all the parts are commensurate with one another.

5. Vitruvius 1.2.4.

Uti in hominis corpore e cubito, pede, palmo, digito ceterisque particulis symmetros est eurhythmiae qualitas, sic est in operum perfectionibus.

As in the human body the quality of being commensurate and well shaped comes from the cubit, the palm, the finger, and from other small details, so too does it arise in a work [of architecture] from its finished details.

6. Vitruvius 6.2.5.

Igitur statuenda est primum ratio symmetriarum, a qua sumatur sine dubitatione commutatio, deinde explicetur operis futuri locorum unum spatium longitudinis, cuius semel constituta fuerit magnitudo, sequatur

171

eam proportionis ad decorem apparatio, uti non sit considerantibus aspectus eurhythmiae dubius.

[Appearances can be deceptive. Optical illusion and distortion must be taken into account by an architect, and he must make additions and subtractions in his work, based on his own intuition, in order to achieve the proper effect. (See *ingenium*, passage 4.)] Therefore it is necessary first to establish a theoretical system for the relationship of parts, from which adjustment can be made without hesitant uncertainty; thereupon a unit of length for the site of the future work should be laid out, and, once its size is determined, the construction of the work should follow it while paying heed to appropriateness of proportion, so that the appearance of being well formed should be beyond doubt to all viewers.

7. Lucian (or [Pseudo] Lucian) *Am.* 14.

ὁ γ’οὖν Ἀθηναῖος. . . ἀνεβόησεν, ‘Ηράκλεις, ὅση μὲν τῶν μεταφρένων εὐρυθμία, πῶς δ’ ἀμφιλαφεῖς αἱ λαγόνες, ἀγκάλισμα χειροπληθές.

[Compare ἀκρίβεια, passage 10.] The Athenian at that point . . . shouted, "By Heracles! How well shaped the back is, how ample the flanks! What an armful to embrace!"

8. Lucian *Im.* 6.

τὰ μῆλα δὲ καὶ ὅσα τῆς ὄψεως ἀντωπὰ παρ’ Ἀλκαμένους καὶ τῆς ἐν Κήποις λήψεται καὶ προσέτι χειρῶν ἄκρα καὶ καρπῶν τὸ εὔρυθμον καὶ δακτύλων τὸ εὐάγωγον ἐς λεπτὸν ἀπολῆγον παρὰ τῆς ἐν Κήποις καὶ ταῦτα.

[The beauty of Panthea, mistress of the emperor Lucius Verus is described through comparisons with famous statues:] The cheeks and the front part of the face he will take from Alcamenes and from the [Aphrodite] in the Gardens, and in addition the well-shaped quality of the hands and wrists and the well-executed fine tapering of the fingers will also derive from the Lady in the Gardens.

9. Lucian *Hist. Conscr.* 27.

. . . ὥσπερ ἂν εἴ τις τοῦ Διὸς τοῦ ἐν Ὀλυμπίᾳ τὸ μὲν ὅλον κάλλος τοσοῦτον καὶ τοιοῦτον ὂν μὴ βλέποι μηδὲ ἐπαινοίη μηδὲ τοῖς οὐκ εἰδόσιν ἐξηγοῖτο, τοῦ ὑποποδίου δὲ τό τε εὐθυεργὲς καὶ τὸ εὔξεστον θαυμάζοι καὶ

τῆς κρηπῖδος τὸ εὔρυθμον καὶ ταῦτα πάνυ μετὰ πολλῆς φροντίδος διεξιών.

[Some historians fail to distinguish what is important from what is trivial,] just as if someone were to fail to observe and praise and explain the extent and quality of the overall beauty of the Zeus at Olympia and instead marvel at the good workmanship and fine finish of the footstool and the well-shaped quality of the base, relating all this in detail, with the utmost concern.

10. Lucian *Salt.* 35.

οὐκ ἀπήλλακται δὲ (ἡ ὄρχησις) καὶ γραφικῆς καὶ πλαστικῆς, ἀλλὰ καὶ τὴν ἐν ταύταις εὐρυθμίαν μάλιστα μιμουμένη φαίνεται, ὡς μηδὲν ἀμείνω μήτε Φειδίαν αὐτῆς μήτε Ἀπελλῆν εἶναι δοκεῖν.

Nor has she [the personification of Dance] remained aloof from painting and sculpture, but in these she appears to imitate above all the beauty of pose [?], so that neither Phidias nor Apelles seems at all superior to her.

11. Aristides Quintilianus, Περὶ μουσικῆς 1.13 (ed. Winnington-Ingram).

ῥυθμὸς τοίνυν καλεῖται τριχῶς, λέγεται γὰρ ἐπί τε τῶν ἀκινήτων σωμάτων, ὡς φαμεν εὔρυθμον ἀνδριάντα, κἀπὶ πάντων τῶν κινουμένων, οὕτως γὰρ φαμεν εὐρύθμως τινὰ βαδίζειν. καὶ ἰδίως ἐπὶ φωνῆς . . .

Now *rhythmos* is spoken of in three ways; for it is applied to unmoving bodies, as when we speak of a well-shaped statue, and it is applied to all moving things, as when we speak of someone walking rhythmically, and it is applied in ordinary speech to the voice . . .

12. "Damianus" *Optica* (ed. Schöne, p. 28). See σκηνογραφία, passage 12.

Commentary

Much of the reasoning in this commentary is based on conclusions reached in the commentary under ῥυθμός, and it is recommended that that commentary be read prior to the present one.

VITRUVIUS'S DEFINITION

The meaning of εὐρυθμία has been discussed and disputed more than that of any other term in the terminology of ancient art criticism. Since the late

nineteenth century[5] most commentators on the term have taken Vitruvius's definition and use of it as the starting point of their interpretations (see passages 4, 5, and 6) but have not always arrived at the same conclusions. In his basic definition of εὐρυθμία Vitruvius says that it means first and foremost a "pleasant appearance" (*venusta species* and *commodus aspectus*); he then says that εὐρυθμία "is produced" (*haec efficitur*) when all the members of a work correspond symmetrically. It should be emphasized that Vitruvius is speaking about εὐρυθμία in architecture, not εὐρυθμία in general, and also that he does not necessarily say that *symmetria* is always essential to εὐρυθμία. The phrase *haec efficitur* . . . is perhaps intended as an illustration of εὐρυθμία rather than as an essential part of the definition. The fact that a commensurable arrangement of parts produces εὐρυθμία does not mean that it cannot be produced by other means. In 1.2.4 (passage 5), Vitruvius speaks of the *eurhythmiae qualitas* as being, once again, a result of *symmetria,* this time in the human body. But it is in 6.2.5 (passage 6) that he is most explicit about the meaning of εὐρυθμία in architecture and its relationship to *symmetria*. In this passage he discusses the question of optical distortion, that is, the way in which our vision makes the proportions of things seem different from what they really are when measured, and he points out that it is sometimes necessary to alter the real, measurable proportions of the parts of a building to compensate for the distortion of them caused by our vision. When the measurable proportions are altered to suit the *decor* (q.v.) of the temple, the "appearance of *eurhythmia*" results.

While these passages undoubtedly have ambiguities and complexities which will be discussed below, it is clear that to Vitruvius *eurhythmia* in art was a pleasing quality which arose from the alteration and adjustment of concrete forms, and that it was something which had to be understood subjectively rather than demonstrated objectively.

MODERN INTERPRETATIONS

Heinrich Brunn was the first scholar to propose a definition of εὐρυθμία based on an evaluation not only of Vitruvius's definition but of other antique sources.[6] He suggested that in general εὐρυθμία was based on the "Beobachtung des Angemessenen und Gefälligen" of a work of art. In connection with *symmetria,* however, he spoke of a "höhere Bedeutung" in which εὐρυθμία was a "vermittelnde Princip" whose purpose was "die Schärfen und Härten

5. I omit here a discussion of the views of earlier archaeoligists and art historians such as Winckelmann, Jahn, and Wölfflin who took εὐρυθμία in the modern sense of "repetition within flow." For a discussion of some of these views see Eugen Petersen, "Rhythmus," *AbhGött* N.F. 16(1916–17): 1–9.

6. Brunn, *GGK*[2], 1:98.

zu mildern, welche die Anwendung jenes mathematischen Gesetzes nament-
lich auf organische Gesalten erzeugen muss." The second part of Brunn's
interpretation—namely, that εὐρυθμία was a softened, more pleasing form of
symmetria in which deviation from "real" mathematical commensurability
has been allowed—has been widely accepted as the basic meaning of
εὐρυθμία and also of ῥυθμός. (Brunn, like all scholars before Schlikker [see
below] did not draw a sharp distinction between εὐρυθμία and ῥυθμός.)
Among those who followed Brunn's line of thought were Furtwängler,
Puchstein, and Kalkmann,[7] and especially R. Schöne in his studies of
the use of εὐρυθμία by Greek writers on optics.[8]

A variation on this early tradition in the interpretation of εὐρυθμία appeared
in 1909 in Carl Watzinger's study of Vitruvius's architectural terminology.[9]
Watzinger, as noted under διάθεσις, suggested that the six terms which are
listed by Vitruvius (1.2.1 ff.) as being the elements of which architecture
"consists"—*ordinatio*-τάξις, *dispositio*-διάθεσις, εὐρυθμία, συμμετρία, *decor*,
and *distributio*-οἰκονομία—were derived from a late Stoic theory of beauty,
in which the terms had originally been grouped in three pairs. In each
of these pairs, one term referred to an active "doing" and the other
referred to a passive "effect." The terms διάθεσις and εὐρυθμία formed one
of these pairs; the former referred to the placement of the individual units of
a building in relation to one another, while the latter referred to the
optical effect of this placement. Watzinger recognized that εὐρυθμία as a
concept was essentially independent of συμμετρία, although in actual
architectural practice it was necessary to make adjustments in συμμετρία
in order to produce εὐρυθμία.

Eugen Petersen's study of ῥυθμός (q.v.) published in 1917 began a new
trend in the study of εὐρυθμία and ῥυθμός.[1] Petersen's conclusion that the
term ῥυθμός referred to "shape," particularly to the composition of the
human figure in movement, rather than to a softened type of *symmetria* which
aimed at producing a pleasant optical effect through the graceful flow of lines,
has been accepted by Schweitzer and Schlikker. The ways in which these
two scholars have applied Petersen's definition of ῥυθμός to the elucidation of
the meaning of εὐρυθμία, however, differ considerably. Schweitzer[2] proposes

7. Adolf Furtwängler, *Meisterwerke der Griechischen Plastik* (Leipzig, 1893), pp. 427, 444,
508; Otto Puchstein, s.v. *Architecktur* in *RE* (1896); August Kalkmann, *Die Proportionen des
Gesichts in griechischer Kunst* (Berlin, 1893), p. 5n8.

8. R. Schöne, *AA* (1898), p. 181; also his editions of Philo Mechanicus (Berlin, 1893) and
Damianus (Berlin, 1897).

9. Carl Watzinger, "Vitruvstudien," *RhM* 64 (1909): 203–23. This article discussed under
διάθεσις.

1. Petersen, *AbhGött* N.F. 16 (1916–17). The article is discussed in detail under ῥυθμός.

2. Schweitzer, *Xenokrates*, pp. 11–13; his conclusions are based on the use of εὔρυθμος by Xeno-

that εὐρυθμία refers to the adaptation ("Anpassung") of ῥυθμός (which he defines as "die von einem einheitlichen 'Zug' belebte und geregelte Bewegungsvorstellungen erzeugende Form") to a particular motif. He believes, in other words, that ῥυθμός and εὔρυθμος have basically the same meaning, the only difference being that εὔρυθμος refers to a particular application of the general principle. Schlikker, on the other hand, concludes that although εὐρυθμία was originally derived from ῥυθμός, the two words do not have the same meaning. The real meaning of εὐρυθμία, in his opinion, is "gracefulness, charm" ("die Anmut" = Vitruvius's *venusta species*); the term was not used in connection with the visual arts, he feels, before the Hellenistic period and came about as a result of the blending of the fifth-century concept of ῥυθμός with the fourth-century idea of χάρις.[3] Like Schweitzer, Schlikker believes that the idea of movement was an essential part of the meaning of ῥυθμός.[4] He hypothesized an early Hellenistic "Schönheitslehre" in which it was felt that the aim of art was "der Anreiz des Gefühls." Εὐρυθμία, the basic concept of this doctrine, as Schlikker sees it, was formulated to express the Hellenistic conviction that "Anmut als Schönheit der Bewegung aufgefasst wurde."[5]

One of the most recent commentators on εὐρυθμία, Silvio Ferri, appears to have discarded Petersen's conclusions about ῥυθμός. Ferri's views on the meaning of εὐρυθμία are essentially an elaboration of the earlier idea, expressed by Brunn and others, that εὐρυθμία refers to the total effect of συμμετρία.[6] He emphasizes that Vitruvius classifies συμμετρία as a *quantitas* (ποσότης) and εὐρυθμία as a *qualitas* (ποιότης);[7] συμμετρία is thus something which is

phon in the *Memorabilia* (passage 11 in our catalog) and on Robert's suggestion (*Arch. Märch.*, p. 34) that Pliny's phrase *numerosior* in connection with Myron (*NH* 34.58) should be translated as εὐρυθμώτερος. My own view that *numerosior* should be translated as ῥυθμικώτερος rather than εὐρυθμώτερος is presented in the commentary under *numerosus*. I cannot agree with Schweitzer's suggestion that *numerosior* in Pliny means that "der Rhythmos in der Kunst Myrons von weit grösserer Anpassungsfähigkeit an die Natur war...." See *numerosus, numerus*.

3. Schlikker, *HV*, pp. 83–84.

4. Ibid., p. 82, "geregelte Bewegung, Tanzakt, Tanzfigur." He ignores the even more basic meaning of "shape," of which "Tanzfigur" is one aspect.

5. Ibid., pp. 2–3. Schlikker's view of the history of Greek art criticism is open to many objections. For further discussion see ἀκρίβεια, χάρις, and *decor*. See also Ferri's criticism of it in "Problemi di Estetica Vitruviana," *La Critica d'Arte* n.s. 6, no. 10 (1941): 97–102.

6. Ferri's view is most systematically presented in his recent edition of Vitruvius, *Vitruvio*, pp. 50–51, and more briefly in the *Enciclopedia dell'Arte Antica* (Rome, 1958–66), s.v. *eurhythmia*. His definition of ῥυθμός in *Vitruvio*, p. 38, "'Ritmo' e movimento periodico o di voce o di danza o di altro" is much closer to the modern sense of "repetition" than to the ancient sense of "shape" (see commentary under ῥυθμός).

7. Vitruvius 1.2.1–4.

concrete and measurable, while εὐρυθμία is the result of an evaluation.[8] Ferri feels that the two terms existed in Greek art criticism from the Archaic period onward and that, although they were defined differently in different periods, the same *quantitas-qualitas* relationship always existed between them. In the Archaic period, according to Ferri, συμμετρία meant the sum of the modules used in a particular work of art, and εὐρυθμία meant the "presenza di rhythmoi sul corpo del monumento,[9] consequenza di questa somma." In the fifth century B.C. συμμετρία became numerical, a result of mathematical calculation, and εὐρυθμία was again the sum of these calculations but now "piu unitaria dalla omnipresenza del 'numero'". Finally, in the fourth century συμμετρία came to include both actual measurements and also optical effects ("symmetria di posotespoiotes"), hence partly absorbing and partly annulling the "antica" εὐρυθμία (Ferri, *Vitruvio*, p. 51).

REEXAMINATION OF THE ANCIENT SOURCES

In view of the bewildering variety and complexity of the interpretations of εὐρυθμία by modern writers, it is perhaps best to pursue our own investigation by returning, without bias, to the ancient Greek sources for the use of ῥυθμός and εὐρυθμία. The commentary under ῥυθμός presents reasons for believing that the basic meaning of ῥυθμός is "shape" or "form" and that in professional criticism of sculpture in the fifth century this concept of "shape" was especially studied in connection with the "shapes" or "patterns" formed by the human body in movement. It does not necessarily follow, however, as Schweitzer and Schlikker have assumed, that the idea of movement was essential to the meaning of ῥυθμός and that ῥυθμός was inconceivable without movement. If we take ῥυθμός in its most elementary sense of "shape" or "form" and combine it with the simple adverb εὖ, "well,"[1] the resultant meaning of εὐρυθμία is "the quality of being well shaped, well formed." This simple interpretation is the only satisfactory translation of the use of the term in Xenophon's *Memorabilia* (passage 1), the earliest known use of the term in connection with the visual arts.[2] The breastplates which Pistias

8. The factors in a work of art which cause εὐρυθμία are also concrete, but the appreciation of them depends on what Ferri calls "il gusto soggetivo" (*Vitruvio*, p. 48).

9. Ferri does not elaborate upon what he means by "rhythmoi sul corpo"; he seems to mean the periodic repetition of certain modules within a form, that is, an apparent "movimento periodico" of modules.

1. On εὖ see chap. 1, note 6.

2. The earliest preserved uses of εὐρυθμία occur in Aristophanes, *Thesm.* 121 and *Plut.* 759, and Euripides *Cyc.* 563. The Aristophanic passages refer to music and dancing, the Euripidean passage refers to raising a wine cup to the mouth "with good form" (εὐρύθμως).

made were considered better than those of his competitors because they were εὐρυθμωτέρους, "better formed." Socrates asked Pistias if it was possible to make a "well-formed" breastplate for an "ill-formed" wearer (ἀρρύθμῳ σώματι), and Pistias replied that it was possible, because a "well-formed" breastplate simply meant one that fitted its wearer well (ὁ ἁρμόττων γάρ ἐστιν εὔρυθμος). It is clear that to Pistias a breastplate which was εὔρυθμος was neither one that contained an ideal set of proportions, nor one that exhibited the repetition or flow of modules or a complicated numerical *symmetria*; a εὔρυθμος breastplate was one which was simply well shaped with respect to its wearer.[3]

Our interpretation of εὐρυθμία as meaning simply the quality of being well shaped or well formed can be applied not only to Xenophon but to all the passages cited here. In passage 9 Lucian speaks of the well-shaped form of the base of Phidias's Zeus at Olympia; in passage 8 he speaks of the well-shaped quality of the hands and wrists of Alcamenes' Aphrodite in the Gardens; in passage 7 the shapeliness of the back of Praxiteles' Aphrodite of Cnidus is praised; and in passage 10 he implies that the well-shaped quality of forms in painting and sculpture is imitated in dancing. The last of these passages may be compared with passage 11, from the writings of the musical theoretician Aristides Quintilianus (third century A.D.), in which it is said that there are three types of ῥυθμός—that which applies to motionless bodies, as when we speak of a εὔρυθμον statue; that which applies to bodies in motion, as when we speak of walking εὐρύθμως; and that which applies to sound. The deliberate use of ἀκινήτων should make it clear that ῥυθμός does not necessarily imply movement. Here again, the best translation of εὔρυθμον ἀνδριάντα is a "well-shaped statue."[4]

The rest of the passages quoted here refer to architecture, and, here too, our interpretation of εὐρυθμία as meaning "the quality of being well shaped, well formed," or, in a particular, restricted sense, "well proportioned"

3. Schlikker, *HV*, p. 84, insists that a εὔρυθμος breastplate is one in which "der Körper gut darin bewegen kann." His opinion is clearly the results of his insistence that ῥυθμός necessarily implies "Bewegung." It is true that Xenophon does say that a "fitting" breastplate is one which is not so tight that it chafes the wearer when he moves (3.10.14–15), but ῥυθμός and εὔρυθμος clearly refer to the shape of the body. As noted at the end of the commentary on ῥυθμός, it is not innacurate to translate εὔρυθμος as "well proportioned," provided one thinks of "proportion" as referring to the appearance of a single shape and not to a wider series of measurements. Otherwise εὐρυθμία and ῥυθμός become confused with συμμετρία. I have therefore chosen to use "well formed" or "well shaped" in my interpretation of the passages in our catalog, even though "well proportioned" may sound more idiomatic in English.

4. "Well proportioned" would admittedly sound better, but the term *proportion* could be misleading. The derivation of the meaning of ῥυθμός as it applied to dancing and music is discussed under ῥυθμός.

easily fits the context of each passage. In passage 3 Strabo refers in a general way to the "well-formed" quality of the temple of Artemis Leukophryene at Magnesia on the Maeander. In passages 2 and 12, "Damianus" and Philo Mechanicus discuss how architects made alterations in the shapes of the different parts of a building (what "Damianus" calls the ὑποκειμένους ῥυθμούς; see ῥυθμός) in order to compensate for the distortion of these parts through optical illusion. The purpose of these alterations was to preserve the εὐρυθμία, "quality of being well shaped" in the separate parts and in the building as a whole. These passages do not mean, as Schöne and other earlier writers thought, that εὐρυθμία is exclusively the optical effect of alterations and adjustments in συμμετρία, for, as the passage from "Damianus" clearly shows, there was an actual, measurable εὐρυθμία (τῆς κατ' ἀλήθειαν ... εὐρυθμίας) and an optical εὐρυθμία (τῆς πρὸς ὄψιν εὐρυθμίας), just as there was an actual and an optical συμμετρία.[5]

Finally, if we return to the Vitruvian passages with which we began the commentary, we will see that our simple definition of eurhythmia as "the quality of being well shaped" is applicable here too, even though the role which eurhythmia plays in Vitruvius's system is problematical. He does not use the term ῥυθμός, and at times it almost seems, as we have already noted, as if he understands eurhythmia as the qualitative effect of symmetria. But in each of these passages it will be seen that he is really thinking of the effect of an assemblage of shapes (membra in passage 4, parts of the body in 5, parts of a building in 6). Since such shapes, however, have commensurate proportions, and since changes in the shapes require a change in their relative proportions, the concepts of ῥυθμός and συμμετρία seem to have fused in Vitruvius's mind.

Passage 6 calls for special comment because it may offer confirmation of a sort for the aesthetic system which Watzinger (see above and under διάθεσις) has ascribed to Vitruvius. After explaining how our vision makes things which are "real" seem "false" (i.e. makes their proportions seem different from what they really are when measured), Vitruvius explains how a building is designed; first, the basic "symmetries," which are later to be altered for optical effects, are planned; then an actual unit of measurement from which the "symmetrically" arranged members will derive their measurable length is determined; and finally the "proportion" is adapted to the "appropriateness"(that is the form which is appropriate to the meaning and use of the building), so that, in the end, the building will have the "aspect of eurhythmia." We may have here a brief summary of what Watzinger identifies as the three end products of an architect's appli-

5. Schlikker, HV, pp. 74–75, also recognizes this distinction.

179

cation of his knowledge of theory: (1) συμμετρία as the outcome of τάξις, (2) εὐρυθμία as the outcome of διάθεσις, and (3) *decor* (πρέπον?) as the outcome of οἰκονομία. If this is the case, εὐρυθμία and συμμετρία would both be understood as effects rather than cases and could not stand in a cause-and-effect relationship to one another.

CONCLUSION

Combining the results of the application of a simple etymological translation of εὐρυθμία to the passages in our catalog with what we have learned from modern writers on the subject, we may, in summary, draw the following conclusions: εὐρυθμία is the qualitative equivalent of ῥυθμός. Just as ῥυθμός in its most basic sense means "shape" or "form," so εὐρυθμία means "the quality of being well shaped or well formed." The term does not necessarily, as some have held, refer to movement. Among all the positions the human body assumes in the course of movement, certain positions were considered to be characterized by "good form" or "good shape." The positions themselves were ῥυθμοί, and the quality which characterized them was εὐρυθμία. These terms applied both to living persons and also to sculptured images of human beings (passage 11: εὔρυθμον ἀνδριάντα).

The relationship between the use of εὐρυθμία in music and dancing and its use in the visual arts parallels the use of ῥυθμός in both these fields (see ῥυθμός). In both, εὐρυθμία refers to a quality of form. In music the form is conceived of as a pattern of repetitions. In the visual arts the "form" retains its original connection with space and mass.

Eurhythmia may have first appeared in the criticism of the visual arts around the time when it first appears in extant Greek literature—toward the end of the fifth or the beginning of the fourth century B.C.[6] It may be, as suggested in the commentary on ῥυθμός, that at this time the earlier study of ῥυθμός as the composition, shape, or form produced by movements of the body was being replaced by the study of the forms, of the separate ῥυθμοί, of which the body was composed. *Eurhythmia* was perhaps coined to express the artist's personal evaluation of the effect produced by the combination of these ῥυθμοί. The subjective nature of the quality which the term expresses is apparent in most of our passages, and subjectivism was a feature partic-

6. Ferri's assumption that εὐρυθμία was already being studied in the sixth century is unsupported by any evidence. Schlikker's belief that εὐρυθμία in connection with the fine arts was exclusively a Hellenistic term is based on his assumption that the term resulted from a blending of ῥυθμός with χάρις and referred exclusively to "Anmut" in "Bewegung." Against his opinion are the following points: (1) the idea of movement is not essential to the meaning of εὐρυθμία; (2) Xenophon's use of εὔρυθμος in the *Memorabilia* makes it quite certain that the term was already part of the artist's vocabulary in the early fourth century.

ularly characteristic of professional criticism in the fourth century B.C. (see chap. 1).

εὐσταλής *(eustalēs)*

1. Demetrius *Eloc.* 14. See ἀρχαῖος, passage 4.

2. Lucian *Im.* 6. For context see εὐρυθμία, passage 8.

ἡ Σωσάνδρα δὲ καὶ Κάλαμις αἰδοῖ κοσμήσουσιν αὐτήν, καὶ τὸ μειδίαμα σεμνὸν καὶ λεληθὸς ὥσπερ τὸ ἐκείνης ἔσται, καὶ τὸ εὐσταλὲς δὲ καὶ κόσμιον τῆς ἀναβολῆς παρὰ τῆς Σωσάνδρας πλὴν ὅτι ἀκατακάλυππος αὕτη ἔσται τὴν κεφαλήν.

The Sosandra and Calamis will adorn her with modesty, and her smile will be solemn and barely perceptible like that of the Sosandra, and the orderliness and respectability of her drapery shall also come from the Sosandra, except that her head shall be uncovered.

Commentary

The term εὐσταλής, "well ordered, neat, simple," is neither very common nor important in the terminology of Greek art criticism, but we include it here as a complement to our commentary on ἀρχαῖος, in which the attitude toward Archaic sculpture held by Greek writers of the Hellenistic and Roman periods is discussed. The fact that εὐσταλής is transmitted to us by Lucian and Demetrius would seem to suggest that the word, when used in connection with artistic style, was a rhetorician's term. It does not occur, however, as a technical term in any extant treatise on rhetoric and thus should perhaps be taken as characteristic of a type of popular criticism common to both rhetoric and other arts.

The term is used in general by Greek writers to describe characteristics both of physical forms and also of human behavior. In the Hippocratic treatise *On Fractures* (37) it is used to describe the compactness of the end of the thighbone; Plutarch uses it to describe the εὐσταλῆ σώματα, which were the ideal of the Egyptians.[7] On the other hand, Plato uses the term in the sense of "well mannered, well conducted,"[8] and Lucian too, it appears, sometimes uses it in this sense.[9]

7. Plutarch *De Is. et Os.* (*Mor.* 353A).
8. Plato *Meno* 90B, κόσμιος καὶ εὐσταλὴς ἀνήρ.
9. Lucian *Timon* 54, οὗτος ὁ τὸ σχῆμα εὐσταλὴς καὶ κόσμιος; σχῆμα here in the sense of

εὐστοχία (eustochia)

Both Lucian and Demetrius in the passages quoted here use εὐσταλής to characterize an aspect of pre-Phidian art. Demetrius points out that the style of the "older rhetoricians" (apparently those before Gorgias) was εὐσταλές like the ἀρχαῖα ἀγάλματα (those before Phidias), which were characterized by "spareness" (ἰσχνότης) and "compactness" (συστολή). Lucian makes specific reference to the hang of the drapery (ἀναβολή)[1] on the Sosandra of Calamis. Some modern scholars have associated the Sosandra with an Early Classical work known through good Roman copies and conventionally called the Aspasia type or Amelung's Goddess.[2] Whether this attribution is correct or not, the Aspasia, or the Hesita Giustiniani,[3] or any Early Classical peplophoros undoubtedly exemplify the stylistic features that Lucian was praising—large, clear folds of drapery arranged in parallel vertical series distributed throughout predominantly rectangular surface areas.

In the commentary on ἀρχαῖος it was noted that in one tradition of Roman criticism there is evidence of an appreciation for the "innocence" and "sanctity" of Archaic sculpture and that there is a similarity between ancient and modern views in this respect. There was likewise a tradition of Greco-Roman criticism during the Roman Empire which admired the simplicity and clear order of Early Classical sculpture. This tradition would once again be in harmony with modern evaluations and could be contrasted to the earlier phases of ancient art criticism, which saw Early Classical sculpture simply as a development from *durus* to *mollis* and looked upon it as essentially inferior to the sculpture which succeeded it.

εὐστοχία (eustochia)

1. Dionysius of Halicarnassus *Comp.* 25 (ed. Roberts, p. 266).

πολύ τε γὰρ μᾶλλον ἐμοὶ δοκεῖ προσήκειν ἀνδρὶ κατασκευάζοντι
λόγους πολιτικούς, μνημεῖα τῆς ἑαυτοῦ δυνάμεως, αἰώνια μηδενὸς τῶν
ἐλαχίστων ὀλιγωρεῖν, ἢ ζωγράφων τε καὶ τορευτῶν παισὶν ἐν ὕλῃ
φθαρτῇ χειρῶν εὐστοχίας καὶ πόνους ἀποδεικνυμένοις περὶ τὰ φλέβια

"bearing." (The σχῆμα εὐσταλής does not refer to the "Boreas or Triton, like those Zeuxis used to paint" mentioned in a previous sentence.)

1. 'Ἀναβολή—a short cloak, or perhaps a part of the drapery thrown over the shoulder; see Plato *Prt.* 342C, ἀναβολὰς βραχείας (such as were worn by the Spartans). Lucian *Somn.* 6 uses it to indicate a style of wearing drapery.

2. See in particular: Piero Orlandini, *Calamide* (Bologna, 1950); B. S. Ridgway, *The Severe Style in Greek Sculpture* (Princeton, 1970), pp. 65–69.; for a quick reference, G. M. A. Richter, *A Handbook of Greek Art*, 6th ed. (New York, 1969), fig. 126.

3. Ridgway, *The Severe Style*, pl. 103

καὶ τὰ πτίλα καὶ τὸν χνοῦν καὶ τὰς τοιαύτας μικρολογίας κατατρίβειν τῆς τέχνης τὴν ἀκρίβειαν.

For it seems to me much more right and proper for a man who is composing political speeches, eternal memorials to his own ability, not to overlook even the smallest of details than it is for the pupils of painters and sculptors to exercise the exactness of their art by demonstrating the skill and efforts of their hands in perishable materials by representing the veins, and the down [on the cheeks], and the bloom [of the skin], and other such minute details.

2. Dionysius of Halicarnassus *Dem.* 51 (ed. Usener, Radermacher, p. 241, lines 17–19).

οὐ γὰρ δή τοι πλάσται μὲν καὶ γραφεῖς ἐν ὕλῃ φθαρτῇ χειρῶν εὐστοχίας ἐνδεικνύμενοι τοσούτους εἰσφέρονται πόνους, ὥστε . . .

Accordingly, it certainly cannot be the case that painters and sculptors exert such great efforts to demonstrate the skill of their hands in perishable materials [by representing veins etc. and that Demosthenes, on the other hand, failed to take any pains to master the technical aspects of rhetoric].

3. *Anthologia Graeca* 16.310 (Damocharis).

Αὐτή σοι πλάστειρα Φύσις παρέδωκε τυπῶσαι
 τὴν Μυτιληναίαν, ζωγράφε, Πιερίδα.
πηγάζει τὸ διαυγὲς ἐν ὄμμασι. τοῦτο δ'ἐναργῶς
 δηλοῖ φαντασίην ἔμπλεον εὐστοχίης.

Nature herself as the modeler, O painter, allowed you to make a copy of Pieria, the Mytilenaean.
Radiance wells up from her eyes, and this vividly reveals an imagination full of skill [or conveys a complete impression of a piercing mind?].

Commentary

The term εὐστοχία, derived from εὖ plus στόχος (στοχάζομαι), "aim," means literally "good or accurate aim," as in Euripides *Iphigeneia in Tauris* 1239: ἐπὶ τόξων εὐστοχίᾳ γάνυται. A more common use of the term, however, is found in its metaphorical extension to mean "accuracy of intuition, the ability to guess accurately." In the *Nicomachean Ethics* 1142b2 Aristotle describes εὐστοχία as a type of cognition which is ἄνευ τε γὰρ λόγου καὶ ταχύ, "without reasoning and swift." In passage 3 εὐστοχίης is used in

this sense. The φαντασία, "imagination," of the epigram may refer either to the artist or to the portrait of Sappho which is described in the epigram, and εὐστοχίης may thus refer either to the intuition of the artist or of the poetess who was his subject. The term was also used in rhetorical writings to mean "sagacity" in thought and speech: ἐν φιλοσοφίᾳ τὸ ὅμοιον καὶ ἐν πολὺ διέχουσι θεωρεῖν εὐστόχου (Aristotle Rh. 1412a12); εὐστόχως λέγειν (Philodemus Rhet. 2.1085, ed. Sudhaus).

In passage 1 Dionysius of Halicarnassus juxtaposes what is (at times at least) a technical term, ἀκρίβεια, which is used by artists in referring to the rendering of small details that require considerable precision, with a literary term, εὐστοχία, which was roughly equivalent to it. The distinction between ἀκρίβεια and εὐστοχία is the same as that between *diligens* and *sollers* (q.v.). *Sollers* and εὐστοχία are terms whose general significance in literature and philosophy is "skill, accuracy." Their appearance in the criticism of the visual arts as nontechnical equivalents of ἀκρίβεια can probably be explained as the result of the stylistic comparisons of artists and rhetoricians which were popular in the later Hellenistic period (see chap. 3).

εὐσχημοσύνη (euschēmosynē)

1. Maximus of Tyre *Diss.* 26.5

. . . κατὰ δὲ τὴν ἀρετὴν εἰς μίμησιν τοῦ κάλλους τὴν εὐσχημοσύνην τῶν γραμμάτων διατιθέντι

See ἀρετή, passage 4.

Commentary

Maximus probably uses εὐσχημοσύνη here to convey the idea of "appropriateness," more commonly conveyed by πρέπον. See *decor*. For the use of εὐσχημοσύνη to mean "decorum" in social behavior, see Plato *Rep* 413E: εἰ δυσγοήτευτος καὶ εὐσχήμων ἐν πᾶσι φαίνεται, and *Rep*. 401C: τὴν τοῦ καλοῦ τε καὶ εὐσχήμονος φύσιν. See also Plato *Laws* 797B; Aristotle *Eth. Nic.* 1128a7.

ἦθος καὶ πάθος (ēthos kai pathos)

1. Xenophon *Mem.* 3.10.3 and 5.

a. Sec. 3.

Socrates: τὸ πιθανώτατόν τε καὶ ἥδιστον καὶ φιλικώτατον καὶ ποθειν-

ὅτατον καὶ ἐρασμιώτατον ἀπομιμεῖσθε τῆς ψυχῆς ἦθος; ἢ οὐδὲ μιμητόν ἐστι τοῦτο;

[Parrhasius:] πῶς γὰρ ἂν (ἔφη), μιμητὸν εἴη, ὦ Σώκρατες, ὃ μήτε συμμετρίαν μήτε χρῶμα μήτε ὧν σὺ εἶπας ἄρτι μηδὲν ἔχει, μηδὲ ὅλως ὁρατόν ἐστιν; . . .

[Socrates converses with the painter Parrhasius:]

Soc.: Do you not imitate the character of the soul, the character which is most persuasive, the sweetest, the most friendly, the most longed for, and the most beloved? Or is it impossible to imitate these things?

Parr.: But how could a thing be imitated, Socrates, which has neither commensurable proportions or color, nor any of the things which you mentioned just now, and which, in fact, is not even visible?

b. Sec. 5.

[*Soc.*:] Πότερον οὖν, ἔφη, νομίζεις ἥδιον ὁρᾶν τοὺς ἀνθρώπους δι'ὧν τὰ καλά τε καὶ ἀγαθὰ καὶ ἀγαπητὰ ἤθη φαίνεται ἢ δι' ὧν τὰ αἰσχρά τε καὶ πονηρὰ καὶ μισητά;

[Socrates proceeds to argue that since a painter can imitate the facial expressions and postures which are outward indications of a state of mind, he can, in that sense, represent character.]

Soc. And which do you think it is more pleasant to look at, men in whom beautiful and noble and lovable natures are revealed or those in whom shameful, villainous, and hateful natures reveal themselves?

2. Aristotle *Poet.* 1450a24.

αἱ γὰρ τῶν νέων τῶν πλείστων ἀήθεις αἱ τραγῳδίαι εἰσί. καὶ ὅλως ποιηταὶ πολλοὶ τοιοῦτοι, οἷον καὶ τῶν γραφέων Ζεῦξις πρὸς Πολύγνωτον πέπονθεν. ὁ μὲν γὰρ Πολύγνωτος ἀγαθὸς ἠθογράφος, ἡ δὲ Ζεύξιδος γραφὴ οὐδὲν ἔχει ἦθος.

[It is impossible to compose a tragedy which has no action but perfectly possible to compose a tragedy which ignores the study of character.] For the tragedies of most modern dramatists are without character. Indeed there are many poets who are of the type, to use painters as an analogy, represented by Zeuxis as opposed to Polygnotus. For Polygnotus was an excellent painter of character, but the painting of Zeuxis contains no character at all.

3. Aristotle *Pol.* 1340a35.

οὐ μὴν ἀλλ'ὅσον διαφέρει καὶ περὶ τούτων θεωρίαν, δεῖ μὴ τὰ Παύσωνος θεωρεῖν τοὺς νέους, ἀλλὰ τὰ Πολυγνώτου κἂν εἴ τις ἄλλος τῶν γραφέων ἢ τῶν ἀγαλματοποιῶν ἐστιν ἠθικός.

[Visual images cannot provide likenesses of character but only provide signs which are indicative of character.] That is not to say, however, that there is not some difference that results from the observation of these signs. The young should be made to look not at the paintings of Pauson but at those of Polygnotus or of any other painter or sculptor who is concerned with character.

4. Diodorus Siculus 26.1.1.

οὔτε γὰρ Φειδίας . . . οὔτε Πραξιτέλης, ὁ καταμίξας ἄκρως τοῖς λιθίνοις ἔργοις τὰ τῆς ψυχῆς πάθη, οὔτε ᾿Απελλῆς ἢ Παρράσιος . . . οὕτως ἐπέτυχον ἐν τοῖς ἔργοις ὥστε κατὰ πᾶν ἄμεμπτον ἐπιδείξασθαι τὸ τῆς ἐμπειρίας ἀποτέλεσμα.

[Perfection in the arts is impossible and even the works of the greatest artists will always be subject to adverse judgment.] Not even Phidias . . . nor Praxiteles, who instilled the very passions of the soul into works of stone, nor Apelles, nor Parrhasius . . . were so successful in their works that they could put on display a finished product of their skill which was considered completely flawless.

5. Pliny *NH* 35.98.

Aequalis eius fuit Aristides Thebanus. Is omnium primus animum pinxit et sensus hominis expressit, quae vocant Graeci ἤθη, item perturbationes.

Contemporary with him [Apelles] was Aristides the Theban. He was the first to express the disposition and consciousness of man, which the Greeks call *ēthē*, and also the emotions.

6. Plutarch *Alex.* 1.3.

ὥσπερ οὖν οἱ ζωγράφοι τὰς ὁμοιότητας ἀπὸ τοῦ προσώπου καὶ τῶν περὶ ὄψιν εἰδῶν, οἷς ἐμφαίνεται τὸ ἦθος, ἀναλαμβάνουσιν, ἐλάχιστα τῶν λοιπῶν μερῶν φροντίζοντες, οὕτως ἡμῖν δοτέον εἰς τὰ τῆς ψυχῆς σημεῖα μᾶλλον ἐνδύεσθαι, . . .

Accordingly, just as painters produce likenesses from the face and from the features around the eyes (in which the character is revealed) but pay less attention to the other details, so too I must be allowed to concentrate more on the signs of the human spirit [rather than on the great deeds of men].

7. Plutarch *De Alex. fort.* 2.2 (*Mor.* 335B).

. . . διὸ καὶ μόνον Ἀλέξανδρος ἐκέλευε Λύσιππον εἰκόνας αὐτοῦ δημιουργεῖν. μόνος γὰρ οὗτος, ὡς ἔοικε, κατεμήνυε τῷ χαλκῷ τὸ ἦθος αὐτοῦ καὶ ξυνέφερε τῇ μορφῇ τὴν ἀρετήν.

. . . on account of this Alexander gave orders that only Lysippus was to make images of him. For only he, it appears, captured his character in bronze and gave form to his essential nature.

Compare ἀρετή, passage 3.

8. Aelian *VH* 4.3. See ἀκρίβεια, passage 22.

9. Callistratus *Descriptiones* 8.3.

. . . ὃ δὴ καὶ παντὸς ἦν ἐπέκεινα θαύματος, ἡδονῆς ἀφιέναι τὴν ὕλην τεκμήρια καὶ τὴν παθῶν δήλωσιν ὑποκρίνεσθαι τὸν χαλκόν.

[On a statue of Dionysus by Praxiteles:] . . . indeed it was wholly beyond the limits of wonder in that the material [of which it was made] betrayed signs of feeling pleasure and the bronze feigned an exhibition of emotions.

Commentary

The word ἦθος is connected with the root of ἔθω ("be accustomed") and ἔθος ("habit") and seems first to have meant the "accustomed seat" or "accustomed place" of a thing. It is used in this sense by Homer in referring to the "haunts" of animals[4] and by Hesiod with reference to the "abodes" of men.[5] Hesiod also appears to use the word to denote the "customs" or "customary behavior" of men.[6] Presumably, since the customary behavior of men is a result of their nature, ἦθος also came to mean the "nature" or "character" of men individually and collectively. Hesiod, again, is the first author to use the word in this sense.[7] When used in the sense of "character" or "nature," ἦθος is frequently associated with, but distinct from πάθος (from πάσχω, "suffer"), the human emotional reaction produced by external cir-

4. *Il.* 6.511, μετά τ' ἤθεα καὶ νομὸν ἵππων. *Od.* 14.411.
5. Hesiod *Op.* 167, 525.
6. *Op.* 137, θέμις ἀνθρώποις κατὰ ἤθεα. LSJ[9] takes this to mean "according to their customs." It could also mean, however, "wherever their abodes (are)." In the *Theogony* 66, νόμους καὶ ἤθεα, the meaning is clearly "customs."
7. *Op.* 67, 78, ἐπίκλοπον ἦθος (referring to the deceitful nature of Pandora).

187

cumstances. The basic difference between ἦθος and πάθος is that the former is a part of a man's inner makeup, while the latter is a temporary reaction to external stimuli.

In all the passages listed here ἦθος refers, I believe, to the study of and representation of human character in art. The character represented may be of any kind—noble, ordinary, or reprehensible, as Xenophon makes clear in passage 1. In a like manner πάθος refers to the study and representation of all kinds of "emotion." I emphasize this interpretation of ἦθος because it is at variance with a widely accepted modern view that ἦθος often means "loftiness of character" or "high moral bearing." This meaning seems to be based on a nineteenth-century interpretation (in my opinion a misinterpretation) of what Aristotle says about Polygnotus in passages 2 and 3 and what Pliny says about the ἤθη of Aristides in passage 5.

Since I have offered a critique of this nineteenth-century view and an analysis of the meaning of ἦθος in a separate article,[8] I will not repeat all the details here. In brief, however, the following points should be made about the meaning of ἦθος in connection with the visual arts:

A. The meaning of ἦθος in all passages which relate to the visual arts is simply "character, good or bad."

B. Aristotle's comparison of Polygnotus and Zeuxis in passage 2 is simply intended to illustrate the point that character study is no more essential in tragedy than it is in painting. The passage is not intended to disparage Zeuxis.

C. In *Poetics* 6.24 Aristotle suggests that ἦθος is best revealed in situations where a person contemplates the consequences of his own action. Pausanias's description of Polygnotus's paintings in the *leschē* of the Cnidians at Delphi (10.25.1–10.31.12) suggests that Polygnotus's work contained many such scenes. In the *Sack of Troy*, for example, Ajax the son of Oileus was depicted swearing an oath at an altar while Cassandra sat nearby holding the wooden image of Athena to which she had clung as a suppliant before Ajax committed the sacrilege of dragging her away. The characters of both Ajax and Cassandra were revealed more clearly in this quiet scene than they would have been in a violent narrative depiction of the actual sacrilege. Ajax was being forced to judge, through his oath before the gods, the degree of his own guilt (Odysseus had accused him of raping Cassandra and had proposed that he be stoned to death), while Cassandra, the prophetess, mutely contemplated the significance of having taken refuge at the image of a goddess who could not protect her but would punish those who offended her. The Underworld seems to have been especially rich in scenes in which individual figures contemplated the consequences and significance of their chosen

8. "The *ēthos* of Polygnotos and Aristides," in *Studies in Honor of Otto J. Brendel*. (forthcoming).

course of action—for example, Eriphyle and the necklace, Pirithous contemplating the swords which had not been able to save him, and Protesilaus contemplating Achilles, whose fame he had made possible by sacrificing his own life. Aristotle probably had scenes of this sort in mind when he referred to Polygnotus as an ἠθογράφος.

Such dramatic yet contemplative scenes in which a person's ἦθος was vividly conveyed were apparently not typical of the art of Zeuxis. His most famous paintings were known for the seemingly perfect beauty of their figures, as in the *Helen* at Croton (Pliny *NH* 35.64; Cicero *Inv. Rhet.* 2.1.1.); for their novel subject matter and remarkable realism of detail, as in the Centaur Family (Lucian, *Zeuxis*) or the "grapes" (Pliny *NH* 35.65); for what seems to have been allegorical content, as in the Penelope (Pliny *NH* 35.63); and even for their πάθος, as in his Menelaus (Tzetzes *Chil.* 8.196, 198). But none of these works seems to have involved the study of character. In short, ancient descriptions of the works of the two painters seem to confirm Aristotle's judgment of Polygnotus and Zeuxis, but do not force us to conclude that ἦθος in the *Poetics* suggests nobility of character. In the case of Ajax and Eriphyle the character which Polygnotus represented was, if anything, ignoble.

D. Aristotle calles Polygnotus ἠθικός in the *Politics* (passage 3) because the painter's work showed different types of characters in scenes where moral rights and wrongs were at issue. Not all the characters in them were noble, but moral lessons could be learned from them by the young. The paintings of Pauson, with whom Polygnotus is contrasted were often pornographic.

E. The ἤθη which Aristides of Thebes *primus pinxit*, according to Pliny (passage 5), were perhaps stock types of characters, like those in the *Characters* of Theophrastus.

F. Achievements in the representation of ἦθος may have been one of the standards of the "Xenocratic" tradition of criticism. Similarities in the criteria used by Pliny (*NH* 35.58) and Aelian (passage 8) with regard to Polygnotus (e.g. lightness of drapery, representation of facial expression and other fine details in Pliny=ἀκρίβεια and πάθος καὶ ἦθος in Aelian) suggest that the two writers were drawing on the same tradition. The context of Pliny's remarks as well as the nature of the criteria suggest that this tradition might have been that of Xenocrates or Antigonus.

θαυμαστός, θαῦμα (*thaumastos, thauma*)

1. Hesiod *Scut.* 164–65.

τῶν καὶ ὀδόντων μὲν καναχὴ πέλεν, εὖτε μάχοιτο/ Ἀμφιτρυωνιάδης, τὰ δ᾽ἐδαίετο θαυματὰ ἔργα.

189

θαυμαστός, θαῦμα (thaumastos, thauma)

And there was a gnashing of their [the snakes on the shield of Heracles]
teeth when the son of Amphitryon was in combat; and these marvelous
works shone brightly.

2. Diodorus Siculus 4.76.20.

εὑρετὴς δὲ γενόμενος πολλῶν τῶν συνεργούντων εἰς τὴν τέχνην κατεσ-
κεύασε ἔργα θαυμαζόμενα κατὰ πολλοὺς τόπους τῆς οἰκουμένης.

He [Daedalus] was the inventor of many devices which contributed
to the art [of sculpture] and wrought marvelous works in all parts of
the inhabited world.

3. Plutarch Dem. 22.3.

ἑπτὰ γὰρ ἔτεσι συντελέσαι λέγεται τὴν γραφὴν ὁ Πρωτογένης. καί
φησιν ὁ Ἀπελλῆς οὕτως ἐκπλαγῆναι θεασάμενος τὸ ἔργον, ὥστε καὶ
φωνὴν ἐπιλιπεῖν αὐτόν. ὀψὲ δὲ εἰπεῖν, μέγας ὁ πόνος καὶ θαυμαστὸν
τὸ ἔργον, οὐ μὴν ἔχειν χάριτας, δι᾽ ἃς οὐρανοῦ ψαύειν τὰ ὑπ᾽ αὐτοῦ
γραφόμενα.

For Protogenes is said to have taken seven years to complete the paint-
ing [his Ialysus]. And Apelles says that when he saw it he was so im-
pressed that his voice left him; but that, after a time, he expressed the
opinion that the labor was great and the work marvelous, but that it
lacked those graces through which his own paintings managed to touch
heaven.

4. Plutarch Pericles 13.1.

. . . μάλιστα θαυμάσιον ἦν τὸ τάχος . . .

[As the works of the Periclean building program were going up (see
μέγεθος, passage 6)]. . . the most wonderful thing [about it] was the
speed [with which they were completed].

5. Pausanias 8.42.7.

τοῦ δὲ Ὀνάτα τούτου Περγαμενοῖς ἐστιν Ἀπόλλων χαλκοῦς, θαῦμα ἐν
τοῖς μάλιστα μεγέθους τε ἔνεκα καὶ ἐπὶ τῇ τέχνῃ.

There is a bronze Apollo by this Onatas at Pergamon, truly a most
wonderful work both for its size and its artistic quality.

6. Callistratus Descriptiones 8.3.

. . . ἐπέκεινα θαύματος, ἡδονῆς ἀφιέναι τὴν ὕλην τεκμήρια . . .

See ἦθος καὶ πάθος, passage 9.

7. *Suidas*, s.v. "Protogenes."

> ὁ τὸ ἐν ‘Ρόδῳ Διονύσιον ἱστορήσας, τὸ ξένον καὶ θαυμαστὸν ἔργον, ὅ καὶ Δημήτριος ὁ Πολιορκητὴς μεγάλως ἐθαύμασεν.

He did paintings for the sanctuary of Dionysus in Rhodes, [which contained?] the strange and marvelous work at which Demetrius Poliorcetes marveled greatly.

8. Eustathius, commentary on Dionysius Periegetes 504 (see Overbeck, *Schriftquellen*, 1540).

> ἡ δὲ ‘Ρόδος ἄλλα τε ἔσχε θαυμαστὰ καὶ τὸν ‘Ηλίου κολοσσόν . . . καὶ ἦν αὐτὸς ἐν τῶν ἐπτὰ θεαμάτων . . .

Rhodes has other marvels, including the colossus of Helios, . . . and this is one of the seven wonders . . .

Commentary

The term θαυμαστός, "marvelous, wonderful, remarkable," reflects an attitude toward art which was an abiding feature of what we have called popular criticism (see chap. 4). In most of the passages cited here the word is simply used to convey a feeling of enthusiasm and is to be considered a critical term only in the broadest possible sense, (in that it does express a value judgment of sorts about art). It also at times suggests, in addition to enthusiasm and admiration, the feeling that works of art have the capacity to take on a magical life of their own. The idea is a recurrent theme in the rhetorical descriptions of Callistratus (passage 6) and also always seems to have been particularly associated with the works ascribed to Daedalus (passage 2). See also *mirabilis*.

τὸ κάλλος (to kallos)

1. Aristotle *Pol.* 1338a18 and 41; 1338b2.

> a. δοκεῖ δὲ καὶ γραφικὴ χρήσιμος εἶναι πρὸς τὸ κρίνειν τὰ τῶν τεχνιτῶν ἔργα κάλλιον.

[In education the study of music is an end in itself; other subjects, however, have practical applications. Writing is used in business etc.,] and drawing is useful because it better enables one to judge the works of artists.

191

τὸ κάλλος (to kallos)

b. . . . ὁμοίως δὲ καὶ τὴν γραφικήν . . . ὅτι παεῖ θεωρητικὸν τοῦ περὶ τὰ σώματα κάλλους.

. . . likewise the study of drawing . . . [is pursued not for its application to practical business life] but because it makes one better informed concerning the nature of corporeal beauty.*

*Literally "of beautiful bodies," but Aristotle is probably thinking of visible forms in general rather than exclusively of the human body.

2. Strabo 9.1.17.

Ῥαμνοῦς δὲ τὸ τῆς Νεμέσεως ξόανον (ἔχει), ὅ τινες μὲν Διοδότου* φασὶν ἔργον τινὲς δὲ Ἀγορακρίτου τοῦ Παρίου, καὶ μεγέθει καὶ κάλλει σφόδρα κατωρθωμένον καὶ ἐνάμιλλον τοῖς Φειδίου ἔργοις.

*Φειδίου αὐτοῦ: Ludwig Urlichs, RhM 10 (1856): 465.

Rhamnous has a statue of Nemesis, which some say is the work of Diodotus [read "Phidias himself"] and others say is the work of Agoracritus the Parian, a work which is a great success, both in its grandness and its beauty, and is in a class with the works of Phidias.

3. Strabo 13.1.13. See μέγεθος, passage 4.

4. Dio Chrysostom Or. 12.63.

τὸ δέ γε τῆς ἐμῆς ἐργασίας, οὐκ ἄν τις οὐδὲ μανείς τινι ἀφομοιώσειεν οὐδενὶ θνητῷ πρὸς κάλλος ἢ μέγεθος [θεοῦ]* συνεξεταζόμενος.

*θεοῦ secl. Emperus; θεῷ M.

[The speaker is Phidias.] But as for this product of my workmanship, no one, not even a madman, were he to examine it closely from the standpoint of its beauty and the grandness of the god, would liken it to any mortal man.

5. Plutarch Pericles 13.2. See ἀκρίβεια, passage 8.

6. Plutarch Sulla 17.2

τῷ γὰρ Ὀλυμπίῳ Διὶ καὶ τὸ κάλλος καὶ τὸ μέγεθος παραπλήσιον ἰδεῖν ἔφασαν.

[Messengers to Sulla] said that they had seen a figure who in beauty and stature was very like the Zeus at Olympia [i.e. Trophonios].

192

7. Lucian *Hist. conscr.* 27. See εὐρυθμία, passage 9.

8. Maximus of Tyre *Diss.* 26.5. See ἀρετή, passage 4.

9. Themistius *Orationes* 34.11.40. See ἀκρίβεια, passage 23.

Commentary

The analysis which we have made of *pulchritudo* will serve equally well for its Greek equivalent τὸ κάλλος.[9] The semantic range of κάλλος is as simple or as complex as "beauty," "Schönheit" or any other word denoting the same quality. It is probably correct to say that beauty is the quality most commonly looked for in and demanded of a work of art both by the average man and the presumed connoisseur. All claim to be able to recognize it; few attempt to define it.[1]

Κάλλος is used as early as Homer to refer to the beauty of a person,[2] and it is frequently used in the fifth century B.C. and later to refer to the beauty of the human body and physical forms in general. This is clearly the sense in which it is used by Aristotle in passage 1. The beauty one finds in the art of drawing is a reflection of the beauty of the physical world.

As with *pulchritudo*, an unusually high proportion of the passages that use the term κάλλος refer to the art of Phidias (passages 2, 4, 6, 7, and 9 above). It is not unlikely that this connection is another reflection of the *phantasia* theory (see chap. 2). It will be remembered that Phidias was best able to render those ἀρεταί[3] which belonged specifically to the gods—their beauty (*pulchritudo, κάλλος*) and their majesty (*maiestas, μέγεθος*?). Κάλλος καὶ μέγεθος,[4] which occurs frequently in our passages (see numbers 2, 3, 4, and 6), appears to be an established idiomatic phrase in which μέγεθος could be taken either literally or metaphorically (see μέγεθος). The pairing of *pulchritudo* and *maiestas* in Quintilian's evaluation of Phidias (*Inst.* 12.10.9) probably represents a Latin adaptation of this traditional Greek phrase, which the formulators of the *phantasia* theory felt was particularly appropriate to the works of Phidias. Galen, as we have seen, seems to imply that τὸ κάλλος was

9. Schweitzer, *Xenokrates*, p. 40, accepts the equation of κάλλος and *pulchritudo*. Ferri, *Vitruvio*, commentary on *Vit.* 1.2.3, holds that *decor* and *venustas* can equal πρέπον, κάλλος, ἡδονή, χάρις.

1. See Charles Seltman, *Approach to Greek Art* (New York, 1960), chap. 2, who deplores, as many others have, the use of the English word *beauty* in connection with Greek art and reviews the various meanings which κάλλος and τὸ καλόν can have.

2. *Il.* 3.39, ᾽Αλέξανδρος . . . κάλλεί τε στίλβων.

3. Note passage 8, and see commentary under ἀρετή.

4. Compare the Homeric pharses καλός τε μέγας τε *Il.* 21.108; and καλή τε μεγάλη *Od.* 15.418, in connection with persons.

the goal of Polyclitus's system of *symmetria* (Diels, *Fragemente*[7], 40A3; see chap. 1). Whether he is quoting a word used by Polyclitus or whether κάλλος is his own substitute for Polyclitus's τὸ εὖ is, however, impossible to say.

λεπτός (leptos)

1. Homer *Od.* 7.96–97.

θρόνοι . . . ἔνθ'ἐνὶ πέπλοι/λεπτοὶ ἐΰννητοι βεβλῆατο, ἔργα γυναικῶν.

. . . thrones . . . upon which/light finely woven coverings were thrown, the works of women.

2. Dionysius of Halicarnassus *Isoc.* 3.

τὴν (τέχνην) δὲ Λυσίου τῇ Καλάμιδος καὶ Καλλιμάχου τῆς λεπτότης ἕνεκα καὶ τῆς χάριτος.

[One might liken] the art of Lysias to that of Calamis and Kallimachos for its lightness and grace.

3. Lucian *Im.* 6. See εὐρυθμία, passage 8.

4. Lucian *Salt.* 75.

. . . οὔτε πολύσαρκος, ἀπίθανον γὰρ, οὔτε λεπτὸς εἰς ὑπερβολήν, σκελετῶδες γὰρ τοῦτο καὶ νεκρικόν.

(For preceding text see ἀκρίβεια, passage 17.)

[In order to be in accord with the *Canon* of Polyclitus, the body should not be too tall or too short.] Nor should it be too fat, for that would be incredible, nor excessively slender, for this would be skeletal and corpselike.

5. Aelian *VH* 4.3. See ἀκρίβεια, passage 22.

6. Tzetzes *Chil.* 8.358–59.

τῶν ὧν ὁ Ἀλκαμένης μὲν τύπῳ θεᾶς παρθένου λεπτὸν ὁμοῦ εἰργάζετο καὶ γυναικεῖον τοῦτο.

[Alcamenes and Phidias were both commissioned by the Athenians

to set up images of Athena in Athens.] Of the two, Alcamenes made his slender and feminine looking, in the manner of a virgin goddess.

Commentary

The terms λεπτός and λεπτότης derive from the verb λέπω, "to peel"; in rare instances such as *Il.* 22.497,[5] λεπτός may be found used in this literal sense. More often, however, the term refers to the fineness, smallness, or lightness that results from a thing's having been peeled down to its essentials. In the passages just cited we find three variations of meaning for λεπτός-λεπτότης: (1) physical thinness of body, (2) fineness or delicacy of both organic and inorganic forms, and (3) a metaphorical lightness or fineness of style.

The first of these meanings, physical thinness of body, occurs in passage 4. In describing what the body of the ideal dancer must be like, Lucian points out that it must not be λεπτός in excess, so that it appears like a skeleton or a corpse. In this sense, λεπτός is probably the Greek word that Pliny translates by *gracilis* and *exilis* (qq.v.).

Our second meaning, "fineness" or "delicacy" in a physical sense, occurs in passages 1, 3, 5, and 6. Despite the fact that it comes from a Byzantine source, passage 6 is of particular interest because it illustrates how closely the ideas of "thin" and "delicate" were related; in this passage, in fact, the meaning of λεπτὸν is ambiguous and may be translated either way. Aelian's reference to ἱματίων λεπτότητας (passage 5) as a characteristic of the figures in the paintings of Polygnotus is also of particular interest. One is reminded here of Pliny's statement that Polygnotus *primus mulieres tralucida veste pinxit* (*NH* 35.58). The Plinian passage may derive from the "Xenocratic" history of painting (see chap. 6), and it is therefore at least possible that Aelian has preserved for us in λεπτότητας a fragment of the critical vocabulary that "Xenocrates" used to describe the art of Polygnotus.

Finally, in passage 2, we find Dionysius of Halicarnassus using λεπτότης to describe a stylistic feature of the oratory of Lysias and the sculpture of Callimachus and Calamis. The genesis of Dionysius's remark is probably to be sought in a purely rhetorical source. Neither "Xenocrates" nor the author(s) of the *phantasia* theory (see chap. 2; glossary under φαντασία) would have been ready to include an Early Classical sculptor, Calamis, and a late-fifth-century sculptor, Callimachus, in the same stylistic category. What Pliny has preserved for us of "Xenocrates'" thought indicates that Calamis played no great role in the Xenocratic system, while in the critical system preserved by Quintilian and Cicero the best that can be said for Calamis is

5. *Il.* 20.497: ῥίμφα τε λέπτ'ἐγένοντο, of barley being threshed out.

that he was *minus rigidus* than his immediate predecessors. Indeed, in the light of our modern knowledge of the difference between the sculptural style of the Early Classical period and that of the late fifth century, these ancient critics had good reason for not classifying Calamis and Callimachus in the same category. The source of the critical judgment that Dionysius preserves in passage 2, then, was perhaps a comparative canon of great orators and sculptors such as those described in chapter 3.

The Latin equivalent of λεπτός in all the passages except number 4 (where we have compared it with *gracilis* and *exilis*) is probably *subtilis*. For further commentary see *subtilis, subtilitas*.

μεγαλοπρεπής (megaloprepēs)

1. Dionysius of Halicarnassus *Isoc.* 3. See ἀξιωματικός.

2. Demetrius *Eloc.* 14. See ἀρχαῖος, passage 4.

3. Dio Chrysostom *Or.* 12.77.

> Ὅσον δὲ ἦν ἐπιδεῖξαι ταῦτα μὴ φθεγγόμενον, ἆρα οὐχ ἱκανῶς ἔχει κατὰ τὴν τέχνην; τὴν μὲν ἀρχὴν καὶ τὸν βασιλέα βούλεται δηλοῦν τὸ ἰσχυρὸν τοῦ εἴδους καὶ τὸ μεγαλοπρεπές.

> To the degree that such things can be demonstrated without the help of speech, is not the god [i.e. the Olympian Zeus of Phidias] sufficiently well represented according to the capacity of art? The strength of the figure and the grandeur are intended to make clear his power as a ruler and his role as a king.

Commentary

The term μεγαλοπρεπής, "elevated, magnificent, grand," in its various forms has an important place in the criticism of Greek rhetoric. Aristotle, although he generally uses μεγαλοπρέπεια to refer to "magnificence" or "magnanimity" of human character,[6] also uses the term in the *Rhetorica ad Alexandrum* 1441b12, to describe an "elevated" style in rhetoric: ἁρμόσει

6. *Eth. Nic.* 1107b16–20; and also *Eth. Nic.* IV.2.1–20. In Aristotle's ethical thought μεγαλοπρέπεια is a virtue which has a specific connection with the spending of money. It represents a mean between paltriness (μικροπρέπεια) on the one hand and vulgarity (βαναυσία) and want of taste (ἀπειροκαλία) on the other.

μεγαλοπρεπής (megaloprepēs)

δ'ἐν τοῖς ἐπαίνοις καὶ πολλοῖς ὀνόμασι περὶ ἕκαστον χρησάμενον μεγαλοπ-
ρεπῆ τὴν λέξιν ποιῆσαι ("It is fitting in eulogies to make the style elevated
by using many words about each separate topic"). According to Demetrius
(Eloc. 41), Theophrastus also wrote on the quality of μεγαλοπρέπεια in
rhetorical style. In the περὶ συνθέσεως ὀνόματων Dionysius of Halicarnassus
makes frequent use of μεγαλοπρεπής: in section 11 he identifies μεγαλοπ-
ρέπεια as one of the chief subcategories of τὸ καλόν;[7] in section 16 he
identifies it (along with καλλιλογίαν and σεμνότητα) as one of the essential
elements of a beautiful style; and in section 22 he speaks of the ῥυθμοὺς τοὺς
ἀξιωματικοὺς καὶ μεγαλρπρεπεῖς as an essential element in the αὐστηρὸς
χαρακτήρ of composition (see commentary under austerus). By the first cen-
tury A.D. when the ἀρεταὶ of rhetorical style as a whole were becoming
standardized, the μεγαλοπρεπὴς χαρακτήρ (or ἀρετή) had become one of
the established formal divisions of rhetorical style. The most important
description extant of this "elevated style" is preserved by Demetrius Eloc.
38–127. He cites σεμνότης (see σεμνός), μέγθος (q.v.), and ὄγκος (gravitas?)
as essential features of the style, and appears to use μεγαλεῖος (65, 99) as
a synonym of μεγαλοπρέπεια.

The existence of the μεγαλοπρεπὴς χαρακτήρ is also known to Quintilian
Inst. 4.2.61: His tribus narrandi virtutibus adiiciunt quidam magnificentiam, quam
μεγαλοπρέπειαν vocant"; his regular Latin rendering of it is thus magnifi-
centiae virtus (4.2.62).

The three passages listed in the catalog make it clear that the use of
μεγαλοπρεπής and related words in connection with the visual arts is
inseparable from their use in rhetoric. Three rhetoricians— Demetrius,
Dionysius, and Dio Chrysostom—use .three terms formed from the μεγαλ-
root—μεγαλοπρεπής, μεγαλεῖος and μεγαλότεχνος—to express a single critical
judgment.[8] This judgment was that the quality of "elevation" was to be
found in the visual arts principally in the art of Phidias (cf. magnificus, passage
2)and in rhetoric in the art of a group of rhetoricians beginning with Gorgias
and Isocrates.[9]

Like μέγεθος, ἀξιματικός, and κάλλος, and like maiestas, auctoritas, and
pulchritudo, μεγαλοπρεπής is used to describe the particular ἀρετή(both in the
sense of "excellence" and "essence") expressed in the art of Phidias and

7. With ἡδονή, one of the two chief ends of composition.
8. The unity of meaning behind μεγαλοπρεπής, μεγαλεῖος, and μεγαλότεχνος is guaranteed
by their context. All refer to the art of Phidias. Μεγαλεῖος is, in Demetrius's Eloc., a synonym
of μεγαλοπρέπεια (65, 99); Dionysius uses μεγαλότεχνος because he is referring specifically to
τέχνη.
9. On the question of the chronology implied in Demetrius's τῶν μετὰ ταῦτα (passage
2) see the commentary under ἀρχαῖος.

probably reflects a fusion of the *phantasia* theory with rhetorical criticism (see chaps. 2 and 3).

μέγεθος (*megethos*)

1. Isocrates *Evag.* 57.

ὑπὲρ ὧν ἡμεῖς μὲν αὐτοὺς ἐτιμήσαμεν ταῖς μεγίσταις τιμαῖς, καὶ τὰς εἰκόνας αὐτῶν ἐστήσαμεν οὗπερ τὸ τοῦ Διὸς ἄγαλμα τοῦ Σωτῆρος, πλησίον ἐκείνου τε καὶ σφῶν αὐτῶν, ἀμφοτέρων ὑπόμνημα καὶ τοῦ μεγέθους τῆς εὐεργεσίας καὶ τῆς φιλίας τῆς πρὸς ἀλλήλους.

For these reasons [aid given to the Athenians against the Spartans] we bestowed the greatest honors upon them [Conon and Evagoras], and we set up statues of them where the image of Zeus Soter stands [in the Agora in Athens], near to it and to one another, a memorial of the extent of their benefactions and of their friendship for one another.

2. Strabo 8.6.10. See πολυτέλεια, passage 2 and commentary.

3. Strabo 9.1.17. See τὸ κάλλος, passage 2.

4. Strabo 13.1.13.

. . . εἰς δὲ Πάριον μετηνέχθη πᾶσα ἡ κατασκευὴ καὶ λιθεία κατασπαθέντος τοῦ ἱεροῦ, καὶ ᾠκοδομήθη ἐν τῷ Παρίῳ βωμός. Ἑρμοκρέοντος ἔργον, πολλῆς μνήμης ἄξιον κατὰ τὸ μέγεθος καὶ κάλλος.

When the sanctuary [of Apollo and/or Artemis at Adrasteia in Mysia] was torn down, all its equipment and stonework were brought to Parium, and in Parium an altar was built, the work of Hermocreon, and one well worth noting, both for its size and its beauty.

5. Dio Chrysostom *Or.* 12.63. See τὸ κάλλος, passage 4.

6. Plutarch *Per.* 13.1.

ἀναβαινόντων δὲ τῶν ἔργων, ὑπερηφάνων μὲν μεγέθει, μορφῇ δ'ἀμιμήτων καὶ χάριτι, . . .

As the works [of the Periclean building program] were going up, magnificent in grandness and having an inimitable grace of form, [and the workmen strove to outdo one another, the speed with which they were completed was remarkable].

7. Plutarch *Sulla* 17. See τὸ κάλλος, passage 6.

8. Lucian *J Tr.* 11. See ἀκρίβεια, passage 12.

9. Pausanias 7.5.9.

ἔστι δὲ ἐν Ἐρυθραῖς καὶ Ἀθηνᾶς Πολιάδος ναὸς καὶ ἄγαλμα ξύλου μεγέθει μέγα καθήμενόν τε ἐπὶ θρόνου.

There is also in Erythrae a temple of Athena Polias and a wooden image of great size represented as seated on a throne.

10. Pausanias 8.26.7.

τῆς δὲ Ἀθηνᾶς τὸ ἄγαλμα πεποίηται χαλκοῦ Ὑπατοδώρου τε ἔργον, θέας ἄξιον μεγέθους τε εἵνεκα καὶ ἐς τὴν τέχνην.

The image of Athena [at Aliphera in Arcadia] is made of bronze and is the work of Hypatodorus, worth seeing both for its size and its artistic quality.

See also Pausanias 8.42.7; θαυμαστός, passage 5.

11. Aristides, *Or.* 48.41 (ed. Keil).

ἔπειτα οὐ πολὺ ὕστερον ἡ Ἀθηνᾶ φαίνεται καὶ αἰγίδα ἔχουσα καὶ τὸ κάλλος καὶ τὸ μέγεθος καὶ σύμπαν δὴ σχῆμα οἷα περ ἡ Ἀθήνησιν ἡ Φειδίου.

Then not much later Athena appeared, having the aegis and also the beauty, the stature and the whole format which Phidias's image of her in Athens presents [part of a vision seen by Aristides during a plague].

Commentary

The problem of establishing the correct meaning of μέγεθος in connection with the visual arts is complicated by the fact that the word has both a literal meaning—"size, stature"—and a metaphorical meaning—"greatness, grandeur, majesty"—and it is sometimes difficult to determine which meaning is applicable in a given passage.

The metaphorical use of μέγεθος to mean "grandeur" or "majesty" is not uncommon among writers on rhetorical style, and it is possible that this use of the term originated in rhetorical criticism. For example, Dionysius of Halicarnassus recommends the use of an anapestic meter in order to invest a subject with μέγεθος and πάθος (*Comp.* 12.10 [ed. Roberts]). Demetrius

199

advocates the use of words that are harsh and difficult to pronounce in order to achieve the effect of μέγεθος (*Eloc.* 48, 49, also 78, 84). "Longinus" *Subl.* 4.1 uses μέγεθος to describe the occasional grandeur achieved by the fourth-century historian Timaeus; and Hermogenes includes a section περὶ μεγέθους καὶ ἀξιώματος τοῦ λόγου in his περὶ ἰδεῶν (1.5). (In general, see *LSJ*⁹, 2:4.)

Outside of rhetoric the term can also be used to denote the "greatness" of a man (Plutarch *Alex.* 14.3, where Alexander admires the ὑπεροφίαν καὶ τὸ μέγεθος of Diogenes) or of a god (Euripides *Bacch.* 273). An intermediate level of meaning between physical size and metaphorical greatness, that is, "magnitude," is also found (for example, Euripides *Hel* 593 . . . μέγεθος τῶν πόνων.

Turning to our catalog of passages, there seems to be little doubt that in passages 8, 9, and 10 μέγεθος simply means physical size. Needless to say, in these passages it is not really a critical term. Passage 1 seems to use the term in the intermediate sense, that is, magnitude. The remaining passages are ambiguous. Plutarch's attribution of μέγεθος to the structures of the Periclean building program in passage 6, for example, could refer to their physical size or it could refer to their "grandeur." I have used "grandness" in my own translation to reflect this ambiguity.

In passages 3, 4, 5, 7, and 11 we find μέγεθος used as part of the conventional phrase κάλλος καὶ μέγεθος which is also referred to in connection with κάλλος. It is difficult to decide what value should be attached to this phrase in each case. My own reaction is that in passage 4, on the altar of Hermocreon, the term should probably be taken literally; in passage 5, Dio's comment on Phidias's Zeus, it should probably be understood metaphorically, and that in 3, 4, and 11 it probably suggested both "stature" and "majesty."

Passage 2 is also problematical. At first sight it would seem to mean simply that the statues of Polyclitus were smaller and less costly than those of Phidias. And yet the thought expressed, if taken metaphorically, is so similar to what Quintilian says about these two sculptors in the context of the *phantasia* theory (i.e. that Polyclitus lacked *pondus* and failed to convey the *auctoritas deorum*, and that *quae Polyclito defuerunt, Phidiae et Alcameni dantur*) that one wonders if Strabo's passage is not also a reflection of this critical tradition. In this case μέγεθος may be the Greek prototype for Latin terms like *maiestas* or *pondus* when used in connection with the visual arts.

Exact equivalents between Greek and Latin critical terms, however, are difficult to determine. Carl Robert chose to translate μέγεθος by *pondus* in one instance but by *gravitas* in another.[1] Schweitzer prefers *maiestas* as the

1. Robert, *Arch. Märch.*, pp. 52 and 78.

translation of μέγεθος but acknowledges that *maiestas* is also used to translate related terms such as μεγαλεῖον and μεγαλότεχνος (see μεγαλοπρεπής).[2] Schweitzer's translation is closer to μέγεθος both etymologically and semantically and is perhaps preferable to Robert's, although it must be admitted that the exact relationship between such Greek terms as πολυτέλεια, σεμνότης, ἀξιωματικόν and the Latin terms *pondus, gravitas,* and *magnificentia* is difficult to define. It seems likely that the Latin writers who translated the Greek critical vocabulary recognized no universally accepted equivalents between Greek and Latin terms and that the different equations which have been proposed are valid, at best, only for individual authors.

For further commentary see *maiestas, magnificus, pondus,* and πολυτέλεια.

ὁμοιότης, ὁμοίωμα ὁμοῖος (homoiotēs, homoiōma, homoios)

1. Plato *Soph.* 266C-D.

ΞΕΝΟΣ: Τί δὲ τὴν ἡμέτεραν τέχνην; ἆρ' οὐκ αὐτὴν μὲν οἰκίαν οἰκοδο-
μικῇ φήσομεν ποιεῖν, γραφικῇ δέ τιν' ἑτέραν, οἶον ὄναρ ἀνθρώπινον
ἐγρηγορόσιν ἀπειργασμένην;
ΘΕΑΙΤΗΤΟΣ: Πάνυ μὲν οὖν.
ΞΕ: Οὐκοῦν καὶ τ'ἆλλα οὕτω κατὰ δύο διττὰ ἔργα τῆς ἡμετέρας αὖ
ποιητικῆς πράξεως, τὸ μὲν αὐτό, φαμέν, αὐτουργική. τὸ δὲ εἴδωλον
εἰδωλοποιικῇ.*
ΘΕΑΙ: Νῦν μᾶλλον ἔμαθον, καὶ τίθημι δύο διχῇ ποιητικῆς εἴδη. θείαν†
μὲν καὶ ἀνθρωπίνην κατὰ θάτερον τμῆμα, κατὰ δὲ θάτερον τὸ μὲν
αὐτῶν ὄν, τὸ δὲ ὁμοιωμάτων τινῶν γέννημα.

*αὐτοργικῇ et mox εἰδωλοποιικῇ Heindorf; αὐτουργική et mox εἰδωλοποιική mss., secl. Apelt.
†θείαν. . . ἀνθρωπίνην Heindorf; θεία . . . ἀνθρωπίνη B; θειᾷ . . . ἀνθρωπίνη T.

Stranger: And what of our own art? Do we not say that we make one house by the art of architecture, and quite another house by painting, the latter being a kind of man-made dream for people who are awake?
Theaetetus: Yes, exactly.
St.: Well then, the other works of our productive activity are likewise divisible into two categories—the real thing, produced by actual manufacture, and the image, produced by the art of image making.
Th.: I understand better now, and I agree that there are two categories

2. Schweitzer, *Xenokrates*, p. 34.

of production. By one division, there is the divine and the human; and by another division, there is the reality of things, on the one hand, and there is the product which involves likenesses of a sort, on the other.

2. Plato *Criti.* 107C.

. . . καὶ κατοψόμεθα, ὅτι γῆν μὲν καὶ ὄρη καὶ ποταμοὺς καὶ ὕλην οὐρανόν τε ξύμπαντα καὶ τὰ περὶ αὐτὸν ὄντα καὶ ἰόντα πρῶτον μὲν ἀγαπῶμεν ἄν τίς τι καὶ βραχὺ πρὸς ὁμοιότητα αὐτῶν ἀπομιμεῖσθαι δυνατὸς ᾖ . . .

. . . and we will observe that with regard to the earth and mountains and rivers and the entire natural world, including all the things which exist and move within it, we are pleased if a man is able to represent even a slight likeness of these things, [but when it comes to judging representations of the human form, we are severe critics . . .]

Cf. σκιαγραφία, passage 1.

3. Diodorus Siculus 4.76.2.

κατὰ δὲ τὴν τῶν ἀγαλμάτων κατασκευὴν τοσοῦτο τῶν ἁπάντων ἀνθρώπων διήνεγκεν, ὥστε τοὺς μεταγενεστέρους μυθολογῆσαι περὶ αὐτοῦ διότι τὰ κατασκευαζόμενα τῶν ἀγαλμάτων ὁμοιότατα τοῖς ἐμψύχοις ὑπάρχειν. βλέπειν τε γὰρ αὐτὰ καὶ περιπατεῖν καὶ καθόλου τηρεῖν τὴν τοῦ ὅλου σώματος διάθεσιν, ὥστε δοκεῖν εἶναι τὸ κατασκευασθὲν ἔμψυχον ζῷον.

In the production of statues he [Daedalus] so surpassed all other men that later generations preserved a story about him to the effect that the statues which he created were exactly like living beings. For it was related that they could see, and walk, and preserved so completely the disposition of the entire body that the statue which was produced by art seemed to be a living being.

4. Plutarch *Pericles* 31.4.

τὸ δὲ σχῆμα τῆς χειρός, ἀνατεινούσης δόρυ πρὸ τῆς ὄψεως τοῦ Περικλέους, πεποιημένον εὐμηχάνως, οἷον ἐπικρύπτειν βούλεται τὴν ὁμοιότητα παραφαινομένην ἑκατέρωθεν.

[The supposed portrait of Pericles on the shield of Phidias's Athena Parthenos:] The arrangement of the hand, holding up a spear in front

ὁμοιότης, ὁμοίωμα ὁμοῖος (*homoitēs, homoiōma, homoios*)

of Pericles' eyes, was cleverly contrived with the intention of hiding the likeness which is only visible on either side [of the arm].

5. Plutarch *Alex.* 1.3. See ἦθος καὶ πάθος, passage 6.

6. Athenagoras *Leg. pro Christ.* 14 (Overbeck, *Schriftquellen*, 261).

ἐρωτικῶς γάρ τινος ἔχουσα περιέγραψεν αὐτοῦ κοιμωμένου ἐν τοίχῳ τὴν σκιάν. εἶθ ὁ πατὴρ ἠσθεὶς ἀπαραλλάκτῳ οὔσῃ τῇ ὁμοιότητι . . .

[On the invention of modeling by Butades:] For [the daughter of Butades] being in love with a certain man outlined his shadow on the wall while he was asleep. Thereupon her father, having perceived that the likeness was virtually indistinguishable from the real thing [modeled a relief of it].

Cf. Pliny *NH* 35.151; *similitudo*, passage 10.

7. Maximus of Tyre *Diss.* 26.5 (ed. Hobein). See ἀρετή, passage 4.

8. Porphyry *Plot.* 1.

Ἔπειτα γράφοντος ἐκ τοῦ τῇ μνήμῃ ἐναποκειμένου ἰνδάλματος τὸ εἴκασμα καὶ συνδιορθοῦντος εἰς ὁμοιότητα τὸ ἴχνος τοῦ Ἀμελίου εἰκόνα αὐτοῦ γενέσθαι ἡ εὐφυΐα τοῦ Καρτερίου παρέσχεν ἀγνοοῦντος τοῦ Πλωτίνου ὁμοιοτάτην.

[Plotinus refused to allow his portrait to be made. His friend Amelius thereupon arranged to have the painter Carterius attend Plotinus's philosophical gatherings and to prepare a portrait of him from memory.] Then Carterius drew the portrait from the mental image which had been impressed on his mind, and Amelius corrected the first sketch to an even more exact likeness; thus the natural talent of Carterius provided a very exact likeness of Plotinus without his even being aware of it.

9. Callistratus *Descriptiones* 5.3.

ἡ μὲν γὰρ λίθος ὅλη πρὸς ἐκεῖνον μετηλλάττετο τὸν ὄντως παῖδα, ἡ πηγὴ πρὸς τὰ ἐν τῇ λίθῳ μηχανήματα τῆς τέχνης ἀντηγωνίζετο ἐν ἀσωμάτῳ σχήματι τὴν ἐκ σώματος ἀπεργαζομένη τοῦ παραδείγματος ὁμοιότητα καὶ τῷ ἐκ τῆς εἰκόνος κατερχομένῳ σκιάσματι, οἷον τινὰ σάρκα τὴν τοῦ ὕδατος φύσιν περιθεῖσα.

[On a statue of Narcissus and its reflection in a pool:] For the stone

παράδειγμα (*paradeigma*)

was in every way transforming the real boy [i.e. the statue] into the reflected one, the spring was struggling to equal the devisings of art in stone by fashioning in incorporeal form [i.e. a reflection] an exact likeness from the corporeal model and by enveloping the reflection which came from the statue with the substance of water, as if it were a body.

Commentary

'Ομοιότης and ὁμοίωμα are general terms signifying "likeness" and are the words which were normally used to express an accurate representation of "reality" in the sense of "natural appearance" (see the third of the meanings proposed for ἀλήθεια). Since ὁμοιότης, like its Latin counterpart *similitudo*, emphasizes the essential similarity between art and nature, it is frequently used, as is *similitudo*, in connection with realistic portraiture (passages 4, 5, 6, and 8).

Plato's observation in passage 2, I would note in passing, is one of the most illuminating illustrations we have of the Classical Greek attitude toward landscape painting. One could take the passage as a rationale of, or at least an indication of the state of mind behind, the anthropocentric emphasis in Attic vase painting.

On the place of the ὁμοιότης idea in the development of Greek painting, see *similitudo*.

παράδειγμα (*paradeigma*)

EPIGRAPHICAL

(Explanations, rather than translations, are given for the epigraphical passages, with the exception of number 4).

1. *IG* I² 374.248 (from the buiding accounts of the Erechtheum, 409–406 B.C.).

 hέτερον παράδειγμα πλάσαντι τὴν ἄκανθαν heις τὰ καλύματα 'Αγαθάνορ 'Αλοπεκῆσι hοικόν

 (Model for an acanthus ornament for the coffers of a ceiling.)

2. *IG*, IV², 102 (building accounts of the temple of Asclepius at Epidaurus ca. 380 B.C.).

 a. 102A, lines 250–51.

 'Αντιφίλωι κονιατῆρι παραδειχμάτων

204

(Payment to a stucco worker for a model.)

b. 102B. 296 (as above).

παραδείχματος μακέλλο 'Απολ[λ]οδώρωι

(Payment for a model of an "enclosure," probably a fence.)

c. 102B. 303 (as above).

'*Εκτορίδαι παραδείχματος λεοντο[κ]εφαλᾶν ἐνκαύσιος*

(Payment to Hectoridas, for the model of a lion-head spout with encaustic color.)

3. *IG*, IV², 103.90–91 (building accounts of the Tholos at Epidaurus, ca. mid-fourth century B.C.).

Κωμωιδίωνι τοῦ παραδείγματος τῶν ἐγγλυμμάτων ἀστραγαλίων καὶ κυματίων 'Αττικοῦ.

(Models for decorative carvings and architectural moldings.)

4. *IG*, II–III², 1668 (authorization for building the *skeuothēkē* of Philo in Peiraeus).

a. lines 85 ff.

ποιήσει δὲ καὶ κιβωτοὺς τοῖς ἱστίοις καὶ τοῖς παραρρύμασιν τοῖς λευκοῖς ἀριθμὸν ἑκατὸν τριάκοντα τέτταρας, πρὸς τὸ παράδειγμα ποιήσας καὶ θήσει κατὰ τὸν κίονα ἕκαστον.

And one shall make chests for the sails and for the white side-curtains, 134 in all, making them according to the model, and shall place one by each column.

b. lines 94 ff.

ταῦτα ἅπαντα ἐξεργάσονται οἱ μισθωσάμενοι κατὰ τὰς συγγραφὰς καὶ πρὸς τὰ μέτρα καὶ πρὸς τὸ παράδειγμα ὃ ἂν φράζηι ὁ ἀρχιτέκτων.

Those who are hired shall execute all of these things according to the specifications and the measurements and the model, as the architect may advise.

5. *Fouilles de Delphes*, 5.19.106 (accounts of the Council, 342 B.C.).

τοῦτο ἐδόθη Νικοδάμῳ 'Αργείῳ . . . τοῦ παραδείγμ[ατος] τὰς λεοντοκεφαλᾶς, στατῆρες δέκα ἑπτά

παράδειγμα (*paradeigma*)

(Model for a lion-head spout.)

6. *Fouilles de Delphes*, 5.20.4–5 (as above, 341 B.C.).

τοῦτο ἐδόθη [Κ]ε[φά]λωνι το[ῦ ξ]υλ[ί]νου ἀστέρος τοῦ παραδείγματος στατῆρες τέτορες

(Model of a wooden star, probably an architectural ornament.)

7. *IG*, II-III², 1675.23 (provisions for a portico in Eleusis, 337–36 B.C.).

. . . τοὺς δὲ πόλους τορνεύσει στρογγύλους πρὸς τὸ παράδειγμα

(Dowels for columns, to be turned according to the specifications of a model.)

8. *IG*, II-III², 1627b.300, 325–26 (inventory of naval equipment and other gear in Peiraeus, 330–329 B.C.).

παράδειγμα τῶν κεραμίδων τῶν ἐπὶ τὴν σκευοθήκηι . . . παράδειγμα ξύλινον τῆς τριγλύφου τῆς ἐνκαύσεως

(Wooden models of roof tiles for the *skeuotheke*? The same entry occurs in *IG*, II-III², 1629e.983, 325–324 B.C.)

9. *IG*, II-III², 1678a.11ff.(material authorized for the Stoa of the Bulls in Delos, before 315 B.C.).

τοῦ δὲ παραδείγματος τοῦ πεποιημένου [τ]οῦ ἐ[π]ικράνου [ἔσ]ται μίσ[θω]σις [κατὰ λόγο]ν τοῦ [ἀρ] γυρίου, ὅσου ἄμ μισθωθῆι τὸ ἔργο[ν] ὅτ[ι] ἂν τάξει ὁ ἀρχιτέκτων. κομιεῖ δὲ καὶ τὸ παραδ[ειγμα] [τ]οῦ ἐπικράνου εἰς Δῆλον ὁ μισθωσάμενος τέ[λ]εσι τοῖς αὐτοῦ ὑγιὲ⟨ι⟩ς. . .

(Model of a column capital, with authorization for its transportation to Delos.)

10. *IG*, XI, 2.165.17 (*Tabulae Hieropoeorum*, ca. 280 B.C.).

. . . τὸ παράδειγμα τοῦ Κυνθίου.

(Model of the temple of Zeus Kynthios at Delos.)
The same entry occurs in *IG*, XI, 2.199B.90. and *IG*, XI, 2.203B.96.

11. *Inscriptions de Délos*, 504B, 7 (contract, ca. 280 B.C.).

ἐμισθώσατο φανέας [ἐργάσ]ασθαι κατὰ τὴν συγγραφὴν [πάντ?]α πρὸς τὸ παράδειγμα κλιμακίδας τ[ρεῖς καὶ φάτ]νην δραχμῶν τριακοσίων.

206

(The contractor Phaneas undertakes to make a frame for a ceiling with coffers in conformity with the specifications of a model.)

12. *IG*, XI, 2.161A (account of expenses, 279 B.C.).

a. line 43.

τοῦ φοίνικος τοῦ περιγενομένους ἀπὸ τοῦ παραδείγματος, παρὰ φανέου

(Payment for palm wood left over from a model.)

b. lines 75–76.

εἰς τὸ παράδειγμα τοῦ προπύλου. πίνακα ἠγοράσαμεν παρὰ χρησίμου

(A tablet purchased for a model [or plan?] of the Propylon at Delos; see J. A. Bundgaard, *Mnesicles* [Copenhagen, 1957], p. 219, note 217, 16).

13. *Inscriptions de Délos*, 1417A 1.11. 32–33 (inventory in the archonship of Kallistratos, 156–155 B.C.).

π[αράδ]ειγμα ναίσκου ξυλίνου. ᾿Άλλο παράδειγμα

(Wooden model for a small temple stored in the "*oikos* near the *Ekklesiasterion*"; cf. René Vallois, "Topographic Délienne," *BCH* 53 (1929): 302–12.

LITERARY

14. Herodotus 5.62.

. . . τόν τε νηὸν ἐξεργάσαντο τοῦ παραδείγματος κάλλιον, τά τε ἄλλα καὶ συγκειμένου σφι πωρίνου λίθου ποιέειν τὸν νηόν, Παρίου τὰ ἔμπροσθε αὐτοῦ ἐξεποίησαν.

. . . they constructed the temple more beautifully than [what was called for in] the model, for, among other things, though their agreement called for them to make the temple of poros limestone, they made the front of it instead out of Parian marble.

15. Plato *Rep.* 472D.

Οἴει ἂν οὖν ἧττόν τι ἀγαθὸν ζωγράφον εἶναι, ὃς ἂν γράψας παράδειγμα οἷον ἂν εἴη ὁ κάλλιστος ἄνθρωπος, καὶ πάντα εἰς τὸ γράμμα ἱκανῶς ἀποδοὺς, μὴ ἔχῃ ἀποδεῖξαι, ὡς καὶ δυνατὸν γενέσθαι τοιοῦτον ἄνδρα;

Do you think a man would be any less good a painter who, after drawing a model to show what the most beautiful human being should look

παράδειγμα (*paradeigma*)

like and after adding everything possible to make the drawing adequate, would be unable to demonstrate that it is possible for such a man to exist?

16. Plato *Rep.* 484C.

’Η οὖν δοκοῦσί τι τυφλῶν διαφέρειν οἱ τῷ ὄντι τοῦ ὄντος ἑκάστου ἐστερημένοι τῆς γνώσεως, καὶ μηδὲν ἐναργὲς ἐν τῇ ψυχῇ ἔχοντες παράδειγμα, μηδὲ δυνάμενοι ὥσπερ γραφεῖς εἰς τὸ ἀληθέστατον ἀποβλέποντες κἀκεῖσε ἀεὶ ἀναφέροντές τε καὶ θεώμενοι ὡς οἷόν τε ἀκριβέστατα, . . .

[The principal qualification of the guardians of the ideal state should be a knowledge of reality.] Well then, is there any difference between blind men and men who are devoid of knowledge of the real nature of things, men who do not have a vivid ideal pattern in their souls, and who are therefore unable to fix their glance, like painters [looking at a model] upon what is most true and, by always making reference to it and always viewing it with the utmost possible exactitude, . . . [translate the truths of the ideal world into the relative world?]

17. Plato *Rep.* 500E.

’Αλλ’ἐὰν δὴ αἴσθωνται οἱ πολλοί, ὅτι ἀληθῆ περὶ αὐτοῦ λέγομεν, χαλεπανοῦσι δὴ τοῖς φιλοσόφοις καὶ ἀπιστήσουσιν ἡμῖν λέγουσιν, ὡς οὐκ ἄν ποτε ἄλλως εὐδαιμονήσειε πόλις, εἰ μὴ αὐτὴν διαγράψειαν οἱ τῷ θείῳ παραδείγματι χρώμενοι ζωγράφοι;

But if the common run of people perceive that what we say about him [the philosopher who beholds eternal realities] is true, will they then be so hard on philosophers, and will they disbelieve us when we say that no city will ever attain peace and prosperity unless the painters who make use of the divine model [i.e. philosophers] draft a plan for it?

18. Plato *Soph.* 235D.

Μίαν μὲν τὴν εἰκαστικὴν ὁρῶν ἐν αὐτῇ τέχνην. ἔστι δ’αὕτη μάλιστά, ὁπόταν κατὰ τὰς τοῦ παραδείγματος συμμετρίας τις ἐν μήκει καὶ πλάτει καὶ βάθει καὶ πρὸς τούτοις ἔτι χρώματα ἀποδιδοὺς τὰ προσήκοντα ἑκάστοις, τὴν τοῦ μιμήματος γένεσιν ἀπεργάζεται.

The art of making likenesses is one of the divisions within it [i.e. within *mimesis*]. This is certainly the art which is involved whenever someone

produces an imitation in which he adheres to the commensurate measurements of the model in length, breadth, and depth, and also adds the suitable colors to each of these parts.

19. Plato *Ti.* 28A-B.

ὅτου μὲν οὖν ἂν ὁ δημιουργὸς πρὸς τὸ κατὰ ταὐτὰ ἔχον βλέπων ἀεί, τοιούτῳ τινὶ προσχρώμενος παραδείγματι τὴν ἰδέαν καὶ δύναμιν αὐτοῦ ἀπεργάζηται, καλὸν ἐξ ἀνάγκης οὕτως ἀποτελεῖσθαι πᾶν. οὗ δ'ἂν εἰς τὸ γεγονός, γεννητῷ παραδείγματι προσχρώμενος, οὐ καλόν.

For translation and background of this passage see chapter 2, p. 47. See also Plato *Ti.* 39E.

20. Aristotle *Ath. Pol.* 49.3.

ἔκρινεν δέ ποτε καὶ τὰ παραδείγματα καὶ τὸν* πέπλον ἡ βουλή . . .

*This is the reading of the manuscript. One editor, Blass, 4th ed. (Leipzig, 1903), would read τὰ εἰς τόν for καὶ τόν, i.e. the "models" [or "patterns"] for the *peplos*. But the original text is intelligible as it stands.

At one time the Council used to judge models and the *peplos* . . .

21. Aristotle *Poet.* 1461b11.

πρός τε γὰρ τὴν ποίησιν αἱρετώτερον πιθανὸν ἀδύνατον ἢ ἀπίθανον καὶ δυνατόν. <καὶ εἰ ἀδύνατον>* τοιούτους εἶναι, οἷον Ζεῦξις ἔγραφεν, ἀλλὰ βέλτιον. τὸ γὰρ παράδειγμα δεῖ ὑπερέχειν.

*Coni. Vahlen.

[The representation of impossible situations in drama is defensible]. For in poetry the credible but impossible is preferable to something incredible but possible. For it may be impossible that people such as Zeuxis painted ever really existed, but it would be better [if they did]. For the ideal model should be superior [to what actually exists].

22. Demosthenes *De Falsa Legatione* 251.

ἔφη τὸν Σόλωνα ἀνακεῖσθαι τῆς τῶν τότε δημηγορούντων σωφροσύνης παράδειγμα, εἴσω τὴν χεῖρα ἔχοντα ἀναβεβλημένον

He [Aeschines] said that a statue of Solon represented with his cloak drawn around him and his hand inside of it . . . had been set up as a model of the self-restraint of the popular orators of that period.

παράδειγμα (*paradeigma*)

23. Strabo 8.3.30.

ἀπομνημονεύουσι δὲ τοῦ Φειδίου διότι πρὸς τὸν Πάναινον εἶπε πυνθαν-
όμενον, πρὸς τί παράδειγμα μέλλοι ποιήσειν τὴν εἰκόνα τοῦ Διός, ὅτι
πρὸς τὴν Ὁμήρου δι' ἐπῶν ἐκτεθεῖσαν τούτων . . .

And they recount this story about Phidias: that when Panaenus asked
him what model he intended to employ in making the statue of Zeus,
he replied that it was the model provided by Homer with the following
lines . . . [*Il*. 1.527–30].

24. Plutarch *An*. *Vit*. 3 (*Mor*. 498E).

Αἱ πόλεις δήπουθεν, ὅταν ἔκδοσιν ναῶν ἢ κολοσσῶν προγράφωσιν,
ἀκροῶνται τῶν τεχνιτῶν ἀμιλλωμένων περὶ τῆς ἐργολαβίας καὶ λόγους
καὶ παραδείγματα κομιζόντων.

Cities, as everyone knows, when they give advance notice of their in-
tention to let out contracts for temples or colossi, give heed to the
artists who compete with one another for the contract and bring them
estimates and models.

25. Plutarch *Plac*. *Phil*. Epit. 1.6 = Aetius *Plac*. *Phil* 1.5.3 = Diels, *Dox*.
Graec., p. 292.

καὶ πολλὰ παραδείγματά ἐστιν, ὥσπερ ἐπ' ἀνδριάντων καὶ οἰκιῶν καὶ
ζωγραφιῶν.

[Excerpt from a refutation of Plato's view of the essential unity of the
cosmos:] And there are many models, as with statues and buildings and
paintings.

26. Lucian *Rh*. *Pr*. 9.

. . . παραδείγματα παρατιθεὶς τῶν λόγων οὐ ῥᾴδια μιμεῖσθαι, οἷα τὰ
τῆς παλαιᾶς ἐργασίας ἐστίν. Ἡγησίου καὶ τῶν ἀμφὶ Κριτίαν καὶ
Νησιώτην, . . .

See σκληρός, passage 1.

27. Plotinus *Enn*. 5.9.11.

τῶν δὴ τέχνων ὅσαι μιμητικαί, γραφικὴ μὲν καὶ ἀνδριαντοποιία,
ὄρχησίς τε καὶ χειρονομία ἐνταῦθά που τὴν σύστασιν λαβοῦσαι καὶ
αἰσθητῷ προσχρώμεναι παραδείγματι καὶ μιμούμεναι εἴδη τε καὶ

παράδειγμα (paradeigma)

κινήσεις τάς τε συμμετρίας ἃς ὁρῶσι μετατιθεῖσαι, οὐκ εἰκότως ἐκεῖ ἀνάγοιντο, εἰ μὴ τῷ ἀνθρώπου λογῷ.

All those arts which are imitative, for example painting and sculpture, or dancing and pantomimic movements—arts which have their origin, it would seem, in this world, are based on a sensible model, and imitate forms and movements of and transfer to themselves the proportions of that which they see—these arts ought not, properly speaking, to be referred to the higher realm, except insofar as they come within the scope of the human power of reasoning.

28. Callistratus *Descriptiones* 5.3. See ὁμοιότης, ὁμοίωμα, ὁμοῖος, passage 9.

29. Eustathius *Il.* 145.16.

καὶ ὁ γεωγράφος δέ φησι ὅτι πρὸς Ὁμηρικὸν παράδειγμα τὸ "ἐπ' ὀφρύσι νεῦσεν" ὁ Φειδίας ἐποίησε τὸν ἐν Ὀλυμπίᾳ Δία ἐλεφάντινον.

And the geographer [Strabo] says that it was following the Homeric model, "He nodded his dark brows . . ." that Phidias made the ivory Zeus in Olympia.

Commentary

The basic meaning of παράδειγμα (from παραδείκνυμι, "show side by side, compare") is "model" or "pattern."[3] Although παράδειγμα in itself is not a critical term, the different shades of meaning of the word do tell us something about the Greeks' understanding of how an artist conceives and executes a work of art, and for that reason it deserves inclusion in this study.

The passages cited here suggest that, in theory at least, the models on which a Greek artist could base his work were thought to be of three sorts: physical, intellectual, and ideal or spiritual.

It is interesting to note that in the passages in which παράδειγμα refers to a physical model, it most often refers to something that is constructed by man rather than provided by nature. Constructed, man-made models are obviously what are referred to in the epigraphical testimonia in passages 1–13, all of which deal with architecture. The preparation of a παράδειγμα by an architect seems to have been one of the basic steps in the building pro-

3. The other common meaning of παράδειγμα, not of direct concern to us here, is "example" or "precedent," especially a moral precedent, in which case the word has the value of "lesson" or "warning." The most famous example is perhaps Sophocles *OT* 1193: τὸν σόν τοι παράδειγμ' ἔχων/τὸν σὸν δαίμονα, τὸν σόν, ὦ τλᾶμον Οἰδιπόδα, βροτῶν/οὐδὲν μακαρίζω. See also Thucydides 3.10.6; 6.77.1.

cedure normally employed by the Greeks. When construction of a public building was planned, the first step was to appoint an architect to prepare a list of specifications for approval by the financial authority which had the responsibility of overseeing the construction. (A well-known example of such an authorization is *IG*, I², 24, in which Callicrates is assigned the job of preparing specifications for the temple of Athena Nike on the Acropolis of Athens.) The list of specifications presented by the architect was called a συγγραφή. Being a matter of public record, the συγγραφαί were frequently inscribed on stone, and, along with decrees recording actual expenditures (μισθώματα) for particular parts of buildings, they constitute our chief source of information on the stages of ancient construction. All of our epigraphical testimonia belong to one or the other of these categories.[4]

Along with a συγγραφή it would seem that architects usually provided lists of measurements (μέτρα) for their buildings (see passage 4) and also παραδείγματα.[5] These models seem to have been of three sorts:(a) models, usually but not always in wood or clay, for specific details such as moldings and column capitals[6] (see passages 1, 2a-c, 3, 5, 6, 7, 8, 9, 11); (b) models for whole buildings (see passages 4, 10, 13); and (c) graphic models, in the form of either sketches or plans (for which the *pinax* purchased in passage 12 seem to have been provided). The παραδείγματα seem in all cases to have been physical objects rather than a series of instructions. The latter were provided by the συγγραφαί, the μέτρα, and by verbal instructions given by the architect while the work was in progress (ὃ ἂν φράζηι ὁ ἀρχιτέκτων, passage 4). It has been suggested, however, that for certain particularly complex details the architect might have provided additional written instructions, possibly accompanied by drawings, and that the term for such instructions was ὑπογραφή or ἀναγραφεύς.[7]

4. Recent detailed studies of the information to be derived from these building inscriptions are J. A. Bundgaard, *Mnesicles* (Copenhagen, 1957), chaps. 4–6, esp. p. 216n217; Kristian Jeppesen, *Paradeigmata* (Aarhus, 1957); Roland Martin, *Manuel d'Architecture Grecque,* vol 1, *Matériaux et Techniques* (Paris, 1965), esp. pp. 172 ff.

5. On models in ancient architecture see, in addition to the sources mentioned in the preceding note, Otto Benndorff, "Antike Baumodelle," *JOAI* 5 (1902): 175–95; Ferdinand Noack, *Eleusis* (Berlin and Leipzig, 1927), p. 303.

6. A splendid Corinthian capital in stone, apparently the model for the capitals in the interior of the Tholos, has been found at Epidaurus. See W. B. Dinsmoor, *The Architecture of Ancient Greece* (London and New York, 1950), pl. 58; A. W. Lawrence, *Greek Architecture,* rev. ed. (Harmondsworth and Baltimore, 1962), pl. 89.

7. Cf. Martin, *Manuel d'Architecture Grecque,* pp. 176–77. Theophile Homolle, "Comptes et inventaires des temples Déliens en l'année 279," *BCH* 4 (1890): 465n2, first suggested that ὑπογραφή might refer to designs. Martin and Bundgaard, *Mnesicles,* p. 216n215, agree with Homolle. Bundgaard takes ἀναγραφεύς to mean simply "list" (pp. 114 and 216n215); Martin, p. 177, takes it to mean "un dessin, sans doute coté."

It might be noted that these epigraphical testimonia do not lend any support to the contention that παράδειγμα referred only to models which were to serve as the basis for a large number of copies and that τύπος was the term used when one was referring to sketch-models or *maquettes* which were to be copied once and then destroyed (see under τύπος). Some of the παραδείγματα mentioned in the testimonia, the lion-head spouts or the roof tiles, for example, obviously were intended to serve as a basis for multiple copies. On the other hand, it does not seem likely that the small temple models of passages 10 and 13 or the drawn model that seems to be referred to in passage 12 were intended to be repeatedly copied. Παράδειγμα clearly could refer to models of any sort.

In the literary testimonia the use of παράδειγμα to mean a man-made, physical model is also well attested. Herodotus's reference to a παράδειγμα for the Alcmaeonid temple at Delphi seems to be a rather loose usage of the term as found in the inscriptions. When he says that the model called for the temple to be made of limestone but that the Alcmaeonidae proceeded to build it in marble, he seems in fact to be referring to the συγγραφή, the list of specifications, rather than to the model proper (unless we assume that a miniature model was made in the same material as the projected temple, which seems highly unlikely). Not having any special knowledge of architectural technique, Herodotus probably took παράδειγμα to refer to all three basic steps of the building process—the συγγραφή, the μέτρα, and the actual model.

While it is not certain what sort of models Aristotle is referring to in passage 20, it seems quite possible that these might also be architectural models, since Plutarch implies in passage 24 that there were competitions sponsored by different cities in which architects submitted models of temples for judgment.

In addition to man-made physical models, παράδειγμα also referred, as we have said, to natural physical models, most often the human body as copied in the representational arts. This is clearly what Callistratus's use of the term in passage 28 signifies, and what Plutarch and Plotinus have in mind in passages 25 (with reference to sculpture and painting) and 27. It may also be what Plato is referring to in passages 16 and 18, although in these latter the meaning is more problematical. In passage 16 the reference to the visual arts occurs in the form of a casual simile. The meaning seems to be that the guardians of the ideal state should make constant reference to an ideal παράδειγμα which they have ἐν τῇ ψυχῇ, just as painters make constant reference to their models. Exactly what sort of models painters used is not specified; Plato might be thinking of an ordinary physical model, or he might be thinking of a more theoretical system of συμμετρία. It is not likely that he was

213

thinking of an ideal model, although in later antiquity it might have been possible to read the passage in this way. Likewise in passage 18 it is not clear whether the παράδείγματος συμμετρίας refers to the proportions of an actual model or to those of a theoretical canon.

In passage 26 Lucian suggests, by implication, that artists might use old-fashioned works of sculpture as models, just as students of rhetoric were sometimes called upon to imitate earlier styles. Representational works of art, that is, man-made objects which had prototypes in nature, then, could also be thought of as παραδείγματα. It does not seem likely, however, that Lucian is referring in this passage to an actual common practice among artists. What this passage is, in fact, is yet another example of the use of the visual arts among rhetoricians for purposes of stylistic comparison. Passage 22, in which Demosthenes refers to a statue of Solon which some orators of his own (Demosthenes') time cited as a symbol of the σωφροσύνη of Solon's era, is perhaps an earlier example of the same pratice, although here the work of art seems to be thought of more as a moral than as a stylistic exemplar.

The second major category of meaning for παράδειγμα in connection with the visual arts is, as stated at the outset, an "intellectual model." Here again one can identify two subcategories: there is the model in the form of a poetic image, as in passages 23 and 29, in which the Homeric conception of Zeus is said to have inspired Phidias's Zeus at Olympia; and there is what I would call the "sensible ideal of beauty" as represented by passages 15 and 21. By "sensible ideal" I mean a beauty that is based on essentially intellectual conceptions of perfect proportions and form but that can be depicted in physical form and is not thought of as being in any way transcendent—the sort of beauty, for example, that Polyclitus's *Canon* seems to have aimed at. It is this sort of ideal but visible beauty that Aristotle associates with the paintings of Zeuxis in passage 21. His statement calls to mind the story about the eclectic process followed by Zeuxis in painting his Helen at Croton (see ἀλήθεια-*veritas*, passage 14). As noted earlier, Plato may also be referring to this type of beauty in passages 16 and 18 as well as in passage 15.

Finally, there are two passages, 17 and 19, in which παράδειγμα seems to imply a spiritual model or a "model based on an intelligible (as opposed to a "sensible") ideal" (or "form" in the Platonic sense) that is perceived, rather than an intellectual ideal which is created. It is an ideal which in theory could inspire art but which could never be realized in art. In these passages the visual arts, are referred to only in a metaphorical context (philosophers and the cosmic Demiurge are compared to artists), and Plato, as we have noted in the text, did not think that artists in actual practice ever based their work on a knowledge of "real" forms. But the latent im-

plications of these passages may later have played a role in shaping the *phantasia* theory (see chap. 2).

πολυτέλεια (*polyteleia*)

1. Diodorus Siculus 13.90.4.

τὰ μὲν οὖν πολυτελέστατα τῶν ἔργων ἀπέστειλεν εἰς Καρχηδόνα ἐν οἷς καὶ τὸν Φαλάριδος συνέβη κομισθῆναι ταῦρον

He [Himilcar] sent the most precious of the works [from the sack of Acragas] to Carthage, among which the bull of Phalaris happened to have been included . . .

2. Strabo 8.6.10.

. . . καὶ τὸ ʽΗραῖον εἶναι κοινὸν ἱερὸν ἀμφοῖν τὸ πρὸς ταῖς Μυκήναις ἐν ᾧ τὰ Πολυκλείτου ξόανα τῇ μὲν τέχνῃ κάλλιστα τῶν πάντων, πολυτελείᾳ δὲ καὶ μεγέθει τῶν Φειδίου λειπόμενα.

See commentary below and see also under μέγεθος.

3. Lucian *J Tr.* 11.

ΚΟΛΟΣΣ: εἰ γοῦν μὴ ὑπερφυᾶ μηδ᾽ ὑπέρμετρον οἱ ʽΡόδιοι κατασκευάσασθαί με ἠξίωσαν, ἀπὸ τοῦ ἴσου τελέσματος ἑκκαίδεκα χρυσοῦς θεοὺς ἐπεποίηντο ἄν. ὥστε ἀνάλογον πολυτελέστερος ἂν νομιζοίμην.

Colossus: If the Rhodians had not deemed it worthy to make me monstrous beyond measure, they might have made sixteen golden images of gods for the same cost. Accordingly, I should be considered more precious in the same proportion.

4. Athenaeus 205D.

ἐν δὲ ταύτῃ συμπόσιον ἐννεάκλινον ἦν παραπλήσιον τῇ πολυτελείᾳ τῷ μεγάλῳ καὶ κοιτὼν πεντάκλινος.

In this [the women's quarters of the river boat of Ptolemy IV] there was a *symposion* with nine couches, similar to the large dining room in richness, and also a bedroom with five beds.

5. Athenaeus 543C.

οὕτω δὲ παρὰ τοῖς ἀρχαίοις τὰ τῆς τρυφῆς καὶ τῆς πολυτελείας ἠσκεῖτο

πολυτέλεια (*polyteleia*)

ὡς καὶ Παρράσιον τὸν ζωγράφον πορφύραν ἀμπέχεσθαι χρυσοῦν στέφ-
ανον ἐπὶ τῆς κεφαλῆς ἔχοντα, ὡς ἱστορεῖ Κλέαρχος ἐν τοῖς βίοις.

To such an extent were the objects of luxury and lavishness cultivated
among the ancients that even Parrhasius the painter dressed in purple
and wore a gold crown on his head, as Clearchus relates in his *Lives*.

Commentary

In the commentaries under *pondus* and σεμνός all the important points that
must be raised in connection with πολυτέλεια are discussed in their proper
context. Here these points need only be summarized. The term basically
means "costliness" or "material value," and it is so used in passages 1,3,
and 4 above, where it refers to the value of the metal used in the Colossus
of Rhodes, the value of the booty taken by Himilcar from Acragas, and the
value of the furnishings in the famous ship of Ptolemy IV. When referring
to persons rather than things πολυτέλεια has the meaning "extravagance,"
as in passage 5.

These passages, it must be admitted, are of no great importance, and,
were it not for Strabo's use of the term in passage 2, πολυτέλεια would not
even be included in this study. Strabo says that certain works of Polyclitus
in the temple of Hera at Argos, although "most beautiful of all," lacked the
πολυτέλεια and μέγεθος of those of Phidias. It is possible to take this passage,
one must admit, in a strictly literal sense. The most famous works of Poly-
clitus, the Doryphoros and the Diadoumenos, for example, were lifesize
bronzes, while the most famous works of Phidias, the Athena Parthenos and
the Zeus at Olympia, were made of gold and ivory inlaid with jewels and
were of colossal size. Strabo's statement thus may simply mean that Phidias's
works were larger and more costly than those of Polyclitus. On the other
hand, at least one of the works of Polyclitus to which Strabo is referring, the
chryselephantine statue of Hera in the Argive Heraeum,[8] was presumably
neither smaller nor less costly than the famous work of Phidias. This last
fact, combined with the internal resemblance (see μέγεθος, *pondus*, and σεμνός)
between Strabo's statement and Quintilian's evaluation of Polyclitus
(*deesse pondus; non explevisse auctoritatem deorum videtur*) suggests that πολυτέλεια
might be taken in a metaphorical sense just as μέγεθος, which literally means
size, is sometimes given the sense of *maiestas*. If such a metaphorical meaning
exists, it may be something like "spiritual care," "spiritual effort," or "the
care characteristic of a spiritually minded creator," analogous to the use of
πολυτελεστάτην in Plato *Rep.* 507C (see commentary under *pondus*). For the

8. Pausanias 2.17.4.

216

relationship of πολυτέλεια to other Greek and Latin terms of Greco-Roman rhetoric and art criticism see σεμνός.

πρέπον (prepon)

1. Plato *Grg.* 503E.

οἷον εἰ βούλει ἰδεῖν τοὺς ζωγράφους, τοὺς οἰκοδόμους, τοὺς ναυπηγούς, τοὺς ἄλλους πάντας δημιουργούς, ὅντινα βούλει αὐτῶν, ὡς εἰς τάξιν τινὰ ἕκαστος ἕκαστον τίθησιν ὃ ἂν τιθῇ, καὶ προσαναγκάζει τὸ ἕτερον τῷ ἑτέρῳ πρέπον τε εἶναι καὶ ἁρμόττειν, ἕως ἂν τὸ ἅπαν συστήσηται τεταγμένον τε καὶ κεκοσμήμενον πρᾶγμα.

[A good man, when he makes a speech, organizes his material like a craftsman, so that it has structure, and the component elements do not simply appear at random.] One only needs to look, for example, at painters, builders, shipwrights, and all the other craftsmen—take the case of any one you like—to see how each of them arranges his particular material in a certain order, and forces one part to be appropriate to and to fit another, until he has combined everything into an ordered and comely product.

2. Dio Chrysostom *Or.* 12.52–53.

Εἰ δ᾽ αὖ τὸ πρέπον εἶδος καὶ τὴν ἀξίαν μορφὴν τῆς θεοῦ φύσεως ἐδημιούργησας ὕλῃ τε ἐπιτερπεῖ χρησάμενος, ἀνδρός τε μορφὴν ὑπερφυῆ τὸ κάλλος καὶ τὸ μέγεθος δείξας πλήν τ᾽ἀνδρὸς καὶ τ᾽ἄλλα ποιήσας ὡς ἐποίησας, σκοπῶμεν τὰ νῦν. ὑπὲρ ὧν ἀπολογησάμενος ἱκανῶς ἐν τοῖς παροῦσι, καὶ πείσας ὅτι τὸ οἰκεῖον καὶ τὸ πρέπον ἐξεῦρες σχηματός τε καὶ μορφῆς τῷ πρώτῳ καὶ μεγίστῳ θεῷ, μισθὸν ἕτερον τοῦ παρ᾽ Ἠλείων προσλάβοις ἂν μείζω καὶ τελειότερον.

On the other hand, let us now examine the question of whether you [Phidias] have created a visage which is appropriate to, and a form which is worthy of, the nature of the god, using a material which affords delight and rendering him in the form of a man of extraordinary beauty and stature; and also the question of how, aside from having used a human form, you have rendered other details. Making an adequate defense on these matters before those who are present, and persuading them that you have found what is suitable and appropriate as a design and form for the first and greatest god, you might receive another re-

ward, greater and more perfect, than the one which you received from
the people of Elis.

Commentary

Although the extant examples of the use of πρέπον, "appropriateness," in
connection with the visual arts are not, in themselves, of great importance,
the idea that the term represents clearly was of considerable significance in
the later stages of Greek art criticism. On this significance see the com-
mentary under *decor*.

ῥυθμός (*rhythmos*)

1. Xenophon *Mem.* 3.10.10. See εὐρυθμία, passage 1.

2. Philo Mechanicus *Syntaxis* 4.4 (ed. Schöne).

 τοὺς γὰρ τῶν οἰκοδομικῶν ἔργων ῥυθμοὺς οὐ δυνατὸν ἦν ἐξ ἀρχῆς
 συστήσασθαι μὴ πρότερον πείρας προσαχθείσης, . . .

 It was not possible at the very beginning to establish the forms of works
 of architecture without engaging in prior experimentation . . .

3. *Anthologia Graeca* 12.57 (Meleager).

 Πραξιτέλης ὁ πάλαι ζωογλύφος ἄβρον ἄγαλμα ἢ τάχα τοὔνομ' ἔχει
 ταὐτὸν μόνον, ἔργα δὲ κρέσσων,/οὐ λίθον, ἀλλὰ φρενῶν πνεῦμα μεταρρ-
 υθμίσας.

 Praxiteles, the old-time sculptor, [shaped] a graceful image, [but
 another Praxiteles, the poet's lover, is responsible for an even greater
 wonder—his effect on the poet]. Perhaps only the name is the same, for
 his works are greater, in that he has reshaped not stone, but the spirit
 of the mind.

4. Diodorus Siculus 1.97.6.

 τόν τε ῥυθμὸν τῶν ἀρχαίων κατ' Αἴγυπτον ἀνδριάντων τὸν αὐτὸν εἶναι
 τοῖς ὑπὸ Δαιδάλου κατασκευασθεῖσι παρὰ τοῖς Ἕλλησι.

 The form of ancient statues in Egypt is the same as that of those made
 among the Greeks by Daedalus.

5. (Pseudo-) Lucian *Am.* 14. See ἀκρίβεια, passage 10.

6. Lucian *Pr. Im.* 14.

. . . αὖθις τὸν Φειδίαν ἐγκεισαμένον ἑαυτὸν ἐπανορθοῦν καὶ ῥυθμίζειν
τὸ ἄγαλμα πρὸς τὸ τοῖς πλείστοις δοκοῦν.

[Phidias secretly listened to criticisms of his Zeus at Olympia. When
the critics departed,] he once again shut himself away [in his workshop]
and corrected and shaped the image in accordance with what seemed
best to the majority.

7. Diogenes Laertius 7.46.

οἱ δὲ καὶ ἄλλον ἀνδριαντοποιὸν ῾Ρηγῖνον γεγονέναι φάσι Πυθαγόραν,
πρῶτον δοκοῦντα ῥυθμοῦ καὶ συμμετρίας ἐστοχάσθαι.

And they say that there was another Pythagoras, a sculptor from
Rhegion, who seems to have been the first to aim at *rhythmos* and
symmetria.

8. Callistratus Descriptiones 8.1.

αἱ δὲ δὴ Πραξιτέλειοι χεῖρες ζωτικὰ διόλου κατασκεύαζον τὰ τεχνήματα.
ἄλσος ἦν καὶ Διόνυσος εἱστήκει, ἠιθέου σχῆμα μιμούμενος, οὕτω μὲν
ἁπαλός, ὡς πρὸς σάρκα μεταρρυθμίζεσθαι τὸν χαλκόν, οὕτω δὲ ὑγρὸν
καὶ κεχαλασμένον ἔχων τὸ σῶμα, ὡς ἐξ ἑτέρας ὕλης, ἀλλὰ μὴ χαλκοῦ
πεφυκώς.

Indeed the hands of Praxiteles wrought works which seemed thorough-
ly alive. There was a grove, and in it stood an image of Dionysus in the
form of a youth of such delicate softness that the bronze seemed to
change its form to that of flesh; and the body was so supple and relaxed
that it seemed to be made of some other material and not bronze.

9. "Damianus" *Optica* (ed. Schöne, p. 28). See σκηνογραφία, passage 12.

Commentary

The English word *rhythm*, like the French *rhythme* or the German *Rhythmus*,
suggests first of all the systematic repetition of sounds over a period of time.

Rhythm is a quality which belongs primarily to music or speech. We do
however, apply the idea to nonaudible phenomena when a sequence of
regularly repeated elements can be detected in them, and hence we some-

219

ῥυθμός (rhythmos)

times speak of the rhythm of novels, paintings, buildings, and so on. In these latter instances one feels that the use of the word is almost metaphorical: it calls to mind sound, even when there is none. In any case the idea of regular repetition is essential to the modern idea of rhythm.

When we turn to the Greek word ῥυθμός, of which our modern terms are descendants, we find that its basic meaning is less clear. In addition to the familiar value of "repetition" there are other meanings—"shape, manner, condition, temper"—which have an unfamiliar ring to modern ears. We also find that these unfamiliar meanings tend to predominate in the earliest passages in which ῥυθμός occurs, implying perhaps that these meanings bring us closest to the original sense of the word.

ETYMOLOGY AND EARLY USES

'Ρυθμός first appears in Greek literature among the lyric and elegiac poets of the seventh and sixth centuries B.C. The earliest of these is Archilochus, who, in a well-known fragment, implores his heart not to rejoice too much when victorious, nor to lament too much in defeat, but rather to recognize οἷος ῥυσμὸς ἀνθρώπους ἔχει.[9] The word ῥυσμός here has been translated in a variety of ways. LSJ[9], s.v. ῥυθμός 4, gives "disposition" or "temper." Some translators, such as J. A. Moore and Richmond Lattimore, have attempted to preserve at least an allusion to the idea of repetition: Moore renders it "the alternation between prosperity and adversity," while Lattimore suggests "our life is up-and-down like this."[1] Another acceptable translation might simply be "pattern of life."

In the sixth century B.C., Theognis and Anacreon use ῥυθμός in connection with individuals rather than all of human life, and the meaning "disposition" seems appropriate. Theognis associates the word with other terms that clearly refer to human personality: ὀργὴν καὶ ῥυθμὸν καὶ τρόπον οἷον ἔχει (line 964, Bergk); and Anacreon claims to hate all those πάντας ὅσοι χθονίους ἔχουσι ῥυσμοὺς καὶ χαλεπούς, "as many as have earthy and difficult dispositions."[2]

In the fifth century we find Herodotus and Democritus using ῥυθμός to mean "shape" or "form." In speaking of the variations the Greeks made in the Phoenician alphabet, Herodotus says that the Greeks μετέβαλον

9. Theodor Bergk, Poetae Lyrici Graeci (Leipzig, 1914), vol. 2, frag. 66.
1. J. A. Moore, Selections from the Greek Elegiac, Iambic, and Lyric Poets (Cambridge, Mass., 1947), p. 75n7 on frag. 67; Richmond Lattimore, Greek Lyrics, 2d ed. (Chicago, 1960), p. 3, number 9.
2. Bergk, Poetae Lyrici Graeci, frag. 74; Diehl, Anth. Lyr. Graec., 65; J. M. Edmonds, Lyra Graeca, Loeb Classical Library (Cambridge, Mass.; London, 1952), p. 68.

τὸν ῥυθμὸν τῶν γραμμάτων, that is, "they changed the shape of the letters" (5.58). Democritus, according to Aristotle, also used ῥυθμός (Ionic ῥυσμός) to mean shape: in the *Metaphysics* 985b16 he cites Democritus and Leucippus as maintaining that the three differences which can be considered causes of perceptible phenomena are ῥυσμός, διαθιγή, and τροπή (shape, contact, inclination), and he himself adds τούτων δὲ ὁ ῥυσμὸς σχῆμά ἐστιν. The same definition of ῥυσμός is repeated in *Metaphysics* 1042b14. Ῥυθμός, then, can be a synonym of σχῆμα, the "shape, form," or perhaps even "pattern" of objects such as a breastplate (Xenophon, passage 1), a cup (the comic poet Alexis, frag. 59, Kock), boots (Hippocrates *De Articulis* 62), and the like.

There are also a number of instances in authors of the fifth century in which ῥυθμός signifies the "time" or "order" of an action in which repetition is involved—for example, marching or dancing—and the familiar modern connotation of the word is clearly applicable.[3]

This peculiar range in the meanings of ῥυθμός and the consequent uncertainty about what, if anything, is its essential meaning, is reflected in a modern controversy about the etymology of the word. Modern scholars have fallen into two basic camps on this question—those who derive ῥυθμός from ῥέω, "flow," and hence take the idea of "repetition" or "flow" as essential to its meaning; and those who connect it with ἐρύω and related words, either in the sense of "draw" or in the sense of "protect, guard, hold in honor."[4] This dispute about the etymology of ῥυθμός is not without consequence for its meaning in connection with the visual arts. Does it derive from ῥέω and refer to a subjective feeling about the "flow of lines" in a work of art? Or does it refer to clearly definable shapes and patterns, in other words to what we usually call "composition" in art?

3. Thucydides 5.70: μετὰ ῥυθμοῦ βαίνοντες (marching); Aristophanes *Thesm.* 956: ῥυθμὸν χορείας ὑπάγειν; Euripides *Cyc.* 398: the Cyclops kills his victims ῥυθμῷ τινι.

4. The most thorough review of the question is Ernst Wolf, "Zur Etymologie von ῥυθμός und seiner Bedeutung in der älteren griechischen Literatur," *Wiener Studien* 68 (1955): 99–119. See also Werner Jaeger, *Paideia* (New York, 1945), 1:125–26; Robert Renehan, "The Derivation of ῥυθμός," *CP* 58 (1963): 36–39. For a concise summary and further references: Hjalmar Frisk, *Griechisches Etymologisches Wörterbuch* (Heidelberg, 1960–72), s.v. ῥυθμός. Frisk rejects the derivation from ῥέω but also finds the derivation from ἐρύω or ῥύομαι "ganz unwahrscheinlich" because of the short υ in ῥυθμός. Renehan, however, makes what must be considered at least a reasonable attempt to answer this objection. The derivation from ῥέω now seems generally out of favor, although in a recent review of the question in the light of ancient theories of prose composition, Adolf Primmer seems to feel that the traditional etymology has merit and should be considered seriously: *Cicero Numerosus, Studien zum Antiken Prosarhythmos* (Vienna, 1968), pp. 19–24, esp. p. 23; it is also upheld by René Waltz, "ΡΥΘΜΟΣ, et Numerus," *REL* 26 (1948): 109–20.

221

ῥυθμός (rhythmos)

RHYTHMOS IN GREEK ART CRITICISM

Modern Interpretations

In the eighteenth and nineteenth centuries the derivation of ῥυθμός from ῥέω was generally accepted. The great classical art historians and archaeologists of this period, particularly those who were concerned with the ancient literary testimonia on art—Winckelmann and Brunn, for example—all seem to have felt that ῥυθμός was a quality in a work of art which arose from the seeming "flow" of graceful lines, particularly contour lines.[5] What ancient writers saw as ῥυθμος in Greek sculpture, it was felt, must have been a kind of imaginary movement of lines over and around the surface of statues. Hence Brunn and others, trying to see Greek sculpture through Greek eyes, looked for ῥυθμός in the *streng architektonischen Linienführung* of works like the sculptures from the Aphaia temple at Aegina.[6]

One of the offshoots of the prevailing view that ῥυθμος referred essentially to graceful appearance and rhythmic flow, was the opinion among some art historians[7] that the term also signified a kind of modified συμμετρία, in which the rigid laws of measurement were altered in order to produce a more graceful apearance in a building or statue. This idea was based on evidence provided by Greek writers on optics such as Heron, "Damianus" (passage 9), and Philo Mechanicus, but, above all on the definition of εὐρυθμία (q.v.) given in Vitruvius 1.2.3. Brunn, Schöne, and others were particularly preoccupied with the difference between συμμετρία and ῥυθμός and felt that on the basis of the evidence provided by Vitruvius and the optical writers a clear distinction could be drawn.[8] Συμμετρία, they felt, was the application of objective laws of commensurability to art; ῥυθμός, on the other hand, was the subjective evaluation of these laws by the artist and was expressed through the liberties which he took with the established symmetrical relationships. The difference was analogous, as Brunn pointed out, to the difference between μέτρον, "meter," and ῥυθμός as presented by Aristotle *Rh.* 3.8 ff., where μέτρον is considered characteristic of poetic meter and ῥυθμός of fluent prose.

A new direction in the interpretation of ῥυθμός in Greek criticism was

5. For a summary of many earlier interpretations see the important article by Eugen Petersen, "Rhythmus," *Abhandlungen der Kön. Gesellschaft der Wissenschaften zu Göttingen, Phil.-Hist. Klasse,* N. F. 16 (1917): 1–104.

6. Heinrich Brunn, *Kleine Schriften,* ed. Hermann Brunn and Heinrich Bulle (Leipzig, 1898–1906), 2:178.

7. Brunn, Schöne, Kalkmann, Puchstein, Furtwängler, and others. For a discussion of their views see εὐρυθμία.

8. Brunn, *GGK²,* 1.97–98; R. Schöne, *AA* (1898): 181; Petersen, *AbhGött* 16(1917): 7.

initiated in a major and still valuable article by Eugen Petersen in 1917 (see note 5). Petersen began his exposition of the meaning of the word by suggesting that it was derived not from ῥέω, "flow," but from the root ερυ-(ρυ-) "draw," the root of such terms as τὸ ῥῦμα "that which is drawn" (τόξου ῥύματος, Aeschylus *Pers.* 147) and ῥυμός, the pole by which a chariot is dragged (see note 4). He also pointed out that other Greek words joined with the suffix-θμος appear, at least originally, to have signified an active "doing"[9] on the part of someone (as opposed to a more passive "happening," such as is implied in ῥέω): for example, πορθμός, "a ferrying across"; μυκηθμός, "bellowing"; κλαυθμός, "weeping"; and so on, He thus suggested that ῥυθμός might originally have meant not "a flowing" but rather "a drawing." Such a meaning would be, he felt, in perfect harmony with Herodotus's ῥυθμὸν τῶν γραμμάτων, for letters were clearly something which could be "drawn." There is a close connection in many languages between the word for "draw" in the sense of to "pull physically," and the word for a "drawing" in the pictorial sense (such as an architectural drawing), for instance: English "draw" and "drawing," German "ziehen" and "Zug"; Latin *traho* and *tractus* (Propertius 5.3.5), from which come the Italian "tratto di penello," "ritratto"; French "trainer," "trait," "portrait"; and English "portray." Ῥυθμός, Petersen concluded, originally meant a "drawing" and conveyed the same double meaning that the English "draw" and "drawing" convey. This explains, he maintained, not only its use as "shape, form, pattern" as used by Herodotus and Democritus but perhaps also its use by Anacreon and Theognis in the sense of "disposition." For, like the Greek word χαρακτήρ—which originally meant "engraved mark," such as stamped designs or letters of the alphabet, but which also came to mean "human character" because each man had his particular "stamp" or type of character—so also ῥυθμός, a "drawn form," came to mean the way a man was "formed," that is to say, his disposition.[1]

Whether Petersen's etymology is correct or not, the original meaning he ascribes to ῥυθμός—"unbewegten Gestalt, die durch Bewegung entstand"[2]— has considerable merit. It is perhaps the key, in fact, to a proper understanding of those passages in which ῥυθμός is used in connection with ancient art. Werner Jaeger, while not agreeing completely with Petersen about the etymology of the word, has admirably summed up the consequences of a derivation which distinguishes ῥυθμός from ῥέω:

9. Cf. Pierre Chantraine, *La Formation des noms en grec ancien* (Paris, 1933), pp. 136–37.

1. Petersen, *AbhGött* 16 (1917): 12, also suggests that there may have been a relationship between handwriting and character-reading behind the use of ῥυθμός as "disposition," and he takes ῥυσμούς in the lyric of Anacreon to mean "handwriting."

2. Ibid., p. 11.

ῥυθμός (rhythmos)

Rhythm then is that which imposes bonds on movement and confines the flux of things. . . . Obviously, when the Greeks speak of the rhythm of a building or a statue, it is not a metaphor transferred from musical language; the original conception that lies beneath the Greek discovery of rhythm in music and dancing is not *flow* but *pause*, the steady limitation of movement.[3]

If the basic meaning of ῥυθμός is something like "form, shape," or "pattern," how did the word come to develop the sense of "repetition" which it sometimes clearly has? Here again Petersen's analysis is valuable not only in its own right but for the light it sheds on the use of the term in art criticism. His line of thought was that ῥυθμοί were originally the "positions" that the human body was made to assume in the course of a dance, in other words the patterns or *schemata* that the body made. In the course of a dance certain obvious patterns or positions, like the raising or lowering of a foot, were naturally repeated, thus marking intervals in the dance. Since music and singing were synchronized with dancing, the recurrent positions taken by the dancer in the course of his movements also marked distinct intervals in the music; the ῥυθμοί of the dancer thus became the ῥυθμοί of the music. This explains why the basic component of music and poetry was called a πούς, "foot" (Plato *Rep.* 400A) or βάσις, "step" (Aristotle *Metaph.* 1087b37) and why, within the foot, the basic elements were called the ἄρσις "lifting, up-step," and the θέσις, "placing, downbeat."

The transition from ῥυθμός meaning "shape, form, or pattern" to its use as "repetition" of various sorts may have occured at the beginning of the fifth century B.C. Petersen cites a passage from a chorus in Aeschylus's *Choëphoroi* (lines 783 ff.) as marking a transitional stage. In this passage the chorus compares Orestes to a colt and asks Zeus to grant him control on the path of revenge which he must run by instilling "measure" (μέτρον) into him, "preserving his rhythm" (σωζόμενον ῥυθμόν), and seeing that he maintains his stride throughout the race. The colt's stride (βημάτων ὄρεγμα) is here viewed as a regularly recurring pattern; it has become ῥυθμός both in the sense of form and also in the sense of repetition. It was possibly as a result of this sort of semantic development that the term came to be applied, by the end of the fifth century B.C., to actions like dancing and marching (see p. 221 *n*3).

By the fourth century it was possible to speak of ῥυθμός as "repetition" without any direct reference to the physical motion which originally accompanied it. Plato often uses ῥυθμός to refer to the recurring patterns of speech, completely independent of any idea of physical motion (*Rep.* 400A;

3. Jaeger, *Paideia*, p. 126

Cra. 424C), but when he is taking pains to be precise, as in the *Laws* 665A, he remembers that:

τῇ δὴ τῆς κινήσεως τάξει ῥυθμὸς ὄνομα εἴη, τῇ δ' αὖ τῆς φωνῆς, τοῦ τε ὀξέος ἄμα καὶ βαρέος συγκεραννυμένων, ἁρμονία ὄνομα προσαγορεύοιτο χορεία δὲ τὸ ξυναμφότερον κληθείη.

For the ordering of motion the name would be ῥυθμός, for that of the voice (that is, in the simultaneous blendings of highs and lows) the name would be ἁρμονία, and the combination would be called χορεία.

How is all this applicable to art criticism? Petersen offered the interesting and compelling suggestion that patterns of composition in Greek sculpture, particularly Early Classical sculpture, were understood as being like the ἠρεμίαι or "rests" which the musical theoretician Aristoxenus describes in all movement and sound but particularly in dancing and music.[4] In motion ἠρεμίαι were points at which fleeting movements came to a temporary halt, thus enabling a viewer to fasten his vision on a particular position that characterized the movement as a whole.[5]

The Ancient Passages

In the passages cited here we find that in every case ῥυθμός and the verb ῥυθμίζω probably refer to "form" rather than "repetition." In passages 1 and 4 we find the word used in what is perhaps its most basic sense, Diodorus (passage 4) says that the ῥυθμός of the statues of ancient Egypt was like that of the Greek statues of the time of Daedalus. As pointed out in the commentary under ἀρχαῖος, "statue of the time of Daedalus" was a conventional way in which the later Greeks referred to sculpture of what we now would call the "early Archaic period." The similarity in format between large-scale Egyptian sculpture and the early Greek *kouroi* is an acknowledged fact (see chap. 1, n. 4), and it is clearly this similarity to which Diodorus is referring. Again in passage 1, which forms part of Xenophon's conversation with Pistias the armor maker, ῥυθμός clearly refers to the "shape" of the

4. Aristoxenus *Harm.* 12 (ed. Meibom).

5. Analogy can be made to the pendulum of a clock in a painting. When a pendulum is depicted in a completely vertical position, we do not ascribe movement to it in our minds, but when it is depicted at the far left or the far right point of its swing, at the point where it momentarily stops before changing direction (the ἠρεμία), we naturally think of it as being in motion.

Ch. Hofkes-Brukker, "Pythagoras von Rhegium: Ein Phantom?", *BABesch* 39 (1964): 107–14, has recently proposed that Petersen's concept of ῥυθμός as being characterized by a "Stillstandsmoment," while not wrong, is too limited and should be modified in the light of other remarks which Aristoxenus makes about ῥυθμός.

breastplates which Pistias made. These breastplates were better than others because each one was made to fit its owner (ἁρμόττοντας ποιεῖς), that is, each was given the shape of the owner's body.[6]

In passages 3, 6, and 8 we find that the verbs ῥυθμίζω and μεταρυθμίζω mean "to form" and "to change the form of." Thus in purely literary passages, in which there is no hint of a connection with or of influence from professional criticism, the basic sense of ῥυθμός as "form" is maintained, although in passage 8 the form that Callistratus is thinking of is admittedly a "substance" rather than a "shape."

Of much greater importance than these rhetorical and literary usages, however, is passage 7, in which Diogenes Laertius credits the sculptor Pythagoras with being the first to have "aimed at" συμμετρία and ῥυθμός. This passage is discussed in chapter 1 where it is suggested that it may reflect the beginning of formal, professional art criticism (possibly written) among Greek sculptors. The passage should be studied in conjunction with Pliny *NH* 34.58, where it is said that Myron was *numerosior in arte quam Polyclitus et in symmetria diligentior*; for *numerosior*, although at first glance it may seem unlikely, was apparently the Latin translation of ῥυθμικώτερος.[7]

Greek sculptors of the Early Classical period, the time of Pythagoras and Myron, seem to have had a particular interest in the patterns of composition which were formed during the basic ἠρεμίαι, "rests," in any movement. Compositions of this sort are particularly apparent, for example, in the sculptures from the temple of Aphaia at Aegina and in other prominent works of the period.[8] In the case of Pythagoras there is unfortunately little we can do to illustrate the ῥυθμός which Diogenes ascribes to him, since there is no known work, even among Roman copies, which can be attributed to him with reasonable certainty.[9] In the case of Myron, on the other hand,

6. For further comment on this passage, see εὐρυθμία.

7. See Cicero *Orat.* 170; Quintilian 9.4.46 and 54. On the relationship between ῥυθμός and *numerus* see *numerosus, numerus*. Robert, *Arch. Märch.*, p. 34, first suggested εὐρυθμώτερος rather than ῥυθμικώτερος as the translation of *numerosior*. Like most scholars of his time, he did not recognize any difference between ῥυθμός and εὐρυθμία.

8. For some illustrations see my *Art and Experience in Classical Greece* (Cambridge, 1972), pp. 54–60.

9. It has been suggested that a group of ancient gems depicting the limping Philoctetes illustrates the Philoctetes of Pythagoras, but this is only intelligent speculation. Cf. Petersen, *Abh Gött* 16 (1917): 33; Adolf Furtwängler, *Die Antiken Gemmen* (Leipzig, 1900), 1:20 ff. On the Philoctetes of Pythagoras, the existence of which is only postulated from literary sources, see *Anthologia Graeca* 16.112; Pliny *NH* 34.59, *claudicantem*. Another work frequently connected with the Philoctetes is the Valentini torso in Rome; see Henri Lechat, *Pythagoras de Rhégion* (Paris and Lyon, 1905), pp. 57–92; O. Waldhauer, "Der Torso Valentini," *AA* (1926): 326–30. Ludwig Curtius, however, attributed the Valentini torso to Myron; cf. "Zu einem Kopf im Museo Chiaramonti," *JdI* 59 (1944): 41–44.

we have at least one work, the well-known Discobolus, which has been securely identified in Roman copies.[1] The Discobolus above all illustrates ῥυθμός as it was produced in an ἠρεμία. The figure is represented at the farthermost point in his backswing, thus, like the pendulum of a clock, suggesting to the viewer both the fact of the backswing and the potentiality of the forward swing. All this is conveyed, moreover, in a form whose silhouette makes as graphic an outline as a letter of the alphabet.

Toward the end of the Early Classical period the preoccupation of Greek sculptors with composition seems to have taken a new turn. Compositions which conveyed movement seem to have become less important than those which conveyed a majestic "presence." Even works which were exceptions to the dominant *pondus* (q.v.) of the second half of the fifth century (like the flying Nike of Paeonius, in which the composition implies rapid movement) were not constructed to show the ἠρεμίαι of motion.

Did the cultivation of ῥυθμός die out, then, after the Early Classical period? By the fourth century what seems to have been a new term, εὐρυθμία (q.v.), had appeared, which, although closely related to ῥυθμός, had qualitative connotations that the earlier term lacked. In a number of passages we find

A thoughtful and impressive attempt to identify a particular type of ῥυθμός which was characteristic of Pythagoras and could serve as a basis on which to construct a Pythagorean style and corpus, has been made by Ch. Hofkes-Brukker, *BABesch* 39 (1964): 107–14. Hofkes-Brukker sees in a number of works that have been associated with Pythagoras (e.g. the Ludovisi Discobolus in Rome; the Perseus torso in Naples; a bronze statuette from Adrano, now in Syracuse), as well as in certain figures on Sicilian coins (particularly the Acheloös on a stater from Metapontum), a pattern of composition in which the body is stretched out perpendicularly, and emphasis is placed on movement in the extremities. This composition is identified as "der Rhythmus der unbegrenzten Bewegung" and is contrasted with the ῥυθμός of Myron and Polyclitus, which put much greater emphasis on the structure and movement of axes in the middle parts of the body.

In Aristoxenus's discussion of the ῥυθμός of the voice, Hofkes-Brukker notes, a distinction is drawn between the ῥυθμός of the singing voice, which proceeds from tone to tone with clearly defined holds and intervals, and of the speaking voice, which gives the impression of being in continual movement with one syllable following another in quick succession. The "Stillstandsmoment," which Petersen identified as the essence of ῥυθμός in the visual arts, was, in Hofkes-Brukker's view, analogous to the ῥυθμός of the singing voice and characteristic of the sculpture of the Greek mainland, particularly that of Polyclitus and Myron. Pythagoras's ῥυθμός, lacking sharp transitions in the middle parts of the body but emphasizing its perpendicular extension, was, on the other hand, analogous to the ῥυθμός of the speaking voice and was perhaps typical of sculpture in Magna Graecia and Sicily.

As usual the fact that no connection can be proved between Pythagoras and any of the works discussed makes caution inevitable. Hofkes-Brukker's study certainly seems to come closer than any previous effort, however, to making sense out of the tradition which associates ῥυθμός with Pythagoras

1. See Richter, *SSG*⁴, figs. 616–18; Paolo Arias, *Mirone* (Florence, 1940), pp. 17–18.

ῥυθμός used in the plural, implying perhaps that at this stage the term had come to refer to the aggregate of smaller forms which made up a total composition rather than to composition itself. In passage 5 Lucian speaks of the ἠκριβωμένοι ῥυθμοί ("those shapes which have been made precise") which were admired in the composition of the thighs, knees, and feet of Praxiteles' Aphrodite of Cnidus. In passage 9 from the *Optica* of "Damianus"[2] the ὑποκείμενοι ῥυθμοί, the "actual underlying shapes" of a building, are said to be altered by architects in order to counteract optical effects which make them appear to be different from what they actually were And passage 2, from the *Syntaxis* of Philo Mechanicus, serves as part of the introduction of the author's treatment of εὐρυθμία in architecture (see εὐρυθμία). Philo says that it is impossible to combine the ῥυθμοί of a building without prior experiment because only prior experiment will reveal how optical illusion alters the εὐρυθμία, that is, the effect of all the ῥυθμοί of a work. Once again, ῥυθμοί seem to refer to the "shapes," the individual columns, moldings, and the like, within a building.

In short, it may be that as the idea of εὐρυθμία developed, the concept of ῥυθμός as composition was merged with the new idea, and ῥυθμός came to refer to the individual details which, when assembled, produced εὐρυθμία. But it should be emphasized that the paucity of our sources makes it impossible to view this idea as anything more than a hypothesis.

ῥῶπος, ῥωπογραφία (rhōpos, rhōpographia)

1. *Anthologia Graeca* 6.355 (Leonidas).

> Ἁ μάτηρ ζῷον τὸν Μίκυθον, οἷα πενιχρὰ
>
> Βάκχῳ δωρεῖται, ῥωπικὰ γραψάμενα
> Βάκχε, σὺ δ' ὑψῴης τὸν Μίκυθον, εἰ δὲ τὸ δῶρον.
> ῥωπικόν, ἁ λιτὰ ταῦτα φέρει πενία

His mother, poor though she is, gives this picture of Micythus to Bacchus, a crudely painted work. Bacchus, exaltest thou Micythus. If the gift be paltry, it is the only entreaty which poverty can offer.

2. Cicero *Att.* 15.16a (from Arpinum, May, 44 B.C.).

Itaque me referunt pedes in Tusculanum. Et tamen haec ῥωπογραφία ripulae videtur habitura celerem satietatem.

2. For a more complete discussion of this passage see ἀλήθεια-veritas, εὐρυθμία, and σκιαγραφία.

ρῶπος, ῥωπογραφία (rhōpos, rhōpographia)

So my feet are carrying me back to Tusculum. In the final analysis, the scenic quaintness of this coast would probably quickly make me jaded.

3. Dionysius of Halicarnassus. *Ant. Rom.* 16.3.6, on the Salus Temple in Rome.

αἱ ἐντοίχιοι γραφαὶ ταῖς τε γραμμαῖς πάνυ ἀκριβεῖς ἦσαν καὶ τοῖς μίγμασιν ἡδεῖαι, παντὸς ἀπηλλαγμένον ἔχουσαι τοῦ καλουμένου ῥώπου τὸ ἀνθηρόν.

The paintings on the walls were both very precise in their lines and also pleasing in their mixture of colors, which had a brightness completely free of that which is called "prettiness" [or "tawdriness"?].

4. Porphyry *Abst.* 4.3, and Scholia (ed. Nauck).

. . . ἔμελλον δὲ καὶ τέχναι ἄχρηστοι ἐξελαθήσεσθαι σὺν τούτοις, διάθεσιν τῶν ἔργων οὐκ ἐχόντων. τὸ γὰρ σιδηροῦν ἀγώγιμον οὐκ ἦν πρὸς τοὺς ἄλλους Ἕλληνας οὐδὲ εἶχε τιμὴν καταγελώμενον, ὥστε οὐδὲ πρίασθαί τι τῶν ξενικῶν καὶ ῥωπικῶν ὑπῆρχεν, οὐδὲ εἰσέπλει φόρτος ἐμπορικὸς εἰς τοὺς λιμένας.

[Lycurgus simplified Spartan life by, among other things, cutting down on the amount of meat in their diet, and abandoning the use of silver coinage,] . . . and the useless arts were also destined to be driven out, since the works which were products of them had no salability. For the iron money could not be used in dealing with the other Greeks, being without value and an object of ridicule, so that it was impossible to buy any foreign frivolities, nor did any commercial freight sail into the harbor.

Scholiast on ῥωπικῶν.

οὐδενὸς ἀξίων ῥῶπος γὰρ ὁ παντοδαπὸς ἢ καὶ ὁ λεπτὸς φόρτος, ἀλλὰ καὶ μῖγμα χρώματος ἐξ οὗ καὶ ῥωποπώλης ὁ ταῦτα πιπράσκων.

Of no value. For *rhōpos* means "extremely varied" or also "light stuff," but again also a "mixture of colors." From which comes *rhōpopōlēs*, one who sells such things.

5. Photius *Lex.*, s.v. ῥῶπος (ed. Naber) (ninth century A.D.).

a. μίγματα, χρώματα ὅσα βαφεῦσι ζωγράφοις μυρεψοῖς χρησιμεύει. ὅθεν ῥωποπώλης, ὁ μυρωπώλης. τινὲς δὲ καὶ τὸν παντοδαπὸν φόρτον* ῥῶπον εἰρήκασιν.

229

ῥῶπος, ῥωπογραφία (rhopōs, rhōpographia)

Pigments, colors which are used by dyers, painters, perfume makers. Whence comes rhōpopōlēs ["peddlar?"], perfume seller. Some also have spoken of a "varied cargo" ["assorted stuff"?] as rhōpos.

b. ῥῶπος—μηθενὸς ἄξιον.

Rhōpos—worth nothing.

6. Etym. Magn. 705.55 (twelfth century A.D.).

ῥῶπες, ὕλη καὶ ὑλώδη φυτά, καὶ ῥωπογράφους, τοὺς τὰ τοιαῦτα ὑπογράφοντες.

Rhōpes, woodland and the vegetation which grows in the woods; also rhōpographoi, those who paint such subjects.

Commentary

The peculiar collection of passages in the preceding catalog at least makes it clear that words formed from the root ῥωπ- were often used, and sometimes with critical intent, in connection with Greek painting. Beyond that, it is difficult to formulate any general conclusions.

Three general meanings for the ῥωπ- stem can be identified:

A. "Having something to do with landscape and landscape painting." Such a meaning is clearly stated in the *Etymologicum Magnum* (passage 6) and seems to be the essential meaning in passage 2, in which Cicero confesses that one soon could grow tired of the "scenic" landscape around Arpinum.
B. "Of little value, cheap, trivial, vulgar." This meaning is obvious in Leonidas's dedicatory epigram (passage 1), in Porphyry's comments on the arts in Lycurgan Sparta (passage 4), in the comments of the scholiast on Porphyry, and in the second of the definitions given by Photius (passage 5). In the sense of "vulgarity" it may be applicable to Dionysius's comment on the painting by Fabius Pictor in the temple of Salus in Rome.
C. "Denoting a varied mixture" of colors. Such a meaning is clearly stated by the scholiast on Porphyry (passage 4) and by Photius (passage 5).

The passages from Cicero and Dionysius of Halicarnassus (2 and 3) are of exceptional importance because their intent is overtly critical and, if correctly understood, could give us an insight into the taste in painting

among the literati of the Greco-Roman world in the first century B.C. Unfortunately, it is in these passages that the meanings outlined above seem to blur and become problematical. When Cicero speaks of the scenery around Arpinum as a ῥωπογραφία, is he simply thinking of a landscape painting, or is he also implying a kind of "trivial prettiness" (meaning B)[3] or even a richness of color which amounts to gaudiness (meaning C)? And when Dionysius speaks of the paintings in the Salus temple as having a colorful brightness which was "free of that which is called ῥῶπος," does he mean that the paintings were free from cheapness and vulgarity (in color or in subject matter), that the paintings avoided making use of a vast variety of colors, or perhaps that the paintings were megalographic, emphasizing human figures rather than a colorful surrounding landscape such as Dionysius's contemporaries might have used?[4]

This ambiguity of meaning in the ῥωπ-words when they are used in connection with painting, an ambiguity which also clearly puzzled scholars like Photius, Eustathius, and the compilers of the *Etymologicum Magnum* in the Middle Ages, can perhaps be traced to the etymology of the words. The use of ῥωπογραφία and ῥωπογράφω to refer to the woodlands and vegetation which constitute a landscape is apparently derived from ῥώψ, ῥωπός meaning "underbrush, brush, shrub." The nominative singular of this word is given only by Hesychius, but the collective plural ῥῶπες occurs thrice in the *Odyssey* (10.166; 14.49; 16.47), and the epic form ῥωπήϊα occurs in the *Iliad* (13.199; 23.122; 21.559). These Homeric words are perhaps to be connected with ῥαπίς "stick" and ῥαπίζω, "beat with a stick," although these do not occur in Homer.[5]

Porphyry's and Photius's use of ῥῶπος, τὰ ῥωπικά, and similar forms to mean "assorted stuff, frivolities, things of no consequence," and possibly even "junk" seems, on the other hand, to derive from a separate root, the etymology of which, as Boisacq says, is "obscure"[6] but seems to be unconnected with "stick, brush," and so on. The words deriving from this root are particularly associated with the wares of traveling merchants, be they seagoing

3. "Artificial prettiness," for example, is the meaning given in *LSJ*[9].

4. The paintings from the Villa of Livia at Prima Porta might be taken as examples of "Roman" painting near, if not exactly contemporary with, the time of Dionysius, which represent landscape, employ rich colors, and are essentially ornamental (although not gaudy or trivial) in character.

5. Cf. Émile Boisacq, *Dictionnaire étymologique de la langue grecque,* 3d ed. (Heidelberg and Paris, 1938), s.v. ῥώψ; Hjalmar Frisk, *Griechisches Etymologisches Wörterbuch* (Heidelberg, 1960–72), s.v. ῥώψ, passage 1.

6. Ibid., s.v. ῥῶπος. Frisk, *Griechisches Etymologisches Wörterbuch*, gives "ohne Etymologie (zu ῥώψ?)."

traders or simple peddlars.[7] Porphyry's use of ῥωπικά in passage 4 falls into this category, and so does the earliest documented use of ῥῶπος, in a fragment of Aeschylus (Nauck 263).

How ῥῶπος came to refer to "colors" or a "mixture of colors" is difficult to say. If ῥωπογραφία was essentially landscape painting, one might surmise that such painting was characteristically quite florid and that ῥῶπος came to be associated with a profusion of color. On the other hand, if Photius's definition of ῥῶπος (passage 5) as the assorted materials from which painters and dyers made their paints and from which perfume-makers produced their products is accurate, we might assume that the connection between ῥῶπος and color is simply an extension of the meaning "assorted wares, trivia."

Returning to passages 2 and 3, it seems we are bound to conclude that Cicero's ῥωπογραφία is derived from ῥώψ, "brush, woodland,"[8] while Dionysius's ῥῶπος seems more likely to have come from "petty wares, trivia." But one wonders if by the first century B.C. all the meanings associated with ῥωπ- had not merged into a single stream. One gets the impression from the Cicero passage that he is indeed thinking of a landscape painting, but that this landscape had something quaint, *précieux,* or trivially ornamental about it (the diminutive *ripula* contributes to this impression). Dionysius, on the other hand, is clearly thinking first of all of color. When he says that the mixture of colors in the paintings in the Salus temple were ἡδεῖαι and had an ἀνθηρόν which was free of ῥῶπος, he probably means that the colors in this painting were not vulgarly ornate. He may also be implying that the palette of colors used in these paintings was limited (such a limitation is implied by ἀνθηρός). And finally, in thinking of coloration which could be described as ῥῶπος, he may, as already suggested, have had the landscape painting of his own time in mind.

Complex as the evidence is, then, we are probably justified in interpreting ῥῶπος and ῥωπογραφία as the terms by which sophisticated connoisseurs in the first century B.C. characterized, and perhaps expressed their distaste for, a trend toward a kind of rococo floridity in the painting of their time.

One small addendum should be noted. In *NH* 35.112, Pliny mentions a painter named Piraeicus, date unknown, who made a speciality of painting lowly subjects like barber shops, asses, shoemakers' stalls, and the like. Because of this, Pliny tells us, he was called the *rhyparographos.* In the nineteenth century some editors suggested that this title should be emended to

7. Cf. *LSJ*[9], s.v. ῥωπίζω, ῥωπικός, ῥωποπώλης, ῥῶπος. On the derivation see Frisk, *Griechisches Etymologisches Wörterbuch,* s.v. ῥώψ, no. 2.

8. *LSJ*[9] translates ῥωπογραφία in Cicero as "artificial prettiness," apparently deriving it from ῥῶπος, "petty wares, etc." But the *Etymologicum Magnum* as well as the context of the Cicero passage make the association with ῥώψ, ῥωπός more probable.

rhōpographos.[9] But as Brunn pointed out not long after the emendation first became current, ῥυπαρογράφος, "the painter of lowly subjects" (ῥυπαρός = "sordid, mean, uncultured"), makes perfectly good sense.[1] The argument for reading ῥωπογράφος is no stronger, perhaps not as strong; that being the case, we are scarcely justified in altering the reading of the manuscripts.

σεμνός *(semnos)*

1. Dionysius of Halicarnassus *Isoc.* 3. See ἀξιωματικός.

2. Dio Chrysostom *Or.* 12.49.

> εἰ γάρ τις Φειδίαν πρῶτον ἐν τοῖς Ἕλλησιν εὐθύνοι, τὸν σοφὸν τοῦτον καὶ δαιμόνιον ἐργάτην τοῦ σεμνοῦ καὶ παγκάλου δημιουργήματος . . .

> If, for example, one were to examine first of all among the Greeks Phidias, that wise and inspired creator of this holy and in all ways beautiful masterpiece [the Zeus at Olympia] . . .

3. Dio Chrysostom *Or.* 12.74.

> ὃν ἐγὼ μετὰ τῆς ἐμαυτοῦ τέχνης καὶ τῆς Ἠλείων πόλεως σοφῆς καὶ ἀγαθῆς βουλευσάμενος ἱδρυσάμην, ἥμερον καὶ σεμνὸν ἐν ἀλύπῳ σχήματι.

> This I, after using the resources of my art and taking counsel with the wise and good city of Elis, have set up—a gentle and holy god of benign form.

4. Dio Chrysostom *Or.* 12.77.

> τὴν μὲν γὰρ ἀρχὴν καὶ τὸν βασιλέα βούλεται δηλοῦν τὸ ἰσχυρὸν τοῦ εἴδους καὶ τὸ μεγαλοπρεπές, τὸν δὲ πατέρα καὶ τὴν κηδεμονίαν τὸ πρᾷον καὶ προσφιλές, τὸν δὲ πολιέα καὶ τὸν νόμιμον ἥ τε σεμνότης καὶ τὸ αὐστηρόν,

> For the sovereignty [of Zeus] and his regality are intended to be indicated by the strength of the image and its grandeur; his fatherly nature and guardianship by its gentleness and kindness; his role as the protector of cities and upholder of laws by its solemnity and austere quality.

9. Mainly F. G. Welcker in his contribution to Friedrich Jacobs's edition of Philostratus (Leipzig, 1825), pp. 396–97. Cf. the apparatus to Sillig's edition of Pliny.
1. Brunn, *GGK*², 2:174.

σεμνός (*semnos*)

Cf. μεγαλοπρεπής passage 3.

5. Lucian *Im.* 6. See εὐσταλής, passage 2.

Commentary

In its earliest usage σεμνός appears to have referred exclusively to the gods and their divine attributes; for example, in the Homeric hymn *To Demeter* 486 σεμναί is used to describe Demeter and Rhea, and in line 476 σεμνά describes the ὄργια which Demeter taught the Eleusinians. At this stage the term is perhaps best translated in English by the word "holy," which is applicable to divine personages and institutions.

By the time of Aeschylus σεμνός had also come to be used for human things which had a quality of augustness and were thus, like divine things, worthy of reverence.[2] Finally, in the fourth century σεμνός and σεμνότης were used in literary and rhetorical criticism to denote a quality of style. Aristotle held that an "august" style in poetry and rhetoric could be achieved by using language which was outside the range of common usage—*Rh.* 1404b8: τὸ γὰρ ἐξαλλάξαι ποιεῖ φαίνεσθαι σεμνοτέραν, and *Poet.* 1458a21: σεμνὴ δὲ καὶ ἐξαλλάττουσα τὸ ἰδιωτικόν. ἡ τοῖς ξενικοῖς κεχρημένη. Dionysius of Halicarnassus uses σεμνός and cognates frequently in the *De Compositione Verborum* (περὶ συνθέσεως ὀνομάτων); he speaks of σεμνότης as one possible effect to be achieved by the grouping of clauses (sec. 7); of σεμνολογία as a subcategory of τὸ καλόν, one of the two chief ends of all composition (sec. 10); of σεμνότης derived from rhythm (sec. 17): and of the σεμνότης which is lacking in the ἀνθηρός "character" of composition but present in the αὐστηρός character (sec. 23). Likewise in Demetrius's *Eloc.* σεμνότης is cited as a characteristic of the χαρακτὴρ μεγαλοπρεπής (sec. 44).

The passages cited here derived from authors whose critical language belongs to the traditions of Greco-Roman rhetoric. Passages 2–5 refer to specific works of art. Dio Chrysostom, in passages 2, 3, and 4, uses σεμνός and σεμνότης to refer to Phidias's statue of Zeus at Olympia. In these passages we find a combination of the earliest meaning of the word, "holy," and the later, more sophisticated idea of an "august" style. The same connotations are probably to be attributed to the use of the word in passage 5, where Lucian uses it to describe the smile of the Sosandra of Calamis.

In passage 1 Dionysius uses τὸ σεμνόν as an abstract quality of style divorced from its application to any particular work. He compares the rhetoric of Isocrates with the sculpture of Phidias and Polyclitus with respect to τὸ σε-

2. *Agamemnon* 519, σεμνοὶ θᾶκοι, referring presumably to the thrones in the palace of Mycenae.

234

μνόν, μεγαλότεχνον, and ἀξιωματικόν. This passage provides an important link between the Greek terminology of late Hellenistic rhetorical and art historical criticism on the one hand and the Latin terminology preserved by Quintilian and Cicero on the other. The problem of finding the proper Latin equivalent of σεμνός/σεμνότης, however, has proved to be unusually complicated. A possible relationship between ἀξιωματικόν and auctoritas and between μεγαλότεχνος and magnificus (s.v. μεγαλοπρεπής) is discussed elsewhere, as is the suggestion that σεμνός could be rendered in Latin by augustus, possibly also by gravitas, and quite probably by pondus.[3] The latter translation, τὸ σεμνόν = pondus, is proposed by Robert[4] and Schweitzer.[5] The close relationship between Quintilian's contention that Polyclitus lacked pondus (Inst. 12.10.8: deesse pondus putant) and Strabo's statement that Polyclitus lacked the μέγεθος and πολυτέλεια of Phidias (8.372), however, suggests that pondus is a Latin translation of one of Strabo's Greek terms (see pondus). But in spite of the apparent resemblance between the two passages in question, μέγεθος would seem to be more closely related to maiestas than to pondus, while πολυτέλεια is a rare word in art criticism and cannot be clearly related to any Latin term. It is not impossible that Quintilian rendered πολυτέλεια by pondus.

To complicate the scheme of correspondences even further, it is possible that σεμνότης was rendered by the auctoritas in the sense that it is used by Quintilian Inst. 12.10.7: non explevisse deorum auctoritatem videtur (Polyclitus). Quintilian appears to have been translating a term which was applicable primarily to the gods, and σεμνότης, as we have seen, is just such a term. We have already discussed, however, the likelihood of a connection between auctoritas and ἀξιωματικόν, a correspondence particularly favored by Schweitzer.

If σεμνός and σεμνότης are then to be connected with the Latin augustus, gravitas, pondus, and auctoritas, and these Latin terms are in turn to be connected elsewhere with ἀξιωματικόν, μέγεθος, πολυτέλεια, and other Greek terms, we are perhaps compelled to conclude that we may only speak of a "degree of probability" in the correspondences between the Greek and Latin critical terms of Hellenistic and Roman rhetoric on the one hand and the late Hellenistic criticism of the visual arts on the other. If, for example, both pondus and auctoritas in Quintilian are to be connected with σεμνός, we cannot even count on the consistency of equivalents in one author. The rhetoricians, one may assume, used criticial terms in a free, flexible, and informal way, which

3. See auctoritas, augustus, gravitas, and pondus.
4. Robert, Arch. Märch., p. 54. On page 52, however, Robert proposes that pondus also renders μέγεθος.
5. Schweitzer, Xenokrates, p. 34.

σκηνογραφία *(skēnographia)*

contrasted markedly with the precise usage of terms in the professional criticism of an earlier era.

See μεγαλοπρεπής, μέγεθος, πολυτέλεια, *auctoritas, pondus.*

σκηνογραφία *(skēnographia)*

1. Aristotle *Poet.* 1449a18.

τρεῖς δὲ καὶ σκηνογραφίαν Σοφοκλῆς [παρεσκεύασεν].

[Aeschylus introduced the second actor in drama, reduced the role of the chorus, and increased the dialogue.] Sophocles introduced the third actor and also scene painting.

2. Polybius 12.28A1.

. . . βουλόμενος αὔξειν τὴν ἱστορίαν πρῶτον μὲν τηλικαύτην εἶναί φησι διαφορὰν τῆς ἱστορίας πρὸς τοὺς ἐπιδεικτικοὺς λόγους, ἡλίκην ἔχει τὰ κατ' ἀλήθειαν ᾠκοδομημένα καὶ κατεσκευασμένα τῶν ἐν ταῖς σκηνογραφίαις φαινομένων τόπων καὶ διαθέσεων.

. . . [Timaeus,] wishing to enhance the role of historical writing, says first of all that history differs from epideictic speeches in the same way that actual buildings and other structures differ from the appearances of places and subjects in scene painting.

3. Strabo 5.3.8 (236C).

καὶ τὰ περικείμενα ἔργα καὶ τὸ ἔδαφος ποάζον δι'ἔτους καὶ τῶν λόφων στεφάναι τῶν ὑπὲρ τοῦ ποταμοῦ μέχρι τοῦ ῥείθρου σκηνογραφικὴν ὄψιν ἐπιδεικνύμεναι δυσαπάλλακτον παρέχουσι τὴν θέαν.

And the works which are located throughout the area and the land itself, which is covered with grass throughout the year, and the brows of the hills which, in rising above the river and reaching up to its channel, present to the sight a scene painting—all these provide a view which it is difficult to ignore. [Description of the Campus Martius.]

4. Vitruvius 1.2.2.

Species dispositionis, quae graece dicuntur ἰδέαι, sunt hae: ichnographia, orthographia, scaenographia. . . . Item scaenographia est frontis et laterum abscedentium adumbratio ad circinique centrum omnium linearum responsus.

The subcategories, which the Greeks call ἰδέαι, of composition are these: *ichnographia* [ground plan], *orthographia* [plan in elevation], and *scaenographia* And finally *scaenographia* is the semblance of a front and of sides receding into the background and the correspondence of all the lines [in this representation] to [a vanishing point at] the center of a circle.

5. Plutarch *Arat.* 15.2.

πρότερον γὰρ ἡμᾶς ὑπερεώρα ταῖς ἐλπίσιν ἔξω βλέπων καὶ τὸν Αἰγύπτιον ἐθαύμαζε πλοῦτον, ἐλέφαντας καὶ στόλους καὶ αὐλὰς ἀκούων, νυνὶ δὲ ὑπὸ σκηνὴν ἑωρακὼς πάντα τὰ ἐκεῖ πράγματα τραγῳδίαν ὄντα καὶ σκηνογραφίαν ὅλος ἡμῖν προσκεχώρηκεν.

[King Antigonus Gonatas on Aratus:] Formerly he looked askance at us and, looking afar for fulfillment of his hopes, he marveled at the wealth of Egypt, with its elephants and fleets and great halls, but now, after becoming suspicious of its theatricality and seeing that everything there consists of nothing but theatrical performance and scene painting, he has come over to our side.

6. Sextus Empiricus *Math.* 7.88.

. . . ᾿Ανάξαρχον δὲ καὶ Μόνιμον ὅτι σκηνογραφίᾳ ἀπείκασαν τὰ ὄντα τοῖς τε κατὰ ὕπνους ἢ μανίαν προσπίπτουσι ταῦτα ὡμοιῶσθαι ὑπέλαβον.

. . . Anaxarchus and Monimus [abolished a criterion for truth] because they likened existing things to scene painting and supposed them to resemble things experienced in sleep or madness.

7. Heliodorus 7.7.7.

καὶ τέλος τὸ πρὸς τῷ τείχει σύμπαν μέρος* καθ᾿ ὃ προκαθῆστο ἡ ᾿Αρσάκη, διοιδουμένη καὶ οὐκ ἄνευ ζηλοτυπίας ἤδη τὴν Χαρίκλειαν θεωμένη, σκηνογραφικῆς† ἐπληροῦτο θαυματουργίας.

*μέρος secl. Rattenbury, Lumb.
†σκηνογραφισῆς P; σκηνογραφίας B.

To be brief, the entire portion of the crowd on the wall where Arsace was seated (she herself was swollen with anger and by this time could not look at Charicleia without jealousy) was filled with enchantment at this marvelous scene.

237

σκηνογραφία (*skēnographia*)

8. Heliodorus 10.38.3.

ὁ δῆμος ἑτέρωθεν σὺν εὐφήμοις ταῖς βοαῖς ἐξεχόρευε, πᾶσα ἡλικία καὶ τύχη συμφώνως τὰ γιγνόμενα θυμηδοῦντες, τὰ μὲν πλεῖστα τῶν λεγομένων οὐ συνιέντες, τὰ ὄντα δὲ ἐκ τῶν προγεγονότων ἐπὶ τῇ Χαρικλεία συμβάλλοντες, ἢ τάχα καὶ ἐξ ὁρμῆς θείας ἢ σύμπαντα ταῦτα ἐσκηνογράφησεν εἰς ὑπόνοιαν τῶν ἀληθῶν ἐλθόντες.

The people, on the other hand, danced about shouting their blessings, every age and condition being glad at heart; they did not understand most of what had been said, but they either conjectured what had really happened from what had befallen Charicleia, or perhaps they were led to a suspicion of the truth by the divine force which had staged all these marvelous events.

9. Diogenes Laertius 2.125.

[Μενέδημος] Κλεισθένους . . . υἱός, ἀνδρὸς εὐγενοῦς μέν, ἀρχιτέκτονος δὲ καὶ πένητος. οἱ δὲ καὶ σκηνογράφον αὐτὸν εἶναί φασι καὶ μαθεῖν ἑκάτερα τὸν Μενέδημον.

[The philosopher Menedemus, ca. 319–265 B.C.] was the son of Clisthenes, who was a man of good birth, although an architect and also poor. Some say further that he was a scene painter and that Menedemus learned both trades.

10. Hesychius, s.v. σκιά (see Overbeck, *Schriftquellen* 1646).

σκίασις, ἐπιφάνεια τοῦ χρώματος ἀντίμορφος. σκιαγραφίαν, τὴν σκηνογραφίαν οὕτω λέγουσι. ἐλέγετο δέ τις καὶ Ἀπολλόδωρος ζωγράφος σκιαγράφος ἀντὶ τοῦ σκηνογράφος.

Shading—the appearance of color [or "of the skin"] on the surface of a form. *Skiagraphia*—thus do they refer to *skēnographia*. Also, a certain painter, Apollodorus, was called the *skiagraphos* instead of the *skēnographos*.

11. Proclus *Comm. on Euclid* book I (ed. Friedein, p. 40, lines 9–22).

πάλιν ὀπτικὴ καὶ κανονικὴ γεωμετρίας εἰσὶ καὶ ἀριθμητικῆς ἔκγονοι, ἡ μὲν ταῖς ὄψεσι γραμμαῖς χρωμένη καὶ ταῖς ἐκ τούτων συνισταμέναις γωνίαις, διαιρουμένη δὲ εἴς τε τὴν ἰδίως καλουμένην ὀπτικήν, ἥτις τῶν ψευδῶς φαινομένων παρὰ τὰς ἀποστάσεις τῶν ὁρατῶν τὴν αἰτίαν ἀποδίδωσιν, οἷον τῆς τῶν παραλλήλων συμπτώσεως ἢ τῆς τῶν τετραγ-

ώνων ὡς κύκλων θεωρίας, καὶ εἰς τὴν κατοπτρικὴν σύμπασαν τὴν περὶ
τὰς ἀνακλάσεις τὰς παντοίας πραγματευομένην καὶ τῇ εἰκαστικῇ
γνώσει συμπλεκομένην, καὶ τὴν λεγομένην σκηνογραφικὴν δεικνῦσαν,
πῶς ἂν τὰ φαινόμενα μὴ ἄρυθμα ἢ ἄμορφα φαντάζοιτο ἐν ταῖς εἰκόσι
παρὰ τὰς ἀποστάσεις καὶ τὰ ὕψη τῶν γεγραμμένων. ἡ δ᾽ αὖ κανονική...

What is more, optics and the mathematical theory of music are offshoots
of geometry and arithmetic; the former [optics] makes use of the lines
coming from the eyes and of the angles which arise from these and is
divisible into what is properly called "optics"—that is, whatever pro-
vides a reasoned explanation of deceptive appearances on the basis of
the distances between visible things, such as the intersection of parallels
or the theory of rectangles as circles—and into the theory of reflection—
that is, everything which concerns the various types of reflection and is
bound up with knowledge derived from images, and which is demon-
strated in the art which is called *skenographia*, [i.e. the theory of] how
appearances should avoid giving the impression of being ill shaped or
ill formed in pictures, based on the distances and the height of painted
[or drawn] figures. The theory of music, on the other hand . . .

12. "Damianus" *Optica* (ed. Schöne, pp. 28–30) = Heron *Definitiones* 135.13
(see chap. 1, note 44).

τί τὸ σκηνογραφικόν; τὸ σκηνογραφικὸν τῆς ὀπτικῆς μέρος ζητεῖ, πῶς
προσήκει γράφειν τὰς εἰκόνας τῶν οἰκοδομημάτων. ἐπειδὴ γὰρ οὐχ, οἷά
ἐστι τὰ ὄντα, τοιαῦτα καὶ φαίνεται, σκοποῦσι, πῶς μὴ τοὺς ὑποκειμένους
ῥυθμοὺς ἐπιδείξονται, ἀλλ᾽, ὁποῖοι φανήσονται, ἐξεργάσονται. τέλος δὲ
τῷ ἀρχιτέκτονι τὸ πρὸς φαντασίαν εὔρυθμον ποιῆσαι τὸ ἔργον καὶ, ὁπόσον
ἐγχωρεῖ, πρὸς τὰς τῆς ὄψεως ἀπάτας ἀλεξήματα ἀνευρίσκειν, οὐ τῆς
κατ᾽ ἀλήθειαν ἰσότητος ἢ εὐρυθμίας, ἀλλὰ τῆς πρὸς ὄψιν στοχαζομένῳ.
οὕτω γοῦν τὸν μὲν κύλινδρον κίονα, ἐπεὶ κατεαγότα ἔμελλε θεωρήσειν
κατὰ μέσα πρὸς ὄψιν στενούμενον, εὐρύτερον κατὰ ταῦτα ποιεῖ, καὶ τὸν
μὲν κύκλον ἔστιν ὅτε οὐ κύκλον γράφει, ἀλλ᾽ ὀξυγωνίου κώνου τομήν, τὸ
δὲ τετράγωνον προμηκέστερον καὶ τοὺς πολλοὺς καὶ μεγέθει διαφέροντας
κίονας ἐν ἄλλαις ἀναλογίαις κατὰ πλῆθός τε καὶ μέγεθος. τοιοῦτος δ᾽ἐστὶ
λόγος καὶ ὁ τῷ κολοσσοποιῷ διδοὺς τὴν φανησομένην τοῦ ἀποτελέσματος
συμμετρίαν, ἵνα πρὸς τὴν ὄψιν εὔρυθμος εἴη, ἀλλὰ μὴ μάτην ἐργασθείη
κατὰ οὐσίαν σύμμετρος. οὐ γάρ, οἷά ἐστι τὰ ἔργα, τοιαῦτα φαίνεται ἐν
πολλῷ ἀναστήματι τιθέμενα.

What is *skenographia* [or the *"skenographic* part of optics"]? The *skeno-
graphic* part of optics seeks to discover how one should paint [or "draw"]
images of buildings. For since things do not give the appearance of

being what they in fact are, they look to see not how they will represent the actual underlying shapes, but, rather, they render these shapes in whatever way they appear. The goal of the architect is to give his work a satisfying shape using appearance as his standard, and insofar as is possible, to discover compensations for the deceptions of the vision, aiming not at balance or shapeliness based on real measurement [or "reality"] but at these qualities as they appear to the vision. Therefore, since the cylindrical column, as it tapers, is certain to appear to the vision as if it were broken in the middle, he makes it thicker in this part, and at times he represents the square as extended [i.e. as a rectangle], and he represents the columns, which are numerous and of various sizes, in different proportions according to their number and size. And it is also a procedure of this sort which brings about the appearance of commensurability in his creation for a maker of colossal statuary, so that the work has a satisfactory form for the vision and is not, in a futile fashion, worked out according to real [as opposed to apparent] commensurability. For works set up at a great elevation do not appear to have the form which they in fact have.

Commentary

"Stage [σκηνή] painting" or "scene painting" are the most literal translations of σκηνογραφία, but the term at times is also used in a more circumscribed and technical way to mean "the art of depicting spatial perspective." This technical value is represented in our testimonia by passages 4 (Vitruvius), 11 (Proclus), and 12 ("Damianus"). It would appear that σκηνογραφία came to be used as the term for perspective painting because such painting was first employed in the painted stage settings designed for theatrical performances. Vitruvius, in an important but problematical passage, implies that this experimentation was first undertaken by the Athenian painter Agatharchus in the fifth century B.C.:

Namque primum Agatharchus Athenis Aeschylo docente tragoediam ad scaenam fecit et de ea, commentarium reliquit. Ex eo moniti Democritus et Anaxagoras de eadem re scripserunt, quemadmodum oporteat, ad aciem oculorum radiorumque extentionem certo loco centro constituto, ad lineas ratione naturali respondere, uti de incerta re certae imagines aedificiorum in scaenarum picturis redderent speciem et, quae in directis planisque frontibus sint figurata, alia abscedentia, alia prominentia esse videantur. [7.praef.11]

There are two questions which must be asked about this passage: First, what does it mean? And second, to what extent is it historically accurate?

The language and meaning of the passage have been subjected to close scrutiny in a monograph on ancient perspective by John White.[6] He offers the following straightforward translation:

> For in the beginning in Athens, when Aeschylus was presenting a tragedy, Agatharchus set the stage and left a commentary on the matter. Instructed by this Democritus and Anaxagoras wrote about the same thing, how it is necessary that, a fixed center being established, the lines correspond by natural law to the sight of the eyes and the extension of the rays, so that from an uncertain object certain images may render the appearance of buildings in the paintings of the stages, and things which are drawn upon vertical and plane surfaces may seem in one case to be receding, and in another to be projecting.[7]

White makes a good case for a close connection between this passage and Vitruvius's description of *scaenographia* (passage 4). He proposes that together they describe an application to the visual arts of the analysis of optical experience which is elsewhere presented in purely theoretical terms, without reference to art, by Euclid and Lucretius.[8] In this analysis the field of vision is seen as a cone with its apex at the eye and with a vanishing point at the center of its circular base. The Vitruvian description of *scaenographia*, White maintains, is in fact "a description of perspective method," while the description of Agatharchus's achievement "complements it with a reference to the latter's [i.e. perspective's] basis in the fundamental optical principles of the visual cone."[9] The language Vitruvius uses to describe this concept, moreover, is precise and consistent. The phrase *circini centrum* (passage 4), literally "the point of a compass," means the center of a circle; *responsus* (passage 4) and *respondere* (in the Agatharchus passage) refer to the convergence of lines toward a single point.[1] Hence, when Vitruvius says that "the lines correspond by a natural law" to "the sight of the eyes and the extension of the rays," he means that drawn lines converging on a central vanishing point in a painting are analogous to the rays of vision which converge at the apex of the Euclidian visual cone.

White does not deal with the troublesome phrase *de incerta re certae im-*

6. John White, *Perspective in Ancient Drawing and Painting*, Society for the Promotion of Hellenic Studies, Supplementary Paper no. 7 (London, 1956). White's discussion in part attempts to refute the view of G. M. A. Richter, "Perspective, Ancient, Medieval, and Renaissance," in *Scritti in Onore di Bartolomeo Nogara* (Rome, 1937), pp. 381–88, that the language Vitruvius uses in connection with perspective is intentionally vague and nonspecific.

7. White, *Perspective*, p. 46.

8. Euclid *Optics* theorem 4 ff.; Lucretius 4. 426-31.

9. White, *Perspective*, p. 53.

1. Ibid., pp. 46–51.

agines . . . in the passage on Agatharchus. One manuscript tradition reads *incertae imagines* rather than *certae,* and this reading has been accepted by some modern editors (Krohn, Granger). Granger takes the phrase to mean "from an uncertain object, uncertain images give the appearance of buildings. . . . " I take the meaning of the phrase to be that an assemblage of drawn lines, which, when viewed without regard to its illusionistic quality, has no meaning or significance in itself (*incerta res*), becomes, when understood illusionistically, a definite thing, *certa res,* for example, a building. Hence *certae imagines,* the reading adopted in the edition of Rose and in the recent edition of Ferri, seems preferable. Ferri's paraphrase, "le immagini costruite da semplici linee incorporee architettoniche che sembrano corporee e vere,"[2] indicates that he interprets Vitruvius's meaning essentially as I do.

It is clear, then, that whatever problems of detail the two Vitruvian passages in question may offer, Vitruvius took *scaeongraphia* to refer to the representation of spatial perspective in the visual arts, and he seems to have had in mind a specific system of perspective in which a vanishing point was employed.

In ascribing the invention of this system to Agatharchus at a time when *Aeschylo docente tragoediam,* Vitruvius is placing its invention before 456 B.C., the year of Aeschylus's death. This date is surprising and unsettling to modern art historians because the extant monuments, such as they are, reveal hardly any trace of the use of perspective at such an early date. These extant monuments, however, are without exception painted vases, mostly of the red-figure style, and since vase painting follows aesthetic standards which are in a large measure peculiar to itself, the evidence of the vases does not necessarily refute Vitruvius's date for the introduction of perspective. The vase painter is confronted above all with the problem of decorating the curved surface of a utilitarian object. The surface of a vase always impresses the viewer with its solidity and integrity. Unlike a painted panel, where it is easy to yield to the illusion that one is looking through a kind of window into a receding spatial plane, a vase always impresses itself upon one's consciousness as a "thing." Hence the representation of a deep recession of pictorial space is inimical to vase painting, and it would not be surprising if the vase painters took it up only slowly and halfheartedly. It should also be remembered that vase painting, however much modern enthusiasts may protest against the idea, was a minor art, particularly in the fifth century. Literary sources make it clear that painters who were famed as innovators and the formulators of important new movements were mural painters and panel painters, whose works were usually on a large

2. Ferri, *Vitruvio* (Rome, 1960), p. 25.

scale and exhibited a much greater chromatic range than did painted vases. In the fifth and fourth centuries B.C. vase painting gives us only an echo of what the great painters were doing, and the later the date the weaker this echo becomes.

A fuller analysis of the monuments which are relevant to the development of perspective in ancient painting is beyond the scope of the present inquiry, and such an analysis has, in any case, already been undertaken by White and other writers on the subject.[3] The earliest vase paintings in which there is a significant attempt to show the apparent diminution of cubic objects in space and to show the apparent diminution of people and objects in accordance with their distance from one another occur on Attic red-figure vases dating from ca. 430–400 B.C., notably in the works of the Eretria painter and the Meidias painter.[4] More ambitious attempts to work out a seemingly coherent, if never truly rational or scientific, relationship between men and objects in space occur in southern Italian vase painting of the fourth century B.C., most notably on the well-known Apulian crater in Naples representing Orestes and Iphigenia in Tauris.[5] In the third century B.C., when the red-figure tradition in vase painting died out, we have a hint of later developments in some painted funeral stelae, particularly the remarkable interior scene on the Hediste stele from Volo,[6] but there is not enough evidence preserved to enable us to judge whether a coherent system of perspective representation, similar to what Vitruvius describes, had been worked out. None of these monuments presents an integrated system of perspective with a single vanishing point. They convey the "feeling" of space but not a rational relationship between objects in it. On the vases, in particular, each object has its own independent spatial existence, often with a vanishing point belonging exclusively to it, and bears only a very vague relationship to other objects in the same scene.

The next substantial body of evidence bearing on the question of perspective in ancient painting is Romano-Campanian wall painting, particularly of the Second Pompeian Style (the "Architectural Style"). John

3. For bibliography on the subject see G. M. A. Richter, *Perspective in Greek and Roman Art* (London and New York, 1970), pp. 129–30; note particularly H. G. Beyen, "Die Antike Zentralperspektive," *AA* (1939), cols. 47–71.

4. For references: White, *Perspective*, pp. 28 ff.; G. M. A. Richter, *Attic Red-Figure Vases*, rev. ed. (New Haven, 1959), p. 196*n*9.

5. Photograph: White, *Perspective*, 6a; for a drawing of the scene, flattened out and on a large scale, see Furtwängler-Reichhold, *Griechische Vasenmalerei* (Munich, 1904–32), pl. 148; and J. J. Pollitt, *Art and Experience in Classical Greece* (Cambridge, 1972), pp. 162–63, fig. 71.

6. See G. M. A. Richter, *A Handbook of Greek Art*, 6th ed., rev. (New York, 1969), p. 278, fig. 392; Ernst Pfuhl, *Malerei und Zeichnung* (Munich, 1923), no. 748; Pollitt, *Art and Experience*, pp. 147–51, fig. 62.

σκηνογραφία (skēnographia)

White has proposed that there are traces in a number of paintings of the Second Style of a fully developed system of artificial perspective employing a single vanishing point. He refers in particular to architectural scenes in the Corinthian *oecus* in the House of the Labyrinth at Pompeii, to one of the walls in the *cubiculum* from the Villa of Publius Fannius Sinister from Boscoreale (now in New York), and to another fresco from the same villa now in Naples. In all of these scenes the convergence of orthogonals on a single vanishing point, while not perfect, is so extensively employed that it could not be ascribed to accident. In later Romano-Campanian painting this scientific approach to spatial representation is abandoned in favor of more fanciful and ornamental scenes. White therefore suggests that in these Second-Style paintings, all dating from the first century B.C., we are confronted, not with the beginning of a comprehensive system of perspective, but with the breakup of a system that had been fully developed in the preceding centuries.[7] To exactly what century, it is impossible, on the basis of extant evidence, to say. That it should go all the way back to the 460s or so, when Agatharchus was working on stage settings for a play of Aeschylus, is hard to believe. Perhaps Vitruvius's description of Agatharchus's innovation is in part anachronistic: Agatharchus may well have been the originator of certain principles bearing on the representation of spatial perspective in Greek painting, but the fully developed system described by Vitruvius may not have taken shape until the third or second century B.C.

It may also be that the date which Vitruvius seemingly ascribes to Agatharchus should be reduced somewhat. Two anecdotes preserved by Plutarch would seem to associate him with the last thirty years or so of the fifth century. One of these relates how Alcibiades locked Agatharchus in his (Alcibiades') house and did not release the painter until he had executed certain paintings that Alcibiades required (Plutarch *Alc.* 16). The other tells us that the painter Zeuxis once overheard Agatharchus boasting about how rapidly he (Agatharchus) could paint (Plutarch *Pericles* 13).[8] Alcibiades' dates are ca. 450 to 404 B.C.; and presumably he would not have been in a position to lock Agatharchus in his house until the early 420s. Zeuxis seems to have first come to Athens during the Peloponnesian War, hence after 431 B.C., and his career continued into the fourth century. Plutarch's evidence, then, makes Agatharchus active in the 420s or even later. It is not impos-

7. White, *Perspective*, p. 69.

8. It must be admitted that the language of this passage leaves some doubt as to whether Zeuxis "heard Agatharchus boasting" or whether he simply "heard the boast of Agatharchus," without Agatharchus's actually being present or even alive at the time: καίτοι ποτέ φασιν Ἀγαθάρχου τοῦ ζωγράφου μέγα φρονοῦντος ἐπὶ τῷ ταχὺ καὶ ῥαδίως τὰ ζῷα ποιεῖν ἀκούσαντα τὸν Ζεῦξιν εἰπεῖν, Ἐγὼ δ'ἐν πολλῷ χρόνῳ.

244

sible that he could have worked on a stage setting for a play of Aeschylus prior to 456 B.C. and still have been active in the 420s, but that does give him an unusually long career. Perhaps Vitruvius's phrase *Aeschylo docente tragoediam* has the rather vague meaning of "when an Aeschylean tragedy was being performed," and Agatharchus's work was executed for a posthumous performance of one of the poet's dramas. On the other hand, Vitruvius's statement that Anaxagoras and Democritus were instructed by Agatharchus's work, if it is true (and it is difficult to think of a motive for its being a pure fabrication), might be taken to reinforce the earlier date. Democritus lived from ca. 460 to 370 B.C. and could easily have come into contact with Agatharchus if the latter has been active in the 420s, but Anaxagoras seems to have died around 428 B.C., and his expulsion from Athens may have come as early as 450 B.C.[9] Agatharchus's dates must therefore remain problematical. Assigning his career mainly to the 420s would have the virtue of placing him nearer to the first significant traces of perspective in vase painting, but it has the drawback of forcing us to treat Vitruvius's evidence very lightly.

However we date Agatharchus within the fifth century, there is no strong reason for doubting that he and others of his time took the first theoretical and practical steps in the development of graphic perspective; but how big these steps were is impossible to say. Aristotle's ascription of the beginnings of σκηνογραφία to the dramas of Sophocles (passage 1) has neither a positive nor a negative bearing on Vitruvius's evidence. In the first place we do not really know whether Aristotle understood the term as referring to perspective or whether he was simply thinking in a more general way of "painted scenery." Even if he did take the term to refer to the sort of painting Vitruvius ascribes to Agatharchus, the passage would not tell us anything about Agatharchus's dates, since Sophocles' career as a dramatist began as early as 468 B.C. and continued until his death in 406. Agatharchus could have worked with him as well as with Aeschylus in the 460s and early 450s, or he could have worked with him considerably later.

Wherever and with whomever it may have originated, σκηνογραφία became in time one of the formal subdivisions of the science of optics. Its place within optics is described clearly by Proclus (fifth century A.D.) in a commentary on the *Optics* of Euclid (passage 11), thus perhaps suggesting that by at least as early as Euclid's time, ca. 300 B.C., σκηνογραφία has been given a niche in Greek epistemological thinking and in "higher education" within the Greek world.[1] This subdivision of optics must have been particularly

9. The controversial evidence on this point is summarized in G. S. Kirk and J. E. Raven, *The Presocratic Philosophers* (Cambridge, 1962), pp. 362–64.

1. Note in this connection the tradition recorded by Pliny that, as a result of the influence

important to architects, who were obliged to prepare perspective renderings of projected buildings for their clients. Hence its connection with architecture is discussed not only by Vitruvius but also by a writer on optics, "Damianus" (passage 12).[2] This writer emphasized the all-pervasive role that optical illusion plays in architecture. Not only must the architect take it into account in his drawings, but he must even consider it in the actual structures that he builds (by devising "compensations" in the proportions of the parts of his buildings to counteract optical distortion).

In view of the strong emphasis on illusion and deception of the senses in the development of σκηνογραφία, it is not surprising that it was sometimes confused with σκιαγραφία (q.v.), "shading." Both techniques were invented around the same time and formed part of the same artistic quest—namely, the desire to give the illusion upon a flat, painted surface of our normal optical experience of space and mass. Thus we find Hesychius in the fifth century A.D. unable to comprehend any difference between the two terms (passage 10).

Although Plato does not use the term, one wonders if the attacks he directed at the illusionism involved in σκιαγραφία (e.g. Rep. 602D) might not also have been aimed at σκηνογραφία. Hostility toward the σκηνογραφία in the Platonic tradition might account for the pejorative value that seems to attach to the term in several of the passages cited here. In passage 2, for example, Polybius seems to be implying that σκηνογραφία, like epideictic rhetoric when compared to a serious subject like history, caters to external appearance but lacks substance; that it is essentially decorative and perhaps fallacious. So too, in passage 5, Plutarch has King Antigonus liken the splendors of the court of the Ptolemies to a σκηνογραφία, in the sense that the court is all facade and no substance and a perceptive man can easily see through it. And in passage 6 Sextus Empiricus implies that the things represented in a σκηνογραφία are like things seen in a state of dreaming or lunacy.

On the other hand, the straightforward value of the term that must have been current among people who worked in and enjoyed theatrical performances is also preserved in our sources. In passage 3 a σκηνογραφία clearly

of the painter Pamphilus, geometry and arithmetic were given an important role in the education of artists, and drawing was given an important role in general education (NH 35.76-77). The study of the principles of graphic perspective may have played a role in this development. It would have served to intellectualize the training of an artist and therefore have brought sufficient dignity (in ancient Greek eyes) to such training to make it worthy of being a part of general education.

2. The fact that the father of the philosopher Menedemus, and perhaps also Menedemus himself, practiced both architecture and σκηνογραφία (passage 9) reinforces the importance of this connection.

means to Strabo something that is pleasantly decorative or, to adhere more closely to the etymology of the term, "scenic."

In the rather vague use of the term in late antiquity by Heliodorus (passages 7 and 8) the word seems to imply a scene (not necessarily a painted scene) that is not only pleasant to look at, like the stage decorations of a theater, but also a kind of vision that is wondrously and magically conjured up. One wonders if this aura of magic that adheres to Heliodorus's use of the term does not in fact reflect its earlier connection with the art of representing perspective. To an easterner with mystical tendencies like Heliodorus, active around the time of Julia Domna and in tune with the atmosphere of the *Life of Apollonius of Tyana,* the representation of spatial perspective on a flat, painted surface may have seemed like an act of conjuring.

σκιαγραφία (skiagraphia)

1. Plato *Criti.* 107C–D.

> . . . ἅτε οὐδὲν εἰδότες ἀκριβὲς περὶ τῶν τοιούτων, οὔτε ἐξετάζομεν οὔτε ἐλέγχομεν τὰ γεγραμμένα, σκιαγραφίᾳ δὲ ἀσαφεῖ καὶ ἀπατηλῷ χρώμεθα περὶ αὐτά.

[When painters represent mountains, rivers, etc., we are content if there is even a vague similarity of the representation to the original] and having no precise knowledge about things of this sort, we do not examine or criticize very closely what has been painted, but rather accept the fact that they are depicted in an illusionistic representation which is unclear and deceptive. [But when painters seek to depict our own bodies, we are very quick to criticize and find fault.]

Compare with passage 2 under ὁμοιότης, ὁμοίωμα, ὅμοιος

2. Plato *Laws* 663B.

> νομοθέτης δ'ἡμῖν δόξαν εἰς τοὐναντίον τούτου καταστήσει τὸ σκότος ἀφελών, καὶ πείσει ἀμῶς γέ πως ἔθεσι καὶ ἐπαίνοις καὶ λόγοις ὡς ἐσκιαγραφημένα τὰ δίκαιά ἐστι καὶ ἄδικα.

But our lawgiver, by dispelling the darkness, will establish an opinion which is just the reverse of this [i.e. the opinion that totally separates what is pleasant from what is just] and will attempt to persuade people, in some way or other, by habit or by praise or by reasoned argument,

247

σκιαγραφία (skiagraphia)

that their conceptions of the just and the unjust are like things painted in an illusory fashion.

3. Plato *Phaedo* 69B.

χωριζόμενα δὲ φρονήσεως καὶ ἀλλατόμενα ἀντὶ ἀλλήλων μὴ σκιαγραφία τις ᾖ ἡ τοιαύτη ἀρετὴ καὶ τῷ ὄντι ἀνδραποδώδης τε καὶ οὐδὲν ὑγιὲς οὐδ ἀληθὲς ἔχῃ, . . .

The sort of virtue which involves exchanging one group of things for another [i.e. pleasures and pains] without understanding is a kind of *skiagraphia* and is in reality servile, having nothing healthy or true in it . . .

In the same sense: *Rep.* 365C.

4. Plato *Rep.* 365C.

πρόθυρα μὲν καὶ σχῆμα κύκλῳ περὶ ἐμαυτὸν σκιαγραφίαν ἀρετῆς περί- γραπτέον.

[Adeimantus argues that perhaps a reputation for justice, not justice itself, is what really benefits a man.] I must put up a good front and have an illusionistic painting made of myself, wrapped in the cloak of virtue.

5. Plato *Rep.* 523B.

Δείκνυμι δή, εἶπον, εἰ καθορᾷς, τὰ μὲν ἐν ταῖς αἰσθήσεσιν οὐ παρακα- λοῦντα τὴν νόησιν εἰς ἐπίσκεψιν, ὡς ἱκανῶς ὑπὸ τῆς αἰσθήσεως κρινόμενα, τὰ δὲ παντάπασι διακελευόμενα ἐκείνην ἐπισκέψασθαι, ὡς τῆς αἰσθήσεως οὐδὲν ὑγιὲς ποιούσης. Τὰ πόρρωθεν, ἔφη, φαινόμενα δῆλον ὅτι λέγεις καὶ τὰ ἐσκιαγραφημένα.

[Socrates and Glaucon discuss the qualities of mind which will be need- ed by the ideal ruler, including the ability to calculate and to distinguish the different qualities which are present in any sense impression.] "All right, I proceed to point them out," he [Socrates] said. "If you think it out, you will see that there are some sense impressions which do not summon the intellect to examine them, since judgment of them by sensation alone seems adequate, whereas there are others which very definitely compel the intellect to examine them thoroughly, since sensation produces nothing definite." "It is clear," he [Glaucon] said, "that you are speaking of distant things and things which are sketchy [or shadowy?]."

248

6. Plato *Rep.* 583B and 586B.

ἡδονὴ πλὴν τῆς τοῦ φρονίμου οὐδὲ καθαρά, ἀλλ᾽ ἐσκιαγραφημένη....
Ἄρ᾽ οὖν οὐκ ἀνάγκη καὶ ἡδοναῖς ξυνεῖναι μεμιγμέναις λύπαις, εἰδώλοις
τῆς ἀληθοῦς ἡδονῆς καὶ ἐσκιαγραφημέναις,

Pleasure other than intellectual pleasure is not pure, but is rather a kind
of illusionistic painting. . . . And is it not of necessity true that their
[the majority of people, who are devoid of real knowledge] pleasures
are mixed with pain, and are phantoms of real pleasure, shadowy
pictures of them?

7. Plato *Rep.* 602D.

ᾧ δὴ ἡμῶν τῷ παθήματι τῆς φύσεως ἡ σκιαγραφία ἐπιθεμένη γοητείας
οὐδὲν ἀπολείπει, καὶ ἡ θαυματοποιία καὶ αἱ ἄλλαι πολλαὶ τοιαῦται
μηχαναί . . . Ἄρ᾽οὖν οὐ τὸ μετρεῖν καὶ ἀριθμεῖν καὶ ἱστάναι βοήθειαι
χαριέσταται πρὸς αὐτὰ ἐφάνησαν, . . .

And so *skiagraphia* having taken advantage of this weakness in our nature
turns out to be nothing short of sorcery and sleight-of-hand and many
other such tricks But have not measurement and counting and
weighing proved to be our most beneficial aids in combatting these
[so that we can distinguish the apparent from the actual]?

8. Aristotle *Metaph.* 1024b23.

. . . τὰ δὲ ὅσα ἐστὶ μὲν ὄντα πέφυκε μέντοι φαίνεσθαι ἢ μὴ οἷά ἐστιν
ἢ ἃ μή ἐστιν, οἷον ἡ σκιαγραφία καὶ τὰ ἐνύπνια.

[Among things which can be characterized as false are] such things as
really exist but which are of such a nature that they appear to be either
not what they are or like things which do not exist, for example, il-
lusionistic painting and dreams.

9. Aristotle *Rh.* 1414a7. See ἀκρίβεια, passage 2.

10. Dio Chrysostom *Or.* 12.44. See ἀκρίβεια, passage 6.

11. Athenagoras *Leg. pro Christ.* 17 (Overbeck, *Schriftquellen*, 381).

αἱ δὲ εἰκόνες, μέχρι μήπω πλαστικὴ καὶ γραφικὴ καὶ ἀνδριαντοποιη-
τικὴ ἦσαν, οὐδὲ ἐνομίζοντο Σαυρίου δὲ τοῦ Σαμίου καὶ Κράτωνος τοῦ
Σικυωνίου καὶ Κλεάνθους τοῦ Κορινθίου καὶ κόρης Κορινθίας ἐπιγενομ-

σκιαγραφία (skiagraphia)

ἔνων. καὶ σκιαγραφίας μὲν εὑρεθείσης ὑπὸ Σαυρίου ἵππον ἐν ἡλίῳ περιγράψαντος. γραφικῆς δὲ καὶ Κράτωνος ἐν πίνακι λελευκωμένῳ σκιὰς ἀνδρὸς καὶ γυναικὸς ἐναναλείψαντος.

As for images, they were not in use, any more than were modeling and painting and sculpture, up until the time of Saurius of Samos, Craton of Sicyon, and Cleanthes of Corinth (and the Corinthian maiden). For outline drawing [?] was invented by Saurius when he traced the outline of a horse in the sunlight. Painting [or drawing] was invented by Craton when he filled in [?] the shadows of a man and a woman on a whitened tablet.

12. Alexander of Aphrodisias, Diels, *Fragmente*[7], 45.3 (*Comm. Arist. Met.* 827.9, on Aristotle *Metaph.* 1092b8).

τοῦτο θεὶς ἐλάμβανε ψηφῖδας διακοσίας πεντήκοντα τὰς μὲν πρασίνας τὰς δὲ μελαίνας, ἄλλας <δὲ> ἐρυθρὰς καὶ ὅλως παντοδαποῖς χρώμασι κεχρωσμένας. εἶτα περιχρίων τὸν τοῖχον ἀσβέστωι καὶ σκιαγραφῶν ἄνθρωπον καὶ φυτὸν οὕτως ἐπήγνυ τάσδε μὲν τὰς ψηφῖδας ἐν τῇ τοῦ προσώπου σκιαγραφίαι, τὰς δὲ ἐν τῇ τῶν χειρῶν ἄλλας δὲ ἐν ἄλλοις, καὶ ἀπετέλει τὴν τοῦ μιμουμένου, ἀνθρώπου διὰ ψηφίδων ἰσαρίθμων ταῖς μονάσιν, ἃς ὁρίζειν ἔφασκε τὸν ἄνθρωπον.

[Assume that the definition of man is 250 and that of a plant 360 in Eurytos's system.] Having established that, he would take 250 pebbles, some green, some black, others red—in other words, of a great variety of colors. Then, smearing the wall with lime and sketching a man (or a plant), he would divide up the pebbles so that some were placed in the sketch of the face, some in the sketch of the hands, and others in other parts, and thus he would complete the representation of a man by employing, in units, just the number of pebbles which he used to say defined man.

13. Hesychius, s.v. σκιά. See σκηνογραφία, passage 10.

14. Scholia *Il.* 10.265, s.v. πῖλος ἀρήρει.

ζωγράφοι καὶ πλάσται πιλίον ἐπέθεσαν Ὀδυσσεῖ.*
Ἀπολλοδώρου ὁ σκιαγράφος ἐντεῦθεν πρῶτος ἔγραψε πῖλον Ὀδυσσεῖ.†

*Wilhelm Dindorf, ed., *Scholia Graeca in Homori Iliadem* (Oxford, 1875–77), vol. 1.
†Ernst Mass, *Scholia Graeca in Homeri Iliadem* (Oxford, 1878), vol. 5.

Painters and modelers put a felt cap on Odysseus.
Apollodorus the *skiagraphos* hence first painted a felt cap on Odysseus.

Commentary

Σκιαγραφία (and its cognates σκικγραφέω, σκιαγράφημα, etc.) literally means "shadow painting" or "shadow drawing." It is clear from the passages quoted here that there are two types of shadow painting. The simplest type of σκιαγραφία consisted in making an outline or silhouette of a person or thing. This meaning is illustrated by passage 11 and perhaps by passage 12. In passage 11 the second-century Christian apologist Athenagoras gives two versions of the discovery of this technique. In one instance, Saurius of Samos outlined the shadow of a horse which was standing in the sun; in the other Craton of Sicyon sketched the shadows of men and women as they were cast on white boards. The philosophical background of passage 12, which comes from the commentary on Aristotle's *Metaphysics* by Alexander of Aphrodisias, is discussed in chapter 1. It describes how the fourth-century B.C. Pythagorean philosopher Eurytus demonstrated the Pythagorean concept that numbers form the basis of all things by arranging pebbles in geometric patterns (which equaled numbers: for example, a triangle = 3) so that the combination of all these patterns formed a sketch of a man (σκιαγράφων ἄνθρωπον). "Sketch" or "outline" is the simplest interpretation of the term in this passage, although Raven's suggestion that the pebbles were arranged to make a "shaded drawing" is certainly not impossible.[3]

In the sense in which it is used in these two passages σκιαγραφία is of only secondary importance in art history and art criticism, but the other meaning of the term—painting which seeks to simulate our normal optical experience of how light falls on objects, the technique which in later European art is called *chiaroscuro* or simply "shading"—is important in both categories. The credit for having invented this technique of painting with light and shade was attributed by most ancient critics to Apollodorus, an Athenian painter who was active in the last quarter of the fifth century B.C. Passages 13 and 14 refer to Apollodorus as the σκιαγράφος, and Plutarch *De glor. Ath.* 2 helpfully explains the invention which earned this title for Apollodorus: ᾿Απολλόδωρος ὁ ζωγράφος ἀνθρώπων πρῶτος ἐξευρὼν φθορὰν καὶ ἀπόχρωσιν σκιᾶς ᾿Αθηναῖος ἦν . . .

The "fading out" or gradation (φθοράν) and the "laying on" or "building up" (ἀπόχρωσιν) of shades of color were clearly the means that Apollodorus employed to give the impression of "shadow" (that is, the modulation of color values on the surface of an object due to the position and texture of the object and its distance from the beholder) in his painting. Two other terms mentioned by Pliny, τόνος and ἁρμογή,[4] respectively the "contrast" and

3. See G. S. Kirk and J. E. Raven, *The Presocratic Philosophers* (Cambridge, 1962), p. 35. For another example of σκιαγραφία in the sense of outline see Philostratus *VA* 2.28.
4. *NH* 35.29 (see *lumen et umbra*); see also τόνος and ἁρμογή. Splendor (Greek αὐγή) also

251

"blending" of light and shade, were also part of the terminology of σκιαγρα-φία. Whether these terms were part of Apollodorus's original *ratio* of light and shade or whether they were coined at a later date is impossible to say. In his discussion of Apollodorus Pliny does not, it is true, use the term σκιαγρα-φία, but he does say that Apollodorus "first expressed outward appearance" (*primus species exprimere*) (see *species*), that he was the first painter whose works could "hold the eyes" (*teneat oculos*), and that he "opened the doors" of the art of painting (*NH* 35.60–61). These phrases, though rhetorical and vague, seem to mean that Apollodorus's work sought to analyze the nature of human visual perception and to apply that analysis to artistic representation.

Pliny credits Zeuxis with having entered the doors which Apollodorus opened (*NH* 35.61). Quintilian, on the other hand, credits Zeuxis with having invented the *luminum umbrarumque rationem* (*Inst.* 12.10.4; see *lumen et umbra*, passage 5). Quintilian's source appears to have committed the understandable error of attributing Apollodorus's invention to his more famous successor.[5]

After the time of Zeuxis two painters in particular, Pausias and Nicias,[6] appear to have made important contributions to σκιαγραφία. Pausias seems to have been particularly proficient at representing the reflection of light from a glossy surface (see *splendor*), while Nicias, according to Pliny *NH* 35.131, *lumen et umbras custodiit atque ut eminerent e tabulis picturae maxime curavit* (see *lumen et umbra*). Nicias's particular achievement may have been the development of a method of applying light and dark shades of color around the outlines of his painted figures in such a way that they stood out strongly from the background. The Latin term used to refer to this achievement may have been *circumlitio*.[6] Pliny, it is true, uses this term in connection with Nicias's

belongs to the theory of σκιαγραφία but was probably developed after the time of Apollodorus. See commentary under *splendor*.

5. Another interesting possibility, proposed by Vincent J. Bruno, is that Apollodorus and Zeuxis actually used different methods of shading. Bruno associates Apollodorus's style with the simple linear type of shading visible in the ancient Greek tomb at Kazanlak in Bulgaria, and Zeuxis's style with a more "painterly" style preserved in the Macedonian tomb at Lefcadia. Cf. *Form and Color in Greek Painting* (see chap. 7, n.1).

6. Pausias was a pupil of Pamphilus and a contemporary of Apelles (Pliny *NH* 35.123) and hence belongs to the last third of the fourth century B.C. Pliny relates that Nicias at one time refused to sell one of his pictures to Attalus of Pergamon (presumably Attalus I, 241–197 B.C.) and also credits him with having painted the statues of Praxiteles whose floruit Pliny puts in the 104th Olympiad or 362–361 B.C. Since the dates of Attalus and Praxiteles are so far apart and also since some people dated Nicias in the 112th Olympiad (332–329 B.C.), Pliny admitted that he was confused about the painter's dates and suggested that there might be a younger and an older Nicias. Some modern scholars have accepted Pliny's suggestion (the editors of the Loeb edition of Pliny, for example). Plutarch, however, says that the king to whom Nicias refused to sell his painting was Ptolemy I (*Mor.* 1093f), and Brunn has thus

coloring of the statues of Praxiteles (*NH* 35.133: *tantum circumlitioni eius tribuebat*), but Quintilian, *Inst.* 8.5.26, makes it clear that the term could also be applied to representational painting: he defines *circumlitio* as a *circumductio colorum in extremitatibus figurarum, qua ipsae figurae aptius finiuntur et eminentius extant*. The phrase *eminentius extant* is very similar to Pliny's *eminerent e tabulis picturae*. *Circumlitio* was quite clearly not confined only to painting on sculpture and must have been the outstanding characteristic of all Nicias's paintings.[7]

In late antiquity, when the technical terminology of earlier Greek painting was being forgotten and misunderstood, σκιαγραφία was taken to be synonymous with σκηνογραφία, "scene painting." Originally, however, the two terms were not synonymous; σκηνογραφία (q.v.) was perspective drawing and was apparently known and used before the invention of σκιαγραφία by Apollodorus.

Although Apollodorus's inventions appear to have been accepted wholeheartedly by many of the painters of his day, they did not go completely unchallenged, for it was σκιαγραφία that moved Plato to expound the earliest documented "conservative reaction" in the history of art criticism. Plato's own taste in art is discussed in chapter 2, where reasons are given for his determined opposition to the type of painting which employed σκιαγραφία. The basis of his objections was moral and philosophical; σκιαγραφία indulged the tendency of the human mind to yield to deception and thus to lose its capacity to understand truth. Plato was far more concerned, of course, about the human proneness to error in matters of moral perception than he was in matters of simple visual perception. It is therefore not surprising that he most often makes use of σκιαγραφία as an analogy to the confused state of the ethical ideas held by most men. In passages 1 and 5 he discusses the nature of σκιαγραφία on the simple level of sense perception. Objects painted in this way are like things seen at a distance—mere sense perception is not sufficient to understand them, and the mind (νόησιν) is compelled to undertake further examination in order to really understand the objects (passage 5). Most people are content to leave their sense perception unexamined and unproved, just as, in landscape painting, they readily accept things which only approximate in a general way that which they are supposed to represent (passage 1). The parallel that σκιαγραφία provides for the fallibility of

argued effectively that all the events mentioned by Pliny could have taken place in the lifetime of a single Nicias. Brunn, *GGK*², 2:111.

7. Cf. Brunn, *GGK*², 2:132–33. The Greek equivalent of *circumlitio* may have been περιγραφία. Pliny's use of the term in connection with painting on sculpture may simply be an error, or, as Brunn suggested, it may refer to the clear separation of the different parts of a statue through color. Brunn, *GGK*², 2:132–33.

σκληρός (skleros)

human perception in matters of morality and ethics is drawn in passages 2, 3, 4, and 6. In each of these passages σκιαγραφία is used as a metaphor for human ignorance (passage 3), delusion (2 and 6), and hypocrisy (passage 4).

A late extension of Plato's attitude toward σκιαγραφία appears in passage 10, in which Dio Chrysostom, in reviewing the ways in which an artist can create a likeness of the gods, lists first σκιαγραφία, "which is weak and deceptive to the eye." Here the term perhaps refers to a "shaded drawing" or "sketch" as opposed to a fully executed painting, since Dio emphasizes that this type of likeness compares unfavorably with an image created "from the blending of colors and from line drawing which is almost the most precise" (χρωμάτων μίξει καὶ γραμμῆς ὅρῳ σχεδὸν τὸ ἀκριβέστατον). Or possibly this passage is a late reflection of a controversy about the relative merit of the precise, linear style of Parrhasius as opposed to the "shading" favored by Zeuxis (see *lineamenta*).

Whether Plato's attitude toward σκιαγραφία influenced any of the artists of time as it seems to have influenced Dio Chrysostom is questionable. Xenocrates and Antigonus praised Parrhasius for his mastery in draftsmanship, especially his drawing of contour lines (Pliny *NH* 35.68). Such an achievement was held to be rarer in painting than the ability to indicate the mass of a figure through shading. It should be emphasized, however, that Pliny does not say that precise draftsmanship is any better or closer to reality than shading; he says only that it is rarer (see *lineamenta*). It may be that Parrhasius belonged to a more conservative tradition than his colleague Zeuxis and that his style was closer to what Plato would have considered good art, but whether Plato ever actually delivered a judgment to this effect is impossible to say.[8]

In the two passages from Aristotle (8 and 9) we find that σκιαγραφία is also looked upon as a type of deception, but that the strong derogatory connotation which the term has in Plato seems to be lacking.

σκληρός (skleros)

1. Lucian *Rh. Pr.* 9.

εἶτά σε κελεύσει ζηλοῦν ἐκείνους τοὺς ἀρχαίους ἄνδρας ἕωλα παραδ-

8. On this question of line drawing versus shading see *lineamenta*. For possible reflections of Parrhasius's style in white-figured *lekythoi* of the late fifth century see Andreas Rumpf, "Parrhasius," *AJA* 55 (1951): 1–12. Pliny puts Parrhasius in the 95th Olympiad (400–397 B.C.). If this was the painter's ἀκμή (fortieth year of age), then he would have been an older contemporary of Plato. Pliny's dates are derived from the Χρονικά of Apollodorus of Athens. See August Kalkmann, *Die Quellen der Kunstgeschichte des Plinius* (Berlin, 1898), pp. 14–37.

εἴγματα παρατιθεὶς τῶν λόγων οὐ ῥᾴδια μιμεῖσθαι, οἷα τὰ τῆς παλαιᾶς ἐργασίας ἐστίν, Ἡγεσίου καὶ τῶν ἀμφί Κριτίαν καὶ Νησιώτην, ἀπεσφιγμένα καὶ νευρώδη καὶ σκληρὰ καὶ ἀκριβῶς ἀποτεταμένα ταῖς γραμμαῖς,

Then he will command you to emulate those men of old, setting forth obsolete models for speeches which are not easy to imitate—rather like those works of early sculpture, those of Hegesias and of the circle of Critius and Nesiotes, works which are compact and sinewy and hard and precisely divided into parts by lines.

2. Diogenes Laertius 4.18. See αὐθάδεια.

Commentary

The value of σκληρός as a term of art criticism in connection with both painting and sculpture is discussed under *durus*. Σκληρός can be used to mean literally "hard" as in *Mem.* 3.10.1, where Xenophon uses it to refer to the hardness of represented objects, or in Callistratus 6.3, where it refers to the actual hardness of bronze (cf. *durus* passage 2); and it can also mean "hard" or "harsh" in a metaphorical sense referring to style, as in passage 1. Only in the latter sense, of course, does the term have a critical value.

The metaphorical sense of σκληρός and σκληρότης (as with *durus* in the metaphorical sense) has an affinity, like so many of the other terms we have discussed, with the stylistic terminology of rhetoric. In the *Rhetoric* 1408b 9–10 Aristotle describes a certain "hardness" of style which can exist independently of subject matter (τὰ μαλακὰ σκληρῶς... λέγηται). Dionysius of Halicarnassus also recognizes a σκληρὴ φράσις (*Pomp.* 2) and the presence of σκληρότης in composition (*Comp.* 12).

In passage 2 the σκληρότης which Melanthius speaks of seems to have been thought of as a quality of his subject matter—a certain type of harsh ἦθος detectable in the painter's subjects (perhaps portraits)—and not as a quality of his formal style (see αὐθάδεια).

The question of whether σκληρός as a term of art criticism was borrowed directly from the stylistic vocabulary of rhetoric, originating perhaps in a Hellenistic comparative canon of rhetoricians and sculptors, or whether the term was current at an earlier date in the technical vocabulary of practicing painters and sculptors is difficult to answer. Any solution will depend largely on what one considers to be the source of passages 3 and 4 under *durus*, Pliny's references to the "hardness" of coloring in the painting of Aristides and Nicophanes.[9] (See *durus*.)

9. Schweitzer omits both of these passages from his catalog of "Xenocratic" passages. *Xenokrates*, pp. 49–52.

συμμετρία (*symmetria*)

The history and significance of the term συμμετρία are examined at length in chapter 1. For convenience, I give here a list of the passages in which the term is used in connection with the visual arts and also a brief summary of the points made in the text.

Plato *Soph.* 235D-236A (see chap. 1, p. 28; and chap. 2, p. 46).
Xenophon *Mem.* 3.10.3 conversation between Socrates and Parrhasius (see ἦθος καὶ πάθος, passage 1).
Philo of Byzantium *De Septem Miraculis Mundi* (ed. Orelli) *Mirac.* 4 (Overbeck, *Schriftquellen*, 1547, line 10), on the colossus of Rhodes.
Diodorus Siculus 1.98.7, in connection with Egyptian and Greek sculpture (see chap. 1, p. 13).
Vitruvius 1.1.4, role in geometry.
———1.2.1–2, in architectural theory.
———1.2.3–4, definition in relation to εὐρυθμία (q.v.).
———1.3.2, elegance which arises from it.
———1.7.2, in the sites of buildings.
———2.1.5, in temples and public buildings.
———2.1.7, marking a stage of progress in the development of architecture.
———2.10.3, in temples.
———3.1.1, in the planning of temples.
———3.1.9, in the planning of temples.
———3.2.2, in temples *in antis*.
———3.3.8, in the system of Hermogenes.
———3.3.11, adaptation of *symmetria* to the style of the temple being built.
———3.5.1–3 and 5, in the Ionic order.
———3.5.7–8, in Ionic capitals and entablature.
———3.5.9, adjustments in, for optical distortion of temples.
———4.1.1–3, in Corinthian columns.
———4.1.6, general, in the measurement of columns.
———4.1.10–12, in the invention and general design of the Corinthian capital.
———4.2.6, part of the rationality of the art of architecture.
———4.3.1 and 3, in the Doric order.
———4.3.10, general, in all the orders.
———4.4.3, in the special proportions of columns used in constricted spaces.
———4.6.1, the doors of temples in the different orders.
———4.8.1–4 and 6–7, general, with special reference to circular temples.
———5.1.4, in the sites of basilicas.

———5.1.6–7, columns and general proportions of basilicas.

———5.2.1, in the construction of treasuries, prisons, and council chambers.

———5.6.7, in theaters.

———5.9.3, in colonnades connected with theaters.

———5.12.7, in private buildings.

———6. praef.7, in private buildings.

———6.2.1 and 5, general, in planning a building.

———6.3.5–6 and 8, in various parts of houses.

———6.3.11, in Cyzicene *oeci*.

———6.6.5, in farm houses.

———6.7.7, general, in different styles of building.

———6.8.9, gracefulness arising from.

———7. praef. 12 and 14, writers on the subject.

———7. praef. 15, in Cossutius's Olympieion in Athens.

———7. praef. 17, in Gaius Mucius's temple of Honor and Virtue in Rome.
Cf. also 10.10.1 and 10.11.9.

Pliny *NH* 34.58, in the sculpture of Myron.

———*NH* 34.65, in the sculpture of Lysippus.

———*NH* 35.67, in the painting of Parrhasius.

———*NH* 35.107, Asclepiodorus's *symmetria* admired by Apelles.

———*NH* 35.128, in the painting of Euphranor.

Lucian *Im.* 4, in the Athena Lemnia of Phidias.

Galen *De Temperamentis* 1.9, in the art of Polyclitus.

———*De Placitis Hippocratis et Platonis,* ed. Müller, 5:425, in the art of
Polyclitus, see chapter 1, p.14.

Philostratus the Elder *Imag.* 1.proem.1, one of the qualities which relates
art to rational thought.

Diogenes Laertius 8.46, on the sculptor Pythagoras.

Plotinus *Enn.* 5.9.11, a subject in the mimetic arts, such as painting and
sculpture.

Philostratus the Younger *Imag.* proem.5, described as a quality praised by
earlier writers: Philostratus himself considered it subordinate to the
expression of emotion.

Callistratus *Descriptiones* 1.4, in a description of a statue of a satyr.

"Damianus" *Optica,* ed. Schöne, 28, in connection with the optical com-
pensations used by architects (see σκηνογραφία, εὐρυθμία).

Commentary

1. The meaning of συμμετρία is in all cases the "commensurability of parts"
in a work of art.

257

2. A seemingly inborn urge in the Greek character to discover measure and order in all phenomena, an urge which is reflected in many other areas of Greek thought and activity, helps to explain the importance of the συμμετρία concept in art criticism.

3. The concept arose in "professional art criticism" in the fifth century B.C. probably through a fusion of Pythagorean ideas about number and harmony with the purely practical canons of proportions long employed by Greek artists, particularly sculptors.

4. A number of prominent artists propounded systems of *symmetria* and perhaps also discussed the aim of such systems. They did so either in written treatises or through the direct instruction given to their pupils. The most influential treatise of this sort was Polyclitus's *Canon,* which seems both to have been influenced by and to have influenced Pythagorean thought.

5. The general drift toward subjectivism in professional criticism in the fourth century B.C. had an effect on the study and cultivation of συμμετρία. The nature of optical distortion became a topic of increasing interest, and some sculptors seemed to have concentrated on developing an "apparent συμμετρία" as an alternative to "actual συμμετρία."

6. The different approaches to συμμετρία in the Classical period seem to have been summed up by the sculptor and historian Xenocrates.

7. In the Hellenistic period and in later antiquity συμμετρία came to be seen as the hallmark of the traditional, Classical attitude toward artistic form and artistic experience, and there gradually arose a clearly expressed dichotomy between it and the more emotional and intuitive approach to art in the later period (e.g. in the writing of Plotinus and Philostratus the Younger).

σχῆμα (schēma)

Only a selection of passages is given here.

1. Xenophon *Mem.* 3.10.7.

> Οὐκοῦν τά τε ὑπὸ τῶν σχημάτων κατασπώμενα καὶ τἀνασπώμενα ἐν τοῖς σώμασι καὶ τὰ συμπιεζόμενα καὶ τὰ διελκόμενα καὶ τὰ ἐντεινόμενα καὶ τὰ ἀνιέμενα ἀπεικάζων ὁμοιότερά τε τοῖς ἀληθινοῖς καὶ πιθανώτερα ποιεῖς φαίνεσθαι;

[Socrates speaks to the sculptor Cliton:] Is it not true that by representing such bodily actions as putting down and lifting up, squeezing and

letting go, stretching and springing forward through the use of patterns of composition, you make these actions appear more like the real thing and more believable?

2. Demosthenes *De Falsa Legatione* 251.

καίτοι τὸν μὲν ἀνδριάντα τοῦτον οὔπω πεντήκοντ᾽ἔτη φάσιν ἀνακεῖσθαι οἱ Σαλαμίνιοι, ἀπὸ Σόλωνος δὲ ὁμοῦ διακόσι᾽ ἐστὶν ἔτη καὶ τετταράκοντα εἰς τὸν νυνὶ παρόντα χρόνον, ὥσθ᾽ὁ δημιουργὸς ὁ τοῦτο πλάσας τὸ σχῆμα οὐ μόνον οὐκ αὐτὸς ἦν κατ᾽ἐκεῖνον, ἀλλ᾽οὐδ᾽ὁ πάππος αὐτοῦ.

[Criticizing some remarks of Aeschines about Solon:] The people of Salamis say that this statue was not set up until about fifty years ago. Now from the time of Solon to our own time it is about 240 years, so that not only was the artist who modeled this format [i.e. with his himation pulled around him and his hands folded] not of Solon's time, but even his grandfather was not.

See also παράδειγμα, passage 22.

3. Plutarch *Per.* 31. See ὁμοιότης, ὁμοίωμα, ὁμοῖος, passage 4.

4. Pausanias 3.19.3.

τοῦ δὲ ἀγάλματος τὸ βάθρον παρέχεται μὲν βωμοῦ σχῆμα . . .

The base of the image [on the throne of Bathycles at Amyclae] is arranged in the form of an altar . . .

5. Pausanias 5.17.6.

. . . σχήματα δὲ ἄλλα τῶν γραμμάτων βουστροφηδὸν καλοῦσιν Ἕλ-ληνες.

[On the chest of Cypselus some inscriptions read from left to right but] in the case of others the format of the letters is what the Greeks call *boustrophedon*.

6. Pausanias 6.10.3.

σκιαμαχοῦντος δὲ ὁ ἀνδριὰς παρέχεται σχῆμα, ὅτι ὁ Γλαῦκος ἦν ἐπιτηδειότατος τῶν κατ᾽αὐτὸν χειρονομῆσαι πεφυκώς.

The statue represents him in the format of one who is shadow boxing because Glaucus was the most proficient man of his time in that skill.

σχῆμα (schēma)

7. Pausanias 8.40.1. See ἀρχαῖος, passage 6.

8. Aristides Or. 48.41. See μέγεθος, passage 11.

9. Aelian VH 4.3. See ἀκρίβεια, passage 22.

10. Elder Philostratus Εἰκόνες 1.16.1.

Αὐτὸς δὲ ὁ Δαίδαλος ἀττικίζει μὲν καὶ τὸ εἶδος, ὑπέρσοφόν τι καὶ ἔννουν βλέπων, ἀττικίζει δὲ καὶ αὐτὸ τὸ σχῆμα.

Daedalus himself is Atticized in his general appearance, there being a certain surpassingly wise and intelligent look on his face, and he is Atticized in the format of his clothing as well [in that he wears a coarse cloak and no sandals].

11. Scholiast on Plato Euthphr. 11C (Arethae Scholia, late ninth–early tenth centuries A.D.).

Δαίδαλος δὲ ᾿Αθηναῖος . . . πρῶτος δὲ καὶ περισκελὲς ἄγαλμα ἐσχημάτισε τῶν πρὸ ἐκείνου κατὰ τ᾿αὐτὸ συμβεβηκότα τὼ πόδε τὰ βρέτη ἐργαζομένων.

Daedalus the Athenian . . . he first designed an image with its legs apart; before him in that era those who wrought wooden images rendered them with the two feet close together.

12. Suidas and Photius, s.v. ῾Ραμνουσία Νέμεσις, . . .

. . . ἀφίδρυτο ἐν ᾿Αφροδίτης σχήματι.

[The image of Nemesis] was set up in the format [normally characteristic] of Aphrodite.

Commentary

Σχῆμα[1] is a general term for "design" or "format" in the visual arts. With the possible exception of passage 9, in which Aelian enumerates some typical features of the art of Polygnotos and Dionysius (see ἀκρίβεια and ἦθος καὶ πάθος), the term seems to play no significant role in Greek art criticism. The insignificance of the term, in spite of the fact that problems of form and

1. From ἔχω; cf. Latin habitus; originally perhaps "the way a thing held itself together" or the "bearing" of a thing.

design received great emphasis in Greek art criticism, is almost certainly to be explained by the importance of ῥυθμός as a critical term. Σχῆμα seems to be the informal, popular counterpart of ῥυθμός; it may be significant that σχῆμα appears frequently in connection with the visual arts only among writers of the first century A.D. or later—a period when the technical meaning of ῥυθμός in the visual arts was probably largely forgotten.

Schlikker[2] has tried to draw a distinction between ῥυθμός and σχῆμα on the basis of the type of representation in question. 'Ρυθμός, he suggests, always implies the form of a figure in movement (*Bewegungsmotiv*), while σχῆμα implies a figure at rest (*Standmotiv*). He further suggests that σχῆμα must have been the earlier of the two terms because it, and not ῥυθμός, was applicable to Archaic sculpture in which the *Standmotiv* was predominant. There are, however, as Schlikker himself admits, obvious flaws in this argument: Diodorus uses ῥυθμός to describe the Archaic *Standmotiv* of Daedalus (see passage 4 under ῥυθμός), while Xenophon clearly uses σχῆμα to refer to figures in motion (see passage 1 above). It might also be added that the idea of a predominant *Standmotiv* in Archaic sculpture is only applicable, if at all, to freestanding, nonarchitectural sculpture. Reliefs and pedimental groups clearly used *Bewegungsmotive*.

The earliest writer to use σχῆμα in connection with the visual arts was Xenophon, who was also the first to use ῥυθμός. The meanings he gives to σχῆμα and ῥυθμός, moreover, are the reverse of what Schlikker claims to be the basic meanings of the two words; for in *Memorabilia* 3.10 (ῥυθμός, passage 1) ῥυθμός means "shape" and does not, I believe, imply motion of any kind, while in passage 1 above σχῆμα refers to the bearing of the human body at rest (ἑστώτων) but more especially in motion (κατασπώμενα, ἀνασπώμενα, κινουμένων).

In passage 2 Demosthenes provides the earliest example of what was to be the most common meaning of σχῆμα in connection with the visual arts. One of Demosthenes' opponents had praised a statue of Solon on Salamis in which the Athenian statesman was represented as swathed in a himation which covered even his hands. The artist who made the statue was considered a contemporary of Solon and was held to have embodied perfectly in his statue the power and restraint of the era of Solon. Demosthenes rebutted that Solon had lived 240 years before his own time and that the statue had been set up only fifty years before his own time. Hence its σχῆμα could not be characteristic of the age of Solon. Σχῆμα here clearly refers to the composition of the statue—the position of the body and the arrangement of its

2. Schlikker, *HV*, p. 82n34.

drapery. The same meaning appears in passages 6, 7, 10, and 11. The last three of these passages probably refer to what we now call the "*kouros* stance" and hence conform to Schlikker's conception of a *Standmotiv*, but the first passage must certainly refer to a *Bewegungsmotiv*.

Σχῆμα also could be used to refer to the composition of figures in relief sculpture, as in passage 3, where Plutarch describes a figure on the shield of the Athena Parthenos. The figure, traditionally taken to be a portrait of Pericles, was represented as holding up a spear in such a way that his hand covered his face.

Passages 8 and 12 appear to represent a slight extension of the meaning of σχῆμα from "composition" or "design" to "standard format." In passage 8 the orator Aristides speaks of an apparition of Athena in which she appeared to have the σχῆμα of Phidias's Athena Parthenos, and in passage 12 the Nemesis of Rhamnous by Agoracritus is described as being "in the σχῆμα of Aphrodite." Certain σχήματα it appears, became so closely associated with certain deities that one could speak of an "Aphrodite σχῆμα" or an "Athena σχῆμα" (compare certain uses of διάθεσις).

Finally, in passages 4 and 5 σχῆμα is used to describe the format or simply the "form" of nonrepresentational objects.

τέλειος (τέλεος) (teleios)

1. Homer *Od.* 6.232. See χάρις, passage 1.

2. Vitruvius 3.1.5.

> Nec minus mensuram rationes, quae in omnibus operibus videntur necessariae* esse, ex corporis membris collegerunt, uti digitum, palmum, pedem, cubitum, et eas distribuerunt in perfectum numerum, quem Graeci τέλεον dicunt. Perfectum autem antiqui instituerunt numerum qui decem dicitur.
>
> *necessaria: H.

For context and translation see chapter 1, p. 19.

3. Pausanias 9.2.7.

> Πλαταιεῦσι δὲ ναός ἐστιν Ἥρας θέας ἄξιος μεγέθει τε καὶ ἐς τῶν ἀγαλμάτων τὸν κόσμον . . . τὴν δὲ Ἥραν Τελείαν καλοῦσι.

At Plataea there is a temple of Hera, worth seeing for its size and for the beauty of its images . . . they call the Hera the *Teleia*.

4. Aelian *VH* 4.3. See ἀκρίβεια, passage 22.

Commentary

The full importance of τέλεος in the criticism of the visual arts can be best understood by studying the use of its Latin equivalent *perfectus*. The commentary under *perfectus* tries to demonstrate the importance of τέλεος as a technical term in the professional criticism current among artists in the fifth century B.C. We find there that passage 2, in which Vitruvius describes how Greek artists (he refers specifically to *pictores et statuarii* [3.1.2]) adapted the proportions of natural objects to an overall mathematical and geometrical pattern which the Greeks called τέλεον and the Romans *perfectus numerus*, is crucial to our understanding of how the Greek artists of the fifth century B.C. worked.

Besides this technical usage, however, τέλεος is also used in diverse passages on the visual arts to mean simply "perfect, complete, fully developed." The association of τέλει- with works of art in these senses is as old as Homer. In passage 1 the artist who is taught by Hephaestus and Athena is said by Homer to "bring to perfection [τελείει] pleasing works." The word implies not only the production of a flawless work but also the termination of a productive process. Τέλεος often implies a τέλος, "end." Thus it is frequently used to refer to human beings or animals that are "full-grown," that is have reached the end of their growing process.[3] At times there may even be some ambiguity as to whether the term means simply "perfect" or "full-grown." In passage 3, for example, Pausanias refers to a large statue of Hera which had the nickname τελεία and could be translated either the "perfect Hera" or the "full-grown Hera."[4]

In passage 4 there is an ambiguity as to whether Aelian means by ἐν τοῖς τελέοις that Polygnotus worked his ἆθλα "down to the most perfect details" or whether he means that the ἆθλα as a whole were "among those which were perfect." Or the phrase may mean that Polygnotus himself was "among those artists who were perfect," or perhaps even that he rendered the ἆθλα "in their most perfect form."

τετράγωνος-quadratus (tetragōnos-quadratus)

1. Thucydides 6.27.1.

Ἐν δὲ τούτῳ, ὅσοι Ἑρμαῖ ἦσαν λίθινοι ἐν τῇ πόλει τῇ Ἀθηναίων (εἰσὶ δὲ

3. See Plato *Laws* 929C; Xenophon *Cyr.* 1.2, 4, 12, 14.
4. The latter translation is preferred by W. H. S. Jones (Loeb editor of Pausanias) and by

τετράγωνος-*quadratus* (*tetragōnos-quadratus*)

κατὰ τὸ ἐπιχώριον ἡ τετράγωνος ἐργασία* πολλοὶ καὶ ἐν ἰδίοις προθύροις καὶ ἐν ἱερεοῖς) μιᾷ νυκτὶ οἱ πλεῖστοι περιεκόπησαν τὰ πρόσωπα.

*ἡ . . . ἐργασία non legit Schol. Patm.

In the meantime, nearly all the stone herms in the city of Athens (there are many such statues, made according to local custom, in a squarish style, and they stand in doorways and sanctuaries) had their front surfaces mutilated.

2. Diodorus Siculus 17.115.2.

εἰς τριάκοντα δὲ δόμους διελόμενος τὸν τόπον καὶ καταστρώσας τὰς ὀροφάς, φοινίκων στελέχεσι τετράγωνον ἐποίησε πᾶν τὸ κατασκεύασμα.

[Details of the funeral monument of Hephaestion at Babylon:] Having divided the area up into thirty compartments and covered the roofs of these with palm trunks, they erected the entire structure on a quadrilateral plan.

3. Diodorus Siculus 18.26.5.

. . . ὑπὸ δὲ τὴν ὑποροφίαν πὰρ' ὅλον τὸ ἔργον θριγκὸς* χρυσοῦς, τῷ σχήματι τετράγωνος, ἔχων τραγελάφων προτομὰς ἐκτύπους.

*θριγκὸς Wachsmuth; θρᾶνος Ussing; θρόνος libri.

[On the funeral wagon of Alexander the Great] there ran, beneath the eaves around the whole work a golden cornice which was square in format, and had goat-stag protomes in relief upon it.

4. Pausanias 1.19.2.

ταύτης γὰρ σχῆμα μὲν τετράγωνον κατὰ ταὐτὰ τοῖς Ἑρμαῖς, τὸ δὲ ἐπίγραμμα σημαίνει τὴν Οὐρανίαν Ἀφροδίτην τῶν καλουμένων Μοιρῶν εἶναι πρεσβυτάτην.

For the format of this figure [a statue of Aphrodite in Athens, perhaps a female herm] is square like that of the herms, and the inscription indicates that Aphrodite Ourania is the oldest of those [goddesses] called the Fates.

5. Pausanias 9.40.3–4.

Δαιδάλου δὲ τῶν ἔργων δύο μὲν ταῦτά ἐστιν ἐν Βοιωτοῖς, . . . καὶ

Sir James Frazer, *Pausanias's Description of Greece* (London, 1898), 1:447. Pausanias 8.22.2 suggests that "full-grown" in the sense of "of marriageable age" is the meaning.

Δηλίοις 'Αφροδίτης ἐστὶν οὐ μέγα ξόανον, λελυμασμένον τὴν δεξιὰν χεῖρα ὑπο τοῦ χρόνου. κάτεισι δὲ ἀντὶ ποδῶν ἐς τετράγωνον σχῆμα.

Of the works of Daedalus the following two are in Boeotia [a Heracles in Thebes and a Trophonius at Lebadeia] . . . and at Delos there is a hewn image [*xoanon*] of Aphrodite of no great size, the right hand of which has suffered from the ravages of time. Instead of feet it has a square arrangement [at its base].

6. Athenaeus 196B.

ἐφ' ὦν ἐπιστύλιον καθηρμόσθη τετράγωνον, ὑπερεῖδον τὴν σύμπασαν τοῦ συμποσίου στέγην.

On these [the columns of the festival tent of Ptolemy II] was fitted a square epistyle, which held up the entire roof of the *symposion*.

7. Themistius *Orationes* 15.316a (Overbeck, *Schriftquellen*, 68).

πρὸ μὲν Δαιδάλου τετράγωνος ἦν οὐ μόνον ἡ τῶν ʽΕρμῶν ἐργασία, ἀλλὰ καὶ ἡ τῶν λοιπῶν ἀνδριάντων, . . .

Before the time of Daedalus not just the workmanship of Herms was "squarish," but also the style of other statues as well. [Daedalus was considered inspired because he added feet to his statues.]

8. Pliny *NH* 34.56.

Proprium eius est, uno crure ut insisterent signa, excogitasse, quadrata tamen esse ea* ait Varro et paene ad [unum]† exemplum.

*quadrata tamen (ea *add.* G) esse **B** G; *om. rv.*
†exemplum **B**, *Sillig, Mayhoff*; unum exemplum *rv., Detlefsen.*

It was purely his [Polyclitus's] own invention to make his statues throw their weight on one leg; Varro says, however, that his figures are squarish and almost all based on a single model.

9. Pliny *NH* 34.65 (on Lysippus).

Non habet Latinum nomen symmetria, quam diligentissime custodiit nova intactaque ratione quadratas veterum staturas permutando, vulgoque dicebat ab illis factos quales essent homines, a se quales viderentur esse.

There is no Latin word for *symmetria*, which he cultivated with the utmost diligence, altering the square builds [of the body] used by the

older sculptors; and he used to say, so the story goes, that men were rendered by them [the older sculptors] as they really were, but by him they were rendered as they appeared.

See also Vitruvius 3.1.3; 9. praef.4–5, 13.

Commentary

The term τετράγωνος (literally "having four angles") is used in passages 1–7 to mean simply "square" (or "rectangular" or "quadrangular"), "squarish," or perhaps "blocklike," and were it not for the use of *quadratus*, surely the Latin translation of τετράγωνος, in passages 8 and 9, the word would be of little interest in a study of Greek art criticism, since it is used neither for serious stylistic analysis nor for making value judgments.

In connection with sculpture the term is used, for obvious reasons, to refer to the "quadrangularity" or "squarishness' of herms, or to very early Archaic sculpture which had the same qualities characteristic of herms. Two of the passages in our catalog (1 and 4) directly refer to herms, and two others (5 and 7) refer to sculpture from the "time of Daedalus," which was the later Greeks' way of referring to the style we would call "early Archaic." The figure of Aphrodite mentioned by Pausanias in passage 4 could be a "female herm,"[5] but since the phrase τετράγωνον σχῆμα is in a way characteristic of all the Archaic *korai* in what Richter calls the "Nikandre-Auxerre group,"[6] we cannot be certain.

The same straightforward meaning—"squarish" or "quadrangular"—is also applicable in passages 2, 3, and 6, in which τετράγωνος refers to architectural forms.[7]

Besides this literal usage of τετράγωνος, there is also a metaphorical use of the word, similar to the English word "foursquare," meaning "having a character which is morally perfect," for example, Aristotle *Rh.* 1411b27, . . . οἷον τὸν ἀγαθὸν ἄνδρα φάναι εἶναι τετράγωνον μεταφορά; and Simonides 5. 2, χερσίν τε καὶ ποσὶ καὶ νόῳ τετράγωνον. . . τετυγμένον, but this meaning does not seem to occur in connection with the visual arts.

5. See Reinhard Lullies, *Die Typen der griechischen Herme* (Königsberg, 1931), p. 55. Female herms first appear in Greece in the fourth century B.C. See the representation on a votive relief in the Lateran Museum, *Einzelaufnahmen antiker Sculpturen* (1893–), number 2226. Lullies suggests an oriental origin for this type of herm. On herms of this sort see also E. B. Harrison, *The Athenian Agora*, vol. 11, *Archaic and Archaistic Sculpture* (Princeton, 1965), pp. 138–39, 168–69, pls. 58–59.

6. G. M. A. Richter, *Korai* (London, 1968), pp. 23–36.

7. In passage 3 it is irrelevant for our purposes whether the passage refers to a throne (θρόνος), a supporting beam (θρᾶνος), or a cornice (θριγκός)—all could be square. See Kurt F. Müller, *Der Leichen-Wagen Alexanders des Grossen* (Leipzig, 1905), pp. 56–58.

The use of *quadratus* in passages 8 and 9, however, is more complicated. Varro's characterization of pre-Lysippean sculptures, particularly those of Polyclitus, as *quadrata*, does seem to have critical value and probably is based on a Greek source (on Varro see chap. 6). But the precise meaning of *quadratus* in this context is a matter of controversy. Most scholars have taken Varro's phrase to mean that Polyclitus's figures seemed blocklike or squarely built in comparison with those of Lysippus.[8] This interpretation would be in accord with what we know about the works of Polyclitus from Roman copies and also with Varro's further statement that the works of Polyclitus were *paene ad*[*unum*] *exemplum*, all made according to one format. The original source for the observation might have been Xenocrates, who perhaps used τετράγωνος in comparing Polyclitus's system of "real" συμμετρία with the more flexible and variable "optical"συμμετρία and εὐρυθμία(q.v.) of Lysippus (see chap. 1, p. 29). If this is the correct derivation of the passage, *quadratus* would not really have a derogatory value, at least in passage 9 (in 8 it might); it would simply be a way of characterizing a certain stage in the evolution of sculpture. A few modern commentators, however, have interpreted the term as being openly derogatory; Robert, for example, took it to refer to "unschöne Proportionen."[9]

There is always the possibility, of course, that passages 8 and 9 represent Varro's and Pliny's own view of the Polyclitan style and are not dependent on any Greek source. In this case, *quadratus* might mean no more than "compactly built," a meaning which it sometimes has in Latin literature—for example, Celsus 2.1: *corpus antem habilissimum quadratum est, neque gracile neque obesum;* Suetonius *Vespasian* 20: *statura fuit quadrata, compactis firmisque membris.* Overbeck seems to have been of this opinion, since he cites both of these references in his note on *NH* 34.56 (*Schriftquellen*, 967).

A far more ambitious and ingenious interpretation of *quadratus* has been proposed by Silvio Ferri,[1] who suggests that Pliny's use of the term may have analogies with its use in the criticism of rhetoric. Since, as we have noted on many occasions, there are close similarities between the critical terminology of the visual arts and that of rhetoric, there is, on the surface at least, nothing unlikely about the suggestion. Ferri began his study by pointing out that in *NH* 34.65 (passage 9) the term *quadratus* seems to refer to a certain type or aspect of συμμετρία. The *quadratas staturas* of early sculp-

8. E.g. Brunn, *GGK*², 1:155; Wilhelm Klein, *Geschichte der Griechischen Kunst* (Leipzig, 1904–07), 2:164; Richter, *SSG*⁴, p. 190; also Rhys Carpenter, *Greek Sculpture* (Chicago, 1960), p. 107, who thinks it refers specifically to the emphasis on four angles of view (front, two sides, back) which Polyclitus's figure had in common with *kouroi*.

9. Robert, *Arch. Märch.*, p. 29; Jahn, *UKP*, pp. 131–32.

1. Ferri, *NC*, pp. 117–52.

tors like Polyclitus, far from being scorned by Lysippus, served as a point of departure for his own "new and untried" system of συμμετρία. This view would seem to be supported by Cicero's statement (*Brut.* 296) that Lysippus took the Doryphorus of Polyclitus as his model.

To determine more precisely in what way *quadratus* was related to συμμετρία Ferri analyzed a group of literary passages in which τετράγωνος meant not "square" or "blocklike" but rather "having four elements in harmony." He then concluded that if the elements of a sentence could be considered τετράγωνος for the purposes of stylistic analysis, perhaps the elements of a statue could also be; and with this in mind he undertook an elaborate study of the different works attributed to Polyclitus and Lysippus—emphasizing especially the Doryphorus of Polyclitus as opposed to the Agias of Lysippus.

Ferri's line of argument is too elaborate to be summed up here, but in essence what he proposes is that passages 8 and 9 refer to Lysippus's invention of a new system of *quadratio* which was based on that of Polyclitus but which paid much more attention to optical effects and much less to measurable συμμετρία (the same contrast which "Damianus" observes between εὐρυθμία which was πρὸς ὄψιν and εὐρυθμία which was κατ' ἀλήθειαν; see under σκηνογραφία, passage 12). Possibly this is what is meant by Pliny's controversial statement that Polyclitus made men as they were but Lysippus made them as they appeared.

As we have seen, a difference between Polyclitus and Lysippus such as Ferri describes, would be completely in keeping with the subjectivism which became characteristic of professional criticism in the fourth century B.C. His interpretation also has the virtue of taking into account the essentially technical nature of Pliny's remarks on Lysippus. Yet there are a few points which make me hesitant to accept it without reservation. First, there is the presence of *tamen* in passage 8 which makes it sound as if Varro's use of *quadrata* in connection with Polyclitus did have derogatory[2] overtones (i.e. "Polyclitus made significant contributions to the art of sculpture, *but* his works were *quadrata* and all alike"). Second and perhaps more important is the fact that Ferri's analysis of the Doryphorus and the Agias does not really seem to deal with συμμετρία as the Greeks understood it. Συμμετρία

2. Ferri, however, has argued that the text should be rearranged *NC* 145–46. The word *eam* appears in one of the manuscripts after *esse*. Ferri suggests that this *eam* refers to *scientiam* in the preceding sentence, which reads *hic consumasse hanc scientiam consummasse iudicatur* (see *consummatus*); *consummo*, according to Ferri, means "sum up," "give an epitome of" and refers to Polyclitus's *Canon*. He suggests that *quadratam tamen esse eam* should come after *iudicatur*. In this case it would be Varro's explanation of what Polyclitus's *Canon* contained—the principles of *quadratio*.

always meant the commensurability of parts, real or apparent. Ferri's analysis really deals with the adjustment of parts within a form and the effects that are produced by these adjustments—features which the Greeks expressed, as far as I can determine, by διάθεσις and εὐρυθμία (qq.v.). (Possibly τετράγωνος-*quadratus* in the sense of a "harmony of four parts" is to be connected with these terms, although passage 9 gives us no indication that this was the case.) If it cannot be demonstrated that the elements which he points out in these statues as *quadrata* are somehow related to συμμετρία, the cogency of his interpretation of passage 9 is weakened.

τόλμα, τόλμη (tolma)

1. Plutarch, *Alex.* 72.3.

. . . ἐπόθησε μάλιστα τῶν τεχνιτῶν Στασικράτην, μεγαλουργίαν τινὰ καὶ τόλμαν καὶ κόμπον ἐν ταῖς καινοτομίαις ἐπαγγελλόμενον.

[Alexander wished to build a sumptuous tomb for his companion Hephaestion, and] therefore of all artists he longed most of all for Stasicrates because in his [Stasicrates'] inventive works there always promised to be a certain grandiosity and daring and *éclat*.

2. Lucian *Zeux.* 3.

ἐν δὲ τοῖς ἄλλοις τολμήμασι καὶ θήλειαν Ἱπποκένταυρον ὁ Ζεῦξις οὗτος ἐποίησεν, ἀνατρεφουσάν γε προσέτι παιδίω Ἱπποκεντaύρω διδύμω κομιδῇ νηπίω.

Among other daring inventions Zeuxis also painted a female centaur, and what is more, he depicted her nursing twin centaur children, mere infants.

Commentary

Τόλμα like the Latin term *audacia,* is used in art criticism to mean "daring originality" or "daring defiance of artistic conventions." The different qualities of character implied by τόλμα in poetry and drama, such as "courage" or "recklessness," seem not to apply to the term in connection with the visual arts. Both τόλμα and *audacia* refer basically to artistic daring, whether it be in technique (passage 1 above; passage 2 under *audacia*) or in subject matter (passage 2 above).

Τόλμα does not appear to have been connected with any systematic

approach to art criticism. It was perhaps first employed by the anecdotal writers of the Hellenistic period and may have some psychological kinship to θαυμαστός(q.v.). Although *audacia* was in all likelihood the Latin word which translated τόλμα, there is no need to postulate a Greek source for every passage in which the Latin term appears; *audacia* also had an independent value in a peculiarly Roman system of art criticism. See *audacia*.

τόνος (tonos)

1. Pliny *NH* 35.29.

> Quod inter haec [lumen] et umbras esset, appellarunt tonon . . .

See *lumen et umbra*, passage 2.

Commentary

Pliny's use of τόνος as a technical term describing the relationship in a painting between light and highlight (*lumen* and *splendor*) on the one hand and shade (*umbra*) on the other is almost unparalleled in Greek literature. Only in one other place, Plutarch's essay *On the Delays of Divine Vengeance*, do we find τόνος referring to light and color (*Mor.* 563E). Here Plutarch recounts the story of a certain man who had died and whose soul was carried upward on a beam of light which αὐγήν τε τῇ χρόᾳ θαυμαστὴν ἀφιέντα καὶ τόνον ἔχουσαν.[3] The use of τόνος here, however, can hardly be considered a technical term in the sense that Pliny's use of the word is.

It seems likely that τόνος and also ἁρμογή, which Pliny defines (but does not attempt to translate), were part of what Quintilian calls the *luminum umbrarumque rationem* (*Inst.* 12.10.4) which was introduced into Greek painting toward the end of the fifth century B.C. by Apollodorus and developed by Zeuxis (see commentary under σκιαγραφία). Pliny's passage thus provides a rare insight into the substance and nature of the theory of painting, or a portion of that theory, current among professional painters of the Classical period. In τόνος and ἁρμογή he may give us an idea of at least what the chapter headings may have been in such works as Euphranor's *De coloribus* (*NH* 35.129).

The use of τόνος to indicate the contrast between light and shade in painting may have been adapted by Apollodorus and his successors from the terminology of music. Coming from the verb τείνω ("stretch"), τόνος appears

3. The exact translation of τόνος in this passage is difficult. It may mean "intensity," or it may suggest a "tension" between the various colors of the spectrum within the beam of light.

originally to have signified a "stretching" or "things which are stretched." Herodotus uses the word to refer to the cords which are stretched on beds and chairs (9.118: οἱ τόνοι τῶν κλινέων) and also to the "stretching" or "tension" of the cables of the bridge built by Xerxes over the Hellespont (7.36: ὁ τόνος τῶν ὅπλων). The term also referred to the sinews or tendons of animals (Hippocrates *De Articulis* 11). The word perhaps first came to be used in connection with sound through the use of stretched strings (animal hide or gut) in musical instruments. The volume and pitch of a sound produced from a plucked string was relative to the amount of tension on the string. *Τόνος* was most commonly used, in the fourth century B.C., to refer to the volume and pitch of the human voice (Xenophon *On Hunting* 6.20: ὁποσαχῇ οἷόν τ᾽ἂν ᾖ τοὺς τόνους τῆς φωνῆς ποιούμενον; Aristotle *Rh.* 1403b:... πῶς τοῖς τόνοις οἷον ὀξείᾳ καὶ βαρείᾳ καὶ μέσῃ; (Pseud-) Aristotle *Physiog.* 807a17). The last important phase in the semantic development of τόνος occurred in Stoic cosmology where the word was used for the tension in matter, which, during each universal cycle, created the natural and human forms of the world.[4]

Of these various meanings of τόνος, the significance of the word in music provides the closest parallel to painting. The terminology of music, in fact, provides parallels for many of the terms used in connection with the visual arts, ῥυθμός, ἁρμονία, ἁρμογή, and even χρόα, "color," which in developed musical theory referred to tonal variations within a given scale (Aristoxenus *Harm.* 24; see also χρωματικός, treated in the same passage). *Τόνος* in music represented the pitch at which a scale was played and is analogous to our word *key* (Aristoxenus *Harm.* 37); τόνοι were, in other words, systems of tones which were differentiated according to their pitch. When Apollodorus developed his *ratio* of contrasts between lights, highlights, and shades, he may have looked upon the various lights and darks in his paintings as visual analogies to the musical τόνοι.

Greek musical terminology would appear to have been first developed by the Pythagoreans.[5] Since at least one other important term in the professional art criticism of the fifth century—συμμετρία—was closely related to Pythagorean thought, it is possible that τόνος too should be ascribed ultimately to this source.[6]

4. Von Arnim, *SVF*,1:128:πληγὴ πυρὸς ὁ τόνος ἐστί (Cleanthes); 2:134, 235, 215.
5. Curt Sachs, *The Rise of Music in the Ancient World* (New York, 1934), p. 199, where The earliest musicians discussed all have Pythagorean backgrounds; cf. also Theo Smyrnaeus on Lasos of Hermione and the Pythagoreans: Diels, *Fragmente*[7], 18A3, lines 5 ff.
6. See chapter 1. Note especially the tradition that Pythagoras first developed his ideas of harmony by observing the different tones produced by a plucked string.

τύπος (typos)

Τύπος is not, strictly speaking, a critical term; it never signifies a criterion by which the quality of a work of art is evaluated. On the other hand, the meaning of the term has occupied such an important place in modern discussions of the processes by which Greek sculptors translated their preliminary conceptions into final form, that an entry analyzing the meaning of the term is warranted.

The following condensed catalog illustrates the use of *τύπος* in contexts which directly involve the visual arts or, when the use of the term is metaphorical, in implied comparisons which emphatically call the visual arts to mind. (If, as some have suggested, the original meaning of *τύπος* is a "mold" in which a work of art is shaped, all uses of the term, even the most abstract, are metaphorical; but only obvious metaphors are given here.)

1. *Anthologia Graeca* 9.716 (Anacreon).

 Βοίδιον οὐ χοάνοις τετυπωμένον

 [On Myron's heifer:] Molded?

2. Democritus, Diels, *Fragmente*[7], 68B228.

 . . . ἢν ἁμάρτωσι τοῦ πατρικοῦ τύπου . . .
 φιλέουσι διαφθείρεσθαι.

 (If children of thrifty parents miss the "mold" set by their parents, they usually go to ruin just as dancers who dance among swords do, if they miss the stepping place or pattern which is set out for them.)

3. Euripides *Phoen.* 1130.

 σιδηρονώτοις δ'ἀσπίδος τύποις

 (Reliefs on the shield of Capaneus.)

4. Euripides *Rhes.*305.

 χρυσοκόλλητος τύπος

 (Relief work on an ornamental shield, attached to Rhesus's horses.)

5. Euripides *Tro.* 1074.

 χρυσέων τε ξοάνων τύποι

 (The now destroyed images [?] of Troy.)

6. Euripides, Frag. 764 (Nauck), Hypsipyle.

 ἰδού . . . γραπτούς . . . τύπους

 (Painted pedimental reliefs? Or perhaps simply painted representations. Blumenthal [see commentary] gives "gamalten Abbilder.")

7. Herodotus 2.86.

 ξύλινον τύπον ἀνθρωποειδέα

 (An Egyptian anthropoid sarcophagus analogous to a hollow mold.)

8. Herodotus 2.106.

 δύο τύποι ἐν πέτρῃσι

 (Reliefs of Sesostris in Ionia.)

9. Herodotus 2.136.

 τύπους ἐγγεγλυμμένους

 (Referring to architectural reliefs.)

10. Herodotus 2.138.

 τύποισι δὲ ἐξαπήχεσι

 (Referring to architectural reliefs.)

11. Herodotus 2.153.

 τύπων πλέην

 (Referring to architectural reliefs.)

12. Herodotus 3.88.

 τύπον . . . λίθινον ἔστησε

 (A relief with the figure of a horseman and an inscription set up by Darius.)

13. Sophocles *El.* 54.

 τύπωμα χαλκόπλευρον

 (A bronze urn presumably cast from a mold.)

273

τύπος (*typos*)

14. *IG*, IV², 102.36–37.

Τιμόθευς ἕλετο τύπος (=τύπους) ἐργάσασθαι

See commentary.

15. Isocrates *Evag*. 74.

τύπους, statues, unlike verbal portraits, must remain where they are set up.

16. Plato *Leg*. 656E.

γεγραμμένα ἢ τετυπωμένα

(Things written or pictures graven.)

17. Plato *Leg*. 876E.

περιγραφήν τε καὶ τοὺς τύπους

(Judges given an outline and mold; see commentary.)

18. Plato *Rep*. 377B.

Metaphor: when a person is young, πλάτταται καὶ ἐνδύεται τύπος, "a mold is pressed and an impression is taken" most easily.

19. Plato *Rep*. 414A.

Rulers and guardians of the ideal state are treated τύπῳ, μὴ δι' ἀκριβείας—"as in a sketch" or possibly "as in a relief" (i.e. an image which is not whole).

20. Plato *Soph*. 239D.

εἴδωλα . . . γεγραμμένα καὶ τὰ τετυπωμένα,

(Images painted and molded?)

21. Plato *Symp*. 193A.

οἱ ἐν ταῖς στήλαις καταγραφὴν ἐκτετυπωμένοι

(Men might be further bisected by the gods like those who are depicted in outline and in relief on stelae.)

22. Plato *Tht*. 191D.

Impressions are made on the mind (ἀποτυποῦσθαι) in the form of memory, just as seals on rings leave an impression on wax.

23. Plato *Ti.* 50C.

 . . . μιμήματα, τυπωθέντα . . .

 (Things in nature are imitations of ideal forms, "molded" or "stamped" in a marvelous way.)

24. Xenophon *On Horsemanship* 1.1.

 ἔργα ἐξετύπωσεν

 (Deeds of Simon, inscribed on the base of an equestrian statue [letters inscribed in sunken relief?])

25. Aristotle *Eth. Nic.* 1098a22.

 ὑποτυπῶσαι πρῶτον, εἶθ᾽ ὕστερον ἀναγράψαι

 (Make a sketch first, then fill it in?)

26. Aristotle *Eth. Nic.* 1107b14.

 Topic discussed τύπῳ καὶ κεφαλαίῳ, in sketch form and summary.

27. Aristotle *Parts of Animals* 676b9.

 The viscera of snakes etc. are shaped like their bodies, κάθαπερ ἐν τύπῳ, "as if in a mold."

28. Aristotle περὶ Μνήμης καὶ Ἀναμνήσεως 450a31.

 οἷον τύπον . . . καθάπερ οἱ σφραγιζόμενοι τοῖς δακτυλίοις.

 (Impressions from a seal ring.)

29. *IG*, II², 1533.30 (338–37 B.C.).

 τύπος ἀργυροῦς πρὸς πινακίῳ

 [Inventory of the overseers of the sanctuary of Asclepius at Athens:] a tablet in relief.

30. Theophrastus *De Sensu* 51.

 . . . τὴν ἐντύπωσιν οἷον εἰ ἐκμάξειας εἰς κηρόν

 [Discussing the theories of Democritus:] (Visual impressions carried through the air are like impressions on wax.)

31–37. Inventories from Delos (*Tabulae Hieropoeorum*) all referring to vessels decorated with ornaments in relief.

τύπος (*typos*)

31. *IG*, XI, 161B16 (280–279 B.C.).

φιάλη ἔκτυπον ἔχουσα Ἡλίου πρόσωπον

32. *IG*, XI, 161B67.

φιάλη ἔκτυπον ἔχουσα ἅρμα καὶ Νίκην καὶ ζώιδια δύο

33. *IG*, XI, 161B73.

φιάλη καρυωταὶ δύο ἔκτυπα ζῶια ἔχουσαι

34. *IG*, XI, 161B76.

[φιάλη] ἐπάργυρος ἔκτυπα ζῶια ἔχουσα προσηλωμένα

35. *IG*, XI, 162B13 (280–278 B.C.).

As in 161B16.

36. *IG*, XI, 162B53.

As in 161B67.

37. *IG*, XI, 199B7 (274 B.C.).

καρυωτὴ ἔκτυπος . . . ἄλλαι ἐκτυπώται.

38. *IG*, II², 1534 (Asclepius sanctuary inventory, 276–275 B.C.), votive reliefs.

a. Line 35.

καὶ τύπος, ἃ ἀνέθ[ηκε].

b. Line 64.

τύπος ἔγμακτος, πρόσωπον γυναικὸς προσευχομένης

c. Lines 87–88.

τύπος μέγ[ας κατά]μακτο[ς], ἔνεισι προσευχόμενοι καλλίστω, Ἀφόβητος: τύπος κατάμακτος: τύποι δύο κατάμακτοι.

39. *Anthologia Graeca* 7.730 (Perses).

γραπτὸς ἔπεστι τύπος Νευτίμας

(Probably a painted grave relief.)

40. *IG*, II–III² 839 (dedication to the Heros Iatros, 221–220 B.C.), inventory of votives in the sanctuary of the Heros Iatros with frequent reference to what must be votive reliefs, see lines 18, 30, 56–88.

 a. Line 18.

 . . . τῶν τύπων τῶν ἀνακει[μένων ἐν τῷ ἱερῷ . . .]

 b. Lines 56–57.

 τύπον ὃν ἀνέθηκε Λαμίδιον, τύπον ὃν ἀνέθηκεν Ζωίλος . . .

41. Kaibel *Epigr. Gr.* 89 (from Euboea?), line 6.

 . . . ἐν ξεστῶι γραμμ᾿ἐτύπωσε πέτρωι

 (Letters carved on a grave stele.)

42. Polybius 9.10.12.

 After the sack of Syracuse the Romans should have decorated their city with sanctity and magnanimity rather than γραφαῖς καὶ τύποις, paintings and statues (or reliefs).

43. Polybius 21.37.6.

 ἄλλοι . . . ἔχοντες προστηθίδια καὶ τύπους

 (Gauls having pectorals and "images" or "reliefs.")
 See also 21.6.7.

44. *Anthologia Graeca* 13.2 (Phaidimos). ·

 Καλλίστρατος . . . ἔθηκε μορφῆς ξυνὸν ἥλικος τύπον

 (Relief or statue.)

45. *Inscriptions de Délos* (Compte des Hiéropes) 406.44 (ca. 190 B.C.).

 . . . ποι]ῆσαι τύπον κεραμὶς. . .

 (Mold from a type of roof-tile.)

46. *Inscriptions de Délos* (Compte des Hiéropes) 442B. 72 (179 B.C.).

 τύπον ξύλινον κεραμίδων τῶν ἐπὶ τὸν κερατῶνα

 (Mold from a roof-tile for the Keraton at Delos.)

τύπος (*typos*)

Same in *ID* 444.12 (177 B.C.). Same reading in *ID* 457.22 (174? B.C.) and probably in *ID* 468.29.

47. *Inscriptions de Délos*, 1417 A 2.44–46. Inventory in the Archonship of Kallistratos, 156–155 B.C.

στήλας λίθινας δύο, τύπους ἐκτυπωτοὺς ἐχούσας χαλκοῦς δύο καὶ πίνακας χαλκοῦς [δυὸ ἐπιγρα]φὰς ἔχοντας

(Stelae with bronze reliefs in the temple of *Agathē Tychē*.) Bronze reliefs, which may be identical with those mentioned in the inscription have been found at Delos. See *BCH* 45 (1921): 244–45. Essentially the same appears in the inventory of the Archon Metrophanes, 146–145 B.C.

48. *Anthologia Graeca* 12.57 (Meleager).

Praxiteles wrought a μορφᾶς κωφὸν . . . τύπον, a dumb image.

49. *Anthologia Graeca* 12.56 (Meleager).

Κύπριδος παῖδα τυπωσάμενος

[Praxiteles] moulded an image (?) of the son of Cypris.

50. *Anthologia Graeca* 16.179 (Aulus Licinius Archias).

τοίαν ἐτύπωσε

(Apelles made an image of Aphrodite as she appeared when he caught sight of her rising from the sea.)

51. Cicero *Att.* 1.10.3.

typos tibi mando

(Cicero gives Atticus instructions to purchase some "reliefs" for insertion into the wall of his villa at Tusculum.)

52. Diodorus Siculus 18.26.5.

τραγελάφων προτομὰς ἐκτύπους

(Goat protomes on Alexander's funeral wagon. The protomes are probably understood as being in high relief.)

53. Strabo 8.3.30.

ἀναζωγραφεῖν μέγαν τινὰ τύπον

(Homer's lines stir our imagination to visualize a great "image" of Zeus.)

54. Dionysius of Halicarnassus *Comp.* 25 (ed. Robert, p. 268. line 2).

ἄσκησις . . . τύπους τινὰς ἐν τῇ διανοίᾳ . . . καὶ σφραγῖδας ἐνεποίησεν

(Practice leaves "impressions" on the mind.)

55. *Anthologia Graeca* 16.216 (Parmenion).

Ἥρην . . . ὅσην εἶδε τυπωσάμενος

(Polyclitus made an image of Hera as he saw her.)

56. Philo Judaeus *De Eb.* 22.90.

ὁμοιότητας ἐτύπωσε

(In the case of twins, nature "stamps" or "molds" likenesses in different materials, just as the stamp of Phidias's art was evident in whatever materials he used.)

57. (Pseudo-)Aristotle *Mund.* 399b35.

τὸ ἑαυτοῦ πρόσωπον ἐντυπώσασθαι

(Phidias rendered his own portrait in relief on the shield of the Athena *Parthenos.*)

58. Seneca *Ben.* 3.26.

imaginem Tib. Caesaris habens ectypa . . . gemma

(A ring with a portrait of Tiberius in relief.)

59. Pliny *NH* 35.128.

Euphranor . . . typos scalpsit

(Reliefs?)

60. Pliny *NH* 35.151.

Butades . . . inpressa argilla typum fecit

(A portrait in relief in clay.)

61. Pliny *NH* 35.152.

Butades also invented the use of masks with reliefs to be used as antefixes

τύπος (*typos*)

for temples, *quae inter initia prostypa vocavit; postea idem ectypa fecit* (possibly molds, *prostypa*, and impressions taken from them, *ectypa*; see commentary).

62. Dio Chrysostom 12.44.

ῥυέντων ἐπί τινας τύπους

(Pressing of images "into molds.")

63. Dio Chrysostom 60.9.

καὶ γὰρ ἐκεῖνοι τύπον τινὰ παρέχοντες, ὁποῖον ἂν πηλὸν εἰς τοῦτον ἐμβάλωσιν, ὅμοιον τῷ τύπῳ τὸ εἶδος ἀποτελοῦσιν.

(Workmen give clay whatever form they wish by pressing it in molds; philosophers do the same with myths.)

64. "Longinus" *Subl.* 13.4.

πλασμάτων ἢ δημιουργημάτων ἀποτύπωσις

(Borrowing stylistic traits from great authors is not theft but is like "making an impression" or "mold" from modeled figures and other works of art.)

65. Kaibel *Epigr. Gr.* 955 (Hadrianic?).

κεστοφόροι ξυνῷ ἀνέθεντο τύπῳ

(A herm portrait.)

66. Lucian *J. Tr.* 33.

μιμηλῇ τέχνῃ/σφραγῖδα χαλκοῦ πᾶσαν ἐκτυπούμενος

(Pitch placed on the Hermes *Agoraios* [a bronze statue in Athens] by sculptors who wished to make molds from it [ἐκτυπούμενος].)

67. Lucian *Philo.* 38.

᾿Απόλλωνος τοῦ πυθίου εἰκόνα ἐκτυποῦντα τὴν σφραγῖδα

(A ring with an image of Apollo "impressed" or "rendered in relief" upon it.) ᾿Εκτυποῦντα is the reading of Fritzsche; other manuscript readings are ἐκτυποῦσαν, ἐκτυπούσης; but the meaning is not doubtful.

280

68. Lucian *Alex.* 21.

 ἀπέματτε τὸν τύπον

 (A mold in plaster taken from a wax seal.)

69. Lucian *Hist. conscr.* 10.

 ἀκριβῆ τὸν τύπον

 (The accurate minting or stamping of coins.)

 See Pollux 3.86: ἔντυπον.

70. Lucian *Amor.* 14.

 ἐνεσφραγισμένων . . . τύπων

 (Surface features of the Aphrodite of Cnidus.)

71. Pausanias 2.19.7.

 τύπω ταύρου μάχην ἔχων καὶ λύκου

 (A relief before the temple of Apollo in Argos.)

72. Pausanias 6.23.5.

 τύπος Ἔρωτα ἔχων ἐπειργασμένον

 (Relief in a gymnasium in Elis.)

73. Pausanias 8.31.1.

 Reliefs at the entrance of the Sanctuary of the Great Goddesses at Megalopolis.

74. Pausanias 8.37.1.

 Reliefs on the wall of a sanctuary of Despoina in Arcadia.

75. Pausanias 8.48.4.

 A stele at Tegea carved in relief, ἐκτετύπωται.

76. Pausanias 9.11.3.

 Sculpture in relief, ἐπὶ τύπου, in an ancient house in Thebes.

τύπος (*typos*)

77. Pausanias 9.11.6.

 Large reliefs of Athena and Heracles by Alcamenes at Thebes.

78. Athenagoras *Leg. pro Christ.* 14 (Overbeck, *Schriftquellen*, 261).

 τύπος by Butades (see ὁμοιότης, passage 6).

79. Athenaeus 5.199E.

 . . . πρόστυπα ἐπιμελῶς πεποιημένα

 (Relief work on a large metal mixing bowl.)

80. Athenaeus 11.492D.

 . . . τῶ ποτηρίῳ ἐντυπῶσθαι τὰς πλειάδας . . .

 (Engraving or embossing on a cup.)

81. Dio Cassius 47.25.3.

 . . . ἐς τὰ νομίσματα . . . ἐνέτυπου . . .

 (Brutus's coinage.)

82. Dio Cassius 60.22.3.

 . . . τὴν ἐικόνα αὐτοῦ ἐνετυπωμένην . . .

 (Coinage stamped with the image of Caligula.)

83. *Historia Augusta, Heliogabalus* 3.4.

 Matris typus, "image" or "relief" of the Great Mother (whether the sacred stone of Pessinus or another image is unclear).

84. *Historia Augusta, Heliogabalus* 7.1.

 typum (Matris) eriperet.

85. Iamblichus *Protrepticus* 21, KY.

 θεοῦ τύπον μὴ ἐπίγλυφε δακτυλίῳ

 (Impression from a ring.)

86. Himerius *Eclog.* 32.10 (Overbeck, *Schriftquellen*, 714).

 . . . τοσοῦτον, ὅσον ἐκτυπωσάμενος

(Phidias represented in his Zeus as much of Zeus's nature as was expressible in form.)

87. Callistratus *Descriptiones* 3.1.

χαλκός δὲ αὐτόν ἐτύπου, καὶ ὡς ἂν Ἔρωτα τυπῶν

On a statue of Eros by Praxiteles: (Bronze gave him form, and, as if to demonstrate that it was giving form to a great and powerful deity, it was subdued by him.)

88. Callistratus, *Descriptiones* 11.1.

. . . τὸν ἀληθῆ τύπον μεγιστάμενος

(Bronze transcended its limitations and was transmuted into the real "subject" [?] or "model" [?] or "prototype" [?].)

89. *Anthologia Graeca* 16.310 (Damocharis).

Φύσις παρέδωκε τυπῶσαι τὴν Μιτυληναίαν

(Nature made it possible for the painter "to form" the features of Sappho.)

90. *Anthologia Graeca* 6.20.6 (Julianus of Egypt).

σκιόεντα τύπον

(Even a "shadowy image" of an aging woman becomes hateful to see.)

91. *Anthologia Graeca* 6.56.5 (Macedonius "the Consul").

ἀφθόγγοισι τύποις

(Art imitates nature with "mute images" or "molded replicas.")

92. Hesychius, s.v. "Kyzicene staters."

πρόσωπον δὲ ἦν γυναικὸς ὁ τύπος

(Relief or engraving on coinage.)

93. Hesychius, s.v. χοάνη.

χώνη, τύπος εἰς ὃν μεταχεῖται τὸ χωνευόμενον

(A mold for receiving molten metal.)

τύπος (*typos*)

94. *Suidas,* s. v. λιθουγική.

Λυσίας ἐν τῷ πρὸς Ναυσίαν περὶ τοῦ τύπου

(Title of a work, relief carving[?].)

95. Eustathius *Od.* 11.634.

Γοργόνος δὲ παράγωγον κτητικῷ τύπῳ καὶ τὸ γοργόνειον

(Image in relief on the shield of [Phidias's?] Athena.)

96. Tzetzes *Chil.* 8.357.

. . . 'Αλκαμένης μὲν τύπῳ θεᾶς παρθένου . . . εἰργάζετο

("Image" of Athena by Alcamenes.)

Of uncertain date:

97. *Anthologia Graeca* 16.138 (anonymous).

. . . ἄγαλμα (of Medea) . . . Τιμομάχου χειρὶ τυπωσαμένου

Formed by Timomachus.

98. *IG,* VII, 2424.31 (Thebes; first century B.C.–first century A.D.?).

'Αρι[στο]γείτα φι[λ]λέου τύ[πον]

(Relief [?].)

Commentary

The meaning of τύπος has long been an active topic of discussion and dispute among modern writers on Greek sculpture. And in spite of the large number of passages illustrating the use of the term in connection with the visual arts, the modern controversy has essentially arisen from and focused on the meaning of the term in only one source: *IG,* IV², 102, the building accounts of the temple of Asclepius at Epidaurus (passage 13). In lines 36–37 of this inscription we are told that Τιμόθεος ἕλετο τύπους ἐργασάσθαι, "Timotheus undertook to execute τύπους" for the temple, for which he received 900 drachmas. Since Timotheus is known from other sources to have been one of the most important and admired sculptors of the fourth centruy, it is not surprising that some modern scholars have tried to read as much significance as possible into this enigmatic epigraphical source. A brief summary of how various writers have interpreted the passage may be helpful.

Soon after the initial publication of the Epidaurus inscription (by Kavvadias, 1886), Paul Foucart began the discussion of the inscription by stating succinctly an interpretation which still has adherents:

"Timothéus s'est chargé d'exécuter et de fournir des modèles, 900 drachmes; caution Pythoclès." Les τύποι dont il est ici question ne désignent pas les modèles des moulures ou des ornements destinés à la décoration du temple; pour cette catégorie, le terme usité était παράδειγμα. Le mot τύποι s'emploie pour les modèles dont font usage les peintres ou les sculpteurs. Ici ce sont des dessins, peut-être même des maquettes pour les statues des frontons et des acrotères.[7]

Foucart felt, in short, that Timotheus must have made models in plaster, clay, or some similar substance for the pedimental sculptures of the temple (and possibly also for the acroteria), which were subsequently copied in stone by lesser artisans, some of whose names appear elsewhere in the inscription.

Objections to what I shall for convenience call the "model theory" were not long in coming. J. Baunack, S. Kayser, F. Ebert, and R. Vallois[8] all criticized Foucart's interpretation because it ignored all the other literary and epigraphical evidence bearing on the meaning of τύπος. The most common meaning of τύπος when used in connection with art, they pointed out, was "relief." The term did have other meanings, but nowhere did it ever seem to mean "model." The properly attested word for "model" was παράδειγμα; hence the τύποι of the Epidaurus inscription must refer to reliefs of some kind, perhaps metopes or other ornamental decorations on the temple.

The next stage in the τύπος controversy was undertaken by Georg Lippold and K. A. Neugebauer.[9] Lippold produced a more thorough collection of literary sources than had previously been brought to bear on the question. He acknowledged that τύπος did in many cases mean "relief," but noted a few passages in Plato and Aristotle in which the word seemed to mean "sketch." (See passages 19, 25, 26.) Lippold admitted that nowhere in the extant sources did τύπος ever seem to refer to a sculptor's sketch or "ma-

7. Paul Foucart, "Sur les sculptures et la date de quelques édifices d'Epidaure," *BCH* 14 (1890): 590.
8. See Johannes Baunack, *Aus Epidauros* (Leipzig, 1890), pp. 71 and 103; Simon Kayser, "Inscription du temple d'Asclépios à Epidaure," *Musée Belge* 6 (1902): 152–58, esp. 157–58; Friedrich Ebert, "Fachsausdrücke des griechischen Bauhandwerks" (Ph.D. diss., Würzburg, 1910), p.35; René Vallois, "ΣΤΟΙΒΑ et ΚΕΡΚΙΣ," *BCH* 36 (1912): 229n1.
9. Georg Lippold, "ΤΥΠΟΣ," *JdI* 40 (1925): 206–09; K. A. Neugebauer, "Timotheus in Epidauros," *JdI* 41 (1926): 82–93.

quette" but speculated that the general usage of τύπος as "sketch" in Plato and Aristotle might indicate that the artists of the time nomally used the term in this sense. He noted that if the τύποι in the Epidaurus inscription were architectural reliefs of some kind intended for the Asclepius temple, the inscription would have included some additional phrase to clarify their exact function.[1] Moreover the verbs ἐργάσασθαι καὶ παρέχεν, "execute and furnish," seemed to make no sense when applied to reliefs (that the artist would furnish them would be taken for granted), but they would make some sense if the τύποι were understood as models for the pedimental sculptures. Since the reference to τύποι in the Epidaurus inscription occurs in a context in which provisions for an ἐργαστήριον are mentioned, Lippold suggested that this "workshop" might have been the building in which Timotheus was expected to prepare his maquettes. Finally he attempted to draw a distinction between τύπος and παράδειγμα, the normal term, as earlier writers had pointed out, for "model." A παράδειγμα, Lippold suggested, was a prototype from which many copies are to be made (like the sample Corinthian capital found at Epidaurus), while a τύπος must have been a sketch model for a single final product (on this point see παράδειγμα).

Neugebauer supported Lippold's arguments for τύπος = "model" by adding to the discussion two further passages, Plato *Laws* 876E (passage 17) and Democritus, frag. 288 (passage 2), in which this interpretation seemed to him to be confirmed. He further argued that the fee paid to the sculptor Hectoridas for doing one whole set of pedimental sculptures, 3010 drachmas, seems unreasonably low when one notes that Timotheus received 2,240 for three acroteria. But if Hectoridas was a subordinate artist working from models already prepared by Timotheus, his fee might be considered reasonable. As a final point, Neuegebauer undertook a stylistic comparison of those acroteria of the temple which presumably come from its west end (and are presumably to be associated with Timotheus) with the surviving pedimental sculptures. Similarities between the two groups in the rendering of hair, drapery, and other details convinced him that the influence of one artist could be detected in both. If Timotheus had created models for the pedimental figures, their similarity to his acroteria, Neugebauer argued, would be quite understandable. (The equally logical conclusion that Timotheus might have been influenced by Hectoridas or one of the other artists who worked on the temple was not entertained by Neugebauer, presumably

1. Lippold specifically discounted the possibility, suggested by some earlier writers, that the τύποι could be metopes. No sculptured metopes were ever found in connection with the Asclepius temple, and in other inscriptions in which metopes are referred to the word τύποι is never employed. Recently, the idea that the τύπος were metopes has undergone a revival.

286

because Timotheus was, in later tradition at least, the most famous of them and therefore presumably the most influential.)[2]

A brief and pointed rebuttal to some of the views of Lippold and Neugebauer by G. M. A. Richter appeared in 1927.[3] She reemphasized the point that there is not a single ancient source in which τύπος means a sculptor's maquette. The supposition that Plato's and Aristotle's loose usage of the term as "sketch" (on which see the views of Blumenthal discussed below) is derived from an earlier and more specific use among artists is, she further emphasized, pure hypothesis. On the other hand a perfectly good word for sculptor's maquettes, προπλάσματα, is preserved in Pliny NH 35.156. (Neugebauer had taken note of this reference but felt that it was so much later than the Epidaurus inscription that it should not be used as evidence.) In opposition to the idea that παράδειγμα refers only to a model of which many copies are to be made, she cited Herodotus's use of the term in connection with the Alcmaeonid temple at Delphi (5.62). The παράδειγμα in question clearly refers to the whole temple, and obviously the architect did not make several copies from it.[4] Finally, she contested the view that 3,010 drachmas was an unreasonably low fee for a set of pedimental sculptures. The sculptors clearly would have been paid for the amount of working time they actually expended on the sculptures, and the pedimental figures from Epidaurus, she observed, are worked in only a very perfunctory fashion on the back. Care was expended only on those parts which were to be visible, and they are, as a result, only half finished.

Richter's article was followed in 1928 by a thorough linguistic analysis of τύπος and παράδειγμα by Albrecht von Blumenthal, who collected virtually all of the ancient references to τύπος.[5] He suggested that τύπος was not, as Lippold and others had maintained, formed directly from τυπόω, "strike" (hence meaning a "blow" or "stamp"), but rather that it was connected with a group of words—τύπτω, τύπωσις, ἀποτυπόω, ἀποτύπωσις, ἐναποτύπωσις—whose basic meaning was connected with "mold" and "forming by molds." Many of the earliest uses of τύπος seem to imply a mold (particularly a hollow

2. Neugebauer also attempted to invalidate the suggestion first made by Svoronos and later entertained by Richter that two reliefs representing a seated deity, presumably Asclepius, found at Epidaurus and now in Athens, might be the τύποι referred to in the inscription (see Richter, SSG⁴, p. 216, figs. 761–62). These reliefs, he noted, are not architectural, as the τύποι of the inscription might be expected to be, and are not Attic in style, which, by implication, Neugebauer felt the work of Timotheus should be.

3. G. M. A. Richter, "Τύπος and Timotheus," AJA 31 (1927): 80–82.

4. Whether the παράδειγμα mentioned by Herodotus referred to an actual model or to a more general "set of specifications" is a difficult question. See παράδειγμα.

5. Albrecht von Blumenthal, "ΤΥΠΟΣ und ΠΑΡΑΔΕΙΓΜΑ," Hermes 63 (1928): 391–414.

mold) or the product which is produced from a mold by pressing, casting, or beating (for "mold" see passages 2, 7, 17, 18, 23, 27, 45, 46, 62, 63, 66, 68). It is easy to see how the meaning "relief" could arise from this basic meaning. A mold, positive or negative, is itself a kind of relief, and images made from a mold in clay or metal, when attached to a flat background are also reliefs. It is equally easy to see how, by analogy with clay and metal reliefs, carved stone reliefs might come to be called τύποι, and why coins (made from molds, that is, dies, and in relief) and seal rings (used like a mold to make impressions) should be associated with τύποι (for "relief" see passages 3, 4, 8–12, 21, 29, 31–41, 47, 51, 57, 60[?], 61[?], 71–77, 79, 95; for coins, seals, and rings see passages 22, 28, 30, 54, 58, 67, 68, 69, 81–82, 85, 92). Since products of a mold could be called τύποι, it appears that at times, by extension, "images" in general could be referred to loosely as τύποι (passages 5, 15, 53, 65, 91), and the verb τυπόω could mean simply "make an image" (passages 49, 50, 55).

Another less common meaning of τύπος is a "crude form, rough shape" (e.g. Empedocles, frag. 62: οὐλοφυεῖς μὲν πρῶτα τύποι χθονὸς ἐξανέτελλον). Von Blumenthal suggests that this meaning is based on an analogy with the mass of material from which a τύπος, that is, a mold-made image is produced. As it is pressed into the mold, such material can be said to gradually assume a rough shape. It is probably from this shade of meaning that the general sense of "vague impression, sketch" (see *LSJ*9, 8) arises.

The general abstract sense of "type" and also "pattern" or "model" (*LSJ*9, 7, 9) can also be derived from the basic idea of "mold" without any difficulty. A mold is in essence a prototype from which copies are to be made. But whenever τύπος refers to a "sketch" or "mold," the use of the term is general and abstract. Nowhere, when used in this sense, does it seem to refer to anything concrete like a sculptor's maquette; παράδειγμα, on the other hand, very frequently refers to concrete models.[6]

After von Blumenthal's thorough analysis of the meaning of τύπος, it became impossible to maintain that the Epidaurus inscription referred sim-

6. Blumenthal cited one passage, Plato *Laws* 876E, in which he thought τύπος might possibly be interpreted as "plastic sketch." In this passage Plato says that lawmakers, in giving instructions to qualified judges, have often τὸ περιγραφήν τε καὶ τοὺς τύπους τῶν τιμωριῶν εἰπόντας δοῦναι τὰ παραδείγματα τοῖσι δικασταῖς, "stated an outline and *typous* of penalties and provided the judges with models." Von Blumenthal felt that since περιγραφή could mean an actual drawn outline, τύπος might also refer in an equally concrete way to a plastic model. It seems to me, however, that all the terms in this passage are used in an abstract way. The use of the verb εἶπον seems to indicate that no metaphor is intended. And even if a metaphor is intended, "mold" or "material to be molded," as J. F. Crome has pointed out (*Die Skulpturen des Asklepiostempels von Epidauros* [Berlin, 1951], pp. 16–17), would make just as much sense.

ply to sculptors' models, but a number of writers still felt that the "model theory" in some form could be defended. Ernst Langlotz suggested, for example, that the models for the pedimental sculpture must, in fact, have been reliefs and that the term τύπος in the inscription was therefore perfectly appropriate.[7] But it was Carl Blümel who proposed the most original and thoughtful arguments.[8] A realistic assessment of the problems involved in making large-scale stone pedimental sculptures based on analogies with the technique of modern sculptors, makes it inevitable, Blümel felt, that Greek sculptors used large-scale detailed models for their works, and not simply small sketch-figures.[9] He also noted that Greek sculptors often worked directly in the negative in preparing molds for terracotta figures and were expert in this technique. That is to say, instead of modeling a figure and then making molds from that model, they would often prepare a mold without the use of a model by carving it out directly in the negative. In such cases the mold itself was the "original." The τύποι which Timotheus made at Epidaurus may have been molds for full-scale models for the pedimental figures; or possibly they were the casts already taken from such molds. In any case, in Blümel's opinion, the τύποι of the Epidaurus inscription did refer to models for the pediments; and, hence, Timotheus was the guiding spirit behind them.

In a new publication of the Epidaurus sculptures in 1951, J. F. Crome took Blümel's new interpretation of the inscription into account but rejected it for four reasons:[1] (1) There is no evidence, or even likelihood, that

7. See *JdI* 49 (1934): 25. Paul Wolters, "Banausos," in *Corolla Curtius* (Stuttgart, 1937), p. 95n1, also felt that the τύποι were mold-made reliefs. He had earlier taken the term as referring to models, but after reviewing Blumenthal's evidence, and adding some of his own, he changed his opinion.

8. Carl Blümel, summary of a lecture on the use of models in Greek sculpture, *AA* (1939): cols. 302–13.

9. Blümel rejected the view of Hermann Thiersch, "Zur Bau-Inscrift des Asklepiostempels von Epidauros," *NAKG, Phil.–Hist. Kl.*, N.F., *Fachgruppe* 1, Bd. II, 1938, pp. 163–72, that τύποι meant small sketch-models because the fee received by Timotheus, 900 drachmas, was a relatively small sum (in Thiersch's opinion about one-tenth of what his total fee for the finished sculptures must have been). Blümel estimates from the building accounts of the Erechtheum, however, that 1 drachma per day was the standard wage for a stonecutter (including sculptors) and concludes therefore that 900 drachmas was really a substantial payment.

1. Crome, *Die Skulpturen des Asklepiostempels*, pp. 12–19. Using Blümel's estimate that the average sculptor's wage was 1 drachma per day (Blümel estimated that each figure on the Erechtheum frieze would have taken 60 days to complete, and the fee per figure in the Erechtheum building inscription was 60 drachmas), that the average cost of an Epidaurian pedimental figure was 120 drachmas, and that the maximum number of figures in each pediment was sixteen, Crome estimated the total wages paid for the actual carving of each pediment to have been 1,920 drachmas. The remaining 1,090 drachmas must have been for

molds were used on such a grand scale simply for the preparation of models. (2) Παράδειγμα is the word for model and occurs as such both in the inscription in question and in the nearly contemporary inscription relating to the construction of the *tholos* at Epidaurus (see παράδειγμα, passages 2a, 2b, 2c, and 3). (3) The τύποι seem to have been made in connection with the ἐργαστήριον while that building was in the course of construction; if they had been intended for the temple, one would expect some qualifying phrase so stating (e.g. πρὸς τὰ ἐναέτια, as von Blumenthal had earlier suggested). (4) The cost of the models for the pedimental sculptures, in his opinion, was included in the 3,010 drachmas which the sculptor of each pediment received (and hence the 900 drachmas paid to Timotheus must have been for something else). In Crome's opinion the τύποι must have been reliefs of some sort connected with the ἐργαστήριον.

Since the publication of Crome's study, most scholars who have commented on the τύπος question have rejected the model theory and have leaned toward the interpretation of τύποι in the Epidaurus inscription as "reliefs."[2] Georges Roux, for example, has suggested that they might have been metopes for the *pronaos* of the Asclepius temple. While admitting that no trace of such metopes remains, he notes that such an arrangement had precedents in the Doric architecture of the Peloponnesus in the temples of Zeus at Olympia and Apollo at Bassae. Thinking along quite different lines, P. G. Leoncini has emphasized that there is considerable stylistic diversity in the Epidaurus sculpture (contrary to the view of some earlier writers, such as Neugebauer), more than would be allowable if Timotheus were the director of the whole project and had imposed his own stylistic standards upon it through models.

At least one scholar, however, Barbara Schlörb, has attempted to uphold Lippold's view that the meaning of τύπος in the Epidaurus inscription is "sketch-model" ("Skizze").[3] Although she does not reexamine the literary

models. Since work on the Epidaurus temple took about 600 days, and the sculptors were credited with roughly 1,920 "man-work-days," Crome estimates further that there were three sculptors per pediment, each of whom received about 600 drachmas for his work. If the average price per figure was 120 drachmas, each sculptor must have made five figures.

Crome's reckoning is ingenious, but it should be remembered that it consists essentially of hypotheses based on other hypotheses, and if one does not accept the initial estimates (i.e. Blümel's average wage), one is not obliged to accept any of the subsequent deductions. Hence those who feel differently about the τύπος question, like Schlörb, can dismiss Crome's argument, as "weitreichenden Schematisierung."

2. Georges Roux, in *BCH* 80 (1956): 518–21; P. G. Leoncini, "Contributo all' interpretazione dei 'typoi' di Timotheus," *Aevum* 30 (1956): 20–29; Roland Martin, *Manuel d'Architeture Grecque* (Paris, 1965), 1: 68n5, 177n4.

3. Barbara Schlörb, "Timotheus," *JdI Ergänzungsheft* 22 (1965). Karl Schefold, *Gnomon* 25 (1954): 313, also accepts the "model theory."

evidence or propose any new shades of meaning for the term, she does
feel that it cannot reasonably be disassociated from the extant temple sculp-
tures. She rejects Blümel's idea that the models in question were full scale
because the extant sculptures show more variety of surface detail than one
would have expected if the sculptors had been working from large, detailed
models. In Schlörb's opinion the models produced by Timotheus must have
been small and must have been in clay or wax. When the models were ready,
they were turned over to two masters who then proceeded, with the help of a
number of assistants, to translate them into stone on a larger scale, exercising
as much freedom in the rendering of detail and composition as their own
reputations vis-à-vis that of Timotheus permitted.

It is obviously difficult to pass any kind of final judgment on a problem
that has been debated for so long, but it does seem that the preponderance of
the evidence is *against* the interpretation of τύπος as "model." The two
really clear-cut meanings of the term when applied to the visual arts are
"mold" and "relief." The meaning "sketch," favored by Lippold, does occur in
a few passages (e.g. passages 25, 26), but the reference never seems to be
to a plastic sketch; and in any case it is arguable whether a sketch is really
the same thing as a model. There admittedly exists, however, a residue of
passages in which τύπος does seem to have been used to refer to a mold-made
image or perhaps any sort of statue that resembled a mold-made image.
If the term has this loose meaning in the Epidaurus inscription, it *could*
refer to maquettes for the pedimental sculptures, but such an interpretation
hardly seems likely. The normal word for model is παράδειγμα, and, as
already noted, this term was known to the authors of the Epidaurus inscrip-
tion (see παράδειγμα).

Blümel's idea that the τύποι at Epidaurus were large molds with con-
siderable detail executed in the negative, from which casts were made, at
least makes some linguistic sense but is otherwise riddled with difficulties.
Would Timotheus receive only 900 drachmas for executing about thirty-
five large-scale figures (even allowing for the fact that they probably would
have been of clay) when he received more than twice that amount for three
acroteria? Can detailed models be reconciled with the stylistic variety
evident in the sculptures? Would such an important undertaking be referred
to in such a perfunctory and obscure way in the inscription?

One is inclined to wonder if the "τύπος problem" ever would have arisen
if the name of Timotheus had not been associated with it. Since Timotheus
is known to have been one of the more important sculptors of the fourth
century, there has been, as I stated at the outset, a natural tendency to
ascribe as much significance as possible to his presence at Epidaurus. Art
historians in the Classical field are perhaps often frustrated by the anonymity
of much of the material with which they deal. Hence when we are provided

with evidence which might help us to associate known works with particular artists, it is natural that we try to "squeeze" that evidence for all that it is worth. If Timotheus made models for all the Epidaurus sculptures, he then becomes a kind of Phidias of the fourth century. But such a picture is probably a product of wishful thinking. We cannot even be certain that the Timotheus of the Epidaurus inscription is the same man who later worked on the Mausoleum. And even if he is, we have no evidence as to how old or how important he was ca. 380 B.C., when the Asclepius temple was being built. Quite possibly he was a young man, inferior in stature to Hectoridas and the others who worked on the temple. (He was certainly less prestigious than Thrasymedes, the sculptor who did the chryselephantine cult image for the temple and who is more likely than anyone else to have been the Phidias of the Epidaurus project.)

As an epilogue to this discussion a word should be added about the terms ἔκτυπος and πρόστυπος. There is not enough evidence to enable us to determine whether there was any consistent distinction in meaning between these two terms or whether either of them is distinguishable from τύπος.

Of the two, ἔκτυπος (along with ἐκτυπόω) is the more common. In most cases this term seems to refer to "relief" (passage 21, 31–34, 37, 47, 52, 67, 75) and seems to be simply a synonym for τύπος. (In passage 86 ἐκτυπόω seems to mean simply "render.") Likewise πρόστυπος, as used by Athenaeus quoting Callixenus, seems to mean simply "relief" (passage 79).

In one passage, however, Pliny *NH* 35.152 (passage 61), *prostypa* and *ectypa* are distinguished. The nature of this distinction is not clear. We are told that the sculptor Butades, in producing terracotta antefixes for temples, first made *prostypa* and later made *ectypa*. This sounds as if it might refer to the making of a mold (i.e. that to which [πρός] the clay of a τύπος was applied, or a mold [τύπος] which was applied [πρός] something) and to the derivation of images (τύποι) from (ἐκ) a mold. Since a mold would normally be done in the negative, and something made from such a mold would be a positive, it might also be possible to interpret *prostypa* and *ectypa* as sunken and raised relief respectively. But if this distinction holds true for Pliny, it cannot be said to apply to all other writers. In passage 24, for example, Xenophon used ἐκτυπόω to refer to an inscription on a statue base. The letters in this inscription, as in virtually all Greek inscriptions, surely must have been in sunken relief.

Some translators of Pliny[4] have taken *prostypa* to refer to low relief and *ectypa* to high relief, presumably on the theory that the relief surfaces in low

4. Harris Rackham in the Loeb Classical Library edition (Cambridge, Mass. and London, 1952); K. Jex-Blake in Sellers, *EPC*.

relief would be closer to (πρός) the background, while in high relief it would be farther from (ἐκ) it.

φαντασία (phantasia)

1. Diodorus Siculus 1.98.7.

 παρ' ἐκείνοις γὰρ οὐκ ἀπὸ τῆς κατὰ τὴν ὅρασιν φαντασίας τὴν συμμε-
 τρίαν τῶν ἀγαλμάτων κρίνεσθαι, καθάπερ παρὰ τοῖς Ἕλλησιν . . .

 For context and translation see p.13.

2. Quintilian *Inst.* 6.2.29.

 Quas φαντασίας Graeci vocant, nos sane visiones appellamus, per quas imagines rerum absentium ita repraesentantur animo. Ut eas cernere oculis ac praesentes habere videamur. Has quisquis bene conceperit, is erit in affectibus potentissimus.

 There are things which the Greeks call *phantasias* and which we, of course, call imaginary visualizations, through which images of things which are absent are so [vividly] presented to the mind that we seem to perceive them with our eyes and to have them present before us. Whoever perceives these vividly will be best able to generate emotions.

3. Quintilian 12.10.6.

 Concipiendis visionibus, quas φαντασίας vocant, Theon Samius . . . praestantissimus est.

 In the use of imaginative scenes, which they call *phantasias,* Theon of Samos . . . was outstanding.

4. Aelian *VH* 2.44.

 . . . καὶ ὁ στρατιώτης ἐβλέπετο τοῦ μέλους ἐναργεστέραν τὴν φαντα-
 σίαν τοῦ ἐκβοηθοῦντος ἔτι καὶ μᾶλλον παραστήσαντος.

 [Description of a picture by Theon of Samos, depicting a soldier rushing to the aid of his country. Theon ordered that a military trumpet should be sounded when the picture was unveiled] . . . and at the sound of the trumpet the impression of the soldier as one who was coming to the aid of his country was made very vivid, and the impression of him as one who stood ready to defend it was even more vivid.

φαντασία (*phantasia*)

5. Athenaeus 196C.

τῶν δὲ κιόνων οἱ μὲν τέσσαρες ὡμοίωντο φοίνιξιν, οἱ δ'ἀνὰ μέσον
θύρσων εἶχον φαντασίαν.

Of the columns [in the festival tent of Ptolemy II] the four in the
corners resembled palm trees, while those in the middle had the
appearance of *thyrsoi*.

6. Philostratus *VA* 6.19.

οἱ Φειδίαι δέ, εἶπε, καὶ οἱ Πραξιτέλεις μῶν ἀνελθόντες ἐς οὐρανὸν καὶ
ἀπομαξάμενοι τὰ τῶν θεῶν εἴδη τέχνην αὐτὰ ἐποιοῦντο, ἢ ἕτερόν τι
ἦν, ὃ ἐφίστη αὐτοὺς τῷ πλάττειν; ἕτερον, ἔφη, καὶ μεστόν γε σοφίας
πρᾶγμα. ποῖον; εἶπεν, οὐ γὰρ ἄν τι παρὰ τὴν μίμησιν εἴποις. φαντασία,
ἔφη, ταῦτα εἰργάσατο σοφωτέρα μιμήσεως δημιουργός. μίμησις μὲν
γὰρ δημιουργήσει ὃ εἶδεν, φαντασία δὲ καὶ ὃ μὴ εἶδεν, ὑποθήσεται γὰρ
αὐτὸ πρὸς τὴν ἀναφορὰν τοῦ ὄντος, καὶ μίμησιν μὲν πολλάκις ἐκκρούει
ἔκπληξις, φαντασίαν δὲ οὐδέν, χωρεῖ γὰρ ἀνέκπληκτος πρὸς ὃ αὐτὴ
ὑπέθετο.

"Well, did artists like Phidias and Praxiteles," he [Thespesion] said,
"after going up to heaven and making copies of the forms of the gods,
then represent them by their art, or was there something else which
stood in attendance upon them in making their sculpture?" "There
was something else," he [Apollonius] said, "a thing full of wisdom."
"What is that?" he asked. "Certainly you would not say that it was
anything other than imitation?" "*Phantasia*," Apollonius answered,
"wrought these, an artificer much wiser than imitation. For imitation
will represent that which can be seen with the eyes, but *phantasia* will
represent that which cannot, for the latter proceeds with reality as its
basis; moreover, panic often repels imitation, but never *phantasia*,
which proceeds undismayed toward that which it has set up as its goal."

7. Philostratus the Younger Εἰκόνες proem.5–6.

Δοκοῦσι δέ μοι παλαιοί τε καὶ σοφοὶ ἄνδρες πολλὰ ὑπὲρ ξυμμετρίας
τῆς ἐν γραφικῇ γράψαι, οἷον νόμους τιθέντες τῆς ἑκάστου τῶν μελῶν
ἀναλογίας ὡς οὐκ ἐνὸν τῆς κατ' ἔννοιαν κινήσεως ἐπιτυχεῖν ἄριστα μὴ
εἴσω τοῦ ἐκ φύσεως μέτρου τῆς ἁρμονίας ἠκούσης. τὸ γὰρ ἔκφυλον καὶ
ἔξω μέτρου οὐκ ἀποδέχεσθαι φύσεως ὀρθῶς ἐχούσης κίνησιν. (VI) Σκοπ-
οῦντι δὲ καὶ ξυγγένειάν τινα πρὸς ποιητικὴν ἔχειν ἡ τέχνη εὑρίσκεται
καὶ κοινή τις ἀμφοῖν εἶναι φαντασία.

φαντασία (*phantasia*)

The wise men of early times, it seems to me, have written much about *symmetria* in painting, laying down laws, so to speak, for the proportional relationship of one part to other parts, as though it were not possible to express inner emotion successfully if the proportion of the body did not come within that range of measurement which is derived from nature. For a figure which is abnormal and exceeds the proper measure cannot, they maintain, admit of a right and natural emotional disposition. To one who examines this question critically, however, it will be clear that the art of painting has a certain kinship with poetry and that there is a certain element of imagination which is common to both.

8. Porphyry *Plot.* 1.

. . . τὰς ἐκ τοῦ ὁρᾶν φαντασίας πληκτικωτέρας λαμβάνειν διὰ τῆς ἐπὶ πλέον προσοχῆς συνείθισεν.

[Since Plotinus refused to allow his portrait to be made, the painter Carterius was hired by Amelius to frequent Plotinus's philosophical gatherings and, after attending these for a time, to make a portrait of him from memory.] . . . from seeing Plotinus frequently he became accustomed to visualizing more and more striking likenesses of him, owing to his increasingly accurate observation.

9. "Damianus" *Optica* (ed. Schöne, p. 28).

τέλος δὲ τῷ ἀρχιτέκτονι τὸ πρὸς φαντασίαν εὔρυθμον ποιῆσαι τὸ ἔργον . . .

See σκηνογραφία, passage 12.

Commentary

The term φαντασία (from φαίνω, "bring to light, make to appear") means "appearance"—either an external appearance perceived through the senses or an internal appearance, such as a vision or a dream existing solely in the mind. In the latter sense the term is sometimes translated as "imagination."

In the sense of "external appearances" φαντασία can refer either to the impression made by specific objects or to more general sense impressions, such as colors. Polybius, for example, describes how the Allobroges were terrified by the appearance of Hannibal's elephants: ἐκπληττόμενοι τῆς τῶν ζῴων φαντασίας (3.53.8); and the author of the pseudo-Aristotelian *De Coloribus* states that an area which is not visible has a black "appearance," τὸ γὰρ μὴ ὁρώμενον, ὅταν ὁ περιέχων τόπος ὁρᾶται φαντασίαν ποιεῖ μέλανος (791a

φαντασία (phantasia)

18). Examples of this simple meaning in connection with art occur in passage 5, where Athenaeus describes how certain columns in the frame of the festival tent of Ptolemy II had the appearance of Bacchic *thyrsoi*, and in passage 9 from "Damianus's" treatise on optics, which discusses the methods employed by architects to give their buildings the "appearance" of εὐρυθμία. The same literal value should be attached to φαντασία in passage 1, where Diodorus says that *symmetria* in Greek art was calculated from "appearances presented to the eyes," while Egyptian *"symmetria"* was a practical working formula unconnected with appearances.[5] On this level it is clear that φαντασία is not really a term of art criticism, nor does it imply any particular theory of aesthetics.

Psychological φαντασία or "imagination," on the other hand, played an important role in the history of Greek aesthetics. The concept of φαντασία as "imagination" in the Classical period is most thoroughly explained by Aristotle in the *De Anima* 428a ff. where φαντασία is described as a faculty of the soul which retains images, which is different from sensation (αἴσθησις), and which is independent of opinion or rational thought. The images which arise may be either true or false. Aristotle emphasizes, however, that although φαντασία is not the same as αἴσθησις, it is dependent on αἴσθησις for its existence. As one moving object sets another in motion, so sensation, which is a type of κίνησις sets φαντασία in motion. Aristotelian imagination is thus a psychological extension of outward sense experience.

The Aristotelian sense of the term seems to apply to Porphyry's φαντασίας πληκτικωτέρας in passage 8, although here the term is used to refer to specific "imagined or visualized likenesses" rather than "imagination" in general.

Beginning some time in the later Hellenistic period and continuing into later antiquity, φαντασία underwent a further development in which it came to signify a "creative imagination" or "intuition" which was able to give form to spiritual forces and was completely independent of ordinary sense perception. The background of this development in the use of the term, which is represented in our catalog by passages 6 and 7, is discussed in detail in chapter 2.[6] As a supplement to those passages already commented upon, note should also be taken of the presence of the *"phantasia* theory" in Dio Chrysostom's Twelfth Oration, although the term used here is φάντασμα rather than φαντασία. In this oration Homer and Phidias are praised for having created images of the gods which have permanently benefited mankind by helping it to comprehend the divine nature. In an imaginary speech which

5. On the significance of this passage see pp. 13. On the "Damianus" passage see ἀλήθεια, εὐρυθμία, and σκηνογραφία.
6. See the section entitled "Late Hellenistic Idealism," pp.52–55.

χάρις (charis)

Dio puts into the mouth of Phidias, the sculptor is made to say that his own
creation of a divine image was more difficult than Homer's because a poet,
once he has a vision (φάντασμα), can record the vision before it fades away,
but the sculptor must keep this vision in his mind throughout the entire time
(τὴν εἰκόνα ἐν τῇ ψυχῇ τὴν αὐτὴν ἀεί) that it takes him to finish his statue
(*Or.* 12.70–71). Something like the *phantasia* theory also seems to be present
in Maximus's contrast between a μίμησις based on τέχνη and a μίμησις
based on ἀρετή (see ἀρετή), although here the language employed seems
to be more Platonic than Stoic.

Quintilian's and Aelian's use of φαντασία in passages 2, 3, and 4 seems
to fall somewhere between the Aristotelian usage of the term and its signi-
ficance in the *phantasia* theory. There is no connotation of spiritual insight or
intuition in these passages, but there is an emphasis on "imagination" in the
modern sense—that is, an inventive, creative, activity of the mind. Quin-
tilian's attribution of φαντασίας to the painter Theon (passage 3) is clearly an
example of that interlocking of rhetorical criticism with criticism of the visual
arts which characterizes all of Quintilian's history of painting. In passage 2
he defines exactly what φαντασία means in rhetoric, and in passage 4 Aelian
gives an example of how it was applied by Theon to the art of painting. In
both instances there is a special emphasis on using the power of visualization
to make a vivid impression on others. In other words, the simplest meaning
of the term—an outward "visual impression"—has been combined with
the psychological sense used by Aristotle; and an element of creative imagi-
nation, hinting at the *phantasia* theory, has been added to the mix. This use
of φαντασία to express both a mental process and its effect was probably
a special development in rhetorical criticism in the Hellenistic period, to
which Quintilian was so heavily indebted (see chapters 3 and 7).

χάρις (*charis*)

1. Homer *Od.* 6.232.

> ὡς δ'ὅτε τις χρυσὸν περιχεύεται ἀργύρῳ ἀνὴρ/ ἴδρις, ὃν Ἥφαιστος
> δέδαεν καὶ Παλλὰς Ἀθήνη/τέχνη παντοίην, χαρίεντα δὲ ἔργα τελείει,/
> ὡς ἄρα τῷ κατέχευε χάριν κεφαλῇ τε καὶ ὤμοις.

As when a skilled craftsman blends gold upon silver, one whom He-
phaistos and Athena have taught intricately varied artistry, and he
brings to perfection pleasing works of art, so did Athena pour forth
grace on his [Odysseus's] head and shoulders.

297

χάρις (*charis*)

2. Dionysius of Halicarnassus *Isoc.* 3. See λεπτός, passage 2.

3. Pliny *NH* 35.79.

Praecipua eius in arte venustas fuit, cum eadem aetate maximi pictores essent; quorum opera cum admiraretur, omnibus conlaudatis deesse illam suam venerem dicebat, quam Graeci χάριτα vocant.

A graceful beauty was particularly distinctive of his [Apelles'] art, even though there were very great painters active in the same period; although he used to admire the works of these contemporaries, he used to maintain, even after praising them all, that they lacked his quality of charm, which the Greeks call *charis*.

Cf. *ingenium*, passage 11.

4. Plutarch *Dem.* 22.3. See θαυμαστός, θαῦμα, passage 3.

5. Aelian *VH* 12.41.

Πρωτογένης ὁ ζωγράφος τὸν Ἰάλυσόν φασιν ἑπτὰ ἔτεσι διαζωγραῶν ἐξετέλεσεν. ὃν Ἀπελλῆς ἰδὼν τὰ μὲν πρῶτα ἔστη ἄφωνος, ἐκπλαγεὶς ἐπὶ τῇ παραδόξῳ θέᾳ, εἶτα ἐπιδὼν ἔφη 'καὶ ὁ πόνος μέγας καὶ ὁ τεχνίτης. ἀπολείπεταί γε μὴν τῆς χειρουργίας ἡ χάρις, ἧς ὁ ἀνὴρ εἰ τύχοι, ὁ πόνος αὐτοῦ τοῦ οὐρανοῦ ψαύσει.

Protogenes the painter, they say, spent seven years painting his Ialysus. When Apelles saw it he was at first struck dumb, so impressed was he by the remarkable sight; but then he remarked, "The labor is great and so is the artist. It lacks, however, that grace of workmanship through which, if a man achieves it, his labor will touch heaven."

Cf. also Pliny's version of this anecdote, *NH* 35.80.

Commentary

The noun χάρις means essentially "favor, given, received, or possessed." It is applied both in an objective sense to describe the outward grace or beauty of a thing and also in a subjective, internal sense to mean "grace" or "favor" which one receives from another or which one bestows on another. In general we may say that χάρις with its various adjectival and verb forms (χαρίεις, χαρίζω) is best translated by the English word *grace* which has the same range of meaning.[7]

7. In the objective sense we speak of "graceful" appearance; in the subjective sense we speak of receiving "divine grace" or of "being gracious" to another.

A simple illustration of χάρις in the objective sense can be found in passage 1 from the *Odyssey* where the χάρις that Athena bestows upon Odysseus is compared to works of art (χαρίεντα δὲ ἔργα) in which gold is overlaid with silver. Χάρις here means essentially an external beauty or grace applicable to both persons and things. In the fact that Athena bestows χάρις on Odysseus, however, we see the root of the concept of internal grace—both given and felt—which occurs among later Greek writers, for example Aristotle, who actually defines χάρις in the *Rhetoric* 1385a18–20:

χάρις, καθ' ἣν ὁ ἔχων λέγεται χάριν ὑπουργεῖν δεομένῳ μὴ ἀντί τινος, μηδ' ἵνα τι αὐτῷ τῷ ὑπουργοῦντι, ἀλλ' ἵνα ἐκείνῳ τι.

Favor, according to which one who has it is said to render a favor to one who needs it, not in return for something, nor in the interest of him who renders it, but in the interest of him who receives it.

In interpreting the meaning of χάρις in the passages cited in our catalog we are faced with the problem of deciding whether the word is to be taken in the subjective-psychological sense—referring to some kind of inspirational grace felt by the artist—or whether the word is used in an objective sense to refer to the visible grace in a certain artist's work, or whether it refers to both. The Latin equivalents of χάρις, *venustas* and *gratia,* provide some evidence on this question. *Venustas* seems to refer exclusively to external, visible grace or beauty. Thus, if we assume in passage 3 that Pliny's translation of χάρις by *venustas* and *venus* is accurate, we might deduce that the Greek term is used to refer to outward visible grace in Apelles' paintings and that this is what Apelles prized so highly in his own works.

On the other hand, Quintilian *Inst.* 12.10.6 (see *gratia,* passage 3) speaks of Apelles' *ingenio et gratia, quam in se ipse maxime iactat.* The phrase *quam in ipse maxime iactat* seems to suggest that Quintilian's information is derived from the same writing by Apelles that Pliny quotes in passage 3. In it, Apelles acknowledged his inferiority to other artists in various technical aspects of artistic composition[8] but held that the work of these artists lacked his own χάρις. One example of this χάρις seems to have been the knack or gift of knowing when to stop working on a picture (*NH* 35.80). In other words, it involved instinctive, inborn perception, as well as elegance of manner. This seems to be just what is implied in Quintilian's phrase *ingenio et gratia,* that is, "genius" or "inborn ability" and "grace." In short, when χάρις was used to characterize an artist, it seems to have been the outward expression of an inner disposition, an external grace in his work deriving from intuition or inspiration.

8. Pliny *NH* 35.80, *Melanthio dispositione cedebat* . . . indicates that Apelles discussed the works of other artists in some detail.

χάρις (charis)

Pliny follows his citation of Apelles' views about χάρις with a contrast of the painter's pleasing, unlabored work to the *opus immensi laboris ac curae supra modum* of Protogenes. This contrast must represent a generalization upon the anecdote about the Ialysus of Protogenes preserved in passages 4 and 5. The anecdote and the generalization probably also go back to Apelles' own writing, although it might have been transmitted to Pliny through an intermediate work like the περὶ ζωγραφίας of Duris of Samos. In Plutarch's version of the anecdote it is not clear whehter it is the πόνος or the ἔργον, which lack χάρις, or whether it is Protogenes himself. In Aelian's version χάρις is certainly looked upon as part of the χειρουργία of painting, but the phrase ἧς ὁ ἀνὴρ εἰ τύχοι indicates that it is also a quality which the artist himself may possess. The χάρις referred to by Apelles in the original version of this anecdote might thus have been the artist's "talent" or "gift" (hence roughly synonymous with *ingenium*), and the phrase οὐρανοῦ ψαύειν may refer to the exercising of the "gift"; or χάρις in this anecdote might simply refer in a more modest way to the visible "grace" in a work of art. As with the Quintilian and Pliny passages, it seems most likely that it referred to both.

In passage 2 one can be fairly certain that Dionysius uses χάρις, like λεπτότης (=*subtilitas*), to refer to an objective quality of style. In the critical terminology of rhetoric χάρις was classified as an essential element in the γλαφυρὸς or ἀνθηρὸς χαρακτήρ of style and composition.[9] It was, in other words, a result and characteristic of elegance in the arrangement of words with regard to their rhythms, melody, transitions, and appropriateness.[1]

In his survey of Hellenistic theories of beauty in connection with Vitruvius, Schlikker suggests that χάρις (which he translates "Anmut") first became a term of art criticism around the time of Apelles and that it described a quality which was somehow opposed to the ἀκρίβεια of earlier Greek art.[2] This interpretation was suggested to Schlikker by the anecdote about Apelles' reaction to the Ialysos of Protogenes discussed in passages 4 and 5. Apelles no doubt felt that his own χάρις was superior to Protogenes' πόνος. Schlikker assumes that ἀκρίβεια and πόνος were synonymous and concludes therefore that Apelles also matched his χάρις against the ἀκρίβεια of others. Πόνος (see *cura*), however, was a nontechnical term which implied hard, tedious work carried out over a long period; whereas ἀκρίβεια in professional criticism seems to have meant "precision" in the use of all the theoretical and technical features of sculpture and painting (συμμετρία, ῥυθμός, κρᾶσις χρωμάτων, etc.; see ἀκρίβεια). Apelles may have rejected πόνος, but it is not likely that he altogether disapproved of ἀκρίβεια. Xenocrates, after all, who was

9. See Dionysius of Halicarnassus *Comp.* 22; Demetrius *Eloc.* 129 ff.
1. Dionysius of Halicarnassus *Comp.* 10–20.
2. Schlikker, *HV*, pp. 85–87.

apparently a strong traditionalist himself and who used ἀκρίβεια as one of the principal critical standards of his history, looked on Apelles as the greatest of Greek painters.

Schlikker is probably right, however, in suggesting that χάρις first became an important critical term in systematic art criticism around the beginning of the Hellenistic period.[3] Whether the term first belonged to the visual arts and was later adopted by literary critics, or whether it was used by both simultaneously is difficult to say. Χάρις does not seem to be of importance as a term of literary criticism in any writer before Dionysius,[4] and it may be that the critics of painting and sculpture anticipated the literary critics in the use of this particular term. In view of the fact that the critical writings of Theophrastus, the most important writer on rhetoric in the early Hellenistic period, are mostly lost, it seems best to reserve judgment on this problem. See also *venustas* and *gratia*.

absolutus

1. Pliny *NH* 34.55.

 . . . duosque pueros item nudos, talis ludentes, qui vocantur astragalizontes et sunt in Titi imperatoris atrio—quo opere nullum absolutius plerique iudicant.

 [Among the works of Polyclitus were] two nude figures of youths playing with dice, figures which are called the Astragalizontes and are in the atrium of the Emperor Titus—a work than which, in the opinion of most people, there is none more perfect.

2. Pliny *NH* 35.17.

 Iam enim absoluta erat pictura etiam in Italia.

 For the art of painting had already [even before the founding of Rome] been brought to perfection even in Italy.

3. Pliny *NH* 35.55.

 . . . eodum anno quo Romulus, nisi fallor, manifesta iam tunc claritate artis, adeo absolutione.

3. Χάρις is thus to be contrasted to τὸ εὖ and perhaps τὸ κάλλος, the terms used to denote the result produced by Polyclitus's system of *symmetria* (Diels, *Fragmente*[7], 40B2, 40A3). The latter terms perhaps suggest an ideal of the Classical period (see chap. 1).

4. We are speaking here of χάρις as a critical term. One can, of course, trace the *idea* of

[Candaules of Lydia gave his weight in gold for a certain picture. He died in the 18th Olympiad, 708–705 B.C. (according to Pliny), in other words] in the same year as Romulus, indicating, unless I am mistaken, that the renown of the art [i.e. painting], in fact its full development, was already apparent.

4. Pliny *NH* 35.74.

Pinxit et heroa absolutissimi operis, artem ipsam complexus viros pingendi.

[Timanthes] also painted a hero, a work of the most perfect workmanship and one in which he encompassed the very art of painting men itself.

5. Pliny *NH* 35.82. See *subtilitas*, passage 10.

6. Pliny *NH* 35.97. See *claritas*, passage 2.

7. Pliny *NH* 36.31.

. . . non tamen recesserunt nisi absoluto, iam id gloriae ipsorum artisque monimentum iudicantes.

[Although Queen Artemisia had died, the sculptors of the Mausoleum of Halicarnassus] refused to abandon the work without its being finished, deciding, even at that stage, that it would be a monument to their own glory and to their art.

Commentary

The use of the term *absolutus* in a context relating to art is confined to the Elder Pliny. It belongs to a circle of Latin words including *perfectus* and *consummatus*, which under certain circumstances rendered the Greek word τέλειος.

Absolutus is used in the passages cited above in three senses: (a) "formally perfect" (passages 1, 4, 5); (b) "come to fulfillment" (passages 2, 3); (c) simply "finished, completed" (passages 6, 7). Being a participial form of *absolvo*, the original sense of the word may be presumed to be "set free, released." It probably acquired the meaning of "completed" from the fact that, if one was "released from" an obligation, the obligation could be considered "completed." Cicero uses *absolvo* in this basic sense in connection with the visual arts when (quoting P. Rutilius Rufus) he notes that no

"grace" or "charm" in earlier literature, as, for example, Julius Walter does in *Geschichte der Aesthetik im Altertum* (Leipzig, 1893), pp. 51–62.

artist could be found who was capable of completing Apelles' unfinished painting of Venus at Cos: . . . *nemo pictor esset inventus, qui in Coa Venere eam partem, quam Apelles inchoatum relinquisset, absolveret* (*Off.* 3.10).

The meaning of *absolutus* in passages 2, 3, 6, and 7, in other words, seems to be its natural Latin sense, and there is nothing in these passages to suggest that the word translates a Greek critical term, particularly since the two passages which have some critical implication (2 and 3) do not deal with Greek art, and the two which do deal with Greek subject matter (6 and 7) have no critical value.

The meaning "artistically perfect" found in passages 1, 4, and 5, on the other hand, seems not to be inherent in the Latin, and it may be that *absolutus* is used in these cases as a translation of the Greek τέλεος (q.v.) in a nontechnical sense. Like *absolutus*, τέλεος could mean "brought to completion, finished" as well as "perfect"; *absolutus* would hence seem to be a natural translation of it. All three of these passages deal with prominent examples of Greek art in Rome, the sort of works which one might have expected to be mentioned in Pasiteles' *nobilia* or *mirabilia opera* (see chap. 6). The background story for the "lines" of Apelles and Protogenes (passage 5), however, probably predates Pasiteles and derives from the anecdotal tradition associated with Duris of Samos (see chap. 6).

A more common translation of τέλεος, however, seems to have been *perfectus* (q.v.), which was used in particular to convey the technical value of the Greek term in connection with systems of proportion. *Absolutus* and *perfectus*, it might be noted, were closely related terms and were frequently used together in the sense of "brought to completion" and "carefully finished off" respectively, e.g. Cicero, *De Or.* 36.91; *Off.* 3.3.14.

amplus

1. Vitruvius 2.7.4.

 Namque habent et statuas amplas factas egregie et minora sigilla floresque et acanthos eleganter scalptos.

 For they [monuments in the town of Ferentum] have large statues, extraordinarily well made, and smaller figures, and flowers and acanthi, elegantly sculptured.

 See also: Vitruvius 1.5.6; 1.2.2; 5.1.1,4; 5.5.3; 5.9.6; 5.11.3; 6.8.5.

2. Quintilian *Inst.* 12.10.5.

 Nam Zeuxis plus membris corporis dedit, id amplius atque augustius ratus atque, ut existimant, Homerum secutus . . .

For Zeuxis gave more emphasis to the parts of the body, judging that this made his art more elevated and more august, and, people assume, in the tradition of Homer . . .

Commentary

The basic meaning of *amplus* is simply "large, great, ample," and when used in this literal sense, as it is by Vitruvius in passage 1, the term has no critical value. In passage 2, however, Quintilian seems to use *amplus* in the more abstract sense of "magnificent, elevated," when he characterizes the figures of Zeuxis.

Quintilian's observation seems curiously related to another judgment on Zeuxis preserved in Pliny *NH* 35.64: *reprehenditur tamen ceu grandior in capitibus articulisque.* In both passages Zeuxis is said to have exaggerated the proportions of the body so that his figures became *amplus*, but the implication of Pliny's remarks is derogatory, while Quintilian's observation is clearly intended to praise Zeuxis.

It may be that both passages stem ultimately from an observation of Xenocrates, but that Quintilian's version of it has been transformed by the "canon tradition" (see chap. 3) in Hellenistic rhetoric. Xenocrates, trained in the Sicyonian school and hence accustomed to the slender proportions favored by Lysippus, may have spoken of the heads, limbs, and so on of Zeuxis's figures as μεγάλαι. Later, a Hellenistic writer with an essentially classicistic outlook who was analyzing the different ἀρεταί of famous Greek artists may have altered μεγάλαι to μεγαλεῖαι, thereby converting Xenocrates' criticism into praise. In the critical terminology of Greek rhetoric μεγαλεῖος (see μεγαλοπρεπής) referred to an "elevated" style, and it was one of the terms used to compare rhetoricians and artists. Demetrius, for example, compares the style of Gorgias and others to that of Phidias for its τι καὶ μεγαλεῖον καὶ ἀκριβὲς (*Eloc.* 14; see ἀρχαῖος, passage 3). For the use of *amplus* to describe an elevated style in rhetoric see Cicero *Orat.* 20, where he speaks of rhetoricians who stressed clarity at the expense of grandeur: *omnia docentes et dilucidiora, non ampliora facientes.* . . .

animum et sensus pingere

1. Petronius *Sat.* 88.

. . . et Myron, qui paene animas hominum ferarumque aere comprehenderat non invenit heredem.

[Eumolpus discourses upon the arts to Encolpius] . . . and Myron,

who almost captured the souls of men and beasts in bronze, left behind no heir.

2. Pliny *NH* 34.58.

. . . et ipse tamen corporum tenus curiosus animi sensus non expressisse.

. . . and he himself [Myron], however, although very attentive to the rendering of bodies [or assemblages of parts?] is deemed not to have expressed sufficiently the consciousness of the mind.

3. Pliny *NH* 35.98.

[Aristides] . . . animum pinxit et sensus hominis . . .

See ἦθος καὶ πάθος, passage 5.

Commentary

We have already examined the questions of when and in what way the representation of character and emotion became a standard of judgment in Greek art criticism (see chap. 1, p. 30, and ἦθος καὶ πάθος in glossary). The principal question to be raised here is whether or not the passages listed can be assigned to any definable tradition of criticism.

Pliny's ascription to Aristides of the introduction of ἦθος, and probably πάθος (=*perturbationes?*), into painting (passage 3) is perhaps most reasonably derived from Antigonus of Carystus (see Chap. 6). The observation is couched in the *Is primus* formula which we have associated with Xenocrates, but there is at least one good reason for not taking Xenocrates as its source. As is suggested in chapter 6, Xenocrates seems to have been the champion of the Sicyonian school of painting and cited Apelles, the outstanding master of the Sicyonian school, as the supreme exemplar of all that was excellent in painting. And yet Aristides of Thebes, to whom the mastery of ἦθος and πάθος is attributed, was a contemporary of Apelles and the chief master of the rival Attic school.[5] Antigonus, on the other hand, who seems to have extended Xenocrates' material, but who was probably free of Sicyonian bias and, as a result of his connection with the art of Pergamon, perhaps more sensitive to the problem of representing emotions in art, was just the sort of writer whom one might expect to have appreciated Aristides' particular virtues and to have fitted them into a reasoned scheme of criticism.

5. On the schools see Robert, *Arch. Märch.*, pp. 83–91. The relevant passages are translated in my *The Art of Greece: 1400–31* B.C., *Sources and Documents* (Englewood Cliffs, N.J., 1965), pp. 162–79.

Passage 2, which notes a lack of *animi sensus* in Myron's sculpture, may also stem ultimately from Antigonus, since it appears in a distinctly "Xenocratic" context and yet does not seem to reflect Xenocrates' particular interests.

The remark which Petronius puts in the mouth of Eumolpus in passage 1 seems to contradict Pliny's remark on Myron. It is probably pointless to attempt to ascribe a passage as casual as this one to any system of criticism. There is a remote possibility, however, that it bears some remote relationship to a version of what I have called the "museographic theory," in which *successus* in representing animals (hence Petronius's rather strange reference to *animas ferarum*) marked a certain stage in the development of bronze sculpture (see chap. 5). It is more likely, however, that Petronius cites Myron as a successful portrayer of animals because of the great fame, particularly in epigrams, of the sculptor's heifer in Athens (see Overbeck, *Schriftquellen*, 550–91).

argutiae

1. Pliny *NH* 34.65.

> Propriae huius videntur esse argutiae operum custoditae in minimis quoque rebus.

> Particularly characteristic of this artist [Lysippus] seems to be a most careful attention to the subtle points of his works, even in the smallest details.

2. Pliny *NH* 35.67.

> Primus symmetrian picturae dedit, primus argutias voltus, elegantiam capilli . . .

> He [Parrhasius] was the first to make use of *symmetria* in painting, the first to render the subtleties of the face, the elegance of the hair. . .

Commentary

Argutiae, in the sense of "subtleties" or "lively details," is possibly, as Schweitzer[6] has suggested, a Latin translation of the Greek ἀκρίβειαι. The passages cited here seem to be based on judgments deriving from "Xenocrates"; passage 1 for example, appears, at the end of a list of the technical virtues of the art of Lysippus, virtues particularly emphasized by "Xeno-

6. Schweitzer, *Xenokrates*, p. 12.

crates" and passage 2 is presented in the unmistakably Xenocratic *primus* formula.

Coming from *arguo*, "make bright, show," *argutiae* most commonly meant "things which are bright, lively, animated." It was used, among other things, to convey the song of a nightingale (Pliny *NH* 10.85) or a quick movement of the fingers (Cicero *Orat.* 59). Apparently from indicating something which was lively and quick, the word took on the additional significance of something which was subtle, such as a lively wit. Pliny, *NH* 35.117, uses it in this sense to characterize a Roman painter.

If Schweitzer's association of *argutiae* with ἀκρίβεια is correct, then, a Latin term which really meant "subtleties achieved through rapidity" was apparently used to translate a Greek term which basically implied subtlety or complexity by virtue of great precision. Perhaps the phrase "fine points," which I have used above, is the simplest and most flexible translation.

The more technical uses of ἀκρίβεια, its use to mean precision of correspondences in *symmetria*, for example, seem normally to have been translated by the Latin *diligentia*, although in the case of passage 1 *argutiae* might have some technical connotation (see *diligens*).

asperitas, asper

1. Vitruvius 3.3.9.

> Pteromatos enim ratio et columnarum circum aedem dispositio ideo est inventa, ut aspectus propter asperitatem intercolumniorum habeat auctoritatem.

> For the system of arranging the *pteroma* [of a temple] and the arrangement of columns around the temple were devised in such a way that their appearance gained in impressiveness because of the contrast of depth provided by the intercolumniations.

2. Vitruvius 7.5.5.

> Apaturius Alabandius eleganti manu finxisset scaenam in minisculo theatro . . . in eaque fecisset columnas, signa, centauros sustinentes epistylia, tholorum rotunda tecta, fastigiorum prominentes versuras, coronasque capitibus leoninis ornatas, quae omnia stillicidiorum e tectis habent rationem, praeterea supra ea nihilominus episcenium, in qua tholi, pronai, semifastigia omnisque tecti varius picturis fuerat ornatus, itaque cum aspectus eius scaenae propter asperitatem eblandiretur omnium visus et iam id opus probare fuissent parati, tum. . .

Apaturius of Alabanda fashioned with a very deft hand a stage setting in a small theater . . . in which he included columns, statues, centaurs holding up entablatures, *tholoi* with round roofs, the projecting angles of pediments, cornices decorated with lions' heads (which are designed to carry off rainwater from roofs); and further, on top of all this, an *episcenium* in which were *tholi, pronai,* half-pediments, and every kind of roof decorated in various ways with paintings; and so, when the appearance of the stage setting won acceptance in the vision of all on account of its variation of surface, and they were ready to give their approbation to the work . . . [it was criticized by the mathematician Lycimnius].

For noncritical usage see also Vitruvius 2.3.1; 2.4.1.

3. Vergil *Aen.* 9.263–64.

Bina dabo argento perfecta atque aspera signis,
pocula, devicta genitor quae, cepit Arisba, . . .

I will give a pair of goblets, deftly wrought in silver and bearing images in relief, which my sire won when he took Arisba. . .

4. Vergil *Aen.* 5.266–67.

Tertia dona facit geminos ex aere lebetas
cymbiaque argento perfecta atque aspera signis.

As third prize he decrees a pair of bronze cauldrons and small cups deftly wrought in silver and bearing images in relief.

5. Pliny *NH* 33.139.

Vasa ex argento mire inconstantia humani ingenii variat nullum genus officinae diu probando. Nunc Furniana, nunc Clodiana, nunc Gratiana—etenim tabernas mensis adoptamus—nunc anaglypta asperitatemque exiso circa liniarum picturas quaerimus.

Silver tableware occurs in astonishing variety owing to the changeability of the human disposition, with no type of work remaining in favor for very long. At one time we long for Furnian ware, at another for Clodian, at another for Gratian—indeed we select whole workshops for our tables—and, at still another, ware with its surface worked in relief, emphasized by incision along the linear boundaries of the pictorial subject.

For other examples of the standard Latin usage of this term in connection with the visual arts, see:

Propertius 2.6.17–18: aspera . . . pocula.
Ovid *Met.* 12.235: signis exstantibus asper antiquus crater.
Ovid *Met.* 13.701: . . . inaurato crater. . . asper acantho.
Suetonius *Nero* 44.2: nummum asperum.
Seneca *Hipp.* 899: regale parvis asperum signis ebur/capulo refulget.

Commentary

The essential meaning of *asper* is probably "rough, having an uneven surface," in a physical sense, but, as with the English words *rough* or *harsh*, the metaphorical use of the term (e.g. to refer to such things as taste, or character, or rhetorical style) is so widespread as to make it seem coeval with the literal use of the term. Within the scope of the present study the only real problem relating to *asper*, or more exactly to the noun *asperitas*, is its meaning in the two passages from Vitruvius in our catalog (passages 1 and 2).

F. W. Schlikker[7] understood passage 1 as referring to the work of the architect Hermogenes and, in particular, to Hermogenes' temple of Dionysus at Teos, which Vitruvius mentions in the preceding paragraphs. The remains of the temple at Teos[8] betray, in Schlikker's opinion, considerable attention on the part of the architect to the role of light and shade in the building. Vitruvius speaks of a "rhythmic" alternation of light and shade in connection with intercolumniations of the temple, and Schlikker feels that this alternation is also visible in many other details of the building. He concludes that *asperitas* in Vitruvius refers to a *"rauher rhythmos"* of light and shade.

Schlikker's interpretation of the passage is criticized by Silvio Ferri, who notes, quite rightly, that passage 1 is really a general statement about the function of the peripteral colonnade in all Greek temples,[9] and that it does not refer specifically to Hermogenes and the temple at Teos. Ferri proposes that *asperitas* was a technical term for a quality of style and that Vitruvius's use of the term is derived from, or at least parallel with, its use in rhetoric. It means, he feels, a kind of rhythm (in the sense of "orderly repetition") of uneven, opposing elements (e.g. light columns and dark intercolumniations) within a unified, ordered, system. In rhetoric this involves the type of composition that Seneca refers to when he notes that *quidam*

7. Schlikker, *HV,* pp. 22–23, 91.
8. Although it is briefly described in most of the standard handbooks of ancient architecture, there is no thorough publication of the remains of this temple. See, however, Society of the Dilettanti, *Antiquities of Ionia* (London, 1769–1915), 4.35, 5.10, 13, 28; Yves Bequignon and Alfred Laumonier, "Fouilles de Teos," *BCH* 49 (1925): 281; Ekrem Akurgal, *Ancient Civilizations and Ruins of Turkey* (Istanbul, 1970), pp. 140–42.
9. Ferri, *Vitruvio,* pp. 103, 110.

praefactam et asperam compositionem probant; virilem putant et fortem, quae aurem inaequalitate percutiat.[1]

Since there were, as we have seen, important connections between the criticism of rhetoric and the criticism of the visual arts in the Hellenistic period (see chap. 3), Ferri's interpretation is not unreasonable. But an analysis of the other passages in which *asper* and *asperitas* are used in connection with the visual arts makes one wonder whether he too, like Schlikker, has not gone beyond what is warranted by the evidence. Leaving aside the Vitruvius passages, we find that in all cases *asper* and *asperitas* refer to "unevenness of surface, contrast of surface levels," or simply "relief." The terms seem to be frequently used to refer to relief work in the toreutic arts— for example, on engraved cups and bowls. Nowhere is there any suggestion that "rhythm," in any sense of the word, is implied. In fact, the term does not seem to have any critical value at all.

These relatively simple meanings, "contrast of depth, relief" can also be applied without any difficulty to the Vitruvian passages. In passage 1 he makes the general statement that the peripteral colonnades of Greek temples gain in impressiveness (*auctoritas*) through the "contrast of depth" between the surrounding columns and the wall of the cella. He then adds that this contrast is particularly marked in pseudodipteral temples, like those of Hermogenes, because the distance between the columns and the cella is much greater in such temples.

In passage 2 Vitruvius seems to apply this same meaning not to architecture itself but to a painted representation of architecture.[2] The roofs, architraves, statues, and so on which Apaturius devised seem to have created an illusory contrast of depth which "won over" or "won the acceptance" (*eblandiretur*) of those who saw Apaturius's *scaena*. *Asperitas* here really seems to refer to the effect of σκηνογραφία (q.v.). In yielding to the illusion of spatial perspective, the citizens of Alabanda were lulled into ignoring the question of what could, and what could not, really exist, and it was for that reason that Lycimnius criticized them. *Asperitas* here again simply means [an apparent] "contrast of depth." Ferri, it should be noted, accepts this meaning of the term in passage 2.[3]

1. Seneca *Ep.* 114; also Cicero *Orat.* 53; Quintilian 9.4.142.
2. Vitruvius does not actually say that the decorations which Apaturius made were painted. One could understand the passage, taking it out of its surrounding context, to mean that Apaturius devised some elaborate, three-dimensional scenery. But the facts that the passage occurs in a section on fresco painting and is used as an illustration of the sort of fresco painting of which Vitruvius disapproved, make it quite likely that he is thinking of a painted stage setting.
3. See Ferri, *Vitruvio*, pp. 272–73. He translates *asperitas* as "la perfetta illusione del rilievo."

It is difficult to determine whether *asperitas* bears any relationship to Greek art ciriticism at all. Vitruvius (passages 1 and 2) and Pliny (passage 5) use the term in connection with Greek art; and the description of the stage setting at Alabanda, in particular, seems clearly to be derived from a Greek source. But whether in any of these passages *asperitas* can be said to be a translation of a Greek term is another question. Its likely prototype, τραχ-ύτης, does not seem to be used in connection with the visual arts. although it does appear as a critical term in the stylistic analysis of rhetoric.[4]

auctoritas

1. Vitruvius 1.1.2.

 Itaque architecti, qui sine litteris contenderant, ut manibus essent exercitati, non potuerunt efficere ut haberent pro laboribus auctoritatem; qui autem ratiocinationibus et litteris solis confisi fuerunt, umbram non rem persecuti videntur. At qui utrumque perdidicerunt, uti omnibus armis ornati, citius cum auctoritate quod fuit propositum, sunt adsecuti.

 And so architects, who have striven to develop their manual skill without formal learning have not been able to bring about a situation in which they have prestige for their labors; on the other hand, those who have confined themselves to theories and formal learning alone seem to have pursued the shadow and not the substance. But those who have given themselves over to both, like men equipped with all possible armament, have sooner attained, and with prestige, that which was their goal.

2. Vitruvius 1.2.5. See *decor*, passage 2.

3. Vitruvius 3.3.6.

 Sic enim habebit et figurationis aspectum venustum et aditus usum sine inpeditionibus et circa cellam ambulatio auctoritatem.

 For thus [by using the proportions called *eustyle*] the building will have a beautiful appearance derived from its plan; its entrance will be usable without impediment, and the ambulatory around the cella will have impressiveness.

4. See the references collected in J. C. Ernesti, *Lexicon Technologiae Graecorum Rhetoricae* (Leipzig, 1795; reprinted Hildesheim, 1962), pp. 356–57.

4. Vitruvius 6.8.9.

Cum magnificenter opus perfectum aspicietur, a domini potestate inpensae laudabuntur; cum subtiliter, officinatoris probabitur exactio; cum vero venuste proportionibus et symmetriis habuerit auctoritatem, tunc fuerit gloria area* architecti.

*area *Ferri, Granger*; aria *HG*; *om. SGᶜ*

When a finished work [i.e. a house] has a magnificent appearance, the expenses on the part of the owner are praised; when it has a refined, skillful appearance, the supervision of the building foreman is commended, but when the work has a beautiful appearance and an impressiveness derived from its individual proportions and overall commensurability, then the glory will be the halo* of the architect.

*The meaning of *area*, if this indeed is the correct reading, is difficult to establish. I follow Ferri, *Vitruvio*, p. 24, who interprets *area* to mean the nimbus surrounding an astronomical body (see Seneca, *QNat.* 1, 2).

5. Vitruvius 7.praef.17.

Id vero si marmoreum fuisset, ut haberet, quemadmodum ab arte subtilitatem, sic ab magnificentia et inpensis auctoritatem, in primis et summis operibus nominaretur.

[The temple of Honos et Virtus by Gaius Mucius in Rome was impressive for its *symmetria*.] If it had also been of marble, so that, in addition to having a subtle refinement derived from art, it also had an impressiveness derived from magnificence and costliness, it would be counted among those buildings which are of the first and highest order.

6. Vitruvius 7.5.4. See *decor*, passage 4.

7. Vitruvius 7.5.7. See *subtilitas*, passage 5; see also Vitruvius 1.praef. 2; 3.3.8; 3.5.10; 5.1.10.

8. Phaedrus *Fab.* 5.prolog.

Aesopi nomen sicubi interposuero
cui reddidi iam pridem quicquid debui
auctoritatis esse scito gratia

If anywhere I shall have interposed the name of Aesop
To whom I have returned whatever it was that I have long owed him
Know that it is for the sake of having an authority behind me.

[This is compared to the practice of some Roman sculptors who put the names of Praxiteles and Myron on their works.]

9. Pliny *NH* 33.157.

Habuit et Teucer crustarius famam, subitoque ars haec ita excolevit, ut sola iam vetustate censeatur usuque attritis caelaturis* si nec† figura discerni possit auctoritas constet.

*caelatura =τορευτική. See chap. 6 n. 4.
†si nec *Urlichs*; si ne **B**; ne *rv(J)*; sic ne *Mayhoff*.

Teucer the engraver also had great renown, but all of a sudden this art [i.e. *toreutikē*] so died out that it now is only reckoned to be of value in early examples [or "for its age"], and a reputation [or value?] adheres to engravings which are worn with use, even those in which it is not possible to discern the figure.

10. Pliny *NH* 34.5.

. . . nunc incertum est, peior haec sit an materia, mirumque, cum ad infinitum operum pretia creverint, auctoritas artis extincta est.

[In former times, skill in the working of copper was highly regarded,] but now it is uncertain which is worse, the art or the metal, and what is more remarkable is that while the prices of works in this material have risen ad infinitum, the *auctoritas* of the art is defunct.

11. Pliny *NH* 34.22.

Alia causa, alia auctoritas M. Horati Coclitis statuae . . .

There is another motive behind and a different importance in the statue of M. Horatius Coccles [in Rome, i.e. it commemorated his bravery at "the bridge"].

12. Pliny *NH* 35.59.

Vel maior huic auctoritas, siquidem Amphictyones, quod est publicum Graeciae consilium, hospitia ei gratuita decrevere.

The esteem accorded to him [Polygnotus] was even greater, in that the Amphictyones, who are a public council in Greece, voted him free lodging and sustenance.

13. Pliny *NH* 35.75.

Ipsius auctoritas tanta fuit, ut diviserat picturam . . .

His [Eupompus's] influence was such that he divided up the art of painting [into different schools].

14. Pliny *NH* 35.77.

Huius auctoritate effectum est Sicyone primum deinde in tota Graecia, ut pueri ingenui omissam* ante graphicen (hoc est picturam) in buxo docerentur . . .

*omissa ante, *coni. Mayhoff*; omnia ante **B**; ante omnia *v*.

It came about as a result of his [Eupompus's] influence, first at Sicyon and then in Greece as a whole, that free-born boys were taught *graphikē* (that is,. painting) on wood, although this had previously been omitted [from the curriculum].

15. Pliny *NH* 35.86.

Tantum erat auctoritati iuris in regem alioqui iracundum.

[Apelles felt free to taunt Alexander when the latter expressed uninformed views about painting.] So assured was he in the influence of his judgment over a king who was otherwise of an irascible temper.

16. Pliny *NH* 35.135.

. . . Metrodorus, pictor idemque philosophus, in utraque scientia magnae auctoritatis.

. . . Metrodorus, a painter and also a philosopher, and a man of considerable reputation in both disciplines.

17. Pliny *NH* 36.36.

Ex honore apparet, in magna auctoritate habitum Lysiae opus . . .

From the honor accorded to it, it would appear that a work of Lysias [which Augustus dedicated on the Palatine] was held in great esteem . . .

18. Quintilian *Inst.* 12.10.8.

. . . ita non explevisse deorum auctoritatem videtur [Polyclitus].

See *decor*, passage 5.

Commentary

The noun *auctoritas* is derived from the verb *augeo*, "produce, bring into effect, increase."[5] It perhaps basically denoted the quality which was characteristic of an *auctor*, a person who had the power to bring something into existence and/or insure that its existence continued.[6] Perhaps the most all-encompassing translation of *auctoritas* would be "the power to initiate or sanction something and the effect of that power." Its English derivative, "authority," is a workable translation of it in many cases but lacks the range of nuances that is characteristic of the Latin term.

In connection with the visual arts *auctoritas* appears to have three basic values:

A. The personal characteristics of one who possesses the power to sanction— the "esteem, influence, prestige, reputation" of an artist. This meaning seems to be applicable in passages 1, 12, 13, 14, 15, and 16. By what may have been a metaphorical extension, this meaning was also at times applied to works of art (passages 9 and 17).

B. A basis that is sanctioned by some real force (as opposed to a frivolous or imaginary basis), hence, a "sound basis," a "sound reason for the existence of something, sanction, soundness," or simply "good authority." I would apply this meaning to passages 6 and 8 and probably to some of the more doubtful passages discussed below (e.g. 2 and 10).

C. The effect produced by the power of sanction and the fact of being sanctioned—"impressiveness, worthiness," or "dignity" (passages 3, 5, 7, 18).

In a number of the passages quoted here the value of *auctoritas* is highly ambiguous. In passage 2, for example, *cum auctoritate* could mean "with a sound basis, with good authority" (meaning B) or it could mean "impressiveness" (meaning C). Perhaps an extension of the "soundness" idea to mean simply "competence, the ability to do something" would be fitting here.

The *auctoritas* which is said to arise from proportions and is the glory of architects in passage 4 might be understood as "soundness," but since the passage as a whole emphasizes effects rather than causes, "impressiveness" seems more likely.

5. On the range of meaning applicable to the term and its cognates see Alfred Ernout and Antoine Meillet, *Dictionnaire étymologique de la langue latine*, 4th ed. (Paris, 1959), s.v. *augeo*.

6. Artists and builders were considered *auctores*. See Lewis and Short, *A Latin Dictionary*, s.v. *auctor* I.B.

When Pliny states in passage 10 that the prices of copper work had risen enormously but that the *auctoritas* of the art was defunct, he does not seem to mean that the "reputation, value," or "impressiveness" of the art were defunct, for in that case it seems unlikely that the prices for it would have risen so.[7] "Soundness" or "sound basis" would fit well here, particularly since in the section immediately following this passage Pliny characterizes the artists of the past as noble men who practiced their art for the sake of glory and contrasts them with his contemporaries, who worked only for profit. This sounds as if the *auctoritas* which he has in mind might simply be a "sound reason" for practicing the art. "Competence" could also fit the meaning of this passage, but to take *auctoritas artis* as "competence in the art" perhaps puts an undue strain on the grammar.

In passage 11 Horatius's exploit at the bridge is cited as the "cause" and the *auctoritas* for a statue of him in Rome. Here almost any of the meanings which we have suggested for *auctoritas* could apply. It could mean that Horatius's exploit was a "sound basis" or "sanction" for setting up a statue of him. Or it could mean that the "reputation" or "impressiveness" of the statue derived from the heroic action of the man whom it commemorated.

For the purposes of this study the principal question about *auctoritas* is not what the range of its meanings in Latin are but whether it in any way reflects the terminology and ideas of Greek art criticism. Some connection with Greek terminology seems almost certain in passage 18, in which Quintilian takes note of Polyclitus's failure to express the *auctoritas* of the gods. The word here clearly refers to one of those exalted attributes of divinity which an inspired artist is able to grasp through his own φαντασία. Schweitzer has suggested that *auctoritas* in this case is a translation of τὸ ἀξι-ωματικόν (q.v.) as used by Dionysius of Halicarnassus to characterize the art of Phidias.[8] The facts that ἀξιωματικός derives from the basic adjective ἄξιος meaning "worthy, of a certain value" and that *auctoritas* also frequently connotes "value" lend weight to Schweitzer's suggestion. Unfortunately Dionysius also applies τὸ ἀξιωματικόν to Polyclitus, which would force one to conclude that if his observation does owe anything to the *phantasia* theory, the debt must be primarily for the terminology as such rather than for the ideas behind it.

Whether one should look for a Greek prototype for *auctoritas* in the other passages in our catalog is less clear. In Vitruvius's discussion of the *eustyle*

7. "Value" or "impressiveness" might make sense if one were to assume that Pliny is contrasting his own opinion as a connoisseur with the ignorance of the general public, but there is no overt indication of this in the passage.

8. Schweitzer, *Xenokrates*, p. 34.

plan in Greek architecture, for example (passage 3; see also 3.3.8), it would not be unreasonable to assume that since this plan was invented by the Hellenistic architect Hermogenes, who was one of Vitruvius's sources, *auctoritas* is used here as a translation of some Greek term used by Hermogenes to describe the merit of his new system. However, when Vitruvius translates a Greek aesthetic term, he usually makes it clear what the Greek term is and what the translation is (as in 1.2.1 ff.); and he also usually takes the time to define and discuss the term as a separate topic before using it.[9] Neither of these conditions can be said to apply to his use of *auctoritas*. The term is used spontaneously and without comment throughout the course of the *De Architectura*. This spontaneity perhaps is best explained by assuming that *auctoritas* was purely a Roman expression, so familiar and natural to Vitruvius that the need to define it never occurred to him.

Silvio Ferri, in his edition of Vitruvius, proposes that *auctoritas* is sometimes used by Vitruvius in a purely Latin way but that at other times it is used to translate two different Greek terms.[1] In regard to passage 2, for example, he suggests that the prototype of *auctoritas* is probably ἀξίωμα, "dignity." Here he is thinking along the lines suggested earlier by Carl Watzinger.[2] In connection with passage 3 (and also with 3.5.10 and 5.1.10), however, Ferri makes the novel proposal that *auctoritas* is equivalent to *augmentum* (also from *augeo*) and that it translates the Greek term αὔξησις, literally "increase in size" or "growth." In passage 3 Vitruvius says that the arrangement of columns which is called *eustyle* will give a graceful appearance to the colonnade as a whole, will leave the entrances to the temple unimpeded, and will make the ambulatory around the cella have *auctoritas*. In Ferri's opinion, *auctoritas* here means that the size of the ambulatory will actually be increased.[3] In reality, however, the adoption of the *eustyle* system[4] would have no effect on the scale of the ambulatory; its principal effect being on

9. *Decor* (q.v.) is the only important term that seems to be based on a Greek prototype and yet for which no Greek equivalent is given. *Decor* is defined, however.

1. Ferri, *Vitruvio*, pp. 33 and 58.

2. *RhM* 64 (1909): 216. Watzinger translates *cum auctoritate* by μετὰ ἀξιώματος. An equation of ἀξίωμα and *auctoritas*, as Ferri notes, seems to occur in the *Res Gestae* of Augustus, chap. 34, where the Greek correlates with an incomplete Latin word beginning with *a* on the *Monumentum Antiocheum* which can be restored as *auctoritas*. See Jean Gagé, *Res Gestae Divi Augusti* (Paris, 1950), pp. 146–47.

3. Ferri translates the final phrase by: "anche la circolazione attorno alla cella ne riceverà incremento"; *Vitruvio*, p. 109.

4. See D. S. Robertson, *A Handbook of Greek and Roman Architecture*, 2d ed. (Cambridge, 1954), p. 154. In the *eustyle* system the intercolumniations were $2\frac{1}{4}$ times the lower diameter of the columns, except before the entrance, where the space between the columns was 3 times the diameter of the columns.

the size of the intercolumniations and columns. The *auctoritas* of the space between the columns and the cella was probably, like the *venustum aspectum* of the arrangement as a whole, a question of aesthetic effect, not size. In 3.5.10 Vitruvius says that the frieze above the architrave of the Ionic order should generally be one-fourth shorter than the architrave. If sculptured figures are added to the frieze, however, it should be one-fourth taller than the architrave, *uti auctoritatem habeant scalpturae*. Ferri interprets this to mean "affinché le sculture abbiano una grandezza sufficiente." It seems more likely, however, that the phrase really means something like "that the sculptures may be appreciated" or "that the sculptures may be effective."

Finally, in Vitruvius's description of his own basilica at Fano (5.1.10), we are told that the device of carrying single columns straight up to the roof beams without any intervening entablature gave the building an air of *magnificentiam inpensae et auctoritatem*. The effect of this device, Ferri proposes, was to make the basilica bigger; this is not impossible; but here too, it seems to me more likely, in view of Vitruvius's use of the term elsewhere, that *auctoritas* means "dignity" or "impressiveness."

Ferri has also applied his equation of *auctoritas* and αὔξησις to Quintilian's statement that Polyclitus failed to express the *auctoritas* of the gods (passage 18). In his opinion the passage simply means that the statues of Polyclitus "non erano . . . grandi abbastanza rispetto agli dei che esse rappresentavano."[5] However, in view of what we know about the context of Quintilian's remark that is, its connection with the *phantasia* theory—an interpretation of the passage on this simple level hardly seems justified. It is true, as we have said above, that *auctoritas* in this passage does seem to be a translation of a Greek word, but that Greek word was almost certainly one which referred to a quality or characteristic of the divine nature that Polyclitus failed to express. Schweitzer's suggestion of ἀξιωματικός is certainly more fitting than αὔξησις.

audacia

1. Petronius *Sat.* 2.

 . . . Aegyptiorum audacia tam magnae artis compendiariam invenit.

See *compendiaria*, passage 1.

2. Pliny *NH* 34.38.

Evecta supra humanam fidem ars est successu, mox in audacia.

5. First proposed in Ferri, *NC*, p. 142, and repeated in Ferri, *Vitruvio*, p. 33.

See *successus*, passage 1.

3. Pliny *NH* 34.39.

> Audaciae innumera sunt exempla. Moles quippe excogitatas videmus statuarum, quas colosseas vocant, turribus pares.

> Examples of daring are innumerable. Indeed we see that massive statues, which they call *colossi*, were devised, as huge as towers.

Commentary

In chapter 5 the possibility was mentioned in passing that the terms *successus* and *audacia* as used in passage 2 were to be associated with what I have called the Roman museographic theory. The substance of this theory, found principally in Pliny *NH* 34.6–17, is that the history of bronze sculpture can be constructed on the basis of the uses made of the metal from the beginning of the art to its high point. Thus the use of bronze begins in the minor arts—vessels, furniture, and so on—but ultimately comes to be used for images of the gods. Different places specialized at first in the use of bronze for their own characteristic minor art—Corinth in vessels (34.6), Delos in metal couch frames (34.9), Aegina in candelabra (34.10–11)—but eventually each progressed toward the production of statues of gods and men: *transiit deinde ars vulgo ubique ad effigies deorum* (34.15) or *pervenit deinde et ad deum simulacra effigiemque hominum et aliorum animalium* (34.9).

Perhaps we can extend our understanding of this evolutionary theory by recognizing two subcategories under the final heading of *simulacra deorum et hominum*. These two categories are *successus* and *audacia*. *Successus* (q.v.) indicated a complete technical mastery of the material (e.g. bronze) used to create realistic representations of nature in art. *Audacia*, "daring," perhaps marked a stage which was thought to follow *successus* in naturalistic representation. As with the Greek τόλμα (q.v.), the daring it expressed seems to have meant a boldness in technique rather than in conception (in other words this term was probably not connected with what we would call "originality"). An example of it was colossal statuary (passage 3), particularly colossal works with some striking technical feature, such as the colossus by Lysippus at Tarentum, which was so well anchored that a storm could not dislodge it, but which was also balanced in such a way that it could be moved by a touch of the hand.

The disjointed manner in which Pliny presents the museographic theory in book 34 suggests that he was, as usual, borrowing his information in somewhat disconnected fragments. His source seems to have been a Roman

writer, perhaps Varro. At any rate it seems that whoever originated the system based it largely on material which could be seen and studied in Rome. Of the colossal statues mentioned in *NH* 34.40, for example, all but one (the Rhodian colossus, which would have been familiar to any educated man of the time) stood in Rome. Some of the examples cited, however, postdate Varro's lifetime (see 34.45), and we must therefore assume that if Varro originated the theory in question, Pliny illustrated it with some examples of his own.

The *audacia* of the Egyptians, which Petronius refers to in passage 1, is probably not to be connected with any systematic tradition of criticism, but here too the term may refer to some sort of technical achievement in art. The *compendiaria* (q.v.) which *audacia* is said to have characterized appears to have been a new technique in painting, which enabled artists to work more quickly. In this passage, however, it is clear that the term also has a stylistic connotation and means "audacity" as much as "daring." The sort of painting that *compendiaria* denoted may have been an Egyptian invention and seems to have employed Egyptian subject matter. It was apparently as a result of this "oriental" association that the speaker in the *Satyricon* (Encolpius) chose it as an analogy for the florid "Asiatic" style of rhetoric, which he was in the process of denouncing. *Pictura compendiaria* apparently seemed florid and exotic to one who professed a taste for the Attic syle.

augustus

1. Valerius Maximus 8.11.5.

> Nam cum Athenis XII deos pingeret, Neptuni imaginem quam poterat excellentissimis maiestatis coloribus complexus est, perinde ac Iovis aliquanto augustiorem repraesenturus.

> For when he [Euphranor] did a painting of the Twelve Gods in Athens, he composed the image of Poseidon with colors of the most majestic color scheme he could devise, and in a like manner he intended afterward to make an even more august depiction of Zeus [but his inspiration by that time was exhausted].

2. Quintilian *Inst.* 12.10.5.

> . . . id amplius atque augustius ratus [Zeuxis]. . .

> See *amplus*, passage 2.

Commentary

Augustus in the two preceding passages is probably a Latin translation of the Greek σεμνός. The Greeks generally translated the Roman imperial title "Augustus" by σεβαστός;[6] the adjective σεμνός (q.v.), "revered, august, holy," is derived from the same root (verb form σέβομαι). Like σεμνός, *augustus* is most often used to describe some aspect of a divinity or a religious institution.

Passage 2, like most of Quintilian's chapter on painting, is probably derived from a Hellenistic comparative canon of rhetoricians and artists, which in turn collected certain critical judgments from professional criticism in the fourth and early third centuries B.C. The idea that Zeuxis used forms which were *amplius atque augustius* probably has some connection with Pliny's statement that Zeuxis made the heads and extremities of his figures too large. In rhetorical criticism, as suggested in connection with *amplus*, this largeness, which had originally been considered a flaw in Zeuxis's work, perhaps came to be viewed as the painter's stylistic ἀρετή (q.v.). As used by Quintilian, *augustus* may imply that Zeuxis's figures appeared "godlike" as a result of their "grand" proportions.

Although *augustus* itself is rare in both literary criticism and the criticism of the visual arts, σεμνός is more common and is often associated with the αὐστηρὸς χαρακτήρ of rhetoric (see *austerus*).[7]

austerus

1. Pliny *NH* 34.66.

. . . sed ante omnes Euthycraten, quamquam is constantiam potius imitatus patris quam elegantiam austero maluit genere quam iucundo placere.

[The pupils of Lysippus were Laippus, Boedas] but before all Euthycrates, although he having imitated the harmonious composition of his father rather than his elegance, preferred to find favor through an austere style rather than a pleasing one.

6. E.g. Strabo 3.3.8; frequent also on Greek coins of the time of the Roman Empire. See Waldemar Wruck, *Die Syrische Provinzialprägung von Augustus bis Traian* (Stuttgart, 1931), pp. 14 ff.

7. Note that *augustus* is probably not the only term used to translate σεμνός; see also *pondus* and perhaps *gravitas*.

2. Pliny *NH* 35.30.

> Sunt autem colores austeri aut floridi. Utrumque natura aut mixtura evenit. Floridi sunt—quos dominus pingenti praestat—minium, Armenium, cinnabaris, chrysocolla, Indicum, purpurissum; ceteri austeri.

> Now some colors are "austere" and others are "florid." Both derive either from nature or from mixture. The florid colors—which the patron provides for the painter—are *minium* [red lead, vermillion], *Armenium* [blue, ultramarine, from azurite], *cinnabaris* [a blood color, see *NH* 33.115], *chrysocolla* [copper green], *Indicum* [indigo], *purpurissum* [purple]; the other colors are austere.

3. Pliny *NH* 35.97. See *claritas*, passage 2.

4. Pliny *NH* 35.134.

> Niciae comparatur et aliquando praefertur Athenion Maronites, Glaucionis Corinthii discipulus, austerior colore et in austeritate iucundior, ut in ipsa pictura eruditio eluceat.

> Athenion of Maronea, the disciple of Glaucion of Corinth, is compared with Nicias and sometimes even preferred to him; he is more austere in his use of color [than Nicias] and also more pleasing in his austerity, so that his knowledge radiates within the picture itself.

Commentary

In passages 2, 3, and 4, *austerus*[8] appears to be a quasi-technical term describing a certain group of colors used in ancient painting, while in passage 1 the term refers to a particular quality of style characteristic in the works of the sculptor Lysippus. The relationship between these two meanings provides us with an interesting illustration of how the terminology of Greek art criticism was perpetuated over several centuries.

The critical terminology used by Pliny in passage 1 bears a close resemblance to an important branch of the terminology of Greek rhetoric, and it seems likely that Pliny (perhaps via Varro) has either derived his information from a Greek writer on rhetoric or at least modeled his own criticism of Euthycrates on familiar patterns of rhetorical criticism. Pliny says that the works of Lysippus exhibited both an *austerum* and a

8. A direct cognate of the Greek αὐστηρός, which is presumably from αὔω and may have originally meant "dried up." By the fourth century B.C., however, the term meant "bitter" or "harsh" both in a literal (Plato *Ti.* 65D: τραχύνοντα αὐστηρά) and moral sense (Aristotle *Eth. Eud.* 1240a2).

iucundum genus of style; Lysippus's son Euthycrates followed only the *austerum genus* of his father's work, imitating his *constantia* (q.v) but not his *elegantia* (q.v.). The parallel between these two stylistic genera and the αὐστηρός and γλαφυρός (or ἀνθηρός) χαρακτήρ of rhetorical composition, which are first described in detail by Dionysius of Halicarnassus in the περὶ συνθέσεως ὀνομάτων (*Comp.* 21 ff.),[9] is too close to be accidental. In the austere style of rhetorical composition each word and phrase is clearly defined, occasional harsh cadences are employed, and the total effect is one of seriousness and intensity (*Comp.* 22). The γλαφυρὸς χαρακτήρ, on the other hand, emphasizes smooth transitions between words and phrases and aims at charm rather than gravity (*Comp.* 23).[1]

The background of passages 2, 3, and 4, in which *austerus* refers to color in painting, would seem to differ from that of passage 1. Passage 2, for example, in which Pliny describes the two *genera* of color—the *austeri colores* and the *floridi colores*—does not refer either to style or to taste. It is simply an objective classification of certain colors and would seem to derive not from rhetorical criticism but rather from professional treatises on painting. We know, for example, that Euphranor wrote a treatise *De coloribus* (*NH* 35.111), and other writings of this sort may have existed in the fourth century B.C. and later. Passage 2 suggests that *floridi colores* referred basically to two of the primary colors of the spectrum, that is, reds and blues with variants such as purple. *Chrysocolla*, however, seems to have been a shade of green. Perhaps, in the broadest sense, the *floridi colores* simply signified colors which were bright, while the *austeri colores* signified those which were more

9. The other basic description of the χαρακτῆρες or λόγοι of rhetorical style is in Demetrius, περὶ Ἑρμηνείας (*Eloc.* 38 ff.). Demetrius uses the term μεγαλοπρεπής rather than αὐστηρός for the austere or elevated style.

1. One could speculate endlessly, but perhaps futilely, about how the *iucundum* and *austerum genera* apply to the extant works that are ascribed to Lysippus (all but the Agias at Delphi are Roman copies; the Agias must be considered a "Greek" copy). The "austere" character might refer to Lysippus's rigid application of *symmetria*, while the *iucundum* character might connote elegance in surface detail. Or the austere genus might refer to the extreme spatial independence of some of the Lysippean figures—the way they project limbs, knees, and so on into the viewer's space and require the viewer to study them from many angles, as in the Apoxyomenus and the Heracles Epitrapezius, for example (see F. P. Johnson, *Lysippos* [Durham, N.C., 1927], pls. 12, 13, 15, 16). Note in this connection that Dionysius also says that words in the austere character of rhetoric should be like columns in a temple, firmly planted and visible on every side (ὥστ'ἐκ περιφανείας ἕκαστον ὄνομα ὁρᾶσθαι, *Comp.* 22). The "austere" genus might even refer to the somewhat burly quality of the faces on some of the statues attributed to Lysippus (the Apoxyomenus, the Heracles Farnese, the Agias, the Heracles Epitrapezius; see Johnson, *Lysippos.*, pls. 12, 13, 15, 16, 20, 37) as opposed to the *iucunda symmetria* of the bodies of these statues. The last idea could not be applicable, however, to Lysippus's Eros (Johnson, *Lysippos*, p. 17), nor to the Alexander portraits.

somber (possibly as a result of having been blended with other colors). Such a distinction is implied in passage 3, where Pliny describes a varnish used by Apelles which had the effect of giving *austeritatem* to colors which were "too florid."[2] If Apelles, as Pliny tells us, was one of the "four-color painters" and used these colors exclusively,[3] then he did not use all the colors which are precisely described by Pliny as *floridi* in the passage discussed above (e.g. blue[4] and purple), and this may have made his color-schemes seem "austere."

Austerus and *floridus* (αὐστηρός and ἀνθηρός), then, were probably originally general terms used in professional treatises on painting of the fourth century B.C. to describe groups of colors. Assuming that there is a connection between this terminology and the rhetorical χαρακτῆρες already described, we must now ask how such a connection came about. The answer may be that Dionysius of Halicarnassus actually invented[5] the concept of the χαρακτῆρες of rhetorical composition and that, in formulating the concept, he was influenced by terminology which had long been used in the criticism of painting. In section 21 of the *De Compositione Verborum* Dionysius says that before his own time there were no recognized terms for the types of rhetorical composition and that he himself invented the ones which he uses in his essay (ἐγὼ μέντοι κυρίοις ὀνόμασιν οὐκ ἔχων αὐτὰς προσαγορεῦσαι ὡς ἀκατονομάστους μεταφορικοῖς ὀνόμασι καλῶ τὴν μὲν αὐστηράν, τὴν δὲ γλαφυρὰν ἢ ἀνθηράν,[6] τὴν δὲ τρίτην εὔκρατον). Just prior to this passage he says that in painting he found not a bad illustration of the different styles of composition (οὐ φαύλῳ παραδείγματι χρώμενος ζωγραφίᾳ), for painters use the same pigments but mix them in various ways (οὐδὲν ἐοικότα ποιοῦσιν ἀλλήλοις τὰ μίγματα). This unambiguous reference to the art of painting as providing the nearest analogy for the characteristics of rhetorical style

2. This information, too, would seem to be derived from professional criticism, perhaps from Apelles' own *volumina* on painting; see *NH* 35.79.

3. *NH* 35.92 and 35.50; see commentary under *lineamenta*; the four colors are red, yellow, white, and black.

4. At least it would seem that he did not use bright blue. Vincent J. Bruno argues convincingly that the black (*atramentum*) may actually have been a dark blue; see his *Form and Color in Greek Painting*, chap. 5 (see chap. 7, note 1)

5. Dionysius seems to have been the inventor of a three-part division specifically designed for the criticism of literary composition. A general division of all rhetorical style into three types, however, existed before him. A division of rhetoric into *gravis*, *mediocris*, and *attenuatus* styles appears in the *Rhetorica ad Herrenium* 4.8.11 (ca. 85 B.C.), and Cicero gives a similar division (*gravis*, *medius*, and *subtilis*) in the *De Oratore* 3.45.177 (45 B.C.). These divisions are probably modeled on the ἀρεταί of rhetorical style first formulated by Theophrastus and perpetuated by the peripatetics. See commentary under ἀρετή.

6. ἢ ἀνθηράν omitted in one manuscript, *codex Parisinus Bibl. Nat.* 1741.

suggests that Dionysius may actually have adopted his terminology directly from the color theory of Greek painting.

Passage 4, in which Pliny describes the painter Athenion as *austerior colore et in austeritate iucundior*, would appear to be a blending of the color theory of professional art criticism with the categories of rhetorical style. Athenion was perhaps fond of using the *austeri colores* and hence was *austerior*. The fact that he was also *in austeritate iucundior*[7] may mean either that his paintings were bright in spite of his use of the austere colors or that his style of composition was elegant even though his colors were somber.

claritas

1. Pliny *NH* 35.55. See *absolutus*, passage 3.

2. Pliny *NH* 35.97.

> Inventa eius et ceteris profuere in arte; unum imitari nemo potuit, quod absoluta opera atramento inlinebat ita tenui, ut id ipsum, cum* repercussum† claritatis‡ colorum** omnium*** excitaret custodiretque a pulvere et sordibus, ad manum intuenti+ demum appareret, sed et luminum⁻ ratione magna, ne claritas colorum offenderet veluti per lapidem specularem intuentibus et e longinquo eadem res nimis floridis coloribus austeritatem occulte daret.

(*)cum *add. Mayhoff.*
(†)repercussum **B**¹; repercussu *rv.*
(‡)claritatis *Bh, Sillig, Mayhoff;* claritates *rv.*
(**)Colorum **VR dh** *G;* colorem **BS;** oculorum *v.*
(***)onium(=omnium) *coni. Mayhoff;* aluum **B**¹; alium **B**², *Sillig;* album *Traube;* om. *rv.*
(+)intuenti et **B.**
(⁻)et luminum *Mayhoff;* etium **B**¹; etiam **B**²; et cum *rv.*

His [Apelles] inventions have also been useful to other artists, but there is one which no one has been able to imitate: namely, when his work was finished, he would coat it with a black varnish of such thinness that it itself, while it brought about a radiance of the brightness of all the colors* and protected the painting from dust and dirt, was only apparent to one who inspected it close at hand; but also [the varnish was of such thinness] that, by using a calculated system of lighting, the brightness of the colors would not be offensive to those who looked at

7. As noted earlier, the *iucundus genus* equals the γλαφυρὸς χαρακτήρ, also called the ἀνθηρὸς χαρακτήρ of composition.

them (it would be as if they were looking through transparent mica) and this same device, from a distance, might give an austere quality to colors which were too bright.

*This passage, as Jex-Blake, *EPC* 132, note 6, has observed, "offers grave difficulties." Many variations of text and translation are possible, and I do not insist that the version given above is necessarily the correct one. I do feel, however, that Mayhoff's reading *colorum omnium* is a better reading than Jex-Blake's *colorem album*, particularly if one accepts her suggestion that *albus* is a mistranslation of the Greek λευκός in the sense of brilliant. If that were the case, *claritas* and *album* would have virtually the same meaning.

I suspect that Apelles' varnish may have made his colors glisten in the same way that a thin sheet of water will heighten the colors of a floor mosaic. The word *repercus sum* may have come to Pliny's mind because Apelles' colors seemed analogous to the reflection of colors from a pool of water or some other shiny surface. With this idea in mind, I have rendered *repercussum* "radiance" rather than the more literal "reflection."

Commentary

When referring to colors, the term *claritas*, I believe, simply means "brightness, brilliance." In general the adjective *clarus* has three meanings: (a) "distinct" or "clear," (b) "bright, shining," and (c) the metaphorical meaning "famous, distinguished, glorious." When describing color, however, it seems always to mean "brilliance": e.g. *purpura poeniceusque color clarissimus multo* (Lucretius, *De Rer. Nat.* 2.830. This is the meaning to be applied in passage 2 above.

Passage 1 may be a Roman elaboration, perhaps Pliny's own, on "Xenocrates' " chapter on Archaic art. Pliny is attempting, on the basis of a painting which he dates in the time of Romulus (in his opinion, the end of the eighth century B.C.), to apply the "Xenocratic" view of the development of Archaic art to Roman chronology (*NH* 35.55 ff.). He reasons that "Xenocrates' " scheme—in which monochrome painting came first, then the differentiation of men and women by colors by Eumarus, and finally the *catagrapha* of Cimon of Cleonae—must have come to an end by the time of Romulus, since the painting by Bularchus which he is discussing has already attained *claritas*, in fact, *absolutio*. The meaning of *claritas* here is undoubtedly the third of those mentioned above—"distinction."

The source of passage 2 cannot be identified with any certainty. It may well be, however, that this small glimpse into Apelles' use of materials is derived from the artist's own treatises on his art (see chap. 1). We may perhaps speculate that the Greek word used by the original source was σαφήνεια. *Claritas* does not seem to have been part of any particular system of critical terminology.

Those passages in which *claritas* simply has the value of "personal fame" (e.g. Pliny *NH* 34.37, on Lysippus) are omitted here.

compendiaria

1. Petronius *Sat.* 2.

Pictura quoque non alium exitum fecit, postquam Aegyptiorum audacia tam magnae artis compendiariam invenit.

[Rhetoric, Encolpius says, has degenerated since the Asiatic style began to replace the Attic style.] Likewise painting came to an end not much different, after the audacity of the Egyptians invented an abbreviation of such a great art.

2. Pliny *NH* 35.110.

Idem pinxit lasciviam, in qua tres Sileni commissantur. Hic celeritatem praeceptoris secutus breviores etiamnum quasdam picturae compendiarias invenit.

The same artist [Philoxenus of Eretria] also painted a lascivious picture in which three Sileni were reveling. Following the rapidity of his teacher [Nicomachus], he invented certain even briefer types of painting, *compendiariae*.

Cf. Pliny *NH* 35.109.

Nec fuit alius in ea arte velocior . . . paucisque diebus absolvisse et celeritate et arte mira.

Nor was there anyone who was a more rapid worker in in this art [than Nicomachus. He received a commission from the tyrant Aristratus of Sicyon, and although he arrived only a few days before the painting was supposed to be finished,] he completed it in a few days, a marvel both for the rapidity with which it was finished and for its artistic quality.

Commentary

No term in ancient art criticism has been interpreted so widely on the basis of such limited evidence as has *compendiaria*. And yet, in spite of all the interpretive speculation which has been devoted to the word over the past sixty years, one of the most recent writers on the subject has felt compelled to declare that "what it means specifically in relation to painting is, and has been, anyone's guess."[8] The term basically appears to refer to a "shortcut, a quick way of doing things."

8. B. R. Brown, *Ptolemaic Painting and Mosaics* (Cambridge, Mass., 1957), p. 90.

Compendo, "weigh together," implies that one combines or avoids separate steps in the procedure of weighing; in other words, it is a quick method of weighing. The noun *compendium* means a "saving" or a "shortcut." Cf. Pliny 21.70: *res praecipui quaestus conpendiique cum favet* (on the savings derived from having one's own apiary); Quintilian 4.2.46–47: . . . *spatii amplioris, minus fatigat quam durum aridumque compendium* (against shortcuts in a rhetorical narrative). *Compendiaria* is really a feminine adjectival form used substantively; perhaps the original phrase was *pictura compendiaria* or *via compendiaria.*

Among the interpretations offered by modern scholars of the passages cited here, the most widely held appears to be that *compendiaria* refers to an impressionistic technique of painting developed in Ptolemaic Egypt, particulary in Alexandria, during the early Hellenistic period.[9] By "impressionism" the proponents of this interpretation meant a style of painting which was both "sketchy" (that is, a style in which figures and details are "suggested" by a few brush strokes rather than by precise linear detail) and also "coloristic" (that is, a style in which figures are built up through patches of color which blend into one another without sharp outlines, as in much "impressionist" painting of the nineteenth century). Such a style would be said to contain "shortcuts" in that it did not require meticulous draftsmanship and did not insist on the "completeness" of every pictorial detail.

The reasons for associating such a style with Egypt are somewhat devious. The first point of evidence, naturally enough, is the fact that Petronius (passage l), writing in the first century A.D., associates *compendiariae* with Egypt. The second reason is that the painter Antiphilus, who, as Pliny tells us (*NH* 35.114 and 138), was born in Egypt and painted Egyptian subjects, is said by Quintilian to have been *praestantissimus* in *facilitate.* The latter term has generally been taken to mean "rapidity in technique," although this is probably not its correct meaning (see below and under *facilitas*). In addition to this literary evidence, scholars have pointed to certain examples of Roman wall painting and mosaics which have Egyptian subjects; and some of these may be said to have an impressionistic technique.[1]

9. Werner Weisbach, *Impressionismus* (Berlin, 1910), esp. pp. 9–15; Mary Swindler, *Ancient Painting* (New Haven, 1929), pp. 275, 283, 284, 336–37; Sellers, *EPC*, pp. 143n16, 145n18, 238; Andreas Rumpf, in Ulrich Thieme and Felix Becker, *Allgemeines Lexikon der bildenden Künstler von der Antike bis zur Gegenwart* (Leipzig, 1907–50), s.v. "Philoxenos" (Egyptian connections not discussed in the latter). The belief in Alexandrian impressionism has been given its classic form by C. R. Morey, *Early Christian Art* (Princeton, 1942), pp. 40–45. See also Paolo Moreno, in *Enciclopedia dell' Arte Antica,* s.v. "Petronio," p. 103.

1. See Goffredo Bendinelli "Influssi dell' Egitto Ellenistico sull' arte romana," *Bulletin de la Société Royale d'Archéologie d'Alexandrie* 24 (1929): 21–38; "Éléments alexandrins dans la peinture romaine de l'époque de l'empire," ibid. 26 (1931): 227–41.

Closely bound up with the idea that Alexandrian art developed an impressionistic technique is the belief that it also developed landscape painting, especially sketchy landscapes in which trees, mountains, and rivers blend in a hazy background.[2] The "Nilotic landscapes" from Pompeii provide the principal examples of this type of landscape with Egyptian subject matter.[3] Besides the Pompeian evidence, there are a few literary references that tend to associate landscape painting with Egypt. Pliny tells us that the painter Nealces depicted a battle scene along the edge of the Nile (*NH* 35.142), and he also mentions a painter with an Egyptian-sounding name, Serapion, who *scaenas optime pinxit* (*NH* 35.113).

Brown's study of the extant remains of Alexandrian painting, however, suggests that the conception of Alexandria as the birthplace of impressionism has little basis in fact.[4] Alexandrian painting seems to have followed, in the main, the general tendencies of all Hellenistic art and was not characterized by either landscape painting or impressionism. Most of the examples of landscape painting with Egyptian subject matter come from Italy and are not earlier than the first century B.C. It is possible that some of them were created by Romanized Greeks from Ptolemaic Egypt, but the landscape style as a whole is no more genuinely Egyptian than English "chinoiserie" was genuinely Chinese.

The literary evidence in support of a tradition of impressionistic landscape painting in Alexandria is also very shaky. In the Hellenistic period a name like Serapion need not have been exclusively Egyptian. The Egyptian gods Isis and Serapis were worshiped outside of Egypt, and human names based on the divine names—Isidorus, for example—were known in Greece and elsewhere.[5] The *scaenas* which Serapion painted, moreover, are just as likely to have been stage settings as landscape scenes. Again, in the case of Nealces' painting of a battle along the Nile, we really have no way

2. Ernst Pfuhl, *Malerei und Zeichnung* (Munich, 1923), par. 975; Franz Wickhoff, *Roman Art*, trans. Mrs. S. Arthur Strong (London and New York, 1900), p. 124. A typical example would be any one of the Pompeian "sacred landscapes" now in Naples, see Amadeo Maiuri, *Roman Painting* (Geneva, 1953), p. 122.

3. C. M. Dawson, *Romano-Campanian Mythological Landscape Painting* (New Haven, 1944), p. 40; and the articles by Bendinelli cited above.

4. Cf. Brown, *Ptolemaic Painting and Mosaics*, and the review of same by O. J. Brendel, *AJA* 65 (1961): 211–14. Andreas Rumpf, *Malerei und Zeichnung*, pp. 153–54, felt that some of the Alexandrian painted grave stelae exhibited a "kühne skizzenartige Manier," and he connected this *kompendiöser Stil* with Petronius's remark about *compendiaria*. He noted in particular the lack of sharp outlines and careful shading in works like the Helixo stele (*Taf.* 51.6). But that the combination of casual workmanship and weathering on these stelae can really be said to amount to a consciously applied impressionistic technique seems to me doubtful.

5. See Sterling Dow, "The Egyptian Cults in Athens," *Harvard Theological Review* 30 (1937): 184–232, esp. pp. 216–24.

of knowing to what extent it could be considered a landscape painting and, if it was, to what extent the landscape could be called impressionistic. I also believe that we can disregard the generally accepted notion that the *facilitas* which Quintilian ascribes to the Greco-Egyptian painter Antiphilus implies the same rapidity in technique which Pliny ascribes to Nicomachus and Philoxenus.[6] It should be remembered that Quintilian's treatment of the history of painting was intended to provide a series of comparisons between the styles of outstanding rhetoricians and painters. The Hellenistic painters in particular are listed according to their *diversis virtutibus* (ἀρεταῖς), that is, the stylistic qualities for which they could serve as *exempla*. It is therefore reasonable to assume that the *facilitas* which Antiphilus displayed in his paintings was analogous to *facilitas* in rhetoric. The Greek word of which *facilitas* (q.v.) was a translation was, as Quintilian himself tells us (*Inst.* 10.10.1), ἕξις, "trained habit, acquired manner, polished skill"; the term does not necessarily imply rapidity or sketchiness.

The other evidence which might associate Antiphilus with the invention of an impressionistic technique is equally unsubstantial. Pliny relates that Antiphilus painted a humorous picture of a man named Gryllus dressed in a ridiculous costume and that, as a result, an entire genus of comic pictures arose which was called *grylli* (γρύλλοι). It seems clear that these *grylli* were some kind of comic caricatures. Since caricatures are generally thought of as being sketchy compositions lacking meticulous linear detail, some have felt that Antiphilus's role in the invention of *grylli* also reflects his role in the invention of an impressionist technique.[7] Yet what Antiphilus really seems to have invented was not caricature in general, but, specifically, animal caricatures.[8] Caricature as such already existed in the fifth century B.C.[9] In the same way the lighting effects which were apparently used to advantage in Antiphilus's painting of a boy blowing on a fire (Pliny *NH* 35.138) do not necessarily suggest an impressionistic technique.[1]

6. See Swindler, *Ancient Painting*, p. 275; Rumpf, *Malerei und Zeichnung*, p. 149; Filippo Magi, *Enciclopedia dell' Arte Antica*, s.v. Antiphilos.

7. Swindler, *Ancient Painting*, p. 275; Rumpf, *Malerei und Zeichnung*, p. 150; Giovanni Becatti, *Enciclopedia dell' Arte Antica*, s.v. Grylloi.

8. Suggested by O. J. Brendel, "Der Affen-Aeneas," *RömMitt* 60–61 (1953–54): 156.

9. The use of caricature in Greek art seems to have had a special connection with the masks used in the Greek theater, especially comic masks. Some of the best early examples of caricature in Greek vase painting appear on pots connected with Attic theatrical festivals. For examples dating from the late fifth century see Margaret Crosby, "Five Comic Scenes from Athens," *Hesperia* 24 (1955): 76–84. A number of late fifth-century vases from the sanctuary of the Cabiri at Thebes are also relevant. See Rumpf, *Malerei und Zeichnung*, p. 118, pl. 38, illus. 2. On theatrical masks and comic figures in general see Margarete Bieber, *The History of the Greek and Roman Theatre*, 2d ed. (Princeton, 1961), pp. 36–50.

1. See Brown, *Ptolemaic Painting and Mosaics*, p. 91. She notes Caravaggio as an example

It is clear from the foregoing discussion that there is no evidence to associate *compendiaria* with Alexandrian impressionism and not much to associate it with impressionism in general. Others have felt that since Philoxenus of Eretria is the only painter whose name is directly associated with *compendiaria,* our understanding of the term should be based on what we can find out about the paintings of Philoxenus. This, in effect, amounts to saying that our understanding of *compendiaria* should be based on the venerable hypothesis that the Alexander Mosaic in Naples[2] is a copy of Philoxenus's painting, executed for Cassander, which *continuit Alexandri proelium cum Dario* (Pliny *NH* 35.110). The technique of the Alexander Mosaic is obviously not "impressionistic"; in fact, it is quite the opposite. Franz Winter and, after him, Heinrich Fuhrmann have suggested, therefore, that *compendiaria* refers not to impressionism but to the way in which many figures in the background of the mosaic are cut off by other figures which are placed in front of them. These background figures could be considered "shortcuts" because the artist was required to draw and paint only a small portion of the full human figure. At least two valid objections can be made to this theory: first, the Alexander Mosaic cannot by any means be proven to be based on a work by Philoxenus; and, second, the type of overlapping and cutting off of figures which appears in the Alexander Mosaic existed in Greek painting and relief sculpture before the fourth century B.C. and hence could not have been "invented" by Philoxenus.[3]

Another possible interpretation of *compendiaria* is that it referred, if not to a full-fledged impressionistic style, at least to a sketchy technique in painting. This was the view of Andreas Rumpf, who, as we have seen, felt that a sketchy style was typical of some of the Alexandrian grave stelae. He also suggested that the use of hatching for shading on the paintings from one of the Macedonian tombs at Naoussa and the use of extremely foreshortened

of a later European painter who produced such effects without an impressionist technique. Another obvious example would be Georges de la Tour.

2. Franz Winter, *Das Alexandermosaik aus Pompeji* (Strassburg, 1909); Heinrich Fuhrmann, *Philoxenos von Eretria* (Göttingen, 1931); for a more recent summary with bibliography see Bernard Andreae, *Das Alexandermosaik,* Opus Nobile no. 14 (Bremen, 1959).

3. Such overlapping was a particularly common device in, for example, Corinthian painting in the seventh and sixth centuries B.C. As an especially prominent example one need only cite the Chigi olpe in the Villa Giulia in Rome (Paolo Arias and Max Hirmer, *Greek Vase Painting* (New York, 1962), pls. 16 and IV).

An example of overlapping in monumental painting is preserved in the story that Micon painted a figure of the hero Butes (apparently in his painting of the Argonauts in the sanctuary of the Dioscuri in Athens) which represented him as hidden behind a rock in such a way that only his helmet and one eye were visible. This figure gave rise to the ancient proverb "quicker than Butes" (equivalent to something like "quicker than you can say Jack Robinson"). See Overbeck, *Schriftquellen,* 1085.

figures like the horses on the Alexander Mosaic might be part of a "kompendiöse Art der Darstellung."[4] This interpretation is certainly possible, although it is difficult to see why Petronius would have found anything peculiarly Egyptian about them. Foreshortening was invented in Greek painting in the late sixth century B.C., was not Egyptian, and could not as a whole be said to have been invented by Philoxenus. *Compendiariae* could, it is true, have referred to special types of foreshortening, but one wonders if a complex foreshortening would really qualify as a shortcut in painting. Hatched shading, on the other hand, is more likely to have so qualified.

Still another interpretation of *compendiaria* is possible. Even though the "Alexandrian impressionism theory" does not seem to be sustained by any evidence, Petronius's association of *compendiaria* in painting with "the audacity of the Egyptians" must have some historical significance, and it is certainly reasonable to search for the key to the meaning of *compendiaria* in the artistic relations between Roman art in the Hellenistic and Julio-Claudian periods and art in Greco-Roman Egypt. We have already had occasion to mention the existence of a certain type of landscape representation, characterized by Egyptian subject matter, found in the pictorial arts in Italy from the first century B.C. onward. The most impressive example of such a landscape is to be found in the great mosaic from the temple of Fortuna at Praeneste,[5] in which a series of vignettes with Egyptian motifs—shrines, crocodiles, and pygmies—are depicted against a background of water and reeds which must represent the Nile. It has frequently been noted that the appearance of the mosaic as a whole is like an illustrated map, in which significant features in a particular geographical area are represented pictorially,[6] and that this type of landscape representation may have some connection with the art which the Greeks called τοπογραφία. This was the general term in Greek geography for a written description of a particular

4. Rumpf, *Malerei und Zeichnung*, p. 150.
5. Now in the Palestrina Museum; see Giorgio Gullini, *I Mosaici di Palestrina* (Rome, 1956) (with the best recent illustrations); Orazio Marucchi, "Il grande mosaico prenestino ed il 'lithostraton' di Silla," *AttiPontAcc, Dissertazioni* 10 (1910): 149–90, pls. 11–14; G. E. Rizzo, *La pittura ellenistico-romana* (Milan, 1929), pls. 188–89; Swindler, *Ancient Painting*, fig. 509. The mosaic probably dates from the time of Sulla's rebuilding of the temple of Fortuna, around 80 B.C., although some scholars have dated it as late as the time of Hadrian; on the arguments for the later date see Eva Schmidt, "Studien zur Barberinischen Mosaik in Palestrina," *Zur Kunstgeschichte des Auslandes* 127 (1929): pp. 9–78. Giulio Iacopi, *Il santuario della fortuna primigenia e il Museo Archeologico Prenestino* (Rome, 1967), p. 24, prefers an Augustan date.
6. Swindler, *Ancient Painting*, p. 318; Dawson, *Romano-Campanian Mythological Landscape Painting*, p. 52n12.

region,[7] but there appears also to have been a kind of pictorial "topography."

Valerius Maximus (5.1.1) mentions a painter named Demetrius, called the τοπογράφος, who painted in Egypt at the court of Ptolemy VI, Philometor. According to Diodorus Siculus (31.18.2), this Demetrius later went to Rome, where he acted as host to Ptolemy Philometor, when the latter was in exile from Egypt in 164 B.C. The migration of artists like Demetrius from Hellenistic Egypt to Rome undoubtedly accounts for the growing popularity of Egyptian motifs in Roman wall paintings and mosaics in general,[8] and the fact that Demetrius was known particularly as a *topographos* may help explain why Egyptian motifs became so common in the type of pictorial landscape exemplified by the Praeneste mosaic. A full discussion of the relationship between Roman painting and the painting of Hellenistic Egypt and an analysis of the nature of Roman landscape painting are beyond the scope of this study. But as far as the problem at hand is concerned, we might suggest that the individual scenes or vignettes which were incorporated into topographic paintings or mosaics (such as the one from Praeneste) were called *compendiariae* in Latin.[9] In Greek they may have been called σύντομα or τὰ συντομώτατα.[1] Not all of these abbreviated topographic landscapes

7. E.g. Strabo 8.1.3.

8. Most of the Egyptian motifs used in Roman wall painting (particularly of the Augustan period) are purely decorative—e.g. the Farnesina house; the Hall of Isis; the golden frieze from the house of Livia in Rome; the villa of Agrippa Posthumus at Boscotrecase; and the house of Lucretius Fronto in Pompeii. The only Roman building in which the content of the Egyptianizing scenes is perhaps to be taken seriously is the temple of Isis from Pompeii; see Olga Elia, *Le pitture del tempio d'Iside* (*Monumenti della pittura antica*), (Rome, 1941), sec, 3, fasc. 3–4.

9. This interpretation is based on ideas derived from lectures given by Peter von Blanckenhagen and O. J. Brendel. On the connection between the "topographic" tradition in Greek painting and later Roman wall painting, see Peter von Blanckenhagen and Christine Alexander, *The Paintings from Boscotrecase* (*RömMitt, sechstes Ergänzungsheft*) (Heidelberg, 1962), pp. 51–58. A number of the Boscotrecase paintings could be classified as *compendiariae*, see esp. pls. 3, 18, 30, 31, 32.

1. If σύντομος or one of its variants is the Greek prototype of *compendiaria*, as seems likely, it is interesting to speculate on which particular meaning of the Greek word may be behind its use in connection with painting.

Aristotle uses συντομία and σύντομος to mean "conciseness" and "concise" in connection with rhetoric (*Rh.* 1407b28, 1414a25). Since Petronius's use of *compendiaria* occurs in a passage in which rhetoric is being discussed, it may be that there was some analogy between the meaning of σύντομος in rhetorical criticism and its meaning in connection with painting.

The term συντομώτατον, however, could mean an actual, geographical, shortcut (e.g. Herodotus 2.158, 4.183; Thucydides 2.97.1). If the theory that *compendiariae* in painting were abbreviated representations of geographical locales (as in the Palestrina mosaic) is correct, it might be that the term, like the Greek τὰ συντομώτατα, meant "shortcuts" in a very literal

need have had Egyptian subjects, but the fact that Egyptian subjects were fairly common in them would be sufficient to explain why Petronius should have looked upon them as being characteristic of the *Aegyptiorum audacia.* If *compendiaria* are, in fact, abbreviated landscapes of the sort found in the Praeneste mosaic, we may perhaps postulate, on the basis of Pliny's association of *compendiaria* with Philoxenus, that simple landscape vignettes, perhaps developed primarily for use in scrolls and decorative maps, first appeared in the early Hellenistic period.

concinnus

1. Pliny *NH* 35.111.

> Adnumeratur his et Nicophanes, elegans ac concinnus ita, ut venustate ei pauci comparentur;

See *cothurnus.*

Commentary

Concinnus, "well adjusted," "skillfully put together," appears to be a translation of the Greek εὔρυθμος (q.v.). Pliny uses the word to describe the leaves of a type of helix: *parva sunt et angulosa concinnioraque, cum reliquorum generum simplicia sunt* (*NH* 6.148). This appears to be a direct translation of the phrase used by Theophrastus to describe this same type of helix: μικρότητι καὶ τῷ γωνοειδῆ καὶ εὐρυθμότερα εἶναι (Theophrastus περὶ Φυτῶν Ἱστορίας 18.8.7). Since Theophrastus is mentioned in the index to book 16 of the *Naturalis Historia* and again in the text (16.144), there is little doubt that the two passages are related.

Cicero uses *concinnus* to refer to a refined, polished style of oratory: . . . *alii in eadem ieiunitate concinniores, idem faceti, florentes etiam et leviter ornati* (*Orat.* 20), especially one variety of Asiatic rhetoric: *concinnis et venustis* (*Brutus* 325). In rhetorical criticism *concinnus* would seem to refer to sentences and phrases which are "well put together, well formed," a meaning that is very close to the basic sense of εὔρυθμος.[2]

The fact that *concinnus* served as a Latin translation of εὔρυθμος may

sense. Perhaps *pictura compendiaria* was the technique of representing in a single scene geographical areas which were actually remote from one another.

2. Alfred Ernout and Antoine Meillet, *Dictionnaire étymologique de la langue latine,* 4th ed. (Paris, 1959), s.v. *concinno,* suggest κομψός, "refinement" as the equivalent of *concinnus* when referring to rhetoric. Εὔρυθμος, however, is equally common in the stylistic criticism of rhetoric. See Dionysius of Halicarnassus *Comp.* 11, 12, 23, 25.

lend support to our contention that *numerosus* is the Latin translation not, as some have thought, of εὔρυθμος but rather of ῥυθμός (see under *numerosus* and εὐρυθμία). The two Greek terms should, as we have said, be distinguished.

On the meaning of passage 1, see *elegans*.

constantia

1. Pliny *NH* 34.66.

. . . Euthycraten . . . constantiam . . . imitatus patris . . .

See *austerus*, passage 1. Note also Vitruvius 6.4.2.

Commentary

The basic meaning of *constantia* (*con* plus *sto*) is "standing firm, firmness," but the term is sometimes used in a more abstract way to mean both "steadfastness in character" and "inner consistency, harmony."

The significance of *constantia* in Pliny's remark about Euthycrates is perhaps to be understood in the light of the terminology of Greco-Roman rhetoric. Pliny seems to have in mind the "austere" and "elegant" *genera* —the αὐστηρὸς χαρακτήρ and γλαφυρὸς χαρακτήρ—which Dionysius of Halicarnassus applies to verbal composition.[3] On the relationship of these *genera* to the terminology of Greek art criticism, see *austerus*. If *constantia* in this passage belongs exclusively to the sphere of rhetorical terminology, it probably refers simply to an overall feeling of harmony in the works of Lysippus and Euthycrates and may in fact be a translation of ἁρμονία. On the other hand, if the term derives ultimately from professional art criticism, it may refer to some specific type of composition.[4] On this question see *iucundus*.

3. Dionysius of Halicarnassus *Comp.* 21 ff.

4. Silvio Ferri has suggested that *constantia* here is a translation of the Greek σύστασις (*NC*, pp. 139–40). He places particular emphasis on the linguistic similarity of the two words (*con*=σύν; *sto*=ἵστημι), although he ignores the different character of their suffixes. He also notes that σύστασις is a synonym of σύνθεσις, the word which Dionysius of Halicarnassus uses for verbal composition (the Greek title of *De Compositione Verborum* is περὶ συνθέσεως ὀνομάτων). When Pliny uses *constantia* in connection with Euthycrates and Lysippus, Ferri proposes, he means "composition," and the passage as a whole means that Euthycrates used his father's theories of συμμετρία as a model but failed to capture (or did not wish to capture) the χάρις or γλαφυρία (i.e. *elegantia*) which characterized his father's work. Lysippus's system of composition, it is further proposed, may have been classed under the αὐστηρὸς σύνθεσις because, like the austere style of verbal composition, it was rigidly architectonic.

consummatus

1. Pliny *NH* 34.56.

Hic consummasse hanc scientiam iudicatur et toreuticen sic erudisse, ut Phidias aperuisse.

He [Polyclitus] is judged to have perfected this science [bronze casting?] and to have refined *toreutikē*, just as Phidias is judged to have opened it up.

2. Pliny *NH* 35.18.

. . . fatebiturque quisquis eas diligenter aestimaverit nullam artium celerius consummatam, cum Iliacis temporibus non fuisse eam appareat.

. . . and whoever evaluates these works [early paintings in Italy] carefully will admit that none of the arts reached maturity more quickly [than painting], since it would appear that it did not exist at the time of the Trojan War.

3. Pliny *NH* 35.66.

[Zeuxis] processit iratus operi et dixit: "uvas melius pinxi quam puerum, nam si et hoc consummassem, aves timere debuerant."

[Zeuxis painted a picture of a boy carrying some grapes. When some birds flew up to the picture to peck at the painted grapes], he strode up to the work in anger and said: "I painted the grapes better than the boy, for if I had painted him perfectly too, the birds would have been afraid."

4. Pliny *NH* 35.71.

Fecundus artifex, sed quo nemo insolentius usus sit gloria artis, namque et cognomina usurpavit habrodiaetum se appellando aliisque versibus principem artis et eam ab se consummatam. . . .

He [Parrhasius] was a prolific artist, but no one enjoyed the glory of the art with greater insolence, for he adopted a number of cognomens, calling himself the "Lover of Pleasure" and, in other verses, saying that

The usual opinion of modern critics has been that Pliny is referring to a general quality of "consistency" or perhaps "harmony" in the work of Lysippus. Brunn, for example, translates *constantia* as "Beharrlichkeit" (*GGK*², 1:286).

he was the "Prince of the Art" and that it had been brought to perfection by him . . .

5. Pliny *NH* 35.122.

Quidam Aristidis inventum putant, postea consummatum a Praxitele;
. . .

Some think that it [the encaustic technique] was an invention of Aristides, and that it was later perfected by Praxiteles . . .

Commentary

Consummatus, "brought to the highest degree, perfect," was commonly used to describe the nature of an intellectual discipline—rhetoric or art, for example—when it had reached its fullest development; hence Quintilian with reference to eloquence: *Nam est certe aliquid consummata eloquentia, neque ad eam pervenire natura humani ingenii prohibet (Inst.* 1.proem.20); or Pliny on the art of viticulture: *In nostra aetate pauca exempla consummatae huius artis fuere (NH* 14.47).

In passages 4 and 5 the word seems clearly to be derived from original Greek sources. In passage 4, in fact, it is even possible that *consummatus* translates a word which Parrhasius used to describe his own art. The Greek word in question was very likely τέλεος (q.v), which had a variety of systematic and technical usages in Greek art criticism. Whether Parrhasius was speaking of the formal perfection of his art or simply making a general boast is not clear. In view of the context of the passage the latter seems more likely.

Passage 5, on the invention and development of encaustic painting by Aristides and Praxiteles has sometimes been attributed to Xenocrates.[5] The fact that "Xenocrates" appears otherwise to have ignored Praxiteles perhaps suggests, however, that Pliny derived this passage from some later writer, possibly Antigonus, who had devoted a special section to the various claimants for the honor of having first invented encaustic.[6] *Consummatus* clearly refers here to the perfection of a technique.

There is no reason for thinking that τέλεος = *consummatus* is used in passages 4 and 5 with the meaning of "perfection derived from mathematical correspondences," a meaning which it seems to have had in the professional art criticism of the Classical period. That use may be reflected, however,

5. Sellers, *EPC*, p. xxxiii; Robert, *Arch. März.*, p. 69.
6. Xenocrates may have attributed the invention of encaustic painting to Pausias; others to Polygnotus and Nicanor; and still others to Aristides. See Pliny *NH* 35.122–23.

in passage 1 by the verb *consummasse* (=τελεῶσαι) which seems to be part of the "Xenocratic" scheme. The exact meaning of passage 1 has been disputed. Silvio Ferri[7] has criticized many of his predecessors for equating *hanc scientiam* and *toreuticen* and connecting both with the verb *consummasse*, thus interpreting the passage to mean that Polyclitus perfected the art of *toreuticē*.[8] *Scientiam*, Ferri feels, refers, in passage 1, not to *toreuticen* but to Polyclitus's own theories of proportion, the content of his famous *Canon* mentioned by Pliny in *NH* 34.55; and *consummasse* means not "to have perfected" but rather "to have summed up." The Greek word which *consummasse* translates, Ferri feels, is συνκεφαλαιόω.[9] The passage would then mean that Polyclitus "summed up" the *scientia* of proportions, that is, that he wrote down his ideas in a highly abbreviated form. Ferri further suggests that the passage is intended as a criticism of Polyclitus rather than as praise; *iudicatur* may mean that Polyclitus "was blamed" or "was censured" for abbreviating the science of proportion too much, that is, for presenting his conclusions in a kind of shorthand that was difficult to understand.[1]

Ferri could be correct in separating *scientiam* from *toreuticen* and in suggesting that *scientiam* (ἐπιστήμη?) refers to Polyclitus's system of proportions, although the context of Pliny's remarks make it more likely that he is referring, in a general way, to the art of making bronze statues. In spite of the ingenuity shown in his interpretation of *consummasse*, however, I prefer to retain the more traditional translation of "perfect, bring to perfection," rather than "sum up." Polyclitus's *Canon* may have consisted of a variety of numerical proportions which were arranged in "perfect numbers," which the Greeks called τέλεια.[2] Perhaps *consummasse* refers to this numerical perfection in the *Canon* and should be translated by τελεῶσαι.

Passage 3, Pliny's anecdote about Zeuxis's painting of a boy and some grapes, may again represent the use of *consummasse* to translate τελεῶαι, but the context is clearly that of "popular criticism," and the verb must mean "execute perfectly" in a general sense.

Passage 2, Pliny's comment on the rise of Italian painting, in which art is discussed as a self-developing phenomenon independent of artists and

7. Ferri, *NC*, pp. 140–42.

8. Jahn, *UKP*, p. 129. Brunn, *GGK*[2], 1:153, distinguishes between *hanc scientiam* and *toreuticen* (i.e. the theory behind the art and the art itself) but feels that *consummasse* means that Polyclitus perfected both. On the meaning of τορευτική see chap. 6, n. 4.

9. *Summa*, in the sense of "heading" or "summary," may be related to κεφάλαιον "summing up, summary" (e.g. Plato *Ti.* 26C: ἐν κεφαλαίοις).

1. Note, however, that the use of *iudicatur* in *NH* 34.55, *artem ipsam fecisse artis opere iudicatur*, does not seem to imply a derogatory criticism.

2. See τέλειος and *perfectus*.

personalities,[3] may reflect an approach to the history of art which is related, in principle if not in detail, to the Roman "museographic theory" (see *audacia* and *successus*). Just as painting was said to have attained *claritas* (*NH* 35.55) through its own inner evolution, so also it was perhaps thought to have become eventually *absolutus* (35.17) or *consummatus*. It may be significant that all the passages which employ this approach to works of art discuss primarily Italian art. As with the museographic theory, the basic idea seems to be Roman, and we need not hypothesize a Greek term underlying the Latin.

cothurnus

1. Pliny *NH* 35.111.

> Adnumeratur his et Nicophanes, elegans ac concinnus, ut venustate ei pauci conparentur; cothurnus et gravitas artis multum a Zeuxide et Apelle abest.

> Among these artists [Nicomachus, Philoxenus, and others] should also be numbered Nicophanes, an elegant and polished artist, to whom few are comparable for the beauty of their work; but the dramatic seriousness and gravity of his art falls far short of that of Zeuxis or Apelles.

Commentary

Cothurnus = Greek κόθορνος, literally a "high boot" used by actors in tragedy, is probably to be translated here as "tragic seriousness" or "depth." (For the Greek use of the word see Herodotus 1.155; for its association with Dionysus, the presiding deity of tragedy, see Aristophanes *Ran.* 47.)

The symbolic use of *cothurnus* to mean "tragic seriousness" occurs only in Latin: see Quintilian *Inst.* 10.1.68, . . . *gravitas et cothurnus et sonus Sophocli* . . . ; Vergil *Ecl.* 8.10; Horace *Carm.* 2.1.12, and elsewhere. The similarity in the phraseology between the passage from Pliny and Quintilian (*cothurnus et gravitas*) suggests that they are drawing from a common source—probably the stylistic terminology of late Hellenistic rhetoric. Pliny's comparison of Nicophanes with Zeuxis and Apelles is perhaps modeled on the distinction between the γλαφυρὸς and the αὐστηρὸς χαρακτήρ of composition in rhetorical criticism (see *elegans, floridus,* and *austerus*). Cicero, in *Brutus* 325, uses terminology very similar to that of Pliny to describe the

3. See, for example, *NH* 35.29: *tandem se ars ipsa distinxit et invenit lumen atque umbra.*

difference between the two types of Asiatic rhetoric: *sententiis non tam gravibus et severis quam concinnis et venustis* . . .

The purely rhetorical nature of the criticism contained in the passage quoted above is made more apparent by a contrast with the second passage which Pliny devotes to Nicophanes (*NH* 35.137). Here the painter is praised for his understanding and control of theoretical aspects of painting (*diligentia quam intellegant soli artifices*) and is cited (and perhaps criticized) for the "hardness" of his colors (see *durus* and *diligens*). The different tone of Pliny's judgments in this case seems to indicate an altogether different source, probably one which had access to the criteria of professional criticism.

cura

1. Pliny *NH* 34.92. See *diligens*, passage 7.

2. Pliny *NH* 35.80.

 . . . Protogenis opus immensi laboris ac curae supra modum anxiae

 See *laboriosus, labor,* passage 1.

3. Quintilian *Inst.* 12.10.6.

 Nam cura Protogenes . . . praestantissimus est.

 For care [or "attentiveness"] Protogenes . . . was foremost.

Commentary

Cura refers to "extreme care" or "painstaking attentiveness" in the work of an artist. It is closely connected with *labor* (q.v.) and seems to be related to μελέτη or ἐπιμέλεια in Greek. *Laboris ac curae* in passage 2 seems to parallel closely τῆς μελέτης καὶ τῆς ἐπιμελείας as used by Demosthenes *De Cor.* 309.

Passage 2 is perhaps derived from a section of Apelles' own writings on painting in which he contrasted his own χάρις with the stylistic characteristics of other painters (see διάθεσις and χάρις). Protogenes was famed for his tendency to agonize over each detail of his paintings (see *NH* 35.102–03). He took, for example, seven years to finish his *Ialysos* (on the relevant passages see *labor* and θαυμαστός). Apelles appreciated and praised this thoroughness but observed that, unlike himself, Protogenes had no innate sense which told him when to stop struggling with a painting (*manum de tabula tollere;* see Pliny *NH* 35.80).

Quintilian's citation of *cura* as Protogenes' stylistic *virtus* (see chap. 7) is most likely derived from Apelles' writings or from a popular source such as Duris who recorded Apelles' opinion.

Pliny's observations on the *diligentia* and *cura* of the sculptor Callimachus pose an interpretive problem. Modern critics usually see Callimachus as one of the Athenian sculptors of the later fifth century B.C. who developed the elegant "flying drapery" style found in the sculptures of the parapet from the temple of Athena Nike in Athens. Sculptures in this style were characterized by extensive application of the running drill, and we have the testimony of Pausanias (1.26.7) that Callimachus was particularly adept in the use of this tool. Perhaps the simplest interpretation of *cura* and *diligentia* in this case is that they referred to an elaboration of the surface detail of Callimachus's work with ridges, furrows, swirls, and the like. We have noted, however, that *diligentia* seems at times to translate a rather technical use of ἀκρίβεια in the sense of "precision in the application of theoretical principles in a work of art." There is a (perhaps remote) possibility that Pliny's source used the term in this sense with regard to Callimachus and that Pliny himself, not understanding the term (he does say that it was something which *intellegant soli artifices*), took it to mean attentiveness in the Protogenean sense. This interpretation of *diligentia*, if true, would change the meaning of the passage considerably. It would suggest that Callimachus's unusual preoccupation with theory robbed his work of spontaneity.[4]

decor

1. Vitruvius 1.2.1.

> Architectura autem constat ex ordinatione, quae graece taxis dicitur, et ex dispositione, hanc autem Graeci diathesin vocitant, et eurhythmia et symmetria et decore . . .

> Architecture consists of order, which in Greek is called *taxis,* and of arrangement, which the Greeks call *diathesis;* also of *eurhythmia* and *symmetria* and appropriateness . . .

2. Vitruvius 1.2.5–7.

> Decor autem est emendatus operis aspectus probatis rebus conpositi

4. In this connection it is perhaps worth noting that Pausanias 1.26.7, describes Callimachus as "not among the foremost artists" but as σοφίᾳ πάντων . . . ἄριστος. The term probably means simply "clever" or "skillful," but I would call attention again to the suggestion of some scholars that the term is connected with the theoretical basis of an art (chap 1, n. 28).

cum auctoritate. . . . Veneri, Florae, Proserpinae, Fonti Lumphis corinthio genere constitutae aptas videbuntur habere proprietates, quod his diis propter teneritatem graciliora et florida foliisque et volutis ornata opera facta augere videbuntur iustum decorem. . . . Ad consuetudinem autem decor sic exprimitur, cum aedificiis interioribus magnificis item vestibula convenientia et elegantia erunt facta. Si enim interiora prospectus habuerint elegantes, aditus autem humiles et inhonestos, non erunt cum decore. . . . Naturalis autem decor sic erit, si primum omnibus templis saluberrimae regiones aquarumque fontes in his locis idonei eligentur. . . . Item naturae decor erit, si cubiculis et bybliothecis ab oriente lumina capiuntur.

Decor is the faultless appearance of a work composed from the right parts with a sound basis. [It is based on convention, Greek *thematismos,* or on standard usage, or on natural circumstances. For example, it is based on convention when open-air temples are built to the sky god Jupiter, and austere Doric temples are built to martial gods and goddesses, like Mars, Minerva, and Heracles.] Temples designed in the Corinthian order will appear to have the features suitable to Venus, Flora, Proserpine, Fountains, and Nymphs, because for these deities, on account of their gentle nature, works which are constructed so as to be rather graceful and to have a floral quality, in other words those decorated with foliage and volutes, will seem to have exactly what is appropriate. [Deities of an intermediate nature, like Diana and Bacchus will be best served by the Ionic order.] As for standard usage, appropriateness will be achieved when harmonious and elegant vestibules are made to fit magnificent interiors in buildings. For if interiors have elegant appearances, but have approaches which are lowly and ugly, they will not be executed with appropriateness. [The same will be true if the architect mixes the details of the different architectural orders.] And finally, appropriateness derived from natural circumstances will occur if, first, the most salubrious sites for all temples are chosen and there are suitable springs in the places. [On such sites temples should be built to deities like Asclepius.] Again, there will be appropriateness of natural circumstances, if light for bedrooms and libraries is derived from the east . . .

3. Vitruvius 6.2.5. See $\varepsilon\dot{\upsilon}\rho\upsilon\theta\mu\dot{\iota}\alpha$, passage 6.

4. Vitruvius 7.5.4.

Iudiciis autem infirmis obscuratae mentes non valent probare, quod potest esse cum auctoritate et ratione decoris.

[Criticizing those who approve of the fantastic wall paintings of his day:] Minds obscured by weak powers of judgment are not able to make a valid judgment, with authority and with rational knowledge of what is appropriate about what can exist in reality.

See also Vitruvius 6.5.2, 6.7.7, 7.4.4.

5. Quintilian *Inst.* 12.10.7–8.

Diligentia ac decor in Polyclito supra ceteros, ciu quanquam a plerisque tribuitur palma, tamen, ne nihil detrahatur, deesse pondus putant. Nam ut humanae fromae decorem addiderit supra verum, ita non explevisse deorum auctoritatem videtur.

The precision of detail and appropriateness in the art of Polyclitus surpassed that in the work of other artists; he was an artist in whom, although he is given the victor's palm by many, they nevertheless feel (lest they find themselves in the position of saying nothing derogatory about him) that a certain weightiness is lacking. For though he gave an ideally appropriate form to the human body, he is felt not to have expressed the impressiveness of the gods.

Commentary

Decor is connected with *decet* in the basic sense of "it is seemly, fitting, or proper." Along with another variant, *decorum,* the term implies the quality of a thing's "being as it should be," hence "appropriateness" or "propriety." *Decorum* more often implies propriety in an ethical sense, *decor* in an aesthetic sense. Hence the latter frequently, and the former sometimes, can be used to express the "comeliness, elegance," or "beauty" which arises when a person or thing is appropriately or suitably adorned.

Vitruvius lists *decor* as one of the six basic components of architecture along with τάξις (ordinatio), διάθεσις (dispositio), συμμετρία, εὐρυθμία, and οἰκονομία (*De Arch.* 1.2.1 ff.). *Decor* is the only Latin term on the list for which no Greek equivalent is given. In passage 2, he defines *decor* as the "faultless appearance of a work composed from approved details with *auctoritas*" (q.v.). More important than this broad definition, however, are the examples which Vitruvius gives of *decor* in passage 2. In all of these examples it will be seen that the essential idea behind *decor* is appropriateness—the form given to a building must be appropriate to the building's meaning.

The idea of appropriateness is also essential to the other examples of the use of *decor* in the *De Architectura.* In passage 3, for example, he says that once a mathematical system of *symmetria* for a particular building has been calculated from selected modules, an adaptation of this system to *decor* must

follow in order that the temple have "good form" ($\varepsilon\vec{v}\rho\upsilon\theta\mu\acute{\iota}\alpha$, q.v.). *Decor* must refer here to a specific style in which a particular building is to be built (e.g. a Corinthian temple or an Ionic temple). Any abstract system of measurements would have to be adjusted to the particular style of the building, that is, its appropriate form, its *decor*. In passage 4, which forms part of his criticism of the anticlassical trends in the painting of his day, Vitruvius says that minds obscured by weak judgment cannot appreciate the value of art produced with "authority [or 'competence' or 'sound judgment'] and with a rationale of appropriateness" (*cum auctoritate et ratione decoris*). The real failing of the type of painting which showed reeds holding up roofs or statues growing from stalks (Vitruvius 7.5.4) was that it lacked "appropriateness" in Vitruvius's eyes. There was semantic incongruity in such painting because the forms employed had no referent in "reality" (see $\grave{\alpha}\lambda\acute{\eta}\theta\varepsilon\iota\alpha$-*veritas*); their meaning was "false" in Vitruvius's reasoning and hence inappropriate.[5]

The most probable Greek equivalent of *decor* in architecture and in other disciplines was $\tau\grave{o} \pi\rho\acute{\varepsilon}\pi o\nu$.[6] The commentary under $\delta\iota\acute{\alpha}\theta\varepsilon\sigma\iota\varsigma$ discusses Carl Watzinger's proposal that Vitruvius's six basic components of architecture should be arranged in three pairs, one term in each pair referring to an architect's $\check{\varepsilon}\rho\gamma o\nu$, the other to the $\tau\acute{\varepsilon}\lambda o\varsigma$, "goal" or "effect" of that $\check{\varepsilon}\rho\gamma o\nu$. The terms $o\grave{\iota}\kappa o\nu o\mu\acute{\iota}\alpha$ and *decor*-$\pi\rho\acute{\varepsilon}\pi o\nu$, Watzinger suggested, formed one of these pairs. Vitruvius's two-part definition of $o\grave{\iota}\kappa o\nu o\mu\acute{\iota}\alpha$ seems to support Watzinger's contention: "Economy" is described first as the use of suitable building material, that is, materials appropriate to the type of building being constructed and the site at which the construction takes place (1.2.8). The second phase of Vitruvius's definition of $o\grave{\iota}\kappa o\nu o\mu\acute{\iota}\alpha$ states that houses and villas should be appropriate to the person for whom they are built, that is, the houses of city businessmen should differ from those of country squires, and so on (1.2.9). It is clear from these definitions that $o\grave{\iota}\kappa o\nu o\mu\acute{\iota}\alpha$, like *decor*, deals with the question of appropriateness.

Watzinger proposed that Vitruvius's chapter on the components of architecture was a somewhat confused version of a system of architectural aesthet-

5. We are concerned here only with Vitruvius's point of view. It is quite obvious. that other critics, especially the painters themselves, must have disputed Vitruvius's analysis of this style of painting.

6. See Carl Watzinger, "Vitruvstudien," *RhM* 64 (1909): 215; Schlikker, *HV*, p. 108. André Jolles, *Vitruvs Aesthetik* (Freiburg Br., 1906), and Otto Puchstein, *RE*, s.v. *Architektura*, suggested $\kappa\acute{o}\sigma\mu o\varsigma$. Schweitzer, *Xenokrates*, p. 35, has suggested $\kappa o\sigma\mu\acute{o}\tau\eta\varsigma$ and $\varepsilon\grave{\upsilon}\tau\alpha\xi\acute{\iota}\alpha$; he cites as evidence the (pseudo-) Platonic *Definitiones* (412D): $\kappa o\sigma\mu\acute{o}\tau\eta\varsigma$ $\acute{\upsilon}\pi\varepsilon\iota\xi\iota\varsigma$ $\grave{\varepsilon}\kappa o\upsilon\sigma\acute{\iota}\alpha$ $\pi\rho\grave{o}\varsigma$ $\tau\grave{o}$ $\phi\alpha\nu\grave{\varepsilon}\nu$ $\beta\acute{\varepsilon}\lambda\tau\iota\sigma\tau o\nu$, $\varepsilon\grave{\upsilon}\tau\alpha\xi\acute{\iota}\alpha$ $\pi\varepsilon\rho\grave{\iota}$ $\kappa\acute{\iota}\nu\eta\sigma\iota\nu$ $\sigma\acute{\omega}\mu\alpha\tau o\varsigma$ ("willing compliance to the best appearance. Good order in bodily movement"). These terms lack, however, the essential idea of appropriateness which is essential to *decor*.

ics formulated by Posidonius, which, in turn, was eclectic, deriving terms and ideas from other philosophical schools and having many parallels in the criticism of rhetoric and other disciplines. This derivation is certainly possible, but the background of the different aesthetic terms which Vitruvius uses is so diverse, and his use of them at times so obscure, that it seems doubtful to me that his entire section on aesthetics was adopted in toto from any single Greek writer (see chap. 5). The *decor*-πρέπον principle provides a very good example of just how complex the philosophical and critical background of Vitruvian terminology can be.

The history of τὸ πρέπον has been the subject of a thorough analysis by Max Pohlenz.[7] The verb πρέπω in its most basic sense meant "to be seen clearly, to be conspicuous." From referring to whatever was conspicuous in a person or thing it came to refer to what was "characteristic" or "natural" in a thing, that is, the thing's most conspicuous trait. And since whatever was natural in persons or things could be considered "appropriate" to them, this meaning also came to be attached to the verb. The "appropriateness" expressed by πρέπω, τὸ πρέπον, and so on was recognized in human behavior and also in the appearance of objects.[8]

The first systematic use of τὸ πρέπον as a term in a branch of art criticism seems to occur in the Peripatetic analysis of rhetorical style. In the third book of the *Rhetoric* Aristotle insists that the style chosen in rhetoric, as in poetry, should be appropriate to the subject—trivial matters should not be cloaked in weighty language, ordinary ideas should not be expressed in highly ornamental language, and so on. Following the line of thought developed by his teacher, Aristotle's pupil Theophrastus established πρέπον as one of the basic ἀρεταὶ τῆς λέξεως (see ἀρετή).[9]

In Hellenistic literary criticism, particularly among the Alexandrian commentators on Homer, the use of the πρέπον principle seems to have been

7. Max Pohlenz, "τὸ πρέπον," *NAKG, Phil.-Hist. Klasse* (1933), pp. 53–92.

8. Of the many references collected by Pohlenz note particularly Plato *Ion* 540B ff. and *Hippias Maior*, 294C ff. In the former, Ion justifies the rhapsode's profession by asserting that although a rhapsode may not have the real knowledge which would be typical of the people he impersonates—e.g. a physician—he does know ἃ πρέπει . . . εἰπεῖν, "what ought to be said," that is, what is in character for all types of people. In the *Hippias Maior* the doctrine that beauty is dependent upon τὸ πρέπον (e.g. a man becomes beautiful when his clothing and shoes fit him) is ascribed to Hippias. Neither idea represents Plato's own view, but both probably represent popular viewpoints of his time.

9. Aristotle *Rh.* 3.7.1–5 (1408a): τὸ δὲ πρέπον ἕξει ἡ λέξις ἐὰν ᾖ παθητική τε καὶ ἠθικὴ καὶ τοῖς ὑποκειμένοις πράγμασιν ἀνάλογον. W. Rhys Roberts suggests on the basis of this passage that "the Greek rhetoricians drew the term from the language of ethics" (see *Dionysius of Halicarnassus on Literary Composition* [London, 1910], p. 319, note on πρέπον). On Theophrastus see Cicero *Orat.* 79, where *quid diceat circumspicietur* is identified as one of Theophrastus's stylistic criteria.

applied particularly to human character. It was felt that the words which a character spoke in a drama or a narrative poem should always be appropriate to his rank, position, and role. If, when judged by Alexandrian standards, they seemed not to be fitting, they were often athetized.[1] As a typical example: Zenodotus excluded *Il.* 24.1.24, in which Hermes is said to have stolen the corpse of Hector from Achilles, because τὸ γὰρ κλέπτειν δὲ 'Ερμοῦ θεοῖς οὐ πρέπον, stealing was improper behavior for a god.

The final major stage in the development of the πρέπον idea in the Greek world, Pohlenz suggests, was the achievement of Panaetius. Basing his interpretation mainly on Cicero's restatement of Panaetius's thought in the *De Officiis,* Pohlenz proposes that Panaetius fused the traditional aesthetic values of πρέπον with the idea of moral propriety which had developed particularly in early Hellenistic literary criticism. The highest ethical goal of man was to live a ὁμολογούμενος βίος, a "consonant life," which by its moral rectitude was an expression of the cosmic *logos.* Such an existence was a source of aesthetic as well as moral satisfaction. It made behavior congruous with the deepest nature of man and was hence πρέπον; at the same time it was an outward expression of the inner harmony and order of the soul: "Das Sittlichgute ist nichts anderes als die harmonische Vollendung der menschlichen Natur, es ist damit aber zugleich das Schöne, das nach aussen hin im einzelnen als πρέπον in Erscheinung Tritt."[2]

As one would naturally suspect, this concept of τὸ πρέπον as a quality which was at once both spiritual and aesthetic, formulated by one of the first and most influential philosophers of the Middle Stoa, seems to have been of considerable importance in the *phantasia* theory. Quintilian's attribution of *decor supra verum* to the art of Polyclitus (passage 5) probably meant that the outward harmony of Polyclitan figures was felt to convey the higher nature of the human ψυχή. Perhaps πρέπον-*decor* was also ultimately the basis of the evaluation of Phidias in the *phantasia* theory. His achievement was thought to have been the discovery of forms which were appropriate to the natures of the deities which he represented (*adeo maiestas operis deum aequavit*; see *maiestas,* passage 3).

If with this background in mind we return to the question of what Vitruvius's source for his use of *decor* might have been, it seems to me that the evidence points more to Peripatetic than Stoic influence.[3] Vitruvius's *decor* is a

1. See Pohlenz, *NAKG* (1933), p. 68.
2. Ibid., p. 92.
3. Besides Watzinger, Schlikker also favored a Stoic background for *decor* in Vitruvius (*HV*, pp. 96–112). In his opinion the *decor* concept was the rallying point for all late Hellenistic, classicistic art criticism, just as *eurhythmia* had been the basic critical standard of early Hellenistic criticism, and *symmetria* had been the basic standard of Classical criticism. Pohlenz,

purely aesthetic term, like the Peripatetic use of πρέπον in rhetoric,[4] and lacks the moral or religious connotations of the term as used in the Middle Stoa. In addition, Vitruvius's association of *decor* with *oeconomia* seems to have Peripatetic overtones. Aristotle uses the adjective οἰκεῖος as a synonym of πρέπον, and Theophrastus, as indicated by Demetrius, seems also to have used οἰκεῖος in the sense of appropriateness.[5] It is possible that Vitruvius, in his definition of οἰκονομία, has fused οἰκονομία (like οἰκεῖος, from οἶκος, "house," hence originally "domestic management") with οἰκειότης.[6]

But perhaps even the extent of Peripatetic influence on Vitruvius should, in the final analysis, not be pressed too far. The *decor* concept, as pointed out in chapter 5, had a life of its own in Roman thought and appears to have played a more important role in connection with the visual arts than it did in Greek thought.

dignatio, dignus, dignitas

1. Vitruvius 3.praef.2.

> Maxime autem id animadvertere possumus ab antiquis statuariis et pictoribus, quod ex his, qui dignitates notas et commendationis gratiam habuerunt, aeterna memoria ad posteritatem sunt permanentes, uti Myron, Polycletus, Phidias, Lysippus ceterique, qui nobilitatem ex arte sunt consecuti.

> [Some artists of great ability are well known, while others of equal ability are little-known.] We can observe this particularly well in the case of ancient sculptors and painters, because out of these there are some who have a recognized worth and have the satisfaction of com-

NAKG (1933), pp. 89–90, makes brief reference to Vitruvius's use of *decor* but does not suggest that it has any particularly close connection with Stoicism.

4. On the continuation in Roman rhetorical criticism of the πρέπον idea and the other ἀρεταί τῆς λέξεως see ἀρετή. In particular note Cicero *Orat.* 70: πρέπον *appellant hoc Graeci, nos dicamus sane decorum.* See also J. C. Ernesti, *Lexicon Technologiae Latinorum Rhetoricae* (Leipzig, 1797), p. 103, s.v. *decorum.*

5. Aristotle 3.7.4: ἡ οἰκεία λέξις. Demetrius *Eloc.* 114: Θεοφράστος οὕτως, ψυχρόν ἐστι ὑπερβάλλον τὴν οἰκείαν ἀπαγγελίαν . . .

6. The literal meaning of οἰκεῖος is "pertaining to the house." Hence it could refer to things which "belonged to the family." From that it came to mean "one's own" and also "personal" or "private." What was "personal" was "proper to oneself," hence, as a final extension, the term came to mean "fitting or suitable." Οἰκονομία was also a term of literary criticism in the sense of "managing or organizing one's material"; see Dionysius of Halicarnassus. *Comp.* 18; Longinus *Subl.* 1.4. The connection of οἰκονομία with appropriateness, however, is confined to Vitruvius.

mendation and who are permanently enshrined in unending memory
for posterity—men like Myron, Polyclitus, Phidias, Lysippus, and
others, who have attained renown from their art. [And there are others
who were also gifted but who won no substantial reputation.]

2. Vitruvius 4.3.8.

In mediano contra fastigium trium triglyphorum et trium metoparum
spatium distabit, quod latius medium intercolumnium accedentibus
ad aedem habeat laxamentum et adversus simulacra deorum aspectus
dignitatem.

[Description of the arrangement of triglyphs and metopes in the systyle
class of temples:] In the middle [of the frieze] against the pediment
there will be a space of three triglyphs and three metopes, in order
that the middle intercolumniation, being wider, may provide ample
room for those approaching the temple and a dignified aspect as one
views the images of the gods.

See also Vitruvius 1.2.9, 2.7.4, 4.3.1, 5.1.6, 5.2.1, 6.7.3, 7.4.4.

3. Seneca *Controv.* 10.5.8.

Non vidit Phidias Iovem, fecit tamen velut tonantem, nec stetit ante
oculos eius Minerva, dignus tamen illa arte animus et concepit deos
et exhibuit.

Phidias did not see Zeus, but nevertheless he represented him as the
Thunderer; nor did Athena stand before his eyes; his soul, however,
was worthy of that art, and hence he conceived the deities' appearance
in his mind and portrayed them.

4. Pliny *NH* 34.74.

Cresilas* . . . et Olympium Periclen dignum cognomine [fecit].

*Ctesilas **V**.

Cresilas . . also made an Olympian Pericles, a work worthy of its
cognomen.

5. Pliny *NH* 34.79.

Lycius Myronis discipulus fuit, qui fecit dignum praeceptore puerum
sufflantem languidos ignes. . .

Lycius, who was a pupil of Myron, made a statue, worthy of his teacher, of a boy blowing on a faint fire. . .

6. Pliny *NH* 34.93.

Tot certaminum tantaeque dignationis simulacrum id fuit.

[A statue of Hercules in a tunic bore three inscriptions stating who the prominent Romans were who had owned it at different times.] So many were the rivalries connected with the statue and so great was its value.

7. Pliny *NH* 35.22.

Dignatio autem praecipua Romae increvit. . .

But the principal increase in the value attached to the art of painting took place in Rome [when Messala exhibited a painting illustrating his victory over the Carthaginians in 264 B.C.]

8. Pliny *NH* 35.28.

Hactenus dictum sit de dignitate artis morientis.

So much may be said for the value of this art which is now dying out [i.e. the art of painting].

9. Pliny *NH* 35.55.

Tanta iam dignatio picturae erat.

[Myrsilus of Lydia paid its weight in gold for a picture by Bularchus.] So great had the value of the art of painting become [by that time].

10. Pliny *NH* 35.128.

Hic primus videtur expressisse dignitates heroum et usurpasse symmetrian, sed fuit in universitate corporum exilior et capitibus articulisque grandior.

He [Euphranor] seems to have been the first to have expressed the dignified traits of heroes and to have made [extensive?] use of *symmetria*, but he made the body as a whole too thin and the head and limbs too large.

Commentary

Dignatio, "worth," is used by Pliny to mean "financial value," i.e. worth

in terms of money. Passages 6, 7, and 9 may be based on information derived from Varro, or they may represent Pliny's own inquiries into the traditions of the art market of his time.

Dignum and *dignitas* are used to imply worth in a moral and intellectual sense. Passages 3, 4, 5, and 10 appear to be derived from Greek sources, although the exact sources in most cases are not immediately apparent. Passage 10, with its mention of *symmetria* (and possibly also passage 5), appears to have a connection with "Xenocratic" criticism. Passage 3, in which Seneca dwells on Phidias's excellence in conveying the qualities of the gods, is probably to be associated with the *phantasia* theory. The other passages offer little internal evidence by which they could be ascribed to a particular source.

The Greek equivalents of *dignus* and *dignitas* are in all probability ἄξιος and ἀξία. Like *dignus*, ἄξιος had the general meaning of worth in both a concrete and a moral sense. Thus Plato speaks of both the ἀξία of a slave (*Leg.* 936D) and also the ἀξία of a government (*Leg.* 945B). With reference to art, Dio Chrysostom, *Or.* 12.52, speaks of τὴν ἀξίαν μορφὴν τῆς θεοῦ φύσεως of Phidias's Zeus at Olympia. The similarity between this judgment and Seneca's remarks on Phidias in passage 3 should be noted. (Both passages may have some connection with the *phantasia* theory.) Compounds formed from ἄξιος, such as ἀξιοθέατος, also occur in the literature on art.[7]

In passages 3, 4, 5, and 8 ἄξιος and ἀξία fit perfectly as equivalents of *dignus* and *dignitas*. There is no indication that these passages are connected with any particular system of art criticism. They can refer to either artists or works of art.

Vitruvius's use of *dignitas* in passages 1 and 2 may well be independent of a Greek prototype.

Passage 10, referring to Euphranor's ability to express the *dignitas heroum* as well as his mastery of συμμετρία, raises the problem of whether or not "Xenocrates" used nonobjective criteria such as *dignitas* = ἀξία in his scheme of art criticism as well as technical features such as συμμετρία. In Pliny *NH* 35.98, in an apparently "Xenocratic" passage, the painter Aristides was credited with first having introduced ἤθη and πάθη into painting. In the commentary on *animum et sensus pingere* it is suggested that the statement about ἤθη may have been an addition to "Xenocrates'" material made by Antigonus or some later source. The same suggestion, which is only a hypothesis, can also be made here. Since Pliny attributes the introduction of *symmetria* into painting to Parrhasius, a predecessor of Euphranor (*NH* 35.67),

7. See Strabo 9.410 on Praxiteles' Eros at Thespiae and other monuments; Plutarch *Arat.* 13.2, on a portrait of Aristratus of Sicyon executed by Apelles and Melanthius.

passage 4 perhaps means that Euphranor's particular achievement was to have made use of *symmetria* and to have expressed the *dignitates* of the heroes simultaneously.[8]

diligens

1. Vitruvius 3.1.1.

 Aedium compositio constat ex symmetria, cuius rationem diligentissime architecti tenere debent.

 The designing of temples depends on *symmetria*, to the calculation [or "theory" or "principle"?] of which architects should adhere with the utmost exactitude.

 See also Vitruvius 1.3.2, 2.5.1, 6.8.5, 7.praef.4, 7.1.1, 7.10.2, 10.praef. 2, 10.praef. 3.

2. Pliny *NH* 7.34. See *ingenium*, passage 5.

3. Pliny *NH* 34.58.

 Primus hic multiplicasse veritatem videtur, numerosior in arte quam Polyclitus et in symmetria diligentior.

 On the translation of this passage see commentary below and also under *numerosus, numerus*; ἀλήθεια; and ῥυθμός.

4. Pliny *NH* 34.59.

 Hic primus nervos et venas expressit capillumque diligentius.

 He [Pythagoras] first rendered the sinews and veins and represented the hair more exactly.

5. Pliny *NH* 34.65.

 Non habet Latinum nomen symmetria, quam diligentissime custodiit nova intactaque ratione . . .

 See τετράγωνος-*quadratus*, passage 9.

8. Parrhasius *dedit symmetrian* to painting, whereas Euphranor *videtur usurpasse symmetrian*. The meaning could also simply be that Parrhasius first made use of *symmetria* in painting but that Euphranor was the first to "employ it extensively." Euphranor, it will be remembered, wrote a treatise on the subject.

6. Pliny *NH* 34.81.

Silanion Apollodorum fudit, fictorem et ipsum, sed inter cunctos diligentissimum artis et iniquum sui iudicem, crebro perfecta signa frangentem . . .

Silanion cast a statue of Apollodorus, who was himself a modeler but who was eminently exacting in his art and an uncompromising judge of his own work, to the extent that he often smashed finished statues [when he was not completely satisfied with them.]

7. Pliny *NH* 34.92.

Ex omnibus autem maxime cognomine insignis est Callimachus, semper calumniator sui nec finem habentis diligentiae, ob id catatexitechnus appellatus, memorabili exemplo adhibendi et curae modum. huius sunt saltantes Lacaenae, emendatus opus sed in quo gratiam omnem diligentia abstulerit.

But of all sculptors Callimachus is the most outstanding for his cognomen; he was a always a stern critic of his own work and his attention to detail knew no limit, and on account of this he was given the name *catatexitechnus*,* a memorable example of the need for establishing a limit even to meticulousness. Also by this artist are the Laconian Dancers, a flawless work, but one in which attention to detail has taken away all its charm.

**Catatexitechnus*, perhaps literally "the one who melts down his art," although the sense is clearly "the one who spoils his art." Vitruvius 4.1.10 refers to Callimachus as the *catatechnos*, which could mean "the artificial one" but is probably an error for *catatexitechnos*. Manuscripts of Pausanias 1.26.7 give the reading κακιζότεχνος, "the spoiler of art," although κατατηξίτεχνος is usually adopted as the correct reading.

8. Pliny *NH* 35.64.

Reprehenditur tamen ceu grandior in capitibus articulisque, alioqui tantus diligentia ut Agragantinis facturus tabulam . . .

However he [Zeuxis] is criticized for making the heads and limbs of his figures too large, although otherwise he was so committed to exactitude that, when he was about to make a picture for the people of Acragas [he inspected the most beautiful maidens of the city in order to select the finest features from each of them, which he then combined into a picture of Helen].

9. Pliny *NH* 35.80.

Dixit enim omnia sibi cum illo paria esse aut illi meliora, sed uno se praestare, quod manum de tabula sciret tollere, memorabili praecepto nocere saepe nimiam diligentiam.

For he [Apelles] said that all his own achievements were on an equal level with that artist [Protogenes] or that the latter's achievements were superior, but that there was one thing in which he was preeminent, namely, that he knew when to take his hand away from a picture, a memorable lesson about the frequently harmful effects of too much attention to detail.

10. Pliny *NH* 35.130.

Ipse diligentior quam numerosior et in coloribus severus* maxime inclaruit discipulo Nicia Atheniense, qui diligentissime mulieres pinxit.

*Severior **dTh**.

He [Antidotus] paid more attention to detail than to composition and was severe in his colors; he became best known for his pupil, Nicias the Athenian, who painted women with the utmost precision.

11. Pliny *NH* 35.137.

Sunt quibus et Nicophanes, eiusdem Pausiae discipulus, placeat diligentia quam intellegant soli artifices, alias durus in coloribus et sile multus.

There are those to whom Nicophanes, a disciple of this same Pausias, is also pleasing for his precision of detail, a quality which only artists can appreciate, but he was otherwise hard in his colors and lavish in his use of yellow ocher.

12. Pliny *NH* 36.40.

Accidit ei, cum in navalibus ubi ferae Africanae erant per caveam intuens leonem caelaret, ut ex alia cavea panthera erumperet non levi periculo diligentissimi artificis.

It happened to him [Pasiteles] once, when he was in the shipyards where there were wild African animals and he was peering into a cage at a lion of which he was making an engraving, that a panther broke out

353

of another cage, causing no slight danger to this most assiduous of artists.

13. Quintilian *Inst.* 12.10.7.

Diligentia ac decor in Polyclito supra ceteros . . .

See *decor*, passage 5.

Commentary

In the commentary under ἀκρίβεια it is suggested that *diligens* and *diligentia* were of particular importance in the history of Greek art criticism because they seem to have served as translations of the Greek terms ἀκριβής and ἀκρίβεια as technical terms in professional criticism. 'Ακρίβεια referred to precision in the application of small details—proportions, measurements, or fine points in naturalistic representation—in a work of art. The importance of these two terms was first clearly perceived by Carl Robert, who noted that both ἀκριβής and *diligens* were used in an apparently similar way in passages dealing with systems of proportion.[9]

Diligens and *diligentia* appear in five passages that seem either to derive directly from the technical judgments of the "Xenocratic" tradition in professional criticism (passages 3, 10, 11, 12) or to reflect the reuse of the judgments of that tradition in other critical traditions (passage 13). The terms also occur in six other passages which might be interpreted at least as offshoots of professional criticism. The technical nature of the terms is most clearly indicated by Pliny in passage 11, where he says that the art of the painter Nicophanes was characterized by *diligentia,* "which only artists understand" (or "appreciate"). If *diligentia* meant only "care" or "attentiveness," it is difficult to see why only artists would have been able to appreciate it. (In passage 12, for example, and elsewhere, Pliny does not seem to have any difficulty in appreciating this quality.) But if the term referred to ἀκρίβεια in the application of theories of proportion, or even to the special problems involved in representing small details like the hair or veins in a painting, it is understandable that Pliny might have considered a full understanding of *diligentia* beyond his personal competence.

The most complex and potentially meaningful passage in which *diligentia* is associated with professional criticism is, of course, passage 3, which is also discussed in connection with ἀλήθεια-*veritas,* ἀκρίβεια, and ῥυθμός. Pliny's

9. Robert, *Arch. März.*, pp. 31–34. He noted in particular the passages from Pliny which we give as numbers 3 and 5 and Galen's and Lucian's use of ἀκριβής in connection with the *Canon* of Polyclitus (see ἀκρίβεια).

diligentior in symmetria seems to reflect "Xenocrates'" judgment that Myron was ἀκριβέστερος ἐν συμμετρίᾳ (Carl Robert's translation) than Polyclitus. In view of the fact that Polyclitus was generally recognized as the greatest master of συμμετρία in antiquity, "Xenocrates'" judgment is somewhat surprising. It is possible that ἀκρίβεια implied not only "precision" but also "complexity of detail"[1] and that the system of *symmetria* which Myron used was more elaborate than that of Polyclitus—that is, it contained more μέτρα and ῥυθμοί. The statements that Myron was *numerosior in arte* and also *in symmetria diligentior* may be complementary ideas, since *numerus* was the Latin equivalent of ῥυθμός, and ῥυθμοί were the basic shapes produced by the application of a system of *symmetria* to sculpture and painting. "Xenocrates" may have been implying that Myron's canon of *symmetria* was more complex than Polyclitus's (i.e. it had more constituent parts) without necessarily implying that Myron's system was superior.

The idea of complexity of detail as well as precision may also be implied by Pliny's use of *diligentissime* in connection with Lysippus's system of *symmetria* (passage 5). The application of Lysippus's *ratio nova intactaque* of *symmetria*, in which various compensations for optical distortion seem to have been introduced (see chap. 1 and also τετράγωνος-*quadratus*), to the actual modeling and casting of a bronze statue would presumably have entailed more "steps" and also greater technical control than had previously been demanded of sculptors.

Vitruvius's mention of a *ratio* of *symmetria* to which architects should adhere *diligentissime* (passage 1) is remarkably similar in language to Pliny's comment on Lysippus, and since this passage occurs in the portion of the *De Architectura* which is most deeply indebted to Greek architectural theory and its terminology, it seems possible that here too *diligentissime* (ἀκριβέστατα?) refers not simply to a general diligence but rather to precision in the application of theory to technique.

The language of passage 10, in which the painter Antidotus is described as *diligentior quam numerosior* and Nicias is said to have represented women *diligentissime*, is also strikingly similar to passages 3 and 5 and clearly belongs to the milieu of professional criticism. Andreas Rumpf suggested that Pliny's peculiar statement about Nicias may mean that this painter was the first to have applied the Apollodoran technique of σκιαγραφία to the female form[2] (thereby bringing a degree of professional ἀκρίβεια, i.e. proficiency

1. It may be this shade of meaning in the term which was sometimes translated into Latin, as Schweitzer has suggested, by *argutiae* (q.v.).

2. Andreas Rumpf, "Diligentissime mulieres pinxit," *JdI.* 49 (1934): 6–23. This article is primarily devoted to a review of the extant monuments of Greek painting which illustrate the rise of shading. Rumpf holds that shading was not applied to the female figure until

in the application of theory to practice, to a subject not previously characterized by it). On the meaning of Pliny's characterization of Antidotus (translated perhaps as ἀκριβέστερος ἢ ῥυθμικώτερος) see *numerosus, numerus.*

Quintilian's attribution of *diligentia* to Polyclitus in passage 13 is to be interpreted in the context of the *phantasia* theory. It seems likely that the use of the *diligentia* in this laten tradition of criticism represents a rather hazy memory of the ἀκρίβεια which was distinctive of Polyclitus's *Canon* of *symmetria.* This does not mean, of course, that Quintilian or the framers of the *phantasia* theory themselves understood or used the term in a precise technical sense. To them it probably signified a general "feeling" of "precision in detail" which was conveyed by the works of Polyclitus.

The commentary under ἀκρίβεια notes that since the term seems to have signified, in its most basic sense, precision in executing any kind of small details, it may be that it referred, even in professional criticism, to exactitude in the representation of naturalistic details as well as to precision in the application of proportion. Passage 5, which seems to belong to the "Xenocratic" tradition, may provide an illustration of the use of the term in this sense. Even in this case, however, there is a possibility that *diligentius* implies the application of some theory or formula. Pythagoras may have instituted formal procedures for representing sinews, veins, hair, and the like, thus standardizing such representations and bringing them within the realm of systematic criticism.

Since Pliny admitted that *diligentia* was a quality in art which was difficult to understand, it could be that he was largely unaware of the technical significances of ἀκρίβεια-*diligentia* in the passages discussed above. This might in turn mean that in some of the other passages in which he used *diligentia* there lurk judgments deriving from professional criticism which are not immediately apparent. In passage 7, for example, as noted under *cura,* the obvious meaning of the passage is that Callimachus expended so much energy on small ornamental details (presumably by extensive use of a running drill) that his work lost all spontaneity. But if *diligentia* is taken as ἀκρίβεια in a technical sense—be it in the application of proportion or of some other theoretical precept—the meaning of this passage would become much more specific. It might be seen as a contrast, stemming from the ideas of the Sicyonian school in the later fourth century B.C., between the new subjectivism of Lysippus and Apelles (see chap. 1, p. 30 and χάρις) and the

about 350 B.C. As the earliest monument illustrating shading in a female figure he cites the Etruscan Amazon sarcophagus from Tarquinii; see *JHS* 4 (1883): pl. 36; Pericle Ducati, *Storia dell' Arte Etrusca* (Florence, 1927), fig. 478; Massimo Pallottino, *Etruscan Painting* (New York, n.d.), pp. 93–96.

more scrupulous adherence to theories and procedures among artists of the fifth century. It is also at least possible that a contrast of this sort is implied in passage 9. Popular tradition remembered Protogenes as an artist who was remarkably slow and meticulous in his work. Perhaps this reputation stemmed in part from the fact that he was an upholder of established rules of proportion and composition, and it was this particular aspect of Protogenes which Apelles compared with his own χάρις. Apelles (as noted under διάθεσις) freely admitted, in regard to certain other painters, that they were superior to him in various technical and theoretical aspects of the art. A similar interpretation of *diligens* and *diligentia* might also be applied in passages 6 and 8, although in the case of the latter its application seems to me highly unlikely.

Passages 2 and 12 are probably best taken as examples of *diligens* in the ordinary Latin sense of "diligent, assiduous" and appear to have no significant connection with Greek art criticism.

dispositio

1. Vitruvius 1.2.1. See διάθεσις, passage 3.

2. Vitruvius 1.2.2.

 Dispositio autem est rerum apta conlocatio elegansque conpositionibus effectus operis cum qualitate.

 Dispositio is a suitable positioning of parts and an elegant effect arising from the composition of the work, taking into account the exigencies of vision.*

 *"Taking into account the exigencies of vision" may seem a strange translation of *cum qualitate*, but it does appear that Vitruvius uses the term *qualitas* to refer to the subjective element in appreciating a work of art. See διάθεσις and also Ferri, *Vitruvio*, pp. 48–51.

3. Vitruvius 6.8.9.

 Itaque omnium operum probationes tripertito considerantur, id est fabrili subtilitate et magnificentia et dispositione.

 [Because of various limitations an architect cannot always use all the materials which he would ideally want.] Therefore the standards by which all works should be judged are threefold: namely, subtlety of workmanship, magnificence, and composition.

 See also Vitruvius 1.1.9, 1.3.2. 4.2.2, 7.praef.16, 7.3.3, 7.14.3.

4. Pliny *NH* 35.80.

Melanthio dispositione cedebat [Apelles], Asclepiodoro de* mensuris, hoc est quanto quid a quoque distare deberet.

*de *fortasse delendum, an potius* dimensuris (*Mayhoff*).

[Apelles] acknowledged his inferiority to Melanthius in composition, and to Asclepiodorus in fineness of measurements, that is, how far one thing ought to be from another [in a painting].

Commentary

Dispositio is, as Vitruvius explicitly states in passage 3, the Latin equivalent of the Greek διάθεσις in the sense of "composition" or "arrangement." For additional commentary see διάθεσις.

docilis

1. Vitruvius 1.1.3.

Itaque eum etiam ingeniosum opportet esse et ad disciplinam docilem.

He [the aspiring architect] should therefore be naturally gifted and at the same time amenable to learning in his discipline.

2. Pliny *NH* 35.128.

Euphranor . . . docilis ac laboriosus ante omnes . . .

See *laboriosus, labor,* passage 2.

Commentary

Docilis (from *doceo,* "teach") means "learned" or "receptive to learning." Pliny's recognition of Euphranor as a particularly learned artist is paralleled by Quintilian's praise of the artist for the breadth of his achievements: *Euphranorem admirandum facit, quod et ceteris optimis studiis inter praecipuos et pingendi fingendique idem mirus artifex fuit*" (*Inst.* 12.10.6). One can only speculate as to how this respect for Euphranor's learning came into Latin literature. Perhaps it stems from the fact that he was *both* a painter and a sculptor. More probably, it stems from the breadth of learning shown in Euphranor's two treatises, *On Symmetria* and *On Colors* (*NH* 35.129), which may have been very technical in character. Perhaps a Hellenistic writer like Duris of Samos described Euphranor as εὐμαθής, and when the practice of comparing

orators and artists later became popular (see chap. 3), εὐμάθεια was selected as Euphranor's particular *virtus*.

On the background of Vitruvius's insistence that architects have a certain amount of formal learning as well as manual skill, see chapter 5.

durus

1. Cicero *Brut.* 70.

 Calamidis dura illa [signa] quidem, sed tamen molliora quam Cana-chi . . .

 The statues of Calamis are also, it is true, hard, but nevertheless softer than those of Canachus . . .

2. Ovid *Ars Am.* 3.218-20.

 Multaque, dum fiunt, turpia, facta placent;
 Quae nunc nomen habent operosi signa Myronis
 Pondus iners quondam duraque massa fuit.

 Many things, while they are being made, are ugly, but when finished, are pleasing. Statues which now bear the signature of industrious Myron were once merely an inert mass and a hard lump.

3. Pliny *NH* 35.98.

 . . . durior paulo in coloribus.

 [Aristides] was a little too hard in his colors.

4. Pliny *NH* 35.137.

 . . . alias durus in coloribus [Nicophanes] . . .

 See *diligens*, passage 11.

5. Quintilian *Inst.* 12.10.7.

 Nam duriora et Tuscanicis proxima Callon atque Hegesias, iam minus rigida Calamis, molliora adhuc supra dictis Myron fecit.

 For Callon and Hegesias made works which are rather hard and similar to works in the Etruscan style; Calamis made his figures somewhat less stiff, and Myron produced works which were softer still compared to those of the artists mentioned above.

Commentary

The term *durus,* "hard," was used in both a literal way—"physically hard," which was no doubt its original meaning—and a figurative or stylistic way—"hard" in the sense of "rude" or "undeveloped." A similar semantic division is found in the use of the Greek word σκληρός, which is undoubtedly the Greek equivalent of *durus* (see citations under σκληρός).[3]

When used with reference to sculpture, *durus* and σκληρός can have either the literal or the figurative significance. Ovid's *duraque massa* (passage 2) and Callistratus's χαλκός . . . σκληρός (*Descriptiones* 6.3), for example, use the terms in the sense of "physically hard."

The figurative sense of *durus-*σκληρός as a criterion of sculptural style is preserved by writers who clearly drew on the classicistic criticism (i.e. the φαντασία theory as developed with rhetorical terminology) of late Hellenism —Cicero, Quintilian, and perhaps Lucian (see *durus,* passages 1 and 5, and σκληρός, passage 1). It appears that Quintilian and Lucian, both of whom cite *durus-*σκληρός as a characteristic of the sculpture of Hegesias, may even be drawing on the same passage within "the source." These writers also appear to use *rigor* (q.v.) and *rigidus* as an alternate translation of σκληρός. In passage 5, for example, Quintilian appears to use *durus* and *rigidus* as variant expressions for the same principle. Both words serve as antonyms for their opposite *mollis.* The term σκληρός and its variants (σκληρότης) had the sense not only of "hard" but also of "stiff."[4] I suspect that for the later Hellenistic art critics it was used to describe (a) the surface modeling of Archaic and Early Classical sculpture (which, when compared to Praxiteles, for example, may have appeared "hard") and (b) the largely torsionless composition of Archaic and Early Classical sculpture.[5] In Greek, σκληρός conveyed both concepts.

The original formulation of this critical evaluation of Archaic and Early Classical sculpture may go back to "Xenocrates," whose chapter on *rudis antiquitas,* that is, sculpture before the Early Classical period, appears to have traced the preliminary developments of sculpture that led to the basic forms from which Phidias and others began their more subtle innovations. Pliny's comments on Polygnotus (see chap. 6 and also *rigor*), presumably from "Xenocrates' " treatise on painting, give us an idea of the critical standards that may have been employed in his parallel chapter on early sculpture. He praises Polygnotus for having shown the mouth open, for rendering the teeth, and for varying the face from its *antiquo rigore.*

3. This equivalence has long been recognized. See Robert, *Arch. Märch.,* p. 52.
4. Aristotle [*Pr.*] 881a10.
5. *Durus* may have referred to surface modeling and *rigor* to composition.

The *durus-mollis* antithesis that we find in Cicero and Quintilian was probably created by the later classicistic critics to serve as a chronological and stylistic guide to pre-Myronic sculpture. We know that the "Xeno-cratic" tradition did concern itself with the rendering of such naturalistic details as the hair (Pliny *NH* 34.58), veins (34.59), and so on, but the rigid scheme by which artists were placed on a scale between the two opposing poles of *mollis* and *durus* appears to have been an invention of the classicistic school itself. The real purpose behind Cicero's and Quintilian's presentation of the *durus* to *mollis* development in art is to provide an analogy for a similar development in rhetoric, and the terminology used in this analogy is basically that of rhetorical criticism. (Quintilian, for example, uses *durus* to describe consonants, 9.3.35; words, 7.3.32; syllables, 12.10.30, etc.) The basic information upon which the *durus* to *mollis* development in later Hellenistic and Roman criticism was based, however, might well have been derived from the treatise of Xenocrates.

The use of *durus* to describe colors (passage 3 and 4) probably falls into a different context from that which we have thus far discussed. It is not easy to say exactly what is meant by a "hard color," since the phrase is really meta-phorical. Pliny's use of *durus* in these passages is clearly intended to indicate a fault in the use of color (unlike *austerus,* which seems either to have been used in an objective technical sense or to have denoted a stylistic genre, but does not appear to have had a derogatory connotation). It may be that *durus* simply means "harsh"—in the sense of a bright color unmodulated by light and shade. This might suggest that Aristides and Nicophanes (the artists referred to in passages 3 and 4) eschewed any extensive use of chiaroscuro and preserved a type of coloration similar to that used by the Early Classical painters such as Polygnotus. If this were so, it would make the stylistic im-plication of *durus* in connection with colors analogous to its use in connection with sculpture (i.e. it would suggest the Early Classical style). In chapter 2 it was observed that Plato praises simplicity of color as a characteristic of good painting, and it is not impossible that, by ignoring σκιαγραφία, Aristides and Nicophanes were practicing an aesthetic dictum laid down by Plato. On the other hand, it is doubtful that Aristides and Nicophanes made their reputations by being the ancient equivalents of either the Pre-Ra-phaelites or the Fauves. It is perhaps safest to interpret *durus* in connection with colors as referring to extreme brightness of individual colors or to the lack of gentle transitions between colors (see ἁρμογή).

It is possible that *durus*-σκληρός referring to colors was originally a term of professional criticism in fourth-century painting, when it may have denoted an aspect of the *austerum genus* of colors (see *austerus*).[6]

6. Schlikker suggests something of this sort when he proposes that *durus,* σκληρός, αὐθάδεια

elegantia, elegans

1. Cicero *Verr.* 2.4.126.

Silanionis opus tam perfectum, tam elegans, tam elaboratum, quisquam non modo privatus sed populus potius haberet, quam homo elegantissimus atque eruditissimus Verres?

This work of Silanion [Sappho in Syracuse], a work so perfect, of such fine detail—is there any individual or indeed any country which has a better right to it than that most refined and well-informed of men, Verres?

2. Vitruvius 1.1.13.

Non enim in tantis rerum varietatibus elegantias singulares quisquam consequi potest, quod earum ratiocinationes cognoscere et percipere vix cadit in potestatem.

[The architect should have a general knowledge of many arts and sciences, but he cannot be expected to have mastery over all of them.] For in so great a number of disciplines, no one can be expected to master the individual fine points [of all], since only with great effort is it within his capacity to know and comprehend even the basic theoretical structures behind them.

3. Vitruvius 1.3.2.

. . . venustatis vero, cum fuerit operis species grata et elegans membrorumque commensus iustas habeat symmetriarum ratiocinationes.

[Construction should take into account durability, utility, and beauty.] . . . beauty on the other hand [will be taken account of] when the appearance of the work shall be pleasing and elegant and the commensurability of the component parts shall have the appropriate principles of *symmetria* as its basis.

(q.v.), and other terms are to be grouped under the *genus austerum* (as opposed to the *genus iucundum*) referred to by Pliny (*NH* 34.66) in connection with the art of Lysippus and Euthycrates. But he inserts the suggestion into a complex hierarchy of terms which is difficult to accept. He feels that the *austerum genus* and the *iucundum genus* represent two opposing poles within the general concept of εὐρυθμία (which in Schlikker's opinion simply means "Anmut"). He also connects the *genus iucundum* with ἦθη, which he defines as "Teilnahme und Rührung in Menschenherzen," while he connects the *genus austerum* with πάθη, the "Leidenschaftliche" which "packt und erschüttert" (Schlikker, *HV*, pp. 3 and 87–89).

4. Vitruvius 4.1.10.

Tunc Callimachus qui propter elegantiam et subtilitatem artis mar-
moreae ab Atheniensibus catatechnos fuerat nominatus, . . .

. . . Callimachus, who on account of the elegance and fineness of his
work in marble was given the name *catatechnos** by the Athenians . . .

*See note on *diligens,* passage 7.

5. Vitruvius 7.5.5.

Etenim etiam Trallibus cum Apaturius Alabandius eleganti manu
finxisset scaenam in minusculo theatro, quod ecclesiasterion apud eos
vocitatur, . . .

For example, at Tralles when Apaturius of Alabanda arranged with
great elegance of hand a stage setting in a small theater, which they call
the *ecclesiasterion,* . . . [his fantastic designs were ridiculed by the
mathematician Lycymnius].

See also Vitruvius 1.1.16, 1.2.6 (see *decor,* passage 2), 1.6.1, 2.1.7, 2.7.4
(see *amplus,* passage 1), 5. praef. 1, 6.5.2., 6.8.10, 7. praef.15, 7.5.4 (see
ἀλήθεια-*veritas,* passage 16), 7.9.2. 7.14.2.

6. Pliny *NH* 34.66. See *austerus,* passage 1, and also commentary on *iucundus.*

7. Pliny *NH* 35.67. See *argutiae,* passage 2.

8. Pliny *NH* 35.111. See *cothurnus,* passage 1.

9. Cassiodorus *Var.* 7.15.

. . . Iovis Olympii simulachrum, quod Phidias primus artificum sum-
ma elegantia ebore auroque formavit.

[Early writers mention seven wonders of the ancient world, including]
the image of Olympian Zeus, which Phidias, the foremost of artists,
shaped out of ivory and gold with consummate elegance.

Commentary

Elegantia (probably from *eligo,* "pick out, choose") was used, as the pas-
sages in the catalog show, in the criticism of sculpture, painting, and archi-
tecture. The term appears to imply not only "elegance" but also "good
taste, the quality of being carefully chosen."[7]

7. Cicero *Fam.* 7.23: *intellego te hominem in omni iudicio elegantissimum*; see also *elegantissimus*
in passage 1 above.

Elegantia occurs in a wide variety of contexts, and it is not possible to associate the term with any one system of art criticism. The *elegantia* which Pliny connects with Lysippus in passage 6, for example, appears to have some connection with the γλαφυρὸς χαρακτήρ of rhetorical composition described by Dionysius of Halicarnassus and Demetrius.[8] The Greek equivalent of *elegantia* is γλαφυρία, although χάρις, which Demetrius lists as a basic feature of the γλαφυρὸς λόγος,[9] is also an occasional possibility.

Passage 7 is almost certainly derived from the "Xenocratic" tradition and suggests that γλαφυρία in small details, such as the hair, may have been one of the features which "Xenocrates" looked for within the general quality of ἀκρίβεια. Passage 8, in which the painter Nicophanes is described as being *elegans ac concinnus* (perhaps γλάφυρὸς καὶ εὔρυθμος), could stem either from rhetorical criticism or from the "Xenocratic" tradition.[1]

In passage 1, on the other hand, Cicero's *elegantissimus* seems to represent a purely Roman usage.

Of the passages in which Vitruvius uses *elegans*, only 3 and 4 suggest a close connection with a term in Greek art criticism. *Elegans* and *elegantia* may again be viewed as translations of γλαφυρός (-ία) or χάρις. It will be remembered that the concept of an *elegans species* plays a basic role in Vitruvius's definition of εὐρυθμία, which in turn is to be coupled with διάθεσις, "arrangement" (the former being the effect of the latter).[2] *Elegantia*, being a part of εὐρυθμία, is thus connected primarily with composition, and Vitruvius's use of the term in this way may be modeled, as some have suggested, on literary criticism.[3] The reference to *verborum elegans dispositio* in 5.praef.1, suggests this. Likewise the description of the style of the sculptor Callimachus as having *elegantiam et subtilitatem* (passage 4) is paralleled by a similar description in the writings of Dionysius of Halicarnassus: Καλλιμάχου τῆς λεπτότητος ἕνεκα καὶ τῆς χάριτος (*Isoc.* 3; see χάρις).

Both Dionysius in the passage quoted above and Vitruvius in passage 4 contradict Pliny's judgment of Callimachus in *NH* 34.92 (. . . *gratiam omnem diligentia abstulerit*). The passages in question are discussed under λεπτότης, *cura*, and *diligens*. Dionysius and Vitruvius praise the χάρις and *elegantia* of the art of Callimachus, while Pliny tells us that the *diligentia* of Callimachus's Laconian Dancers deprived the work of all *gratia*. It is sug-

8. Dionysius of Halicarnassus *Comp.* 22; Demetrius *Eloc.* 128 ff.

9. Demetrius *Eloc.* 128–36.

1. In the subsequent lines *cothurnus et gravitas artis* . . . perhaps suggests that the whole passage is connected with rhetorical criticism. See *cothurnus* and *gravitas*.

2. Vitruvius 1.2.3. See commentary under διάθεσις; see also Carl Watzinger, "Vitruvstudien," *RhM* 64 (1909): 202.

3. Pietro Tomei, "Appunti sull' Estetica di Vitruvio," *BIA* 10 (1947): 57–73.

gested under *diligens* that Pliny's passage on Callimachus may reflect a dispute among professional critics of the fourth century B.C. as to the relative merits of ἀκρίβεια, "precision" in the application of technical formulas, and χάρις, spontaneous, intuitively conceived charm. The great proponent of χάρις in the fourth century was Apelles, but there is no indication that Apelles ever wrote on sculpture as such. (In discussing the labored quality of the painting of Protogenes, however, he might have cited the excessive *diligentia* of Callimachus's sculpture as a parallel.)

The view of Callimachus's style preserved by Dionysius and Vitruvius, on the other hand, seems clearly to stem from rhetorical or literary criticism. All our sources make it clear that Callimachus's sculpture was characterized by extreme refinement of detail. In the Hellenistic period this refinement was probably understood not as ἀκρίβεια but rather as *subtilitas*, λεπτότης. Callimachus would thus be understood as an *exemplar* of a smooth, pleasing style, the γλαφυρὸς χαρακτήρ of Hellenistic rhetoric rather than the αὐστηρὸς χαρακτήρ, and it may be that Dionysius's and Vitruvius's opinion of him derives from a comparative canon of rhetoricians and sculptors.

A similar contrast between sources (i.e. professional criticism on the one hand and rhetorical criticism on the other) seems to exist in Pliny's remarks on Nicophanes (*NH* 35.111 and 137) as pointed out under *concinnus*.

emendatus

1. Vitruvius 1.3.2.

> . . . utilitatis autem, < cum fuerit > emendata et sine inpeditione usus locorum dispositio . . .

> . . . utility will be taken into account when the disposition of sites is faultless and without impediment to their use . . .

Cf. *firmitas*, passage 1, and *venustas*, passage 2.

2. Pliny *NH* 34.58. See *animum et sensus pingere*, passage 2.

3. Pliny *NH* 34.92. See *diligens*, passage 7.

Commentary

Emendatus, from *e* + *mendum*, "free from fault," hence "perfect," could, particularly in passage 3, be the Latin equivalent of the Greek ἄμεμπτος used by Diodorus Siculus in book 26, frag. 1: . . . οὔτε Ἀπελλῆς ἢ Παρράσιος, οἱ τοῖς ἐμπειρικῶς κεκραμένοις, χρώμασι προαγαγόντες εἰς ἀκρότατον τὴν

ζωγραφικὴν τέχνην, οὕτως ἐπέτυχον ἐν τοῖς ἔργοις ὥστε κατὰ πᾶν ἄμεμπτον ἐπιδείξασθαι τὸ τῆς ἐμπειρίας ἀποτέλεσμα. Although, since passage 2 represents the type of stylistic analysis characteristic of "Xenocrates," it is conceivable that *emendatus* in this case could be a translation of τέλεος (q.v.), an important term in the vocabulary of professional criticism.

exemplum, exemplar

1. Plautus *Poen.* 1272 ff.

> O Apella, o Zeuxis pictor,
> cur numero estis mortui, hoc exemplo ut pingeretis?
> nam alios pictores nil moror huius modi tractare exempla.

> O Apelles, O painter Zeuxis!
> Why did you die too soon, so that you missed the chance of painting with this as your model?
> For I care nothing for the other painters who might deal with scenes of this sort.

2. Vitruvius 1.1.4. See *species,* passage 3.

3. Vitruvius 7.5.1.

> Namque pictura imago fit eius, quod est seu potest esse, uti homines, aedificia, naves, reliquarumque rerum, e quibus finitis certisque corporibus figurata similitudine sumuntur exempla.

> For a picture is an image of something which either really exists or at least can exist, for instance, men, buildings, ships and other things, from whose clearly defined and actually existent forms, pictorial representations are drawn by copying.

4. Seneca *Controv.* 10.34. praef.

> Parrhasius pictor Atheniensis, cum Philippus captos Olynthios venderet, emit unum ex iis senem. perduxit Athenas, torsit et ad exemplar eius pinxit Promethea.

> Parrhasius the Athenian painter, when Philip sold the captives from Olynthus, bought one of them, an old man, brought him to Athens, tortured him, and painted his Prometheus on the basis of this model.

5. Pliny *NH* 34.56.

. . . quadrata tamen esse ea ait Varro et paene ad [unum] exemplum
. . . [the works of Polyclitus].

See τετράγωνος-*quadratus,* passage 8.

6. Quintilian ·*Inst.* 5.12.21.

An vero statuarum artifices pictoresque clarissimi, cum corpora quam speciosissima fingendo pingendove efficere cuperent, numquam in hunc inciderunt errorem, ut Bagoam aut Megabyzum aliquem in exemplum operis sumerent sibi, sed Doryphoron . . .

Outstanding sculptors and painters, when they wanted to produce the most beautiful possible bodily form through modeling or painting, never fell into the error of taking some Bagoas or Megabyzus [i.e. an oriental eunuch?] as the model for their work, but rather the *Doryphorus* . . .

Commentary

The terms *exemplum* and *exemplar* can mean both "model" and "copy." When the word means "copy," however, it always has the sense of a "representative copy" and hence is still very close in meaning to model.[4]

In each of these passages the meaning of the term is slightly different, and there does not seem to be a consistent distinction between *exemplum* and *exemplar.* In passage 1 *exemplo* refers to a subject, while *exempla,* in the following line, seems to refer to actual representations or drawings. In passage 2 Vitruvius clearly uses *exemplaribus* to refer to drawn models of projected buildings, whereas *exempla* in passage 3 means "copies" or "representations." *Exemplar* in passage 4 refers to a human model. *Exemplum* in passage 5 seems to refer to a system of proportions which served as a model for all of Polyclitus's statues, particularly the Doryphorus (passage 6).

The Greek prototype of *exemplum* and *exemplar* in the sense of "model" would certainly be παράδειγμα (q.v.), although it is only in passage 5 that there seems to be a strong reason for taking one of the Latin terms as a direct translation of a Greek original (see τετράγωνος-*quadratus*). Where *exemplum* means "representation" or "copy" (passage 3) it may, assuming that it has a connection with a Greek term, be related to a word like ὁμοίωμα.

4. Cicero *Att.* 8.6.1: *Pompei litterarum ad consules exemplum attulit: "Litterae mihi a L. Domitio a.d. XIII Kalend. Mart. allatae sunt. Earum exemplum infra scripsi."*

exilis

1. Pliny *NH* 35.128.

. . . sed fuit in universitate corporum exilior et capitibus articulisque grandior.

See *dignatio, dignus, dignatus,* passage 10.

Commentary

Exilis, "thin, lean," is, like *gracilis* (q.v.), probably a translation of the Greek λεπτός (λεπτότης). Compare Pliny, *NH* 35.64, where a similar criticism is made of the proportions of the figures of Zeuxis (*reprehenditur tamen ceu grandior capitibus articulisque*). The source of these two passages is probably Xenocrates. Being trained in the Sicyonian school of which Lysippus was the outstanding master, Xenocrates would have favored the *corpora graciliora siccioraque* (*NH* 34.64) which Lysippus had developed. Neither Zeuxis nor Euphranor belonged to the Sicyonian school of painting, and the proportions which they employed for the human figure were probably those of Attic painting and sculpture of the first half of the fourth century.[5] Presumably Euphranor's figures seemed *exilior* to Xenocrates not because they had the *graciliora* proportions of Lysippean sculpture but because their large heads and limbs were out of proportion with their torsos.

Carl Robert noted the apparent discrepancy between the statement that Euphranor was *corporum exilior* and the statement in *NH* 35.129, where Euphranor was reported to have said that the Theseus in one of his paintings was "fed on meat," while the Theseus in a painting by Parrhasius was "fed on roses."[6] The latter passage seems to imply that Euphranor's figures were

5. Pliny gives Zeuxis's floruit as the 95th Olympiad or 400–397 B.C., Euphranor's as the 104th Olympiad or 364–361 B.C., and Lysippus's as the 113th Olympiad or 327–324 B.C. (see *NH* 34.50, 51, and 35.61). Euphranor was probably an older contemporary of Lysippus; his treatise *De Symmetria* (*NH* 35.129) may have clashed with the views of Lysippus and consequently with those of Xenocrates, a member of the Lysippean school. The proportions employed by Euphranor and Zeuxis were probably similar to those of the Eirene of Cephisodotus (Richter, *SSG*⁴, figs. 704–08). The Apollo Patroos of Euphranor found in the Athenian Agora is unfortunately not sufficiently well preserved to enable us to draw any conclusion about the proportions of its extremities; see G.M.A. Richter, *A Handbook of Greek Art,* 6th ed. (New York, 1969), fig. 210, p. 157.

6. "Excurs über den Ares Borghese," *Hall. Winckelmannsprogramm* 19 (1895): 25. Brunn, *GGK*², 2: 126–27, felt that the contrast between the Theseus of Parrhasius and that of Euphranor was intended to emphasize a new realism in the latter. His view was rejected by Adolf Furtwängler, who suggested that Euphranor's remark referred to the different flesh

robust in appearance, and *exilis* in the sense of "slender" is not, Robert suggested, an apt term to describe such figures. He therefore suggested that *exilis* was a translation of a Greek term like βραχύτερος meaning "too short" or "too squat."

Sellers felt that the discrepancy pointed out by Robert could be resolved by recognizing that the two traditions about Euphranor preserved by Pliny were derived from different sources. The remark about his being *corporum exilior* was, she felt, clearly a Xenocratic criticism, while the anecdote about the painting of Theseus was probably derived from Duris of Samos.[7] Her solution to this problem seems reasonable.

facilitas, facilis

1. Quintilian *Inst.* 12.10.6.

> . . . facilitate Antiphilus . . . est praestantissimus.

> In ease of execution Antiphilus . . . was foremost.

2. Fronto *Ep.* (ed. C. R. Haines) 1.128.

> Facilius quis Phidian, facilius Apellen, facilius denique ipsum Demosthenen imitatus fuerit aut ipsum Catonem, quam hoc tam effectum et elaboratum opus.

> It will be easier to imitate Phidias, easier to imitate Apelles, easier to imitate in the final analysis even Demosthenes himself or Cato himself, than it will be to imitate such an effective and studied work [Marcus Caesar to Fronto, A.D. 143]

Commentary

Facilitas, "ease, facility," is a technical term in Latin rhetoric, where it denotes fluency of speech which has been acquired through constant exercise. The equivalent term in Greek rhetoric is, as Quintilian tells us, ἕξις (. . . *facilitas, quae apud Graecos* ἕξις *nominatur* . . . , *Inst.* 10.1.1).[8]

The context of passage 1 suggests that *facilitas,* as a critical term in the

tints used in the two paintings; *Masterpieces of Greek Sculpture,* trans. Eugénie Sellers (New York, 1895; Chicago, 1964), p. 348.

7. Sellers, *EPC,* p. 238.

8. Philodemus *Rhet.* 1.69s defines τέχνη as a whole as ἕξις ἢ διάθεσις ἀπὸ παρατηρήσεως. Possibly ἕξις was also used to describe a painter's facility in drawing developed by extensive observation (παρατήρησις) of models.

visual arts, was preserved through its use in a comparative canon of rhetoricians and artists formulated in the Hellenistic period (see chap. 3), although it is even possible that the term was first used in connection with the visual arts by Quintilian himself simply in order to make his comparison of famous orators with famous sculptors and painters more complete.[9]

Since Quintilian tells us that *facilitas* equals the Greek ἕξις, it is clear that *facilitas* does not mean facility in the sense of "rapidity" or "quickness of hand." The Latin words used to convey this quality were *velox* and *velocitas* (see Pliny *NH* 35.109, *nec fuit alius in ea arte velocior*, and 148, *nec illius velocior*).

Perhaps the best translation of ἕξις (derived from ἔχειν, "to have," hence something which is firmly in one's possession) is "an ability developed by training." Note, for example, Aristotle's use of the term in connection with the virtues (chap. 3) and also Plato's use of it in *Phaedrus* 268E: . . . οὐδὲν μὴν κωλύει μηδὲ σμικρὸν ἁρμονίας ἐπαΐειν τὸν τὴν σὴν ἕξιν ἔχοντα (τὴν σὴν ἕξιν having the sense here of "your stage of development" or "your degree of facility").

A correct understanding of the meaning of *facilitas* is essential if we are to evaluate properly the significance of the art of Antiphilus. In the commentary under *compendiaria* (q.v.) it is suggested that the misinterpretation of *facilitas* as meaning "rapidity" has given rise to the opinion of a number of modern writers that the term refers to an impressionistic technique of painting which first appeared in Alexandria. Both the linguistic and historical evidence available in connection with this problem suggest that the theory of Alexandrian impressionism is improbable.

Passage 2 documents the use of *facilis* in connection with Greek artists, but there is no reason to assume that the passsage has any connection with Greek art criticism.

felix

1. Vitruvius 3.praef.2.

> . . . quod hi non ab industria neque artis sollertia sed a Felicitate fuerunt decepti, ut Hegias . . .

> [Some artists did excellent work but, through bad luck, gained no reputation] for these men suffered disappointment not through a lack

9. Our other sources on Antiphilus do not mention *facilitas* as one of the characteristics of his art. Most of the *virtutes* that Quintilian mentions in connection with other painters are also documented in other sources.

of industriousness or skill but from the absence of fortune, for example Hegesias . . .

2. Vitruvius 7.praef.13.

Quibus vero felicitas maximus summumque contulit munus . . .

And on these artists [Satyrus and Pythius, the architects of the Mausoleum], good fortune conferred the highest possible boon.

3. Pliny *NH* 34.69.

Praxiteles quoque, qui marmore felicior, ideo clarior fuit, fecit tamen et ex aere pulcherrima opera.

Likewise Praxiteles, who was more successful in marble and for that reason more renowned, nevertheless also made extremely beautiful works in bronze.

Commentary

The root meaning of *felix* (coming from *feo/fevo*, to bear," "to produce") is "fertile, productive."[1] That which was productive was also by nature "prosperous," "good omened," "fortunate." Hence the most common use of *felix* in Latin is in the sense of "fortunate, lucky." In passage 1 Vitruvius uses the noun *felicitas* as an equivalent of *fortuna* (Greek τύχη and εὐτυχία); the word here becomes personified and expresses not a quality of the artist's work but rather an external daemonlike force. In passage 2 the personification of *felicitas* is less vivid, but the same meaning is implied—that "fortune" blessed Pythius and Satyrus by giving their work an unfading freshness.

The adjective *felix* when applied to an artist, as in passage 3, could mean either "more prolific" in a certain medium (i.e. producing a greater number of actual works of art) or "more successful" in a certain medium (i.e. producing better works in that medium but not necessarily more), but the latter is more likely. Not only is it the most common meaning of the word in Latin literature in general, but it also coincides more closely with the Greek word ἐπιτυχής which is probably its equivalent. In *De Isocrate* 3, where Dionysius of Halicarnassus is comparing sculptors and rhetoricians, he also includes an internal comparison among the sculptors themselves, pointing out that Calamis and Callimachus were ἐν τοῖς ἐλάττοσι καὶ ἀνθρωπικοῖς ἔργοις εἰσὶν ἐπιτυχέστεροι, while Phidias and Polyclitus were τοῖς μείζοσι

1. For example, Livy 5.24.2, *felix arbor*.

καὶ θειοτέροις δεξιώτεροι.² Like *felix*, ἐπιτυχής probably also carried the connotation not only of success but also of "fortune" (*felicitas* =εὐτυχία).³

The idea that luck played a certain role in artistic success seems to have been characteristic, as we have suggested (chap. 4), of popular criticism, and the use of *felix* and *felicitas* could conceivably derive from τύχη and ἐπιτυχής as used by a writer like Duris. But the evidence is so slight that perhaps even this speculation goes too far.

firmitas

1. Vitruvius 1.3.2.

> Haec autem ita fieri debent, ut habeatur ratio firmitatis, utilitatis, venustatis. Firmitatis erit habita ratio, cum fuerit fundamentorum ad solidum depressio . . .

> Now these [different apects of building] should be carried out in such a way that consideration is given to durability, utility, and beauty. Durability will be taken into account when the excavation of the foundations is carried down to bedrock [and when the proper materials are used].

See also Vitruvius 6.7.7, 6.8.1, 7.3.8, 7.14.3.

2. Pliny *NH* 35.158.

> . . . mira caelatura et arte suique firmitate, sanctiora auro, certe innocentiora.

> [In Italy and at Rome there are many architectural sculptures] remarkable for their *caelatura* [i.e. *toreutikē*, see chap. 6, note 4], for their artistic quality, and for their feeling of something enduring, holier than gold, and certainly more innocent.

Commentary

Vitruvius uses the term *firmitas* in a literal sense; that is, he refers to the "firmness" of foundations, walls, and so on. Pliny's use of the term to describe early Etruscan statuary, on the other hand, is apparently intended to

2. See also Diodorus Siculus 26.1 for use of ἐπιτυχής in a verb form: . . . οὕτως ἐπέτυχον ἐν τοῖς ἔργοις ὥστε κατὰ πᾶν ἄμεμπτον . . . (on Apelles, Praxiteles, etc.).

3. Ἐπιτυχής is only documented in the sense of "successful," but ἐπιτυχία could mean "luck" or "chance." Cf. *LSJ*⁹, s.v. ἐπιτύχημα.

convey a stylistic quality of these statues rather than their actual physical firmness. The normal metaphorical use of *firmitas*, that is, "steadfastness," refers to a quality of character rather than appearance and hence does not help us understand exactly what Pliny was referring to.[4] It is possible, of course, that Pliny was rather whimsically referring to a quality of steadfastness which he felt he could see in Etruscan sculpture. It seems more likely, however, that *firmitas* was used to express Pliny's reaction to the "*kouros* stance" of Archaic sculpture. The lack of torsion and the customarily heavy appearance of the lower limbs in Archaic sculpture probably suggested to the Romans a solidity that Classical and Hellensitic statuary had sacrificed in order to achieve χάρις (q.v.).

There is no evidence to suggest that the use of *firmitas* in the passages above is related to the terminology of Greek art criticism.[5] As Watzinger and others have pointed out, however, it does appear that Vitruvius was at least following a Greek pattern of thought when he placed *firmitas* in a terminological triad along with *utilitas* and *venustas*.[6] The commentary under διάθεσις discusses Watzinger's arrangement of Vitruvius's six basic components of architecture (1.2.1 ff.) into three pairs of terms, with one term in each pair expressing an activity or ἔργον and the other representing a τέλος. There seems to be some validity for this classification. Among the six basic components of architecture, the three which express the τέλη or goals— i.e. *symmetria*, *eurhythmia*, and *decor* (Greek πρέπον)—may be paralleled in a rough way by the triad *firmitas*, *utilitas*, and *venustas*. *Firmitas* like *symmetria* involves, at least in part, the determination of units (*quaque e materia, copiarum sine avaritia diligens electio*); *utilitas* like *decor* involves the question of appropriateness (*ad regiones sui cuiusque generis apta et conmoda distributio*); and *venustas* like *eurhythmia* refers to the satisfying effect produced by a form (*species grata et elegans*) (see Vitruvius 1.3.2).

floridus

1. Pliny *NH* 35.30.

Sunt autem colores austeri aut floridi. Utrumque natura aut mixtura sunt. Floridi sunt . . .

4. Sellers, *EPC*, p.180, and Harris Rackham in the Loeb Classical Library edition of Pliny (Cambridge, Mass. and London, 1952), translate *firmitas* as "durability," but whether they intend the word in a literal sense, or in a metaphorical sense, is not clear.

5. Note, however, a certain similarity of approach in Demetrius *Eloc.* 14: . . . ὥσπερ καὶ τὰ ἀρχαῖα ἀγάλματα, ὧν τέχνη ἐδόκει ἡ συστολὴ καὶ ἰσχνότης (see ἀρχαῖος).

6. Carl Watzinger, *RhM* 64 (1909): 222; Ferri, *Vitruvio*, p. 50.

floridus

See commentary below and *austerus*, passage 2.

2. Pliny *NH* 35.97. See *claritas*, passage 2.

3. Pliny *NH* 35.120.

Fuit et nuper gravis ac severus idemque floridus humilis* pictor Famulus.

* floridus humilis, **d**; floridus umidus **B**; floridis umidus **B**²; floridus humidis **R**; floridus umidis *rv*. Jan's reading *floridis tumidus*, "puffed up with floridity" is accepted by May-hoff. It assumes that *floridus* means extravagantly colorful, but the term really means simply "brightly colored" and is not necessarily derogatory. Of all the emendations which have been proposed, *floridissimus*, suggested by Urlichs, strikes me as the most satisfactory.

And recently there was the serious and severe but also . . . [?] . . . florid painter, Famulus.

Commentary

Most of the important points concerning the term *floridus*, which is the Latin translation of ἀνθηρός (q.v.), are raised in the commentary under *austerus*. We summarize here the conclusions reached under that commentary. The classification of colors into *floridi* and *austeri colores* (ἀνθηρὰ καὶ αὐστηρὰ χρώματα) appears to stem from professional treatises on Greek painting such as Euphranor's *De Coloribus*. Pliny mentions specifically red, blue, purple, and green (?) as being *floridi colores*, but the term in the broadest sense may have referred to all colors which were bright as opposed to those which were *austeri*, dark or somber. When Dionysius of Halicarnassus, in the late first century B.C., came to coin terms for the different characters of rhetorical and poetic composition, he called these characters αὐστηρός, ἀνθηρός, and εὔκρατος.[7] There is evidence in the text of his *De Compositione Verborum*, moreover, which suggests that Dionysius borrowed these terms from technical treatises on color in Greek painting.

Passages 1 and 2, as pointed out under *austerus*, appear to be derived direct-ly from technical treatises on painting. Passage 2, in fact, may preserve an echo of the writings of Apelles himself. The comment on the Roman painter

7. Descriptions of χαρακτῆρες or λόγοι of rhetorical and poetic composition are found not only in Dionysius but also in Demetrius *Eloc.* 36 ff.; see also Quintilian *Inst.* 12.10.58 on the styles of rhetoric: . . . *unum subtile quod* ἰσχνὸν *vocant, alterum grande atque robustum, quod* ἁδρὸν *dicunt, constituunt, tertium alii, medium ex duobus, alii floridum (namque id* ἀνθηρὸν *appellant) addiderunt.*

Famulus[8] in passage 3 is perhaps one of Pliny's few personal contributions to art criticism, and the use of *floridus* here may be either modeled on the type of criticism contained in passages 1 and 2 or derived from the critical vocabulary of rhetoric current in Pliny's own time.

It should be noted that neither in the professional criticism of painting nor in rhetorical criticism does *floridus* appear to have had the derogatory connotation which sometimes attaches to the English word *florid* (i.e. "excessively ornate, gaudy"). In painting the term simply referred to "brightness," and in rhetorical composition it signified a style which was smooth and consciously free from discordant sounds and rhythms.

See ἀνθηρός, *austerus, durus.*

forma

1. Cicero *Brut.* 70.

 Similis in pictura ratio est, in qua Zeuxim et Polygnotum et Timanthem et eorum, qui non sunt usi plus quam quattuor coloribus, formas et lineamenta laudamus.

 [In the history of sculpture there was a gradual development toward perfection.] The same development occurred in painting, in which, in the case of those who did not make use of more than four colors, we praise their forms and designs [i.e. draftsmanship].

2. Cicero *Inv. Rhet.* 2.1.1.

 Is et ceteras complures tabulas pinxit . . . ut excellentem muliebris formae pulchritudinem muta in se imago contineret, Helenae pingere* simulacrum velle dixit.

 *sese *i*; se *vel ante* pingere *vel post add. J.*

 [Zeuxis was hired by the people of Croton to execute a painting for their temple of Hera.] He [Zeuxis] also painted many other pictures . . . and, in order that his mute image contain within itself the pre-eminent beauty of the female form, he announced that he wanted to paint a likeness of Helen.

3. Cicero *Orat.* 9.

 . . . cum faceret Iovis formam aut Minervae . . . [Phidias].

8. Famulus executed paintings for the Golden House of Nero (Pliny *NH* 35.120), which means that he was active in A.D. 64–68.

gloria

See *pulcher, pulchritudo,* passage 4.

4. Pliny *NH* 34.54.

. . . Minervam tam eximiae pulchritudinis ut formae cognomen acceperit.

See *pulcher, pulchritudo,* passage 6.

Commentary

Unlike its English descendant, *form,* the Latin term *forma* plays only a very minor role in the criticism of the visual arts. The relative unimportance of *forma* is perhaps to be explained by the fact that ῥυθμός was the term most often used to refer to "form" in Greek art criticism, and the Romans rendered ῥυθμός by *numerus* (q.v.) rather than by *forma.* The preceding catalog lists only passages in which there is some reason to think that *forma* might be a translation of some term in a Greek critical source.

In general, *forma* has four meanings that can relate to the visual arts: (a) "form" or "figure," (b) "beauty," (c) "mold,"[9] and (d) "plan."[1] The latter two meanings are parallel to the Greek terms τύπος and παράδειγμα (qq.v.); and presumably *forma* could, at times, have served as a translation of those terms, although I know of no passages related to Greek art criticism in which it obviously does so.

In passage 4 the meaning "beauty" or, more specifically, the "beautiful one, the fair one" clearly applies. Exactly what the Greek cognomen of the bronze statue of Athena by Phidias was is not known from other sources. Καλή, καλλίμορφος, and καλλίστη have been suggested.[2]

In passages 1, 2, and 3 the meaning "form" or "figure" seems indisputable. The Greek prototype for *forma* in each passage, however, may have been different. Cicero's *formas et lineamenta* in passage 1 may reflect the Greek phrase σχήματα καὶ γράμματα (see σχῆμα and *lineamenta*). The *muliebris formae* of passage 2 perhaps derives from εἶδος in the simple sense of a "visible form" (see *species*), and the *Iovis formam* of passage 3 may simply have translated εἰκών in the source.

gloria

1. Pliny *NH* 35.60.

. . . primusque gloriam penicillo iure contulit [Apollodorus].

9. Pliny *NH* 36.168: *formae . . . in quibus aera funduntur*; *NH* 35.173 (a frame for wall paintings on plaster); Quintilian 1.6.3 (in the sense of "a stamp").
1. Cicero *Fam.* 2.8.1: *formam . . . aedificium.*
2. See Brunn, *GGK*[2], 1:129.

See *species,* passage 8.

2. Pliny *NH* 35.61.

. . . audentemque iam aliquid penicillum—de hoc enim adhuc loquamur—ad magnam gloriam perduxit.

[Zeuxis] led forward the paintbrush (for it is this of which we are still speaking), which now would dare anything, to great glory.

3. Pliny *NH* 35.80. See *laboriosus, labor,* passage 1.

4. Pliny *NH* 36.31. See *absolutus,* passage 7.

Commentary

The use of *gloria* in passages 3 and 4 to refer to the "fame, renown" of an artist is straightforward and requires no commentary. Passages 1 and 2, however, in which "glory" is bestowed on an art by an artist, are of special interest. These passages may reflect the metaphorical phraseology used by "Xenocrates" in the sections of his books on painting and sculpture in which he described how successive achievements by the five greatest exponents of each art had brought these arts to perfection (see the outline given in chapter 6). "Xenocrates" apparently began his remarks on the first painter (Apollodorus) and the first sculptor (Phidias) in each sequence of five great artists by pointing out that each had "opened up" a new vista in art (Phidias: *artem toreuticen aperuisse;* Apollodorus: *Ab hoc artis fores apertas*). Besides praising their opening up of each art, he apparently also praised their formal demonstration of the possibilities of each. *Artem toreuticen . . . demonstrasse* (on Phidias, Pliny *NH* 34.54) with reference to sculpture perhaps has the same value as *primusque gloriam penicillo iure contulit* (on Apollodorus, see passage 1) with reference to painting.

In the original text "Xenocrates'" statement may have taken a form generally similar to πρῶτος τῷ γραφείῳ δόξαν κανόνι [or διὰ κανόνος] ἔδωκε. *Gloria* would be a translation of δόξαν and *iure* (literally "by law") a translation of κανόνι,[3] "by a system of rules", the latter word signifying that Apollodorus had developed a formula for σκιαγραφία which other painters could make use of. For the use of δόξα to mean "glory" or

3. Or possibly νόμῳ; νόμος is a more natural equivalent of *ius,* but κάνων can signify a system of rules or prescriptions (cf. *LSJ⁹,* 2). It is conceivable that the Latin translator, Varro or Pliny, would not have understood exactly what the term referred to in connection with Apollodorus.

"reputation" in connection with the visual arts see Plutarch *De def. or.* 47 (*Mor.* 436C): ἆρ' οὖν ὁ βουλόμενος ἅπτεσθαι τῆς ὑλικῆς ἀρχῆς, ζητῶν δὲ καὶ διδάσκων τὰ παθήματα καὶ τὰς μεταβολάς, ἃς ὤχρα μιχθεῖσα σινωπὶς ἴσχει καὶ μέλανι μηλιάς, ἀφαιρεται τὴν τοῦ τεχνίτου δόξαν . . .

gracilis

1. Vitruvius 4.4.3.

Sin autem hoc ita videbitur, non est alienum in angustis locis et in concluso spatio graciliores columnarum symmetrias in opere constituere, cum habemus adiuctricem striatarum temperaturam.

[If a pronaos has two rows of columns in *antis*, the columns of the second row should be thinner than the outer row. But if they appear too slender, extra flutes may be added to them to make them look thicker. Fluted columns, having a greater number of visual stopping points on them, appear thicker.] Now if this is the case, it is not foreign to good practice to employ slenderer proportions for the columns in narrow places and enclosed spaces, since we have adjustment in the number of flutes to help us out.

See also Vitruvius 4.1.1, 4.1.7–8, 4.4.2, 4.6.4.

2. Pliny *NH* 34.65

Statuariae arti plurimum traditur contulisse, capillum exprimendo, capita minora faciendo quam antiqui, corpora graciliora siccioraque, per quae proceritas signorum maior videretur.

He [Lysippus] is held to have contributed much to the art of sculpture, by showing the details of the hair, by making the heads smaller than earlier sculptors had, and by making the bodies slenderer and more compact, as a result of which the height of the statues seemed greater.

Commentary

The meaning of *gracilis* in these passages is to be taken in a literal, physical sense— "physically thin, slender."

Passage 2 appears to be derived from "Xenocrates' " discussion of Lysippus's innovations in συμμετρία, and *gracilis* clearly seems to mean that he made the human body appear physically thinner (see also *siccus*).

In rhetoric and poetry *gracilis* sometimes had the meaning of "simple,

unadorned," but such a meaning does not seem to be relevant to the passages quoted here.[4] One Greek equivalent of *gracilis* in rhetoric was ἰσχνός. This word is also used in connection with art by Demetrius *Eloc.* 14: ἀρχαῖα ἀγάλματα, ὦν τεχνη ἐδόκει ἡ συστολὴ καὶ ἰσχνότης. But the term ἰσχνός really means "spare, compact, unadorned" rather than simply slender" and is probably the prototype for the Latin *siccus* (see passage 1 above and also under *siccus*). The basic Greek prototype for *gracilis* is λεπτός.

grandis

1. Pliny *NH* 35.64.

. . . grandior in capitibus articulisque . . . [Zeuxis]

See *diligens*, passage 8.

2. Pliny *NH* 35.128.

. . . capitibus articulisque grandior [Euphranor].

See *dignatio, dignus, dignitas,* passage 10.

Commentary

In the passages above the same criticism is applied to two different artists. The heads and limbs (joints?) of the figures in the paintings of Zeuxis and Euphranor are apparently felt to be too large in proportion to the figures' overall dimensions.[5] This type of criticism, dealing as it does with form and proportion, seems to come from Xenocrates and appears to represent a certain stage in his concept of the evolution of painting. Being a "grandpupil" of Lysippus, Xenocrates would naturally have had a preference for *capita minora* and *corpora graciliora* (*NH* 34.65), that is, the proportions of the human figure favored by Lysippus and probably by all members of the Sicyonian school in the late fourth century B.C. Neither Zeuxis nor Euphranor belonged to the Sicyonian school, from which Xenocrates derived his notion of what the proper proportions of the human figure should be.

4. Ovid *Pont.* 2.5.26, *materiae gracili sufficit ingenium*; Quintilian *Inst.* 12.10.58, referring to the style of rhetoric which is *gracilis* or *subtilis* = Greek ἰσχνός, "plain." See also Quintilian *Inst.* 12.10.36.

5. Pliny dates Zeuxis in the 95th Olympiad (400-397 B.C.) and Euphranor in the 104th (364–361 B.C.). Zeuxis, if this information is reliable, was probably an older contemporary of Euphranor. Both were active earlier than Apelles, the chief painter of the Sicyonian school.

The Greek word of which *grandior* was a translation was perhaps simply μείζων. The terms are, of course, to be taken as meaning literally "large, physically big."

Compare *amplus* and *exilis*.

gratia

1. Vitruvius 3.praef.2. See *dignatio, dignus, dignitas,* passage 1; see also Vitruvius 1.3.2.

2. Pliny *NH* 34.92.

 . . . gratiam omnem diligentia abstulerit [in a work of Callimachus].

 See *diligens,* passage 7.

3. Quintilian *Inst.* 12.10.6.

 . . . ingenio et gratia [in the art of Apelles].

 See *ingenium,* passage 11.

Commentary

Gratia, along with *venustas,* was one of the Latin translations of the Greek χάρις (q.v.). The essential meaning of *gratia,* "favor," indicates either the esteem in which one is held by others or the favor which one shows to another. The first sense of the word (i.e. the favor in which one is held by others) was extended to mean "pleasant, charming, lovely"; in other words, it took on the same significance as the Greek χάρις. This is clearly the meaning of *gratia* in the passages from Pliny and Quintilian quoted above (passages 2 and 3).

The *gratia* which Quintilian ascribes to Apelles in passage 3 must be the χάρις which was so characteristic of Apelles' work and which Apelles himself wrote about. This passage, like most of Quintilian's history of painting, seems to be the result of a fusion of some of the criteria of professional criticism of the visual arts with the comparative stylistic canons of Hellenistic rhetoric (see *ingenium* and χάρις).

Passage 2 may indicate the contrast which was felt by a fourth-century or Hellenistic writer (Antigonus? or even Apelles himself) between the more immediately appealing qualities in the art of his own time (χάρις) and the more labored art of Callimachus, in which the demands of theory and the

possibilities of technique were pursued at the expense of spontaneity (see *diligens*).

In the passage from Vitruvius (passage 1), however, the basic meaning of the word "favor" (the favor shown by posterity to the great artists of the past), can be maintained.

gravitas, gravis

1. Vitruvius 5.9.3.

> . . . aliam enim in deorum templis debent habere gravitatem, aliam in porticibus et ceteris operibus subtilitatem.

> [Proportions of columns should vary with the function of the building,] for in temples of the gods they [the proportions] ought to have an imposing quality, whereas in porticoes and other such buildings they ought to have subtle refinement.

See also Vitruvius 1.1.7.

2. Pliny *NH* 35.111.

> . . . cothurnus et gravitas artis multum a Zeuxide et Apelle abest [Nicophanes].

See *cothurnus,* passage 1.

3. Pliny *NH* 35.120.

> . . . gravis ac severus . . . pictor Famulus

See *floridus,* passage 3.

Commentary

Gravitas (adj. *gravis*), meaning literally "heaviness," is frequently used in the metaphorical sense of "moral heaviness, seriousness." It belongs to a circle of words, such as *facilitas* and *cothurnus,* which appear to be part of the terminology used by writers belonging to the group which has been called the "literary analogists." Like so many of the other stylistic judgments that derive from the literary criticism, the *gravitas* idea probably took shape in the criticism of Greek and Roman rhetoric in the late Hellenistic period. Cicero uses *gravitas* to describe both a style of delivery in oratory

and also the effect of such delivery.[6] The term is perhaps frequently used as a translation of the Greek σεμνότης (q.v.) or βάρος as used by Dionysius of Halicarnassus in *Comp.* 23: σχήμασί τε οὐ τοῖς ἀρχαιοπρεπεστάτοις οὐδ' ὅσοις σεμνότης τις ἢ βάρος ἢ πίνος πρόσεστιν, ἀλλὰ τοῖς τρυφεροῖς.[7] We need not assume, however, that all the passages quoted here are directly derived from Greek sources. The painter Famulus, for example, appears to have been active in the first century B.C., and the description of him as *gravis ac severus* in passage 3 may represent one of Pliny's personal critical judgments. Even if this is the case, however, Pliny is probably using critical terminology which he has absorbed from literary criticism, particularly that of late Hellenistic rhetoric.

The critical judgments about the art of Nicophanes which are preserved by Pliny (*NH* 35.111 and 137) exhibit some interesting contrasts and are probably derived from different critical traditions. On this question see *concinnus, cothurnus, diligens,* and *elegantia, elegans.*

ingenium

1. Cicero *Verr.* 2.4.4.

> Erat apud Heium sacrarium magna cum dignitate in aedibus, a maioribus traditum, perantiquum, in quo signa pulcherrima quattuor summo artificio, summa nobilitate, quae non modo istum hominem ingeniosum et intellegentem, verum etiam quemvis nostrum, quod iste idiotas appellat, delectare possent.

> There was in the house of Heius [at Messina] a very impressive chapel, handed down from his ancestors, of great antiquity, in which there were four extremely beautiful statues, works of the highest artistic quality and the greatest renown, which not only that gifted and perceptive man [Verres] but even those of us whom he calls boors could appreciate.

2. Cicero *Verr.* 2.4.98.

> Haec Scipio ille non intellegebat, homo doctissimus at humanissimus,

6. Cicero *Att.* 9.9.2: *Illud me praeclare admones, cum illum videro, ne nimis indulgentur, et ut cum gravitate potius loquar;* also *Att.* 9.19.3; *Brut.* 326; *De Or.* 2.17.72; cf. Quintilian *Inst.* 9.3.140.

7. Dionysius is here describing the qualities which the elegant character (γλαφυρὸς χαρακτήρ) of composition lacks. In general σέμνος is far more common in the criticism of rhetoric than βάρος, which most frequently refers to lowness of pitch rather than to a quality of style. Robert, *Arch. Märch.*, p. 78, suggests μέγεθος as the Greek prototype of *gravitas*. Μέγεθος, however, appears to be more closely related to *pondus* and *magnificentia*. See μέγεθος.

tu sine ulla bona arte, sine humanitate, sine ingenio, sine litteris, intellegis et iudicas.

[For what precedes see *lineamenta*, passage 3.] Scipio, that most learned and cultivated man, did not appreciate these things, but you, who are without any worthy skill, without culture, without talent, without learning—you appreciate these things and pass judgment on them.

3. Vitruvius 1.1.3.

Quare videtur utraque parte exercitatus esse debere, qui se architectum profiteatur. Itaque eum etiam ingeniosum oportet esse et ad disciplinam docilem. Neque enim ingenium sine disciplina aut disciplina sine ingenio perfectum artificem potest efficere.

[In all disciplines there are two factors: the subject itself and the systematic demonstration of the nature of the subject.] It would thus appear that he who wishes to be an architect should be experienced in both aspects of the field. In other words, he should be both naturally gifted and also ready to learn. For neither natural ability without disciplined learning nor disciplined leaning without natural ability can make a fully developed artist.

4. Vitruvius 6.2.4.

Cum ergo, quae sunt vera, falsa videantur et nonnulla aliter quam sunt oculis probentur, non puto oportere esse dubium, quin* ad locorum naturas aut necessitates detractiones aut adiectiones fieri debeant, sed ita, uti nihil in his operibus desideretur. Haec autem etiam ingeniorum acuminibus, non solum doctrinis efficiuntur.

*quin *Gs*c; quam *Hs*.

Since, therefore, things which are in fact true appear to be false and some things are affirmed by the eyes as being other than what they really are, there should be no doubt, in my opinion, about the fact that subtractions or additions ought to be made according to the nature and necessities of the sites, but they should be made in such a way that nothing is wanting in the buildings. These changes are effected, however, by the spontaneous insights of genius and not simply by the application of learned rules.

See also Vitruvius 1.1.18, 2.1.6, 3.praef.2 (see *perfectus, perfectio* passage 7), 5.6.7, 7.praef.9–10, 9.8.2, 10.praef. 3, 10.2.11.

5. Pliny *NH* 7.34.

Pompeius Magnus in ornamentis theatri mirabiles fama posuit effigies ob id diligentius magnorum artificum ingeniis elaboratas . . .

Pompey the Great set up among the ornaments of [his] theater images representing famous miraculous events, wrought just for this purpose with great care by the inventive ingenuity of great artists.

6. Pliny *NH* 34.57.

Myronem Eleutheris natum, Hageladae et ipsum discipulum, bucula maxime nobilitavit celebratis versibus laudata, quando alieno plerique ingenio magis quam suo commendantur.

Myron, who was born at Eleutherae and was himself a pupil of Hageladas was especially famous for his calf, which was praised in well-known verses, a good example of the fact that many men owe their fame more to somebody else's talent than to their own.

7. Pliny *NH* 35.73.

Nam Timanthes vel plurimum adfuit ingenii.

As for Timanthes, he possessed a high degree of imaginative ingenuity.

8. Pliny *NH* 35.74.

Sunt et alia ingenii eius exempla, veluti Cyclops dormiens in parvola tabella, cuius et sic magnitudinem exprimere cupiens pinxit Satyros thyrso pollicem eius metientes. Atque in unius huius operibus intelligitur plus semper quam pingitur et, cum sit ars summa, ingenium tamen ultra artem est.

[Timanthes painted a picture of the sacrifice of Iphigeneia. The challenge of showing the appropriate emotions on the face of Agamemnon in this scene seemed so insurmountable that he decided to veil Agamemnon's face.] And there are other examples of his ingenuity, for example, his picture on a tiny panel of a sleeping Cyclops; wishing to express the Cyclops's great size, he painted some Satyrs next to him measuring the size of his thumb [or "big toe"]. And indeed in the works of this artist alone more is always understood than actually painted, and although their artistic quality is great, their ingenuity is still greater.

9. Pliny *NH* 35.142.

. . . Nealces Venerem [pinxit], ingeniosus et sollers, . . .

. . . Nealces, an inventive and extremely skillful artist, painted an Aphrodite . . .

10. Pliny *NH* 36.18.

Pheidian clarissimum esse per omnes gentes quae Iovis Olympii intellegunt nemo dubitat, sed ut laudari merito sciant qui opera eius non videre, proferemus argumenta parva et ingenii tantum. Neque ad hoc Iovis Olympii pulchritudine utemur, non Minervae Athenis factae amplitudinem . . .

That Phidias is the greatest sculptor no one doubts among all those people who appreciate the fame of the Zeus at Olympia, but in order that those who have not seen his works may know that he is justly praised, I shall put foward some small details as a sufficient testimony of his inventiveness. Nor, for this purpose, shall I use the beauty of the Zeus at Olympia, nor the size of the Athena which he made in Athens. . .

11. Quintilian *Inst.* 12.10.6.

. . . ingenio et gratia, quam in se ipse maxime iactat, Apelles praestantissimus est.

. . . for genius and grace, in the latter of which he took the greatest pride, Apelles was foremost.

12. Ausonius *Epigrammata* 71 (Overbeck, *Schriftquellen*, 591).

Aerea mugitum poterat dara vacca Myronis;
sed timet artificis deterere ingenium.
Fingere nam similem vivae, quam vivere, plus est;
nec sunt facta dei mira, sed artificis.

The bronze heifer of Myron could loudly low,
But it fears to impair the artist's inventiveness.
For to make something seem alive, is greater than having it actually
 live,
And it is not the works of God which are wonderful, but those of the
 artist.

Commentary

Ingenium (from *in* and *gigno*, hence "that which is born in one") refers to

the qualities which a person possesses by nature as opposed to those which can be learned by experience. These qualities can be viewed either in a passive sense—the personality or nature of a person—or in an active sense—"natural capacity, talent, genius." Although both meanings seem to be equally common in Latin literature as a whole, the latter sense, natural capacity, is the most frequent, if not the exclusive, meaning of the term in connection with the visual arts.[8]

Within the framework of natural capacity there appears to be a subtle subdivision between those passages in which *ingenium* means "natural ability, talent, genius" (passages 2, 3, 4, 6, 11) and those in which it seems to emphasize particularly "inventiveness, ingenuity" (passages 5, 7, 8, 10). Likewise, the adjective *ingeniosus* can mean simply "gifted" (passages 1 and 3) or "inventive" (passage 9). Ausonius's use of *ingenium* in passage 12 is ambiguous. I have used "inventiveness" in my translation, but "genius" would do as well.

In passages 1 and 2 Cicero uses *ingeniosus* and *ingenium* almost as if the terms meant "tasteful" and "good taste." Despite the fact that they deal with Verres' "collecting" and also deal, indirectly, with Greek art, the language of these passages seems purely Roman in character.

On the other hand, in passages 7, 8, and 11, at least, and quite possibly in all the other passages quoted here, *ingenium* gives the impression of functioning as a translation of a Greek term. What this Greek term was, however, is not easy to establish. Bernhard Schweitzer has suggested that it might be φαντασία, "creative imagination" or "insight," as used in the *phantasia* theory.[9] But φαντασία in this sense places an emphasis on inspired perception, whereas *ingenium*, as far as I can determine, expresses a more mundane, self-generated ingenuity or talent. In Pliny's discussion of the work of the painter Timanthes (passages 7, 8), for example, there is no implication of any spiritual or inspirational (in the religious sense) content in the artist's work. *Ingenium*, in these passages, may possibly be a translation of φαντασία, but, if so, it is perhaps best to interpret φαντασία in the sense in which it is used by Aelian and Quintilian in connection with the painter Theon of Samos—that is, "imaginative ingenuity" (see φαντασία). As an example of Timanthes' *ingenium* Pliny describes two pictures. The subject of

8. In the passive sense of "nature" or "temper" *ingenium* comes very close in meaning to the Greek ἦθος See Terence *An.* lines 53–54: *Qui scire posses aut ingenium noscere/ Dum aetas, metus, magister prohibebant*; Cicero *Inv. Rhet.* 1.45.83: *Sin inverecundum animi ingenium possidet tamen accuses . . .* ; also in connection with other things than human personality: Petronius *Sat.* 126: *Crines ingenio suo flexi per totos se umeros effuderant.* As Quintilian emphasized, however there was no exact Latin translation of ἦθος (see ἦθος καὶ πάθος).

9. Schweitzer, *Xenokrates*, p. 38.

the first of these was the sacrifice of Iphigeneia; the *ingenium* it revealed seems to have resided in the fact that, while all the other figures in the picture were represented as being overwhelmed by grief, the face of Agamemnon was veiled, so that one could only guess what his emotion was. The second painting depicted a huge sleeping Cyclops whose size was emphasized by placing next to him a group of satyrs who were measuring his thumb (passage 8). The *ingenium* of Timanthes, it is clear, meant the imaginative, subtle touches he inserted into the narrative subject matter of his paintings. When Pliny says that *in unius huius operibus intelligitur plus semper quam pingitur et, cum sit ars summa, ingenium tamen ultra artem est,* he seems to mean, not that Timanthes' technique was inadequate for his ideas, but that in his paintings subject matter was always of greater interest than technique.

The meaning that Pliny gives to *ingenium* in connection with Timanthes can also be applied to his use of *ingeniosus* to describe the painter Nealces (passage 9). As an example of Nealces' "ingenuity" Pliny mentions a painting of a battle between the Persians and the Egyptians which was supposed to have taken place along the Nile. In order to indicate that the water in his picture was the Nile and not the sea, Nealces depicted a donkey drinking from the river and a crocodile lying in wait (*NH* 35.142). Here again *ingenium* is explained as a subtle touch within the narrative content of the subject matter of a painting.

Quintilian's use of *ingenio* in connection with Apelles (passage 11) is more difficult to explain. The paintings of Apelles do not appear to have been famed for the ingenious, unconventional features of subject matter which characterized the paintings of Timanthes. Elsewhere in the *Institutio Oratoria* Quintilian uses *ingenium* to refer to the natural ability of his pupils. Perhaps the best explanation of Quintilian's use of *ingenio* in connection with Apelles is the one offered long ago by Brunn.[1] He suggested that *ingenio* in Quintilian was associated with the tradition preserved by Pliny (*NH* 35.80) that Apelles knew when to take his hand away from a picture. Protogenes with all his *cura* and *diligentia* (qq.v) was not the equal of Apelles because, unlike Apelles, he did not have the natural instinct which told him when a painting was finished. This instinct was Apelles' natural capacity, his *ingenium*.

The question of what source (or sources) the judgments in passages 7–10 and 11 were derived from cannot be answered with certainty. Since *ingenium* in these passages does not really equal the late antique meaning of φαντασία, I believe we can discount the theoreticians of the Middle Stoa as possible sources. It is also fairly certain that we can discount "Xenocrates." It may be that Pliny provides a hint as to the source of these passages when he

1. Quintilian *Inst.* 1.4.6 and 1.8.8; Brunn, *GGK*[2], 2:156.

says that Timanthes' Iphigeneia was *oratorum laudibus celebrata*.[2] This remark perhaps suggests that the use of *ingenium* in passages 1-5 is derived from Hellenistic canons of rhetoricians and artists (see chap. 3). It is also worth considering that the Greek word which served as a prototype for *ingenium* was not φαντασία but rather ἐπίνοια, which is used in rhetoric to mean not only "idea, conception" but also "inventiveness, ingenuity."[3]

Vitruvius uses *ingenium* throughout to mean "natural ability, talent," as opposed to *disciplina* and *usus* or *exercitas,* "experience." In passage 3, for example, he states that he who wishes to qualify as an architect must have experience (*exercitatus esse debere*) in both the practical techniques of architecture and also its theory, and he must have both natural ability (*ingenium*) and an ability to learn theoretical principles (*ad disciplinam docilem*). In passage 4 natural ability is also contrasted with theory. Here Vitruvius emphasizes that an architect who approaches the problem of figuring out the variations in form which compensate for optical distortion must have not only theoretical knowledge (*non solum doctrinis efficiuntur*) but also the quickness of understanding that comes from natural talent. Likewise in 5.6.7 he advises that, in case of a shortage of certain materials in a building project, other materials can be substituted, but the architect who does this must be experienced (*usu peritus*) and not devoid of either talent (*ingenio*) or learned skill (*sollertia*).

Carl Watzinger[4] has shown that this three-part division of the qualifications necessary for any activity was known in other fields besides architecture. In rhetoric Cicero and Quintilian used the triad *natura, ars,* and *exercitatio* with the same value as *ingenium, disciplina,* and *usus*.[5] Perhaps the most illuminating observation on this triad occurs in the *Etymologiae* of Isidore of Seville in connection with rhetoric: . . . *ipsa autem peritia dicendi in tribus rebus consistit, natura, doctrina, usu: natura ingenio, doctrina scientia, usu asiduitate. Hae sunt enim quae non solum in oratore, sed in unoquoque homine artifice exspectantur, ut aliquid efficiat.*[6] Watzinger suggests that the Latin triads may perhaps be traced back to the theory first propounded by Protagoras in the fifth century B.C. that ἄσκησις, φύσις, and ἐπιστήμη were the three qualifications necessary for all undertakings.[7] It is doubtful, however, that *ingenium* in Vitruvius is a direct translation of the Greek φύσις. All the passages from Vitruvius

2. Pliny *NH* 35.73; see Cicero's praise of Timanthes' work in the *De Or.* 74.

3. On the "inventions" of rhetoricians see Dion. Hal. *Pomp.* 1: ἅπαντας, ὅσοι τὰς αὐτῶν ἐπινοίας εἰς τὴν κοινὴν φέρουσιν ὠφέλειαν ἐπανορθοῦντες ἡμῶν βίους τε καὶ λόγους. See also, in connection with the arts in general, Pseud. Arist. [*Mund.*] 399b17: τέχνης ἐπίνοιαι.

4. Carl Watzinger, "Vitruvstudien," *RhM* 64 (1909): 208.

5. Quintilian 2.5.1; Cicero *Brut.* 25; Cicero *De Or.* 3.77.

6. Isidore *Etym.* 2.3. (ed. Lindsay). Isidore lived from A.D. 602 to 636 but undoubtedly used earlier sources.

7. Diels, *Fragmente*[7], 80B3: φύσεως καὶ ἀσκήσεως διδασκαλία δεῖται.

discussed here may be general paraphrases of the venerable and widely used Greek triad, and *ingenium* may convey the general meaning of φύσις without actually being its exact equivalent.

iucundus

1. Pliny *NH* 34.66.

. . . [Euthycrates] austero maluit genere quam iucundo placere.

See *austerus*, passage 1.

2. Pliny *NH* 35.134.

. . . Athenion Maronites . . . austerior colore et in austeritate iucundior . . .

See *austerus*, passage 4.

Commentary

The possible role of the terms *austerus* and *iucundus* in the criticism of Greek painting and sculpture is discussed in the commentary under *austerus*. The two terms seem clearly to be connected with the αὐστηρός and γλαφυρός "characters" of rhetorical composition as described by Dionysius of Halicarnassus. Αὐστηρός seems to have played a role in the technical terminology of the Greek painters which was independent of and probably prior to its use in rhetoric. The same may also be true of the Greek prototype of *iucundus* (probably γλαφυρός).

Passage 2 seems to mean that Athenion was fond of using those particular colors which were classified as *austeri,* but that within the austerity created by his use of color, his style was *iucundus,* "pleasing." *Iucundus* here may refer specifically to Athenion's use of the formal elements in design such as συμμετρία, ῥυθμός, and perhaps even διάθεσις, or to his mastery of the principles controlling the application of color such as τόνος and ἁρμογή. This at least is suggested by the phrase *ut in ipsa pictura eruditio eluceat,* which implies that Athenion's achievement was an intellectual one and depended on knowledge of theory.

In passage 1, which is also discussed in connection with *austerus* and *constantia,* Pliny once again juxtaposes *austerus* and *iucundus.* In this passage it seems that *constantiam potius imitatus patris quam elegantiam* should be set off as a participial phrase modifying *is,* and that the *quamquam* introduces *austero maluit genere quam iucundo placere.* The latter part of the sentence thus reads ". . . but before all Euthycrates, although he, having imitated the *constantia* rather than the *elegantia* of his father, preferred to please by the

austere rather than the *iucundus* genre." The two phrases *constantiam potius imitatus patris quam elegantiam* and *austero maluit genere quam iucundo placere* probably mean essentially the same thing; the former phrase states a fact, and the latter expresses an intention. Lysippus apparently combined two styles in his sculpture; his works were characterized by harmony of structure but also by a certain elegance. If we understand Pliny's statement in the light of the rhetorical terminology of his time, then the terms *constantia* and *elegantia* may refer simply to the general effect which Lysippus's work had on its viewers. If we understand the passage as reflecting a judgment originally made in the writings of Xenocrates or in those of one of the professional critics, then the terms may well connote specific aspects of the συμμετρία, εὐρυθμία, and so on in Lysippus's statues.[8] Euthycrates imitated one of the elements in his father's style, that is, its *constantia*. Hence it could be said that he chose to please by the *austerus* genre of composition rather than by the *iucundus*. *Constantia*, by this interpretation, would be the type of composition that is characterized by *austeritas*, and *elegantia* would be the type of composition characterized by *iucunditas*.[9]

Other interpretations of passage 1 are possible, however. If one assumes that *constantia* and *elegantia* represent concepts completely independent of the *austerum genus* and the *iucundum genus*, then one may assume that the *genera* represent subcategories within the broader concept of *constantia*. By this interpretation the passage would mean that Euthycrates, having adopted the *constantia* of his father, then chose to use an austere rather than a *iucundus* type of *constantia*.

I am inclined to favor, however, the interpretation which sees the two sets of terms as complementing one another. The language of the passage is, one must admit, ambiguous. The terms involved may refer to highly technical features in the art of Lysippus and Euthycrates, or they may simply be derived from a loose analogy drawn between the effect produced by certain types of sculpture and that produced by certain types of rhetoric.[1]

laboriosus, labor

1. Pliny *NH* 35.80.

> Et aliam gloriam usurpavit, cum Protogenis opus immensi laboris ac curae supra modum anxiae miraretur . . .

8. One might speculate that συμμετρία was specifically connected with *constantia*, while εὐρυθμία was connected with *elegantia*. Lysippus cultivated both in his statues. See εὐρυθμία.

9. This interpretation would discount Silvio Ferri's view (discussed under *constantia*) that *constantia* alone means "composition," for, in this case, *elegantia* too would indicate a kind of composition.

1. On *iucundus* in rhetoric, see Quintilian *Inst.* 12.10.11, *iucunditatem Crispi* (under the

[Apelles' chief quality was his χάρις (q.v., passage 3).] He also laid claim to another distinction when he admired a work of Protogenes for its immensely painstaking effort and boundless care [but claimed that he was superior in one respect, namely, that he knew when to stop working on a picture. See *diligens*, passage 9.]

2. Pliny *NH* 35.128.

Fecit et colossos et marmorea et typos scalpsit, docilis ac laboriosus ante omnes et in quocumque genere excellens ac sibi aequalis.

He [Euphranor] also made colossal statues, marble statues, and reliefs [see τύπος], being exceptionally well versed and painstaking, excelling in whatever field he entered, and always maintaining his standard.

3. Juvenal *Sat.* 8.102.

. . . Et cum Parrhasii tabulis signisque Myronis
Phidiacum vivebat ebur, nec non Polycliti
multus ubique labor; rarae sine mentore mensae.

[Before the era of men like Verres and others, the homes of foreigners whom the Romans conquered were filled with treasures, such as money, rich clothing,] and along with the paintings of Parrhasius and the statues of Myron, there was the ivory work of Phidias; the work of Polyclitus was everywhere not unplentiful; and rare were the tables without a work of Mentor.

Commentary

Labor, best translated as "painstaking application," appears to have been an informal, nontechnical critical term used by both artists and laymen.

Passage 1, Pliny's remark about the meticulousness of the art of Protogenes, clearly seems to be related to two similar passages in Plutarch (see θαυμαστός, passage 3) and Aelian (see χάρις, passage 5) in which Apelles' reaction to the Ialysos of Protogenes is recorded. All three passages may be derived from a common source, perhaps either Apelles himself[2] or a

genera dicendi); 4.2.63, *iucundam expositionem*; Cicero *De Or.* 1.49.213, . . . *verbis ad audiendum iucundis*.

2. Both Apelles and Protogenes wrote about painting. (On Apelles see Pliny *NH* 35.79 and the index to book 35; on Protogenes see Sudias, s.v. Protogenes.) In these writings each may have discussed the other's work and argued about theory. Apelles, we know, discussed the work of several other artists besides Protogenes; see Pliny *NH* 35.80 (Melanthius, Asclepiodorus).

contemporary anecdotal writer like Duris of Samos. Duris might have contrasted Apelles' χάρις to the πόνος or *labor* of Protogenes.

Having established the equation of *labor*=πόνος, we can with some certainty translate *laboriosus*, which Pliny applies to Euphranor in passage 2, as φιλόπονος. Compare Xenophon *Mem.* 3.4.9, describing businessmen and generals: ἐπιμελεῖς καὶ φιλοπόνους ἀμφοτέρους εἶναι προσήκει περὶ τὰ αὑτῶν ἔργα. The terms ἐπιμέλεια and μελέτη appear to be the Greek prototypes for the Latin term *cura* (q.v.). *Labor* and *cura* ("painstaking effort" and "care") are closely related, as their appearance together in passage 1 indicates. It may be that *labor et cura* was the Latin phrase by which the Romans rendered the Greek phrase φιλοπονία καὶ ἐπιμέλεια (see the passage from Xenophon quoted above).

In passage 3 Juvenal refers in a general way to the "work" of Polyclitus as a sculptor. *Labor* in this sense is clearly not a critical term.

lineamenta, linea

1. Cicero *Brut.*70.

 . . . formas et lineamenta laudamus [in the art of the "four-color painters"].

 See *forma*, passage 1.

2. Cicero *Div.* 1.13.23. See ἀλήθεια-*veritas*, passage 13.

3. Cicero *Verr.* 2.4.98.

 Tu videlicet solus vasis Corinthiis delectaris, tu illius aeris temperationem, tu operum liniamenta sollertissime perspicis . . .

 You [Verres] alone, clearly, are able to appreciate Corinthian [bronze] vases, you alone appreciate the tempering of that kind of bronze, and only you perceive, with greatest sagacity, the fine features of these works . . .

4. Petronius *Sat.* 88.

 . . . Lysippum statuae unius lineamentis inhaerentem inopis extinxit.

 . . . Lysippus, being constantly intent upon the features of one statue, died of want.

5. Pliny *NH* 35.15–16.

Graeci autem alii Sicyone, alii aput Corinthios repertam, omnes umbra hominis lineis circumducta, itaque primam talem . . . inventam liniarem a Philocle Aegyptio vel Cleanthe Corinthio primi exercuere Aridices* Corinthius et Telephanes Sicyonius, sine ullo etiamnum hi colore, iam tamen spargentes linias intus.

*Aridices: *Sillig, Keil, Mayhoff, and most editors*; aradices B; ardices *rv.

[The Egyptians claim that they invented painting.] As for the Greeks, however, some hold that it was invented at Sicyon, others that it was invented among the Corinthians, but all agree that it was invented by drawing lines around the shadow of a man. . . . Line drawing [they maintain], was invented by Philocles the Egyptian or by Cleanthes of Corinth but that the first to really cultivate it were Aridices of Corinth and Telephanes of Sicyon; these artists still used no color whatsoever, but they were by this time adding lines here and there within the form.

6. Pliny *NH* 35.67.

. . . confessione artificum in liniis extremis palmam adeptus. Haec est picturae summa subtilitas.

. . . by the admission of artists themselves he [Parrhasius] won the palm in the rendering of outlines. This is the supreme refinement of painting.

7. Pliny *NH* 35.92.

Invidit mors peracta parte, nec qui succederet operi ad praescripta liniamenta inventus est.

[Apelles began a second Aphrodite of Cos.] But the envy of death intervened when the painting was only partly finished, nor was anyone found who could complete the work in accordance with the preliminary drawings.

8. Pliny *NH* 35.145.

. . . suprema opera artificum inperfectasque tabulas, . . . in maiore admiratione esse quam perfecta, quippe in iis lineamenta reliqua ipsaeque cogitationes artificum spectantur.

. . . the last works of artists and their unfinished pictures . . . are held in greater admiration than [their?] finished works, because in these the

sketch lines remain and the actual thought processes of the artists are visible.

See also *NH* 35.81–83; see *subtilitas,* passage 10.

9. Quintilian *Inst.* 12.10.4.

Parrhasius . . . examinasse subtilius lineas traditur.

[Zeuxis particularly developed the technique of shading.] Parrhasius . . . according to tradition, brought great refinement to draftsmanship. [Literally: "pondered lines with more acuteness".]

Commentary

Linea (also *linia*) literally means a "linen thread" or "string" (compare *linum,* "flax") but also serves, by extension, as the word for "drawn lines." *Lineamentum,* from *linea,* also refers in its most basic sense to a drawn line but is usually employed in the plural to refer to the fundamental lines of something, hence a "basic pattern" (passages 1, 2) or "sketch lines" (passages 7, 8). The idea of a basic pattern is also extended in a general way to mean "features" (passages 3 and 4).

Linea almost certainly served as a translation of the Greek ἡ γραμμή. *Lineamenta* is perhaps to be correlated with τὰ γράμματα in the sense of "drawn figures."[3]

Like a number of other terms in this glossary *linea* and *lineamenta* are not in themselves critical terms, but they represent topics which were of fundamental importance in the history of Greek art criticism. This is particularly true of the critical approaches evident in passages 6 and 9 and in passages 1 and 8.

According to Pliny, Xenocrates and Antigonus praised Parrhasius's mastery of line drawing above that of all other artists, and Pliny emphasizes that the two writers did not simply acknowledge the fact; they praised it boldly (*praedicantes quoque, non solum confitentes, NH* 35.68). Other painters, Pliny says, had won fame by depicting the spatial mass of bodies (*corpora enim pingere et media rerum, NH* 35.67), but Parrhasius's mastery of line was *rarum in successu artis.* Pliny also provides a precise statement as to what is meant by *in liniis extremis palmam adeptus: extrema corporum facere et desinentis*[4] *picturae modum includere rarum in sucessu artis invenitur. Ambire enim se ipsa debet*

3. As in, for example, Theocritus 15.81: ποῖοι ζωγράφοι τ'ἀκρίβεια γράμματ' ἔγραψαν; for other examples see *LSJ*[9], 1.
4. desinentes *V.*

extremitas et sic desinere, ut promittat alia[5] *et post se*[6] *ostendatque enim quae occultat.* ("To make the contour of figures, and to include just the right amount of the subject which is being delimited is a rare event in artistic achievement. For the contour ought to round itself off and so delimit, that it suggests other parts behind it and shows even what it hides.") There is no way of knowing whether this explanation is a later interpolation by Pliny or Varro or whether it is derived directly from Xenocrates.[7]

There may be hints in Pliny's passage on Parrhasius of an ancient controversy between the relative merits of painting and drawing.[8] It should be noted, however, that Pliny does not really say that the mastery of line was a greater or lesser achievement than the painting of mass; he simply says that it was rarer. It is possible, therefore, that the passage is intended to point up not a controversy but simply a stylistic advance, a *primus*, which Xenocrates attributed to Parrhasius. The phrase *corpora pingere et media rerum* must refer to the achievements of Apollodorus and Zeuxis, whose figures, because of the artists' subtle use of light and shade, appeared to have mass (see σκιαγραφία and *species*). Pliny does not say that Parrhasius's figures lacked shading; he only says that his figures also had other qualities, the foremost of which was his mastery of line drawing. Quintilian also preserves the same tradition about the achievements of Zeuxis and Parrhasius (see passage 9).

In short, it may be that in Xenocrates' critical-historical system, Parrhasius was credited with having made several important contributions toward the perfection of painting—he first introduced *symmetria* into painting, he improved the rendering of the hair and other details, and he made contributions to the art of draftsmanship. The last of these may have been cultivated, not instead of, but rather in addition to σκιαγραφία.

Although Xenocrates' and Antigonus's remarks about Parrhasius's draftsmanship are not in themselves sufficient evidence to prove the existence of an ancient controversy between the adherents of precise line drawing and the adherents of σκιαγραφία, this does not mean that such a controversy could not have existed, even among artists. If Xenophon's portrayal of Parrhasius as an acquaintance of Socrates in the *Memorabilia* has any historical validity (see ἦθος καὶ πάθος), it may be that Parrhasius was actually influenced by the Socratic-Platonic tradition and was trying to put some

5. alia et *Mayhoff*; aliae *V*; alia *rell.*

6. post se *V*² *RhG.*; post e *V*; post *d.*; posse *V*.

7. The use of the term *successus* perhaps suggests that at least part of the passage was a Roman gloss on the original criticism found in the works of Xenocrates and Antigonus. See commentary under *successus*.

8. On this question in particular see R.G. Steven, "Plato and the Art of His Time," *CQ* 27 (1933): 149–55; and Sellers, *EPC*, p. xxx. See also *subtilitas*.

of its principles into practice by eschewing shading. Plato, it will be remembered, disapproved strongly of σκιαγραφία. Or it may be that Plato perceived two distinctly divergent techniques in the work of two important contemporary painters and used the contrast between them as an analogy to the difference between real knowledge and sense perception, thus seeing an opposition, and hence a controversy, where the painters themselves saw only a progression.

Another hint of a controversy over the relative merits of draftsmanship and σκιαγραφία can perhaps be detected in the *Twelfth Oration* of Dio Chrysostom (sec. 44), where, in discussing the means that artists use in creating images of gods, Dio mentions σκιαγραφίᾳ μάλα ἀσθενεῖ καὶ ἀπατηλῇ πρὸς ὄψιν ("by means of σκιαγραφία which is weak and deceptive to the eye") and contrasts it to χρωμάτων μίξει καὶ γραμμῆς ὅρῳ σχεδόν τὸ ἀκριβέστατον περιλαμβανούσης ("by the mixing of colors and by a boundary of peripheral lines which is just about the most precise").[9] The language used by Dio in connection with σκιαγραφία is close to that used by Plato in the *Critias* 107C: σκιαγραφίᾳ δὲ ἀσαφεῖ καὶ ἀπατηλῷ χρώμεθα; and it may be that Dio was under the influence of Plato when he contrasted σκιαγραφία with line drawing.

Passages 1 and 8 imply that *lineamenta* were outstanding in works that were either incomplete or at least uncomplicated. This idea that *lineamenta* indicated rudimentary elements in the painter's technique is in marked contrast to the opinions of Xenocrates and Antigonus, for whom the mastery of line represented the *summa subtilitas* of painting. Pliny's passage on the sketches visible in unfinished works represents an attitude which may be familiar today but which was rare in ancient art criticism. These sketches were more admired than finished works, he says, because they brought the viewer closer to the artist's original ideas (*cogitationes*). In the art criticism of the Classical period there is no trace of an appreciation for works which were not precise and finished (ἀκριβῆ and τέλεια). This passage could conceivably represent one of Pliny's personal judgments, but the fact that it is accompanied by several specific examples of unfinished paintings, which are all by Greek artists of the Hellenistic period (Apelles, Aristides,[1] and Nicomachus) but which are not specifically mentioned as being in Rome,

9. The mixing of colors mentioned by Dio probably refers not to shading but to the actual blending of pigments and perhaps also to the juxtaposition of colors in a painting.

1. Presumably Aristides the Younger, son of Nicomachus, see Pliny *NH* 35. 110. The elder Aristides was apparently two generations older than Apelles, since he was the teacher of Pamphilus, Apelles' own teacher (*NH* 35.75). The younger and more famous Aristides was a contemporary of Apelles and Protogenes (*NH* 35.98 ff.). Nicomachus was perhaps the son of the older Aristides, although the reading *Aristides filius* in *NH* 35.108 is reconstructed by Mayhoff from *aristiaci* (*cod. Bamb.*) and *ariste cheimi* (*rell.*).

makes it more likely that Pliny was drawing on some Hellenistic source. If one asks which Hellenistic writer would have been interested in compiling a list of unfinished paintings and at the same time have had an appreciation for the traces of "original inspiration" to be seen in unfinished works, the most likely candidate is perhaps Pasiteles. If the title *Mirabilia Opera* (περὶ θαυμαστῶν ἔργων[?]) given to Pasiteles' book by Pliny in his indexes to books 33 and 34 of the *Naturalis Historia* has any relationship to the substance of Pasiteles' work, then we might expect Pasiteles to have had an interest in the unfinished (hence "remarkable" or "wondrous") pictures in question. Likewise if Pasiteles, as we have suggested (see chap. 6), was in contact with the dominant aesthetic theories of the late Hellenistic period, we would expect him to have been sensitive to the subjective element involved in the creation of a work of art—the artist's own *cogitationes* (see φαντασία).

Cicero's comment on the four-color painters (passage 1) does not seem to be a carefully calculated piece of art criticism. It implies that Polygnotus, Zeuxis, and Timanthes were "primitives" in painting, just as Calamis and Canachus were in sculpture (see *Brut.* 70); since they used only four colors, their coloring was apparently considered unworthy of praise; and hence, if one wished to praise them, one had to turn to their "shapes and lines." At a later stage in the history of painting, Cicero says, Apelles, Aetion, Nicomachus, and Protogenes brought everything to perfection. One has the feeling, as indicated in chap. 7, note 1, that this passage is a rather casual improvisation and that Cicero grouped names rather indiscriminately— Polygnotus (second quarter of the fifth century) hardly fits into the same category as Zeuxis and Timanthes (early fourth cetury). He directly contradicts Pliny who identifies Apelles, Aetion, Melanthius, and Nicomachus (all active in the early Hellenistic period) as the four-color painters.[2] Cicero apparently believed that the use of only four colors was a characteristic of early, undeveloped painting[3] and that, since the colors used in this type of painting were of such slight interest, one was forced, if one chose to find some merit in it, to turn to its composition and draftsmanship.

Passage 5, in which Pliny collates various traditions about early Greek painters, is of interest aside from its naïveté because the latter part of it may reflect what Xenocrates took to be the very first step in the development of painting—that is, drawing without color. Significantly, the achievement of the two artists mentioned appears in a *primus* formula, and one of them is a Sicyonian.

2. Pliny *NH* 35.50.
3. Cicero *Orat.* 169, . . . *antiquissima illa pictura paucorum colorum.*

397

liquidus

1. Horace *Odes* 4.8.4 ff.

> . . . , neque tu pessima munerum
> ferres, divite me scilicet artium
> quas aut Parrhasius protulit aut Scopas,
> hic saxo, liquidis ille coloribus
> sollers nunc hominem ponere, nunc deum.

> . . . nor would you bear off the worst of my gifts if I were rich, natural-
> ly, in the arts which Parrhasius or Scopas displayed, the latter in stone,
> the former in liquid colors—but each with skill—to represent now a
> man, now a god.

2. Pliny *NH* 34.78.

> Eutychides Eurotam, in quo artem ipso amne liquidiorem plurimi
> dixere.

> Eutychides made a [figure representing the river] Eurotas, in which
> many say that the art is more liquid than the river itself.

Commentary

Liquidus is probably not a formal critical term, that is, a word whose mean-
ing is standardized in order to fulfill a precise function in a critical system.
Horace's reference to the "liquid colors" of Parrhasius in passage 1 is best
viewed as an example of independent poetic invention. The names of Scopas
and Parrhasius are used simply to objectify the idea of any great sculptor or
painter, and there is nothing to indicate that Horace is making a serious
critical judgment of Parrhasius's use of color as opposed to that of another
particular painter or painters.

Pliny's remark on the Eurotas of Eutychides (passage 2) is especially
interesting because it is one of the few passages whose immediate source can
be identified with some certainty. This source is quite clearly an epigram by
the rhetorician-poet Philip of Thessalonica (early first century A.D.), which is
preserved in the *Palatine Anthology* 9.709.[4] Pliny appears to have modeled
his comment on the Eurotas on the last two lines of the epigram: ἁ δὲ τέχνα
ποταμῷ συνεπήρικεν. ἆ τίς ὁ πείσας/χαλκὸν κωμάζειν ὕδατος ὑγρότερον.
("Art competed with the river. Who persuaded the bronze to ripple more

4. The comparison is presented by Overbeck, *Schriftquellen*, 1532. It was first noted by
Jahn, *UKP*, p.123.

liquidly than water?'') Pliny's *amne liquidorem* is clearly the ὕδατος ὑγρότερον of the epigram. Whether this appreciation of the Eurotas was original with Philip or whether it goes back to some earlier Hellenistic source, we cannot say.

Liquidus was also used by writers on rhetoric, but the significance which they gave to the term varied, and there is no evidence that the word was a formal critical term in rhetoric either. Cicero uses it in *De Oratore* 2.38.159 to refer to the flowing quality of a speech (*genus sermonis . . . liquidem*), but Quintilian, *Inst.* 5.14.28, uses it to describe the "lucid truth" that serious men search for (*ad liquidum confessumque perducant*).

lumen et umbra

1. Pliny *NH* 33.160.

Sile pingere instituere primi Polygnotus et Micon, Attico dumtaxat. secuta aetas hoc ad lumina usa est, ad umbras autem Scyrico et Lydio.

Polygnotus and Micon first established the custom of painting with yellow ocher, but only the kind from Attica. The succeeding period used this kind for lights, but used the kind from Lydia and Scyros for shadows.

2. Pliny *NH* 35.29.

Tandem se ars ipsa distinxit et invenit lumen atque umbras, differentia colorum alterna vice sese excitante. Postea deinde adiectus est splendor, alius hic quam lumen. Quod inter haec et umbras esset, appellarunt tonon, commissuras vero colorum et transitus harmogen.

At length the art [of painting] differentiated itself and invented light and shades, using a diversity of colors which enhanced one another through their interaction. Finally *splendor* was added, which is something quite different from light. That which exists between light and shade they called *tonos*, and the transition from one color to another they called *harmogē*.

3. Pliny *NH* 35.38.

Hac primum usus est Nicias supra dictus . . . sine usta non fiunt umbrae.

This [*cerussa*, burnt ceruse] was first used by Nicias who was discussed above Without burnt ceruse shadows cannot be made.

399

4. Pliny *NH* 35.131.

> Lumen et umbras custodiit atque ut eminerent e tabulis picturae*
> maxime curavit.

> *figurae *coni. Mayhoff.*

[Nicias] paid close attention to light and shade and took great care to see that his paintings stood out from the panels [on which they were painted].

5. Quintilian *Inst.* 12.10.4 (on Zeuxis and Parrhasius).

> Quorum prior luminum umbrarumque invenisse rationem, secundus examinasse subtilius lineas traditur.

Of these [Zeuxis and Parrhasius] the first invented the systematic calculation of light and shade, the second, according to tradition, brought great refinement to draftsmanship.

Commentary

Lumen and *umbra*, Greek φῶς καὶ σκιά, are not really critical terms, but the development of the *ratio*[5] (passage 5) of using light and shade in painting constituted an important landmark in professional treatises on painting, in philosophical discussions about painting, and in "Xenocrates'" history of painting. Compare Plutarch *De glor. Ath.* 2: 'Απολλόδωρος ὁ ζωγράφος ἀνθρώπων πρῶτος ἐξευρὼν φθορὰν καὶ ἀπόχρωσιν σκιᾶς 'Αθηναῖος ἦν, οὗ τοῖς ἔργοις ἐπιγέγραπται: μωμήσεταί τις μᾶλλον ἢ μιμήσεται.

Passage 1, it should be noted, probably refers only to the existence of light and dark tones in the paintings of Polygnotus and Micon; the other passages emphasize the mixing of light and shade by the technique called σκιαγραφία (q.v.). See also τόνος and ἁρμογή.

magnificus, magnificentia

1. Vitruvius 7.praef.17. See *auctoritas,* passage 5.

5. The basic meaning of *ratio* (from *reor,* "calculate, reckon") is a "reckoning" or "calculation." The word is also used in a general way to mean "theoretical system"; see Cicero *De Or.* 3.50.195, *omnes enim tacito quodam sensu sine ulla arte aut ratione quae sint in artibus ac rationibus recta ac prava diiudicant.* Both the meanings "calculation" and "theoretical system" appear to be applicable in passage 5. Zeuxis probably developed a system whereby the degree of light as opposed to shade in a painting could be calculated. Vitruvius, as we have seen (chap. 5) uses *ratiocinatio* to refer to the intellectual principles, or theory, of any art.

2. Pliny *NH* 35.63.

Magnificus est et Iuppiter eius in throno adstantibus diis . . .

A magnificent work is his [Zeuxis's] Zeus seated on a throne with the gods standing in attendance . . .

3. Pliny *NH* 36.19.

. . . haec sint obiter dicta de artifice numquam satis laudato, simul ut noscatur illam magnificentiam aequales fuisse et in parvis.

[The concluding statement of Pliny's description of Athena Parthenos of Phidias.] These are the things which ought to be said in passing about an artist who can never be praised too highly; at the same time, we learn that the grandeur [which is apparent in the work as a whole] was equally present in its small details.

Commentary

Magnificus, "grand, lofty, dignified," and the noun *magnificentia* do not occur frequently in the criticism of the visual arts but are very common in the stylistic vocabulary of writers on rhetoric. According to Quintilian, *Inst.* 4.2.61 *magnificus* was a translation of the Greek μεγαλοπρέπεια, "loftiness," which was one of the subcategories of the αὐστηρὸς χαρακτήρ of rhetoric (see μεγαλοπρεπής). Cicero also speaks of a *genus dicendi magnificum* (*De Or.* 2.21.89) or a *magnificentius dicendi genus et ornatius* (*Brut.* 123).

The source for passages 2 and 3 was probably a Greek writer with classicistic taste, perhaps Pasiteles, whose five volumes on *mirabilia* or *nobilia opera* must undoubtedly have taken into account the Athena Parthenos and the paintings of Zeuxis. *Magnificus* in passages 2 and 3 is therefore in all likelihood a translation of μεγαλοπρέπεια (see μεγαλοπρεπής).

Vitruvius uses *magnificentia* in passage 1 to refer to the magnificence which can be produced in a building by the use of costly materials. This judgment has no connection with stylistic criticism and is probably not to be connected with μεγαλοπρέπεια.

maiestas

1. Valerius Maximus 8.11.5. See *augustus,* passage 1.

2. Quintilian *Inst.* 12.10.9.

. . . aut Olympium in Elide Iovem fecisset, cuius pulchritudo adiecisse

aliquid etiam receptae religioni videtur; adeo maiestas operis deum aequavit.

[Phidias had no equal as a sculptor in the medium of gold and ivory, and this would still be true even if he had made only his Athena Parthenos] or his Olympian Zeus in Elis, the beauty of which is seen to have added something to traditional religion—to such an extent was the majesty of the work equal to the god.

See also Vitruvius 1.praef.2, 2.8.17, 6.5.2.

Commentary

Maiestas (from *maior, magnus*), the "greatness" of the gods and also of men in positions of high authority, is one of the essential Latin terms associated with the *phantasia* theory (see chap. 2).

Bernhard Schweitzer[6] has suggested that *maiestas* is the translation of the Greek term μέγεθος as used by Strabo 8.6.10.

τὰ Πολυκλείτου ξόανα τῇ μὲν τέχνῃ κάλλιστα τῶν πάντων, πολυτελείᾳ δὲ καὶ μεγέθει τῶν Φειδίου λειπόμενα

Whether *maiestas* can also be used to translate μεγαλεῖον and μεγαλότεχνος, as Schweitzer suggests, is less certain. (For further discussion see μέγεθος and μεγαλοπρέπεια. The latter is perhaps rendered in Latin by *magnificentia*.)

Maiestas as used by Valerius Maximus (passage 1) is probably not to be associated with any particular theory or terminological system, although the meaning of the word—the quality of greatness seen in the gods—is the same.

mirabilis

1. Petronius *Sat.* 83.

 In pinacothecam perveni vario genere tabularum mirabilem.

 In the gallery I came upon a marvelous collection of pictures of every sort.

2. Pliny *NH* Index. 33 and 34.

 Ex auctoribus . . . externis . . . Pasitele qui mirabilia* opera scripsit.

 *One good manuscript, *Codex Parisinus Latinus* 6796, reads *de mirabilibus operibus* in the index to *NH* 34.

6. Schweitzer, *Xenokrates*, p. 34.

From among foreign authors: . . . Pasiteles who wrote *Marvelous Works* . . .

3. Pliny *NH* 7.34. See *ingenium,* passage 5.

4. Pliny *NH* 34.43.

Videmus certe Tuscanicum Apollinem in bibliotheca templi Augusti quinquaginta pedum a pollice, dubium aere mirabiliorem an pulchritudine.

[Colossal statues were also made in Italy.] For instance, we see a Tuscan-style Apollo in the library of the temple of Augustus, fifty feet high when measured from the big toe, and it is difficult to say whether it is more remarkable for its bronze or for its beauty.

5. Pliny *NH* 34.74.

Cephisodorus* Minervam mirabilem in portu Atheniensium et aram ad templum Iovis Servatoris in eodem portu . . .

*Cephisodorus **B**; Cephisodotus *Sillig*; Cephissidorus **VR**.

Cephisodotus made a marvelous Athena at the port of Athens [Piraeus] and an altar for the temple of Zeus the Savior in the same port . . .

6. Statius *Silv.* 4.6.38–40.

. . . et cum mirabilis intra
stet mensura pedem, tamen exclamare libebit,
si visus per membra feras: "hoc pectore. . . .

[Describing the Herakles Epitrapezios of Lysippus:] . . . and although this figure stands only one foot tall, nevertheless you would fain cry out if you cast your eyes over the various parts of his body, "This is the chest [on which the Nemean lion was crushed," etc.].

7. Hyginus *Fab.* 223.

. . . septem opera mirabilia . . . Rhodi signum Solis aeneum . . .

. . . [among] the seven wonders of the world . . . [was] the bronze statue of the Sun [Helios] at Rhodes . . .

8. Scholiast Porphyry on Horace *Sat.* 1.3.91 (ed. Meyer, [Leipzig, 1873]).

. . . qui de personis Horatianis scripserunt aiunt Evandrum hunc caela-

torem ac plasten statuarum quem M. Antonium ab Athenis Alexandriam transtulisse, inde inter captivos Roman perductum multa opera mirabilia fecisse.

. . . those who have written about the people mentioned in Horace's poetry say that this Evander was an engraver and modeler of statues whom M. Antonius had brought from Athens to Alexandria, and after being conveyed from there to Rome along with the other captives, he made many marvelous works.

Commentary

Mirabilis (from *miror*, "wonder at"), like its most common Greek equivalent θαυμαστός (q.v.), represents one of the most common ideas of what we have called popular criticism in antiquity (see chap. 4) and can be translated as "marvelous" or simply as "remarkable." At times the term is associated with subjects or events that are literally marvelous or miraculous, for example, passage 3, where Pliny indicates that one of the *mirabiles effigies* in question represented a women named Alcippe, who had given birth to an elephant. More often, however, *mirabilis* simply reflects an expression of enthusiasm and has about the same critical value as the English word *marvelous* when used by the average visitor to a museum (e.g. passages 1,5,8).

On the other hand, it appears that the phrase *mirabilia opera* did at times have the value of, if not a critical standard, at least of a categorical denomination—a specific class of works of art. The *septem opera mirabilia* mentioned by Hyginus in passage 7 are, of course, the seven wonders of the ancient world, a category apparently created in the Hellenistic period. Here the phrase *mirabilia opera* translates the Greek (ἑπτὰ) θεάματα.[7] A passage from Eustathius suggests that θεάματα and θαυμαστά were closely related in meaning: ἡ δὲ Ρόδος ἄλλα τε ἔσχε θαυμαστὰ καὶ τὸν τοῦ Ἡλίου κολοσσόν . . . καὶ ἦ αὐτὸς ἐν τῶν ἑπτὰ θεαμάτων.[8] The Romans seem at times to have translated both terms by *mirabilia*.

Another important place in which *mirabilia opera* appears to refer to a particular category of works of art is in Pliny's indexes to books 33 and 34 of the *Naturalis Historia* where he refers to *Pasitele qui mirabilia opera scripsit*. This wording suggests that the original title of Pasiteles' book was perhaps περὶ θαυμαστῶν ἔργων. On the other hand, as pointed out in chapter 6, Pliny also refers to Pasiteles' work in 36.39 as *quinque volumina nobilium operum in*

7. See Strabo 14.652; Eustathius, commentary on Dionysius Periegetes, 504 (see Overbeck, *Schriftqvellen*, 1540); Philo Byzantinus *de Septem Miraculis Mundi*.
8. Eustathius *Dion*. 504.

toto orbe, a title which Jahn translated as περὶ ἐνδόξων ἔργων.[9] Since Pasiteles is one of the most important writers on art in the late Hellenistic period, and perhaps a major source for certain aspects of the criticism preserved in Pliny, Cicero, and Quintilian (see chapters 6 and 7), it is of some interest to know exactly what the title of his book was.

There are several ways of reconciling the two titles given to Pasiteles' work by Pliny. It is possible that (a) *mirabilia opera* and *nobilium operum* were alternate translations of the same Greek title; or that (b) one of the words has been inaccurately transmitted in the manuscript tradition; or that (c) neither *mirabilia opera* nor *nobilium operum* is really a title, but that both are simply phrases that Pliny used to characterize Pasiteles' work. If one accepts alternative a, that both phrases translate one Greek title, one is forced to assume that *mirabilis* and *nobilis* were virtually synonymous, which does not seem to be the case. *Nobilis* (q.v.) means essentially "well known, famous," but not necessarily "wondrous." If one accepts alternative b, that one of the words represents a corruption in the manuscript tradition, one still must decide which word has been corrupted. *Mirabilis* and *nobilis* are sufficiently similar so that such a corruption is not beyond the realm of possibility. The fact that *mirabilia opera* occurs twice and *nobilium operum* once might suggest that the latter is the corrupt form, since it is not likely that the same copying error would be made twice. On the other hand *mirabilia opera* has variants in the manuscript tradition,[1] which might suggest that the transmission of the indexes of the *Natural History* may have been more subject to inexactitudes than the actual text (in which *nobilium* occurs; see *nobilis*).

Another possible solution to this problem might be that Pasiteles' *quinque volumina* dealt with different types of works. One or more books may have dealt with works which were famous but not in any way unusual (ἔνδοξα ἔργα = *nobilia opera*), while others treated works which had something distinctly remarkable about them (θαυμαστὰ ἔργα = *mirabilia opera*).

Although there was apparently no single criterion by which works were judged as *mirabilia,* passages 4, 6, and 7 hint at what must have been the most common criterion—an unusual scale. Ancient critics in general, and Roman critics in particular, were always impressed by the display of technical virtuosity on a very large scale (see τόλμα and *audacia*) or on a very small scale (see *ingenium,* passage 11).[2]

9. Jahn, *UKP,* p. 124.

1. I.e. *de mirabilibus operibus* (see note on passage 2).

2. In the case of the Heracles Epitrapezios of Lysippus (passage 6) the cause for wonder seems to have been that the statue expressed bigness, even when it was actually very small. It is interesting to note that recently an overlifesized version of the Epitrapezios type has

mollis

1. Cicero *Brut.* 70.

 Calamidis dura illa quidem, sed tamen molliora quam Canachi.

 See *durus*, passage 1.

2. Quintilian *Inst.* 12.10.7.

 . . . molliora adhuc supra dictis Myron fecit.

 See *durus*, passage 5.

Commentary

Mollis is best translated here as "soft or flexible in appearance." For the interpretation of the passages above see *durus* and *rigidus*. All three terms are connected with the first phase of the evolution of sculpture as described in the art histories of Cicero and Quintilian (see chap. 7).

The Greek equivalent of *mollis* is undoubtedly μαλακός. (See Socrates' conversation with Parrhasius in Xenophon *Mem.* 3.10.1: τὰ σκληρὰ καὶ τὰ μαλακά . . . διὰ τῶν χρωμάτων ἀπεικάζοντες ἐκμιμεῖσθε.)

nobilis

1. Vitruvius 2.praef.4.

 Ita Dinocrates a facie dignitateque corporis commendatus ad eam nobilitatem pervenit.

 Thus Dinocrates [the planner who designed the city of Alexandria], commended by his face and the dignity of his bearing, rose to this distinction.

2. Vitruvius 3.praef.2. See *dignatio*, passage 1.

been uncovered at Alba Fucens in central Italy. This discovery suggests the possibility that Lysippus may have designed both colossal and miniature versions of the Epitrapezios type. See Fernand de Visscher, *Héraklès Epitrapezios* (Paris, 1962). It is unlikely, however, that Statius (and Martial, who also mentions the miniature) were aware of this unusual range of scale and contrast of scales in Lysippus's work.

3. Vitruvius 3.1.2.

. . . quibus etiam antiqui pictores et statuarii nobiles usi magnas et infinitas laudes sunt adsecuti.

. . . and by using these [ideal proportions for the human body] famous painters and sculptors of earlier times have won great and unending praise.

See also Vitruvius 7.praef.12–14.

4. Pliny *NH* 34.71.

. . . sed ne videatur in hominum effigie inferior, Alcmena nullius est nobilior.

[Calamis excelled at rendering horses], but, lest he seem to have been inferior in rendering the human figure, his Alcmena is better known than that of any other artist.

5. Pliny *NH* 34.74.

[Cresilas fecit] et Olympium Periclen dignum cognomine, mirumque in hac arte est quod nobiles viros nobiliores fecit.

[Cresilas also made] an Olympian Pericles, worthy of its cognomen; and it is a marvelous quality in this art that it has made well-known men even better known.

6. Pliny *NH* 34.85.

. . . Polygnotus idem pictor e nobilissimis.

[Among sculptors who produced works of no particular prominence was] Polygnotus, the same man who was also one of the best-known painters.

7. Pliny *NH* 35.83.

. . . inter egregia multorum opera inani similem et eo ipso allicientem omnique opere nobiliorem.

[A panel with a few fine lines painted by Apelles and Protogenes was exhibited on the Palatine.] . . . among the outstanding works of many artists it seemed like an empty picture and by that very fact it attracted more attention and was better known than any other work.

407

8. Pliny *NH* 35.123.

. . . sed etiam docuisse traditur Pausian Sicyonium primum in hoc genere nobilem.

[The painter Pamphilus not only painted in the encaustic technique] but also is recorded to have taught it to Pausias of Sicyon, who was the first to be well known in this technique.

Additional passages covering the same range of meaning are:

Cicero *Verr.* 2.4.4 (see *ingenium*).
Val. Max. 8.2.6 (on Timanthes).
Pompon. Mela 2.3 (on the Zeus of Phidias).
Pliny *NH* 7.127 (Aphrodite by Praxiteles).
———— *NH* 22.44 (Styppax; cf. 34.81).
———— *NH* 33.137 (on Theodorus).
———— *NH* 34.69 (Satyr by Praxiteles).
———— *NH* 35.71 (two paintings by Parrhasius).
———— *NH* 35.78 (paintings by Aëtion).
———— *NH* 35.114 (the "Hesione" of Antiphilus).
———— *NH* 35.129 (a painting by Euphranor).
———— *NH* 36.23 (copy of Praxiteles' Eros).
Servius ad Vergil *Aen.* 6.14.

Commentary

Nobilis (older form *gnobilis*) is derived from *noscere* or *gnoscere*, "to know" (cf. Greek γιγνώσκω), and its basic meaning is "known, renowned" in either a good or a bad sense.[3] A secondary meaning of the word, "high born, noble" developed from the fact that those who were of "good birth" were from "known" families, families whose members had held positions of high authority. The English word *noble* does not really render the sense of the Latin word, which always implies renown. (In English a noble man is not necessarily a well-known man.) However, *nobilis* usually does convey, in addition to the basic meaning of "famous, renowned," the sense of moral elevation implied in the English word *noble*. This is especially true of the noun form *nobilitas*.[4]

Although I have tended to use "well known" or "famous" in my translations, the meaning of *nobilis* in the passages cited above is often ambiguous; it

3. E.g. *nobilis aere Corinthus*, Ovid *Met.* 6.416; but also Plautus *Rudens* 3.2.5: *innocentes qui se scelere fieri nolunt nobiles*.
4. E.g. Ovid *Pon.* 2.5.56: *Eliquio tantum nobilitatis inest.* Juvenal 8.20: *nobilitas sola est atque unica virtus*.

is not always possible to decide whether the word simply means "renowned" or whether it also implies "moral elevation, nobility." In passage 4, for example, when Pliny says that no statue is *nobilior* than the Alcmena of Calamis, does he mean "better known" or "more noble"? In passage 5, when he says that Cresilas *nobiles viros nobiliores fecit*, does he mean that Cresilas made men "more famous" by making portraits of them or that he made his already "noble" sitters appear even more noble in their portraits? The same ambiguity applies to passages 1, 3, 6, and 7. In passages 2 and 8 the sense of "well known" seems beyond doubt.

In *NH* 36.39 Pliny refers to the subject of Pasiteles' book as being *nobilium operum in toto orbe*. The same work is also described in the indexes to books 33 and 34 as dealing with *mirabilia opera*. For a discussion of the relative value of these two titles see the commentary under *mirabilis*.

Otto Jahn suggested that *nobilis*, at least in Pliny, *NH* 36.39, is a translation of the Greek ἔνδοξος (q.v.).[5] This word, like *nobilis*, essentially implies "renown" but also carries the connotation of "noble," both in the sense of being "well born" and of having an "elevated nature."

It is not unlikely, however, that *nobilis* was also used to translate the Greek γενναῖος, which essentially meant "of high birth" but also signified "high minded, noble."[6] Compare Lucian *Pro Merc. Cond.* 42:

ἡδέως μὲν οὖν Ἀπελλοῦ τινος ἢ Παρρασίου ἢ Ἀετίωνος ἢ καὶ Εὐφράνορος ἂν ἐδεήθην ἐπὶ τὴν γραφήν. ἐπεὶ δὲ ἄπορον νῦν εὑρεῖν τινα οὕτως γενναῖον καὶ ἀκριβῆ τὴν τέχνην, ψιλὴν ὡς οἷόν τε σοι ἐπιδείξω τὴν εἰκόνα.

The term *nobilis* can be used to describe both an artist and a work of art. See also ἔνδοξος, where the meanings of that word are discussed in connection with *nobilis*.

numerosus, numerus

1. Cicero *Div.* 1.13.23.

 Quidquam potest casu esse factum quod omnes habet in se numeros veritatis?

 See ἀλήθεια-*veritas*, passage 13.

 Cf. Cicero *Orat.* 170.

 Sed habet nomen invidiam, cum in oratione iudicali et forensi numerus Latine, Graece ῥυθμός inesse dicitur.

5. First suggested by Jahn, *UKP*, p. 124.
6. Aristotle *Rh.* 2.15.3 (1390b28) in the sense of "noble character."

But when what is called *numerus* in Latin and ῥυθμός in Greek is said to exist in judicial and forensic oratory, the term becomes invidious.

2. Vitruvius 3.1.5.

Nec minus mensurarum rationes, quae in omnibus operibus videntur necessariae esse, ex corporis membris collegerunt, uti digitum, palmum, pedem, cubitum, et eas distribuerunt in perfectum numerum quem Graeci τέλεον dicunt. Perfectum autem antiqui instituerunt numerum qui decem dicitur.

For translation and context see chapter 1, p. 19.

3. Pliny *NH* 34.58.

Primus hic multiplicasse veritatem videtur, numerosior in arte quam Polyclitus et in symmetria diligentior . . .

For translation see commentary.

4. Pliny *NH* 35.130.

. . . Antidotus . . . ipse diligentior quam numerosior . . .

See *diligens*, passage 10.

5. Pliny *NH* 35.138.

. . . Aristophon . . . numerosaque tabula, in qua Priamus, Helena, Credulitas, Ulixes, Deiphobos, Dolus.

. . . Aristophon . . . [painted] a panel with many figures, in which are represented Priam, Helen, Credulity, Ulysses, Deiphobos, and Guile.

Cf. Quintilian 9.4.45.

Omnis structura ac dimensio et copulatio vocum constat aut numeris (numeros ῥυθμοὺς accipi volo) aut μέτροις id est dimensione quadam.

Every structure, or measured unit, or joining of words consists of *numeri* (*numeri* I wish to be taken as ῥυθμούς) or of meters, that is, a specific unit of measurement.

Cf. also Quintilian 9.4.54.

. . . nam sunt numeri rhythmi . . .

. . . for *numeri* are *rhythmi* . . .

Commentary

Numerosus has two basic meanings—an essentially literal sense, "manifold, numerous, prolific," and a stylistic sense, "rhythmical, measured." The key question raised by the foregoing passages is which of these meanings should be applied in them. If we understand *numerosus* in the first sense, then passages 3 and 4 would mean simply that Myron made more statues than Polyclitus and that Antidotus was "more accurate than prolific" (which is Lewis and Short's translation *diligentior quam numerosior*). On the other hand, if we take *numerosus* in the stylistic sense and associate it with ῥυθμικός, as Quintilian does, then the term takes on the complex, technical values which are expressed by ῥυθμός (q.v.).[7]

Passage 5 seems to suggest that to Pliny *numerosus* could mean simply something like "having many elements" and hence might mean something like "more prolific" when used in connection with an artist. Hence in passage 3, in which Myron is said to have been *numerosior in arte* than Polyclitus, the meaning might simply be that Myron made more works than Polyclitus or was "more versatile" than Polyclitus. A number of modern scholars have taken this point of view.[8] The context of passage 3, however—that is, its close connection with the "Xenocratic" tradition and professional criticism—suggests that, as with *diligens*, a technical value for *numerosus*, related to composition and style, is not only possible but likely.

The line of thought that sees *numerosior* in Pliny as referring to a stylistic quality connected with ῥυθμός in the work of Myron was initiated by Carl Robert and has been followed more recently by Bernhard Schweitzer and Silvio Ferri.[9] Robert suggested that *numerosior* was a translation of εὐρυθμότερος and that the term referred to a rhythmic flow of lines in Myron's works.[1] Schweitzer, combining the translation proposed by Robert with

7. The discussion here must of necessity be limited to passages which deal with the visual arts. On the significance of *numerus* as a technical term in the analysis of ancient prose composition, see the thorough study by Adolf Primmer, *Cicero Numerosus, Studien zum Antiken Prosarhythmos* (Vienna, 1968). The proposal of René Waltz, "*ΡΥΘΜΟΣ* et Numerus," *REL* 26 (1948): 119, that the use of *numerus* to translate ῥυθμός represents a superimposition by Latin writers of the idea of limited quantity upon a basic Greek idea of continuous flow. does not seem to me convincing.

8. E.g. Richter, *SSG*[4], p. 164, translates it as "more versatile." The same line of thought is followed by Brunn, *GGK*[2], 1:107–08; Jahn, *UKP*, pp. 130–31. All three take *numerosior* to be an elaboration on *multiplicasse veritatem*.

9. Robert, *Arch. Märch.*, pp. 33–34; Schweitzer, *Xenokrates*, p. 13; Ferri, *NC*, pp. 143–45.

1. The different interpretations of ῥυθμός by modern scholars have already been discussed in our commentary under that term. Robert, like most scholars, did not distinguish between

Eugen Petersen's interpretation of ῥυθμός,[2] interprets *numerosior in arte* as "von weit grösserer Anpassungsfähigkeit an die Natur," that is, Myron was able to make the motifs of his statues conform more closely to the natural movements of men.

Silvio Ferri puts forward a far less orthodox interpretation. *Numerosior in arte* refers, he feels, not to an admirable quality in the art of Myron but to a fault. As evidence, he points to the distinction drawn by Dionysius of Halicarnassus between a style of composition which is εὔρυθμος and a style which is ἔνρυθμος.[3] Actual verse, with its rigid metrical formulas, was considered ἔνρυθμος, while "rhythmic prose," prose which contained certain rhythms and meters but did not adhere to them rigidly, was εὔρυθμος. Accepting the equation of εὔρυθμος with *numerus*, Ferri decided that *numerosior* in Pliny meant that Myron's statues, like rhythmic prose, contained μέτρα and ῥυθμοί but that these elements were not fully harmonized and brought into a single system as they were in the works of Polyclitus.[4]

An interesting alternative to the Robert-Schweitzer interpretation of *numerosior* has been suggested by F. W. Schlikker.[5] Rather than εὐρυθμώτερος, Schlikker suggests that the translation of *numerosior* might be ἀριθμητικώτερος, literally "having more numbers," and that the term might indicate that the system of *symmetria* used by Myron had more numbers in it than did the system of Polyclitus. These numbers, Schlikker suggests, may have been the denominators used in certain prescribed proportions. Myron may have been considered *numerosior* than Polyclitus because Polyclitus had been able to describe the perfect relative proportions of the human body using fewer common denominators.

Schlikker's suggestion is attractive because it interprets *numerosior* in the light of the professional criticism from which Pliny's remarks derive. Polyclitus's *Canon*, we are told, dealt with τὸ εὖ παρὰ μικρὸν διὰ πολλῶν ἀριθμῶν,[6] and it seems likely that other fifth-century sculptors also concerned

εὐρυθμία and ῥυθμός. Brunn, *GGK*², was not unaware of the connection between ῥυθμός and *numerus* but chose to reject it.

2. For Eugen Petersen's interpretation see ῥυθμός. Schweitzer follows Petersen's interpretation of ῥυθμός as a "Bewegungsmotif."

3. Dionysius of Halicarnassus *Comp.* 11.

4. Ferri, *NC*, p. 145. As noted under εὐρυθμία, Ferri understood ῥυθμός in the modern sense of "repetition" of single elements. His interpretation of *numerosior* seems unsatisfactory in two points: first, *numerus* translates the Greek ῥυθμός, not εὔρυθμος; second, the derogatory connotation he attaches to *numerosior* is nowhere evident in Dionysius's treatment of εὔρυθμος. This interpretation of the passage seems more reflective of what modern critics feel about the difference between Myron and Polyclitus than of what Pliny actually says.

5. Schlikker, *HV*, p. 55n70.

6. Diels, *Fragmente*⁷, 40B2; see chap. 1, n.6.

themselves with the ἀριθμοί which formed the basis of proportion and composition in statuary. On the other hand, the equation of *numerus* with ῥυθμός is amply documented, and our analysis has suggested that it too was an important concept in the professional art criticism of the fifth century. If we could interpret *numerosior* as referring both to the ῥυθμοί of Myron's statues and also to the ἀριθμοί (the numerical measurements in his theoretical system of proportions), we would have a comprehensive solution to the meaning of passage 3. Such an interpretation is, happily, not impossible. The fact that the Romans chose *numerus* to translate ῥυθμός suggests in itself, as noted under *perfectus,* that there was a close relationship between the ῥυθμός concept and "number," and the truth of this suggestion is borne out by the close connection between ἀριθμός and ῥυθμός in Greek thought. Basically, ῥυθμός refers to a form, shape, or pattern; in connection with the human body and also with the representation of the human body in sculpture, ῥυθμός probably referred both to the entire pattern of composition of the body and also to the shape of its separate parts. These separate shapes could be described by number, as in Eurytus's pebble diagrams (see chap. 1). Plato also uses ἀριθμός in connection with the form of the human body: λέγω δὲ τὸ τοιόνδε, οἷον τοὺς ἀριθμοὺς τοῦ σώματος καὶ ἑκάστων τῶν μερῶν τάς τε θέσεις ᾗ ἔχει . . . (*Laws* 668D–E); the man who is ignorant of the nature of a certain class of bodies, Plato says, will be unable to represent them because he will be ignorant of their ἀριθμούς and also of the position which the various parts of the body should have in relation to one another. 'Αριθμούς appears to refer in this passage to the proportions, expressed in number, which characterize the separate parts of the body. Like ἀριθμός, the Latin word *numerus* is also closely connected with spatial forms. Quintilian states, for example, that *geometria* is divided into numbers and forms.[7]

The basic common ground between ἀριθμός and ῥυθμός is that both were looked upon as delimiting factors; ῥυθμός limited space so as to produce form, while ἀριθμός limited infinity so as to produce specific quantity. This common function for the two words is clearly expressed by Aristotle in the *Rhetoric* 3.8.2–3 (1408b28–29) in connection with diction: περαίνεται δὲ ἀριθμῷ πάντα. Ὁ δὲ τοῦ σχήματος τῆς λέξεως ἀριθμὸς ῥυθμός ἐστιν, οὗ καὶ τὰ μέτρα τμήματα. ("All things are limited by number. The number of the scheme of diction is rhythm, of which metrical feet form the divisions.") Even in this passage ῥυθμός should not be taken in the modern sense of "repetition" or "flow" in diction. What it really means is "regular form" or "pattern" in diction; ῥυθμός is the element which gives form to diction

7. Quintilian *Inst.* 1.10.35: *cum sit geometria divisa in numeros atque formas.*

and delimits it from the unlimited, which, in Aristotle's words, is "unpleasant and unknowable."[8] In order to understand the ῥυθμός of diction one need only think of speech as a spatially extended pattern, as one does, for example, when one makes a metrical diagram of a poem.

'Αριθμός, then, can be understood as the general principle of "quantity" which characterized all finite phenomena; ῥυθμός, as the particular aspect of ἀριθμός which signified limitation by shape or pattern. All the arts were limited in this way; music, poetry, rhetoric, sculpture, painting, and architecture all had ῥυθμός. In the visual arts ῥυθμοί were shapes. These shapes were related to numbers in that they were characterized by a particular number of bounding points (e.g. three for a triangle, four for a square, etc.). It was these points which Eurytus referred to when he established the "numbers" of men, horses, and so on. The shapes were also characterized by proportions (e.g. length to width in a rectangle, side to side in a triangle, etc.), which were in turn expressible by number. If, then, we translate Pliny's use of *numerosior* in connection with the art of Myron as ῥυθμικώτερος, we are not denying the possibility, suggested by Schlikker, that Myron had a canon of his own which had more numbers in it than did the *Canon* of Polyclitus, for in Greek sculpture rhythm and number were two aspects of the same phenomenon—the orderly and congruous arrangement of forms. The basic significance of Pliny's statement, however, as suggested in connection with ῥυθμός, is probably that Myron made use of a greater number of patterns of composition than did Polyclitus.

The technical value of *numerosior* suggested in the foregoing discussion also applies quite clearly to passage 4, in which Pliny describes the painter Antidotus as being *diligentior quam numerosior, ἀκριβέστερος ἢ ῥυθμικώτερος*. Being a pupil of Euphranor, Antidotus was undoubtedly well schooled in professional theories of painting.[9] Pliny's passage on Antidotus probably comes from Xenocrates' book on painting and may be interpreted in two ways. The term ἀκρίβεια seems at times to have referred in professional art criticism to "exactitude" in the relationship between the numerical measurements and geometrical forms within a statue. It was, in short, an aspect of *symmetria* (see ἀκρίβεια). By the time of Xenocrates, if not earlier, however, ἀκρίβεια was also used to refer to "precision" in the rendering of small details, such as the hair, nails, and teeth of a statue. Thus when Pliny says that Antidotus was *diligentior quam numerosior*, he may mean that Antidotus's system of *symmetria* was known for its mathematical ἀκρίβεια but had

8. Aristotle *Rh.* 3.8.2 (1408b26–27); τὸ δὲ ἄρρυθμον ἀπέραντον . . . ἀηδὲς γὰρ καὶ ἄγνωστον τὸ ἄπειρον.

9. Euphranor, as we have often noted, wrote *de symmetria et coloribus* (*NH* 35.129).

relatively few ῥυθμοί; in other words, that Antidotus created a simplified system of *symmetria* in which proportional relationships between all the parts or shapes within a painted figure could be expressed by relatively few numbers. The passage could simply mean, however, that Antidotus was very precise in the rendering of small details but made relatively limited use of ῥυθμοί (here probably "patterns of composition") in his works.

In passage 1 it appears that Cicero's phrase *numeros veritatis* is derived from the Greek phrase ῥυθμοὺς τῆς ἀληθείας. *Veritas* and ἀλήθεια are used in a variety of ways in popular criticism, formal aesthetics, and professional criticism. In professional criticism ἀλήθεια-*veritas* could refer to "true form" —form, that is, not as it is known by sense perception, but rather form of which the properties can be demonstrated by actual measurement and by mathematical equations which express the relationships between these measurements. Such ἀλήθεια was the end product of ῥυθμοί and μέτρα in a work of art. In passage 1 Cicero says that nothing can have all the *numeros veritatis* in it by pure chance. Great works of art, such as the Aphrodite of Cos by Apelles, contain the *numeros veritatis* not as a result of chance but as a result of the artist's design—the ῥυθμοί or "shapes" with which an artist constructs a form.

Vitruvius's description of *symmetria* in passage 2 is discussed in chapter 1,p.19 and also under *perfectus*. We include it again here in order to emphasize that the *perfectum numerum* which Vitruvius describes is perhaps best under stood not only as an abstract numerical quantity but also as a shape, a ῥυθμός. The number ten, for example, to which Vitruvius refers in this passage, was graphically represented in Pythagorean theory by the *tetraktys*: ∴. which is in reality a triangle. Possibly all ῥυθμοί had similar numerical counter parts.

ostentatio

1. Pliny *NH* 35.101–02.

> . . . adiecerit parvolas naves longas in iis, quae pictores parergia appellant, ut appareret, a quibus initiis ad arcem ostentationis opera sua pervenisset.

> [Protogenes, when he depicted the Athenian state flagships, the Paralus and the Hammonias] added little warships along with these, the sort of pictures which painters call *parergia,* in order to show from what sort of beginnings he had developed his works to the peak of display.

Commentary

Ostentatio has the basic meaning of "display, show." The word usually carries a derogatory connotation similar to the English derivative, *ostentation*. In the passage quoted above, however, *ostentatio* seems nevertheless to be used in a complimentary sense. Pliny relates that Protogenes had been a ship painter until the age of fifty, and the small pictures of ships which he had painted as *parergia* (πάρεργα) were a reminder of the heights to which he had risen from such humble beginnings. *Ostentatio*, like *audacia* (q.v.) would seem, in this passage at least, to refer to display in technique rather than conception.

It is not possible to determine on the basis of this one example whether *ostentatio* was really an established critical term or simply a descriptive word occasionally used in art criticism. The Greek equivalent of the term may have been κόμπος as used by Plutarch (*Alex.* 72.3) to describe the art of Stasicrates, the artist whom Alexander commissioned to build the tomb of Hephaistion: . . . ἐπόθησε μάλιστα τῶν τεχνιτῶν Στασικράτην, μεγαλουργίαν τινὰ καὶ τόλμαν καὶ κόμπον ἐν ταῖς καινοτομίας ἐπαγγελλόμενον (see τόλμα).

perfectus, perfectio

1. Cicero *Brut.*70.

. . . pulchriora etiam Polycliti et iam plane perfecta, ut mihi quidem videri solent?

[Who is unable to recognize that] the works of Polyclitus are still more beautiful, in fact by this time quite perfect, at least so they seem to me?

2. Cicero *Brut.* 70.

. . . at in Aetione, Nicomacho, Protogene, Apelle iam perfecta sunt omnia.

[In the art of the four-color painters we praise the forms and draftsmanship (see *forma* and *lineamenta*),] but in Aetion, Nicomachus, Protogenes, and Apelles everything has, by their time, become perfect.

3. Cicero *Orat.* 8.

. . . Phidiae simulacris, quibus nihil in illo genere perfectius videmus
. . .

See *pulcher, pulchritudo,* passage 4.

4. Cicero *Verr.* 2.4.126.

Silanionis opus tam perfectum . . .

See *elegantia, elegans,* passage 1.

5. Vitruvius 1.2.4.

. . . eurhythmiae qualitas, sic est in operum perfectionibus.

See εὐρυθμία, passage 5.

6. Vitruvius 2.1.9.

Nunc revertar ad propositum et de copiis, quae aptae sunt aedificiorum perfectionibus . . .

Now I will return to my subject and deal with the building materials which are suitable to use in bringing buildings to completion [or "perfection"]. . .

7. Vitruvius 3.praef. 2.

At qui non minori studio et ingenio sollertiaque fuerunt nobilibus et humili fortuna civibus non minus egregie perfecta fecerunt opera, . . .

[Some artists, favored by fortune, have become very famous.] But others who were not inferior to those well-known artists in zeal and talent and skill, and who, being of humble status, made works for their fellow citizens which were no less perfect, [nevertheless never developed substantial reputations].

8. Vitruvius 3.1.4.

Ergo si ita natura composuit corpus hominis, uti proportionibus membra ad summam figurationem eius respondeant, cum causa constituisse videntur antiqui, ut etiam in operum perfectionibus singulorum membrorum ad universam figurae speciem habeant commensus exactionem.

Therefore, if nature has composed the human body so that its members correspond in their proportions to an overall figure [i.e. a circle or a square], the ancients seem to have had good reason for stipulating that in the perfected forms of their works they should have an exact com-

mensurability of the individual members to the appearance of a basic, underlying figure.

9. Vitruvius 3.1.5.

. . . mensurarum rationes . . . collegerunt . . . et eas distribuerunt in perfectum numerum, quem Graeci τέλεον dicunt.

For translation and context see p.19,

10. Vitruvius 4.1.10–11.

. . . columnas apud Corinthios fecit symmetriasque constituit ex eo in operis perfectionibus Corinthii generis distribuit rationes.

[Callimachus, in inventing the Corinthian column used as his inspiration a basket of acanthus plants placed on top of a grave stele. Pleased by this model,] he made columns at Corinth and established their canon of proportions. And from that he applied the calculations of the Corinthian order in the *perfectionibus* of the work.

11. Vitruvius 4.2.6.

Omnia enim certa proprietate et a veris naturae deducta moribus transduxerunt in operum perfectiones, et ea probaverunt, quorum explicationes in disputationibus rationem possunt habere veritatis.

[Doric mutuals and Ionic dentils imitate the ends of rafters, consequently they can only occur on a building in certain places. To place them elsewhere would be irrational] For everything which they [the ancients] incorporated into the perfected forms of their works was clearly defined with regard to its suitability and was deduced from the real laws of nature, and they gave approval to those details whose use could be shown by argument to have a rational explanation based on reality.

See also Vitruvius 1.1.3; 1.6.8; 3.5.1, 4; 4.3.1, 3, 9; 4.4.4; 5.4.4; 5.5.6; 5.8.2; 5.9.7; 5.11.2; 6.5.2; 7.4.1; 7.14.3; 8.5.1; 9.8.4–6; 10.praef.1–2; 10.2.2.

12. Valerius Maximus 8.11.3.

Praeter cetera enim perfectissimae artis in eo procurrentia indicia etiam illud mirantur, . . .

[On a statue of Hephaestus by Alcamenes in Athens:] For besides other details in the work of this artist which are indicative of the most perfect

artistry, they admire this statue for the following reason, [namely, that Alcamenes indicated Hephaestus's limp beneath the drapery, but also, by having it draped, mitigated the imperfection which it represented].

13. Pliny *NH* 34.81.

. . . perfecta signa . . . [of the sculptor Apollodorus].

See *diligens*, passage 6.

14. Pliny *NH* 35.57.

Adeo iam colorum usus increbruerat adeoque ars perfecta erat, ut in eo proelio iconicos duces pinxisse traditur, . . .

[Panaenus, the brother of Phidias, painted a picture of the battle of Marathon.] So well developed had the use of color by this time become, and so perfect was the art, that he is said to have painted portraits of the leaders in this battle [Miltiades, Callimachus, etc.].

15. Pliny *NH* 35.145.

. . . suprema opera artificum inperfectasque tabulas, sicut Irim Aristidis, Tyndaridas Nicomachi, Mediam Timomachi, et quam diximus Venerem Apellis, in maiore admiratione esse quam perfecta.

[It is a memorable fact that] the last works of artists and unfinished paintings, such as the Iris of Aristides, the children of Tyndareus of Nicomachus, the Medea of Timomachus, and the Aphrodite of Apelles, which we have mentioned, are held in higher regard than finished works . . .

Commentary

As passage 9 indicates, *perfectus* could be used as a Latin translation of the Greek τέλειος, and the term seems to have conveyed the same range of meanings as τέλειος.

Meaning literally "made through, carried out" (*per* +*facio*), the term implied the end of a process of production, and its most basic meaning is perhaps "complete, finished." This literal sense applies in passages 13 and 15. By a slight extension of this meaning the term could also mean "fully developed" or "perfect" in an evolutionary sense, as in passage 14. But frequently it simply meant "perfect, polished, refined" in a very general way,

without any particular emphasis on the idea of completion (as in passages 4, 7, 12). In all of these passages with the probable exception of passage 4, *perfectus* could be seen as a translation of τέλειος in Greek sources, since the context always concerns Greek art, but there is no way of verifying such an assumption.

Passages 1 and 3 are related, as noted in chapter 2, to the *phantasia* theory; and passage 2 is connected with the analysis of style in Greek rhetoric (chap. 3); in these cases a dependence on Greek sources seems assured. In connection with sculpture, Cicero seems to use *perfectus* in the general sense of "perfect" (passages 1 and 3), whereas in dealing with the history of painting, he seems basically to mean "fully developed" (passage 2).

Vitruvius's use of the noun *perfectio* in the plural with *opus* and *aedificium* in the genitive (passages 5, 6, 8, 10, 11) is more difficult to interpret and translate. *Perfectiones* seems to refer to the perfected details of a work or works. In some cases one might take the perfected details in the simple sense of "finished" or "completed details." In passage 6, for example, Vitruvius might simply mean that he is going to describe the materials to be used "in getting the work done on buildings," and it is possible that in all these passages *operum perfectiones* means nothing more than "in the finishing off of works" or "in executing works."[1]

It is a striking fact, however, that in three of these passages *perfectiones* are related to proportions, in two cases those of the human body (passages 5 and 8), and in the other those of the Corinthian order (passage 10). This raises the possibility that there might be some connection between *perfectiones* and the *perfectum numerum, quem Graeci* τέλεον *dicunt* of passage 9. The significance of the latter passage for professional criticism of the Classical period is discussed in chapter 1. In this passage Vitruvius describes the process whereby the quality of συμμετρία was imposed on a building or statue. The proportions of various parts of the human body were taken (*mensurarum rationes . . . ex corporis membris collegerunt*) and were distributed (*distribuerunt*) in a perfect number, which the Greeks called a τέλεον. To the Greeks, he

1. This is the interpretation usually followed in Frank Granger's *Loeb* edition of Vitruvius and intermittently in M. H. Morgan's, *Vitruvius, the Ten Books on Architecture* (Cambridge, Mass., 1914; reprint New York, 1960), the two most prominent English translations of Vitruvius. Granger renders *aedificiorum perfectionibus* in passage 6 by "the execution of buildings"; Morgan uses "the construction of buildings." In passage 5, however, while Granger renders *sic est in operum perfectionibus* by "so it is with completed buildings," Morgan simply uses "so it is with perfect buildings." Ferri, *Vitruvio*, takes in both alternatives with "cosi è nel perfetto e completo edificio." In the passage on Callimachus and the Corinthian order (passage 10) Granger abandons the attempt to render *perfectionibus* and simply says "throughout the work"; Morgan uses "in finished works"; Ferri renders the whole final phrase by "stabili il complesso delle proporzioni degli edifici."

adds, the perfect number (or "a perfect number") was 10. The problem apparently was, then, to take the proportional ratios of different parts of the body and to arrange them so that the aggregate in some way formed a perfect number in the way that 1:2:3:4 when added together equal 10 (the *tetraktys*). This concept of a *perfectus numerus* (or ἀριθμὸς τέλειος)[2] originated in Pythagorean thought, and its significance may have been extended by an interaction between the Pythagoreans and Polyclitus.

One wonders if *perfectiones*, in passages 5, 8, and 10 at least, might not refer to "forms whose proportions are characterized by perfect numbers" or simply "forms perfected in proportion." In passage 10, it should be noted, Vitruvius again uses the verb *distribuo*. Does he mean that once Callimachus had established in theory the *symmetrias* of the Corinthian order, he applied these *rationes* in such a way that the actual forms of the work which he produced were characterized by perfect numbers? (The question becomes all the more interesting when one remembers the doctrine of spatial equivalents for numbers proposed by Eurytus. If perfect numbers in architecture were embodied in the actual shapes of a building, they could then be described as ῥυθμοί. This might help to explain why the Romans translated ῥυθμός as well as ἀριθμός by *numerus*.)

This admittedly complex interpretation of these Vitruvian passages would suggest that *perfectiones*-τέλεια were among the principal factors of consideration in professional criticism and the theories behind it. *Perfectus*-τέλειος would have a position in professional criticism somewhat similar to that of the allied concept of ἀκρίβεια-*diligens*. ᾿Ακρίβεια seems at times to have referred to precision and accuracy in the application of theoretical formulas (e.g. the mathematical and geometrical formulas connected with συμμετρία) to a work of art. Like τέλειος, it implied a certain standard of perfection, but in the case of ἀκρίβεια this perfection was the result of the artist's own skill—he created ἀκρίβεια by putting his knowledge into action. Τέλειος, on the other hand, would have referred to a quality or condition which was inherently perfect—such as the relationship between the numbers in the Pythagorean decad—and not subject to alteration through human action.

Following this line of thought further, the story of Callimachus's invention of the Corinthian column (passage 10), whether it is true or not, might be understood as providing a picture of the way in which a sculptor of the fifth century proceeded in producing a work of art: certain observations were made from nature in the form of measurements and proportions; these basic observations were then adjusted to an abstract system of numerical rela-

2. Used by Plato *Rep.* 546B to refer to the cycles in which the "divine begetting" occurred.

tionships (συμμετρία) in which certain "perfect" numbers were recognized, and these numbers and relationships dictated the final forms and composition (*perfectiones-τέλεια*) of the work of art. In such a process it is clear that direct imitation of nature would have played only a secondary role. The artist's goal would have been to embody perfection in form through a commensurability of parts which was guided by abstract mathematical patterns.

pondus

1. Quintilian *Inst.* 12.10.7–8.

> . . . deesse pondus putant [Polyclitus].

See *decor*, passage 5.

Compare Livy 22.37.1: *Victoriam auream pondo ducentum ac viginti adferre esse* (for the literal use of *pondus*).

Commentary

Pondus was the quality which, in the critical history of sculpture preserved by Quintilian and Cicero, the art of Phidias had but which the art of Polyclitus lacked. Quintilian's statement to this effect (passage 1) is closely paralleled by a passage in Strabo (8.6.10): τὰ πολυκλείτου ξόανα τῇ μὲν τέχνῃ κάλλιστα τῶν πάντων πολυτελείᾳ δὲ καὶ μεγέθει τῶν Φειδίου λειπόμενα. The similarity between the two passages suggests that *pondus* in Quintilian is perhaps a translation of μέγεθος (q.v.) or πολυτέλεια (q.v.). The problem of finding the proper correspondence between the Latin and Greek terms, however, is complicated by the fact that the literal meanings of the words have little in common (*pondus* = "weight"; μέγεθος = "size, magnitude"; πολυτέλεια = "costliness, expensiveness"), and their metaphorical values are somewhat vague. We have already pointed out that μέγεθος, when used metaphorically as "greatness" or "grandeur," seems to have been translated by *maiestas* (q.v.). *Pondus* in the metaphorical sense of "weightiness, importance" is frequently used by Cicero.[3] A metaphorical use of πολυτέλεια, on the other hand, is difficult to document. The only example known to me in which πολυτελής approaches having a metaphorical value is in Plato *Rep.* 507C, where Socrates asks: ἐννενόηκας τὸν τῶν αἰσθήσεων δημιουργὸν ὅσῳ πολυτελεστάτην τὴν τοῦ ὁρᾶν τε καὶ ὁρᾶσθαι δύναμιν ἐδημιούργησεν; ("Have you ever noticed the extent to which the creator of

3. Cicero *De Or.* 2.74.302: *habet vim is ingenio et pondus in vita*; 2.17.72: *omnium verborum ponderibus est utendum*; *Fam* 12.27: *ut is intellegat meas apud te litteras maximum pondus habuisse.*

the senses has lavished the greatest expense on the power of seeing and being seen?"). Here the "great expense" is not simply one of money but rather one of effort or care. It may be that Strabo's remark (quoted above) commends the same quality in the art of Phidias. Even if we translate πολυτέλεια as "expenditure of care and attention," however, it still does not come very close in meaning to *pondus*. It may be that *pondus* and *maiestas* were both translations of μέγεθος.

Schweitzer has suggested σεμνότης as the Greek equivalent of *pondus*,[4] which gives us still another possibility. It will be remembered that we have already suggested a connection between σεμνός, σεμνότης and the Latin terms *augustus* and *gravitas* (see the commentaries on these terms).

The probable explanation of this variety of correspondences of Greek and Latin terms within the framework of late Hellenistic and Roman literary and art criticism is that there were no rigid one-to-one correspondences between the terms of the two languages. It is possible that the Greek μέγεθος was rendered at different times by *maiestas*, *magnificientia*, and *pondus* and that σεμνότης was also translated in different ways depending on the context in which it was found and the author who was making the translation.

pulcher, pulchritudo

1. Cicero *Brut.* 70.

. . . non dubites pulcra dicere [i.e. the works of Myron].

See ἀλήθεια-*veritas*, passage 12.

2. Cicero *Brut.* 70.

. . . pulchriora etiam Polycliti etiam plane perfecta . . .

See *perfectus, perfectio*, passage 1.

3. Cicero *Brut.* 257.

. . . Minervae signum ex ebore pulcherrimum . . .

[Passing reference to the Athena Parthenos of Phidias:] . . . the extremely beautiful statue made of ivory . . .

4. Schweitzer, *Xenokrates*, p. 35. Earlier Robert, *Arch. Märch.*, p. 52, had suggested μέγεθος as the best translation of *pondus*. Silvio Ferri interprets *pondus* (as he did with *auctoritas*) literally; i.e. he feels that it means "physically heavy," and he suggests that it is a translation of the Greek term σταθμός. See Ferri, *NC*, p. 142. Polyclitus's failing, according to Ferri's interpretation, was that he made his statues of the gods too small and too light, hence inappropriate to their exalted subjects.

4. Cicero *Orat.* 8–9.

> Sed ego sic statuo, nihil esse in ullo genere tam pulchrum, quo non pulchrius id sit, unde illud ut ex ore aliquo quasi imago exprimatur, Quod neque oculis neque auribus neque ullo sensu percipi potest, cogitatione tamen* et mente complectimur. Itaque et Phidiae simulacris, quibus nihil in illo genere perfectius videmus, et eis picturis quas nominavi, cogitare tamen possumus pulchriora. Nec vero ille artifex cum faceret Iovis formam aut Minervae, contemplabatur aliquem, e quo similitudinem duceret, sed ipsius in mente insidebat species pulchritudinis eximia quaedam, quam intuens in eaque defixus ad illius similitudinem artem et manum dirigebat.

*tantum *L*; tamen *Reis*.

> But I believe it to be a fact that there is nothing in any category whatsoever so beautiful that there is not something still more beautiful, from which the thing in question is formed rather like a mask copied from someone's face. This original cannot be perceived with the eyes nor with the ears nor with any of the senses, but we may grasp it with our imagination and our mind. For even in the case of the images of Phidias, than which we see nothing more perfect in any category, and in those pictures which I have mentioned, we are nevertheless able to conceive of something still more beautiful. Nor indeed did that artist when he made the form of Zeus or Athena, contemplate any persons from whom he drew a likeness, but rather a sort of extraordinary apparition of beauty resided in his own mind, and, concentrating on it and intuiting its nature, he directed his art and his hand toward making a likeness of it.

5. Pliny *NH* 34.43.

> . . . dubium aere mirabiliorem an pulchritudine . . .

See *mirabilis*, passage 4.

6. Pliny *NH* 34.54.

> . . . Minervam tam eximiae pulchritudinis ut formae cognomen acceperit.

> [Phidias made] an Athena of such outstanding beauty that it got the *cognomen* "the Fair One."

7. Pliny *NH* 34.69.

> Praxiteles . . . fecit tamen et ex aere pulcherrima opera.

See *felix,* passage 3.

8. Pliny *NH* 35.153.

. . . similitudines reddere instituit; ante eum [Lysistratus] quam pulcherrimas facere studebant.

See *similitudo,* passage 11.

9. Pliny *NH* 36.18.

neque ad hoc Iovis Olympii pulchritudine utemur . . .

See *ingenium,* passage 10.

10. Quintilian *Inst.* 12.10.9.

Olympium in Elide Iovem fecisset, cuius pulchritudo adiecisse aliquid etiam receptae religioni videtur . . .

See *maiestas,* passage 2.

11. Quintilian 12.10.9.

Demetrius . . . fuit similitudinis quam pulchritudinis amantior.

See ἀλήθεια-*veritas,* passage 23.

See also:

Cicero *Div.* 1.13.23, Aphrodite of Cos by Apelles.
———— *Inv. Rhet.* 2.1.1, *muliebris formae pulchritudinem* (the Helen of Zeuxis).
———— *Off.* 3.2.10, copy of Aphrodite of Cos.
———— *Orat.* 2.5, Aphrodite of Cos by Apelles.
———— *Verr.* 2.4.4, Eros by Praxiteles.
———— *Verr.* 2.4.93, *signum Apollonis pulcherrimum* by Myron.
Columella *De Rust.* 1.praef. 21, on Phidias's Zeus.
Pliny *NH* 35.20, on the works of Turpilius of Venetia.
Aulus Gellius *AN* 15.31, Ialysos of Protogenes.

Commentary

Pulchritudo, the equivalent of κάλλος, means "beauty" and is characterized by the same vagueness of definition that afflicts the English word. *Pulchritudo* seems distinguishable from *venustas,* as κάλλος is from χάρις, in that χάρις-*venustas* expresses a graceful appearance or effect which is essentially a matter of simple sense experience, while κάλλος-*pulchritudo* can sometimes express a beauty which is understood as an abstract quality or idea.

The latter shade of meaning undoubtedly explains the frequency with which *pulchritudo* occurs in connection with the *phantasia* theory as preserved by Cicero and Quintilian (chaps. 2 and 7 and passages 1, 2, 4, 10, and 11 above). According to this theory, Phidias's expression of the *pulchritudo* and other qualities of the gods was viewed as the supreme achievement in sculpture, an achievement of such magnitude that it "added something to traditional religion" (passage 10). The influence of the *phantasia* theory in turn probably explains the general frequency with which *pulchritudo* is ascribed to the art of Phidias, even in passages which are not directly related to the theory (e.g. passages 3, 4, 6, 9).

Κάλλος-*pulchritudo* seems to have been used to contrast qualities of Classical Greek art with a growing tendency toward realism (ὁμοιότης-*similitudo*) in Hellenistic art. On this question see *similitudo*.

rigor, rigidus

1. Cicero *Brut.* 70.

. . . Canachi signa rigidiora esse quam ut imitentur veritatem.

See ἀλήθεια-*veritas*, passage 11.

2. Pliny *NH* 35.58.

. . . plurimumque picturae primus contulit, siquidem instituit os adaperire, dentes ostendere, voltum ab antiquo rigore variare.

[Polygnotus] . . . contributed many innovations to the art of painting, since it was he who first established the method of depicting the mouth as open, of showing the teeth, and of varying the face from the rigidity characteristic of earlier times.

3. Quintilian *Inst.* 12.10.7.

. . . iam minus rigida Calamis . . .

See *durus*, passage 5.

Commentary

Rigidus, along with *durus*, probably served as a translation of the Greek σκληρός and was used to express the compositional "stiffness" which some Hellenistic critics of art felt to be characteristic of Archaic and Early Classical sculpture.

In passage 3 *Tuscanicis proxima,* "like Etruscan sculptors," is probably a parenthetical remark added by Quintilian to clarify for his Latin readers what the Greek critics meant by σκληρότης.

For further commentary see *durus.*

severus

1. Pliny *NH* 35.120.

. . . gravis ac severus . . . pictor Famulus.

See *floridus,* passage 3.

2. Pliny *NH* 35.130.

. . . in coloribus severus*. . . . [Antidotus].

*severior *d Th.*

See *diligens,* passage 10.

3. Pliny *NH* 35.137.

Pausiae filius et discipulus Aristolaus e severissimis pictoribus fuit . . .

Aristolaus, the son and pupil of Pausias, was among the most severe painters . . .

Commentary

Severus resembles *durus* (q.v.) in that it can be used to characterize a certain type of color, but it also has other, more general significances. What the term means in connection with colors in passage 2 is difficult to say. It may be related to *austerus* (q.v.) and refer to Antidotus's predilection for *austeri colores*; the fact that passage 2 seems to reflect the language of "Xenocrates" and professional criticism (e.g. *diligentior* and *numerosior*) lends some credence to this idea. *Severus* might, however,. simply refer to strong, unmodulated color (as suggested for *durus*).

In passage 3 *severus* might also refer to a certain type of coloration, although another possibility is that it was Aristolaus's subjects which made him seem *severus*. The subjects of the paintings which Pliny mentions in *NH* 35. 137 —Epaminondas, Pericles, Medea, a Virtue, Theseus, a personification of the people of Attica, and a sacrificial scene—do have a serious ring to them.

As used to characterize the Roman painter Famulus in passage 1, *severus* probably refers to the artist's personality. Famulus was so earnest about his

427

work that he wore a toga even while painting. The fact that he was one of the painters of the Golden House of Nero makes it perhaps unlikely that his *severitas* was in subject matter; and if one takes *severus* as referring to colors in this passage, difficulties arise, since a painter who was *severus* would probably not also be characterized as *floridus*.

What Greek term *severus* translated is not immediately apparent, since none of the terms that would seem most likely to be equivalent—for example, πικρός, χαλεπός, or δεινός—seems to occur in criticism of the visual arts. Perhaps *severus* was an alternate translation, along with *durus*, of σκληρός. Σεμνός and βαρύς are also possibilities (compare under *gravitas*). Βαρύς, in particular, could refer to a "severe" personality (*LSJ*⁹, 2) and also to a sharp or strong sound (*LSJ*⁹, 3.1); hence, βαρύς, like *severus*, could refer both to persons and to sense impressions. But, as far as I can determine, βαρύς was never used to refer to color.

siccus

1. Pliny *NH* 34.65.

. . . corpora graciliora siccioraque . . . [the works of Lysippus].

See *gracilis*, passage 2.

Commentary

As pointed out under *gracilis*, the passage cited above seems to be derived from "Xenocrates' " analysis of Lysippus's innovations in proportion. Lysippus made the bodies of his statues "slenderer" (gracilis = λεπτός) and "*sicciora*," literally "dryer." *Siccus* in this context is undoubtedly a translation of some Greek term, and our understanding of its meaning is dependent on the meaning of the original Greek term. There are two Greek words which may have served as the prototype of *siccus*—ἰσχνός and ξηρός. Like *siccus*, both of these terms can mean literally "dry."[5] Both terms, moreover, also refer to a physical "thinness" or "spareness" in the human body,[6] and both may be derived from the vocabulary of medicine in the fifth century B.C. Ξηρός is used to refer to thinness in the Hippocratic treatise on *Regimen in Health* 2 : τοὺς δὲ στρυφνούς τε καὶ προεσταλμένους καὶ πυρροὺς καὶ μέλανας τῇ ὑγροτέρῃ διαίτῃ χρῆσθαι τὸ πλεῖον τοῦ χρόνου. τὰ γὰρ σώματα τοιαῦτα. ὑπάρχει ξηρὰ ἐόντα. ("Those who are lean and sinewy, whether

5. E.g. Aristophanes *Ach.* 469, ἰσχνὰ φυλλεῖα; Plato *Laws* 746D, μέτρα ξηρὰ καὶ ὑγρά.
6. E.g. Plato *Laws* 665E, χοροὶ . . . ἰσχνοί τε καὶ ἄσιτοι; Euripides *El.* 239: οὔκουν ὁρᾷς μου πρῶτον ὡς ξηρὸν δέμας.

ruddy or dark, should adopt a moister regimen for the greater part of the time, for the bodies of such are dry by nature.") In other words, human bodies which are lean (προεσταλμένους, literally "with skin close against the bones") are also by nature dry. 'Ισχνός is used to mean "thin" in the Hippocratic *Aphorism* 2.44: οἱ παχέες σφόδρα κατὰ φύσιν ταχυθάνατοι γίγνονται μᾶλλον τῶν ἰσχνῶν. ("Those who are extremely fat are more apt to die quickly than those who are thin.")

Thus both ἰσχνός and ξηρός could have been the Greek prototype for *siccus* in Pliny; ἰσχνός, however, may be the more acceptable of the two, for it was more frequently used in connection with style than was ξηρός. Demetrius uses ἰσχνότης in connection with Archaic sculpture: ἀρχαῖα ἀγάλματα ὧν τέχνη ἐδόκει ἡ συστολὴ καὶ ἰσχνότης (*Eloc.* 14); and other writers on rhetoric use ἰσχνός to describe a particular, simple, unadorned style of rhetoric.[7]

It is probable that in Pliny's passage on Lysippus both *siccus* and *gracilis* are intended to convey the same quality in the sculptor's figures. *Gracilis* means "slender," and *siccus* must therefore convey something like "compactness, tightness of musculature." Perhaps "slenderer and leaner" is the best translation of *graciliora siccioraque*.

Graciliora siccioraque seems to describe accurately some of the statues (all, with the exception of the Agias, Roman copies) that are commonly ascribed to Lysippus by modern scholars. The Apoxyomenus in the Vatican and the Agias at Delphi might be called "slim" and "lean" in their musculature.[8] On the other hand, the Heracles Farnese in Naples can hardly be said to be so.[9] Presumably not every work of Lysippus was slender and spare. If, however, Xenocrates, who must have known the work of Lysippus far better than modern archaeologists can ever hope to, felt that slenderness and spareness were characteristic of the statues of Lysippus, the modern critic is safe in assuming that, on the whole, they ·were. In any case, modern opinion about the accuracy or inaccuracy of ancient critical judgments is irrelevant

7. Dionysius of Halicarnassus *Pomp.* 2: ἰσχνὸν χαρακτήρ; Quintilian *Inst.* 12.10.58: *Namque unum* (i.e. *genus dicendi*) *subtile quod* ἰσχνόν *vocant*; Demetrius *Eloc.* 190: τοῦ ἰσχνοῦ χαρακτῆρος.

8. See Richter, *SSG⁴*, figs. 790, 791. F. P. Johnson, *Lysippos* (Durham, N.C., 1927), p. 90, objects to the use of the word *dry* in connection with the musculature of Lysippus: " . . . with its soft and richly modeled flesh it [the Apoxyomenus] is dry only in contrast to a body actually fat."

9. Richter, *SSG⁴*, fig. 801; Johnson, *Lysippos*, pl. 37. This copy was executed by the sculptor Glycon. The Heracles Farnese type is attributed to Lysippos on the basis of an inscription on a statuette in Florence (Johnson, *Lysippos*, pl. 38A). Erik Sjöqvist, however, has drawn attention to another version of the Farnese type from Salamis in Cyprus which is much more *siccus* in appearance; see his *Lysippus* (Cincinnati, 1966), fig. 16.

for our purposes. The fact is that, whether modern students agree or not, some ancient critics *did* feel that the works of Lysippus were λεπτὰ καὶ ἰσχνά.

similitudo

1. Cicero *Nat. D.* 1.27.75.

Dicemus igitur idem quod in Venere Coa: corpus illud non est, sed simile corporis, nec ille fusus et candore mixtus rubor sanguis est, sed quaedam sanguinis similitudo; sic in Epicureo deo non res sed similitudines rerum esse.

[The gods, it is maintained, have no solid, definite outer form.] Therefore we shall speak of them as we would of the Aphrodite of Cos [of Apelles]; for that is not a real body, but the likeness of a body, nor is that real red blood which suffuses her and is blended with her whiteness, but rather only a kind of likeness of blood; likewise in the Epicurean god we shall say that there is nothing real but rather only likenesses of real things.

2. Cicero *Orat.* 9. See *pulcher, pulchritudo,* passage 4.

3. Vitruvius 7.5.1. See *exemplum*, passage 3; see also Vitruvius 1.2.5.

4. Petronius *Sat.* 83.

Tanta enim subtilitate extremitates imaginum erant ad similitudinem praecisae, ut crederes etiam animorum esse picturam.

For with such subtlety were the outlines of the images [in a painting by Apelles] made to accord with verisimilitude, that you would believe it was actually a picture of living souls.

5. Pliny *NH* 34.38.

In argumentum successus unum exemplum adferam, nec deorum hominumve similitudinis expressae. Aetas nostra vidit in Capitolio, priusquam id novissime conflagaret a Vitellianis incensum, in cella Iunonis canem ex aere volnus suum lambentem, cuius eximium miraculum et indiscreta veri similitudo non eo solum intellegitur, quod ibi dicata fuerat, verum et satisdatione.

As evidence of success I would put forward one example, an example of a likeness which was neither a god nor a man. In our own time on the

Capitoline, before it suffered its most recent conflagration when it was burned by the partisans of Vitellius, there was, in the cella of Juno a bronze image of a dog licking its wound, the miraculous excellence and vivid realism of which was shown not only by the fact that it was dedicated there, but also by the means taken to insure its safety.

6. Pliny *NH* 34.64.

. . . item Alexandri venationem, quae Delphis sacrata est, Athenis Satyrum, turmam Alexandri, in qua amicorum eius imagines summa omnium similitudine expressit.

[Lysippus] also did an Alexander's Hunt, which was dedicated at Delphi, a Satyr in Athens, and a Cavalry Squadron of Alexander, for which he made portraits of his [Alexander's] companions, executed with the greatest possible realism.

7. Pliny *NH* 34.83.

Praeter similitudinis mirabilem famam magna suptilitate celebratur . . .

Besides its marvelous fame as a likeness, it [a reputed self-portrait by Theodorus of Samos] is renowned for its great finesse . . .

8. Pliny *NH* 35.88.

Imagines adeo similitudinis indiscretae pinxit, ut—incredibile dictu— Apio grammaticus scriptum reliquerit, quendam ex facie hominum divinantem, quos metoposcopos vocant, ex iis dixisse aut futurae mortis annos aut praeteritae vitae.

He [Apelles] also painted portraits with such remarkable realism that— incredible as it seems—as the grammarian Apio has recorded, a certain one of those whom they call *metoposcopos,* a man who could divine the future from the faces of men, forecast from these portraits either the year of the subject's death in the future or how many years he had already lived.

9. Pliny *NH* 35.140.

Regina tolli vetuit, utriusque similitudine mire expressa.

[Ctesicles painted an obscene picture of Queen Stratonice cavorting with a fisherman, but the Queen was not offended.] The Queen refused

to allow it to be removed, the likeness of the two figures being marvelously expressed.

10. Pliny *NH* 35.151.

. . . fingere ex argilla similitudines Butades Sicyonius figulus primus invenit . . .

. . . Butades of Sicyon invented modeling likenesses in clay. [He did so by making a relief from a shadow outline which his daughter had made of her lover.]

See ὁμοιότης, passage 6.

11. Pliny *NH* 35.153.

Hic et similitudines reddere instituit; ante eum quam pulcherrimas facere studebant. Idem et de signis effigies exprimere invenit . . .

[Lysistratos, the brother of Lysippus, developed the process of making protraits by taking plaster impressions from the faces of living persons.] He also introduced the practice of making likenesses; prior to him they used to try to make portraits as beautiful as possible. He also invented the practice of taking casts from statues . . .

12. Quintilian *Inst.* 12.10.9.

Nam Demetrius tanquam nimius in ea reprehenditur et fuit similitudinis quam pulchritudinis amantior.

See ἀλήθεια-*veritas*, passage 23.

Commentary

Similitudo is the general Latin term for a "likeness" of anything, be it a divine form (passages 1 and 2), a human form, or inanimate objects (passage 3). It is also used in a general way to refer to verisimilitude or realism (passages 4, 5, 8, and 12). These two senses are frequently applied to portraiture, meaning either the portrait itself (passages 9, 10, and perhaps 11) or the realistic quality of a portrait (passages 6, 7, and 8). It seems to have been used to translate the Greek ὁμοίωμα and ὁμοιότης (q.v.).

In a number of passages the language and context in which *similitudo* appears has the ring, as one might expect, of popular criticism—for example, *mirabilem famam* in passage 7, *incredibile dictu* in passage 8, and *mire expressa* in passage 9.

Passage 12, on the other hand, belongs in the tradition of classicistic

criticism that centered around the *phantasia* theory. The naturalistic phase, which terminated the development of sculpture according to this theory, was characterized by the *similitudo* of Demetrius, a sculptor from the Deme of Alopeke in Attica,[1] rather than the *pulchritudo* of Phidias (see chap. 7).[2] It may be that in formulating this judgment the author or authors of the *phantasia* theory were thinking primarily of realistic developments in Hellenistic portraiture.[3]

The critical tradition to which Pliny's comments in passage 11 should be assigned is more problematical. The language of the passage—its contrast of *pulchritudo* with *similitudo*—is very similar to Quintilian's comment on Demetrius and at first inspection seems to associate the passage with the classicistic outlook of the later Hellenistic period. But Lysistratus, as the brother of Lysippus, must have been a member of the Sicyonian school, and his work certainly must have been known to Xenocrates. This fact raises the possibility that the distinction between Classical *pulchritudo* (κάλλος) and Hellenistic *similitudo* (ὁμοιότης) might have originated in the treatise of Xenocrates, without any pejorative connotation being attached to ὁμοιότης, and have later been adopted by the framers of the *phantasia* theory. The terms τὸ κάλλος and τὸ εὖ, as noted in chapter 1, seem to have reflected the goal of the *Canon* of Polyclitus. Perhaps κάλλος-*pulchritudo* was in general the goal of the theories of form and proportion (ῥυθμός and συμμετρία) of

1. Four statue bases bearing the signature of Demetrius are known (*IG*, II², 3828, 4321, 4322, 4895), and these appear to date from the first half of the fourth century B.C., which we may accept as the general period of the sculptor's activity. The literary evidence is less specific with regard to his dates. Pliny informs us that Demetrius made a portrait of Simon, who wrote the first treatise on horsemanship (*NH* 34.76). Simon is mentioned by Xenophon (περὶ ἱππικῆς 1), and hence his work *On Horsemanship* must be dated before 354 B.C., the year of Xenophon's death. Whether Simon himself died before or after Xenophon, however, is not known. D. M. Lewis has proposed the interesting suggestion that Lysimache, the woman who was priestess of Athena for sixty-four years and of whom Demetrius made a portrait (*NH* 34.76) was probably the inspiration for the character of Lysistrata in Aristophanes' comedy (produced 411 B.C.). See his "Notes on Attic Inscriptions II," *BSA* 50 (1955): 3–5. If the connection between Lysimache and Lysistrata is true, it would tend to place Demetrius rather early in the fourth century.

2. Passage 2, it might be noted, is also connected with the *phantasia* theory, but here *similitudo* is used in the simple sense of "a likeness," not the general quality "verisimilitude."

3. Whether the extremely realistic portraiture with which Pliny, as a Roman, would have been familiar, really was created in the time of Lysippus and Lysistratus is doubtful. The wax molds from which Lysistratus made plaster casts may have been used primarily for anatomy rather than for the face. The transition from Classical portraiture, which aimed at *pulchritudo*, to Hellenistic portraiture, which aimed at *similitudo*, was clearly characterized, however, by an increasing interest in the rendering of naturalistic detail. Compare, for example, Cresilas's portrait of Pericles with the Demosthenes of Polyeuctus; see G. M. A. Richter, *The Portraits of the Greeks* (London, 1965), p. 102 and figs. 429–36; pp. 215–23 and figs. 1397–513.

Classical sculpture and painting. The application of these theories certainly would have helped to perpetuate a tendency toward generalization or idealism, as opposed to realism, in Greek art. Lysistratus's practice of taking casts from living models obviously would have conflicted with this tradition and have moved Greek art, as well as art criticism, in a new direction. The realism which must have resulted from it, as Rhys Carpenter has noted,[4] probably affected not only portraiture but also treatment of the human figure as a whole. The term *facies* in Pliny's description of Lysistratus's procedure, *hominis autem imaginem gypso e facie ipsa primus omnium expressit,* refers to the "surface" rather than exclusively to the face of a figure.

simplex

1. Quintilian *Inst.* 12.10.3.

. . . Polygnotus et Aglaophon, quorum simplex color tam sui studiosos adhuc habet.

[For what precedes, see *vetustas,* passage 1.] . . . Polygnotus and Aglaophon, whose simple coloration has even today its zealous admirers . . .

From *sem/sim,* "once," and *plico,* "weave," literally "woven once." For commentary see ἁπλότης.

sollers

1. Cicero *Acad. Pr.* 2.47.146.

. . . sic ego nunc tibi refero artem sine scientia esse non posse. An pateretur hoc Zeuxis aut Phidias aut Polyclitus, nihil ne scire, cum in iis esset tanta sollertia?

. . . thus I now reply to you that it is impossible to have art without knowledge. Indeed, would Zeuxis or Phidias or Polyclitus have tolerated the view that they knew nothing, when there was such great skill in them?

2. Horace *Odes* 4.8.4 ff.

Parrhasius . . . aut Scopas . . . sollers nunc hominem ponere, nunc deum.

4. Rhys Carpenter, "Observations on Familiar Statuary in Rome," *MAAR* 18 (1941): 74.

See *liquidus,* passage 1.

3. Vitruvius 1.1.1.

Ratiocinatio autem est, quae res fabricatas sollertiae ac rationis pro-
portione demonstrare atque explicare potest.

The theoretical basis of architecture [see chap. 5] is that which is able
to demonstrate and explain the constructions of skill and of reasoned
calculation in regard to proportion.

4. Vitruvius 3.praef.2.

At qui non minori* studio et ingenio sollertiaque fuerunt . . . hi
non ab industria neque artis sollertia sed a Felicitate fuerunt de-
cepti. . . . †Non minus item, pictores . . . quos neque industria neque
artis studium neque sollertia defecit.

*minori *HS*; minore *EG*;
†decepti *e²*; desepti *H*.

[For what precedes *Non minus* see *felix,* passage 1, and *perfectus, per-*
fectio, passage 7.] And this was no less true with regard to painters . . .
in whom neither industry nor zeal for their art nor skill was wanting.

See also Vitruvius 1.1.17–18, 2.praef.1, 2.1.6, 2.8.11, 3.3.9, 5.5.7, 5.6.7,
5.8.1, 6.1.10, 6.7.6, 7.praef.15, 8.6.12, 10.praef.3, 10.9.1.

5. Pliny *NH* 35.142.

. . . Nealces Venerem, ingeniosus et sollers . . .

See *ingenium,* passage 9.

Commentary

Sollers and *sollertia* (perhaps from *sollus,* "entire, whole," and *ars,* hence
"with complete art, total skill") mean "very skillful" and "skill" respectively.
The term seems to imply in particular the skill that translates knowledge and
thought into action; hence, perhaps, its association with *scientia* (passage 1)
and *ratiocinatio* (passage 3) and also with *ingenium* (q.v.), "ingenuity."

Ingeniosus et sollers is an idiomatic phrase which denotes an inborn talent
and skill (passages 4 and 5). Carl Watzinger has suggested that these two
terms may represent specific aspects of the general quality of *natura* in the
triad *natura, doctrina,* and *usus* in rhetorical criticism.[5]

5. Carl Watzinger, "Vitruvstudien," *RhM* 64 (1909): 208.

Sollertia is similar in meaning to the Greek word εὐστοχία, "accuracy," and is perhaps to be explained at times (e.g. passage 5) as a translation of that term (see εὐστοχία).[6]

species

1. Cicero *Orat.* 9.

 . . . in mente insidebat species pulchritudinis eximia . . . [Phidias]

 See *pulcher,* passage 4.

2. Cicero *Div.* 1.12.21 (from Cicero's poem "De Consulatu").

 Haec tardata diu species multumque morata, consule te, tandem celsa est in sede locata . . .

 [At the bidding of Etruscan soothsayers a statue of Jupiter on a tall column was set up during Cicero's consulship (63 B.C.) in order to counteract prophecies of an impending destruction of Rome.] This statue was long delayed, and the hindrances to setting it up were many, but in your consulship it at last was placed in a lofty position . . .

3. Vitruvius 1.1.4.

 Deinde graphidis scientiam habere, quo facilius exemplaribus pictus quam velet operis speciem deformare valeat.

 [The architect should have an acquaintance with many disciplines and areas of knowledge.] Further, he should have knowledge of drafting, by which he will be more easily able to illustrate, through pictorial sketches, the appearance of a work which he is proposing.

4. Vitruvius 1.2.2.

 Species dispositionis, quae graece dicuntur ἰδέαι, sunt hae: ichnographia, orthographia, scaenographia.

 See σκηνογραφία, passage 4.

6. Note that πανοῦργος, the term for which *sollers* might be a literal translation, really means "knavery, knavish cunning" and could certainly not be the prototype for *sollers.* The terms δεξιός and δεξιότης imply an intellectual "cleverness" more than "skill."

5. Vitruiuvs 4.3.10.

Quoniam exterior species symmetriarum et corinthiorum et doricorum et ionicorum est perscripta, necesse est etiam interiores cellarum pronaique distributiones explicare.

Now that the external appearance of the proportional relationship of the Corinthian, Doric, and Ionic orders has been described, it is next necessary to explain the interior arrangements of *cellae* and *pronaoi*.

6. Vitruvius 7.praef.11.

. . . aedificiorum in scaenarum picturis redderent speciem . . .

See commentary under σκηνογραφία.

7. Vitruvius 7.5.7. See *subtilitas,* passage 5.

See also Vitruvius 1.2.4, 5; 2.1.8; 2.3.4; 2.8.20; 3.1.4; 3.3.11, 13; 3.5.9, 11,13; 4. praef. 1; 4.1.1, 7; 4.3.1; 5.1.10; 6.5.2; 8.3.6; 9.1.11.

8. Pliny *NH* 35.60.

Hic primus species exprimere instituit primusque gloriam penicillo iure contulit.

He [Apollodorus] first developed the method of expressing outward appearance and conferred glory on the paintbrush through law.

Commentary

Although not a critical term in itself, *species* is relevant to this study because the ideas it was used to express played an important role in professional criticism of painting (passage 8) and in the *phantasia* theory (passage 1). The term is related to *specio* and in its most basic sense means a "seeing" or "a look at something."

There seem to be three essential divisions in the meaning of *species*:

I. "Appearance." This is the most widely used sense of the term and has a number of subdivisions. It can mean (a) "appearance" in the simple sense of a visible form or figure; (b) "inner experience" or "apparition"; and (c) "pretense" or "appearance" as opposed to actuality.

II. "Idea" or "conception" in the philosophical, and particularly the Platonic sense. This usage is perhaps a philosophical extension of the meaning "apparition."

437

III. "Category, kind," or "species" in the English sense.

Of the passages cited here, passage 4 represents the use of *species* in the sense of "category" (meaning III), and passage 1 preserves the use of the term in the sense of "idea" (meaning II). The latter is one of the key passages relating to the *phantasia* theory (see chap. 2 and *pulcher, pulchritudo*). The remaining passages involve various applications of meaning I, particularly Ia. Cicero's use of *species* to mean "statue" in passage 2 is apparently a rare poetic extension of the term in the sense of "form" or "figure." "Form" might also be the simplest translation of *exterior species* in passage 5, where Vitruvius refers to the external appearance of the architectural orders.

In passages 3, 6, 7, and 8 *species* refers to the outward appearance of things as represented in painting. Passage 7 comes from Vitruvius's diatribe on new developments in painting in his own time (see chap. 5), and here *species* seems to preserve some of the derogatory connotation which was attached to the idea of "appearance" in the Platonic tradition (i.e. "appearance as opposed to reality"). This passage should be separated from the other three, which have no derogatory connotation and refer to the visible features of things that can be reproduced in painting through the application of the painter's knowledge and technique. In these cases in fact, *species* seems to be associated with some of the principal topics of inquiry and analysis of professional criticism. Passage 6 is connected with the beginning of the development of graphic perspective in Greek painting (see σκηνογραφία), and the *scientia* mentioned in passage 3 probably refers to the same process.

In passage 8, on the other hand, one of the most important of the "Xenocratic" judgments in Pliny's chapters on painting, *species* seems to refer to the development of shading (σκιαγραφία) in the later fifth century B.C. The great achievement of the painter Apollodorus, Pliny tells us, was that he *species exprimere instituit*. We know from other sources that Apollodorus was nicknamed in antiquity the σκιαγράφος (see σκιαγραφία). According to Plutarch *De glor. Ath.* 2 (see *lumen et umbra*), he was the first artist to discover the techniques of gradation and blending of shadow (i.e. "shading") in painting: πρῶτος ἐξευρὼν φθορὰν καὶ ἀπόχρωσιν σκιᾶς. His paintings were said to have been the first to "hold the eyes" (*quae teneat oculos, NH* 35.60). Apollodorus's immediate successor, Zeuxis, who according to Pliny entered the doors that Apollodorus had opened, is credited by Quintilian with having developed the *luminum umbrarumque rationem* (*Inst.* 12.10.4). The combined evidence of these passages makes it certain that Apollodorus (placed by Pliny in the 90th Olympiad, 420–417 B.C.) was acknowledged as the inventor of σκιαγραφία, the technique of painting in which the spatial mass of painted figures was convincingly depicted through the modulation of

light and shade. This technique achieved its aim not by measurement and clarity of line but rather by simulating human optical experience. Pliny's phrase *species exprimere* must refer to this innovation and should be translated "to express outward appearance."[7]

The Greek prototype of *species* in the simple sense of "appearance" might in some cases have been φαντασία (q.v.) in its basic, nonphilosophical sense, but the term was probably most often a translation of the Greek εἶδος or ἰδέα. These two terms, which are closely related to one another, both (like *species*) derive from a root meaning "see," and both have about the same range of meanings as *species*. Both εἶδος and ἰδέα can refer to outward appearance, sometimes being simply synonyms for σχῆμα, "form";[8] both terms can also refer to philosophical classes or kinds (cf. English *species*);[9] and both can refer to the Platonic "forms."[1]

We can only conjecture what the original Greek phrase was which Pliny translates in passage 8; perhaps it was something like πρῶτος δοκῶν τὰ εἴδη ἀποφαίνειν (or simply γράφειν), analogous to Diogenes Laertius's remark on ῥυθμός and συμμετρία in the art of the sculptor Pythagoras (see ῥυθμός, passage 7).

splendor

1. Vitruvius 7.3.8.

> Cum ergo itaque in parietibus tectoria facta fuerint, uti supra scriptum est, et firmitatem et splendorem et ad vetustatem permanentem virtutem poterunt habere.

> When, therefore, stucco work on walls is executed as described above, it will have solidity and brightneess and a long-lasting excellence.

7. The interpretation of *species* as "appearance" in Pliny's passage on Apollodorus has been widely accepted since the nineteenth century. See Brunn, *GGK*², 2: 49, and more recently Andreas Rumpf, *Malerei und Zeichnung* (Munich, 1953), pp. 120–26. Another possible interpretation is that he instituted the species of painting in a logical sense, that is, the categories or subdivisions of a genus (which in this case would be painting), but in view of what we know about Apollodorus from other sources this interpretation seems much less probable.

8. Cf. Herodotus 3.107: ὄφιες ὑπόπτεροι σμικροὶ τὰ μεγάθεα, ποικίλοι τὰ εἴδεα; Theognis 128: γνώμην ἐξαπατῶσι ἰδέαι. In relation to σχῆμα, see: Plato *Prt.* 315E: ἰδέαν πάνυ καλός; Hippocrates κατ᾽ ἰητρεῖον 3: σχῆμα καὶ εἶδος.

9. See Aristotle *Cat.* 2b7, *Metaph.* 1057b7 (for εἶδος); Plato *Euthphr.* 6D (for ἰδέα). See also passage 4 above.

1. Cicero *Top.* 7: *Formae sunt, quas Graeci ἰδέας vocant, nostri species appellant.* On εἶδος and ἰδέα in Plato see Sir William David Ross, *Plato's Theory of Ideas* (Oxford, 1951), chap. 2.

splendor

See also Vitruvius 7.9.2, 4; 9.2.2, 4.

2. Pliny *NH* 35.29.

. . . postea deinde adiectus est splendor, alius hic quam lumen.

See *lumen et umbra*, passage 2.

Commentary

Passage 2 makes it clear that *splendor*, along with τόνος, ἁρμογή, and φῶς καὶ σκιά, is one of the technical terms of the theory of color and light in Greek painting. As such it should probably be considered as a part of the broader *ratio* of σκιαγραφία. Pliny's phrase *postea deinde adiectus* indicates that *splendor* was a feature added after the basic technique of shading had already been invented.

While *lumen et umbra* apparently referred to the possible range of tonal variation in color produced by an admixture of white and black pigment (through the modulation of which human optical experience of atmosphere and light was simulated), *splendor* probably referred to the shine on the surface of any object in a painting produced when light was reflected from that surface. The modern term often used to describe this effect is *highlight*. This shine is analogous to the reflection of light from the surface of gems, for which Pliny also uses the term *splendor*: *post hunc siderites ferrei splendoris* . . . (*NH* 37.58).

Occurring as it does in a technical passage along with *tonos* and *harmogē*, *splendor* must certainly be a translation of a Greek term, but there is scarcely any direct evidence (such as an analogous passage in a Greek author) to suggest what this term was. Philostratus uses αὐγή to describe the shine from surface of gems: ὅρμοι γὰρ καὶ αὐγαὶ λίθων . . . (*Imag.* 2.8), and, since Pliny, as shown above, uses *splendor* to describe the same phenomenon, there may be some connection between the two words.[2]

For the sake of completeness it should be noted here that *splendor* was also used in rhetorical criticism to denote brilliance of language (Cicero *Orat.* 110: . . . *Aeschini et splendore verborum*) and a good speaking voice (Cicero *Brut.* 239: . . . *et in voce magnum splendorem.* . . . In spite of the frequent connections we have found between the critical vocabulary of rhetoric and that of the visual arts, this is one case in which there seems to be no strong connection between the rhetorical term and its counterpart in the criticism

2. Αὐγή is used as early as Homer to indicate the shine or gleam of shiny surfaces: *Il.* 13.341, αὐγὴ χαλκείη. It most commonly refers to the "rays" of the sun: *Il.* 17.371; *Od.* 6.98, or any bright light.

of painting. *Splendor* in painting referred to a very specific technical achieve-
ment, not simply to a quality of a certain person's style (as in rhetoric),
and belongs to the technical vocabulary of Greek painters.

It is possible that *splendor* was introduced as part of the technique of σκια-
γραφία by the painter Pausias. Pliny credits him with an invention which
many later copied but which no one could equal (Pliny *NH* 35.126–27).[3]
This invention was illustrated by a painting in which Pausias depicted an
ox in foreshortening (*adversum eum pinxit, non traversum*) and indicated the
length of its body (*intellegitur amplitudo*), not by rendering in light color all
the parts he wished to have appear prominent—which was the technique
of other artists—but by rendering everything in black. He gave substance
to the dark body out of the shadow itself (. . . *umbraeque corpus ex ipsa dedit*)
and indicated solids on the level picture plane with great art (. . . *magna
prorsus arte in aequo extantia ostendente et in confracto solida omnia*), apparently by
showing the breaking up of light on the surface of the ox (this is what I take
to be the probable meaning of *in confracto*). Although Pliny's language is
not completely clear, what Pausias may have done was to have shown
highlight or shine reflected from the glossy black surface of the ox—that
is, to have expressed its substance not so much through *lumen et umbra* as
through *splendor et umbra*.

As an example of what *splendor* in fourth-century painting probably looked
like, one might cite the horses of the Alexander Mosaic, particularly the
horse seen in rear-view in the right-center of the mosaic. As the shield next
to this horse demonstrates, the painter whose work the mosaic copies seems
to have had a particular fascination with reflected light.[4]

When used in connection with painting but without the technical con-
notations of passage 2, *splendor* seems to have meant simply "brightness"
or a "bright glow." (See the passages in Vitruvius cited above and also, for
example, Pliny *NH* 33.121.) The passages in which the term is used in this
sense do not seem to have any connection with Greek art criticism.

subtilitas, subtilis

1. Vitruvius 4.1.10.

 . . . Callimachus qui propter elegantiam et subtilitatem artis . . .

3. The portion of this passage which describes the actual composition of Pausias's painting
is usually ascribed to Xenocrates. See August Kalkmann, *Die Quellen der Kunstgeschichte des
Plinius* (Berlin, 1898), p. 77; Sellers, *EPC*, note on *NH* 35.126; O. J. Brendel, "Immolatio
Boum," *RömMitt* 45 (1930): 217–18.

4. For a color illustration see Amadeo Maiuri, *Roman Painting* (Geneva, 1953), p. 69. For
details see Bernard Andreae, *Das Alexandermosaik, Opus Nobile*, no. 14 (Bremen, 1959).

See *elegantia, elegans,* passage 4.

2. Vitruvius 5.9.3. See *gravitas, gravis,* passage 1.

3. Vitruvius 6.8.9. See *dispositio,* passage 3.

4. Vitruvius 7.praef.17. See *auctoritas,* passage 5.

5. Vitruvius 7.5.7.

Quod enim antiqui insumentes laborem ad industriam probare con-
tendebant artibus, id nunc coloribus et eorum eleganti* specie
consecuntur, et quam subtilitas artificis adiciebat operibus auctoritatem,
nunc dominicus sumptus efficit, ne desideretur.

*eleganti *GS*: aligan

That commendation in the arts which the ancients sought through
hard work and care, the present pursues through colors and their
elegant [or enticing] effect, and whereas the refinement of the artist
once added impressiveness to the work, the expenditure of the patron
now produces it, lest something seem missing.

See also Vitruvius 4.praef.2; 4.1.8, 12; 7.9.3; 10.praef.2; 10.7.5; 10.8.6.

6. Petronius *Sat.* 83. See *similitudo,* passage 4.

7. Pliny *NH* 33.157.

. . . fecit idem et cocos magiriscia appellatos parvolis potoriis et e
quibus ne exemplaria quidem liceret exprimere; tam opportuna
iniuriae subtilitas erat.

[Pytheus] also made some figures of cooks, called the *Magiriscia,* in
the form of small cups, of which it was not permitted even to make
casts; so liable to damage was the fineness of the work.

8. Pliny *NH* 34.83.

Praeter similitudinis mirabilem famam magna suptilitate celebratur
[in the portrait of Theodorus of Samos].

See *similitudo,* passage 7.

9. Pliny *NH* 35.67.

. . . confessione artificum in liniis extremis palmam adeptus. Haec
est picturae summa subtilitas.*

*suptilitas **B**: sublimitas *rv*.

See *lineamenta*, passage 6.

10. Pliny *NH* 35.82.

Ferunt artificem protinus contemplatum subtilitatem dixisse Apellen
venisse, non cadere in alium tam absolutum opus; ipsumque alio colore
tenuiorem lineam in ipsa illa duxisse abeuntemque praecipisse, si
redisset ille, ostenderet adiceretque hunc esse quem quareret. Atque
ita evenit. Revertit enim Apelles et vinci erubescens tertio colore
lineas secuit nullum relinquens amplius subtilitati locum.

[Apelles called at the studio of Protogenes and rather than leave his
name, he painted a fine line to identify himself.] The story goes that
when the artist [Protogenes] first contemplated the fineness of the line,
he said that Apelles had come, for such perfect work was not consistent
with any other painter. He himself drew another line in another color
on top of the first one and, leaving the studio, instructed his servant that,
if Apelles returned, he should show him the line and add that this was
the person for whom he was searching. And this is just what happened.
For Apelles returned and, red with shame that he should be defeated,
cut the earlier lines with a third color in such a way that he left no
room for any further subtlety.

11. Quintilian *Inst.* 12.10.4.

Parrhasius . . . examinasse subtilius lineas traditur.

See *lineamenta*, passage 9.

Commentary

Subtilis (from *subtexo*, "weave"; hence, "finely woven" or "fine") is related
in the terminology of art criticism to the Greek term λεπτός of which it
seems to be, in certain cases, the Latin translation (see λεπτός). Unlike
subtilis λεπτός does not have any semantic connection through its etymology
with the idea of weaving; but it was used, as early as Homer, to refer to the
"fineness" of textiles (see λεπτός, passage 1, and ἀκρίβεια, passage 22),

443

and the general association of the two terms in art criticism may derive from this common ground.[5]

Vitruvius uses *subtilis* and *subtilitas* to refer to "refinement" or "subtlety in workmanship" (passages 1, 3, 4, and 5) or a "lightness of effect" (the opposite of *gravitas*) produced by subtle workmanship (passage 2). Both meanings also apply to λεπτός and λεπτότης, although only in passage 1 is there a really compelling reason for thinking that Vitruvius is translating a Greek term: his *elegantiam et subtilitatem* bears a striking resemblance to the phrase λεπτότητας ἕνεκα καὶ τῆς χάριτας which Dionysius of Halicarnassus uses in connection with Callimachus (see passage 2 under λεπτός).

In passages 7 and 8 Pliny also uses *subtilitas* in the general sense of "refinement of workmanship." Passage 7 would certainly seem to be derived from a Greek source, perhaps the treatise *de toreutis* of Menander mentioned in Pliny's index to *NH* 33.

Passages 6, 9, and 11 appear to reflect, directly or remotely, one of the technical judgments of Xenocrates' treatise on painting (see *lineamenta*). In *NH* 35.67–68, Pliny (passage 9) refers to Parrhasius's mastery of outline drawing as the *picturae summa subtilitas* and adds that *hanc ei gloriam concessere Antigonus et Xenocrates, qui de pictura scripsere, praedicantes quoque, non solum confitentes.* The essence of this *subtilitas*, Pliny tells us, was to include just the right amount within the outline (*modum includere*) and to suggest the parts of the figure that are not actually drawn.[6] Quintilian, in passage 11, also attests Parrhasius's preeminence in line drawing. His information, like Pliny's, probably goes back to Xenocrates, although it may have been transmitted by some intermediate source in Hellenistic rhetoric. In both authors the Latin *subtilis* and *subtilitas* are probably to be connected with an original Greek phrase, which was perhaps λεπτότης τῶν γραμμῶν (or τῶν γραμμάτων).

In passage 10, the anecdote about Apelles' and Protogenes' contest in drawing fine lines, *subtilitas* also refers to draftsmanship, but the source of the story is more likely to have been in the tradition of Duris of Samos than in the "Xenocratic" tradition. *Subtilitas* here is again probably a translation of λεπτότης, but the refinement which it expresses is probably understood more as a reflection of χάρις than ἀκρίβεια (qq.v.).[7]

5. Quintilian *Inst.* 12.10.58 uses *subtilis* to translate the Greek ἰσχνόν, the Greek name of the "plain" style of rhetoric. In connection with the visual arts, however, ἰσχνός seems more closely related to *siccus* (q.v.).

6. For the possible reflections of Parrhasius's style of drawing in Attic white-ground lekythoi see Andreas Rumpf, "Parrhasius," *AJA* 55 (1951): 1–12.

7. The *tenuitas* of the lines which the two artists drew may have resided not only in their thinness but also in their graceful curves. When Pliny says that Apelles' final line "cut"

successus

1. Pliny *NH* 34.38.

> Evecta supra humanam fidem ars est successu, mox et audacia. In argumentum successus unum exemplum adferam . . .

> The art [of bronze casting] rose to incredible heights, first in success, and subsequently in daring. As evidence of success I would put forward one example . . . [see *similitudo*, passage 5 for what follows].

2. Pliny *NH* 35.65.

> . . . cum ille detulisset uvas pictas tanto successu, ut in scaenam aves advolarent . . . [Zeuxis].

See ἀλήθεια-*veritas*, passage 20.

3. Pliny *NH* 35.67.

> . . . extrema corporum facere et desinentis picturae modum includere rarum in successu artis invenitur.

> [On Parrhasius's mastery of draftsmanship:] . . . but to make the contour of figures and to include just the right amount of the subject which is being delimited is a rare event in artistic achievement.

4. Pliny *NH* 35.104.

> Hoc exemplo eius similis et Neaclen successus, spumae equi similiter spongea impacta secutus dicitur, . . .

> [Protogenes achieved the effect which he desired in one of his paintings by throwing a sponge at it.] Following this example of his Nealces is said to have achieved a similar success in depicting the foam of a horse, that is, by throwing a sponge at it in the same manner . . .

Commentary

The commentary on *audacia* suggests that *successus*, along with *audacia*, formed part of the critical terminology of a Roman museographic theory of art history, according to which the steps in the history of bronze sculpture

(*secuit*) those drawn previously, he may mean that each line was simply drawn on top of the others, but he could also mean that curving but not necessarily identical designs weres uperimposed upon one another until it came to the point where there was no room for improvement.

could be classified on the basis of the objects which were produced by the sculptors—vessels, furniture, and, eventually, statues of men and gods. This theory was first identified as a unit by Friedrich Münzer and has been cited by Bernhard Schweitzer as a variant or offshoot of the thought of the Middle Stoa.[8]

The suggestion that the terms *successus* and *audacia* form a part of this theory is based on passage 1. Here, at the beginning of his exposition of the history of bronze sculpture, prior to his discussion of the best-known Greek sculptors, Pliny identifies two stages in the history of sculpture—*successus* and *audacia*—and illustrates them both by reference to works then to be found in Rome or elsewhere in Italy.[9] *Successus* is illustrated by a statue of a hound licking its wounds, which had stood in the cella[1] of Juno on the Capitoline before it was burned by the adherents of Vitellius (A.D. 69). The outstanding feature of this work was its *indiscreta veri similitudo* (*NH* 34.38). *Similitudo*, as we have seen, was the popular Latin word for "faithfulness to nature" and also for "portrait"; it thus expressed the criterion which has formed the basis of popular criticism of representational art in all ages— namely, that the copy (the work of art) should look as much like the original as possible. Perhaps in the museographic theory this was the first goal of sculpture after it reached the representational stage. Only after this had been accomplished with *successus* could the artist turn to *audacia*.

In view of the association of *successus* with popular criticism, it is not surprising that two of the passages quoted here stem clearly from popular anecdotes: passage 2 refers to the famous story of the birds which pecked at the lifelike grapes painted by Zeuxis; passage 4 refers of Nealces' success in representing the foam on a horse's mouth.[2]

Passage 3, which is part of Pliny's explanation of Parrhasius's mastery of line drawing (Greek λεπτότης γραμμῶν? Latin *subtilitas*)[3] might at first appear to belong to the level of professional rather than popular criticism, since the judgment about Parrhasius is directly attributed by Pliny to Xenocrates and Antigonus. But in view of the fact that *successus* elsewhere belongs clearly to popular criticism, it is possible that the phrase *rarum in successu artis* is a parenthetical remark made by Pliny himself and inserted into the rather technical language of his source.

8. Friedrich Münzer, "Zur Kunstgeschichte des Plinius," *Hermes* 30 (1895): 499 ff.; Schweitzer, *Xenokrates*, p. 41; see *audacia*.

9. With the exception, as noted under *audacia*, of the Colossus of Rhodes, which would have been known to any educated man.

1. See *similitudo*, passage 1.

2. A similar story is also told of Protogenes (*NH* 35.103).

3. See λεπτός and *lineamenta*.

Successus, like *audacia,* would appear to be a peculiarly Roman critical term, and it is probably not necessary to postulate a Greek term for which it served as the Latin translation. The Greek term εὐτυχία, "fortune, success," as Aristotle points out in *Rh.* 1361b39, can be the cause of some of the things with which the arts are also concerned—beauty and stature for example, but not, like *successus,* the end product of an artistic process. Κατόρθωσις, another possible Greek prototype (Aristotle *Rh.* 1380b4) is not used in connection with the visual arts.

venustas, venus

1. Cicero *Verr.* 4.3.5.

 Erant aenea praeterea duo signa, non maxima, verum eximia venustate, virginali habitu atque vestiti . . .

 There were in addition two bronze statues, not very large, but of extraordinary loveliness, in bearing and in their dress like young girls . . . [i.e. the Kanephorai of Polyclitus, in the collection of Heius in Messina].

2. Vitruvius 1.3.2. See *firmitas,* passage 1, and *elegans,* passage 3. See also Vitruvius 2.8.8; 3.3.6,13; 3.5.11; 4.1.6,8; 5.1.6,10; 6.7.7; 6.8.9; 7. praef. 18.

3. Pliny *NH* 35.67.

 . . . primus symmetrian picturae dedit, primus argutias voltus, elegantiam capilli, venustatem oris, . . .

 [Parrhasius] was the first to make use of *symmetria* in painting, the first to render the fine points of the face, the elegance of the hair, the beauty of the mouth . . .

4. Pliny *NH* 35.79.

 . . . deesse illam suam [Apelles'] venerem dicebat, quam Graeci χάριτα vocant . . .

 See χάρις, passage 3.

5. Pliny *NH* 35.111.

 . . . Nicophanes, elegans ac concinnus ita, ut venustate ei pauci conparentur . . .

447

See *cothurnus*, passage 1.

6. Ammianus Marcellinus 30.9.4.

. . . scribens decore venusteque pingens et fingens et novorum inventor armorum.

[Valentinian] wrote with a proper hand, painted and modeled beautifully, and was the inventor of new types of arms.

Commentary

Venustas seems to be distinguished from *pulchritudo* by the more mundane level of its associations. While there is a tendency in art criticism to use *pulchritudo* (q.v.; equals Greek τὸ κάλλος) to imply transcendental or ideal beauty in the Platonic sense, *venustas* would appear to refer to a more immediate sort of beauty which is known through simple sense perception. This beauty can be both a general feature of an artist's work or a specific quality manifest in a single object.

In passage 3 *venustas* is applied specifically to Parrhasius's ability to paint the human mouth. This passage, on the basis of its context, is probably to be ascribed to the historical system of "Xenocrates." The precise rendering of small details—ἀκρίβεια (q.v.)—appears to have formed an important step in the evolution of both painting and sculpture in "Xenocrates' " system.[4] *Venustatem oris* (χάρις τοῦ στόματος) was possibly one of several critical subcriteria under the general heading of ἀκρίβεια, along with such other features as the rendering of the hair and the veins.

Passage 4 is in all likelihood derived from the writings of Apelles himself and indicates that *venustas* was used by Latin writers to translate the Greek χάρις (q.v.).

While passages 3 and 4 may be taken to illustrate the use of *venustas* on the level of professional criticism (that of Apelles and "Xenocrates")in the early Hellenistic period, passage 5, Pliny's evaluation of the painter Nicophanes, seems to be derived from the later Hellenistic critical tradition, which had its origin in comparative canons of rhetoricians and sculptors. This is evident in the language used in the passage. *Elegans* (q.v.; Greek γλαφυρός) was one of the three principal stylistic categories of literary composition. The term *concinnus* (q.v.) is used by Cicero in connection with rhetorical style: *sententiae non tam graves et severae, quam venustae et concinnae (Brut.* 95);[5] and

4. For the equivalent step in sculpture, see Pliny *NH* 34.59: *hic primus* [Pythagoras] *nervos et venas expressit capillumque diligentius.*

5. See also Cicero *Fin* 5.5: *Aristo concinnus et elegans.*

gravitas and *cothurnus* (qq.v.) belong to the terminology of Greco-Roman literary and rhetorical criticism. In passage 5 *venustas* is again probably a translation of the Greek χάρις.

Passages 1 and 6 are not obviously derived from any Greek source and probably represent independent judgments on the part of the Latin authors in question. Vitruvius's division of the aims of architectural technique into *firmitas, utilitas,* and *venustas* (passage 2), on the other hand, may at least be modeled on a Greek terminological system. Carl Watzinger proposed that this triad, like all the others in Vitruvius's first book, was derived from a theoretical system of architectural aesthetics which went back to Posidonius.[6] This specific triad of terms is not found elsewhere, however, and it is equally possible that *firmitas, utilitas,* and *venustas* in Vitruvius are to be understood not as Latin translations of Greek terms but rather as traditional terms of Roman architectural criticism, here adapted to Greek modes of classification. On this question see *firmitas* and διάθεσις.

vetustas

1. Quintilian *Inst.* 12.10.3.

> Primi (i.e. pictores), quorum quidem opera non vetustatis modo gratia visenda sunt, clari pictores fuisse dicuntur Polygnotus atque Aglaophon . . .

> The first artists whose works should be looked at for the sake of something more than their age, are said to have been the famous painters Polygnotus and Aglaophon . . .

See also Vitruvius 2.1.6; 2.7.4; 2.8.2,6,9; 3.praef.1; 6.7.7; 6.8.3,10; 7.3.5,8; 7.8.4.

Commentary

The value of *vetustas* and its adjectival variants in art criticism is discussed under ἀρχαῖος. For the use of the term in connection with the visual arts but without any critical implication see Petronius *Sat.* 83 (paintings by Zeuxis which were *nondum vetustatis iniuria victas*) and Pliny *NH* 33.153 (see *auctoritas,* passage 9).

6. Carl Watzinger, "Vitruvstudien," *RhM* 64 (1909): 222.

General Index

(Italicized page numbers refer to the principal discussion of that subject.)

Aegina: temple of Aphaia, 226

Aeschylus: scene painting for drama of, 241–42

Aetion (painter), 110n1, 119, 397, 408, 409, 416

Agatharchus, (painter), 23, 118, 123, 240–42, 244–45

Aglaophon (painter), 81, 142–43, 434, 449

Agoracritus (sculptor): statue of Nemesis at Rhamnous, 260–62

Akesas and Helikon, 168

Alberti, Leone Battista, 68, 86n3

Alcamenes (sculptor), 61, 82, 108n7, 194–95, 282, 284; Aphrodite in the Gardens of, 172; Hephaestus of, 418; Hermes Propylaeus of, 157

Alcmaeon of Croton, 19

Alexander the Great, 127, 144, 148, 187, 269, 416, 431; funeral wagon of, 264, 278

Alexander Mosaic, 110n1, 331–32, 441

Alexandria, 60, 328; Alexandrian art, 328–29

Amelius, 203

Anaxagoras, 240–41, 245

Anaximenes, 16

Antidotus (painter), 353, 355, 410, 411, 414, 427

Antigonus of Carystus, 24, 62–63, 73, 74, 76, 77, 81, 85, 109n12, 123, 189, 254, 305, 337, 380, 394–96, 444, 446

Antigonus Gonatas, 237

Antiphilus (painter), 62, 82, 328, 369, 370, 408

Apaturius of Alabanda, 129, 307, 310, 363

Apelles (painter), 4, 11, 27, 62, 75, 76, 80, 82, 86n3, 95n32, 97n2, 107n5, 110n1, 119, 127, 131, 144, 164, 167, 173, 186, 190, 257, 278, 298, 303, 314, 324, 325, 326, 339, 340, 341, 353, 356–57, 358, 365, 366, 369, 374, 380, 381, 385, 387, 396, 397, 407, 409, 416, 430, 443, 444, 448; Aphrodite of Cos of, 129, 135, 393,

415, 425, 430; *charis* in the art of, 30, 299–300, 340, 391, 392, 447; portraits by, 431

Aphrodite, image of: in Athens, 264; on Delos, 265

Apollodorus (architect), 70

Apollodorus (painter), 24, 44, 76, 95n33, 108n10, 238, 250, 251–53, 270, 376, 377, 395, 400, 419, 437, 438

Apollodorus of Pergamon, 62–63

Apollonius of Tyana, 52, 156, 294

Archaic period: art of, 13–14, 22, 64, 182, 266, 360, 373, 429

Aretino, Pietro, 86n3

Aridices (painter), 393

Aristides of Thebes (painter), 24, 31, 186, 189, 255, 305, 337, 359, 361, 396, 419

Aristolaus (painter), 427

Aristophon (painter), 410

Aristotle: on art and character, 49–50; on *ēthos*, 188–89; on *mimēsis*, 39–41; on *phantasia*, 53–54; on *prepon*, 345; on Pythagorean thought, 17; on rhetoric, 59–60, 68; on *technē*, 35–37

Arrachion: Archaic image of, 155

Asclepiodorus (painter), 11, 80, 95n32, 167, 257, 358

Athena, image of: Aliphera in Arcadia, 199; in Amphissa, 156; in Piraeus, by Cephisodotus, 403

Athenion (painter), 245, 248, 261, 322, 389

Athenocles (engraver), 168

Athens: Odeum of Pericles, 161, 164; temple of Athena Nike, 212, 341; temple of Asclepius, 275

Atkins, J. W. H., 60

Bassae: temple of Apollo, 151, 153–54, 157

Bathycles (sculptor): throne of, at Amyclae, 259

Bellori, Giovanni Pietro, 3, 4

Brunn, Heinrich, 5, 174–75, 222

Bularchus (painter), 326, 349,

Index of Ancient Authors and Passages

This index is confined to passages which deal directly with the terminology of art criticism. For passages illustrating the use of τύπος, not indexed here, see pp. 272–84.

Page references to the glossary refer to the citation of particular passages in the initial lists of sources. Page references to the discussion of each passage in the succeeding commentaries are not given, except in the case of unusually long commentaries.

Index of Greek and Latin Terms

(Italicized page numbers refer to the glossary entry for that term.)

461